Beyond the Easel: Decorative Painting by Bonnard, Vuillard, Denis, and Roussel, 1890–1930

BEYOND

DECORATIVE PAINTING B

THE EASEL

ONNARD, VUILLARD, DENIS, AND ROUSSEL, 1890–1930

by Gloria Groom

WITH AN ESSAY BY
Nicholas Watkins

AND CONTRIBUTIONS BY
Jennifer Paoletti and Thérèse Barruel

THE ART INSTITUTE OF CHICAGO
Yale University Press, New Haven and London

This book was published in conjunction with the exhibition "Beyond the Easel: Decorative Painting by Bonnard, Vuillard, Denis, and Roussel, 1890–1930," organized by The Art Institute of Chicago in collaboration with The Metropolitan Museum of Art, New York.

EXHIBITION DATES:
The Art Institute of Chicago
25 February – 16 May 2001

The Metropolitan Museum of Art, New York
26 June – 9 September 2001

The exhibition was supported by an indemnity from the Federal Council on the Arts and the Humanities. In Chicago, the book and exhibition were made possible through the generous support of the Sara Lee Foundation. In New York, the exhibition was made possible in part by Janice H. Levin.

Produced by the Publications Department of The Art Institute of Chicago:

Susan F. Rossen, Executive Director

Edited by Margherita Andreotti, Senior Editor for Scholarly Publications, and Katherine Reilly, Special Projects Editor; assisted by Faith Brabenec Hart, independent editor, Lisa Meyerowitz, Special Projects Editor, and Susan F. Rossen, Executive Director

Production by Amanda Freymann, Associate Director of Publications, Production, and Stacey Hendricks, Production Assistant; assisted by Karen Gephart Altschul, Photo Editor

Designed and typeset by Joan Sommers Design, Chicago, Illinois
Separations by Professional Graphics, Rockford, Illinois
Printed and bound by Butler & Tanner, Ltd., Frome, England

Clothbound edition distributed by Yale University Press, New Haven and London
ISBN 0-300-08925-2
(clothbound edition)

ISBN 0-86559-189-x
(paperbound edition)

First Edition

LIBRARY OF CONGRESS CATALOGING-IN-PUBLICATION DATA

Groom, Gloria Lynn.
 Beyond the easel: decorative painting by Bonnard, Vuillard, Denis, and Roussel, 1890–1930/by Gloria Groom; with contributions by Thérèse Barruel, Jennifer Paoletti, and Nicholas Watkins.
 p. cm.
 Catalog of an exhibition held at The Art Institute of Chicago, Feb. 25–May 16, 2001 and the Metropolitan Museum of Art, June 26–Sept. 9, 2001.
 Includes bibliographical references and index
 ISBN 0-300-08925-2 (cloth: alk. paper)
 1. Decoration and ornament—France—History—19th century—Exhibitions. 2. Decoration and ornament—France—History—20th century—Exhibitions. 3. Symbolism in art—France—Exhibitions. I. Barruel, Thérèse. II. Paoletti, Jennifer. III. Watkins, Nicholas. IV. Art Institute of Chicago. V. Metropolitan Museum of Art (New York, N.Y.). VI. Title.

NK1449.A1 G76 2001
759.4'074'7471—dc21 00-043970
 CIP

For photography credits, see p. 284.

Front cover: See cat. 50.

Back cover: See cat. 80.

Frontispiece: Detail of cat. 58.

Contents: Detail of cat. 18.

Page VIII: Detail of cat. 33.

Endpapers: Detail of cat. 64.

CONTENTS

THE NOTION OF PAINTING AS DECORATION, as an integral enhancement of one's living space, is in many ways as relevant today as it was at the turn of the twentieth century. By that time, the private interior was seen as a realm for meditation and retreat as much as for hospitality and social gathering. The paintings by Pierre Bonnard, Edouard Vuillard, Maurice Denis, and Ker Xavier Roussel gathered here illustrate the rich and varied possibilities of an art that affirmed and enhanced what we would refer to today as individual "life-styles." They also offer some of the finest examples of these artists' oeuvre, works that in many cases had been lost from view, and that have had a widespread, though little recognized, impact on twentieth-century art.

With this exhibition and catalogue, we thus celebrate the achievement of these four artists and friends, and the many ways in which they combined the goals of painting as decoration with the needs of their patrons, the requirements of a particular interior, and their personal struggle to rethink and reinvent their own art. Assembling these paintings has been an unprecedented and ambitious undertaking, a challenge that curator Gloria Groom has met with both her exacting scholarship and her boundless enthusiasm, ably assisted by the staffs of both of our museums. Bringing these works together has been difficult precisely because they were intended for private interiors in ways that went well beyond the conventions of easel painting then governing technique, format, size, and style. In some cases, for example, the paintings were glued to the wall or were painted in the unusual technique of glue-based tempera, known as distemper, following a complicated process that yields the matte, crusted, frescolike surface desirable in *décoration*, but that also requires special care because of the medium's fragility.

Reuniting works that were often conceived as ensembles, pendants, or series and that are now dispersed among many owners and institutions was another challenge. It is with heartfelt thanks, therefore, that we acknowledge all those who made their exquisite paintings, folding screens, and stained-glass-window designs available to this exhibition. Their extraordinary generosity has made it possible to tell the little-known story of these artists' careers as painter-decorators.

Our commitment to this exhibition and catalogue relied on the indispensable and exceptionally generous support of Sara Lee Corporation in Chicago. Additional funding for research assistance came from the David and Mary Winton Green Research Fund. The exhibition in New York would not have been possible without the outstanding generosity of Janice H. Levin. Both our institutions benefited greatly from an indemnity from the Federal Council on the Arts and Humanities, which enabled us to transport safely these stellar examples of painting as decoration from private and public collections around the world.

James N. Wood
Director and President
The Art Institute of Chicago

Philippe de Montebello
Director
The Metropolitan Museum of Art

CURATORS OF THE EXHIBITION

GLORIA GROOM

David and Mary Winton Green Curator in the Department of European Painting at
The Art Institute of Chicago

REBECCA A. RABINOW

Assistant Research Curator in the Department of European Paintings at
The Metropolitan Museum of Art, New York

THE ORIGINS OF THIS EXHIBITION date back to 1981 when, as a graduate student at the University of Texas, Austin, I began two years of research on the decorative projects of the Nabi artists Bonnard, Vuillard, Denis, and Roussel. At the time, I was ambitiously determined to write the history of all of their patrons and projects. Halfway through my research, I realized that the scope of the topic was far too great for a single, in-depth study, and I thus finished by writing only on Vuillard and only on his paintings between 1890 and 1900. This exhibition and the accompanying catalogue are in many respects the realization of my earlier ambitions: to introduce an important and little-known aspect of these artists' careers to a wider audience, to present their decorative paintings in all their variety and richness, and to suggest the ramifications of this type of work for twentieth-century art.

This exhibition would not have been launched, much less brought to completion in the face of repeated challenges, without the encouragement and wholehearted support of James N. Wood, Director and President of The Art Institute of Chicago; Douglas W. Druick, Searle Curator of European Painting at the Art Institute; John Bryan, Chairman of the Art Institute and Chairman of Sara Lee Corporation; David and Mary Winton Green; and Philippe de Montebello, Director of the Metropolitan Museum of Art, New York.

Foremost among the challenges faced by this exhibition was how to transport safely these often large and oddly formatted paintings and folding screens, many of which, because they have stayed in private collections, are unlined and unvarnished. To achieve the decorative goal of creating expressive and harmonious paintings, fully integrated into their intended settings, many of these works, especially those by Vuillard, were painted in a laborious technique known as *à la colle*, or distemper. While marvelously fresh, encrusted, and thus frescolike, these works are more fragile than oil painting on canvas and thus require special consideration. For this, I am deeply grateful to Faye Wrubel, Conservator of Paintings in the Department of Painting Conservation at the Art Institute, who traveled around the world with me to examine each and every work in this medium. She made recommendations to the owners about proper handling and shipping that made it possible to include for the first time in this exhibition many large-scale paintings heretofore deemed too fragile to travel.

Another challenge we faced in organizing the show was that of tracking down and making contact with the various owners, or intermediaries to the owners, of these works, especially in the case of paintings that had been rarely seen, much less published. Aiding me immensely in this effort were Bonnard scholar Sarah Whitfield; Vuillard scholars Guy Cogeval (who is currently writing the catalogue raisonné on the artist), Anne Dumas, Elizabeth Easton, and Belinda Thomson; and Denis's granddaughter Claire Denis, assisted by the dedicated team of Marianne Barbey and Anne Gruson, who are currently working on the catalogue raisonné of Denis's work. The help of the descendants of the four artists or of their patrons was especially crucial to the success of this project. I am particularly grateful to Antoine Terrasse, grandnephew of Bonnard; Brigitte Ranson-Bitker, granddaughter of Paul Ranson; Antoine Salomon, who is both grandson of Roussel and grandnephew of Vuillard; Jacques and Olivier Roussel and Sylvie Bruneau, great-grandchildren of Roussel; Claude Weill, daughter of Henri Kapferer; Alice Clément, daughter of Marcel Kapferer, and her daughter Francine Kapferer; Guy Wildenstein, grandson of Marcel Kapferer; and Guy Patrice and Michel Dauberville, grandsons of Josse Bernheim.

Additionally, dealers and auction houses were very generous in helping us trace the histories of paintings and screens that have long since been separated from the original patrons and interiors for which they were intended. The following deserve special thanks for

going far beyond the call of duty: Joseph Baillio, Luc Bellier, Philippe Brame, Philippe Cazeau, Guy Patrice Dauberville, Jacques de la Béraudière, Roberta Entwistle, Franck Giraud, Waring Hopkins, Libbie Howie, Ay-Whang Hsia, Daniel Malingue, Achim Moeller, Charles F. Moffett, Peter Nathan, Christian Neffe, David Norman, Seiichi Suzuki, Diane Upright, Marina Wegener, Wolfgang Werner, Daniel Wildenstein, Guy Wildenstein, and Pascal Zuber.

Once the exhibition was conceived, organized, and our wish list completed, the research component of the exhibition became all-important. Unlike the work of many of the Impressionists, which has been documented in a vast number of monographs and exhibition catalogues, the decorative paintings of the four artists featured here have never before been the exclusive focus of a publication or exhibition. Moreover, with the exception of Bonnard, for whom there exists a somewhat outdated, but still immensely useful, catalogue raisonné, the other artists still lack the kind of published documentation that would facilitate the proper dating and titling of their works. To this end, I have relied on a team of researchers and volunteers at the Art Institute, who were indefatigable in their devotion to the project: Nell Andrew, Colleen Burke, Nadia Gayed, Rebecca Glenn, Adrienne Jeske, Carola Kupfer, Ulrike Meitzner, Doris Morgan, Carmen Ramos, Capucine Redier, Gabriella de la Rosa, Suze Tegert, and Judy Valentine. I am particularly grateful to Marina Ferretti, independent art historian, Paris, who took on at the last moment exhaustive research on the Kapferer family, important patrons of all four artists, and who until now have been little studied.

Thankfully, I was also not alone in the writing of the catalogue. I take this opportunity to thank Nicholas Watkins, Reader in the History of Art at the University of Leicester, for his elegant, lively, and highly informative essay, which so skillfully lays the groundwork for the exploration of decorative painting in the larger context of late nineteenth-century aesthetics and artistic practices. I am likewise deeply grateful to Thérèse Barruel, independent scholar, for her extended entry on Denis's important bedroom ensemble (see cat. 19–24), a text that offers much new information on this series and an insightful interpretation of its iconography. For a sensitive translation of her text, thanks go to John Goodman. I owe the greatest debt, however, to Jennifer Paoletti, Research Assistant and Exhibition Coordinator, who not only compiled an extensive chronology that was used in every facet of the research and writing, but also was responsible for all the organizational aspects of dealing with lenders and their paintings, as well as the exhibition's installation. For her extraordinary dedication, tact, and patience, I am deeply grateful.

In the Art Institute's Publications Department, special thanks go to Executive Director Susan F. Rossen for her editorial expertise and energetic support. I am also deeply indebted to Margherita Andreotti, Senior Editor for Scholarly Publications, for maintaining an encouraging atmosphere throughout our work on the catalogue, contributing her sensitive and clear-sighted editorial skills to the shaping of the manuscript, and otherwise benefiting the project at every turn. Katherine Reilly, who handled a wide range of editorial responsibilities with unusual poise and resourcefulness, expertly assisted her in these efforts. I am grateful to Amanda Freymann, Associate Director of Publications, Production, and Production Assistant Stacey Hendricks for ensuring the quality of the book's production. Particular thanks are due to Photo Editor Karen Altschul and Ms. Hendricks for undertaking the daunting task of pursuing photographs and permissions for this book from a wide range of sources. Others who were helpful include Cris Ligenza, who skillfully entered many corrections; Lisa Meyerowitz, who edited the Artists' Biographies; Britt Salveson, who handled the project in its earliest stages; and independent editor Faith Brabenec Hart, who applied her discerning eye to the reading of the galleys. Finally, I wish to thank Joan Sommers for the catalogue's elegant design, and Gillian Malpass, John Nicoll, and Tina Weiner of Yale University Press for enthusiastically embracing this book for the press' list.

At the Art Institute, there are many others who deserve thanks for their support of the project. These include Neal Benezra, Deputy Director; Robert Mars, Executive Vice President for Administrative Affairs; Edward W. Horner, Jr., Executive Vice President for Development and Public Affairs; and Dorothy M. Schroeder, Assistant Director of Exhibitions and Budget. I am also grateful to Calvert Audrain, Irene Backus, Geri Banik, Peter Blank, Jack Brown, Darren Burge, William D. Caddick, Jane Clarke, Jay Clarke, Joe Cochand, Lyn DelliQuadri, Emily Dunn, Darrell Green, Barbara Hall, Eileen Harakal, William J. Heye,

x

John Hindman, Sandy Jaggi, Bernd Jesse, Lisa Key, Meg Koster, Mark Krisco, Clare Kunny, Lauren Lessing, Tina March, John Molini, Martha Neth, Alan Newman, Andy Nyberg, Greg Perry, Susan Perry, Daniel Schulman, Mary Solt, David Stark, Steve Starling, Harriet Stratis, Kirk Vuillemot, Colin Westerbeck, Peter Zegers, Ghenete Zelleke, and Frank Zuccari.

For designing the installation of the exhibition, an all-important aspect of a show devoted to decorative painting for the domestic interior, I wish to thank John Vinci and Ward Miller of Vinci-Hamp Architects, as well as Bruce Bradbury, Robert Furhoff, Jo Hormuth, and Christine Tarkowski. I would also like to thank Cal Audrain, William Caddick, Joe Cochand, and William Heye for their work on the installation.

At the Metropolitan Museum, this exhibition has benefited from the curatorship of Rebecca Rabinow, Assistant Research Curator in the Department of European Paintings, and from the continued support of Gary Tinterow, Engelhard Curator of European Paintings. Rebecca has been the best kind of partner, encouraging and helpful in all decisions involving loans and collectors. Ms. Rabinow would like to thank her colleagues: Everett Fahy, Gary Tinterow, Susan Alyson Stein, Dorothy Kellett, Samantha Sizemore, Patricia Mattia, Gary Kopp, Theresa King-Dickinson, and John McKanna, Department of European Paintings; Hubert von Sonnenburg and Lucy Belloli, Paintings Conservation; William S. Lieberman, Kay Bearman, Sabine Rewald, Lisa M. Messinger, and Ida Balboul, Modern Art; Colta Ives, Drawings and Prints; Mahrukh Tarapor and Martha Deese, Office of the Director; Linda M. Sylling, Operations; Carol E. Lekarew, Photograph and Slide Library; Andrew Ferren, Communications; Pamela T. Barr, Editorial; Nelly Silagy Benedek and Jean Sorabella, Education; and Jeffrey L. Daily, Design. The handsome design of the exhibition and its graphics are

the work of Michael C. Batista and Constance Norkin, both of the Design Department.

For their help in many and varied ways, it is, moreover, a great pleasure to thank the following people: Carol Anderson, Michele Audon, Félix Baumann, Sylvain Bellenger, Jean Paul Bouillon, David Brenneman, Etienne Breton, Richard R. Brettell, Sylvie Bruneau, Isabelle de la Brunière, Isabelle Cahn, Mary Campbell, Mathias Chivot, Robert Clémentz, James Clifton, Susie and Claude Cochin de Billy, Philip Conisbee, Arturo Cuellar, David Degener, Agnès Delannoy, the late Dr. Jean Baptiste Denis, Marina Ducrey, Kathleen Ecklund, Marie El Caidi, John Elderfield, Franco Ercole, Eugenia Gorini Esmeraldo, Walter Feilchenfeldt, Jennifer Fields, Dr. Thomas Fohl, Sophie Fourny-Dargère, Josette Galliegue, Diane de Grazia, Kiichiro Hayashi, Françoise Heilbrun, Jennifer Helvey, Madame Hodel, Siegmar Holsten, Shun-Ichi, Daniel Imbert, Colta Ives, Virginia and Ira Jackson, Bernard and Jacqueline Jacqué, Kimberly Jones, Paul Josefowitz, Sam Josefowitz, Carole Juillet, Albert Kostenevich, Charlotte Kotik, Claude Lanzenberg, Isabelle Le Mercier, Catherine Lepdor, J. Patrice Marandel, Mrs. Buddy Mayer, Pascal Mercier, Takao Miura, Katsumi Miyazaki, Jean Paul Monery, Helène Moulin, Claudia Neugebauer, Larry Nichols, Dr. Ursula Perucchi-Petri, Paula Petrova, Marnie Pillsbury, Karin Pritikin, Cécile Reichenbach, Joseph Rishel, Cora Rosevear, Marie Jose Salmon, Monique Sary, Bertha Saunders, Scott Schaefer, George T. M. Shackelford, Kevin Sharp, Marcia Steele, Richard Thomson, Marie Caroline Van Herpen, David Van Zanten, Judy Walsh, Claude Weill, Alice M. Whelihan, Gloria Williams, Nancy Yeide, and Jörg Zutter.

Finally, my heartfelt thanks go to my husband, Joe Berton, for his inexhaustible patience and understanding throughout the course of this undertaking.

Gloria Groom
David and Mary Winton Green Curator
in the Department of European Painting at
The Art Institute of Chicago

THE CATALOGUE PORTION OF THIS BOOK is divided chronologically into two sections: the first, covering the years 1890–99; the second, the years 1900–30. Each section consists of an extended introductory essay, followed by entries on individual works. Within each section, entries are organized alphabetically by artist's name and then chronologically within each artist category. When an entry treats more than one work, paintings are listed alphabetically by their English titles, if there is no other established sequence.

Within each entry, the following criteria have been followed in presenting the relevant information:

TITLE: Priority has been given to English titles, although French titles are provided in parentheses in the Checklist at the back of the book. In addition, variant titles are provided, when known, for lifetime exhibitions of a work.

DATE: Dates have been verified whenever possible by means of existing documents, including early exhibition catalogues, correspondence, journals, etc. They may thus vary in some cases from dates published so far for a particular work.

MEDIUM: A picture's media description relies heavily on information given by the lender and direct visual observation of the work by curator Gloria Groom and conservator Faye Wrubel.

DIMENSIONS: A picture's dimensions are given in centimeters, height before width, followed by dimensions in inches in parentheses.

INSCRIPTIONS: When a work bears a signature and/or date, this information is provided in the Checklist. If this information is missing, the reader should assume that, to the best of our knowledge, the work is unsigned and/or undated.

PROVENANCE: A picture's provenance relies heavily on information provided by the lender of the work.

Whenever possible, we have indicated direct transfer of a work between items of provenance by means of a semi-colon, and a possible gap in the provenance by means of a period. The phrase "Pierre Bonnard Estate" indicates that the work in question was included in a protracted legal dispute, extending from the artist's death in 1947 to 1965, between the heirs of Pierre and Marthe Bonnard (see London 1994, p. 126).

EXHIBITIONS: The exhibition history of a work includes only lifetime exhibitions. If this section is missing for a particular work, the reader should assume that, to the best of our knowledge, the work was never exhibited during the life of the artist. Throughout the discursive parts of the book, the location of all galleries, exhibitions, and institutions is assumed to be Paris, unless otherwise noted. For some of the exhibitions repeated most frequently, the full title has been abbreviated after it is first mentioned (see, for example, Salon de la nationale, for Salon de la Société nationale des beaux-arts; or Indépendants, for Salon de la Société des artistes indépendants).

NOTES: For ease of reference, the notes for the three essays in this book are placed directly following the text, while the notes for the entries have instead been grouped with the rest of the scholarly apparatus in the Checklist. The Selected Bibliography provides abbreviations for those sources that are referred to repeatedly in the notes.

CROSS-REFERENCES: The three essays in this book are cross-referenced by means of the following abbreviations:

Watkins (for Nicholas Watkins, "The Genesis of a
 Decorative Aesthetic")
1890–99 Intro. (for Gloria Groom, "Coming of Age:
 Patrons and Projects, 1890–99")
1900–30 Intro. (for Gloria Groom, "Into the
 Mainstream: Decorative Painting, 1900–30").

DETAIL, CAT. 70

The Genesis of a Decorative Aesthetic

At the beginning of the nineties, a war cry rang from one studio to another: "Away with easel-pictures! away with that unnecessary piece of furniture!" Painting was to come into the service of all the arts, and not be an end in itself. "The work of the painter begins where that of the architect is finished. Hence let us have walls, that we may paint them over. . . . There are no paintings, but only decorations."[1]

JAN VERKADE (1868–1946) THUS ROUSINGLY summed up in his memoirs the idealistic aims of the Nabis at the beginning of the 1890s: a reassertion of the connection between painting and all the other decorative arts; a preference, when commissions allowed it, for mural-size paintings intended for specific architectural interiors; and most importantly, a rejection of the aesthetic and theoretical assumptions associated with easel painting (although not necessarily its physical format). In accordance with this last goal, the Nabis rejected painting as an illusionistic window onto nature—a concept primarily associated with easel painting—in favor of art as *décoration*, a French term that had a highly positive and multilayered meaning in the artistic debates of the period (as opposed to the narrower and largely disparaging sense of the literal English equivalent, "decoration").

Although well known for his memoirs of the period, as a painter Verkade was only a secondary member of the Nabis, a group of precocious young artists that was formed in 1888 and adopted the name Nabi from the Hebrew word for prophet. In addition to the Dutchman Verkade, the group included the Swiss artist Félix Vallotton (1865–1925) and the French sculptor Aristide Maillol (1861–1944), among others. The core of the group (see fig. 1), however, consisted of the painters Pierre Bonnard (1867–1944), Edouard Vuillard (1868–1940), Maurice Denis (1870–1943), and Ker Xavier Roussel (1867–1944). Common elements in their backgrounds cemented the close relationship between the four: in Paris, Vuillard, Denis, and Roussel were school fellows at the Lycée Condorcet; Bonnard got to know Denis at the Académie Julian, where Paul Gauguin's ideas were revealed to them by Paul Sérusier in 1888; Denis, Bonnard, and Vuillard shared an apartment at 28, rue Pigalle in the early 1890s. All four remained life-long friends.

Although the contribution of these artists to the avant-garde of the 1890s has long been recognized, it is only now, in the wake of postmodernism, that the time seems ripe to evaluate their work in a broader context which embraces their subsequent development of styles marginalized by modernism, notably Impressionism and classicism. The large-scale exhibition that occasions this book systematically includes, for the first time, these artists' celebrated

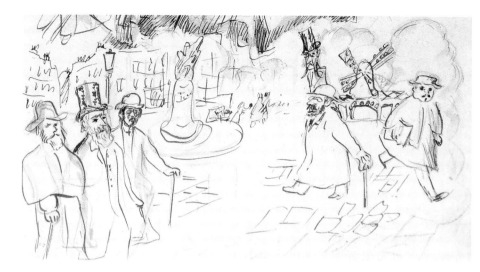

early decorative works, along with their later decorations. Key cycles, now split up in collections around the world, have been reassembled in a sequence of rooms absorbing us in immensely pleasurable, yet at the same time perplexing, decorative ensembles. How are we to look at these paintings, outside of their initial contribution to the avant-garde of the 1890s? The vocabulary of these artists looks familiar, and yet they were dealing with issues in unconventional ways. Mythological painting was in a sense domesticated, while the subjects of interior and still life were elevated to the scale and status of history painting.

This essay is born out of the conviction that these artists were drawing on, and at the same time subverting, a series of assumptions about the status and function of both painting and decoration, which it is my purpose here to reconstruct. It must be said, from the outset, though, that the Nabis, unlike their mentor Gauguin, were not cultural rebels; rather, they were innovators who picked up and developed themes of the moment in often original ways. It is thus especially important in order to appreciate their true originality to become aware of the traditions within which they were operating. To this end, the first of the four sections of this essay focuses on the reasons for the perpetuation of decoration as the highest artistic genre in nineteenth-century France, despite the fact that it did not have the easy accessibility and appeal of easel painting. It also examines the emergence of Pierre Puvis de Chavannes as the greatest decorative painter of the late nineteenth century before the arrival of Gauguin. The second section discusses the widespread interest in breaking down the boundaries between the

arts and crafts and the architectural environment, while the third section investigates the key concepts of abstraction, modernity, and interiority, focusing on the crucial influence of Gauguin. Finally, the concluding section sets out to establish the Nabis' theory and practice of decorative painting in a twentieth-century context.

Decorative painting is one of the most important, but least understood, issues in late nineteenth- and early twentieth-century art. It is an area fraught with contradictions and misunderstandings, particularly for an English-speaking audience. The very word "decoration" conjures up conflicting associations. In English, it is often used pejoratively to imply pretty, but essentially undemanding, minor painting. In French, however, the term *décoration* has a much wider range of associations and, in particular, a long history of being used to indicate painting of the grandest scale and ambition. As these contrasting meanings suggest, the topic of decorative painting encompasses the extremes of conservatism and radicalism, the wish to defend, as well as to subvert, the traditional hierarchy among artistic genres.

MURAL DECORATION

The exalted standing of decoration as the highest artistic genre in nineteenth-century France was inseparably linked with history painting and the communication of public values. Indeed, for many artists, decoration was synonymous with history painting (that is, large-scale paintings of historical or mythological subjects). In a physical sense, a decoration could either refer to a large painting outside the scope of commercial easel painting or to a mural. Verkade's dismissal of easel painting and plea for walls to paint on echoes what had become a familiar refrain by the 1860s and 1870s in both academic and avant-garde circles.[2] The argument was that small-scale easel paintings, designed to supply the market demand for realistic genre scenes to decorate private homes, had led to the decline of history painting, or the public art of decoration, which was regarded as the ultimate medium for the communication of serious content.

Decoration paradoxically maintained its status as the ultimate professional challenge for an ambitious artist even when the popularity of the genre had declined. For example, Jean Auguste Dominique Ingres, the nineteenth century's undisputed guardian

of the academic faith, was appreciated more for his portraits than for his history painting.[3] Indeed, decorations remained the ultimate test for an artist wanting to claim a place in the pantheon of art, alongside Raphael and the greatest artists of the past. The pantheon to be aspired to was literally set out in a mural of 1836–41 by Paul Delaroche, which encircled the Hemicycle above the aspiring art student in the Amphithéâtre d'honneur at the Ecole des Beaux-Arts, and which can still be seen there today.

Ingres and his great rival Eugène Delacroix both attributed the decline of decoration after the death of Raphael to the popularity of portable easel painting. For Ingres, the importance of mural decoration was bound up with the permanence of values and the perpetuation of a coherent, eternally relevant vision of French culture as the inheritor of the classical tradition. The greatness of France demanded *grande peinture*. In *The Apotheosis of Homer* (fig. 2), commissioned in 1826 for the ceiling decoration of the newly constituted museum of Egyptian and Etruscan antiquities in the Musée du Louvre, then known as the Musée Charles X, Ingres summarized the classical tradition, from Homer and Periclean Athens via Renaissance Italy to seventeenth-century France.[4] Although the competition between Classicism and Romanticism had lost momentum by the 1850s and had finally petered out with the deaths of Delacroix and Ingres in

1863 and 1867, respectively, such was the prestige of mural decoration that famous contemporary artists felt obliged to sacrifice successful styles in its cause. For example, Ernest Meissonier, a master of small-scale genre painting, in 1874 took up the challenge of executing a mural decoration for the Panthéon. The subject of this work was to be *The Liberation of Paris by Saint Geneviève*, but, by his death in 1891, Meissonier had failed to adapt his style to the completion of the project.[5] John Singer Sargent offers another example. As a student in Paris in the 1870s, he had assisted his teacher Emile Auguste Carolus-Duran on *The Triumph of Marie de' Medici* of 1878 (Musée du Louvre, Paris), the ceiling decoration for the Palais du Luxembourg, and then made his international reputation as a master of bourgeois realism. But he still believed in the superiority of mural decoration and staked his claim for inclusion in the artistic pantheon on his decorative, allegorical cycles for the Museum of Fine Arts, Boston (begun 1916), and the Widener Memorial Library at Harvard University, Cambridge (1922).[6] Bonnard, Vuillard, Denis, and Roussel similarly respected the ambition to go beyond small-scale, commercial easel painting.

France under the long-lived Third Republic (1870–1940) was paradoxically both politically radical and culturally conservative. Throughout the 1870s, the government became increasingly antimonarchist and anticlerical, but continued to include administrators of the fine arts who were closely allied with the Academy, monarchism, and the clergy. This uneasy relationship between politics and art was symptomatic of a period torn between competing models of modernism and conservatism. As Patricia Mainardi has pointed out, France was at this time both a feudal, agrarian society, with a static social hierarchy based on status, deference, and tradition, and an industrial society driven by economic dynamism and rationality, offering social mobility and advancement based on competence and talent.[7] The philosophical doctrine known as positivism, in its equation of true knowledge with science, proved popular in providing a suitable rationale for Republican anticlericalism and for the belief in science, technology, and material progress.[8] Yet, by the 1890s, the avant-garde (which was loosely labeled Symbolist and included Gauguin, as well as Bonnard, Vuillard, and their circle) had reacted against the whole positivist notion of science, realism, and material progress.[9]

FIG. 2

Jean Auguste Dominique Ingres (French; 1780–1867). *The Apotheosis of Homer*, 1826. Oil on canvas; 386 x 515 cm. Musée du Louvre, Paris.

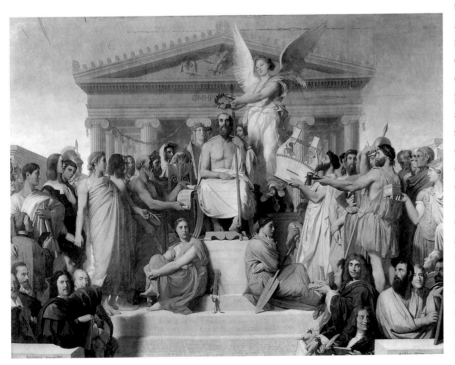

These contradictory views of government and arts administration speak, on the one hand, of a divorce between progressive art and Republican politics and, on the other, of the political necessity to maintain continuity with a cultural tradition that defined French national identity and art in terms of a long-standing series of oppositions. These oppositions had been rephrased in various ways under the previous regime, the Second Empire of Napoleon III (1852–70). Generally speaking, the bourgeois, Protestant, Anglo-Saxon belief in the work ethic, realism, modernity, and progress was unfavorably juxtaposed with the aristocratic, Catholic, Mediterranean, or Latin belief in tradition and the past. Ernest Chesneau, writing in 1868, defined Latin art as abstract in nature, general in form, and devoted to the ideal as manifested in the harmony and unity of *grande peinture*. By contrast, he described Saxon art as interested in the real as opposed to the ideal; in the particular, individual detail as opposed to the general form; and in the accidental as opposed to the eternal.[10] In addition, after France's crushing defeat in the Franco-Prussian war (1870–71) and the polarizing effect on French culture of the Dreyfus Affair (erupting in 1894 and continuing through 1899), the imperative to appear demonstrably anti-German and, in some cases, anti-Semitic, infected the arts as well as politics. If the recently united Germany was a progressive, modern, industrial state, then France would lay claim to eternal verities sanctified by tradition. Such was the atmosphere of hostility and suspicion, that Alfred Dreyfus, a Jewish officer in the French army, wrongfully accused of spying for Germany, was condemned, imprisoned on the notorious Devil's Island off the coast of Guyana, and only finally released after a debate that split both public and artistic opinion. This stark cultural polarization into opposing camps informed the self-definition of artistic groupings. Denis, as Gloria Groom discusses later in this book, echoed these polarities when he grouped the Nabis into Catholic and Semitic camps.[11]

At first sight, it would appear that the avant-garde defined itself in opposition to the Academy and the arts establishment, but in fact the avant-garde shared with the Academy a contempt for the bourgeois taste for small-scale, realistic genre scenes and a concomitant belief in decoration. It is often said that history painting finally died in 1867 with Ingres, the archetypal conservative, who attributed mediocrity in art and

politics to the advent of democracy. The burning of Ingres's celebrated *Apotheosis of Napoleon I*, commissioned in 1853 as a ceiling decoration for the Salon de Napoléon, in the fire that destroyed the Hôtel de Ville during the Commune of 1871, somehow symbolized the passing of the old order along with the regime it represented. In actuality, however, the Third Republic was far from equating the triumph of democracy with the death of history painting, but rather initiated one of the most expansive programs of public decoration in the history of mural painting. Thus, while Verkade's plea for walls to paint on fell on deaf ears as far as government patronage of the avant-garde was concerned, for decorative painters favored by the administration, the new regime ushered in a golden age.

Two recent exhibitions at the Musée du Petit Palais, Paris, *Le Triomphe des mairies: Grand Décors républicains à Paris, 1870–1914*, held in 1986, and *Quand Paris dansait avec Marianne, 1879–1889*, held in 1989,[12] revealed for the first time the extent of the Republic's program to rebrand France in its own image. Every local administration throughout the country was expected to come up with suitable decorative schemes for the embellishment of the public buildings in its charge. In Paris alone, there were major schemes for the decoration of the Panthéon, the Archives Nationales, the new Opéra, the Sorbonne, the Musée d'Histoire Naturelle, the Petit Palais, the Hôtel de Ville, and the numerous *mairies*, or town halls.[13]

Initially insecure and without a Republican majority, the State's program began tentatively, before crystallizing its twin aims: to provide both a history for the Republic, with its heroes and mythology, and an ideological framework for its citizens' lives. The classical iconology of the preceding Second Empire was to be combined with the presentation of the Third Republic as the logical evolutionary outcome of a revolutionary process culminating in the triumphant arrival of the modern democratic state. Notable events in the revolutionary calendar were to be celebrated with ceremonies and public holidays. In 1880, July 14, the day of the storming of the Bastille in 1789, was declared an annual national holiday.[14] The Exposition universelle of 1889 was conceived by the government and municipality of Paris as the centennial celebration of the French Revolution. Some of the most famous landmarks in Paris were the product of this program.

No one style came to dominate the decoration of the local town halls, which essentially became Repub-

FIG. 3
Albert Besnard (French;
1849–1936). *Summer,* or *The
Middle of Life,* 1887. Mural
for the Salle des mariages of
the town hall of Paris's
first arrondissement.

FIG. 4
Pierre Vauthier (French; 1845–
1916). Detail of *Summer, The
Festival of Bagnolet, The Day of
the Crowning of the Rose Queen,*
1892–94. Mural for the Salle
des fêtes of the town hall of
Bagnolet, a suburb of Paris.
Photo: Paris 1986, p. 237.

FIG. 3

FIG. 4

lican temples. The public, educational aspect of the program embodied the highest ideals of history painting, but there was a reluctance in pluralist times to adhere to a coherent style. While wanting to legitimize France's revolutionary political tradition and substitute the Republic for the previous concept of the Nation, the authorities were reluctant to adopt the revolutionary styles of the second half of the nineteenth century. This was partly the result of a need to stabilize the country and root the Republic in the French classical tradition, and partly a reflection of a widespread agreement that the classical style was the most suitable vehicle for the communication of abstract ideals. The problem was solved, or at least shelved, by throwing the projects open to competition, with juries of artists awarding the commissions. The inevitable outcome was that the artists chosen ran the stylistic gamut from the classical school of Ingres to historicist realism to Jules Chéret's airy evocations of the eighteenth century. For instance, between 1889 and 1891, Léon Glaize decorated the Salle des fêtes of the town hall of Paris's twentieth arrondissement with two blatant illustrations of Republican propaganda in a classical style: *Triumph of the Republic* and *Great Men of the Revolution*

before the Tribunal of Posterity.[15] A few years earlier, in 1887, Albert Besnard had adopted a very different solution for the decoration of the Salle des mariages of the town hall of Paris's first arrondissement. Employing loose, open brushwork, he fused the contemporary with the traditional by associating the stages in the life of the citizen with the subjects of the seasons and the times of the day: *Spring* with *The Morning of Life,* *Summer* with *The Middle of Life* (fig. 3), and *Winter* with *The Evening of Life.*[16] Pierre Vauthier, in his decorations for the Salle des fêtes of the town hall at Bagnolet, a Paris suburb, took this process a step further and placed everyday scenes of work in the actual landscape around the suburb, rendering them in a tighter, more realistic style (see fig. 4).[17] The one painter to stand out with an individual style that satisfied the demands of the period to look both traditional and modern was Pierre Puvis de Chavannes.

Puvis de Chavannes's grand style of decorative painting was lauded in his lifetime as the pride of the Republic.[18] He was regarded by both conservatives and radicals as the one artist to have breathed life into the moribund art of mural decoration. In 1890, he helped found the breakaway Salon de la Société nationale des beaux-arts (hereafter, Salon de la nationale), which gave much greater prominence to mural painting than other Salons; and his mural *Inter artes et naturam,* commissioned for the Musée des Beaux-Arts in Rouen, was the centerpiece of its first Salon in 1890.[19] In 1897, he was a founding member of the editorial board of the influential magazine *Art et décoration.* Praised by the press, his art appealed to both wings of the political spectrum. Such was his prestige that he was awarded decorative commissions for the prime sites in Paris: the Panthéon, the Sorbonne, and the Hôtel de Ville. His decorations for the provinces were first exhibited at the Salon and then became destinations for artists on what could be described as the Puvis pilgrimage route. Puvis's influence extended from conservative decorative painters like Besnard and Vauthier to the major figures of the avant-garde: Gauguin, van Gogh, Seurat, the Nabis, and later Matisse and Picasso.

For the Nabis, Puvis was not just a link with tradition. He posited a way out of the dilemma created by competing styles, from classicism to academic realism to Impressionism, and opened up new possibilities for decorative art as an expressive language. Having visited a Puvis de Chavannes exhibition in Paris on 17

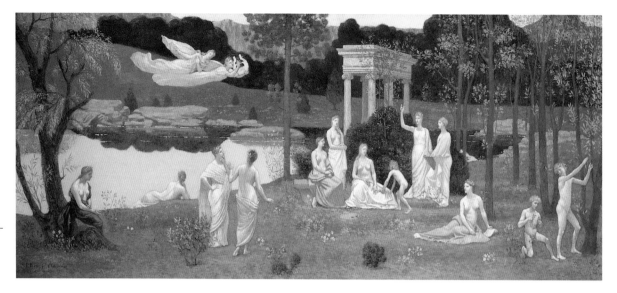

December 1887, Denis (the Nabis' self-appointed spokesman and promoter) described in his diary entry the following day what attracted him to Puvis's work:

I found the decorative, calm, and simple aspect of his paintings very fine: a wonderful mural color: there are marvelous harmonies of pale tones. The backgrounds are very interesting as decoration: backgrounds like this are far preferable to the golden backgrounds of some frescoes. The measured, grand, ethereal composition was astonishing; it has to be extraordinarily knowing.[20]

The expressive language that Puvis's work embodied for the Nabis can be summarized in general terms as follows, and is aptly exemplified by the Art Institute of Chicago's *Sacred Grove* (fig. 5). A painting should evoke a subject through the relationships of the pictorial elements, rather than through detailed narrative description. Static and timeless subjects were preferable to dramatic action tied down in time. Realism, perspective, and chiaroscuro—in fact anything that might disrupt and draw attention away from the flatness of the surface—had to be avoided in the interests of overall lucidity. Many of these tenets were already part of a widely accepted mural aesthetic, even before Puvis. But it was Puvis's merit to have embodied them in a form that was so widely appealing. In the process, he set the stage for a new kind of decorative painting, one predicated on extending the aesthetic principles of the mural to all types of painting. It is this innovation that was seized upon and developed by Bonnard, Vuillard, Denis, and Roussel.

ART AS DECORATION

One of the Nabis' major ambitions was to subvert the academic hierarchy separating the fine arts from the decorative arts and thus reunite art and craft. The mural schemes commissioned by the Third Republic reinforced the academic status of history painting as the highest genre and at the same time narrowed the gap between fine art and decoration. Drawing on the precedents of the English Arts and Crafts Movement, the Rococo, and Japanese art, all of which made little distinction between the fine arts and the decorative arts,[21] the Nabis designed posters, illustrations, theater sets, screens, stained glass, textiles, and ceramics. These activities were particularly intense during the early years of the group. Their program carried with it the wider, although unstated, aspiration to see painting and sculpture as part of a decorative ensemble and ultimately to erode the division between art and everyday life through the production of functional decorative objects. According to Bonnard, "Our generation always sought to link art with life. At that time I personally envisaged a popular art that was of everyday application: engravings, fans, furniture, screens, etc."[22]

Bonnard, a prime mover in this campaign, first came to public attention in late March 1891, aged twenty-three, with the appearance on the streets of Paris of his bright-yellow lithographic poster advertising *France-Champagne* (fig. 6). The poster featured a tipsy hostess trailing a stream of bubbles from her raised glass. This effervescent female image of fun broke with social and artistic decorum and brought a robust energy to a popular art form that came to epit-

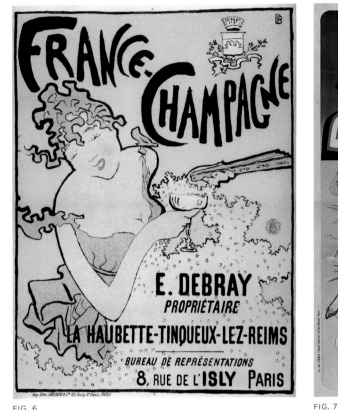

FIG. 6 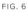 FIG. 7

omize the dynamism of the 1890s, a period known as the *belle époque*.

Bonnard's early reputation was indeed based on his activities as a printmaker rather than as a painter. He executed over 250 lithographs between 1889 and 1902, using the technique of color lithography popularized by Jules Chéret (see fig. 7), a medium previously despised by serious artists and collectors. By the 1890s, critics would refer to Bonnard's "street art" in the same breath as painting, with the decided advantage that the prints were far more available than paintings. Bonnard's posters, notably the celebrated image for the journal *La Revue blanche* of 1894 (fig. 8), depicted street life, boldly blocked out in a pattern of silhouettes, and were returned to the street as functional decorations. Such was Bonnard's commitment to decorative painting that he affirmed in an interview in *L'Echo de Paris* of 28 December 1891: "Painting must above all be decorative. Talent will reveal itself in the way lines are arranged. I do not belong to any school. I am only trying to do something personal."[23]

The Nabis' espousal of decorative painting and the applied arts indicates that they were putting into practice a set of radical assumptions currently in vogue in advanced circles. Reviewing an exhibition of his contemporaries at the Paris gallery Barc de Boutteville, under the pseudonym Pierre Louis, Denis listed the decorative arts to which he and his colleagues could turn their hands:

One of the exhibitors might do fanciful and attractive posters. Another could make wallpapers of imaginative design, very modern tapestries and furniture of unusual style. A third might produce somber mosaics or dazzling stained glass windows. Where is the industrialist who might willingly avail himself of the valuable collaboration of these decorators, so as to consume a little of the time they devote to the execution of far too many paintings?[24]

Verkade also clearly envisaged a role for painting as part of a decorative ensemble: "Painting was to come into the service of all the arts, and not be an end in itself. The work of the painter begins where that of the architect is finished."[25]

While it is true that in certain respects the Nabis were moving onto the territory of the *peintre-décorateur* (painter-decorator), it is also important to realize the ways in which they were subverting and redirecting a traditional understanding of the term. According to Henry Havard's *Dictionnaire de l'ameublement et de la décoration*, published in four volumes in 1887–90: "The *painter decorators* are particularly responsible for executing hunting scenes, allegories, or still lifes, intended as

FIG. 8

Pierre Bonnard. *La Revue blanche*, 1894. Lithograph in four colors on tan wove poster paper; 80.7 x 62.3 cm. The Art Institute of Chicago, John H. Wrenn Memorial Collection.

permanent decorations for ceilings, over-doors, piers, panels, etc."[26] Havard outlined the history of *décoration fixe* (mural decoration) and then moved on to *décoration mobile* (movable decoration): "This consists in the choice, arrangement, disposition of art objects, bronzes, pictures, clocks, vases, etc., chairs, closets, tapestries, curtains, in a word, everything that may be considered furniture."[27]

The Nabis departed from Havard's definition of a painter-decorator in their desire to combine the traditional roles of artist and decorator. They wanted to maintain their status as avant-garde painters and extend the functions and language of painting through decoration, not surrender to the demands of a craft. They certainly wished to move painting away from the public sphere into the private world of the interior. The question is what role was assigned to painting in the modern decorative ensemble? How could painting maintain its identity as fine art when reduced to that of a decorative object among other decorative objects (what Havard called *décorations mobiles*) in a domestic interior?

In attempting to answer this question in an article of April 1892 in *La Revue blanche*, Denis made clear that he and his colleagues were seeking both to restore to

painting a traditional function, the decoration of rooms, and at the same time to extend the language of painting, in keeping with the wider Symbolist quest for an affective art that could transcend the need for narrative description and appeal directly to the emotions:

I can picture quite clearly the role of painting in the decoration of the modern home. . . . An interior artfully executed by a painter of taste like Pierre Bonnard, with modern furnishings and wall hangings of unexpected design—an interior that is light, simple, and pleasing, neither a museum nor a bazaar. In certain spots, but sparingly, paintings of convenient dimensions and appropriate effect. I would want them to have a noble appearance, [to be] of rare and extraordinary beauty: they should contribute to the poetry of man's inner being, to the luxurious color scheme and arabesques without soul; and one should find in them a whole world of aesthetic emotion, free of literary allusions and all the more exalting for that.[28]

In other words, the painter-decorator should elevate and animate the decorative ensemble.

In their generally held wish to "link art with life" and design functional objects, the Nabis were acting, even if not consciously, in accordance with the aims of a whole line of reformers in the nineteenth century, who similarly wanted to demolish the barriers between art, craft, and everyday life. John Ruskin's theories and William Morris's Arts and Crafts Movement were born out of the fundamental conviction that mass production had resulted in mass degradation, shoddy products, slums, and the alienation of labor from work.[29] Their solution was to restore beauty to the built environment and dignity to labor through the unification of art and craft. Acting on the precedents of A. W. N. Pugin, who advocated the integration of all the arts within a revived form of Gothic architecture, and of Henry Cole, who made the first practical attempt to reconcile art with manufacture, Ruskin and Morris envisaged the Arts and Crafts Movement as part of a moral crusade for social improvement. Ruskin's lectures and books, notably *The Seven Lamps of Architecture* (1849), which became one of the handbooks of the Gothic revival, and *The Stones of Venice* (1851–53), provided the vision for the new movement, whose objectives were put into practice by Morris.[30] In the spirit of a medieval guild, Morris established the firm of Morris, Marshall, Faulkner & Co. in 1861 to unite designer and craftsman in the production of everything necessary for the decoration of both domestic house and public building: furniture, tiles, tableware, textiles, screens, wallpaper, and stained glass (see fig. 9).

By his death in 1896, Morris had influenced a whole generation of architects, artists, and designers in both Europe and America. Siegfried Bing (1838–1905), the founder of Art Nouveau in France, who commissioned decorative work from Bonnard, Vuillard, Denis, and Roussel, looked up to Morris as the heir of Ruskin and the spokesman of the new art.[31] Marcel Proust, the social chronicler of his milieu in Paris, became passionately absorbed in Ruskin's writings.[32] The international enthusiasm for the decorative arts in the 1890s brought together a highly influential circle of critics, art historians, museum curators, and dealers.[33]

Although there is no direct connection between Morris and the Nabis, who in any case did not share Morris's social ambitions, they nevertheless often worked from similar sources toward the same aims. Denis, the dynamic entrepreneur in the promotion of the Nabis' decorative agenda, chose in his journal to cast himself in the role of a modest artist-decorator monk at the service of the local community.[34] Verkade actually became an artist-monk in the monastery at Beuron in Austria. Vuillard and Maillol definitely drew inspiration from the medieval tapestries in the Musée de Cluny, Paris.[35] Morris's belief in the therapeutic and regenerative power of nature found its equivalent in

Roussel's pastoral scenes with figures absorbed pantheistically in flower-filled meadows, as if in medieval *mille fleurs* tapestries.[36] It is impossible in most cases to separate the influence of medievalism from that of Morris. What can be said, however, is that, in contrast to its role in England, the Gothic in France was never quite as important as a model for an integrative vision as the Rococo. With the rise of French nationalism during the 1890s, the Rococo had the advantage of being considered quintessentially French and a defining part of the nation's patrimony.

The Rococo revival was born out of nostalgia for a pre-Revolutionary aristocratic vision of life, which stood in complete contrast to contemporary notions of progress, modernity, industrialization, and democracy as espoused by the Third Republic. Put at its simplest, the Rococo revival was a catch-all for everything that contemporary culture was deemed to lack. In terms of the fine and applied arts, it was a reaction against the bombast of history painting, the severity of the Second Empire style, the cult of technology, and the high moral tone of the Arts and Crafts Movement. At the same time, it represented a reassertion of links with a specifically French tradition of national excellence. For late nineteenth-century viewers, Rococo decorations possessed grace, wit, and charm, a lightness of touch designed to give pleasure to the eye and repose to the spirit, and to sanctify a leisured life. Antoine Watteau, François Boucher, and other eighteenth-century artists appeared to look with approval on hierarchy and class, on gently erotic nudes with provocatively raised buttocks and lightly rouged nipples. They seemed to depict a world without work in which men and women took their ease either in pastoral settings orchestrated by the passing hours of the day and the changing of the seasons or in sumptuous interiors of feminine elegance, exquisitely fashioned furnishings, and flowers. The colors these artists employed were those of softness and sensuality, powdery blues and faded greens, relieved by accents of coral, within the pervasive golden glow of a world fleetingly registered on the border between reality and dream.

This defiantly nostalgic and romantic vision acted as a crucial catalyst in the redefinition of art as decoration. Indeed, the Rococo revival was an extremely important factor in the decorations of Bonnard, Vuillard, and their contemporaries, as it created an ideal cultural climate for the development of their

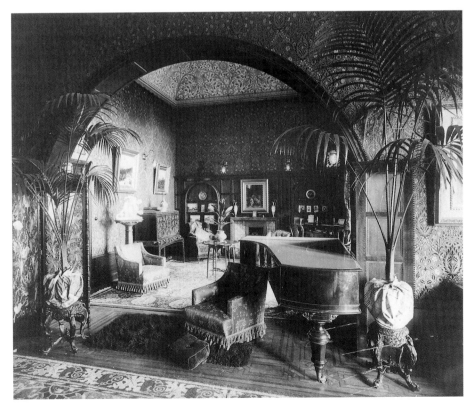

FIG. 10
Installation photograph showing
door-panel decorations by
Claude Monet (French; 1840–
1926) for the grand salon in
Paul Durand-Ruel's apartment,
35, rue de Rome, Paris; com-
missioned 1882, installed 1885,
now dispersed. Durand-Ruel
Archives, Paris.

work. References to the Rococo permeated French culture at the time. In the following pages, I will survey some of the most obvious manifestations of this revival. Specific links to the Rococo are also found in numerous artists' works. For example, Chéret's curtain of 1894 for the Théâtre Grévin, Paris, actually incorporated immense copies after Watteau.[37] In the case of Vuillard and Bonnard, the link to the Rococo is more often seen in the general mood and theme of their work. Vuillard's decorative panels for Alexandre Natanson of 1894, showing elegantly dressed women and children relaxing in a park (see cat. 32–33), have been justifiably taken as an updating of Watteau's *Réunion dans un parc* (*Assembly in a Park*) of 1717 (Musée du Louvre, Paris) in terms of Parisian leisure in the 1890s.[38] Bonnard's decorative panels for Misia Edwards of 1906–10 are bordered by cavorting monkeys reminiscent of eighteenth-century *singeries* (see cat. 45–47). Bonnard's lithographic illustrations to a 1900 edition of Paul Verlaine's often highly erotic poems, *Parallèlement*, are filtered through an essentially Rococo vision of nudes softly outlined in red chalk.[39]

The eighteenth-century way of life was clung to by the aristocracy, which was denied access to politics under the Third Republic, but was also paradoxically aspired to by the *haute bourgeoisie* responsible for the transformation of France in the nineteenth century. This emulation is reflected in the construction of magnificent palaces in the eighteenth-century classical

style, as opposed to the classicism of the First Empire defined by Jacques Louis David, and of the Second Empire, dominated by Baron Georges Eugène Haussmann.[40] Proust documented this milieu where aristocracy mixed with a cosmopolitan elite. The new classicism (exemplified by the architects Ernest Sanson, Gabriel Hippolyte Destailleur, Henri Joseph Aubert Parent and his son Louis Marie Joseph, and René Sergent) provided the style associated with power and success for a new mercantile aristocracy from Paris to Rhode Island.[41] These palaces were designed for entertainment on a lavish scale, and few survive to document an extraordinarily fertile period of architectural activity. Two outstanding examples were fortunately left to the French nation, complete with their contents: the Musée Nissim de Camondo, Paris, rebuilt by Sergent between 1911 and 1914 in the style of the Petit Trianon at Versailles; and the Musée Jacquemart-André, Paris, built by Henri Parent in 1875. Both buildings aptly illustrate how the new classicism in architecture established suitably grand settings for the combination of furniture and decorations in the Rococo style. Their collections are virtual inventories of all the great names in eighteenth-century decorative painting, sculpture, and applied arts.[42]

The appeal of the Rococo revival extended far beyond the limited coterie of the very rich, however. For modern artists like Claude Monet and Pierre Auguste Renoir, the Rococo supplied the grand decorative vision to which they aspired in their growing dissatisfaction in the 1880s with the limitations of *plein-air* easel painting. Monet's transition from the small-scale landscapes of the 1870s to his enormous all-encompassing water-lily *décorations* of the twentieth century was in part mediated through his experience of executing thirty-six panels representing fruit and flowers for six pairs of doors in the grand salon of his dealer Paul Durand-Ruel's apartment (see fig. 10).[43]

For Renoir, the eighteenth century remained a model of an ideal existence in which art and craft thrived without the competition of industrialization and the growing rift between city and country. He began as a porcelain painter in the eighteenth-century tradition and died declaring himself an eighteenth-century artist.[44] At the beginning of the 1880s, he came to see Impressionism as a dead end. In the autumn of 1881, he visited Italy and, deeply impressed by Raphael's decorations for the Villa Farnesina, Rome, and by the antique mural painting at Pompeii,

he returned determined to revive decorative painting in the eighteenth-century manner.[45] "Painting," he told Albert André, "is done to decorate walls. So it should be as rich as possible. For me a picture—for we are forced to paint easel pictures—should be likeable, joyous, and pretty—yes, pretty."[46] He spent from 1883 to 1887 working on *The Great Bathers* (fig. 11), the manifesto in his attempt to link Impressionism with the eighteenth century, which he exhibited in 1887 with the subtitle "trial for decorative painting."[47]

Any account of the genesis of a decorative aesthetic culminating in the decorative paintings of the Nabis cannot ignore the seminal contribution of the Goncourt brothers. Novelists, critics, and art historians, Edmond (1822–1896) and Jules (1830–1870) de Goncourt were gentlemen amateurs who turned the cultivation of taste into a profession and became the unlikely architects of a new modern aesthetic, based on the Rococo, linking art with craft. Their stance toward modern painting in the form of Impressionism was clear: they despised it, along with much of modern life. They withdrew in disgust from the modern world and yet provided a blueprint for the future. They themselves were in little doubt as to where their own achievements lay: "The search for truth in literature, the resurrection of the art of the eighteenth century, the victory of Japonism are the three great literary and artistic movements of the second half of the nineteenth century, and we initiated them all."[48] Although their claim to be initiators of these develop-

ments is to be discounted, they did contribute to the evolution of all three and in the process helped formulate a new aesthetic, which had profound consequences for decorative painting.

The Goncourts were largely responsible for crafting a nostalgic view of the eighteenth century that had direct appeal to their own time. The works of fine and applied art in their considerable collection were lovingly catalogued as souvenirs from a lost era of beauty and refinement. They saw similar qualities in Japanese art and brought the two together, Japonism and the eighteenth century, in the construction of an interior world. They transferred the Rococo from the public domain of hotels, palaces, and salons into a private place of retreat for the recuperation of their neurotically sensitive sensibilities, savaged by the brutality and vulgarity of contemporary life. The objects in their collection assumed personalities and roles in the internal drama of the house. The brothers saw themselves as artists, orchestrating these different visual characters into an organic whole.[49] They appropriated the role held by aristocratic eighteenth-century women, who were responsible for interior architecture and decoration. They were not novel in their neurosis, their *mal du siècle*;[50] their emphasis on neurosis just happened to coincide with contemporary psychology's focus on it as a feature of the modern condition, as we shall discuss in greater detail later in this essay. So, ironically, the brothers found themselves forerunners in the definition of a modern sensibility.

After his brother's death in 1870, Edmond de Goncourt described their house at Arcueil, in the suburbs of Paris, in *La Maison d'un artiste*, published in two volumes in 1881. The book became the bible of a new decorative aesthetic. In the preface, Edmond charted the transition from an eighteenth-century life lived publicly in a *hôtel* (grand mansion) to a private, essentially solitary, contemporary existence within the comforting walls of an agreeable *home*. The pleasure derived from the contemplation of the interior was held out as an antidote to the sadness and uncertainty of contemporary life. He called for the education of the eye and for the cultivation of "an entirely new sentiment, the almost human tenderness for *things*."[51] In lovingly chronicling the history and placement of each object in the house, he provided a detailed profile of his own taste and of the way the fine and applied arts came together in the evocation of an atmosphere appropriate to a room's function. We are guided

FIG. 11
Pierre Auguste Renoir (French; 1841–1919). *The Great Bathers*, 1884–87. Oil on canvas; 117.7 x 170.8 cm. Philadelphia Museum of Art, The Mr. and Mrs. Carroll S. Tyson, Jr., Collection.

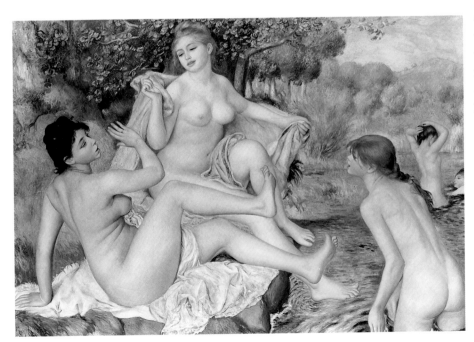

through an unfolding sequence of separate spaces, each different and yet organically linked to the whole: from the vestibule, with walls and ceiling covered in watery-green-colored leather decorated with fantastic golden parrots,[52] to, finally, the garden replanted in the eighteenth-century style to conjure up the type of scene where Watteau's ladies and gentlemen relaxed or took their siestas.[53]

It is ironic that the Arts and Crafts Movement in England and the Rococo revival in France were led by immensely influential pioneers who were contemptuous of mass production and its effects, for it was industrialization that held the key to their countries' economic survival. Given the crucial importance of industry, what relevance did the Rococo revival have for France faced with increasing international competition from Germany and the United States? Edmond de Goncourt's description of his retreat into an interior world would have been little more than an escapist fantasy made real by the objects in his collection if it had not struck a peculiarly contemporary chord. The Goncourts, it transpires, presciently focused on a series of issues that were seen, on the one hand, by officialdom to be important for economic prosperity and national identity, and, on the other, by the avant-garde to open up new possibilities in the relationship between art and craft and in the exploration of fine art as a decorative language.

As Debora Silverman has convincingly argued, the change in taste that the Goncourts helped forge was very far-reaching. In the decade spanned by the Expositions universelles of 1889 and 1900, which showcased French industry, arts, and culture, official support in fact switched from the technological style epitomized by the Eiffel Tower—that archetypal totem pole of modernism—to the Rococo, the decorative ensemble, and interiority. Edmond de Goncourt, the architect of this new sensibility, who had cultivated an aristocratic disdain for modernity, accepted the Legion of Honor in 1895 from the hands of Raymond Poincaré, a Republican politician with a special interest in the revival of the decorative arts. In his citation, Poincaré acknowledged Edmond's contribution to the rehabilitation of the applied arts of the eighteenth century and drew attention to his modernist quest for a new aesthetic language that could capture the complexities of contemporary existence.[54] The language of neurotic withdrawal and the discovery of formal equivalents for sensations had evidently become common parlance.

Edmond's contribution to the revival of the decorative arts found a practical outlet in the Union centrale des arts décoratifs, a society led initially by like-minded amateurs bent on bridging the gap between art and craft in the interests of national cultural identity and economic survival. The Union centrale grew out of the amalgamation in 1882 of the Union centrale des beaux-arts appliqués à l'industrie, founded in 1864 out of rivalry with the English sponsorship of the industrial arts in the Great Exhibition of 1851, and the Société pour un musée des arts décoratifs, formed to educate the public and "to develop the taste of artists and artisans, who carry with them the traditions of our national applied arts."[55] It is significant that the word "industry" was not included in the society's resulting title, as it swung its support behind the elevation of the status of the artisan to the rank of artist and the promotion of luxury crafts and craft modernism.[56] So important did the aims of the society appear that its membership expanded beyond amateurs to include politicians, cultural administrators, and official educators.[57] The society encouraged fine artists to participate in design. Accordingly, in October 1891, Bonnard entered a competition organized by the Union centrale with the slightly confusing aim of designing, without "plagiarism" but at the same time respecting the "rules of French taste," and within a limited budget, wooden furniture for a dining room for people of modest means.[58] To avoid "plagiarism," Bonnard turned to the organicist craft modernism pioneered by the Japanese and English Arts and Crafts, but his design (see fig. 12) evidently did not pay sufficient respect to the "rules of French taste" and was rejected.[59]

The Union centrale was acting in the context of growing public interest in interior decoration, which was no longer seen as the exclusive preserve of the very rich and their professional architects and artists. Middle-class women as consumers now began to influence the fashion industry and to contribute to the creation of an "intimate" style of interior décor.[60] In their effort to attract customers, the department stores, such as Bon Marché (founded in 1852), Magasin du Louvre (founded 1855), Printemps (founded in 1865), and Samaritaine (founded in 1869), which were the temples of the new consumerism, staged increasingly lavish settings to display their goods.[61] Successful commercial galleries such as that of Georges Petit followed suit, showing modern paintings in the type of sumptu-

FIG. 12

FIG. 12
Pierre Bonnard. *Two Projects for a Furniture Ensemble* (detail), 1891. Watercolor, pen, and black ink on paper; 36.6 x 50.2 cm. Musée du Louvre, Département des arts graphiques, Fonds du Musée d'Orsay, Paris.

FIG. 13
James McNeill Whistler (American; 1834–1903). *Variations in Flesh Color and Green: The Balcony*, 1865. Oil on wood; 61.4 x 48.8 cm. Freer Gallery of Art, Smithsonian Institution, Washington, D.C.

ous setting favored by their clients in their homes. The opening of the Salon de la nationale in May 1890 was distinguished by its luxurious installation.[62] The drive on all fronts was to see painting as part of the interior ensemble, setting the tone of the décor. Paul Signac, the leader of the Neo-Impressionists, came to defend modern painting in terms of decoration: "These canvases which restore light to the walls of our urban apartments, which enclose pure color within rhythmic

lines, which share the charm of Oriental carpets, mosaics, and tapestries: are they not also decorations?"[63]

Of all the oriental sources, Japanese art was the major stimulus in the evolution of decorative painting. In addition to providing a model for the integration of arts and crafts, it suggested novel ways of reconciling nature with decoration and of creating space through the abstract elements of decorative design, pattern, color, line, and form.

Bonnard, Vuillard, Denis, and Roussel drew extensively on Japanese art in their reworking of traditional Rococo decorative subjects in a demonstrably modern decorative style. In this they were not pioneers. James McNeill Whistler, for instance, was one of the first artists in the evolution of decorative painting to systematically exploit Japanese sources. In *Variations in Flesh Color and Green: The Balcony* of 1865 (fig. 13), he combined the Japanese subject of geishas posed on a balcony, based on a woodcut by Torii Kiyonaga, with a realistic view of the river Thames, in a composition that anticipates Roussel's *Conversation on a Terrace* of 1891 (cat. 28). Bonnard's enthusiasm for all things Japanese was so marked that he was singled out by his colleagues as the "very Japanese Nabi."[64] Japanese prints opened his eyes to the representational and expressive possibilities of color. Overwhelmed by the enormous exhibition of Japanese wood-block prints and illustrated books at the Ecole des Beaux-Arts in 1890, Bonnard later stated: "I realized that color could express everything, as it did in this exhibition, with no need for relief or texture. I understood that it was possible to translate light, shape, and character by color alone, without the need for values."[65] From Japanese prints, he evolved a language of pattern in which shape and color changed with content.[66] His four panels *Women in a Garden* of 1891 (fig. 14; cat. 2–3) were first envisaged as joined together like a Japanese screen, perhaps representing the very traditional eighteenth-century subject of the four seasons.[67] The impact of Japanese art, along with that of Puvis de Chavannes, is similarly evident in Roussel's *Seasons of Life* of 1892/93 (cat. 26–27) and Denis's series of 1891–92 representing the months of the year (cat. 10–13).

The production of screens is a prime example of the ways in which Japanese art served as a catalyst in the Nabis' adaptation of a traditional Rococo decorative genre to contemporary ends. Their enthusiasm can be seen, on the one hand, as continuing a French

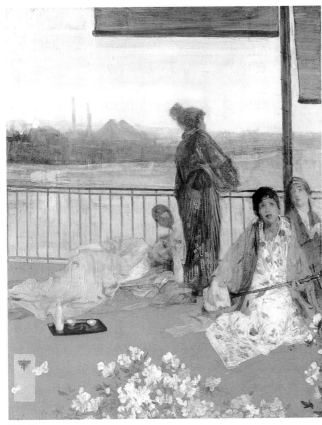

FIG. 13

FIG. 14

Pierre Bonnard. *Women in a Garden*, 1891. Oil on paper, mounted on canvas; four panels: each panel, 160 x 48 cm. Musée d'Orsay, Paris.

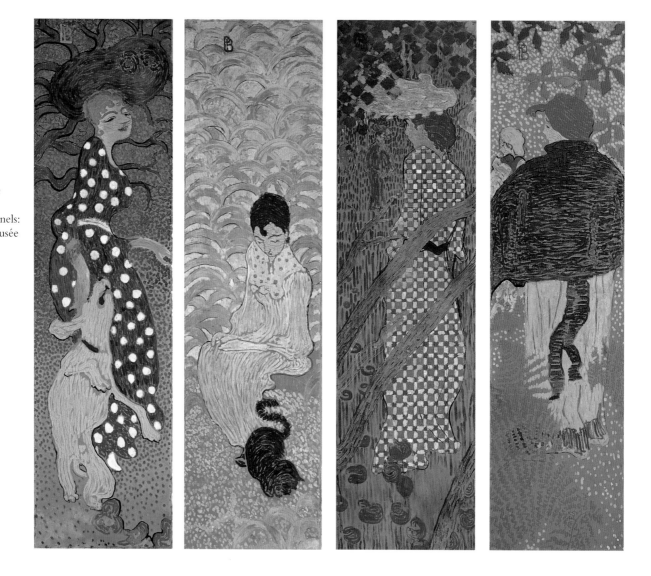

decorative tradition going back before Whistler and the Impressionists to the sixteenth century (when folding screens were first introduced to Europe from Japan) and, on the other, to their growing interest in space and the relationship between spectator and decorative art object. Chinese and Japanese screens had proved useful decorative pieces in the subdivision of rooms into separate, private spaces and in the prevention of drafts. Watteau, Boucher, Huet, Lancret, and other leading Rococo artists either painted or provided designs for screens. Corot and Cézanne executed screens in the eighteenth-century tradition, Morris produced "medieval" screens, Manet included Japanese screens in his paintings, and Whistler actually made his own screens in the Japanese style. But only with the Nabis did screens became a major vehicle for formal exploration: Bonnard, Vuillard, Denis, and Roussel all designed them.

However, it was neither Whistler nor the Nabis but another foreigner in Paris, the German Jewish entrepreneur Siegfried Bing, who was largely responsible for converting the Japanese aesthetic into a decorative program. Bing in fact did for the decorative arts in France what Morris had achieved in England: he promoted the integration of the arts and crafts and put the enterprise on a commercial footing. While acknowledging his debt to Ruskin and Morris, Bing criticized them for failing to come to terms with their own times.[68] Whereas Ruskin and Morris tried to turn the clock back to a medieval past, Bing discovered in Japanese arts and crafts the model for an integrative approach to decoration that could—in alliance with nature—escape the stagnation of tradition. He immersed himself in Japanese art and culture, visiting Japan for the first time in April and May 1880. By the late 1880s, Bing had become convinced of a link

of construction employing wrought iron against which it reacted).[69]

Bing progressed from dealer in Asian art to active promoter of an integrative Japanese aesthetic via three main outlets: his shop on rue Chauchat, opened in 1878; his magazine *Le Japon artistique*, first published in 1888 in three languages; and a succession of important exhibitions, most notably the largest survey exhibition of Japanese arts and crafts ever held in France to that time—the very one that so moved Bonnard—of some 725 Japanese wood-block prints and 421 Japanese illustrated books at the Ecole des Beaux-Arts during April and May of 1890. By this date, Japanese wood-block prints had been absorbed into French culture, and major galleries specializing in modern painting were exhibiting them. Bing's contribution to the revitalization of the decorative arts was recognized by Henri Roujon, Director of Fine Arts, who asked him to report on American industrial arts, following Bing's visit to the United States in 1894. Bing's fundamental argument in the report was that America was innovative and progressive because it was not bound by imitation and tradition.[70] A practical outcome of the trip was his involvement in leading young French artists to design stained-glass windows for Tiffany and Co., New York (see fig. 15). Bonnard, Vuillard, Denis, and Roussel were among the eleven artists whose designs went into production (see cat. 29–30, 34).

Bing's redevelopment and expansion of his shop on rue Chauchat enabled him to put his ideas on decoration into practice. The new building, called the Maison de l'Art Nouveau, which opened in 1895, became a showcase for an all-embracing rather than a specific style. Bing's program stated:

L'Art Nouveau has as its aim to bring together from amongst the manifestations of art all those which are no longer incarnations of the past; to offer, without excluding any categories and without preferring any schools, a gathering place for all works marked by a clearly personal sentiment. L'Art Nouveau will fight to eliminate ugliness and the pretentious luxury of every object, to effect the penetration of taste and the charm of simple beauty even into the least object of utility.[71]

To demonstrate the stylistic variety and adaptability of *art nouveau*, the Maison included model rooms by innovative artists and designers. Vuillard painted panels for a small waiting-room, Denis designed a child's bedroom, with simple wooden furniture and comforting wall decorations in a restful, blue color scheme conducive to sleep. The dining room, designed, along with the furniture, by the Belgian architect Henry Van

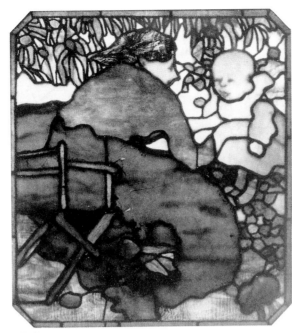

FIG. 15

FIG. 15
Tiffany and Co., New York. *Maternity*, 1894. Stained-glass window after a cartoon by Pierre Bonnard, 70 x 64 cm. Private collection. Photo: Mauner 1978, fig. 37.

FIG. 16
Contemporary photograph of the dining room designed by Henry Van de Velde (Belgian; 1863–1957), with decorative panels by Paul Ranson (French; 1865–1909) and ceramic plates by Edouard Vuillard, for the Maison de l'Art Nouveau, Paris, 1895. Private collection. Photo: Weisberg 1986, p. 69, fig. 57.

between French and Japanese aesthetics. There was for him something immediate and energetic about Japanese art that made it quintessentially modern: so much so that in 1888 he described the decorative program he envisioned, based on these aesthetic principles, as *art nouveau* (an elastic term that, as we shall see, confusingly conflicts with its original use—to designate the recently developed technology for and style

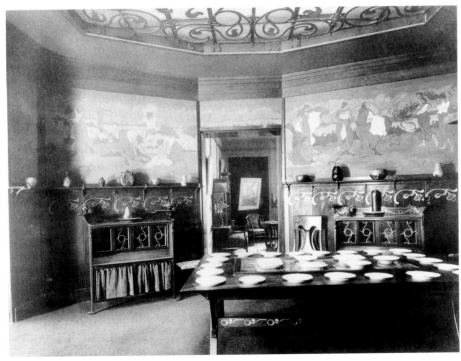

FIG. 16

de Velde, included plates decorated by Vuillard and wall decorations by his fellow Nabi Paul Ranson (see fig. 16).[72]

It is a measure of Bing's achievement that the term *art nouveau*, first employed in 1889 by architects, state planners, and commentators to describe the new technology and design of wrought iron used to build structures such as the Eiffel Tower, became synonymous with the curvilinear, "organic," luxury style of interior decoration found throughout turn-of-the-century Europe.[73] Although he saw himself as continuing the integrative program pioneered by Edmond de Goncourt and the Union centrale, the Maison that he set up in 1895 to promote his *art nouveau* was savaged by the press, and in particular by Edmond de Goncourt, as anti-French. For critic Arsène Alexandre, a supporter of the decorative arts, "It all smacks of the vicious Englishman, the Jewess addicted to morphine, or the Belgian spiv, or a good mixture of all three poisons."[74] While these words express rampant xenophobia and anti-Semitism, they also suggest that, as Debora Silverman has pointed out, in importing talent (for example, the work of the Belgian Van de Velde) from France's trade rivals to galvanize domestic design, Bing had inadvertently given credence to the very notion of foreign superiority that the Union centrale had been set up to counteract.[75] He had, in other words, not respected "the rules of French taste." Bing's somewhat spineless response was to shift his position back toward an acceptable modern version of the Rococo, so much so that by the Exposition universelle of 1900 his pavilion was placed alongside the main exhibition hall. Bing had become more "French," while French design had become more *art nouveau*.

ABSTRACTION, MODERNITY, AND INTERIORITY

Throughout their careers, the decorations of Bonnard, Vuillard, Denis, and Roussel were informed by two beliefs. The first, that the creation of a mood of protective intimism was a fundamental psychological requirement to cope with the stress of contemporary life, was closely associated with the Rococo revival in France, as we have seen. The second, that a painting was in itself a decorative object which functioned through an abstract "language" of design to communicate a feeling of tranquility, stemmed in part from Puvis de Chavannes's work, as discussed in the first section of this essay. Both beliefs achieved widespread currency in the 1890s. The language of neurotic withdrawal, pioneered by the new psychology and popularized in the writings of the Goncourts, became commonplace. In 1897, Bing outlined his view of the modern interior in these terms:

Here the imitation of physical life is an absurdity, where art in an enclosed space is intended to supply peace for the eye and the nerves. The great mistake of so many artists of our time who want to renew our domestic environment is to misinterpret this inevitable requirement. Instead of striving for the tranquility which is mainly what makes an interior attractive as a refuge from the feverish haste of modern existence, they paint outdoor perspectives on the walls to create an impression that the walls have been opened to permit a glance at the outdoors.[76]

The shift in focus of advanced opinion in the 1890s from public life to the private world of the individual brought a redefinition of modernity in terms of interiority. In one sense, interiority suggested a transition from the masculine and public to the feminine and domestic, and, in another, it meant introspection, the myth that knowledge involves "looking inward," rather than outward, which suggests a disjunction between the artist and society. The modern artist was not part of life, or a common culture, but somehow outside it, a spectator looking out from an interior world and finding in art a set of signs to engage with experience in the consciousness that he was making art. This attitude reflected in part an uncertainty about the ability of subject matter to communicate in the absence of the common culture once supplied by religion. It also reflected an increasing interest in the inherent capability of art to function as an affective language and as a means of reconciling the artist to himself in his isolation.

The interior became both a place of retreat and a laboratory in which to pursue a new decorative language. Claims to modernity lay not in the selection but in the treatment of subjects, whether street, interior, or landscape. The impetus was toward abstraction—the evocation of mood through the abstract elements of line, color, form, and composition. In his preface to the catalogue of the nineteenth exhibition of Impressionist and Symbolist painters of 1895, Denis concluded: "In their work they prefer to achieve expression through the work as a decorative entity, through the harmony of forms and colors, through the physical substance of the paint surface, to expression by the subject."[77]

Gauguin was a major stimulus in this drive toward abstraction and was without doubt one of the most

FIG. 17
Paul Sérusier (French;
1864–1927). *The Talisman*, 1888.
Oil on panel; 27 x 21 cm.
Musée d'Orsay, Paris.

program, most notably the impact of Puvis de Chavannes's work and Japanese prints. He also became practically involved in decorative projects. He carved a cupboard in wood in 1881 and began to make ceramics in 1886.[78] The experience of carving wood may have led to his first prints. His antinaturalistic stance was already formulated in his letter to Emile Schuffenecker of August 1888:

One bit of advice, don't copy nature too much. Art is an abstraction; derive this abstraction from nature while dreaming before it, but think more of creating than of the actual result. The only way to rise towards God is by doing as our divine Master does, create.[79]

The process of abstraction was an act of liberation from naturalistic representation and a simulacrum of divine creation that posited a new freedom for the artist. The work of art was a decorative entity in its own right, a concrete and symbolic reality that dealt with truths beyond surface appearances.[80]

Gauguin's message was revealed to the future Nabis Denis, Bonnard, Ranson, and Ibels at the Académie Julian by Paul Sérusier. The latter had painted in 1888 under Gauguin's tutelage, in the Bois d'Amour near Pont-Aven in Brittany, a little landscape on a cigar-box lid, known as *The Talisman* (fig. 17), which he took back to Paris. Gauguin's advice to Sérusier was later recalled by Denis:

What color do you see that tree? Is it green? Then use green, the finest green on your palette. And that shadow? It's blue, if anything? Don't be afraid to paint it as blue as you possibly can.[81]

Crude as *The Talisman* first appeared to them, it initiated the formation of the Nabis group and their drive toward decorative abstraction. The opportunity to see a large body of work by Gauguin and his disciples came soon after in the exhibition *Impressionist and Synthetist Group*, organized by Gauguin at the Café Volpini in June 1889 to coincide with the Exposition universelle. Reviewing the exhibition, Denis noted:

Instead of being windows onto the natural world, like the pictures of the Impressionists, these were large, strongly colored decorative expanses with harsh contour lines; the words used to refer to them were *cloisonnism* and *Japonism*.[82]

The following year Denis published his celebrated "Définition du néo-traditionnisme" ("Definition of Neotraditionism"), one of the key texts in the history of modernism, with its celebrated and oft-quoted statement:

It is well to remember that a picture—before being a battle horse, a nude woman, or some anecdote—is essentially a plane surface covered with colors assembled in a certain order.[83]

important influences on the formation of the Nabis and their development of decorative painting. His advice and example touched on all areas of decoration: mural painting, the role of the *peintre-décorateur*, the injunction to work in different media, the artist's construction of an interior world of his own making, and the reaction against naturalism. It was largely owing to Gauguin that decoration became a feature of the modernist agenda. He had a charismatic personality, a singular dogmatism, and the proselytizing zeal of a prophet. He was a raw and primitive presence among the sophisticated, largely middle-class, urban youth of the Parisian avant-garde, where rawness and primitivism came to stand for signs of authenticity. He pointed a way to artistic and spiritual renewal that was of direct appeal to the next generation.

Gauguin's art and theory of decoration struck the young Nabis at the end of the 1880s with the conviction of divine revelation. En route to defining his artistic goals, Gauguin had absorbed many of the influences that were to shape the Nabis' decorative

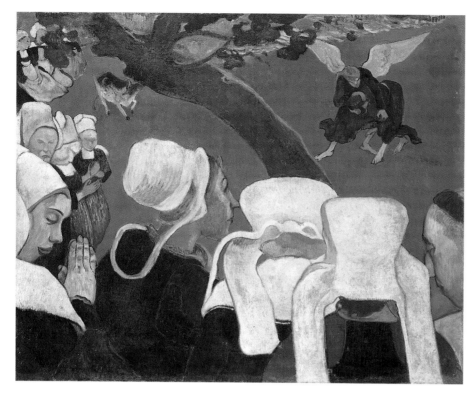

FIG. 18
Paul Gauguin (French;
1848–1903). *The Vision after the
Sermon: Jacob Wrestling with the
Angel*, 1888. Oil on canvas; 73 x
92 cm. The National Gallery of
Scotland, Edinburgh.

The use of flat, bright color was akin, for Gauguin, to a return to the directness and moving simplicity of more "primitive" art forms, which were not bound by any distinction between painting and decoration. This resulted in the Nabis' reevaluation of a whole range of "primitive" decorative traditions, from the Egyptians to Fra Angelico and the Japanese, which they sought to legitimize as the true art of painting. Great art for Denis was decorative: "Universal triumph of the imagination of the aesthetes over crude imitation; triumph of the emotion of the Beautiful over the naturalist deceit."[84]

By the time Gauguin left for the South Seas in 1891, his ideas on the decorative, which had come to define visual Symbolism, had been adopted by the young generation of painters, including the Nabis, loosely grouped under the label Symbolist. The critic Georges Albert Aurier described Gauguin—whose works he compared to "fragments of old frescoes"— and Puvis de Chavannes as the only great decorators of the nineteenth century. Drawing on German philosophy, neo-Platonism, and mystical thought, Aurier introduced a note of profound antimaterialism into contemporary criticism. He saw the Symbolist painters as direct descendants of the great mythological image makers of the past, going back as far as the Assyrians.[85] In an article entitled "Symbolism in

Painting: Paul Gauguin," published in the review *Le Mercure de France* in 1891, he gave a definition of "decorative" as his concluding point on the distinguishing features of the new art:

Decorative—for decorative painting in its proper sense, as the Egyptians and, very probably, the Greeks and the Primitives understood it, is nothing other than a manifestation of art at once subjective, synthetic, symbolic, and idea-ist.

He then continued:

Now, we must reflect well upon this: decorative painting is, strictly speaking, the true art of painting. Painting can be created only *to decorate* with thoughts, dreams, and ideas the banal walls of human edifices. The easel-picture is nothing but an illogical refinement invented to satisfy the fantasy or the commercial spirit in decadent civilizations. In primitive societies, the first pictorial efforts could be only decorative.[86]

Gauguin left for the South Seas in 1891 feeling that he had not been able to fulfill his talent as a decorator. He wrote to his friend Daniel de Monfreid from Tahiti in August 1892:

It can only do you good to be forced to decorate. But beware of *modeling*. The simple stained-glass window, attracting the eye by its divisions of colors and forms, that is still the best. A kind of music. To think that I was born to do decorative art and that I have not been able to achieve it. Neither windows, nor furniture, nor ceramics, nor whatever. . . . There lie my real aptitudes much more than in painting strictly speaking.[87]

Gauguin's extant decorative projects vary greatly in scope. The famous *Vision after the Sermon: Jacob Wrestling with the Angel* of 1888 (fig. 18) was offered as a decoration for the church at Pont-Aven, but was turned down.[88] The dining room of Marie Henry's Buvette de la Plage inn, at Le Pouldu in Brittany, executed in 1889, represents one of the few instances in which he was able to put his decorative ideals into practice. The works for this dining room by Gauguin, Meyer de Haan, Sérusier, and Maxime Maufra display a common decorative style: the bold compartmentalization of form into units of flat color like the divisions of stained glass, the repetition of floral motifs, and simplified backgrounds. Any surface was a suitable vehicle for decoration, whether wall, door panel, or glass window. To give just one example, Gauguin's *Caribbean Woman* (fig. 19) (which may actually be a symbolic personification of Lust) originally decorated the lower panel of a door in this room.[89]

Gauguin was a catalyst, an irritant, the sand in the oyster that stimulated but was uncomfortable. He saw himself as a seer guiding and exhorting his followers. When in Paris in 1891, he visited Bonnard, Vuillard,

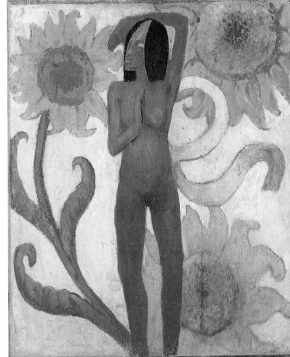

FIG. 19
Paul Gauguin. *Caribbean Woman*, 1889. Oil on panel; 64 x 54 cm. Private collection.

Greek while I am a savage, a wolf in the woods without a collar."[93] It was left to Pablo Picasso and the twentieth-century innovators of modernism to pick up on Gauguin the "savage": the Nabis remained Greeks.

Although all the Nabis were in their various ways drawn to Gauguin, they were, as Gloria Groom points out (see 1890–99 Intro.), split in their attitudes to decorative painting. Gauguin, as Aurier observed, had in mind a public art of decoration, a contemporary updating of history painting, which he was convinced belonged to the classical tradition of Ingres and therefore demanded elevated subjects and a grand, linear style. Denis believed himself and Sérusier to be following this Latin route, in contrast to Bonnard's and Vuillard's scenes drawn from life and painted in a somber palette. Denis thus constantly assessed the progress of his style in opposition to Vuillard's taste in decoration.[94] This polarization of attitudes to decorative painting within the Nabi group indicates the complexity of the ever-changing patterns of fashions, allegiances, and ideas during the 1890s. To say that Bonnard and Vuillard domesticated Gauguin, translating his public, symbolic art of decoration into everyday scenes for private interiors, would on one level certainly be true. But to condemn them as half-hearted in their response to Gauguin would be to neglect the ways in which they subtly redirected earlier conceptions of modern life in relation to novel concepts of interiority found in contemporary psychology, literature, and avant-garde theater. Taken together, these developments in psychology, literature, and theater formed the final strand in the genesis of their decorative aesthetic.

By the 1890s, previous descriptions of modernity in terms of the glorious revolutions made possible by science and technology seemed dated, and attention shifted to the negative effects of material progress. Emile Zola exemplified this loss of faith when he wrote in 1896: "Modern society is racked without end by a nervous irritability. We are sick and tired of progress, industry, and science."[95] So prevalent was this view that it slipped into everyday discourse as an established fact. A writer like Achille Segard, commenting on the decline in the number of able decorators worthy of the name, felt obliged to preface his comments with the observation: "In times that are so troubled, so conflicted, so nervous, so superficial from many points of view. . . ."[96]

Denis, and Aurélien Lugné-Poë at 28, rue Pigalle. In a letter of 1895, he encouraged Denis to carry on the struggle with both pen and brush.[90] Much as the Nabis responded to Gauguin's decorative program, they could not entirely subscribe to what they saw as his rejection of modern life and his assault on the French Rococo tradition. For Bonnard, who based his great decorative painting *Twilight*, or *Croquet Game,* of 1892 (cat. 5) on the composition of Gauguin's *Vision after the Sermon*, there was something anachronistic about Gauguin's work in its avoidance of modernity for a highly romantic vision of the past, especially when compared to Japanese prints. As he later recalled, "To me, Gauguin and Sérusier alluded to the past. But what I had in front of me [Japanese prints] was something tremendously alive and extremely clever."[91] Aristide Maillol, while acknowledging the "revelation" of Gauguin's art, put his finger on his rupture with modern life and the French tradition when he noted that "it seemed to me impossible to decorate the gardens of Versailles with the sculptures of Gauguin" and that the artist was "a stranger in our time."[92] This was a view that Gauguin himself seems to have encouraged. In a typically graphic comparison of his own art with that of Puvis de Chavannes, Gauguin concluded: "He [Puvis] is a

The popular perception of society as essentially decadent and neurotic was partly the outcome of what was referred to as "the new psychology." This analysis of society's ills had been pioneered during the second half of the nineteenth century by Dr. Jean Martin Charcot, the leading figure in the Salpêtrière school of psychology. As Jan Goldstein pointed out, by his death in 1893, Dr. Charcot had become a household name thanks to his work in classifying the stages of an hysterical attack. This was indeed, as Goldstein noted, the "golden age" of hysteria.[97] Sigmund Freud came to see the work being done on hysteria at the centers in Paris and Nancy at first hand between 1884 and 1886.[98] And it was this focus on the inner workings of the psyche, however crude it may appear to us today, that contributed to an emphasis at this time on interior decoration, as Debora Silverman showed convincingly in her book *Art Nouveau in Fin-de-Siècle France: Politics, Psychology, and Style*. Silverman demonstrated how the "new psychology" invested interior decoration with new meanings by eroding the borders between subject and object, conscious and unconscious, dream and reality.[99] The appropriately decorated interior thus became both a refuge from, and a substitute for, public life. Interior decoration could be so composed as to convey the required mood of protective intimism through the selection and arrangement of the abstract elements of design. The "outdoor perspectives" condemned by Bing could be replaced with evocative decorative paintings, which were given the form of natural life, without the illusionistic pretense associated with traditional easel painting. The viewer assumed a passively receptive role toward the moods and sensations suggested by these decorations. Objects became patterns and patterns objects; space, form, and color were elements to be fashioned by the artist's inner "self." A specific scene could thus be transformed into an interior "moodscape," a proposition that was of direct appeal to many modern artists. To give but one example, Vincent van Gogh described the painting of his bedroom in Arles in a way that illustrates how he thought colors could combine to effect a mood of peace:

Flat surfaces, though coarsely brushed with heavy pigment; the walls pale lilac, the floor of a broken and faded red, the chairs and the bed chrome yellow, the pillows and the sheet very pale lemon green, the blanket blood red, the dressing table orange, the washbasin blue, the window green. I should have liked to express absolute peacefulness through all these various colors, you see, where the only white note is given by the small spot of the mirror with its black frame (so as to cram yet the fourth pair of complementaries into the painting).[100]

Literature and theater, which were less constrained than painting by the practical demands of patronage, offered the most extreme examples of the language of interiority to which decorative painting aspired. Styles are often fashioned by extremes, and few writers were more extreme and at the same time more articulate in propounding the ideas behind the new interiority than Joris Karl Huysmans. The fact that he placed the topic center stage marks a significant development in the evolution of a decorative aesthetic. In his trendsetting novel *A Rebours* (*Against the Grain*), published in 1884, Huysmans followed Edmond de Goncourt's *Maison d'un artiste* in describing the retreat of a neurotically sensitive individual into a self-fashioned interior world. Other sources for his novel included Charles Baudelaire's theory of correspondences and Edgar Allan Poe's *Fall of the House of Usher*, with the haunted Roderick trapped by his memories within the confines of his decaying rooms. The hero of *A Rebours*, Floressas Des Esseintes, is the sole surviving scion of an inbred line, alienated from both his own class—the aristocracy—and the bourgeoisie. Ever fearful of the modern world, Des Esseintes dreams of "a desert hermitage combined with modern comfort." Des Esseintes, as Huysmans wrote, was "Like an eremite, he was ripe for solitude, harassed by life's stress, expecting nothing more of existence."[101]

Huysmans included in *A Rebours* evocative descriptions of the rooms of Des Esseintes's retreat—a converted cottage in the suburbs of Paris—which reveal the alternative visions facing the novel's protagonist. Fluctuating between the sensuality of an eighteenth-century boudoir and the spartan simplicity of a monk's cell, Des Esseintes's decorative program becomes a spiritual odyssey. Was his bedroom, for instance, to be a "place for pleasure, contrived to excite the passions for nightly adventure" or "a retreat dedicated to sleep and solitude, a home of quiet thoughts, a kind of oratory"?[102] The Louis XV style was for Des Esseintes "pre-eminently the one for refined minds, for people exhausted above all by the stress and strain of mental sensibility; indeed, only the Eighteenth Century has known how to envelop woman in a vicious atmosphere, shaping its furniture on the model of her charms, copying the contortions of her ardor, imitating the passions of her amorousness in the waving lines and intricate convolutions of wood

and copper."[103] Commensurate with his spiritual progress, he opts for the second alternative, the monk's cell. But with a difference. Unable to abide its "plain ugliness," he perversely sets out to achieve its general effect using "costly and magnificent materials."[104] He then proceeds to discuss how the illusion is to be achieved through the judicious combination of materials and colors studied under his favored artificial illumination.

The sheer "staginess" of Huysmans' descriptions, in which interiors reveal Des Esseintes's inner life and evoke mood through the abstract elements of design, found direct parallels in the development of the avant-garde theater with which the Nabis were actively engaged in the 1890s. Pierre Quillard, writing in *La Revue d'art dramatique* (1 May 1891), suggested that it was enough to have ornamental stage sets, rather than representational ones. The décor should complement the text of the play simply with "analogies of colors and lines."[105] Bonnard, Vuillard, and Denis executed designs for programs and sets for both the Théâtre Libre and the Théâtre de l'Art, but, above all, they were most closely associated with Lugné-Poë's Théâtre de l'Oeuvre, founded in 1893. Although none of their sets has survived, the experience of designing them seems to have been crucial to their development of the intimist interior. Bonnard and Vuillard were probably instrumental in edging Lugné-Poë away from realism. In his memoirs, *Le Sot du tremplin: Souvenirs et impressions du théâtre*, Lugné-Poë wrote that Vuillard was ingenious in creating atmosphere, and he singled out Bonnard as "the imaginative user of research, line and color."[106]

The transformation of the concept of modernity from one that emphasized public life and technological progress into one that focused on the private, interior world of the individual represented a shift that had major implications for the Nabis' decorative painting. Bonnard and Vuillard adopted a set of strategies fully in keeping with the new interiority. Their interiors are domestic havens of peace and security, a largely feminine world formed through the intimacy of close personal relationships. Space is closed down and expressed through an emotional atmosphere. Figures lose their identity and blend with their surroundings, which define them. Vuillard noted in his journal: "Really, for a decoration for an apartment, a subject that's objectively too precise could easily become unbearable. One would grow less quickly

tired of a textile, of designs that don't have too much literary precision."[107] His decoration *The Dressmaking Studio* of 1892 (cat. 31, fig.1) is a case in point. It features a frieze of female figures all dressed in strikingly active patterns, which both define and camouflage them. Nothing is definite. Figures and objects merge in the atmosphere of the interior.

DECORATIVE PAINTING AND THE TWENTIETH CENTURY

Bonnard, Vuillard, Denis, and Roussel, in the fertile period up to the beginning of World War I, placed the issue of decorative painting firmly at the center of the modernist agenda. In so doing, they were instrumental in countering what E. H. Gombrich referred to as the neurotic compulsion of high art to divorce itself from the decorative.[108] There is little in Matisse's theory and practice of art as decoration that was not anticipated by these earlier artists. The application of a decorative aesthetic to all kinds of paintings, the perpetuation of the scale and ambition of mural decoration in modernist painting, the intention to subvert the academic hierarchy separating the fine arts from the decorative arts, and the transformation of the public art of history painting into private art for interiors were all features of their achievement. They were also crucial in establishing an ancient pedigree for decorative painting, in the creation of a mood of protective intimacy as a fundamental requirement to cope with the stress of contemporary life, and in promoting the concept of painting as a decorative object that communicates a feeling of tranquility and functions through an abstract language of design to fashion space. Matisse was but reiterating points pioneered by the Nabis when he wrote in his celebrated "Notes of a Painter" of 1908:

Composition is the art of arranging in a decorative manner the various elements at the painter's disposal for the expression of his feelings. . . . What I dream of is an art of balance, of purity and serenity devoid of troubling or depressing subject matter, an art which might be for every mental worker, be he businessman or writer, like an appeasing influence, like a mental soother, something like a good armchair in which to rest from physical fatigue.[109]

The Nabis' contribution to decorative painting in the twentieth century has never received its due recognition for three principal reasons. First, their ambitions and achievements were soon overtaken by events in the evolution of modernism. As Bonnard put it, looking back in 1937:

You see, when I and my friends adopted the Impressionists' color program in order to build on it we wanted to go beyond naturalistic color impressions. *L'Art n'est pourtant pas la nature* [art is not nature after all]—We wanted a more rigorous composition. There was also so much *more* to extract from color as a means of expression. But developments ran ahead, society was ready to accept Cubism and Surrealism before we had reached what we had viewed as our aim. . . . In a way we found ourselves hanging in mid-air.[110]

Secondly, a simplistic reading of art-historical developments in France up to World War II has resulted until recently in French decorative painting being regarded as outside contemporary developments, whereas the reverse is true.[111] And thirdly, a lingering prejudice against painting that was both "tasteful" and often highly colored persisted throughout the twentieth century.

For all their novelty, the Nabis were not rebels. There is nothing violent or iconoclastic about their decorative painting. While in no way hostile to modern developments, they absorbed what they needed from them on their own terms. They respected "the rules of French taste" when formal audacity became a criterion of good modernist painting. From the perspective of post–World War II art and art criticism, tasteful painting looked weak. Clement Greenberg, the high priest of a formalist reading of modernism, put his finger on what he saw as the crucial difference between the French and American versions of Abstract Expressionism, despite their seeming convergence of aims. Writing in 1953, he noted:

In Paris they finish and unify the abstract picture in a way that makes it more agreeable to standard taste (to which taste I object, not because it is standard—after all, the best taste agrees in the long run—but because it is usually a generation behind the best of the art contemporaneous with it).[112]

In other words, tasteful French painting carried the stigma of seeming easy and unchallenging, whereas it was a *sine qua non* of good modernist painting that it be difficult and challenging and take a generation or more to absorb. In addition, the deeply rooted prejudice against highly colored decorative painting persists to this day. John Elderfield, in a recent exchange of letters with the painter Howard Hodgkin, wondered if "the root of the problem is the association of high color with decoration: whether you like or dislike high-colored paintings, they can't be serious because they are 'decorative.'"[113] In other words, painting that looks facile and attractive cannot have content. Beauty and good taste thus become signs of failure.

Another factor that has contributed to the misunderstanding of the Nabis' decorative painting as divorced from contemporary developments is their refusal to follow the course set by Fauvism, the first avant-garde movement of twentieth-century modernism. The Nabis, along with most critics and collectors, found it difficult to accept the Fauves' exaltation of the abstract pictorial elements to a point where they appeared to transcend any representational function, an approach epitomized by Matisse's *Woman with the Hat* of 1905 (private collection, San Francisco).

In comparison with the the work of the Fauves, the Nabis' decorative paintings looked tame and tasteful. It was not a question of subject matter but of style. After all, Matisse's seminal decorative painting *The Joy of Life* of 1905–06 (fig. 20) shared with their work the subject of languid nudes relaxing in a Mediterranean setting. Both Matisse and the Nabis had a common ambition to fuse the transient and contemporary with the timeless and classical. The great difference between them was that Matisse transformed the setting into a Gauguinesque earthly paradise, using unusually large areas of flat color articulated by sinuous arabesques. These formal traits appeared to many informed observers to shift too drastically the balance between representation and decoration in favor of abstraction. Signac, Matisse's mentor at St.-Tropez during the summer of 1904, had bought the younger artist's first large-scale imaginary composition, *Luxe, calme et volupté* (1900–30 Intro., fig. 2). Signac nevertheless found *The Joy of Life* to be a severe disappointment. As he explained:

Matisse, whose efforts I have liked up to now, seems to have gone to the dogs. Upon a canvas of two and half meters he has surrounded some strange characters with a line as thick as your thumb. Then he has covered the whole with flat, well-defined tints, which—however pure—seem disgusting.[114]

In the face of Matisse's new, overtly "abstract" decorative style and his leadership of the avant-garde, the Nabis turned in the opposite direction, their painting paradoxically becoming both more classical and more Impressionist. Their style, in fact, is neither resolutely linear and classical, nor dogmatically atmospheric and Impressionist.[115]

Seen now from a postmodern perspective, the Nabis' decorative paintings do not appear to be out of kilter with their times. Quite to the contrary. As David Elliott pointed out in a discussion of art between 1930 and 1945, "the idea of a specialized, fragmented and

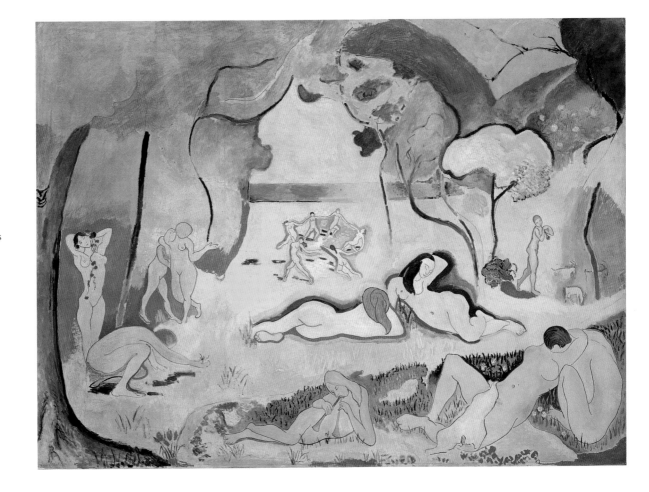

FIG. 20
Henri Matisse (French;
1869–1954). *The Joy of Life*,
1905–06. Oil on canvas;
174 x 238.1 cm. The Barnes
Foundation, Merion,
Pennsylvania.

modern world became a pervasive double to that of the romantic, unitary being of the alienated but 'noble savage'—the human being who had not been corrupted by the decadence and idleness of despotism."[116] The Nabis' cutting back and forth between different genres, realities, and styles became a recognizable feature of postmodernism. They looked with uncertainty on a fragmented world, conscious of an enormous sense of loss. Their perpetuation of a classical tradition became an important ingredient in the decorative work of Picasso and Matisse. This emphasis on classicism was also given a fresh impetus by the *rappel-à-l'ordre* (call-to-order) movement during and after World War I, which advocated a return to the cultural certainties of tradition at a time of international crisis.

The outstanding difference between the Nabis and the artists who responded to the call to order was that they did not return to the classical tradition: they had never left it. Educated in the classical tradition, they were trained to see its relevance in the present and to think allegorically. This was not unusual. In 1900, more than half the lycée curriculum was devoted to classical

languages, grammar, and rhetoric, and only one-eighth to science.[117] Denis, convinced of the superiority of classical culture, wrote in his journal in 1896 that Greek philosophy represented "the most perfect ideal of the most advanced civilization."[118] Roussel, whom Verkade described as an "Impressionist Claude Lorraine," knew the writings of Virgil and Lucretius by heart.[119] Vuillard was encountered by the novelist André Gide visiting the gallery of Greco-Roman frescoes in the Musée du Louvre in 1902.[120] Bonnard's pastoral vision, played out in his large-scale decorative paintings, was first developed in his illustrations for a 1902 edition of the Greek writer Longus's pastoral prose romance *Daphnis et Chloé*, in which the painter's native landscapes of the Ile-de-France and the Dauphiné became his Lesbos (see fig. 21).[121]

What is striking, though, about the critical reception of both Bonnard and Vuillard in particular is that they were not credited with continuing the French classical tradition, but rather Impressionism. This assessment had a double edge. Depending on the critic's stance, it was either a sign of approval or weak-

FIG. 21

Pierre Bonnard. Illustration
for Longus's *Daphnis et Chloé*
(Paris, 1902). Lithograph; book:
30.5 x 25 cm. Photo: Bouvet
1981, p. 144.

ness. In the 1920s, for example, Bonnard was castigated
for his loose, Impressionist handling.[122] The reputa-
tions of these artists, which had declined between the
two World Wars along with that of the Impressionists,
came into focus again in the 1940s after their deaths.
In an extremely hostile article in *Cahiers d'art* of 1947,
written in response to the Bonnard retrospective exhi-
bition at the Orangerie, Paris, Christian Zervos dis-
missed Bonnard as a latter-day Impressionist.[123] In the
catalogue introduction to the Bonnard–Vuillard exhi-
bition held at the Royal Scottish Academy during the
Edinburgh Festival of 1948, Clive Bell thought that
historians of the twenty-first century would probably
end up by classifying the two young Nabis of the
1890s, Bonnard and Vuillard, as the last of the
Impressionists.[124] This view of them remained largely
unchallenged until the 1980s. In the catalogue to the
exhibition *Bonnard and His Environment* (organized in
1964 by the Museum of Modern Art, New York, in
collaboration with the Los Angeles County Museum
of Art and the Art Institute of Chicago), James Thrall
Soby wrote:

It's a paradox of Pierre Bonnard's long and most distinguished
career that in the United States, where the French Impressionists
found a number of early and fervent champions, their spiritual
heir, Bonnard, has only lately come to great fame. . . . Possibly
our taste for visual revolution, once aroused, found Bonnard
belated in aim. At any rate his following and patronage
remained predominantly European until after the war.[125]

Nobody after World War I wanted to talk seriously
about the Nabis' decorative paintings. But there again

this was largely the fate of decorative painting in
general. The Nabis' roots lay so thoroughly in the
nineteenth century that it was difficult for twentieth-
century commentators to accept them in terms of the
modern. Their achievements had seemingly been
absorbed into early twentieth-century modernism and
they remained in the present as reminders of a lost
world of human happiness, eminently suitable in fact
for official commissions from the long-lived Third
Republic. In this they were not alone. Monet's
magnificent *grandes décorations*, his water-lily series,
proved similarly hard to place and were not accorded
the reception they deserved when finally unveiled in
the Orangerie on 17 May 1927 (see fig. 22).[126]

The revival of mural decoration was a major objec-
tive of the organizers of the 1937 World's Fair in Paris,
but of the commissions presented, only Picasso's
Guernica (1937; Centro Reina Sofía, Madrid) stood out
as having reinvented the art of history painting in a
way that had any relevance to a post–World War II
generation of artists traumatized by seven years of loss
and destruction. When in 1946 Picasso abandoned
Paris and his war-time themes of alienation and vio-
lence for the Mediterranean, he cut himself off from
the aspirations of the contemporary avant-garde. His
wish to engage in a freewheeling dialogue with the
classical tradition and to recapture an inventive spon-
taneity, sensuality, and humor by creating murals and a
ceramic art that broke down the barriers between fine
art and craft were seen as irrelevant at the time. A sim-
ilar fate initially greeted Matisse's overtly decorative
paper cut-out projects that he began in 1942 and con-
tinued to execute until his death in 1954. Violence,
alienation, and loss, rather than sex, euphoria, and sen-
sual well-being, typified the postwar mood. For the
postwar French avant-garde of Dubuffet, Fautrier,
Hartung, and their generation, the classical Mediter-
ranean vision, as exemplified by Matisse, Picasso, and
the Nabis, had been closed off by the fascists, who had
appropriated the vocabulary of classicism and con-
verted it into a language of oppression.[127]

Left behind by histories of modernism, no satisfac-
tory framework, no theory, no substantial body of crit-
icism emerged after World War II to accord Bonnard,
Vuillard, Denis, and Roussel the attention they
deserved. Clement Greenberg, writing in 1948, while
acknowledging the decline in Cubism, still found it
hard to account for the fact that Bonnard and Vuillard
had continued to produce good paintings: "The prob-
lem for criticism is to explain why the Cubist genera-

FIG. 22
Claude Monet. Installation of *Water Lilies* (detail), 1916–26, at the Musée de l'Orangerie des Tuileries, Paris.

tion and its immediate successors have . . . fallen off in middle and old age, and why belated Impressionists like Bonnard and Vuillard could maintain a higher consistency of performance during the last fifteen years."[128]

It was largely owing to artists, rather than critics, that more complex readings of Bonnard and Vuillard began to take shape. The English painter Patrick Heron, who wrote extensively as a critic, drafted a highly influential article on Bonnard in 1947, which was published in 1955. Like Greenberg, Heron saw young French painters turning more to Bonnard and Matisse than to Picasso:

So, when we regard Bonnard solely in the context of twenti-eth-century painting; even, that is, if we study him with eyes accustomed to the lens that is Picasso, we shall not make the mistake of assigning him to the Past: we shall not look upon him as an intruder into the Present from the Impressionist Nineties; as the final ambassador of an anachronism. He is nothing of the kind.

Bonnard for Heron was a painter of the highest imaginative order. Neither entirely decorative, nor pedantically imitative, he combined "the abstract music of interacting form-color" with subject matter drawn across the surface in an all-over pattern.[129]

In the light of Abstract Expressionism and the need to provide the New York School with a pedigree stemming from the achievements of the European masters of modernism, Greenberg in the mid-1950s came to reconsider his view of Monet's great water-lily decorations, irrespective of the fact that none of the leading

Abstract Expressionists had publicly associated themselves with the French painter.[130] He isolated a development linking artists like Rothko (see fig. 23), Still, and Newman with Monet, Bonnard, and Vuillard:

This development involves a more consistent and radical suppression of value contrasts than seen so far in abstract art. We can realize now, from this point of view, how conservative Cubism was in its resumption of Cézanne's effort to save the convention of dark and light. . . . The late Monet, whose suppression of values had been the most consistently radical to be seen in painting until a short while ago, was pointed to as a warning, and the *fin-de-siècle* muffling of contrasts in much of Bonnard's and Vuillard's art caused it to be deprecated by the avant-garde for many years. . . . This expansion of sensibility has coincided with the emergence of Clyfford Still [along with Newman and Rothko].[131]

Bonnard's and Vuillard's suppression of value contrasts was but one aspect of their art. It was as though Greenberg, conscious of the quality of their work, was groping for reasons to accommodate it within a formalist reading of modernist paintings that did not really fit.

There were always independent artists who valued their work. Bonnard set the agenda for Matisse's intimist, light-filled domestic interiors of both the early Nice period, from 1918 to 1930, and the 1940s. On reading Zervos's hostile article on Bonnard, Matisse wrote directly on its pages, "Yes! I assure you that Pierre Bonnard is a great painter for today and surely for the future."[132] Balthus regarded Bonnard as the greatest painter of the twentieth century.[133] The

FIG. 23

Nabis' diversity of intentions and styles made it difficult for critics and historians to tie them down to a specific contribution. They were not single-issue painters. Neither realists, classicists, nor Impressionists, the Nabis evolved art from an awareness of the contradictions inherent in the relationships between the transience of experience, the fragility of cultural traditions, and the permanence of painting, and they floated between both the intimist and the decorative aspirations of their early Nabi careers.

With the passing of modernism, more complex readings of their art have emerged. Hodgkin has taken up and developed Bonnard's and Vuillard's combination of highly decorative means and emotional content. Eric Fischl has focused on the erotically charged atmosphere generated by nudes sprawled out in domestic interiors. Roy Lichtenstein continued Bonnard's and Vuillard's interest in the dialogue between surface pattern and pictorial depth in his late series of paintings of interiors (see fig. 24). Timothy Hyman has written of Bonnard's "retrieval of space and self . . . [and] his freedom from any obvious stylistic ideology" as full of promise to a younger generation of painters.[134] Denis, outside of his initial theoretical contribution to the evolution of decorative painting, and Roussel are both still largely unknown to a wider public. And Vuillard's contribution to decorative painting is only now receiving wider recognition. Recent exhibitions devoted to the Nabis have incorporated decorative painting, but this is the first major, large-scale exhibition to be devoted solely to this highly important topic; the opportunity to re-evaluate it has finally come at the beginning of the twenty-first century.

FIG. 24

1. Verkade 1930, p. 88.

2. Marc J. Gotlieb, *The Plight of Emulation: Ernest Meissonier and French Salon Painting* (Princeton, N.J., 1996), pp. 9–10.

3. New York, The Metropolitan Museum of Art, *Portraits by Ingres: Image of an Epoch*, exh. cat. by Gary Tinterow and Philip Conisbee (1999), p. 3.

4. Ibid., pp. 277–78.

5. Gotlieb (note 2), p. 83.

6. London, Tate Gallery, *John Singer Sargent*, exh. cat. by Elaine Kilmurray and Richard Ormond (1998), p. 24.

7. Patricia Mainardi, *The End of the Salon: Art and the State in the Early Third Republic* (Cambridge, 1993), p. 2.

8. Nicholas Watkins, *Matisse* (Oxford, 1984), p. 27.

9. Ibid., p. 28.

10. Patricia Mainardi, *Art and Politics of the Second Empire: The Universal Exhibitions of 1855 and 1867* (New Haven/London, 1987), p. 163.

11. Denis, *Journal*, vol. 1, entry, Mar. 1899, p. 150.

12. Paris 1986; and Paris, Musée du Petit Palais, *Quand Paris dansait avec Marianne, 1879–1889*, exh. cat. (1989).

13. Mainardi (note 7), p. 58.

14. Paris 1986, p. 182.

15. Paris, *Quand Paris . . .* (note 12), pp. 169–71.

16. Ibid., p. 179.

17. Ibid., pp. 237–38.

18. Michael Marlais, "Puvis de Chavannes and the Parisian Daily Press," *Apollo* 149, 444 (Feb. 1999), p. 3.

19. Juliet Simpson, "The Société nationale: The Politics of Innovation in Late Nineteenth-Century France," *Apollo* 149, 444 (Feb. 1999), p. 52. Puvis executed almost all of his murals in oil on canvas in his studio. This procedure allowed him to exhibit a finished mural before it was permanently attached with glue, by means of the *marouflage* technique, to the wall for which it had been commissioned. Puvis also seems to have created smaller versions, or reductions, of his murals, which allowed him to continue to exhibit the compositions after the full-scale originals were permanently installed; see George Manning Tapley, Jr., *The Mural Paintings of Puvis de Chavannes* (Ann Arbor, Mich., 1981), pp. 67, 69.

20. Denis, *Journal*, vol. 1, entry, 18 Dec. 1887, p. 67. For an extended discussion of the aesthetic concepts that governed murals and distinguished them from easel paintings in mid-nineteenth-century France, see Aimée Brown Price, *Puvis de Chavannes: A Study of the Easel Paintings and a Catalogue of the Painted Works* (Ann Arbor, Mich., 1972), pp. 143–47; idem, "The Decorative Aesthetic in the Work of Puvis de Chavannes," in Ottawa, National Gallery of Canada, *Puvis de Chavannes*, exh. cat. (1977), p. 22; and Tapley (note 19), pp. 47–54.

21. Weisberg 1986, p. 9.

22. Cited in Watkins 1994, p. 25.

23. J. Daurelle, "Chez les Jeunes Peintres," *Echo de Paris*, 28 Dec. 1891, p. 2, tr. in Giambruni 1983, p. 75.

24. Denis's review, [Pierre Louis, pseud.], "Pour les jeunes peintres," appeared in the 20 Feb. 1892 issue of *Art et critique*; the passage cited here is translated in Washington, D.C. 1984a, p. 77.

25. Verkade 1930, p. 38.

26. Havard 1887–90, vol. 2, p. 46.

27. Ibid., p. 54.

28. Cited in Groom 1993, p. 14.

29. Gillian Naylor, *The Arts and Crafts Movement: A Study of Its Sources, Ideals, and Influence on Design Theory* (London, 1971), p. 8.

30. Fiona MacCarthy, *William Morris: A Life for Our Time* (London, 1994), p. 69.

31. Weisberg 1986, p. 99.

32. Isabelle Ottaviani and Philippe Poulain, *Le Paris de Marcel Proust* (Paris, 1996), p. 38.

33. Robert Jensen, *Marketing Modernism in Fin-de-Siècle Europe* (Princeton, N.J., 1994), p. 208.

34. Denis, *Journal*, vol. 1, p. 69.

35. Paris 1993, p. 335; and Frèches-Thory and Terrasse 1990, p. 179.

36. Paris 1986, p. 155.

37. Segard 1914, vol. 1, p. 245.

38. Groom 1993, p. 49.

39. Watkins 1994, p. 9.

40. Béatrice de Andia, "Un Elan fastueux," in Gérard Rousset-Charny, *Les Palais parisiens de la belle époque* (Paris, 1990), p. 16.

41. Ibid., pp. 26–43.

42. See Jean Messelet et al., eds., *Le Musée Nissim de Camondo* (Paris, 1998); and Nicolas Sainte Fare Garnot et al., eds., *Le Musée Jacquemart-André* (Paris, 1997).

43. Virginia Spate, *The Colour of Time: Claude Monet* (London, 1992), p. 165.

44. John House, "Renoir's Worlds," in London, Hayward Gallery, *Renoir*, exh. cat. (1985), p. 16.

45. Ibid., p. 220.

46. Albert André, *Renoir* (Paris, 1928), p. 30, cited in House (note 44), p. 14 n. 75.

47. John Rewald, *The History of Impressionism* (New York, 1961), p. 488.

48. Robert Baldick, ed., *Pages from the Goncourt Journal* (Oxford, 1962), cited in Anita Brookner, *The Genius of the Future* (London/New York, 1971), p. 124.

49. Silverman 1989, p. 20.

50. Brookner (note 48), p. 123.

51. Edmond de Goncourt, *La Maison d'un artiste*, vol. 1 (Paris, 1881), pp. 1–3.

52. Ibid., pp. 4–13.

53. Ibid., pp. 376–82.

54. Silverman 1989, p. 136.

55. Ibid., pp. 115, 118.

56. Ibid., pp. 110, 118.

57. Ibid., p. 135.

58. Frèches-Thory and Terrasse 1990, p. 175.

59. Paris 1993, pp. 361–63.

60. Rémy Saisselin, *The Bourgeois and the Bibelot* (New Brunswick, N.J., 1984), p. 40.

61. Ibid., pp. 33–34.

62. Simpson (note 19), p. 52.

63. Cited in Hilary Spurling, *The Unknown Matisse: A Life of Henri Matisse, the Early Years, 1869–1908* (London/New York, 1978), p. 292.

64. On Whistler's use here of Japanese sources, see London, Tate Gallery, *James McNeill Whistler*, exh. cat. by Richard Dorment and Margaret F. MacDonald (1994), p. 16. The critic Félix Fénéon called Bonnard "trés japonard" in 1892; see Paris 1993, p. 107.

65. Cited in Gaston Diehl, *Bonnard* (Paris, 1943), n. pag.

66. Watkins 1997, p. 35.

67. Watkins 1994, p. 29.

68. Nancy J. Troy, *Modernism and the Decorative Arts in France: Art Nouveau to Le Corbusier* (New Haven/London, 1991), p. 8.

69. See the first issue of Bing's journal, *Le Japon artistique*, published in 1888, cited in Weisberg 1986, p. 26.

70. Ibid., p. 48.

71. Bing, cited in Troy (note 68), p. 17.

72. Frèches-Thory and Terrasse 1990, p. 131.

73. Silverman 1989, p. 5.

74. Arsène Alexandre, "L'Art nouveau," *Le Figaro*, 28 Dec. 1895, cited in Silverman 1989, p. 278.

75. Ibid., pp. 277–78.

76. Bing, cited in Weisberg 1986, p. 148.

77. Cited in Denis 1920, tr. in Watkins 1994, p. 28.

78. Douglas Druick, "Foreword," in London, Royal Academy of Arts, *Gauguin and the School of Pont-Aven: Prints and Paintings*, exh. cat. by Caroline Boyle-Turner (1986), p. 15.

79. Paul Gauguin to Emile Schuffenecker, Pont-Aven, 14 Aug. 1888, cited in John Rewald, *Post-Impressionism: From van Gogh to Gauguin* (New York, 1962), p. 196.

80. Françoise Cachin, "Gauguin Portrayed by Himself and by Others," in Washington, D.C., National Gallery of Art, and The Art Institute of Chicago, *The Art of Paul Gauguin*, exh. cat. by Richard Brettell et al. (1988), p. xxiii.

81. Maurice Denis, "L'Influence de Paul Gauguin," *Occident* 23 (Oct. 1903), tr. in Watkins 1994, p. 18.

82. Cited in Frèches-Thory and Terrasse 1990, p. 19.

83. Denis 1890, pp. 540–42, 556–58, tr. in Chipp 1968, p. 94.

84. Denis, cited in Chipp 1968, p. 100.

85. Denis, cited in Michael Marlais, *Conservative Echoes in Fin-de-Siècle Parisian Art Criticism* (University Park, Penn., 1992), pp. 126, 130.

86. Georges Albert Aurier, "Le Symbolisme en peinture: Paul Gauguin," *Mercure de France* 2 (1891), pp. 159–64, tr. in Chipp 1968, p. 92.

87. Gauguin to Daniel de Monfried, Tahiti, Aug. 1892, tr. in Chipp 1968, p. 64.

88. Washington, D.C., and Chicago (note 80), p. 103.

89. Valle d'Aosta, Centro St.-Benin, Museo Archeologico Regionale, *Gauguin e i suoi amici pittori in Bretagna*, exh. cat. (1993), pp. 72–73.

90. Denis, *Journal*, vol. 1, p. 113.

91. Bonnard, cited in Gaston Diehl, "Pierre Bonnard dans son univers enchanté," *Comoedia* (10 July 1943).

92. Maillol to Denis, 1907, in Denis, *Journal*, vol. 2, p. 61.

93. Gauguin to Charles Morice, Tahiti, July 1901, tr. in Chipp 1968, p. 66.

94. Denis, *Journal*, vol. 1, p. 154.

95. Emile Zola, in "Souvenirs des Goncourts," *Revue encyclopédique* 6, 153 (8 Aug. 1896), p. 552, cited in Silverman 1989, p. 7.

96. Segard 1914, vol. 1, p. 10.

97. Jan Goldstein, *Console and Classify: The French Psychiatric Profession in the Nineteenth Century* (Cambridge, 1987), pp. 238, 322.

98. Silverman 1989, p. 83.

99. Ibid., p. 75.

100. Vincent van Gogh to Gauguin, [Arles, Oct. 1888], cited in Rewald 1962, p. 242.

101. Joris Karl Huysmans, *A Rebours* (Paris, 1884), tr. by P. G. Lloyd (London, 1946), p. 69.

102. Ibid., p. 67.

103. Ibid.

104. Ibid., p. 68.

105. Pierre Quillard, cited in Jacques Robichez, *Le Symbolisme au théâtre* (Paris, 1957), p. 188, tr. in Nell Andrew, "Theater in the Flat," M.A. paper, University of Chicago, 1998, p. 6.

106. Lugné-Poë 1930, p. 195.

107. Vuillard, Journals, entry, 28 Aug. 1894, MS 5396, cited in Groom 1993, p. 58.

108. E. H. Gombrich, *The Sense of Order: A Study in the Psychology of Decorative Art* (London, 1979), p. 17.

109. Henri Matisse, "Notes d'un peintre," 1908, tr. in Alfred H. Barr, *Matisse: His Art and His Public* (New York, 1951), pp. 119, 122.

110. Bonnard, cited in Ingrid Rydbeck, "Hos Bonnard i Deauville 1937," *Konstrevy* 13, 4 (1937), pp. 119–23, tr. by Anne Marie Kelsted in Watkins 1997, p. 9.

111. Romy Golan, *Modernity and Nostalgia: Art and Politics in France between the Wars* (New Haven/London), 1995, p. ix.

112. Clement Greenberg, "Symposium: Is the French Avant-Garde Overrated?" *Art Digest* 27, 20 (15 Sept. 1953), in John O'Brian, ed., *Clement Greenberg: The Collected Essays and Criticism* (Chicago/London, 1993), vol. 3, p. 155.

113. John Elderfield and Howard Hodgkin, "An Exchange," in Michael Auping et al., *Howard Hodgkin Paintings* (London/New York, 1995), p. 71.

114. Signac to Charles Angrand, 14 Jan. 1906, tr. in Barr (note 109), p. 82.

115. Watkins 1994, p. 85.

116. David Elliott, "The Battle for Art," in London, Hayward Gallery, *Art and Power: Europe under the Dictators, 1930–45*, exh. cat. (1996), p. 4.

117. Mainardi (note 7), p. 131.

118. Denis, *Journal*, vol. 1, entry, July–Aug. 1896, p. 115.

119. Verkade 1930, pp. 72–73.

120. André Gide, entry, 18 Jan. 1902, in *The Journals of André Gide*, vol. 1, tr. by Justin O'Brien (New York, 1947–51), p. 99.

121. Watkins 1994, p. 73.

122. Golan (note 111), p. 10.

123. Christian Zervos, "Pierre Bonnard: Est-il un grand peintre?" *Cahiers d'art* 22 (1947), pp. 1–6.

124. Edinburgh, Royal Scottish Academy, *Bonnard–Vuillard*, exh. cat. by Clive Bell (1948), pp. 3, 6–7.

125. New York, The Museum of Modern Art, *Bonnard and His Environment*, exh. cat. by James Thrall Soby (1964), p. 9.

126. Paul Hayes Tucker, "The Revolution in the Garden: Monet in the Twentieth Century," in Boston 1998, p. 79.

127. Nicholas Watkins, "Ceramics, Satyrs and the Mediterranean: Picasso, Matisse and Miró," lecture, Royal Academy of Arts, London, 23 Sept. 1998.

128. Clement Greenberg, "The Decline of Cubism," *Partisan Review* 15, 3 (Mar. 1948), pp. 366–67, cited and discussed in Irving Sandler, *Abstract Expressionism: The Triumph of American Painting* (London, 1970), p. 273.

129. Patrick Heron, *The Changing Forms of Art* (London, 1955), pp. 116–19, cited and discussed in Watkins 1994, pp. 227–28.

130. Michael Leja, "The Monet Revival and the New York School of Abstraction," in Boston 1998, p. 101.

131. Clement Greenberg, "'American-Type' Painting," *Partisan Review* 22, 2 (spring 1955), pp. 189–90, 192, 194, cited and discussed in Sandler (note 128), pp. 273–74.

132. Matisse's response to Christian Zervos (note 123), cited in Watkins 1994, p. 85.

133. Hyman 1998, p. 212.

134. Ibid., p. 213.

Catalogue

PART I: 1890–99

BY GLORIA GROOM

WITH A CONTRIBUTION BY
THÉRÈSE BARRUEL

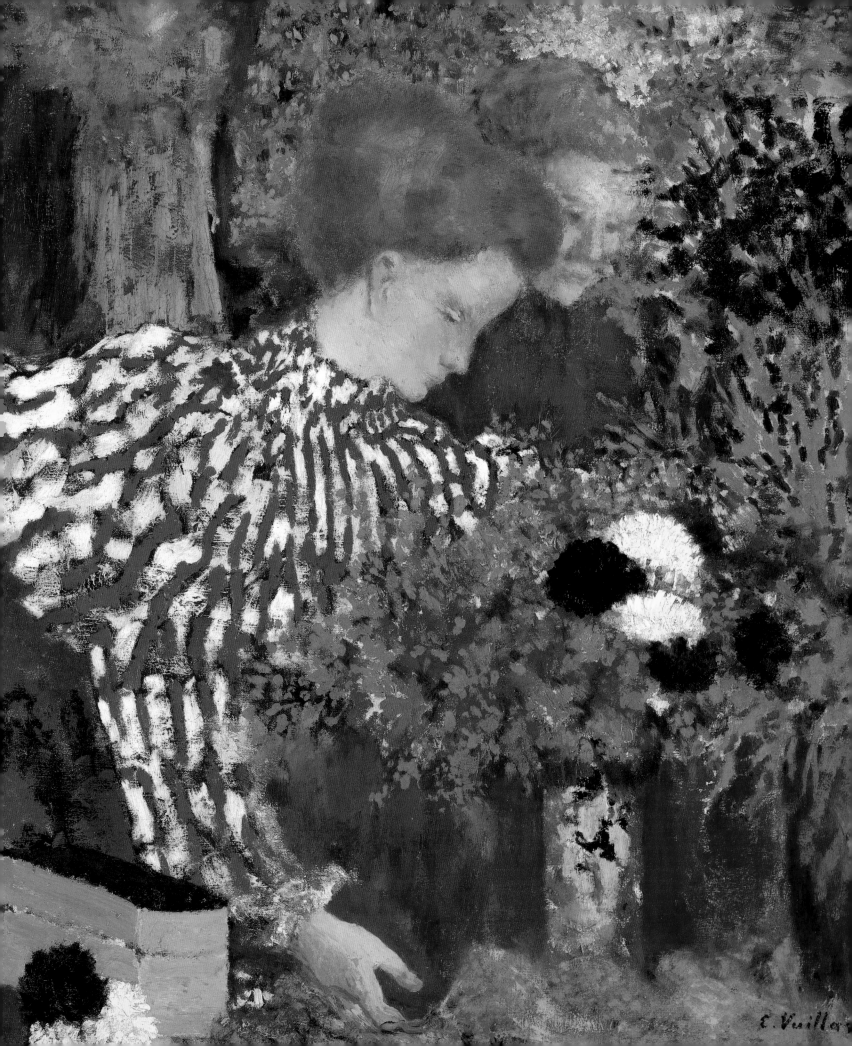

Coming of Age: Patrons and Projects, 1890-99

IN THE FIRST DECADE OF THEIR CAREERS, PIERRE Bonnard, Edouard Vuillard, Maurice Denis, and Ker Xavier Roussel all worked to expand their art beyond conventional easel painting according to shared decorative aims. The concepts that informed their work and the goals for which they strived, however, have often seemed elusive. This essay aims to examine first of all what was meant by *décoration* in the context of Nabi aesthetics, using as a point of departure an important 1899 exhibition in which they participated. The essay then traces Denis's crucial role in promoting the group within a circle of collectors who supported the Nabis and their belief in *décoration* as a new and progressive kind of painting. Because what follows relies largely on issues of patronage, Vuillard and Denis, who received numerous commissions for decorative paintings during this period, feature more prominently here than do Bonnard and Roussel, who were active in other ways: Bonnard as a sought-after printmaker and designer of furniture and screens; Roussel as an experimenter in various media.[1] As we shall see, the differences between Vuillard and Denis in style and patronage exemplify broad trends in late nineteenth-century decorative tastes and provide insights into the social and political circumstances that influenced those tastes.

ISSUES OF GROUP IDENTITY: THE 1899 "MODERN SCHOOL" EXHIBITION

In trying to grasp the group identity of these artists, there is perhaps no better place to start than the 1899 exhibition of the "Modern School" held at the prestigious Paris gallery of Paul Durand-Ruel. This event, organized by Paul Signac in homage to Odilon Redon, marked the first time the work of artists who had banded together ten years previously under the private and unofficial name of "Nabis" was shown in a truly major gallery and alongside better-known avant-garde artists.[2]

In his preface to the exhibition catalogue, André Mellerio, author of *Le Mouvement idéaliste en peinture* (*The Idealist Movement in Painting*) (1896), applauded the show, stating: "A certain number of painters, having exhibited separately or in groups, these last years, at the Salon des Indépendants, at the Barc de Boutteville gallery, etc., have gathered here. Their exhibition . . . aims at bringing out the sum of all contemporary trends." For Mellerio, one of the impulses behind the art on display was toward "the decorative" (*l'aspect décoratif*). These artists, he wrote, being "enthralled with the decorative aspect, sought a balance of colors and shapes to compose a surface pleasing to the eye as well as meaningful."[3]

The exhibition divided the artists into three separate rooms: Denis's group (referred to as "poetic Symbolists")[4] consisted of Bonnard, Denis, Hermann-Paul, Ibels, Ranson, the Hungarian painter Rippl-Rónai, Roussel, Sérusier, Vallotton, and Vuillard; Redon and the mystical-spiritual Rosecrucian (*Rose + Croix*) group, including Bernard, Filiger, and La Rochefoucauld, among others, made up another; and the group of Neo-Impressionist painters included Signac and Belgian painter van Rysselberghe. The relationships between these groups were ambivalent. Signac, for instance, conspicuously excluded allusion to the Nabis from his influential book *D'Eugène Delacroix au néo-impressionnisme,* published that year. In it, the artist praised Delacroix as the father of the color theories that were still in use among modern artists. Signac also advocated breaking down the barriers between fine and applied arts when he described the role of painting as wall illumination and decoration for the interior. But he made no reference to the Nabis' contribution to modern painting. Indeed, in his journal, Signac voiced his general disapproval of their art, and his resentment of the group's success and recognition, which he felt had been obtained too quickly and without the struggles of colorists (by which he meant the Impressionists and Neo-Impressionists).[5]

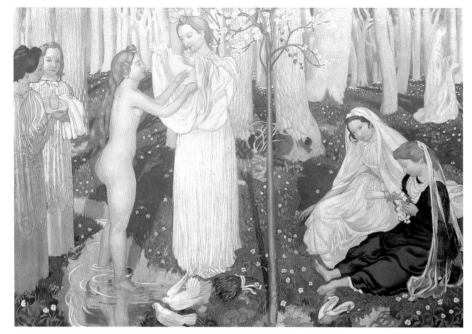

FIG. 1
Maurice Denis (French;
1870–1943). *Virginal Spring*,
1899. Oil on canvas; 80.6 x
97.8 cm. Private collection.
This is one of the works exhib-
ited at the "Modern School"
exhibition held at Galeries
Durand-Ruel, Paris, in 1899.

Other artists included in the exhibition were equally ambivalent toward the painters represented in the first room. Count Antoine de La Rochefoucauld, former director of the esoteric journal *Le Coeur* and a founding member of the Rosecrucians, called it "a heterogeneous group of artists [featuring] Maurice Denis and his guests."[6] In fact, in subject matter and technique, the art of this room could indeed be seen as a disparate lot, including Denis's "large and glassy" canvases (see, for example, fig. 1),[7] Vallotton's uncomfortable glimpses of bourgeois domesticity, Vuillard's four oil paintings entitled *Interior Scenes* (*Scènes d'intérieures*; see fig. 2), Roussel's pastel landscapes, and Bonnard's mythological subjects, such as the small painting *Faun* (fig. 3). Despite Mellerio's general comments in the preface to the catalogue on the "decorative" impulse of the artists exhibiting in this first room, only Paul Ranson, who showed a tapestry design and an oil painting described as "Eve, a decorative study," and Paul Sérusier, who showed "fragments of a decoration," seem to have exhibited strictly "decorative" works.[8]

The star of the Nabi room, judging from the reviews, was Vuillard. Signac, in a journal entry, extolled the virtues of "Saint" Vuillard for the way he expressed "the joy and tenderness of things!" and compared him favorably to Bonnard, "whose charm I cannot sense, in spite of all the good that is told me about him by Vuillard."[9] André Fontainas, critic for *Le Mercure de France*, singled Vuillard out as embodying

"the innovative look of this group." He too, however, was bothered by the lack of any one pervasive style or technique: "In front of these one doesn't understand the tie that unites them, unless it is a *serious friendship* [my emphasis]."[10]

One of the factors feeding into this critical ambivalence was the absence of a definitive artistic nomenclature for the group. Called "harmonists," "idea-ists" (*idéistes*), and "synthetists" (to distinguish them from the literary associations inherent in the term "Symbolist"), the Nabis shared aims that, as outlined by Denis in his 1890 article for *L'Art et critique*, "Définition du néo-traditionnisme," were wide and inclusive.[11] Unlike the Neo-Impressionists, whose label, like that of "Impressionist," indicated a new style and technique, "Nabi" (literally "prophet" in Hebrew), referred philosophically and ethically to a mission to reinvigorate traditional art, but did not indicate what that art should look like. Between 1890 and 1892, the Nabis met at Restaurant Brady and at Ranson's home (which they called "The Temple") to exchange ideas and perspectives on a wide range of philosophical and religious beliefs. Sérusier's theories on art and life, for example, stemmed from his knowledge of German Idealist philosophy, Ranson favored the Christian occultism of Ernest Hello and Edouard Schuré, and Denis—a devout Roman Catholic since childhood—believed that art was the "sanctification of nature."[12] The "secular" Nabis—Bonnard, Vuillard, and Roussel—on the other hand, resisted any specific formulas, philosophies, or religions, preferring to arrive at artistic "truths" empirically. All of their artistic concerns, however, were voiced in the confines of a special circle of friends, and these colleagues kept their esoteric name "Nabi" a secret at least until 1896.[13] As Sérusier remarked to Denis, "Nabi" referred both to the wisdom of the ancient sages and to the aspiration of youthful seekers of a neo-Platonic brotherhood: "I dream of a future brotherhood, purified, composed only of artists, dedicated lovers of beauty and good, putting into their work and way of conducting themselves, the undefinable character that I would translate as 'Nabi.'"[14]

Sérusier's dream of a "brotherhood" can be understood as a corollary to the "serious friendship" that Fontainas felt was the only validation for the group. It was friendship extending beyond artistic discussions to collaborations that gave them a group identity—even though that identity had as much to do with social connections as actual art theories. Ironically, by the

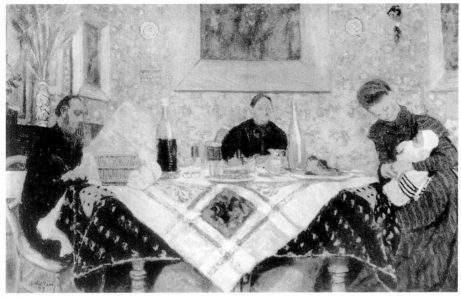

FIG. 2

FIG. 2
Edouard Vuillard (French;
1868–1940). *The Roussel Family
at Table*, 1899. Oil on cardboard;
58 x 91 cm. Private collection.
This work was probably one
of four *Interior Scenes* Vuillard
exhibited in 1899 at Durand-
Ruel (see fig. 1).

FIG. 3
Pierre Bonnard. *Faun*, 1899.
Oil on panel; 32 x 22.5 cm.
Private collection. This is
one of the works Bonnard
exhibited in 1899 at Durand-
Ruel (see fig. 1).

time of the Durand-Ruel exhibition in 1899, which publicized the Nabis' achievement within the larger context of avant-garde painting, the broad philosophical convictions they had shared were already eroding, along with the personal ties that had once held them together socially and professionally.[15]

Denis, the Nabis' spokesman and unofficial leader (as suggested by La Rochefoucauld's reference to "Denis and his guests"), commented in his journal on

FIG. 3

the paintings in the first room of the Durand-Ruel exhibition, noting that there were certain characteristics that differentiated his group into two distinct factions: on the one side, Bonnard, Vallotton, and Vuillard; on the other, Ranson, Sérusier, and himself. (Excluded from this list was Roussel, who did not participate as actively in exhibitions and who was increasingly using the pastel technique.) Denis characterized the first group as favoring small formats, somber palettes, and subjects drawn directly from nature or adapted from memory. These artists put less emphasis on the human figure and shared a predilection for a "complicated surface" (*matière compliquée*), that is, a surface characterized by highly idiosyncratic brushwork. The result, in Denis's opinion, was art that appealed to the *goût sémite* (Semitic taste). Because of these qualities, Denis felt the works of Vuillard, Bonnard, and Vallotton would be better seen in small and dimly lit apartments than in public exhibition spaces. By contrast, he characterized the artists of his own group as stressing the use of pure colors and of "symbols" rather than "subjects," and as relying on geometry and perspective and on the traditions of history painting. This approach to painting placed more value on the human figure, and utilized a more conventional technique to create a smooth, even surface—all of which appealed to the *goût latin* (Latin taste).[16]

These journal comments by Denis in part reveal how the group was perceived and received by its closest supporters. Indeed, the Nabis' early success, as well as their ultimate dispersal around 1899, depended on a distinct circle of enlightened collectors who not only purchased, but also commissioned, decorative paintings for their private interiors. Denis's assessment, however, implied as well that there were significant distinctions within this circle, having as much to do with political and social differences as artistic ones.[17] The adjectives Denis chose to distinguish the two styles employed by his group, "Latin" and "Semitic," were used somewhat interchangeably at the time, along with terms such as "Mediterranean" or "classical" on the one hand, and "Eastern" or "foreign" on the other. Neither neutral nor casual choices, such terms were invested with especially potent connotations. In 1899, when Denis wrote these comments in his journal, France was at the height of the Dreyfus controversy. The novelist Emile Zola had published his damning article "J'Accuse," in January of the previous year, in which he charged the French government

with framing a Jewish officer.[18] Subsequently, the nation split into Dreyfusards (those who supported Dreyfus's innocence) and anti-Dreyfusards, many of whom, like Denis, were Catholic intellectuals. In interpreting Denis's comments, however, one needs to keep in mind that, through this period, he was a close friend of Vuillard, Roussel, and Bonnard, all of whom were Dreyfusards (shortly after writing these comments in his journal, Denis asked Vuillard to be godfather to his second daughter, Bernadette, born in April 1899), and he was an intelligent and insightful art critic. Denis's point of view, as we shall see, had more to do with the collaborations and contacts that helped launch these young artists than with the most extreme forms of anti-Semitism then evident in French politics.

THE LANGUAGE OF AESTHETIC DEBATE

Before exploring further the patronage groups that supported and helped make possible the Nabis' early successes, it seems important to discuss, at least briefly, the language that shaped the aesthetic debates surrounding the Nabis and their goals. A general understanding of terms such as "arabesque," "harmony," "synthesis," "easel painting," "decorative panel," and so forth, as they were used by the Nabis, their supporters, and their critics, is indispensable to any discussion of their work. Confusion about the meaning of these and similar terms is indeed one of the major obstacles to a general understanding of "decorative painting," as Nicholas Watkins suggests in his essay here. The term "arabesque," for example, can be generally related to Paul Gauguin's credo that painting has its own abstract language and that the language of painting is linked to that of music. The Nabis—as well as the musicians, poets, art critics, and actors associated with them— found particular relevance in these analogies, and in such terms as "arabesque," then widely used in music. Originally referring to ornamental friezes in Moorish architecture, arabesque took on new significance among nineteenth-century composers such as Robert Schumann and Claude Debussy, who used it for thematic variation.[19] It also developed rich literary associations. The Nabis, however, generally employed the term to describe specifically the ornamental and sinuous line (literally, S-curve) that distorted the subject in painting. The arabesque also offered a means to link the composition and flatten it, since by its very nature, the S-curve tends to thwart the illusion of depth or

recession into space.[20] In Denis's words, the Nabis considered the arabesque to be "without a soul," that is, a dispassionate, purely objective, and essential formal feature of decorative art. In his summary of the evolution of art, entitled "Définition du néo-traditionnisme," in fact, Denis stated, "In the beginning was the pure arabesque" ("à l'origine, l'arabesque pure").[21] For the purposes of this essay, the arabesque is understood in this sense, as a purely formal feature used to alter the motif in order to achieve expressive and harmonious compositions.[22]

Another musical term with a long pedigree in the language of art is "harmony," understood by the Nabis to refer to the balance of relationships between line, color, form, and even mood. Max Kozloff, in his study of Bonnard's modern pictorial language, *Pierre Bonnard: From Impressionism to Abstraction,* regarded harmony as an indefinable catch-all term used in the 1890s.[23] The comments Vuillard made in his journal during his first year as a member of the Nabi group, however, imply that harmony for the Nabis had concrete meaning. Not only did it refer to the balance between elements, but it was also associated with scientific discoveries about color and light. Writing in his journal in October 1890, Vuillard described harmony as really only another way of saying *science*, or knowledge of the relationship of color:

One tone goes with another, falsifies the expression, this color that you put on your palette is homogeneous with this other, it is matte or varnished and every gradation in between; in the past, under the pretext of harmonizing the tones, we did not see any difference between the luminosity of two colors and the way a painting looks when seen from far away where one couldn't distinguish anything.[24]

Related to harmony is the term "synthesis," which for the avant-garde in the 1890s conveyed both the artistic obligation to achieve balance, harmony, and overall rhythm, as well as the moral obligation to fuse the real with the ideal, or nature and the unknown (which for Denis meant the "spiritual," and for Ranson the "occult"). In their works, the Nabis sought synthesis through the use of arabesque and color harmonies. For critics like Gustave Geffroy, an early Nabi supporter, synthesis provided a healthy antidote to what he thought was the overly obsessive and analytical method that characterized two preceding movements: the art of the Neo-Impressionists and of their leader, Georges Seurat, and the more literary expressions of the Symbolists.[25]

Other terms that appear prominently in the aesthetic debates of the period are *tableau*, or *tableau de chevalet* (easel painting), and *décoration*, or *panneau décoratif* (decorative panel), terms that are especially relevant to the subject of this study. Some critics, as we shall see, made very clear distinctions between the two. In the work of the Nabis, these distinctions were often blurred because they were resolved by the very aesthetic principles they promoted. For the Nabis, it was not exclusively the destination or specific architectural setting for a work, but the artist's *intention* vis-à-vis subject, style, format, surface, and frame, that determined whether or not a painting was a *tableau* or a *panneau décoratif*.

As shown, one of the major goals of this new kind of "decorative" painting was the creation of artworks that were no longer "windows onto nature" in any traditional illusionistic sense—a characteristic associated with easel painting—but rather evoked, through harmonious colors and forms, a thought, emotion, or, in the case of Bonnard and Vuillard, a transcription of reality.

Format was also a key to whether or not a painting was perceived as a *décoration*. The Nabis typically chose formats that were emphatically horizontal, vertical, square, and even round in shape—in other words, dimensions that were outside standard (precut and prestretched) canvas sizes. Equally unconventional was the way the Nabis referred to their works—not as *toiles* (canvases) but as *panneaux* (panels), a term formerly reserved for paintings on wood or in enamel. In the early 1890s, progressive artists and critics applied the terms *panneau* and *panneau décoratif* to all kinds of painted works, whether destined for a specific location or not. This terminology emphasized the work's connection to architecture (as decorative overdoors, friezes, door jambs, ceilings), thus distancing it from the category of traditional easel painting.

Surface or finish was another way the Nabis distinguished their works. These artists preferred non-varnished, matte surfaces, which, like the works of Pierre Puvis de Chavannes, evoked fresco or mural painting. And, finally, framing figured in the perception of a painting as a *tableau* or *panneau décoratif*. The Nabis considered heavy, ornate, gold frames taboo, since they denoted a traditional approach to easel painting and, even worse, art as "packaged" commodity.

Frames still played a considerable role in the works of these artists, however, especially those they made themselves. As Denis remarked in 1892, a frame could be a harmonious enrichment of, rather than a distraction from, the overall design.[26] But the unframed, or minimally framed, work was even more prevalent among the Nabis, since, together with a flat (decorative) treatment of surface and design, it suggested a connection to a larger surface—an image that was to be completed by its placement within an interior.[27] In fact, in many instances, a painting could be deemed "decorative" simply because it was perceived as needing a wall to complete and frame it.[28] In practical terms, this could be achieved in several ways: by hanging the *panneau* so that it seemed to fit within the pre-existing framework of wood or plaster moldings that characterized the typical French interior at the time (see fig. 6); or, as was the case for Vuillard's series of paintings known as *Album* (cat. 35–39), by installing the *panneau* unframed and painted in such a way as to appear to be emerging from the existing wallpaper designs.

It should be stressed, however, that these definitions of *tableau* and *décoration*, while generally valid, were not always applied consistently, even by the Nabis. Terms such as *panneau décoratif*, *décoration*, and *peinture décorative* were often used interchangeably and arbitrarily. Some artists and critics insisted that a decorative painting should only be designed for a specific wall. This was the feeling of Camille Pissarro, who considered the more loosely defined concept of what he referred to as a *tableau-décoration* an "absurdity."[29] It was also true of the critic and Nabi sympathizer Camille Mauclair, who, upon seeing Denis's paintings at an exhibition of works by the Nabis at the Barc de Boutteville gallery, in December 1894, remarked: "And does one put in a frame a work painted in solid flat colors [*à plat*] and having the feeling of tapestry with tones laid side by side? A decoration is not a painting [*tableau*, or easel painting], and so there it is, the difference that not one of the young painters realizes."[30] The Dutch painter Jan Verkade included in his memoirs a very limited definition of decorative painting. Writing over twenty years after his association with the Nabis, he recalled that their goal was to do away with easel painting entirely so that painting would only be wall decoration.[31] A similar limited definition, and thus confusion, followed Sérusier's published announcement in 1892 that he would henceforth make only mural paintings. Sérusier emphasized that he would paint in the new style (large areas of flat colors, non-illusionistic subjects, matte surfaces) and only for patrons rather than

the market. His idealistic boast, however, was met with little enthusiasm. And, in truth, with the exception of an actual mural project he undertook in 1895 for the studio of his mistress, Gabriella Zapolska, he continued to paint and exhibit what were essentially "easel" paintings.[32]

In general, the members of the Nabi group and other artists represented by the Barc de Boutteville gallery were more interested in the purely aesthetic qualities of "decorative painting." Thus these artists had no trouble referring to a painting of a non-conventional style, format, and subject as a *panneau*, *décoration*, or *peinture décorative*, regardless of medium, final destination, or function.[33]

Bonnard, Vuillard, Denis, Roussel, and their circle approached painting intuitively and inventively. For example, at the Salon de la Société des artistes indépendants of 1892 (henceforth, Indépendants), Bonnard exhibited both a small and witty panel entitled *Poodles* (cat. 4) and the large-scale, nearly square *Twilight* (cat. 5). Neither was intended to adorn a specific wall, yet both embody all the concepts Bonnard shared with Vuillard, Denis, and Roussel of a new type of painting that was both intimate (reflective of mood) and decorative. Whether in a small or large format, the compositions cover the surface with pattern and lines that impede any suggestion of one-point perspective or a specific (narrative) subject. Critics saw the decorative qualities of *Twilight* as having affinities with Symbolist poetry, as well as with ornamental tapestries. The relation of *Poodles* to interior decor is perhaps even more direct, since the subject repeated, or inspired, a similar motif in Bonnard's contemporary preparatory designs for a never-realized dining-room sideboard (see Watkins, fig. 12; cat. 4). These oil paintings successfully combine the intimate, expressive, and decorative with a practical application and meaning that have significance beyond framed easel paintings.

For Bonnard, Vuillard, Denis, Roussel, and their circle, *décoration* thus represented a pictorial ideal that had moral, aesthetic, and physical components: moral because opposed to the narrowly defined and capitalistic commodity of easel painting; aesthetic because concerned with overall unity and balance more than subject matter; and physical because intended as an expressive complement and mural-like embellishment for a specific interior.

MAURICE DENIS: PROMOTIONAL STRATEGIES

It is not an exaggeration to say that the Nabis' message and mission for painting as *décoration* would have remained a private and unrealized ideal had it not been for the gifted writing of the deeply spiritual, but highly pragmatic, Maurice Denis. He was the most articulate exponent of the aesthetic concepts discussed above, exhibiting the greatest skill in using the language of aesthetic debate to the Nabis' advantage. Rather than becoming mired in niggling arguments about definitions, as some did, he emerged as the author of inspired statements about the Nabis' goals, many of which have since become canonical expressions of the broad aims of modern art.[34] But Denis's gifts in promoting the group were not limited to writing. He also was crucial to the Nabis' success through his practical ability to arrange exhibitions, ensure publicity (even if authored by him under an assumed name), and cultivate connections with major patrons in the worlds of theater, literature, music, and art. It thus seems important to focus briefly here on the unique role Denis played in the early history of Nabi patronage.

The only son of a railroad administrator, Denis seems unique among his immediate circle for having had to support himself through his art. His journals (published in three volumes in 1957 and 1959) reveal his awareness of the moral, as well as financial, need to succeed, and his scorn toward the portraits he was forced to paint to make ends meet. Perhaps it was because his economic situation was less promising than that of his friends—Bonnard was the son of a senior administrator in the War Ministry; Roussel, the son of a wealthy homeopathic doctor; and Vuillard, the coddled and encouraged youngest child in a household run by his widowed and financially independent mother—that Denis felt compelled to ensure his group's (and his own) success.[35]

The 1980s buzzword "networking" is almost too passive a term to describe the aggressiveness with which Denis promoted himself and his friends. Most likely, it was Denis who arranged for his group to exhibit at the Barc de Boutteville gallery from 1891 to 1895; he may have also suggested the title "Impressionists and Symbolists" for these exhibitions.[36] In 1891, Denis became a member of the organizing committee for the annual exhibitions held at

the Château de St.-Germain-en-Laye (1891, 1892, and possibly 1894). Not only did he orchestrate exhibitions for himself and his colleagues, but he also invited critics to write about these events.[37] He even went so far as to author articles himself: in 1891, for example, Denis penned a review of the first annual exhibition at St.-Germain-en-Laye, which was published under the name of his friend the playwright Aurélien Lugné-Poë, in the magazine *L'Art et critique*.[38] The article was subsequently reprinted nearly verbatim in another review under the name of the artist and critic Georges Roussel. Denis may have requested a review as well from Arthur Huc, editor of *La Dépêche de Toulouse*, a newspaper based in Toulouse and Paris. This would explain Huc's letter to Denis in August 1891, shortly before the opening of the exhibition at St.-Germain-en-Laye, requesting that the artist send him "some appropriate words" with which to write an article "to your taste and that of your friends."[39]

In addition to generating publicity for his group, Denis extended personal invitations to major critics and collectors to see his own work, beginning in 1892 with the decorative ceiling painting *Ladder in Foliage* for Henry Lerolle (cat. 14). Even Signac, although not a fan of Denis's art, admired his smooth social skills, noting in his journal: "Maurice Denis comes to see me. How refined and diplomatic he is; he knows how to attract people, how to compliment you and how to ask questions on what he wants to know."[40] Perhaps Denis's most effective strategy on behalf of the Nabis was the clear and intelligent articles he wrote under the pen names Pierre Louÿs, or Louis, and Pierre Maud for *L'Art et critique* and *La Revue blanche*. In these, Denis extolled younger artists (*les jeunes*), praised his own works in the third person, and laid out the principles for the new painting as expressive and decorative, and as reinvigorating the tradition begun by pre-Renaissance artists.[41] So influential was Denis that some art critics felt compelled to seek his approval. In spring 1892, shortly after the Indépendants closed, critic Charles Henry Hirsch asked Denis to critique *his* critique: "Would you please, after having read [my manuscript], give me a frank critique, at least for the parts that concern you. I would like to know if I've read in your painting things that you have truly put there. And if I've noted the emotions that you have felt, your true intentions."[42]

The fact that an art critic should be soliciting Denis's attention, and vice versa, was all part of Denis's larger strategy to gain adherents to the group's cause. For Denis saw that connections to the other arts (music, literature, and theater) would ideally contribute to advancing the Nabis among collectors. In a letter to Lugné-Poë, he complained that the poet Adolphe Retté (whose poem "Trinitarian Evening" ["Soir trinitaire"] had inspired Denis's 1891 painting of that title, in the Musée d'Orsay, Paris) was no longer in their camp. Denis recommended that they rely instead on Paul Percheron (a journalist whom Denis called "Vuillard's intimate Nabi friend") and the poet Gabriel Trarieux. "If there is something to be gained *practically* from poets," Denis wrote to Lugné-Poë, "our two friends, Percheron and Trarieux, will be very well placed to *serve us* [my emphasis]."[43] In another letter to Lugné-Poë, Denis voiced his hope that Trarieux would succeed in finding them "rich collectors." Indeed, his admiring description of Trarieux could easily have been his own motto at that time: "He works, produces, and is destined for a quick success."[44]

Among the Nabis, Denis aligned himself most closely with Bonnard and Vuillard, with whom he, along with Lugné-Poë, shared a studio-apartment on rue Pigalle in the Montmartre district. Bonnard, Vuillard, and Roussel represented another, overlapping subgroup; they were so inseparable that the father of one of their friends dubbed them "The Three Musketeers."[45] Roussel, whose parents were divorced, became around 1889 an intimate of the Vuillard household and in 1893 married Vuillard's sister, Marie, who was seven years Roussel's senior. Although Roussel's personal aims would take a different direction, away from both the intimist style of Bonnard and Vuillard and Denis's spiritual (Catholic) Symbolism, he shared, along with Bonnard and Vuillard, Denis's mixture of idealism and pragmatism. Optimistic and energetic, conciliatory rather than rebellious toward other established artists, these young men wanted to fit into, rather than defy, existing art circles.[46] And Denis was the zealot for their cause. In a letter to Lugné-Poë, he exuded pride in the group's expanding influence: "Good relations to be added to old ones: Father and son Pissaro [*sic*]: We are very good with Signac."[47] Denis's enthusiasm may have been somewhat exaggerated. Signac, as discussed above, resented what he considered to be the group's too-rapid success. And Pissarro, whom Denis claimed as a convert to their aims in 1892, was actually opposed, as noted above, to the banner of "decorative painting" they had adopted for themselves.

The relationship between the Nabis and Gauguin was likewise mixed. Aside from Sérusier and Verkade, who had actually painted with Gauguin, none of the group could claim to have been his student. But since Gauguin was the avant-garde figure of the moment, especially in the early 1890s when his reputation as the initiator of the Symbolist movement in art was at its height, Denis exploited his group's marginal involvement with the older artist.[48] While the Nabis clearly admired Gauguin, Denis's comments to Lugné-Poë just after a sale of Gauguin's paintings took place at Durand-Ruel in January 1891 are calculated and oddly defiant: "I am definitely exhibiting at the Indépendants. I cannot let the vogue for Gauguin go by without doing something about it. You have heard the stories of his unexpected success rapidly escalated by the press. It will be the moment for us to meet Geffroy and others if possible. . . . The exhibitions of Bonnard's and of my works must not go unnoticed."[49]

While Denis invoked Gauguin's name to underscore his group's modernity, Gauguin regarded these young artists with wary admiration. He also took full credit for their success. After learning of Albert Aurier's important article on pictorial Symbolism, which appeared in March 1891, Gauguin wrote petulantly to his wife: "I created this new movement in painting, and many of the young people who have profited are not devoid of talent, but once more, it is I who have shaped them. And nothing in them comes from themselves, but through me."[50]

THE CIRCLE OF *LA REVUE BLANCHE*

Although the Nabis found their earliest patrons through their collaborations with the naturalist theater of André Antoine, the Symbolist theater of Paul Fort, and the highly successful Théâtre de l'Oeuvre, founded by Lugné-Poë in May 1893, they were also associated, by 1892, with the literary and artistic journal *La Revue blanche*. Writing about the Nabis' showing at the the Barc de Boutteville gallery in December 1892, the magazine's art editor, Thadée Natanson, enthusiastically commended the group of "harmonists"("if," he added, "they must be labeled"), but wondered if their works would have a larger aesthetic significance: "Interesting, interesting, but when is the masterpiece going to be produced?"[51]

By the time Natanson raised this rhetorical question, he was already very much involved with the Nabis, and especially with Bonnard, Vuillard, Denis, and Roussel. These "artists of *La Revue blanche*" (Ibels, Toulouse-Lautrec, and Vallotton were also part of this

FIG. 5

Alfred Natanson or Edouard Vuillard. Photograph, c. 1898, of Thadée and Misia Natanson in their rue St.-Florentin apartment, Paris. Bibliothèque Nationale, Paris.

ary and artistic news of Paris" under the pseudonym "Athis."[53] Financing this ambitious undertaking to a large extent was their father, Adam Natanson, a wealthy Jewish investment banker who had moved his family from Poland to France in 1878.

The magazine quickly grew and by 1892 was in competition only with the prestigious *Le Mercure de France*, headed by Symbolist writer Alfred Vallette. Unlike its rival and other similar Symbolist publications, such as *La Plume* and *L'Ermitage*, *La Revue blanche* was not exclusively Symbolist in its affinities, but rather was dedicated to expressing all kinds of artistic ideas. The aims of the Natansons, as announced in the inaugural issue, were similar to those of the Nabis:

We wish to develop our personalities and it is to determine them through their complementaries of sympathy and admiration that we respectfully solicit our masters and gladly welcome the young.[54]

Even before the magazine was taken over by the Natansons, Lugné-Poë, who frequently hawked his friends' works among the theatrical crowd, viewed it as a potential marketing tool for the group: "They [the staff of *La Revue blanche*] especially, are going to help you in a big way," he wrote optimistically to Vuillard. "You have [Lucien] Muhlfeld [journalist and art critic], there's Léon Blum [essayist and future politician], Schapfer [by which he meant Jean Schopfer, a journalist and early patron of Vuillard] is going to subscribe, Thadée also, Timon and maybe Alexandre. It's too early to tell what this revue will become, they have a big job to do, but [Romain] Coolus [novelist and playwright] loves you a lot, [and] they will be on your side."[55]

The "big job," accomplished by the Natansons in the following year, resulted in a formidable list of contributors that included, in addition to the artists and authors mentioned above, writers Tristan Bernard, André Gide, and Marcel Proust.[56] The Natansons saw themselves not only as literary agents but also as knowledgeable collectors and patrons. Others viewed them as "imposing and snobbish . . . tough, chic and full of lofty ambitions." Proust, for example, was forbidden by his mother to consort with the Natansons outside of their offices, and Gide, while admiring their industriousness (and serving as art editor from 1900), faulted their social pretensions.[57] Whether for or against Thadée and Alexandre Natanson, witnesses to their rapid rise to celebrity conceded that the brothers were successful in achieving a solid footing in the

group) made original lithographs for the magazine, which were published in monthly issues or in luxury portfolios.[52] They were also given private exhibitions in the magazine's offices on rue Lafitte, which were then reviewed in Natanson's art column, "La Petite Gazette d'art." Like the theater, the magazine offered access to avant-garde collectors and art critics. Natanson first met Vuillard, Bonnard, Denis, and Lugné-Poë in the summer of 1891, when he visited their studio and soon became their most ardent defender. Having just left his law-office position, he threw himself into the publication of the "new series" of *La Revue blanche*, launched in October of that year. The magazine had first been conceived in Liège in 1889 by August Jeunehomme, Joë Hogge, and the brothers Paul and Charles Leclercq, with Thadée and his brother Louis Alfred (called Alfred) taking on roles as contributors. The Natansons gradually shifted the base of operation from Liège to Paris in 1891, and the publication became a family affair: Thadée's older brother, Alexandre, an appellate-court lawyer, was director; Thadée edited and held the post of secretary; and Alfred served as treasurer and contributor of the "liter-

intellectual and cultural landscape of Paris through their exclusive control of *La Revue blanche*. "There is without a doubt," wrote Gide after the magazine folded in 1903, "no painter, no writer of recognized real value today, who does not owe the Natanson brothers and Félix Fénéon [influential art director after 1895] an ample tribute of gratitude."[58]

The Natansons indeed became close and lifelong friends of both Bonnard and Vuillard. Not only did they provide Vuillard with his first one-man exhibition in 1891 (his only exhibition of this scale until 1906, when he signed a contract with the Bernheim-Jeune gallery), but Thadée and his wife, Misia, also made Bonnard and Vuillard part of their family. For the next ten years, the two artists were regulars not only at *La Revue blanche*'s offices, but also at the unofficial second office of the journal, known as the "Annex," at Thadée and Misia's apartment on rue St.-Florentin.

As Vuillard's celebrated depiction of the "Annex" (fig. 4) reveals, this loftlike apartment off Place de la Concorde was decidedly unconventional. Photographs by Vuillard and Alfred Natanson (see fig. 5), as well as other painted images of the apartment by Vuillard, Bonnard, Vallotton, and Toulouse-Lautrec, attest to its unorthodox layout, which consisted of one large space serving as informal parlor, salon, and music room, adjoined by several small alcoves. The apartment dated

FIG. 6

Pierre Bonnard. *The Four Natanson Daughters*, 1908. Oil on canvas; 125 x 139 cm. Private collection. Photo: Dauberville, vol. 2, p. 186, no. 593.

from the eighteenth century, and thus originally included around the dado area of the wall woodwork that the Natansons must have had removed. The walls were then covered by a sinuous floral frieze along the cornice and by decorative wallpaper below. Stretching from floor to ceiling and across joints, this continuous expanse of wallpaper created the illusion of open space.

It was to this kind of eclectic and cluttered interior, with its emphasis on textures and objects, that Denis referred when he commented on the small quarters and "Semitic tastes" suited to the paintings of Vuillard and Bonnard. In many ways, Denis's observations echo similar distinctions made by Ernest Chesneau, nearly fifty years earlier, when he pitted Protestant culture (materialist and realist) against the Catholic (idealist and classicist).[59] By 1899, however, when Denis was writing in his journal about Latin versus Semitic taste, the Dreyfus Affair had divided the country, elevating nationalism to a state religion. Within this peculiarly narrow world-view, nationalism meant French and Catholic. French citizens who found themselves sympathetic to Dreyfus's plight experienced deep discomfort. Albert Besnard, for example, referred to himself as a "shame-filled Dreyfusard" (*Dreyfusard honteux*), since he believed in the innocence of the wrongly convicted Jewish officer, but could not declare it without feeling guilty toward his country.[60] The Dreyfus Affair fueled the anti-Semitism already prevalent among French intellectuals and resulted in publications that were either markedly anti-Semitic, such as the journal *Le Ralliement,* or pro-Catholic, like the journal *L'Occident.*[61] Catholicism became synonymous with an intense identification with French traditions, lifestyle, and perceptions of the world. "French" implied honored traditions and a generally understood agreement on what these traditions entailed.

Denis's comments about Vuillard's and Bonnard's appeal must be understood within this ideological framework. Clearly, the fluid space in which the Natansons lived for almost a decade ran counter to classic French tastes, just as their very mobile and fast-paced life (which did not include children) set them apart from traditional French family ideals. On the other hand, Thadée and Misia were notable exceptions to, rather than indicative of, an entire patronage group. Their comfortable, eccentrically decorated rue St.-Florentin apartment provided the perfect ambiance for

the informal discussions and concerts presented by contributors to *La Revue blanche*, and appealed especially to Vuillard and Bonnard. Vuillard seems to have found less interesting the residence of Thadée's brother Alexandre, who lived in a mansion on avenue Foch that reflected conservative, aristocratic French tastes. Although Vuillard executed a commission for Alexandre, the nine panels known as *Public Gardens* (see cat. 32–33), he did not depict this Natanson's home in his work. Bonnard's portrait of Alexandre's daughters (fig. 6) shows that his residence was decorated in the Louis XV style, with gold *boiserie* (wood trim) on white woodwork. Alexandre's formal tastes reflected those of his father, Adam, who upon arriving in France in the late 1870s, bought or rented châteaux for his family to live in before settling in a private mansion in Paris.

Denis's remarks, however, have implications beyond mere preferences in interior decor. To have "Latin," rather than "Semitic," tastes was to embrace permanence and stability over mobility. This dynamic extended to levels of French society. If one was "Old French," one was connected to a dynasty with deep roots and inherited furnishings and material goods, resulting in a certain comportment, education, and good taste: values that remain discernible today in France among the *bonne* and *haute bourgeoisie*. For no matter how "French" the Natansons had become through appropriation of the nation's culture and language, they were, in comparison to the "true" French, nomads, without the profound sense of tradition, it was presumed, one has when living in the ancestral home.[62] In addition, that Denis made these observations in 1899 suggests that his choice of the term "Semitic" may have been colored by his own recent, personal experiences. Having previously been sympathetic to *La Revue blanche*, in which he had published articles and a lithograph, Denis cut off all relations with the magazine in 1898 because of its pro-Dreyfus stance. Writing to Vuillard from Rome in February of that year, he voiced his anger at the *Revue*'s editorial office (in other words, the Natansons) for its brazen endorsement of Zola's indictment of the French government without considering the wider and more nuanced range of opinion of the contributors to the journal.[63] By 1899, Denis's entourage consisted mostly of French nationals, while Vuillard's patrons were, as he would jokingly muse, like Rembrandt van Rijn's, primarily Jewish.[64]

HENRY LEROLLE AND HIS CIRCLE

A letter of 1892 from Ranson to Verkade attests to the early emergence of two sets of collectors centered around Vuillard and Denis, respectively, groupings that would become the subject of the 1899 journal entry by Denis discussed above:

Vuillard has finished the panels for the Natansons' salon; I think all six are very good. What an effort, what a task for Vuillard. . . . Denis has just delivered to the painter Lerolle a very pretty little ceiling painting for the *hôtel* of this academic dauber.[65]

In the history of Nabi patronage, Henry Lerolle was to Denis what Thadée Natanson was to Vuillard. To use Denis's own words, Lerolle "discovered and protected" him. Just as the Natansons' apartment was a place to meet other notable artists, musicians, and writers, Lerolle's home likewise offered attractive possibilities of meeting wealthy patrons and art lovers, as well as a wide range of artists, musicians, and poets. "Thus," wrote Denis in his posthumous homage to Lerolle, "the debutant that I was penetrated a refined, elegant, and leisured milieu, which, without being worldly, or formal, was all the same very different from the brasseries, the pastry shops, and the modest clubrooms [*cénacles*] where the young painters hung out."[66]

Ranson called Lerolle an "academic dauber," and Vuillard, after meeting Lerolle at the rue Pigalle studio in spring 1891, referred to him pejoratively as "a salon painter."[67] Lerolle's status in late nineteenth-century painting, however, is more complicated than these remarks imply. Like Besnard, he was a curious hybrid—an academically trained, successful Salon painter, whose clear and intelligent style could be appreciated by both academic and avant-garde artists. In 1891, when he first noticed Denis and his friends, Lerolle was already an established artist. He had been officially recognized with the Legion of Honor for his role in the 1889 Exposition universelle and for murals for the Hôtel de Ville, Paris, completed that same year (see fig. 7).[68] In 1890, he aligned himself with Puvis de Chavannes and the newly founded Société nationale des beaux-arts, which, as Watkins mentions, was the first such organization to allow decorative objects and furniture to be exhibited with the "fine" art of painting.

In addition to his artistic achievements, Lerolle was also a minor composer and accomplished violinist. His family mansion, located at 20, avenue Duquesne, in

use as decoration and expression and to synthesize the real and ideal worlds, Lerolle wrote approvingly to the author, "I read [it] with interest and even more than interest."[74]

Lerolle was particularly compelled by the Catholic component of Denis's ideology and style. His first acquisition from Denis, the painting *Catholic Mystery* (fig. 8)—in its blond, frescolike colors, matte finish, simple and evocative imagery, and absence of fussy details—met the qualifications that Lerolle sought in the works of art he collected. Lerolle had purchased, for example, Puvis's *Prodigal Son* (1879; Collection Bührle, Zurich) from the Salon as early as 1883. Lerolle also admired and collected works by Puvis's contemporary Jules Cazin, from whom he commissioned a ceiling painting for his avenue Duquesne residence.[75]

As in the case of Thadée Natanson, whose friendship with Vuillard resulted for the artist in five commissions from other members of Natanson's extended family, Lerolle's patronage of Denis spread to Lerolle's brothers-in-law, Ernest Chausson, mentioned above, and Arthur Fontaine. Chausson, who commissioned his first ceiling painting from Denis in 1893 (cat. 16), was also an avid collector of modern art who owned works by Carrière, Degas, Gauguin, Puvis, Renoir, Signac, and Vuillard, among others. He shared with Lerolle a hatred for "false mysticism" (that is, religious art of the Rosecrucian or occult variety) and a love for modern poetry, both Christian (Catholic) and Symbolist, such as that by Mallarmé, Mauclair, and Verlaine, among others, whose verses he set to music in his *chansons* for the piano.[76] Like Lerolle's residence, the Chausson family mansion near Parc Monceau constituted a bastion of tradition and civility to which were invited young musicians, writers, and artists (see fig. 9). As Camille Mauclair, one of Chausson's preferred poets and frequent guests, remembered:

Paris's stylish seventh arrondissement, served as a gathering place for musicians, such as his brother-in-law Chausson, Debussy, Dukas, and d'Indy. It is likely that Lerolle introduced Denis to Claude Debussy in 1893, around the time that Denis was making a lithograph to illustrate the composer's piano score *The Blessed Damsel*.[69] Lerolle was also host to many other distinguished guests, thinkers, and writers such as Claudel, Gide, Louÿs, and Mallarmé; and painters such as Degas (whose works Lerolle collected), Morisot, and Renoir (who painted several portraits of Lerolle's daughters).[70] Denis, a newcomer to this circle, remembered the interior of the Lerolle home as an oasis of calm and good taste:

> Neither the bric-a-brac of an antique dealer, nor a hospital room: [instead] a harmonious ensemble of furniture both modern and handed down through the family, [and] carefully selected works of art; in addition to Degas, canvases by Fantin[-Latour], Puvis, Besnard, Corot, Renoir, [and] some good old canvases on the walls hung with the light wallpapers of William Morris.[71]

A devout Catholic, Lerolle was active in the movement to revive old French music that lead to the founding of the Schola Cantorum in Paris in 1894, for which he painted monumental murals.[72] He enthusiastically embraced " 'advanced' decorative painting of a Symbolist strain," as Roger Benjamin termed the Nabis' aesthetic in order to distinguish it from that of academic decorative painting.[73] After receiving from Vuillard a copy of Denis's 1890 article "Définition du néo-traditionnisme," which emphasizes the wish among younger artists to return painting to its original

> His home was a marvel of taste and art, graced by Henri [*sic*] Lerolle's delicate decorations: A gallery where the Odilon Redons and the Degas were neighbors with the Besnards, the Puvis [de Chavannes] and the Carrières. He lived there among the high, closed drapes, the pianos, the restrained furniture, the scores and the books. . . . The friends who came often to spend the evening were the premier artists of our time.[77]

Over the next five years, Denis enjoyed the Chaussons' friendship and patronage, resulting in the latter's purchase of numerous paintings and lithographs and in commissions for two additional ceiling paintings, *Spring* (1896; private collection) and *The Chausson*

FIG. 8

FIG. 8
Maurice Denis. *Catholic Mystery*, 1890. Oil on canvas; 51 x 77 cm. Private collection.

FIG. 9
Photograph, c. 1891, of the composer Claude Debussy sight-reading a score by Boris Godunov at the Paris residence of composer Ernest Chausson.

Family, Villa Pariniano (cat. 16, fig. 1).[78] A few months after Denis completed this last project, Chausson was killed in a bicycle accident on his property in Limay (near Giverny, northwest of Paris), thus ending one of Denis's most fertile friendships and collaborations.

Lerolle's other brother-in-law, Arthur Fontaine, who in 1893 commissioned Denis's *The Muses* (cat. 15), was generally less involved with Denis both professionally and socially. Holding an important government position as Chief Engineer of Mines (and by 1900 as Minister of Labor), Fontaine was connected to Lerolle's circle less, it seems, because of shared religious

beliefs than because of a shared aesthetic sense.[79] Fontaine's divorce around 1905 and remarriage a few years later seem to have marked the end of his relationship with Denis. It may have been that Fontaine, having divorced the sister (Marie Escudier) of Lerolle's wife (Madeleine Escudier), was no longer an integral part of Lerolle's circle. Vuillard, however, continued to be on good terms with both the current and former Madame Fontaine, and continued painting members of the Fontaine family, while Denis moved on to other patrons.[80]

BONNARD AND ROUSSEL BEFORE 1900: WORKING INDEPENDENTLY

Bonnard's and Roussel's involvement with commissioned decorative paintings for specific interiors dates, for the most part, to after 1900. Although Bonnard was the most prolific and visible decorator among the Nabis, with his highly successful poster *France-Champagne* (Watkins, fig. 6) and lithographic screen *Nannies' Promenade, Frieze of Carriages* (cat. 6), it was not until the twentieth century that he received important commissions for painted *décorations* from a variety of French and international patrons, as discussed in the next chronological section of this book. On the other hand, Bonnard was, among the Nabis, the most willing to experiment in a variety of media. As he wrote to Lugné-Poë in 1890, "It's a matter of varying one's pleasures."[81] This statement not only reveals Bonnard's desire to work in all media, for all purposes, but also the nature of his personality. Grounded by strong family ties through his grandparents' estate at Le Grand-Lemps, through his sister's family, and after 1894 through his lifelong relationship with Marthe de Méligny (her real name was Maria Boursin, and they married in 1925), he did not seem to struggle with life as his best friend Vuillard did. Critics often compared the similar styles of Bonnard's and Vuillard's intimist scenes in the 1890s, commenting on the melancholy seriousness of Vuillard and the whimsical irony of Bonnard.[82] Bonnard's letters to his mother demonstrate his self-critical nature and modesty, which he covered up with humor. Commenting to her on a screen that he intended to exhibit at the 1894 Indépendants, the artist jokingly mused: "It will be . . . the 8th wonder of the world. . . . It will be more commented upon than the ones before. There are people [in it] in place of ducks and leaves."[83]

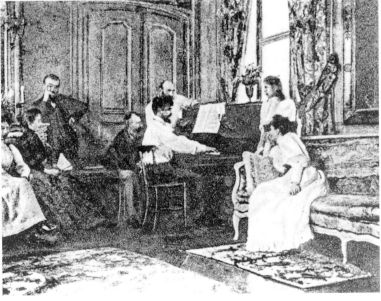

FIG. 9

Often in the 1890s, Bonnard's decorative paintings, such as *Women in a Garden* (Watkins, fig 14; cat. 2–3) and *Poodles* (cat. 4), relied on the "posteresque" and linear style he employed in prints at that time. Perhaps, as many scholars have posited, his attraction to Japanese art encouraged him to conceive the canvas as a multipaneled screen. Of the four artists featured here, Bonnard made the largest number of screens during the 1890s, either fully realized or initially conceived as screens and then transformed into another art form. The latter was the case for *Women in a Garden*, which he began as a folding screen and shortly thereafter divided into four separate panels. The same can be said of *The Terrasse Family in the Garden* (cat. 43, fig. 2), a large, rectangular canvas that he originally conceived as a four-panel screen.

Like Henri de Toulouse-Lautrec, with whom he was closely linked through the *Revue blanche* milieu and by their shared interest in printmaking, Bonnard was an intense observer of modern life with a mischievous eye that saw the *gamin* (street urchin) in the schoolboy, and the *gamine* buried beneath the fashionable boa of the *Parisienne* (see Watkins, fig. 8). The two poles of Bonnard's art in the 1890s are embodied in *Twilight,* or *Croquet Game,* of 1892 (cat. 5), and the portrait of his family painted in 1900 (cat. 43, fig. 1). In the former, Bonnard imparted to the scene a symbolic weightiness (achieved by dense greens and gestureless figures) that jars with the levity of the event itself. In the latter, he employed an almost-caricatural style for a full-scale portrait that can be considered a decoration by virtue of its insistently horizontal composition and cool, even tones. As we shall see, Bonnard's evolution as a painter-decorator was not only far more complex than that of Vuillard and of Denis, but it has also remained surprisingly unstudied.

Roussel was also not known as a painter of large-scale and mural-like decorations before 1900. He seems, in fact, to have spent most of the decade experimenting with the different stylistic possibilities inherent in the open-ended and all-inclusive theories of the Nabis. Among the wealthiest of the group (except for Paul Ranson, whose family was associated with the famous Houbigant perfumeries), Roussel was also the most self-critical. One of the reasons his oeuvre is so difficult to assess is that he destroyed or painted over many of his works.[84] An avowed agnostic who supported anarchist causes in the 1890s, Roussel, during this period, vacillated between Christian and allegorical imagery in the mode of Puvis and intimist interior scenes similar to those by Vuillard from the early 1890s. A horizontal panel known as *Conversation on a Terrace* (cat. 28) is thought to be a study for a mural competition, which Roussel did not win, for the town hall at Bagnolet, a suburb of Paris. In general, Roussel seems to have been the most passive, idealistic, poetic, and perhaps for those reasons, the weakest of the four friends in dealing with the practical side of life.[85] Like Vuillard, Roussel showed his work at exhibitions in the *Revue blanche* offices, and with the Nabis at St.-Germain-en-Laye and the Barc de Boutteville gallery. He avoided larger exhibitions, such as the Indépendants and the Salon. Much of his time was spent in the studio at his apartment in Paris, and after 1899, at L'Etang-la-Ville, near St.-Germain-en-Laye, where he and his wife, Marie, rented and eventually built a house and raised their children, Annette and Jacques. But the personal details that could bring us understanding of Roussel himself are few. Even the two doctoral dissertations devoted to Roussel's life and art are apologetic about the great gaps in our knowledge of the artist's early career, his marriage, and his interaction with patrons and clients.[86]

It is interesting, then, that knowledgeable critics such as Gustave Geffroy grouped Roussel with Vuillard and Bonnard as "*modern* decorators."[87] Apart from his lithographs published in *La Revue blanche* and a handful of sketches for unrealized screens and decorative projects, however, Roussel's commitment to *décoration*, at least at this point in his career, remains hard to define.

PATRONAGE GROUPS: BLURRING THE BOUNDARIES

Throughout the 1890s, Bonnard, Vuillard, and Denis experimented with decorative paintings, screens, and objects, and also shared collectors and friends. Their supporters were drawn largely from the *haute bourgeoisie*, involved in finance, industry, medicine, literature, music, art, and cultural administration, or from independently wealthy men of letters. This network was further divided, as previously discussed, into two tightly knit circles, apparent already in 1892 when Ranson wrote to Verkade of the Nabis' projects. One of the subgroups, referred to here as the Lerolle group, was "Old French" and ardently Catholic. Intelligent and successful, these patrons were open to modern

writing and art (André Gide and Paul Valéry were among the writers in this circle) as long as such work fell within the parameters of clarity and stylistic purity associated with the *goût latin*.[88] The other group, centered around the Natansons, was most actively involved with avant-garde and Symbolist literature. They were also more liberal politically, including among them the acquitted anarchist Félix Fénéon and anarchist sympathizer Octave Mirbeau.[89] Many, like Léon Blum, Romain Coolus, and Jean Schopfer, were contributors to *La Revue blanche*, frequented the same galleries, theaters, and dinner parties, and visited one another's summer residences.

The crossovers between these two groups, in their professional and social support of the Nabis, were many. As mentioned, Lerolle purchased one of Bonnard's decorative panels in 1891, a companion to the vertical *The Robe* (1891; Musée d'Orsay, Paris). Vuillard, a dinner guest at the Lerolles, was struck by the "calm impression" of their home, the "reserved but likeable" Lerolle and his sister-in-law, whom he contrasted with the women associated with Lugné-Poë's theater, "these sensual Jewesses, their silks shimmering in the shadows."[90] While Vuillard was a "court painter" of sorts to the Natansons, he was also a favorite of Lerolle's brother-in-law Fontaine, for whose home he painted many interiors and portraits throughout his career (see cat. 15, fig. 2). The Swiss and Protestant Jean Schopfer, who commissioned a porcelain dinner service from Vuillard (see fig. 10), as well as three decorative paintings in 1897 and 1901, was also close to Denis,

with whom he shared a passion for Italian art.[91] Gide, too, although a friend to and collaborator with Denis, worked for *La Revue blanche* and later purchased portraits of Thadée Natanson by both Vuillard and Bonnard.[92] And Arthur Huc, one of Denis's earliest patrons, was also an admirer of Vuillard. In 1897, for example, he asked Denis to let him know which new works by Vuillard were exhibited in a group show at Ambroise Vollard's gallery, Paris, and to help him select one for purchase. In a subsequent letter, Huc apologized to Denis, having realized the presumptuousness and inherent awkwardness of asking one artist to judge the work of another.[93]

While these two groups of patrons and artists frequently overlapped in their aesthetic and social activities, it was in the commission of decorations for specific interiors that broad differences emerged. In addition, as a recent dissertation by Laura Morowitz on the rise of both Medievalism and anti-Semitism at the end of the century has shown, artists and collectors were indeed biased in favor of certain artists whose beliefs most closely paralleled their own, even if this did not preclude frequent interactions between those all along the political and religious spectrum.[94] The complex results of these overlapping aims and motives are perhaps best illustrated through close consideration of some specific commissions.

FIG. 10
Edouard Vuillard. Plate from the porcelain dinner service Vuillard decorated for Jean Schopfer, c. 1895. Private collection.

VUILLARD AND DENIS IN THE 1890S: SEVERAL CASE STUDIES

As noted, unlike Bonnard and Roussel, Vuillard and Denis received numerous commissions for interior decorations between 1892 and 1899, and thus lend themselves especially well to a comparison of patronage groups. They often defined their decorative styles in opposition to each other, while all the while admiring each other's works.[95] Denis's trips to Italy in 1895, and again with Gide in 1897, where he rediscovered the art of Raphael and the High Renaissance, convinced him of the advantages of an aesthetic system based on intellectual reflection rather than on instinct and visual impressions. Writing to Vuillard in February 1898, he voiced his objection to the artistic aim of producing "an immediate pleasure, a pleasing exterior," seeing it as an impulsive and misguided reaction to academic art. In response, Vuillard remarked that for him the danger was applying theory to art that had not been arrived at through trial and error.[96]

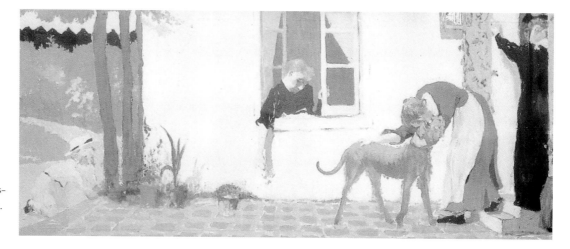

One of the first to recognize this important distinction in the aesthetic aims of these two artists was Achille Segard.[97] The chapters on both in Segard's *Peintres d'aujourd'hui: Les Décorateurs* (1914) provide analyses of their decorative ensembles and single works from 1891 to 1913, as well as an invaluable listing of titles, dates, and the names of original and contemporary owners. It thus seems useful to summarize Segard's comments before examining specific commissions. Indeed, Segard's general assessment of the appeal of these decorative works reinforced Denis's comments of 1899, discussed above, about differences in tastes between those who preferred complicated surfaces and hard-to-read imagery and those who favored clearly defined forms, smooth surfaces, and recognizable themes.

Citing Lerolle's earliest purchases from Denis, including *Catholic Mystery* (fig. 8), *Trinitarian Evening* (*Soir trinitaire*, 1891; Musée d'Orsay, Paris), and *Ladder in Foliage* (cat. 14), Segard categorized Denis as a "con-

ciliator" of the spiritual and the earthly in his works. Interestingly, Segard felt that Denis was incapable of painting the details of everyday life, details that Denis criticized Vuillard for exploiting in his art to the detriment of beauty.[98] Segard astutely noted Denis's insistence on aesthetic concerns, and his displeasure that his Nabi colleagues had begun to confuse personal expression with beauty.[99] In essence, Segard echoed the major criticism that Denis had leveled at his Nabi comrades in an article written in 1899: that, in order to render their emotional response to the natural world, they had gone too far in the direction of distortion through color and line, and had thus abandoned the basic rules of classical painting, which demanded restraint and order. These rules also insisted on a respect for, rather than a jettisoning of, the past, in terms of subject matter.[100] Ironically, the restraint and order that marked Denis's works, from his earliest commissions, were ingredients in a working method that, as he explained to Signac, was complicated and

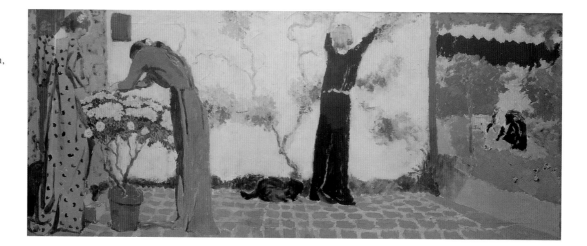

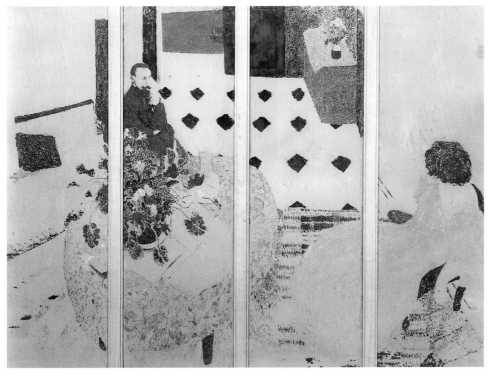

secret.[101] Whereas Denis relied on "important prepara-
tory work," which enabled him to proceed quickly
and confidently, Vuillard continually berated himself
for having to worry about technique and style with
each new project. And, as Vuillard noted enviously in
his journal, Denis was able to produce without worry-
ing about the opinions of others.[102]

From the beginning, moreover, Denis was assured
of ready subject matter through his strong religious
faith and devotion to nature. In Marthe Meurier, his
fiancée and, after 1893, his wife, who appears in
numerous paintings and *décorations* in the 1890s, he
found the perfect link between the sacred past and
secular present.[103] In part because Denis had no
uncertainties about subject matter and style, he was
able to execute *Ladder in Foliage*—the ceiling painting
for Lerolle in which he depicted Marthe three
times—in less than one month; he produced two
large-scale door panels for Arthur Huc (cat. 17–18) in
a similarly short period. Vuillard, however, had no such
immediately accessible subject matter, and his early
journal entries are filled with observations of everyday
life and the problem of finding a viable working
method. In 1891, he queried, "Why do I still worry
about what my style will be?"[104] He realized he could
and should use his sketches as decorative motifs, but

lacked the confidence and assurance to do so. "But
why my discomfort each time I begin a series?
It's important that I no longer have this concern for
originality . . . *to free myself* first and to rid myself of
some of the most generalized [theoretical] ideas."[105]

If, as Segard analyzed it, Denis's appeal, while
largely spiritual, was expressed in clear, legible forms
that were easily accessible to the viewing public, then,
he found, Vuillard's decorative appeal was purely cere-
bral and therefore less appealing to a general audi-
ence.[106] Seeming to second Denis's evaluation of the
destinations for which Vuillard's aesthetic would be
best suited, Segard remarked that works by the latter
were better seen in such non-public spaces as offices,
libraries, studies, waiting rooms, and antechambers:
"the rooms of repose where, in the intervals of his
studies, the intellectual toiler comforts himself with
the gentle sensations for which nature provides the
source."[107] The uneducated masses would not be able
to understand the subtleties in Vuillard's style and tech-
nique that made his works so unconventional. Asking
"Is the purpose of decorative painting to address itself
to everyone?" Segard then answered:

It is out of the question that these paintings would please the
working class [*collectivité*] without education, but it is sufficient
that the *élites* can find pleasure for themselves in the atmosphere
created by these paintings, which on the walls of their interiors
are undeniably decorative.[108]

As Segard explained, in contrast to Denis, who edited
the material world so that it could be understood on a
spiritual plane, Vuillard endowed the smallest detail of
the physical world with mystery, using a personal, sym-
bolic language that would not necessarily be under-
stood by everyone. Whereas Denis's clear and classic
decorations were intended for ceiling paintings and
murals in spacious mansions, Segard felt that Vuillard's
paintings demanded an altogether different environ-
ment, since they conferred a kind of psychic power to
the place they inhabited.[109] Understood in Segard's
comments is the notion that Denis's paintings were
less limited in their appeal, because they were linked
both thematically and physically (e.g. the way the
paint is applied) to a timeless (Christian) tradition.[110]

As Ranson noted in the letter to Verkade cited
above, both Denis and Vuillard received important
decorative commissions in 1892. Vuillard's came
through Thadée Natanson, and from Thadée's archi-
tect cousin, Stéphane Natanson, who in turn con-
vinced his sister and her wealthy industrialist husband,

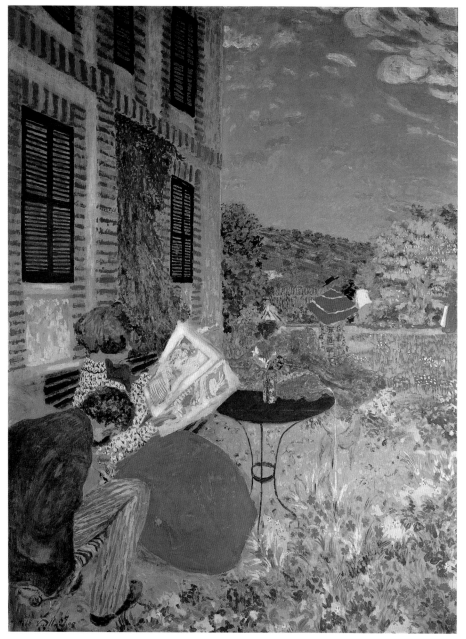

FIG. 14
Edouard Vuillard. *Woman Reading on a Bench,* or *In Front of the House,* 1898. Distemper on canvas; 214 x 161 cm. Private collection.

of the first-floor of the family apartment that served as his mother's dressmaking studio. As Elizabeth Easton pointed out, although Madame Vuillard was registered in a professional directory as a corset maker (*corsetière*), she was also a successful dressmaker (*couturière*).[111] Coming from a family with a long history in textile manufacturing, Madame Vuillard set up a workshop on rue St.-Honoré that was able to hold its own against the growing competition from ready-made clothing sold through department stores. Although his mother actually employed only two women in addition to his sister Marie, Vuillard multiplied and embellished these female figures in his paintings to transform this cottage industry into a lively arena where women preen and primp, and costumes are held up, sewn, and donned.

In addition to this series of six panels destined to be cornice decorations for Madame Desmarais's boudoir, Vuillard made a five-panel folding screen known as *The Dressmakers* (1892/93; private collection). This screen, which has since been dismantled and is missing its fifth panel, marks Vuillard's first decorative project (outside the quickly executed, and largely forgotten, sets he did for the avant-garde theater) using the time-consuming process of *à la colle,* or glue-based distemper paint.[112] Vuillard's last commissioned project for the Desmarais family, a four-panel screen (fig. 13), since remounted as a wall painting, was completed a few years later (c. 1895) and may well have been specifically commissioned by Stéphane, since it shows him sitting across a flower-laden table from his cousin's wife, Misia. It is even possible that the screen belonged to Stéphane, whose premature death in 1904, only one year after completing a new luxury mansion for the Desmarais, put an end to Vuillard's relations with this family.[113] In fulfilling the above commissions for panels and screens, however, the artist took a critical step toward defining a decorative style and a thematic repertoire.

Paul Desmarais, to commission six decorative panels from the twenty-four-year-old artist. This series of long, horizontal vignettes, paired by subject and framing devices, shows women in country houses, city workshops, and public parks (see figs. 11–12; cat. 31, fig. 1). The panels remain with the same family, and are represented in this exhibition by an early version of *The Dressmaking Studio I* (cat. 31). In contrast to the horizontal paintings of idealized women in landscapes that both Denis and Roussel were painting at this time, Vuillard's motif and execution are down-to-earth and personalized, reflecting the bustling environment

Denis's 1892 commission for a ceiling painting for Henry Lerolle (see cat. 14) played a similar role in helping him to develop what would be his primary aesthetic. Instead of narrative vignettes based on modern life, Denis conceived *Ladder in Foliage* as a kind of secularized Jacob's Ladder, as one scholar has put it.[114] Instead of a complicated and patterned surface, Denis selected four basic colors, so that his image reads clearly from below or at eye level. And instead of panels that would be seen in sequence around a woman's boudoir or most intimate room, Denis created a paint-

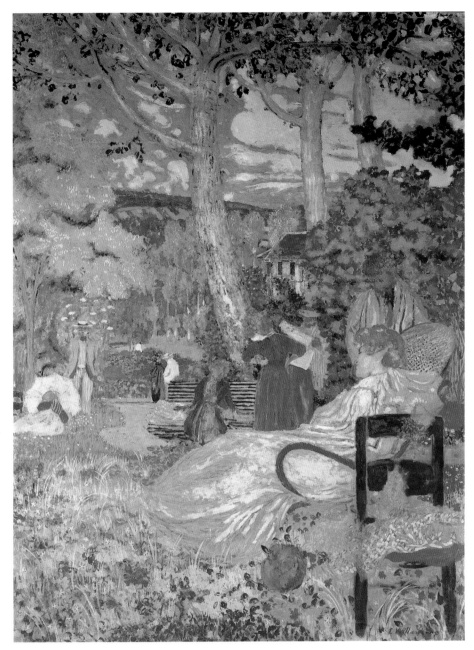

FIG. 15
Edouard Vuillard. *Woman Seated
in a Garden*, 1898. Distemper
on canvas; 214 x 161 cm.
Private collection.

Vuillard would have known Schopfer, who adopted the pen name Claude Anet, from the Lycée Condorcet, Paris, which they both attended, or the salon that Schopfer hosted with his brother on quai Voltaire. The salon was frequented by Thadée Natanson and many of those who were to become, like Schopfer, contributors to *La Revue blanche*. In 1897, Schopfer wrote an article for the American publication *Architectural Record*, in which he illustrated and discussed at length a porcelain dinner service decorated by Vuillard that Schopfer himself had actually commissioned and that was exhibited at Bing's Maison de l'Art Nouveau (see fig. 10; Watkins, fig. 16). When Schopfer and his wealthy American bride moved, in March 1897, to a luxury apartment house on avenue Victor-Hugo, he commissioned the two panels from Vuillard for his small salon.[116]

While Schopfer had social ambitions and his advantageous marriage gave him access to a circle of intellectual and aristocratic elite from which the Natansons would have been excluded, he nonetheless remained close to this family.[117] It was Misia Natanson and her friends (Bonnard; Bonnard's future wife, Marthe; Misia's half-brother Cipa; and others) whom Vuillard depicted in these two panels for Schopfer, works that could be described as decorative genre paintings, and that perhaps are the most beautiful of his career. Inspired by a summer spent with the Natansons at their Villeneuve residence in 1897, Vuillard worked throughout the winter to complete them, which, as indicated on the right-hand panel, he did in May 1898.

Coincidentally, Denis worked that same summer on a decorative ensemble for Baron Cochin—philosopher, historian, politician, liberal Catholic, and participant in intellectual circles that included Lerolle and Chausson—while staying at Beauvoir, his estate near the Forest of Fontainebleau.[118] Vuillard's and Denis's compositions were inspired by real-life experiences, reflected, for example, in the portraitlike figures they both include. Vuillard's panels show the Natansons—his hosts (and also the hosts of the Schopfers)—at their casual country home; Denis's series shows Cochin and his family on the grounds of their extensive baronial estate. But there the similarites between the two projects end.

While Vuillard chose to depict themes favored by the Impressionists—women reading or dozing in private gardens—Denis was commissioned to treat "the

ing for the large public space of Lerolle's small salon, where it would be admired and commented upon by family and guests.

One final comparison of *décorations* by Denis and Vuillard from this period serves to position both artists artistically and socially during the 1890s: two panels Vuillard made for the writer Jean Schopfer, *Women Reading on a Bench* and *Woman Seated in a Garden* (figs. 14–15), completed in 1898; and the seven-panel series known as *The Legend of Saint Hubert* (figs. 16–18), which Denis painted in 1897–98 for Baron Denys Cochin.[115]

FIG. 16

FIG. 17

FIG. 16
Maurice Denis. *The Miracle*, 1897.
Oil on canvas; 225 x 212 cm.
Musée Départemental Maurice
Denis "Le Prieuré,"
St.-Germain-en-Laye.

FIG. 17
Maurice Denis. *Losing the Scent*,
1897. Oil on canvas; 225 x
175 cm. Musée Départemental
Maurice Denis "Le Prieuré,"
St.-Germain-en-Laye.

hunt." This subject—which combines figures, animals, and landscape—has enjoyed a long pedigree as *décoration* dating back to antiquity. In particular, it occurs frequently in the medieval and Renaissance tapestries the Nabis admired, where it symbolized not only the bounty of the land and a much-loved sport among the landed classes who commissioned such wall hangings, but also the process involved in spiritual quest. Hunting was also Cochin's favorite pastime and a theme whose larger meanings the baron recognized, to judge from letters he wrote to Denis.[119] In determining the panels' iconographic program, Denis followed Cochin's desire to include depictions of the Cochin family (to which the artist added portraits of himself and his wife; see fig. 17) and the stories of two celebrated huntsmen. The first is Saint Hubert, a seventh-century nobleman whose wild excursions on horseback pushed him to exhaustion, followed by submission to a higher power, leading ultimately to a revelation of the divine, symbolized by a crucifix that appeared in the antlers of a stag (fig. 16). The second is

Pecopin, the unfortunate protagonist of Victor Hugo's fantastic tale *Le Rhin* (1839–40), who lost his body and soul to the frenzy of the hunt.[120] Denis's last panel (fig. 18) is a scene of spiritual reconciliation in which the Cochin family wears what one author termed "spiritualized" dress, rather than hunting clothes, and is shown in prayer under the welcoming watch of Saint Hubert. The subtext of both narratives—the intensity, challenges, and rewards of the spiritual quest—is explicitly Christian.[121]

While Vuillard's image of Misia sleeping in a bentwood rocker may be seen as having Symbolist overtones, his work definitely lacks the overtly religious spirit of Denis's panels. Denis's symbolic treatment of a complicated subject is at the opposite aesthetic pole from Vuillard's intimate image of Misia and her circle relaxing in nature. While the presence in Denis's panels of portraits of actual people, alongside and within religious narratives, imparts both secular and allegorical meanings to his work, Vuillard's panels, by contrast, lack a specific allegorical program. Rather, they evoke

FIG. 18

FIG. 19

the reverie and relaxation of a summer's day at a bourgeois country home among intimate friends. Denis was very attentive to Cochin's wishes in creating his series; Vuillard's decorative paintings, on the other hand, have less to do with Schopfer than with the artist's own life at the time (it has been stated, for example, that Vuillard painted this work when he was "more or less under Misia's spell").[122] Although, unlike Denis, Vuillard did not insert himself literally into the scene, the sense of his being there, and the very personal way in which he approached his subjects, was admired by reviewers like André Gide, who called him "the most personal, the most intimate of storytellers."[123]

Denis originally intended his series of paintings for Cochin as two large murals on facing walls, but he subsequently divided these into six individual panels and added a seventh. They were to be hung side by side and examined from left to right, along the walls of a narrow office lit by a single window, with the seventh and widest panel (fig. 16) placed at the end of the room opposite the window. The widest panel served as

a focal point for the ensemble; its sky area extended onto and covered the entire ceiling of the study. Even in this intimate setting, the panels, meant to be read as a processional, are more akin to Renaissance mural paintings than to Nabi decorations. Part of their public appeal, even in Cochin's private study, is due not only to the monumental theme but to the legibility of the forms and the uniform finish. Denis's brush strokes are absorbed into clear areas of color with strong value contrasts held in check by the artist's rigorous draftsmanship. Nothing could be further from Vuillard's scumbled, tufted surface, resulting in part from the distemper technique he used and exploited throughout the composition to suggest a woven effect. In the case of the Schopfer panels, this chalky surface extends over the entire canvas so that the background has the same texture as the figures, making the exact physiognomies of these "portraits" difficult to read.

For Vuillard, the "installation" and "integration" of his paintings into a particular setting had to do with fitting into a general scheme of decoration rather than into a specific architectural interior. Segard correctly observed that it was the ability of the Schopfer panels to match the atmosphere and mood of the place for which they were destined, rather than the actual phys-

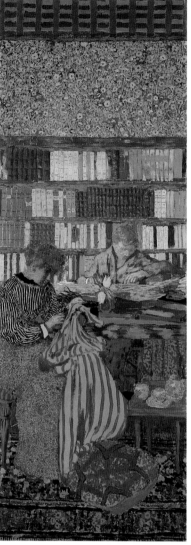

FIG. 20

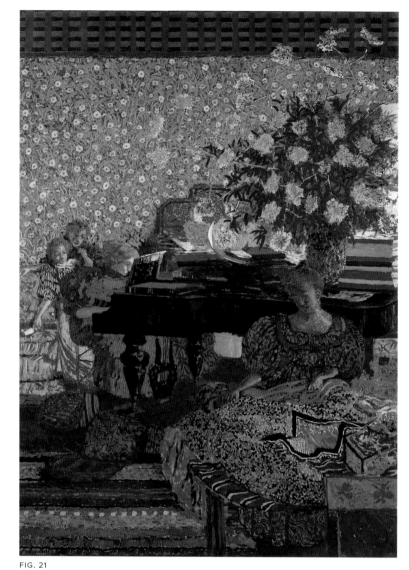

FIG. 21

ical site, that made them appropriate as décor.[124] When Signac saw Vuillard's panels in December 1898 at the Schopfer residence, he made a similar observation:

What is especially noteworthy about these two panels, is the clever way in which they fit into the decoration of the room. The painter based himself upon the dominant colors of the furniture and drapes, repeating them in his canvases and harmonizing them with their complementary tones. These panels are painted *à la colle*. . . . It seems as though oil painting would have been more out of tune. Truly, these panels do not look like painting: it seems as if all the tones in the furniture had concentrated here, in the corner of that wall, and defined in handsome shapes and handsome rhythms. From that viewpoint it is absolutely successful, and it is for the first time that I get this impression from a modern interior.[125]

Vuillard understood the nature of decorative painting as a subtle enhancement of, rather than a remarkable addition to, an exisiting interior, a painting that would

resemble a textile without "too precise [a] subject."[126]

What Signac attempted to describe about the effect of the Schopfer panels can perhaps best be sensed from a photograph of the period (fig. 19), showing *Woman Reading on a Bench* hung about three feet above the floor, over a cushioned and carved *cassone*, and framed by heavy velvet curtains (*portières*). He stressed how they "fit into" the room's combination of textures and dominant tints of cushions and carpets, suggesting that the panels were conceived with the Schopfers' participation and with a thorough knowledge of the apartment for which they were intended. Signac regarded favorably the way the panels integrated themselves into their surroundings, even though they were not architecturally specific. They were successful because they contributed to the room's "overall decorative cohesion," a phrase Vuillard

another decorative project for
-in-law, the wealthy collector Jack

endants for Schopfer and Denis's
 for Cochin mark an important
1 the meaning of *décoration* for these
5, Vuillard abandoned the intimate,
ind complicated surfaces that had
arlier works. The "cerebral" quality
1 by the mind as through observa-
oted is discernible in these works,
in Impressionist open-air painting.
ents with and eventual adoption of
nique, which slowed him down and
le relationship between object per-
irmed through art, seems to have
s change in approach. It is as if the
ue made it morally acceptable to
ithout worrying about the naturalist
y difficult character of distemper,
epared and applied quickly in single
or, paradoxically allowed Vuillard a
1an when he worked in oil. It also
e rigorously constructed decorative
g patterns, borders, and background
-21). In the scenes from modern life
s that the Schopfer panels prefigure,
oped a broader paint handling. This,
inherent graininess of the distemper
ontributed to breaking up the surface
d distanced them from Impressionist
pite similarities in theme.

Denis's allegorical series for Baron Cochin signaled
the artist's move *away* from the representation, in his
large-scale decorative works, of genrelike subjects. As
discussed in the next chronological section, Denis's
works after 1897 became more conservative stylistically.
For his church decorations (beginning in 1898), as well
as his secular commissions, he adopted more classical
compositional strategies, themes (drawn increasingly
from allegory, mythology, and religion), and technique.
Denis's early goal to dedicate himself to creating an art
that reconciled religious content with avant-garde
painting gave way to a style that was clearly legible,
crisply delineated, and increasingly centered on the
human figure. Instead of the variety of techniques and
palettes that had marked his early decorative paintings,
from the late 1890s to the end of his career his works
become easily identifiable by their subjects and a near-
codified palette of pale blues, greens, pinks, and whites.

~ ~ ~

By 1900, each of the four artists featured in this book,
while remaining close and supportive of one another's
art, had evolved an increasingly distinct decorative
program and aesthetic. Their patrons by that point had
also changed, in some instances radically, owing to
economic loss, divorce and other altered personal situ-
ations, and evolving tastes. New patrons emerged,
consisting of clients from a more international set of
wealthy collectors associated with Bernheim-Jeune,
Vollard, and Druet, Paris galleries with which
Bonnard, Vuillard, Denis, and Roussel all joined forces
in the new century.

1. Bonnard received numerous requests for lithographs, posters, and illustrations for books, albums, and music scores. Thus, in a sense, he was a commissioned decorator, but because he worked with publishers and public distribution rather than with individual collectors for their private interiors, those works fall outside the scope of this study. Likewise, Roussel was very involved with the theoretical and aesthetic significance of *décoration*, but seems not to have executed decorative paintings for private commissions until after 1900.

2. Paris, Galeries Durand-Ruel, *Exposition,* exh. cat. with preface by André Mellerio (10–31 Mar. 1899).

3. "A certain number": Mellerio, paraphrased and tr. in Rewald 1953, pp. 28, 72. "Enthralled with": Mellerio, in Paris (note 2), pp. 5–6.

4. See, for example, [Henri Ghéon], "Lettre d'Angèle," *Ermitage* 10, 4 (Apr. 1899), pp. 315–16.

5. Signac's *D'Eugène Delacroix au néo-impressionnisme* appeared first in the form of articles in *La Revue blanche* 16, 119 and 122 (15 May, 1 July 1898), pp. 13, 115, 357; and the following year in book form from Editions de La Revue blanche. For his disapproval of the Nabis, see, for example, his condemnation of their exhibition at the Champ-de-Mars in 1895, in his journal entry for 26 Apr. 1895, tr. in Rewald 1949, p. 172. In a letter to Charles Angrand of 23 Mar. 1899, Signac wrote that more than thirty canvases were sold from the exhibition, including one by Denis and one by Bonnard, but not a single sale occurred of works from the room that contained works by himself and Angrand; see Rewald 1953, p. 50. For Signac's resentment of the Nabis' early success, see his journal entry for 6 Mar. 1895, tr. in Rewald 1949, p. 173.

6. Antoine de La Rochefoucauld to Emile Bernard, 28 Mar. 1899, tr. in Rewald 1953, p. 78. The other artists he cited were Bonnard, Hermann-Paul, Ibels, Lacombe (a sculptor whose works were actually installed in a separate room), Ranson, Rippl-Rónai, Roussel, Sérusier, Vallotton, and Vuillard.

7. Signac used these words to describe one of Denis's works in the exhibition; see journal entry, 15 Mar. 1899, tr. in Rewald 1953, p. 77.

8. The catalogue of this exhibition (note 2) indicates that the Nabis were represented by ten works by Bonnard, nine by Ranson, seven by Denis, six by Vallotton, five by Sérusier, four each by Vuillard and Roussel, as well as examples by Hermann-Paul, Ibels, and Rippl-Rónai.

9. Journal entry, 15 Mar. 1899, tr. in Rewald 1953, p. 79.

10. See André Fontainas, "Art moderne," *Mercure de France* 30 (1899), p. 248. See also La Rochefoucauld's similar conclusion in a letter to Bernard: "Vuillard is very much admired. For me he is a 'painter' gifted with great qualities of finesse and distinction"; La Rochefoucauld (note 6).

11. Denis 1890.

12. For the Rosecrucian Society and occult Christianity, see Filiz Eda Burhan, "Vision and Visionaries: Nineteenth-Century Psychological Theory, the Occult Sciences, and the Formation of the Symbolist Aesthetic in France," Ph.D. diss., Princeton University, Princeton, N. J., 1979, pp. 24–38 passim. For German Idealist philosophy, whose proponents believed that the distinction between the mind (knowable) and spirit (unknowable) leaves open the possibility that reality is dependent upon the mind, see the entry "German Idealism," in Edward Craig, ed., *Routledge Encyclopedia of Philosophy* (London, 1998), pp. 42–43.

13. Mauner 1978, p. 91.

14. Tr. in Groom 1993, p. 8.

15. In many ways, the Nabis had disbanded practically and philosophically as early as 1896. This was the year Denis wrote his "Notes sur la peinture religieuse," in which, in an increasingly dogmatic tone, he advocated the importance of a reconciliation between religion and art. See Denis 1993, pp. 32–48. For Mauner (1978, p. 198), the 1899 Durand-Ruel exhibition marked the end of the Nabis as "Symbolists."

16. See Denis, *Journal,* vol. 1, entry, Mar. 1899, p. 150.

17. In her informative thesis on Bonnard's early years, Helen Giambruni ascribed a less prejudicial emphasis to Denis's references to Semitic taste, taking them to refer to the peoples of Western Asia, who spoke languages of Semitic origin, and thus to the tendency in the works of Bonnard and Vuillard toward richly interwoven backgrounds, such as those found in Islamic art. See Giambruni 1983, p. 226.

18. Emile Zola, "J'Accuse," in *Aurore,* 13 Jan. 1898.

19. Debussy's *Deux Arabesques* (1888) is an example of the musical use of the term to describe a piece in which the composer aims at a decorative, rather than purely emotional (romantic), effect. See Maurice J. E. Brown's entry for "Arabesque," in Stanley Sadie, ed., *The New Grove Dictionary of Music and Musicians,* vol. 1 (London/Washington, D.C., 1987), pp. 512–13. A recent dissertation offered the etymology of the term "arabesque" in French literature and art, and analyzed its significance for the advanced decorative painting practiced by the Nabis; see Wendy Corcoran, "Painting and Ptyx: The Nabis, Language, and Literature," Ph.D. diss., University of Toronto, 2000.

20. As Joseph Masheck argued, "The emphasis on decorativeness as a positive quality, in fact, arose as a compensatory exaggeration of the ornamental, at the expense of pictorial, values"; see Joseph Masheck, "The Carpet Paradigm: Critical Prolegomena to a Theory of Flatness," *Arts Magazine* 51, 1 (Sept. 1976), p. 86.

21. See the phrase *une arabesque sans âme* in Denis [Pierre Louis, pseud.], "Pour les jeunes peintres," *Art et critique* 90 (20 Feb. 1892), p. 94. For Denis, "Définition du néo-traditionnisme," see Denis 1993, p. 13, tr. in Chipp 1968, p. 98.

22. Even this definition, however, was not always consistently adhered to by the Nabis. In his early journals (see Vuillard, Journals), Vuillard reflected the fluid understanding of the term when he observed, "The same arabesque drawn by two different personalities will give two different expressions." He concluded, however, that he need not worry too much if his views on this subject departed from the specific theories of "Sérusier and the group," because he believed that they all shared the same, basic point of departure ("la même arabesque dessinée par 2 caractères donnera 2 expressions différentes. . . . pas s'inquiéter de Sérusier et la bande parce qu'on part du même principe"). This particular journal entry, for 12 July 1890, MS 5396, is transcribed in Court 1992, n. pag.

23. Kozloff 1958, pp. 25–26.

24. Vuillard, Journals, Oct.–Nov. 1890, MS 5396, in Court 1992, n. pag.: "Le mot harmonie veut dire seulement *science,* connaissance des rapports des couleurs: un ton va avec un autre, fausse expression, cette couleur que vous prenez sur votre palette est homogène avec cette autre, elle est mate ou vernisée et les degrés entre; sans cela nous étions auparavant sous prétexte d'harmoniser des tons—à ne faire aucune différence lumineuse entre 2 couleurs et les tableaux de loin où l'on ne distingue rien."

25. See Paradise 1985, p. 399.

26. See Denis [Pierre Louis, pseud.], "Notes sur l'exposition des Indépendants," *Revue blanche* 2, 7 (25 Apr. 1892), p. 233.

27. Denis, for example, framed *Catholic Mystery* (fig. 8), the first oil painting he exhibited at the Indépendants, "with a liner of white wood and a border of natural yellowed wood"; see Segard 1914, vol. 2, p. 157. In addition, a notice to artists published in *La Revue blanche* called for decorative paintings to be included in an upcoming exhibition at Siegfried Bing's Maison de l'Art Nouveau, on the theme of canvases without frames (*toiles sans cadres*); see "Beaux-Arts," *Revue blanche* 11, 85 (15 Dec. 1896), p. 618.

28. See, for example, Segard's remarks (Segard 1914, vol. 2, p. 283) about Vuillard's panels for Jean Schopfer (figs. 14–15): "And it's definitely decorative art. These panels are not in themselves independent. They require space around them. There is the feeling that the gold border limits them arbitrarily. They need to occupy a wall, to fit into the wainscotting [of a room]."

29. Pissarro to his son Lucien, 2 Oct. 1892, in John Rewald, ed., with the assistance of Lucien Pissarro, *Camille Pisarro: Letters to His Son Lucien* (New York, 1943), p. 204.

30. Camille Mauclair, "Choses d'art chez Le Barc de Boutteville," *Mercure de France* 13 (Dec. 1894), p. 384.

31. See Verkade 1930, p. 88. Verkade, however, was writing roughly twenty-five years later, from a monastery in Beuron, Germany, where he had indeed succeeded in reviving religious mural painting.

32. For Sérusier's announcement, see Rémy de Gourmont, "Choses d'art," *Mercure de France* 5, 30 (June 1892), p. 186, cited in Carole Boyle-Turner, *Paul Sérusier* (Ann Arbor, Mich., 1980), p. 72. For the skeptical response of critics, see François Thiébault-Sisson's remarks in a review of a group exhibition at the Barc de Boutteville exhibition, in Groom 1993, pp. 24, 212 n. 59. For the Zapolska mural project, see Boyle-Turner, op. cit., p. 94.

33. With the notable exception of Vuillard and Denis, in fact, the Nabis painted few *décorations* that could be strictly termed site-specific.

34. See Denis, "Définition du néo-traditionnisme" (note 21), tr. in Chipp 1968, pp. 94–100.

35. In a January 1891 letter to Aurélien Lugné-Poë, Denis lamented, "I have put myself in a very bad place, sacrificing my independence to profit from those people"; see Lugné-Poë 1930, p. 252. In the same letter, Denis mentioned with envy the success of Bernard and Gauguin: "My dear old man, if I could sell *my* paintings, with what pleasure I would refuse to do these bourgeois portraits." On the relative prosperity of Vuillard's mother's dressmaking establishment by 1890, see Houston 1989, pp. 26ff. Denis's engagement in 1892 to Marthe Meurier and the prospect of future responsibilities as a husband and father further fueled his quest for recognition and patronage.

36. Denis, for example, was the most ardent supporter of the group's exhibitions at the Barc de Boutteville gallery, exhibiting in each of these events over the five years in which they occurred (they ceased with the death of the gallery's owner in 1897), creating the monogram that served as the events' emblem from December 1893 onward, and authoring the preface for the catalogue of the show that took place 27 Apr.–May 1895, which is reprinted in Denis 1993, p. 25.

37. The St.-Germain-en-Laye exhibition committee allowed the display of porcelain and enameled objects, architectural models, and tapestries, all of which accorded with the inclusive decorative aesthetic embraced by the Nabis and their circle. Later exhibitions seem to have become less receptive to the work of avant-garde artists, and by 1895 Denis was no longer involved. For information on the St.-Germain-en-Laye exhibitions, I am grateful to Katherine Kuenzli, a doctoral candidate at the University of California, Berkeley, who is working on early Nabi decorative ensembles. See also Martha Ward, "Impressionist Installations and Private Exhibitions," *Art Bulletin* 73, 4 (Dec. 1991), pp. 599–622.

38. For the reprint of Denis's review for the St.-Germain-en-Laye exhibition, see Lugné-Poë 1930, pp. 213–14. *L'Art et critique* was run by their mutual friend Jean Jullian, who had published Denis's "Définition du néo-traditionnisme" (note 21) in this journal in the previous year.

39. Unpublished letter from Arthur Huc to Denis, 20 Aug. 1891, Musée MD, MS 5600: "If you could take the trouble to send me some appropriate words, I will write an article here which I will try to fashion according to your taste and that of your friends" ("Si vous voulez bien prendre la peine de m'envoyer les quelques mots nécessaires je ferai ici un article que je tacherai de mettre à votre goût et à celui de vos amis").

40. Journal entry, 7 Feb. 1899, tr. in Rewald 1953, p. 76.

41. See, for example, Denis, "Pour les Jeunes Peintres" (note 21); and idem, "Notes sur l'exposition des Indépendants" (note 26), dedicated to his fiancée and speaking of the mosaic by "my friend Maurice Denis" ("mon ami Maurice Denis") exhibited that spring at the Indépendants. As noted by Segard (1914, vol. 2, p. 252), Denis sought recognition and publicity, whereas Vuillard, whose entry had been rejected for the Salon de la nationale in 1890, basically limited his exhibition participation to the smaller, alternative salons.

42. Unpublished letter from Charles Henry Hirsch to Denis, 18 June 1892, Musée MD, MS 5567: "Voudrez-vous quand vous l'aurez lu me faire de ce travail—au moins en ce qui *vous* concerne une franche critique. Je voudrais savoir si j'ai lu dans votre peinture des choses que réellement vous y avez mises. Si j'y ai noté des sensations que vous avez éprouvées, des intentions véritables." It is not clear which manuscript this letter refers to. Early in 1892, Hirsch had published an article in *La Revue blanche* in which he discussed works by Gauguin and Denis, among others; see Charles Henry Hirsch, "Notes sur l'impressionnisme et le symbolisme des peintres," *Revue blanche* 2, 5 (Feb. 1892), pp. 103–08.

43. Denis to Lugné-Poë, Dec. 1891/Jan. 1892, in Lugné-Poë 1930, p. 244. Percheron, who is frequently mentioned in Vuillard's early journals, converted to Catholicism and followed Verkade to a monastery, but later reconverted to Protestantism; see Mauner 1978, p. 118.

44. Denis to Lugné-Poë, 4 Dec. 1890, in Lugné-Poë 1930, pp. 270–71.

45. François Jourdain, *De Mon Temps* (Paris, 1963), p. 108, cited in Giambruni 1983, p. 30.

46. Bonnard's first patrons were the more conservative painters Henry Lerolle and Albert Besnard, both of whom purchased vertical panels depicting females painted in a highly decorative manner. It was Besnard who first acquired, from an exhibition of Bonnard's work in 1891 at the Barc de Boutteville gallery, a "panel on red felt," which he hung in his dining room. Apparently, Besnard thought the panel's silhouetted female resembled his wife. See François Jourdain, *Né en 76* (Paris, 1951), p. 14. See also Bonnard to his mother, Dec. 15, 1892: "Can you believe that I have again sold a panel, and again to a celebrity? It's the painter Besnard who bought it"; see Terrasse 1988, p. 44.

47. Denis to Lugné-Poë, undated, in Lugné-Poë 1930, p. 256.

48. Lugné-Poë mentioned Gauguin as a visitor to the rue Pigalle studio he shared with Bonnard, Vuillard, and Denis, without indicating whether he was there one or several times; see Lugné-Poë 1930, pp. 190–91. The Nabis jointly owned Gauguin's painting *The Little Girls* (1889; location unknown); see Paris, Hôtel Drouot, *Gauguin*, sale cat., 23 Feb. 1891, no. 24.

49. Denis to Lugné-Poë, [probably c. Jan. 1891], in Lugné-Poë 1930, p. 247.

50. G[eorges] Albert Aurier, "Le Symbolisme en peinture: Paul Gauguin," *Mercure de France* 2, 13 (Mar. 1891), pp. 159–64, tr. in Marla Prather and Charles F. Stuckey, *Gauguin: A Retrospective* (New York, 1987), pp. 150–56. Gauguin to Mette Gauguin, [prob. Sept. 1892], in Maurice Malingue, *Lettres de Gauguin à sa femme et à ses amis*, 2d ed. (Paris, 1949), letter 128, p. 169. Gauguin's reference to the Nabis' debts to him reads almost as if he were citing the book of John 14:6, where Christ tells his disciples, "No man cometh unto the Father, but by me." See also Gauguin to Charles Morice, Tahiti, July 1901: "Of course, the youth of today who are profiting owe all this to me. They have plenty of talent. . . . But perhaps without me they would not exist; without me would the world accept them?"; see Malingue, op. cit., letter 174, p. 226.

51. Thadée Natanson, "La Petite Gazette d'art: Expositions," *Revue blanche* 2, 4 (Jan. 1892), p. 74.

52. Some important sources on the activities of *La Revue blanche* are New York, Wildenstein and Co., *La Revue blanche: Paris in the Days of Post-Impressionism and Symbolism*, exh. cat. by George Bernier (1983); A. B. Jackson, *La Revue blanche, 1889–1903: Origine, influence, bibliographie* (Paris, 1960); Evelyn Nattier-Natanson, *Les Amitiés de La Revue blanche et quelques autres* (Vincennes [Seine], 1959); and Rochester 1984.

53. See Geneviève Aitken, "Les Peintres et le théâtre autour de 1900 à Paris," Ph.D. diss., Ecole du Louvre, Paris, 1978, p. 17.

54. [Thadée Natanson], in *Revue blanche* 1, 1 (15 Oct. 1891), p. 1, tr. in Rochester (note 52), pp. 28, 30. This statement is also reprinted in Olivier Barrot and Pascal Ory, *La Revue blanche: Histoire, anthologie, portraits*, 2d ed. (Paris, 1994), p. 30, with an attribution to Lucien Muhlfeld. For further information on the Natansons, see Groom 1993, pp. 16–17, 146.

55. See Lugné-Poë 1930, p. 229.

56. The playwright Paul Bernard changed his name to Tristan in 1893.

57. "Imposing and snobbish": see Camille Mauclair's thinly disguised parody of the Natanson brothers in *Le Soleil des morts* (Paris, 1897 [repr. 1979]), p. 121. On Proust and the Natansons, see Gold and Fizdale 1980, p. 48. On Gide and the Natansons, see Groom 1993, pp. 65, 220 n. 122.

58. Cited in Groom 1993, p. 213 n. 94.

59. Ernest Chesnau, *Les Nations rivales dans l'art* (Paris, 1868), pp. 5–6, cited in Patricia Mainardi, *The End of the Salon: Art of the State in the Early Third Republic* (Cambridge, 1993), p. 163. In a long article, "The Arts of Rome," published in 1899, Denis again pitted the French classical tradition against those of the Far East and the Semites, citing the Semitic "exaggerated love of effect, of rich materials, of color at the expense of form, structure, and classical restraint"; see Denis 1993, p. 68.

60. Besnard, cited in Jourdain (note 46), p. 190. Henry Lerolle was another reluctant Dreyfusard. In his memorial essay on the artist, Denis remembered the "bitterness of our discussions," and was glad that their friendship survived the controversy. See Denis 1932, p. 19, and note 61 below.

61. See Roger Magraw, *France, 1815–1914: The Bourgeois Century* (New York, 1986), pp. 273–80. Lerolle, for example, subscribed to both of these journals; see Thomson 1988, p. 60. For more on the conservative, Catholic, intellectual circle to which Lerolle and Denis belonged, see Michael Marlais, *Conservative Echoes in Parisian Art Criticism* (University Park, Penn., 1992), pp. 209–19.

62. Albert Boime suggested that, like avant-garde artists, Jewish businessmen were relegated to the fringes of French society, and that only the wealthiest, such as Proust's Swann, were able to overcome the prejudices inherent in the upper echelons of French society; see Albert Boime, "Entrepreneurial Patronage in Nineteenth-Century France," in Edward C. Carter, ed., *Enterprise and Entrepreneurs in Nineteenth- and Twentieth-Century France* (Baltimore, 1976), pp. 186–87. See also the discussion of Vuillard and Alexandre Natanson in Groom 1993, pp. 47–49.

63. Until that time, *La Revue blanche* had stayed out of the controversy; see Groom 1993, p. 230 n. 14. See also Madame Chausson's letter to Gide about an argument over the "Dreyfus question" between Vuillard and Louis Rouart, cited in Lyons 1994, p. 106 n. 15.

64. Vuillard, cited in Salomon 1968, p. 31.

65. Ranson to Verkade, Oct./Nov. 1892, in Mauner 1978, app., letter 11, p. 282. Ranson was speaking of Vuillard's panels for the Desmarais family.

66. Denis 1932, p. 2.

67. Vuillard, cited in ibid., p. 4.

68. Lerolle's murals for the Hôtel de Ville were entitled *Crowning of Science* and *Teaching of Science*, reduced versions of which are in the Musée du Petit Palais, Paris. With some exceptions, such as the Sorbonne's *Flight into Egypt*, the majority of Lerolle's murals were church commissions and the work he did for the Schola Cantorum, Paris, a center for the study of old French music that he helped found. See note 72 below and "La Schola Cantorum de Paris," *Pèl et Ploma* 3 (Apr. 1903), pp. 106–11, which illustrates Lerolle's murals for the school.

69. See unpublished letter from Lerolle to Denis, 1892/93, Musée MD, MS 6979: "I would be very happy to see a little of you and also to introduce you to Bussy [Debussy], for the music out of which you are to make, I believe, a lithograph [*The Blessed Damsel (La Demoiselle élue)*]" ("Je serais très heureux de vous revoir un peu et aussi de vous faire faire la connaissance de Bussy, pour la musique de qui vous devez faire, je crois, une lithographie").

70. For Lerolle's works by Degas, see Paul André Lemoisne, *Degas et son oeuvre* (Paris, 1946), vol. 2: nos. 316, 376, 402, 480, 486, 683, 702; vol. 3: 735, 738, 755, 854, 1033, 1192. Another of Lerolle's guests was Octave Maus, founder of the Belgian avant-garde artists' group Les Vingt and the journal *La Libre esthétique*. For Renoir's relationship with Lerolle, see Ottawa, National Gallery of Canada, *Renoir's Portraits*, exh. cat. by Colin B. Bailey et al. (1997), pp. 227–28. Lerolle was well known as a collector of modern art. In 1890, Gauguin wrote to Théo van Gogh urging him to persuade Lerolle to purchase his wood relief sculptures, which he felt were languishing at the Boussod and Valadon gallery, Paris, where Théo worked; see ibid., p. 327 n. 18.

71. Denis 1932, p. 5.

72. The Schola Cantorum, founded by French music scholar and composer Charles Bordes, began as the Chanteurs de St.-Gervais in 1894 and, two years later, was transformed into a school for the revival of old French music. See entry for Charles Bordes in Sadie (note 19), vol. 3, p. 45.

73. Roger Benjamin, "The Decorative Landscape, Fauvism and the Arabesque of Observation," *Art Bulletin* 75, 2 (June 1993), p. 298.

74. Apparently, Vuillard passed the article on to Lerolle during Lerolle's first visit, in May or June 1891, to the studio that Vuillard shared with Denis and others on rue Pigalle; see unpublished letter from Lerolle to Denis, Musée MD, MS 6971.

75. The date and subject of this ceiling painting are not known; see Meier-Graefe 1908, p. 52.

76. Chausson owned several paintings of Martinique and Tahiti by Gauguin; see Georges Wildenstein and Raymond Cogniat, *Gauguin: Catalogue* (Garden City, N.Y., 1974), nos. 232, 236–37, as well as the large *Why Are You Angry?* (ibid., no. 550, which is in the Art Institute of Chicago).

For works by Degas in Chausson's collection, see Paul André Lemoisne, *Degas et son oeuvre* (Paris, c. 1946), vol. 2: nos. 133, 615; vol. 3: 719, 760, 786, 822, 849, 865, 1095. See also Paris, Hôtel Drouot, *Collection de Mme Ernest Chausson*, sale cat., 5 June 1936, pp. 5–10, nos. 1–8. On Chausson's and Lerolle's shared likes and dislikes, see Chausson to Denis, in Barruel 1992, p. 69, letter 17. See also Ernest Chausson, *Vingt Mélodies* (Paris, 1910), which was published posthumously by Lerolle and his son-in-law Eugène Rouart.

77. Tr. in Ralph Scott Grover, *Ernest Chausson: The Man and His Music* (Lewisburg, Pa./London, 1980), p. 16.

78. Barruel 1992, nos. 7, 9, 15, respectively. Chausson also owned *Farandole* (cat. 19), a copy of one of the panels from the series based on *The Love and Life of a Woman* (cat. 19–24). In 1896, Denis painted a triptych for the composer in honor of the birth of his son, Laurent; see Chausson to Denis, in ibid., p. 19, letter 18 n. 3.

79. By 1900, Fontaine was close to Odilon Redon and his family, commissioning from the artist a portrait of his wife and acquiring a number of his works; see Chicago 1994, p. 261, fig. 5, and p. 328.

80. See Roger-Marx 1946, pp. 100, 109 (ills.).

81. Bonnard to Lugné-Poë, Nov./Dec. 1890, in Lugné-Poë 1930, p. 243.

82. See, for example, Gustave Geffroy on Vuillard and Bonnard: "As a colorist, Vuillard is so direct, vivid, and enduring that he achieves stunning blossoming of blues, reds, and golden yellows which, at the same time, express a sense of melancholy and serious thought. On the other hand, Bonnard is a gray painter, pleasing himself with nuanced violet, sandy, and somber tones; however, each of his details reveals the artist reveling in sharp observation and boyish gaiety, with charming distinction"; see Geffroy 1892–1903, vol. 6, p. 297, cited in Paradise 1985, p. 389.

83. Bonnard to his mother, early 1894, cited in Terrasse 1988, p. 45. Bonnard may have been referring to *Ducks, Heron, and Pheasants* (cat. 1).

84. See Stump 1972, p. 13; and Verkade's assessment of Roussel, cited in ibid., p. 62 n. 19.

85. For an account of Roussel's many illnesses and breakdowns, notably during World War I, for which he was committed to a Swiss asylum, see ibid., p. 131, and 1900–30 Intro.

86. See Stump 1972, pp. 2–4; and Götte 1982, vol. 1, pp. 2–3. This situation will presumably change with the publication by the Wildenstein Foundation of the catalogue raisonné of Vuillard, which will include photographs, correspondence, and other important documents related to Roussel.

87. In an article written in 1899 on the occasion of an exhibition of Roussel's work at the Bernheim-Jeune gallery, Paris,

but published with earlier reviews on Vuillard and Bonnard, Geffroy concluded, "M. Roussel, like M. Bonnard, like M. Vuillard, is not only a painter of paintings but a *modern* decorator, a rare species"; see Geffroy 1892–1903, vol. 6, p. 299, and Paradise 1982, p. 391.

88. In many ways, the make-up of this group was analogous to the decorative-arts circle affiliated with the Union centrale des arts décoratifs, discussed in Watkins.

89. See Joan U. Halperin, *Félix Fénéon, Aesthete and Anarchist in Fin-de-Siècle Paris* (New Haven/London, 1988), pp. 300–01.

90. Vuillard, Journals, entry, 7 Nov. 1894, MS 5396, cited in Court 1992: "Yesterday afternoon: Lerolle and his sister-in-law. These amiable people, reserved but like-able, give a calm impression, not too much that is frivolous, as opposed to the evening at Lugné's theater [with] all these sensual Jewesses, their silks shimmering in the shadows" ("Hier après-midi: Lerolle et sa belle-soeur. Impression calme de ces gens aimables, réservés mais sympathiques, pas trop de choses oiseuses, à opposer le soir au théâtre Lugné ces juives sensuelles brillantes de soies dans l'ombre").

91. See Denis to Vuillard, Rome, 15 Feb. 1898; and Denis to Vuillard, Rome, 22 Feb. 1898, in Denis, *Journal*, vol. 1, pp. 133–35, 138–41, respectively.

92. See Groom 1993, p. 145.

93. See unpublished letters from Huc to Denis, 10 Apr. 1897, 15 Aug. 1897, Musée MD, MSS 5646, 5629, respectively.

94. See Laura Morowitz, *Consuming the Past: The Nabis and French Medieval Art* (Ann Arbor, Mich., 1999), pp. 216–22. In her article "Anti-Semitism, Medievalism and the Art of the Fin-de-Siècle," *Oxford Art Journal* 20, 1 (1997), p. 44, Morowitz accused Huc and Denis of complicity in creating what she called pre-Christian, Gothic, tapestrylike images that, she claimed, exhibit an "anti-Semitic" quality that would have appealed to Huc. I disagree entirely. Huc, an ardently anticlerical Republican, was one of the first to commission work from Toulouse-Lautrec and the "secular" Nabis (Bonnard, Vuillard, and Roussel); there is no evidence that he dictated a decorative theme to Denis, or that he had any ideas about "anti-Semitic" painting when he commissioned Denis. His letters show instead that he was far more interested in the way a work was made and how it would fit within the interior for which it was intended. See unpublished letters from Huc to Denis of 17 and 27 Apr. and 14 May 1894, Musée MD, MSS 5621–23, respectively.

95. See Groom 1993, p. 211 n. 45.

96. Denis to Vuillard, 15 Feb. 1898, in Denis, *Journal*, vol. 1, pp. 133–34; and Groom 1993, p. 122. Vuillard to Denis, 19 Feb. 1898, in Denis, op. cit., p. 137.

97. Segard first noted these distinctions when both artists received their first public commission, in 1913, to make *décorations* for the newly constructed Théâtre des Champs-Elysées, Paris; see 1900–30 Intro.

98. See Groom 1993, pp. 160–61.

99. See Segard 1914, vol. 2, p. 209; and Maurice Denis, "Notes sur la peinture religieuse," repr. in Denis 1993, pp. 32–48.

100. Segard 1914, vol. 2, pp. 208–09. These criticisms are also implicit in Denis's writings; see, for example, Denis, "Les Arts à Rome, ou la méthode classique," *Spectateur catholique* 4 (July–Dec. 1898 [1899?]), pp. 197–209, repr. in Denis 1993, pp. 55–69.

101. Signac visited Denis's studio in 1898 and was frustrated by what he perceived as the artist's pretentiousness: "I furnished him with all the technical information he requested on my painting, and when I asked him what was his way of gathering material from life, he gave me this amazing reply: 'My art calls for important preparatory work according to a method which is my own.'" Signac then compared Denis's lofty answer to "that [of the] good Vuillard," to whom he had once posed the same query, eliciting by way of answer a generous and complete showing of his work, "up to the tiniest sketch"; tr. in Rewald 1953, p. 76.

102. See Groom 1993, p. 12.

103. Maria E. Di Pasquale, "La Crise Catholique: Avant-Garde Religious Painting in France, 1890–1912," Ph.D. diss., University of Texas, Austin, 1999. I am indebted to Di Pasquale for having shared a chapter of her dissertation that summarizes the many links between Catholic thought and avant-garde Symbolism at the turn of the century, especially as they pertain to Denis's writings and paintings from 1889 to 1897.

104. Vuillard, Journals, entry, 2 Apr. 1891, MS 5396. For the full entry and its translation, see Groom 1993, p. 12.

105. Vuillard, Journals, entry, 2 Oct. 1890, MS 5396, tr. in Groom 1993, p. 41.

106. Segard 1914, vol. 2, p. 247.

107. Ibid., pp. 252–53.

108. Ibid., p. 248.

109. Ibid., p. 252.

110. One might also infer that Denis's paintings were legible from afar, whereas Vuillard's needed to be observed close-up to make out the subject. As will be seen, Denis's works after 1897 were less and less avant-garde, which may also account for Segard's assessment of their "mass" appeal.

111. See Houston 1989, pp. 26–35. For the series of six panels, see Groom 1993, pp. 19–34.

112. For Vuillard's theater scenery, see Washington, D.C., National Gallery of Art, *Artists and the Avant-Garde Theater in Paris, 1887–1900*, exh. cat. by Patricia E. Boyer

(1998), pp. 104–07. For *The Dressmakers*, see Groom 1993, pp. 35–36, pls. 51–52.

113. For Stéphane's prize-winning design, see Groom 1993, pp. 36–39, 41, pls. 57, 59–60.

114. See Bouillon 1993, p. 42.

115. Neither of the two decorative ensembles was exhibited before being installed in a Paris apartment (Schopfer's) or mansion (Cochin's). Unfortunately, they could not be included in this exhibition, owing to scale (in the case of Denis's panels) and fragility (in the case of Vuillard's; for these, see note 116 below).

116. Jean Schopfer, "Modern Decoration," *Architectural Record* 6 (Jan.–Mar. 1897), pp. 243–55. For Schopfer's commissions of works by Vuillard in 1898 and again in 1901, see Groom 1993, ch. 5, esp. pp. 99–108.

117. When Schopfer arrived wearing tails at a reception Misia Natanson was hosting, she asked him why he was so dressed up, to which he responded proudly that he was invited afterward to see Princesse Murat, in whose circle, he added, Misia and her group would never be welcome; see Groom 1993, p. 100.

118. See Lyons 1994, p. 225, cat. 85.

119. See Cochin to Denis, winter 1895/96, in St.-Germain-en-Laye 1999, pp. 121–22, letter 9.

120. See Lyons 1994, p. 226.

121. Ibid., p. 231.

122. Groom 1993, pp. 106–07. "More or less under. . .": Stuart Preston, *Edouard Vuillard* (New York, 1985), p. 101.

123. André Gide, "Promenade autour du Salon," *Gazette des beaux-arts* 47, 3, 34 (1 Dec. 1905), tr. in Russell 1971, p. 96.

124. Segard 1914, vol. 2, p. 283, referring to the panels for Jean Schopfer (Claude Anet, pseud.), which by 1914 were in the collection of Antoine and Emmanuel Bibesco.

125. Journal entry, 16 Dec. 1898, tr. in Rewald 1953, p. 74.

126. Vuillard, Journals, entry, Aug. 1894, MS 5396.

127. It is interesting to compare Vuillard's comments about another decorative project to Signac's description of the Schopfer panels. Writing to Vallotton in 1900, Vuillard voiced his pleasure at having completed decorative works for the home of Jack Aghion (Vallotton's brother-in-law) and invited Vallotton and Ranson to contribute decorative paintings "which will echo the shades of the paintings [already in place] and give an overall decorative cohesion to this wonderful room"; see Vuillard to Vallotton, 8 July 1900, L'Etang-la-Ville, cited in Guisan and Jakubec 1973–75, vol. 2, pp. 41–42, letter 133.

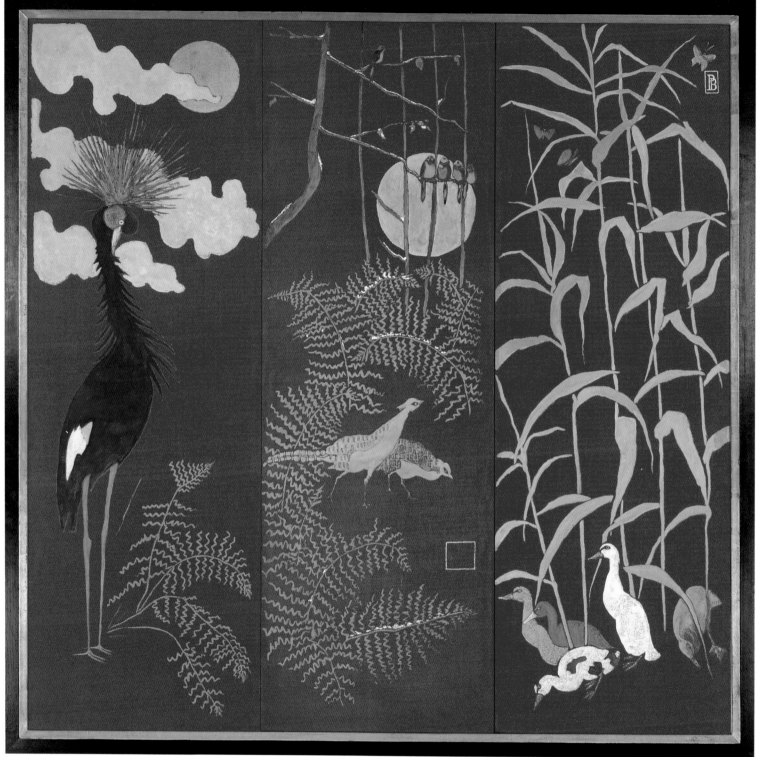

CAT. I

PIERRE BONNARD

Ducks, Heron, and Pheasants, 1889

Distemper on red-dyed cotton fabric
Three-panel screen: each panel, 159.5 x 54.5 cm
(62 ¾ x 21 ½ in.)
Tom James Co./Oxxford Clothes

JAPANESE FOLDING SCREENS ARE THE OBVIOUS inspiration for two early screens by Bonnard, *Ducks, Heron, and Pheasants* (cat. 1) and *Marabout and Four Frogs* (fig. 1), which left the artist's family collection only recently, entering the market for the first time. These two three-panel screens, identical in scale and technique, were delicately painted in distemper on a very fine-weave, red cotton canvas. Executed two years before Bonnard's *Women in a Garden* panels (Watkins, fig. 14; cat. 2–3), which were originally envisioned as a folding screen, they represent the artist's first experiments with this genre.

References to Japanese art were particularly in vogue when Bonnard made these screens, during the apogee of Siegfried Bing's influential, luxury publication *Le Japon artistique*, which featured beautiful, full-color reproductions of seventeenth- and eighteenth-century Japanese decorative panels and screens, such as the vertical panel *Poppies* (possibly from a six-panel screen) then ascribed to Ogata Kōrin (fig. 2).[1] While Bonnard drew heavily on non-Western sources, his assimilation of Japanese pictorial devices and motifs was always tempered by his sense of humor and deeply rooted French cultural bias, as seen in his better-known Japonist works, *Women in a Garden* and *Screen with Rabbits* (cat. 2–3, 44).

Both screens, for example, utilize numerous pictorial devices from Japanese art, including the screen format itself, the types of vegetation depicted, and even the artist's monogram as a compositional device. *Marabout and Four Frogs*, however, is purportedly based on a fable by the seventeenth-century French writer Jean de La Fontaine, *The Frogs Who Demand a King*.[2] According to the story, a colony of frogs asks Jupiter for a king, and in response he sends them a debonair and gentle leader whom the frogs reject because they consider him too weak to rule. When they ask for a more energetic monarch, Jupiter sends down a crane who kills and eats frogs for pleasure. When the frogs complain again, Jupiter responds angrily that they had better be satisfied or they might receive something even worse.[3] Family tradition has it that Bonnard represented not the evil crane in this screen, but the first king in the form of the sweet and gentle marabout (a type of crane with a pouch like that of a pelican), whom the frogs approach with confidence.[4]

The companion screen, *Ducks, Heron, and Pheasants* (cat. 1), also draws heavily on Japanese artistic tradition. The clouds in the left-hand panel are scalloped, decorative, flat shapes, one of which intersects with the gray circle of the moon. Their soft forms, typical of the ornamental patterns found in Nabi landscapes, contrast with the spiky head of the heron, a symbol for the Japanese of long life. Silhouetted against the moon, songbirds sit on the hanging branches in the

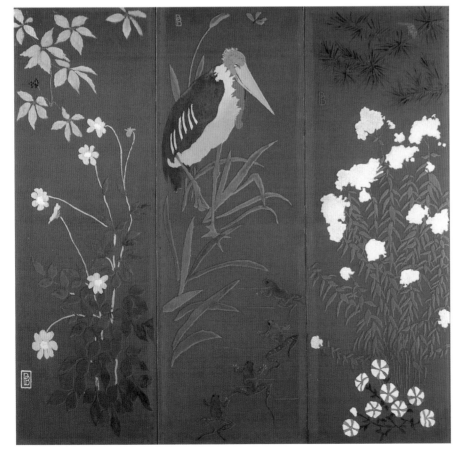

FIG. 1
Pierre Bonnard. *Marabout and Four Frogs*, 1889. Distemper on red-dyed cotton fabric; three-panel screen: each panel, 159.5 x 54.5 cm. Private collection.

middle panel. The fernlike vegetation in the left-hand panel reappears here, curving around pheasants hunting for food. In the left-hand panel, the tall, leafy stalks of bamboo, a frequent symbol in Japanese art of fertility and virility,[5] form an insistent pattern. Ducks, often Japanese symbols of conjugal love and fidelity, huddle at the base of the bamboo. Painted in flat blues, oranges, and whites, they walk, stand, or sniff around in a very lifelike manner. At the top, barely discernible through the bamboo, are three butterflies, frequently associated in Japan with the souls of the dead.[6]

While the screen's wealth of symbolism is overwhelmingly Japanese-inspired, it is also possible that the fancy-feathered, even arrogant-looking, heron alludes to a portion of yet another well-known fable by La Fontaine, *The Heron*. According to the story, a haughty and disciplined heron, who passes up a feast of pike and carp to wait for the perfect moment, goes on to turn up its nose at less pleasing fish when it is ready to dine, and is eventually unable to find any fish to eat at all.[7]

The Nabis and other vanguard artists, writers, and musicians in the 1890s were deeply inspired by children's stories, fables, puppet and marionette shows, and shadow-box presentations. These allowed them to expand their repertoire of subjects beyond the traditional heroic and historical ones, or the themes of modern life celebrated by the Impressionists. Seeking the essential in these seemingly unsophisticated modes of expression, these artists wanted to re-experience a childlike freedom, to return, as Paul Gauguin put it, to the "rocking-horse" of childhood.[8]

Bonnard perhaps intended the vibrant red background of both screens to simulate the exotic effects of Chinese lacquerware. It is also possible that he had seen or heard about Gauguin's striking *Vision after the Sermon* (Watkins, fig. 18), dominated by a similar blood-red color, exhibited at the salon of Les Vingt in Brussels in February 1889.[9]

Bonnard gave both screens to his sister, Andrée, before she was married, suggesting that these were purely decorative experiments, intended for use in his family's home.[10] It is possible that *Ducks, Heron, and Pheasants* was exhibited or at least submitted to a jury. A letter to his mother written while he was working on the screen *Nannies' Promenade, Frieze of Carriages* (cat. 6, fig. 1), seems to suggest this. In it, Bonnard expressed the hope that *Nannies*, showing people instead of "ducks," would be more successful when exhibited.[11]

One could look at these two screens as the least personal of Bonnard's experiments in the decorative arts, since they are the most obviously "borrowed" from Japanese culture. Reminiscent not only of Japanese art, but also of the eighteenth-century French decorative tradition, which was obsessed with Chinese lacquers and screens, they are ambitious undertakings for an art student who was already convinced that art should enhance and be wedded to everyday life.

CAT. 2–3

PIERRE BONNARD

2 *Women in a Garden: Woman in a Polka-dot Dress* (first version)
1890/91
Distemper over charcoal, pencil, and white chalk on paper, mounted on canvas
154 x 47 cm (60 ⅝ x 18 ½ in.)
Kunsthaus Zürich, Society of Zurich Friends of Art, with a contribution in memory of Ernst Gamper

3 *Women in a Garden: Woman in a Checked Dress* (first version)
1890/91
Distemper over charcoal, pencil, and white chalk on paper, mounted on canvas
154 x 47 cm (60 ⅝ x 18 ½ in.)
Kunsthaus Zürich, Society of Zurich Friends of Art, with a contribution in memory of Ernst Gamper

IN MARCH 1891, BONNARD MADE HIS DEBUT at the Indépendants with four panels known collectively as *Women in a Garden* (Watkins, fig. 14), which he exhibited again later that year at the Barc de Boutteville gallery.[1] In both venues, the works were positively reviewed by the critics, one of whom described them as "extraordinary," with "visionary color, sparing design, rendered with restrained and simple brushwork."[2] Four preparatory studies of the works exist, one for each of the panels. Two of these, *Woman in a Polka-dot Dress* (cat. 2) and *Woman in a Checked Dress* (cat. 3), are almost as finished as the final versions. Since the earlier works are comparable in dimensions, composition, and support (paper glued to canvas) to the final versions, it is only with knowledge of the later panels that their status as studies (*études*) becomes clear.

CAT. 2

CAT. 3

Bonnard originally conceived these images of young and alluring women, dressed in up-to-the-minute fashions and sporting extravagant hats, as a four-panel screen. Toward the end of 1890, he wrote to actor-writer and fellow Nabi Aurélien Lugné-Poë, describing his work on "a serious painting" for the upcoming (and, for Bonnard, the first) Indépendants exhibition, as well as a "screen that will also be in the exhibition."[3] On 13 March of the following year, however, one week before the opening of the Indépendants, Bonnard wrote to his mother that he had decided to transform the screen into four independent wall panels, because "they look much better against a wall [than as a screen]. It [the work] was too paintinglike [*trop tableau*] to be a screen."[4] A week later, Bonnard exhibited the four panels under the generic title *Panneaux décoratifs*. While Bonnard's original concept of a screen is in line with the Nabis' mission to dissolve the distinction between painting and the applied arts, his decision to transform the three-dimensional art object into a wall decoration reflects the Nabis' even stronger desire to return painting to the tradition of mural decoration, and in so doing, to break out of the traditional format of easel painting.[5]

The multipaneled and freestanding screen was in many respects the perfect means to create decorative surfaces that could function as both fine and applied art. Screens were an art form, as Nicholas Watkins put it, "designed literally to shape domestic space."[6] In this instance, however, Bonnard was dissatisfied with the result, feeling that the women compressed into this long, vertical (*kakemono*) format rendered the panels "too paintinglike"; in other words, the panels would be better suited to a flat surface. When one imagines the relationships established by folding one or more panels inward, as they would be in a free-standing screen, Bonnard's self-critical comments concerning these highly ornamental, but congested, canvases are more clearly understood. It is likely he found the four women and the patterned foliage too dense, too hieratic, and thus not suited to the more subtle compositional possibilities inherent in the folded image. In subsequent screens, *Nannies' Promenade, Frieze of Carriages* (cat. 6) and *Screen with Rabbits* (cat. 44), for example, Bonnard left open large areas of canvas, in keeping with the "quiet emptiness" recommended in manuals of Chinese and Japanese screen painting.[7] The panels of the *Women in a Garden* series, particularly the two whose studies are included here, combine the

61

compressed exuberance of Bonnard's highly successful *France-Champagne* poster image of 1889–91 (Watkins, fig. 6) with the ambitions of mural painting—ambitions that mark his slightly earlier and near life-sized decorative portrait of his sister, Andrée (fig. 1). The latter is probably the "serious painting" for the Indépendants to which Bonnard referred in the above-mentioned letter to Lugné-Poë.[8] Compared to the portrait of Andrée, the females in the four-panel series are even more insistently flat and abstract.

The panel figures appear nearly to burst out of the narrow format, but the panels themselves are self-contained stylistically, with no common motif or color scheme to connect them. Instead, the women, whose dynamic movement is implied, rather than depicted, by the way they twist their heads in a direction opposite from that of their bodies (and, in *Woman in a Polka-dot Dress*, by the upward thrust of the dog), exist independently of one another. Although the panels have often been described as representations of the seasons, an interpretation suggested by the different fashions and the changes in the background foliage, Bonnard's titles were purposely vague, thus ensuring the works' decorative status, rather than alluding to a possible allegorical significance.[9] Together, the panels present a riotous mélange of color and movement, and may well have been the inspiration for Armand Séguin's similarly scaled, four-panel screen of dancing figures, *The Delights of Life* (fig. 2). Unlike Bonnard's composition, where, as noted, there is no overlapping or connecting motif to unify the figures compositionally or narratively, in Séguin's highly successful work, objects, such as the bottle in the third and fourth panels, are depicted across breaks in the screen, reinforcing visually the fact that the panels were to be seen together.[10] As Bonnard himself realized, the panels' stylistic strength lies in their inherent flatness, which is presented to best advantage against a wall. Their position on the wall would also have served as a neutral separation from the surrounding furnishings, competing rhythms, and often strong hues of a typical bourgeois interior, where they would likely have been hung.

The two Zurich panels featured here undoubtedly represent the artist's final studies, after he had resolved the composition completely and after his decision, sometime between his letter to Lugné-Poë at the end of 1890 and his letter to his mother in March 1891, to separate the panels. The two other Zurich studies, *Seated Woman with Cat* and *Woman with Blue Shawl* (figs. 3–4), were left in the raw stages of colored

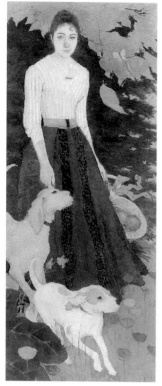

FIG. 1
Pierre Bonnard. *Portrait of Andrée Bonnard*, 1890. Oil on canvas; 188 x 80 cm. Private collection. Photo: Dauberville, vol. 1, p. 91, no. 13.

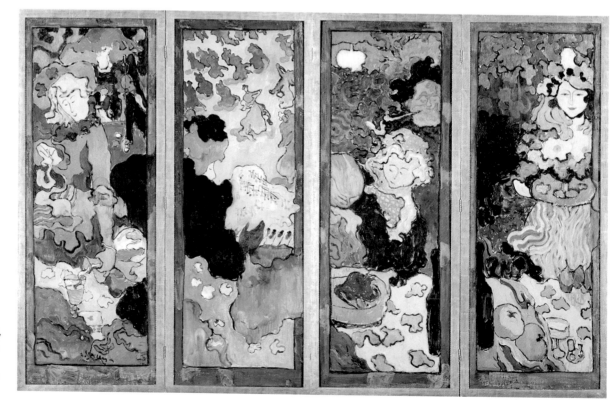

FIG. 2
Armand Séguin (French; 1869–1903). *The Delights of Life*, 1892/93. Four-panel screen, oil on canvas with painted and gilded frame; 159.1 x 256.5 cm. Private collection, New York.

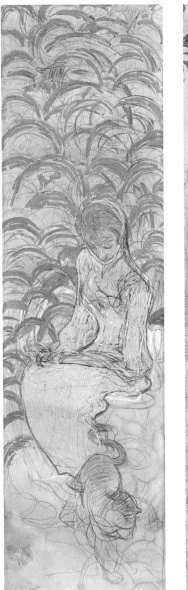

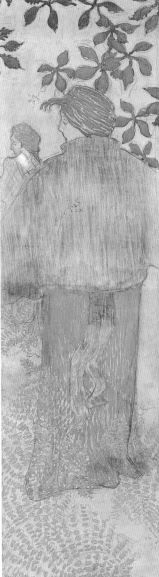

FIG. 3

FIG. 4

FIG. 3
Pierre Bonnard. *Seated Woman with Cat*, 1890/91. Distemper over charcoal, pencil, and white chalk on paper, mounted on canvas; 154 x 47 cm. Kunsthaus Zürich.

FIG. 4
Pierre Bonnard. *Woman with Blue Shawl*, 1890/91. Distemper over charcoal, pencil, and white chalk on paper, mounted on canvas; 154 x 47 cm. Kunsthaus Zürich.

the Zurich study, the woman is embedded within heavily applied, lush vegetation.

It is possible, in fact, to consider the Zurich studies the more adventurous and experimental of the two versions.[11] In the Paris panels, for example, Bonnard made the women less prominent, and reduced their scale in relation to their surroundings, so that they are more integrated into and contained within the composition, whereas, as noted above, the women in the studies seem about to expand beyond their frames. The artist also subtly changed the physiognomy of the woman in the red-and-white dotted dress (the only one of the four women whose face is clearly depicted), regularizing her prominent nose and lips and changing her from a dark-browed brunette to a lighter-skinned blonde.[12] Although still caricatural, she appears less exotic and closer to the flirtatious poster girls of Jules Chéret.[13]

Another difference between the Zurich and Paris versions of these two panels is the inclusion in the Zurich study for *Woman in a Checked Dress* of croquet wickets, which are barely visible at the feet of the two silhouetted female figures in the panel's upper left-hand corner. This detail was omitted from the final version, possibly to avoid any suggestion of a specific narrative. In the Zurich study, the wickets and the positioning of the figures (particularly that of the russet-haired woman, identifiable as Berthe Schaedlin, Bonnard's cousin and favorite model at this time) in relation to the larger female in the checked gown foreshadow the subject and composition of Bonnard's *Twilight*, or *Croquet Game* (cat. 5), exhibited at the Indépendants the following year.

Despite Bonnard's redesignation of the series as four independent panels rather than as a screen, the works were referred to at the Indépendants not only as *panneaux décoratifs*, but also as *feuilles de paravent* by art critic Félix Fénéon and by Lugné-Poë, who would have been familiar with them before they were exhibited.[14] The fact that both the finished panels and the studies remained in Bonnard's studio until his death suggests their importance to the artist as presentations of figural types to which he was partial; this may also reflect his reluctance to "let go" of a project he may have felt had not completely attained the status of *décoration*, a concept he was to develop and realize more fully in later works.

sketches. The studies included here, however, are as heavily worked as the final panels, if not more so. If sketchiness designates "unfinished" and a completely covered surface is "finished," then the Zurich version of *Woman in a Checked Dress* is indeed more "finished" and more fully realized than its Paris counterpart. There are also stylistic dissimilarities between the panels, especially evident in the variation in the paint handling in the foliage surrounding the woman's brilliant pink and mauve dress. In the final version, the foliage is barely suggested by short, vertical streaks of "grass" peppered by very freely brushed "poppies," whereas in

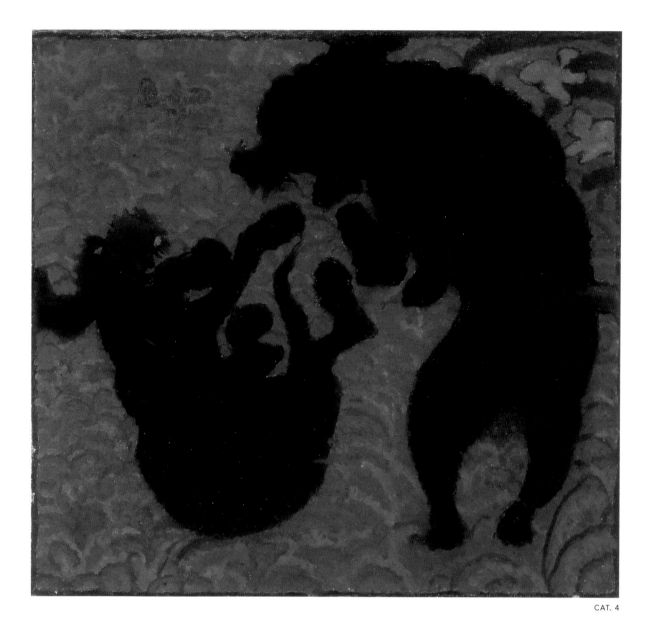

CAT. 4

PIERRE BONNARD

Poodles, or *Two Poodles,* 1891
Oil on canvas
37 x 39.7 cm (14 ¼ x 15 ½ in.)
Southampton City Art Gallery, England

THIS WORK SHOWS BONNARD'S EARLY COM-
mitment to one of the Nabis' major tenets:
the breakdown of the distinction between the
fine and applied arts. The painting was completed, in
fact, several years before Bonnard's 1894 screen
Nannies' Promenade, Frieze of Carriages (cat. 6, fig. 1) and
his stained-glass-window design *Maternity* (1894;
Watkins, fig. 15), in which he developed these ideas
more fully. Writing to his friend Aurélien Lugné-Poë
in 1890, Bonnard recounted the numerous artistic
projects, executed in a variety of media and styles, and
not limited to the fine art of painting, in which he was
involved at the time. He not only wrote about a fold-
ing screen he was working on for the seventh Indépen-
dants exhibition the following spring (see cat. 2–3), but

also mentioned a possible project to illustrate musical scores (undoubtedly through his brother-in-law, the composer Claude Terrasse). While he had given up color lithography for the moment (after the great success of his *France-Champagne* poster; Watkins, fig. 6), he stated that he would return to it when he grew tired of oil painting. His conclusion, "[It's] a matter of varying one's pleasures," demonstrates his desire to work in all media, for all purposes. It also perhaps indicates his belief in the basic equality of the varied projects he undertook in both the fine and applied arts.[1]

The small oil painting *Poodles* is a telling example of his credo, having evolved from a design for a china cabinet or sideboard that in turn was part of "the design of wooden furniture for a dining room" that Bonnard had entered in a contest sponsored in the summer of 1891 by the Union centrale des arts décoratifs.[2] The rules of the competition required that the furniture designs have an "imprint of taste" and "the prestige of art," while being at the same time modestly priced for the bourgeois apartment.[3] Of the four drawings he submitted, that for the sideboard (Watkins, fig. 12) is the most striking, with its whimsical combination of dogs and sinuous line. Perhaps these features struck the judges as objectionable, since they eventually rejected Bonnard's submission. These drawings show the same Japanese-inspired subjects drawn from life and exuberant linear quality that mark his works of the 1890s, such as the *France-Champagne* poster and the four decorative panels known as *Women in a Garden* (Watkins, figs. 6, 14; cat. 2–3). Trained, like his Nabi colleagues, as a painter, Bonnard only stumbled into the applied arts through his love of decorative line and color. It is not surprising then that his conception for the sideboard was primarily a surface design applied to a three-dimensional form. The painting *Poodles*, in fact, repeats the subject of the sideboard's lower right panel, which shows two dogs frolicking against a busy, patterned background.

Bonnard's painting is subtly but significantly different from the original composition for the sideboard. In the painting, the dogs are strong, darkly silhouetted forms, whereas they are rendered in contrasting black and white in the furniture design. For the competition, Bonnard may have chosen the black-and-white dogs to complement the pattern of dark-and-light forms in the ornamental wallpaper he intended for the room. The wavy lines in the pen-and-watercolor sketch may have indicated the burled quality of the

FIG. 1
Pierre Bonnard. *Dogs*, 1893. Lithograph printed in brownish black ink; 28 x 17 cm. First published in *Escarmouche* 5 (10 Dec. 1893). Photo: Bouvet 1981, p. 32.

wood grain that Bonnard anticipated using in the final project. In the furniture design, Bonnard's Japonism is more overt than in the painting. The dogs, which appear in all four cabinet doors, seem dragonlike, with exaggeratedly elongated necks and bodies. The rectangular cartouches of the door handles are also reminiscent of similar forms in Japanese prints, which Bonnard owned and which he must have admired a short time before at a huge exhibition of Japanese art at the Ecole des Beaux-Arts in 1891. The Japanese spirit of the painted panel can be seen in the cropping of the pink flowers and slender, curving leaves in the upper right and in the placement of the artist's signature and date in the upper left, integrated into the composition like the calligraphy of Japanese prints. Despite the vogue in the 1890s for all things Japanese and the originality of the design, which certainly did not derive from eighteenth-century styles (a common complaint about furniture at this time from those who felt contemporary designs lacked originality), the entire conception was not, apparently, sufficiently "French" in taste to capture the judges' attention as something entirely new.

ornamental quality of these otherwise ordinary dogs overrides any such narrative interpretation. Even compared with the Clark Art Institute's similarly formatted and tightly organized *Women with Dog* (fig. 2), *Poodles* is startling in its rigorous reduction of line and color. As in the four panels known as *Women in a Garden*, foliage fills the tight space between subject and frame. *Poodles* is especially close to a study for one of these panels, known as *Woman in a Checked Dress* (cat. 3), in that they both share the modulated greens of a lush surround that do not suggest shading, but rather exist as independent ornamental forms that fill in and flatten the pictorial space.

The stenciled shapes of the canine protagonists in *Poodles* also recall Bonnard's interest in the avant-garde shadow theater at the Montmartre café Le Chat Noir in the late 1880s. Instead of displaying the sharp edges of cut-out silhouettes, however, Bonnard's forms are arched, fuzzy, indecipherable, and altogether humanized in their interactions. Are they playing or fighting? Bonnard's title is more neutral and open-ended than the "dancing dogs" epithet that is sometimes attached to this image. Critics, however, saw these creatures as engaged in a joyous romp or as elegant decorative motifs. One wrote, "The poodles are very funny on the unmown grass"; and another exclaimed, "These black dogs have the most sophisticated forms."[4]

One regrets that Bonnard's sideboard with dog designs was never realized. (Among the other elements in this ensemble were twelve formal dining-room chairs, whose backs were decorated with the images of sleeping cats.) Like so many of the Nabis, Bonnard, whose second attempt in 1895 to compete in a furniture design contest was also thwarted, was never allowed to realize a total coordinated ensemble, the type of project that was to become the mainstay of Art Nouveau.[5]

For Bonnard, however, this scene of cavorting dogs seems to have had special significance. Not only did he exhibit it alongside the more ambitious *Twilight* (cat. 5) at the Indépendants in the spring of 1892, but he also included it among the works exhibited two years later at the Nabi exhibition organized by Arthur Huc in the offices of his newspaper, *La Dépêche de Toulouse*. The dogs (perhaps, here repeated twice, the beloved Ravageau of Bonnard's sister) seem also to have inspired a lithograph published in *L'Escarmouche* in December 1893 (fig. 1). In the lithograph, a narrative is clear: one black and six white mutts chase a carriage, splinter into groups, or lift hind legs to urinate. In both the furniture design and the painted panel, the

CAT. 5

CAT. 5

PIERRE BONNARD

Twilight, or *Croquet Game,* 1892

Oil on canvas
130 x 162.5 cm (51 ⅛ x 64 in.)
Musée d'Orsay, Paris, gift of Daniel Wildenstein
through the Société des Amis du Musée d'Orsay

ENCOURAGED BY THE CRITICAL SUCCESS OF his four-panel series *Women in a Garden* (Watkins, fig. 14; cat. 2–3), shown at the Indépendants and at the Barc de Boutteville gallery in 1891, Bonnard submitted this large canvas to the Indépendants the following year. Rightly described as "Bonnard's first multi-figure composition,"[1] this fulfills Denis's definition of a painting as an art of equivalents, its nature-based theme transformed through a successful synthesis of color, surface pattern, and emotion. It is also one of Bonnard's last full-scale paintings to be exclusively devoted to the world of adults. In the

FIG. 1
Pierre Bonnard. *Woman in a Green Dress in a Garden*, c. 1892. Oil on canvas; 45.8 x 37.8 cm. Private collection.

another woman (probably Bonnard's cousin Berthe Schaedlin, recognizable by her wavy, russet-colored hair) contemplates her next play. Yet this is not just a "Garden Scene" (as the work was titled in 1926, when Bonnard chose it to represent himself in a retrospective of the Indépendants), a painted "snapshot" of an event from everyday life.[4] Instead, as Cogeval has asserted, the painting presents "a sort of closed and shuttered twilight zone" laden with symbolism, analogous to certain scenes from works by the contemporaneous Belgian poet and playwright Maurice Maeterlinck. Maeterlinck used the devices of proximity and gesture to create a subplot to the superficial subject of his plays, shrouding his works in an aura of anticipation and mystery that far exceeded a play's ostensible theme.[5]

For the Nabis, choosing a game as a subject (the croquet game, in this instance) was a way of evoking the profound, the essence, or another reality, since it removed one from life's routines. Denis's image of women at play known as *Shuttlecock*, or *Racket Game (Jeu de Volant)* (1900; Musée d'Orsay, Paris), for example, was originally entitled *Sacred Wood (Le Bois sacré)*, after Pierre Puvis de Chavannes's famous mural *The Sacred Grove* for the Musée des Beaux-Arts, Lyons (see Watkins, fig. 5). For the Nabis, titles, like words, which Stéphane Mallarmé claimed could evoke but not name a subject, were insufficient, but not entirely insignificant, guides for understanding a work of art. Indeed, *Crépuscule* was a popular title in literature, music, and art in the last decades of the century, describing not only the close of day and the light that lingers after sunset, but also a human closing, or rather waning, of hopes, ambitions, health, and life.[6] Was Bonnard playing with the idea of the "twilight of life" when he placed his graying father with croquet mallet-*cum*-cane in the foreground of the composition?

The evocative subject is not the only important aspect of this work, however. The way the paint was applied to the canvas is also of great significance and is an aspect that critics of the 1880s had difficulty grasping. In an insightful analysis of the shift in the nature of pictorial symbolism in painting at this time—from the use of overt signs to the employment of signs distanced from meaning by the very way in which they were painted—James Kearne argued that these early critics, accustomed to using a Symbolist vocabulary to describe the meaning of a painting, were at a disadvantage when it came to appreciating the revolution-

following years, with the births of his six nephews and nieces between 1892 and 1899, children were to take an increasingly prominent place in his work.[2]

When it was first shown publicly in 1892, and at least until 1899, this painting was exhibited as *Crépuscule*, or *Twilight,* underscoring what Guy Cogeval has termed the painting's "elegiac mood."[3] Indeed, *Twilight* may be considered Bonnard's final and most resolved bow to the Symbolist and decorative painting of his Nabi years, one that adheres to the Nabis' quest to celebrate and find mystery in the everyday by heightening the emotional "pitch" of lines and colors. On one level, the croquet game takes place in real time and depicts figures identifiable as Bonnard's father, brother-in-law, and sister, who watch intently as

ary approaches of the Nabis and their generation. They were not able to discuss the actual practice of painting or to analyze the resulting surfaces.[7] It is thus not surprising that Gustave Geffroy, in his commentary on *Twilight* ("where the women undulate in a delicious dance, on a lawn, in the background of a landscape whose light is almost extinguished"), utilized evocative, Symbolist imagery, but shied away from any discussion of the way in which the pigment was applied to the canvas and how this contributed to the artist's expression.[8]

The importance of surface (*matière*), however, had been a prime issue for Paul Gauguin, Vincent van Gogh, and their circle, and was considered by the late 1880s as much a part of the meaning of the artwork as the symbols or corresponding motifs used to express the ostensible subject. Bonnard, for example, applied rich greens in buttery, broad, and short strokes to build the surface of his cloistered garden scene. Not only does the resulting hushed and tufted surface emphasize the inherent intimacy of this backyard (*huis-clos*) scene, but it also sets this *Partie de croquet* apart from the numerous Salon and *plein-air* paintings of the period that depict this fashionable pastime. According to a contemporary definition, this game could "animate all gatherings, big or small," and was "equally appropriate to women as to men."[9] Less overtly decorative than

Women in a Garden (cat. 2–3), *Twilight,* with its large scale and lush, emerald surface, is nonetheless a highly successful decorative painting, one of the "tapestries" (*tapisseries*)—as Thadée Natanson called Bonnard's wall decorations—that were lamentably (in Natanson's view) the least-known works of Bonnard's career.[10]

The color symbolism of this exaggerated tapestry, or *verdure,* is even clearer in two related and nearly identical studies, *Young Woman in a Landscape* (c. 1892; private collection) and *Woman in a Green Dress in a Garden* (fig. 1).[11] In both, a sole figure, a woman in a plaid dress, stands shrouded by the same vegetation and half-light pictured in *Twilight.* No movement or gesture distracts from the overall mood of mystery and anticipation. By similarly imbuing a popular subject, a game of croquet, with evocative foliage and lighting, Bonnard showed his assimilation, as well as his rejection, of Nabi theories. For him, as for Vuillard, modern themes could be put to the service of the "beyond" (*au-delà*) just as direct observation could reveal the surreality of the thing seen.

The soft, dusky light that fills *Twilight* seems to evoke a specific time of day, but upon closer inspection reveals its origins in design rather than in nature. The twilight is brilliantly distorted to make a crazy quilt of greens and oranges under which women frolic in summery, white dresses. Indeed, the composition, which includes a real game in the foreground juxtaposed with a dreamlike dance in the distance, is similar to Gauguin's distinction between reality and spirituality in his famous *Vision after the Sermon* (Watkins, fig. 18), in which the fervent meditation of a group of Breton women allows them a shared vision of Jacob wrestling with the Angel.[12]

Bonnard reused and personalized certain feminine types throughout his oeuvre, as did Denis. The coquettish dancer second from right, for example, mirrors the pose and gesture of Bonnard's *Woman in a Polka-dot Dress* from the *Women in a Garden* series (see cat. 2). But Denis's young girls in white, seemingly so similar to Bonnard's, carry completely different meanings. In *April* (cat. 12), one of four decorative panels that Denis exhibited at the Indépendants in 1892, white-robed damsels walk in pairs and seem intimately linked, not only stylistically but physically, creating a quiet evocation of feminine ritual and innocence. In both *April* and *Twilight,* the artist placed the female figures strategically in order to flatten the composition and to prevent the illusion of deep space.

FIG. 2
Pierre Bonnard. Study for *Twilight,* or *Croquet Game,* c. 1892. Watercolor and pencil; 19 x 26 cm. Private collection, Switzerland. Photo: Courtesy of Galerie Salis, Salzburg.

Bonnard's young women, however, are visual and symbolic counterpoints to Denis's. Because they are not bound by the self-contained line of Denis's females, but rather are comprised of expressive and open forms to which line is subordinated, they exude a teasing, flirtatious innocence very different from the Symbolist-laden concept of developing womanhood that Denis's girls so solemnly proclaim. Unfettered, carefree, and completely liberated from any ritual or feminine duty, they dance with outstretched arms within the irregular patches of twilight that form their stage. Bonnard's sketchbook drawings (see fig. 2) show his fascination with these fluid, amoebic shapes, which are similar to the figures in traditional Japanese Manga, or casual studies, that he would have known from a volume Vuillard owned.[13]

During the 1890s, when his grandmother was alive, and at least until the death of his father in 1901, Bonnard painted almost obsessively the grounds of his beloved family home at Le Grand-Lemps, located between Lyons and Grenoble. He used this country home and the ideal of family harmony it embodied as motifs in *Twilight* and in at least three other major works from that period, including *Family in the Garden* (cat. 43), *The Terrasse Family in the Garden* (cat. 43, fig. 2), and *Bourgeois Afternoon* (cat. 43, fig. 1). *Twilight*, however, stands out among these as the most emphatically ornamental in execution and hermetic in meaning. In the later works, Bonnard opened up both the subject and his technique to a more fluid, "Impressionist" vision that would continue to be the hallmark of both his decorative and easel paintings.

PIERRE BONNARD

Nannies' Promenade, Frieze of Carriages
1895/96

Lithograph in five colors on paper
Four-panel screen: each panel, 149.9 x 47.9 cm
(59 x 18 ⅞ in.)
Private collection

THIS LITHOGRAPHIC SCREEN, PUBLISHED in 1895/96 in an edition of 110, was based on an original painted screen (fig. 1) The latter served as a template for the lithographs, which number among Bonnard's most successful decorative objects for the contemporary interior. In fact, the screen of nannies (actually wetnurses, or *nourrices*) was sold in sheets (40 francs) or mounted as a screen (60 francs), so that the print could be enjoyed either as an art object or as a framed picture.[1] Of all Bonnard's decorative undertakings, this was the most complete expression of his earliest quest for "a popular art that was of everyday application: fans, furniture, screens."[2]

Writing to Félix Vallotton in the mid-1890s, Vuillard reported that "Bonnard is occupied with making four sheets for a lithographic screen after his carriages, an enterprise he is undertaking in conjunction with Moline[s]."[3] The painted screen (probably owned by Thadée Natanson) upon which Bonnard based his lithograph had been exhibited and positively reviewed at Siegfried Bing's Maison de l'Art Nouveau in December 1895 and at the artist's retrospective at Durand-Ruel in January 1896.[4] While the particulars of the commission for the lithographs are unknown, Bonnard undoubtedly endorsed their production, especially given his fondness for the original screen. Unlike his earlier, less successful attempts at screen design—the aborted project for the *Women in a Garden* panels (see cat. 2–3) and another screen of "ducks and leaves" that was apparently realized but unpopular with critics (possibly cat. 1)—Bonnard was confident that *Nannies' Promenade* was special. Writing to his mother in early 1894, he boasted in his usual self-deprecating fashion:

I'm making a screen for the Champ-de-Mars [Indépendants]. In any case it will be for the present time the eighth wonder of the world. From my point of view I'm pleased with it and I also believe that if it goes to the Champ-de-Mars, it will be more

CAT. 6

noticed than its predecessors. There are people in place of ducks and leaves. It's the Place de la Concorde, where a young mother passes with her children, [there are] some nannies, some dogs, and at the top, making a border, a waiting station for carriages, all of which is placed on an off-white ground that looks indeed like the Place de la Concorde when there is dust and it resembles a mini-Sahara.[5]

Bonnard's comments to his mother about the ground are significant, since, in both the painted and lithographic screens, he left areas of the composition open to suggest dusty pavement, thus using the canvas (and paper, in the lithograph) as both a pictorial and literal "ground" onto which he placed the figures. The emphasis is on the fashionable woman and her bon-

neted child, past whom race two *gamins*, or street urchins, playing with sticks and hoops. The small collared dog in the foreground is obviously a member of the female party, in contrast to the unattended dog directly behind the woman and the strays who wander aimlessly among the frieze of carriages at the top (Bonnard here made the same association with dogs running after carriages that one does with dogs running after cars today).

By 1894, the denizens of the streets and parks of Paris were frequent subjects in Bonnard's and Vuillard's paintings, works on paper, and decorative ensembles. In his lithograph *Dogs* from 1893 (cat. 4, fig. 1), Bonnard juxtaposed a fancy carriage with stray dogs,

FIG. 1

FIG. 1
Pierre Bonnard. *Nannies' Promenade, Frieze of Carriages*, 1894. Distemper on canvas; four-panel screen: each panel, 147 x 45 cm. Private collection, New York.

FIG. 2
Photograph, c. 1898, of M. Rémond, secretary to Pierre Bonnard's brother-in-law, the composer Claude Terrasse, in his office in front of Bonnard's screen *Nannies' Promenade, Frieze of Carriages*. Terrasse family archives. Photo: Paris 1993, p. 368, fig. 188.1.

and in a poster advertising *La Revue blanche* (Watkins, fig. 8), published in May 1894, Bonnard depicted a female in a very similar guise and pose as the up-to-date *Parisienne* of the *Nannies* screen, also accompanied by an energetic *gamin*. Women and children feature prominently in the art of the Nabis, as seen in Vuillard's nine-panel series on the theme of nannies and their charges, *Public Gardens* (see cat. 32–33), painted in 1894, which may have been fresh in Bonnard's mind when he executed this large street scene. Vuillard's panels (many of which evoke the

FIG. 2

Tuileries gardens, bordered on the west by Place de la Concorde) represent a similar mixing of social classes in a world without men. One of Vuillard's decorative panels from that series, *Asking Questions* (see cat. 33, fig. 3), has much in common with the principal group in the third panel of Bonnard's screen. It similarly includes a young *Parisienne* leaning over (a pose borrowed from Japanese prints[6]) to attend to her daughter, attired in fancy dress and hat, surrounded by two little girls as unrestrained as the *gamins* in the Bonnard screen.[7]

Whereas Bonnard shared the theme of women and children in public spaces with Vuillard and other artists of the time, the frieze of carriages is typical of Bonnard's own uniquely playful and witty approach to art. In both painting and lithograph, these horse-drawn carriages resemble toy locomotives or the stenciled decorative cornice borders that were touted for children's rooms during this period. But they recall also the type of frieze used to fill background space in the shadow theater at the café Le Chat Noir, which Bonnard frequented.[8] In this way, Bonnard brought together in one image his affinity for childlike pleasures, the sophistication of Japanese prints, and allusions to contemporary theater.

The final narrative element in this scene is the group of wetnurses, standing at the balustrade, waiting for one of the carriages to pull away from the station and pick them up. Like Georges Seurat, whose famous painting *A Sunday on La Grande Jatte—1884* (cat. 52–54, fig. 2) shows a woman wearing a stylized version of the traditional wetnurse uniform, consisting of a triangular shawl and round hat with streamer ribbons, Bonnard simplified the lines of his wetnurses to create rocklike figures that function as a counterweight to the animated and angular cluster of woman, children, hoops, and dogs in the foreground.[9]

Although Bonnard did not attempt to popularize a painted screen again, *Nannies' Promenade* was a successful and practical transformation of a work of fine art into something with quotidian applications. Not only could the lithograph function as a mural, but also, as seen in a contemporary photograph of M. Rémond, the secretary of Bonnard's brother-in-law (fig. 2), and in Vuillard's portrait of Marcel Kapferer (1900–30 Intro., fig. 12), it was equally practical and effective when used as a room divider and decorative object.

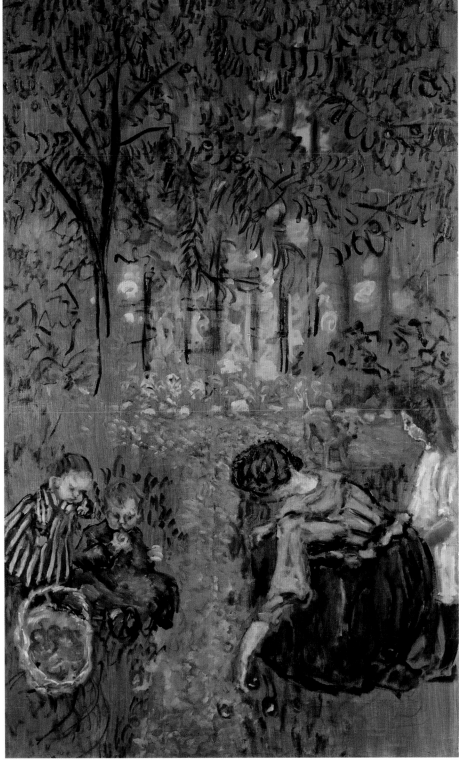

CAT. 7

PIERRE BONNARD

7 *Apple Gathering*
1895/99
Oil on canvas
169 x 104 cm (66 ½ x 41 in.)
Virginia Museum of Fine Arts, Richmond,
Millenium Gift of Sara Lee Corporation

8 *Apple Gathering*
1895/99
Oil on canvas
169 x 131 cm (66 ½ x 51 ½ in.)
Pola Museum, Tokyo

9 *Children Playing with a Goat*
1895/99
Oil on canvas
168 x 130 cm (66 ⅛ x 51 ⅛ in.)
Pola Museum, Tokyo

THESE THREE PANELS BELONG TO A LARGER group of works of similar subject, format, palette, and technique (thinly applied oil paint). Still relatively unknown in the Bonnard literature, this group includes at least two other paintings: *Large Garden* (fig. 1) and *Plum Harvest* (1895/99; private collection).[1] While the date of these works still remains uncertain, the available evidence, as we will discuss below, points to the period between 1895 and 1899.[2]

Because of insufficient provenance information, it is difficult to reach definitive conclusions about the destination of these works and their relationship to one another. On stylistic, thematic, and technical grounds, however, the paintings in this group may be seen as a loose ensemble, an evocation of nature meant to enliven a room, much in the same way that Vuillard's *Public Gardens* panels of 1894 functioned in Alexandre Natanson's salon and dining room (cat. 32–33). In conceiving such an ensemble, Bonnard could have easily had in mind the decorative series shown by Denis and Vuillard in December 1895 at Siegfried Bing's Maison de l'Art Nouveau (see cat. 19–24, 35–39). Both of these projects consisted of multiple panels of differing formats that were only loosely linked by palette and theme. Vuillard's five-panel series, *Album* (cat. 35–39), in fact, went

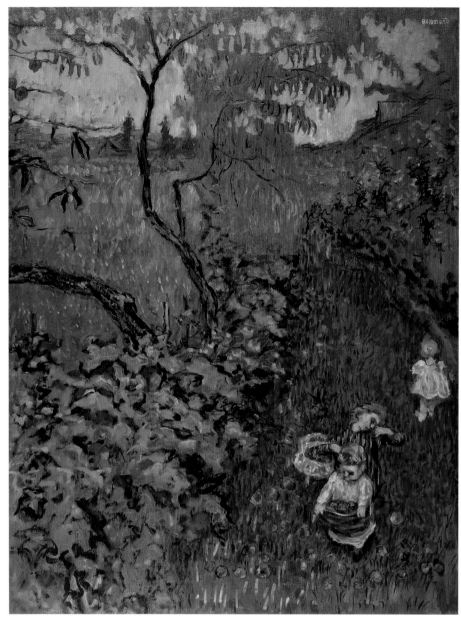

CAT. 8

directly from Bing's gallery to the Paris apartment of Thadée and Misia Natanson, where Bonnard would have seen it.

The setting of this group of paintings is the orchards at Le Clos, the Bonnard family estate at Le Grand-Lemps, where members of the household—the artist's sister, nephews, niece, and possibly a nanny or servant—are shown gathering fruit (cat. 7–8) and playing with a goat (cat. 9). A letter of this period from Bonnard to his brother Charles suggests that picking fruit was indeed one of the family's favorite activities:

Finally I arrived [at Le Clos] and hope you can get leave next Sunday so we can all be together. . . . There are masses of fruit. Maman does her rounds every afternoon with her basket. It's pleasant to see our cousin [Berthe Schaedlin?] up in the big peach tree, in the midst of the branches and the blue sky.[3]

Bonnard returned every year to his family's home in the summer and early fall until the estate was sold in 1925. The subjects that inspired him there generally varied each year. The subject of children at play and picking fruit, however, was a staple of the artist's Grand-Lemps repertoire. Indeed, the seasonal activity of the harvesting of apples and plums coincided exactly with the timing of Bonnard's June to September visits to Le Grand-Lemps. It is also a theme he returned to at the end of his life, when he painted six decorative panels for the dining room of Richard Bühler in 1946.[4] Thadée Natanson, who visited Bonnard while these later paintings were in progress, recalled how the artist preferred the word *cueillette* (gathering) to the more explicit *moisson* (harvest), as implying a voluntary, graceful activity rather than a necessary task.[5]

Compared to other decorative paintings inspired by Bonnard's childhood home (see cat. 5), the paintings in this group are especially tapestrylike in their overall palette of textured greens and in their relatively airless and flattened compositions. They are, at the same time, posterlike in the predominance of dark, wavy lines used to distinguish the forms and delineate the foliage. Minor variations in style are also noticeable. For instance, *Large Garden* (fig. 1), showing three of the Terrasse children and a maid carrying laundry in a fenced-in area populated by chickens and a dog, is much more finished and illusionistic in its narrative detail than the other works in the group.

The dating of these paintings relies on circumstantial evidence pointing to as early as 1895 and as late as 1899. The reasons supporting the earlier date include

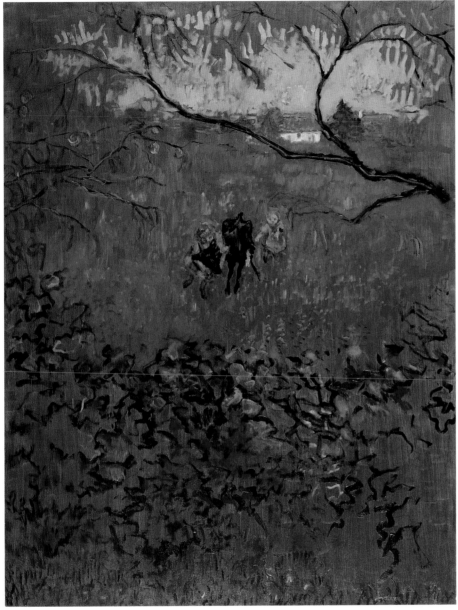

CAT. 9

the direct relationship between *Large Garden*, and a number of the artist's sketchbook drawings datable to 1894 or 1895. *Large Garden* is also clearly related to a smaller signed and dated painting entitled *The Orchard* (1895; location unknown) that shows the same view of the fenced-in field.[6] The sketchbook drawings of 1894–95 relate more generally to the other decorative panels in this group, suggesting an earlier date for those as well.[7] Also strengthening the connection to the earlier date are the affinities between the panels known as *Apple Gathering* and *Children Playing with a Goat* (cat. 8–9) and Bonnard's three-panel screen *Ensemble Champêtre* (The Museum of Modern Art, New York). The latter can be dated to 1894–96 (based on a sketchbook drawing from those years) and is painted in the same sketchlike fashion on a monotone background.[8]

The number of children depicted in these paintings and their approximate ages also point to an earlier date. Only three of the six children that Bonnard's sister, Andrée, and her husband, Claude Terrasse, had by 1899 are depicted in this group of paintings at any one time.[9] Bonnard's practice in other Grand-Lemps paintings from 1899 to 1901, such as *Bourgeois Afternoon* (cat. 43, fig. 1) and *Family in the Garden* (cat. 43), was to include all the members of the Terrasse clan. In addition, the oldest child seen in this group of works (the child in *Large Garden* appearing to run out of the picture on the far right, and the one who appears standing at the right beside the kneeling female of the Richmond version of *Apple Gathering* [cat. 7]) must be at least three or four years old. These paintings thus cannot be dated much earlier than 1895, when Bonnard's oldest nephew, Jean, would have been around that age.

The evidence suggesting a date as late as 1899 for this group of works includes photographs from around 1899 of the Terrasse children picking apples which may have inspired the subject.[10] Furthermore, there are sketches on the reverse of the Richmond version of *Apple Gathering* that are datable on the basis of their subject to around 1899. These five charcoal drawings are in the style of, if not actually executed by, Henri de Toulouse-Lautrec, and one of these represents Lautrec himself (fig. 2). Each sketch occupies a "square" of the canvas between the stretcher bars, indicating that they were added after the painting had been completed and mounted. At least two, and perhaps three, of the caricatures represent Dr. or "Admiral" Paul Viaud (see fig. 3),

FIG. 1

FIG. 1

Pierre Bonnard. *Large Garden*, 1895/96. Oil on canvas; 168 x 222.5 cm. Musée d'Orsay, Paris.

FIG. 2

Henri de Toulouse-Lautrec (French; 1864–1901) [?]. Charcoal drawing of Henri de Toulouse-Lautrec on the verso of cat. 7.

FIG. 3

Henri de Toulouse-Lautrec [?]. Charcoal drawing of Dr. Paul Viaud on the verso of cat. 7.

FIG. 2

FIG. 3

who became a kind of parole officer for Lautrec after the artist was released from the clinic of Dr. Sémelaigne (where he had been confined for an alcoholism cure) in May 1899. Viaud was responsible for making sure that Lautrec stayed away from drink and for procuring art supplies for him.[11] His involvement in Lautrec's life around 1899 adds some support to the idea that this painting and perhaps others were completed at this time. A similar caricature by Lautrec, emphasizing Viaud's bald pate and angular features, has indeed been dated by both Gustave Coquiot and M. G. Dortu to around 1899.[12]

Were these caricatures drawn by Lautrec or by Bonnard himself? Arguing in favor of Lautrec's authorship is Thadée Natanson's presumed ownership of the painting,[13] and the fact that Lautrec was a frequent visitor to the Natansons' Paris apartment and country homes between 1895 and 1898.[14] As Lautrec scholar Richard Thomson commented, it is not impossible that Lautrec made them "if not quite [as] an act of vandalism—[as] an act of subversion, making one's mark on another artist's work, albeit on the verso."[15] In his memoirs, gallery owner Ambroise Vollard offered an anecdotal story of Lautrec's visit to his home while Bonnard was at work on a *décoration* for his dining room, according to which Lautrec left a self-portrait drawing on the verso of a "study" (*étude*) as a "calling card."[16] It is possible that Lautrec could have done the same on the verso of *Apple Gathering* on a similar visit to the Natansons' before the work was permanently installed.[17] The existence of clever shorthand drawings on the verso of the Richmond *Apple Gathering* by Lautrec (or possibly Bonnard himself as a kind of homage to the artist, who died in 1901)[18] reinforces one of the characteristics of decorative painting among the Nabi artists in the 1890s. While decorative paintings were sometimes installed to fit specific architectural interiors, they were more often regarded casually and placed informally (see, for example, Vuillard's *Album* series, cat. 35–39). The winsome, silly drawings of Dr. Viaud and others—caricatures that are clearly intended as a practical joke or hidden pun—reinforce the notion that *décorations* were not precious and inviolable art objects, but just one element in a familiar interior, appreciated in relationship to a particular space and to the people whose personal dramas and joys enlivened it.

CAT. 10-13

MAURICE DENIS

Suite of Paintings on the Seasons, 1891–92

10 *September Evening*, or *September: Women on a Terrace*
1891
Oil on canvas
38 x 61 cm (15 x 24 in.)
Musée des Arts Décoratifs, Paris

11 *October Evening*, or *October*
1891
Oil on canvas
37.5 x 58.7 cm (14 ¾ x 23 ⅛ in.)
Mr. and Mrs. Arthur G. Altschul, New York

12 *April*
1892
Oil on canvas
37.5 x 61 cm (15 x 24 in.)
Kröller-Müller Museum, Otterlo, The Netherlands

13 *July*
1892
Oil on canvas
38 x 60 cm (15 x 23 ⅝ in.)
Fondation d'Art du Docteur Rau, Embrach-Embraport, Switzerland

CAT. 10

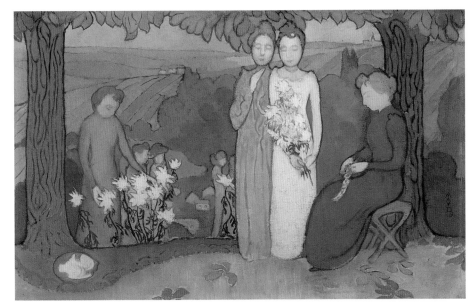

CAT. 11

THESE FOUR PANELS DEPICT WOMEN IN different stages of life, which are reflected in the seasonal scenes they inhabit. In undertaking this series, Denis was undoubtedly aware of Bonnard's own "seasonal" panels, *Women in a Garden*, exhibited in 1891 (Watkins, fig. 14; cat. 2–3). Denis's paintings, begun that same year and completed in time for the Indépendants exhibition in March 1892, can be seen in many respects as a response to his friend's ambitious and successful undertaking. Instead of the *kakemono* format—a long vertical suggesting a screen or door panel—used by Bonnard, Denis chose a horizontal canvas, suggestive of overdoor decorations. The format anticipates the six overdoor panels Vuillard painted in 1892 for the dressing room of Madame Paul Desmarais (1890–99 Intro., figs. 11–12; cat. 31, fig. 1) and Roussel's panels from 1892/93 known as *The Seasons of Life* (cat. 26–27).

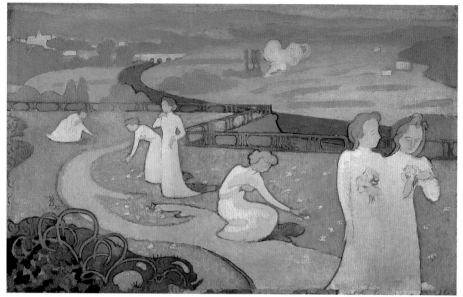

CAT. 12

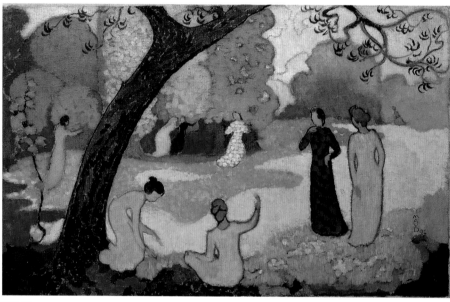

CAT. 13

The titles and stated purpose of these works as "four panels for the decoration of the bedroom of a young girl" suggest a specific site, as well as a narrative or allegorical program; their exact meaning, however, remains ambiguous. No doubt Denis appreciated the open-ended quality of these feminine idylls when he exhibited them in March 1892 under the general epithet "poetic subject."[1] Also, he painted the four works in a different chronological order from that in which they were listed in the Indépendants catalogue,[2] suggesting, if one assumes that he determined how the panels were listed, that he had no particular linear

sequence in mind. A sketch made for each of the four panels on a single sheet supports the idea that they were originally intended as a group.[3] While Denis clearly conceived them as a set, he apparently also believed that they could function successfully as independent works, and even exhibited them separately, showing the two panels from 1891, *September Evening* and *October Evening*, one month before the Indépendants at the exhibition of Les Vingt in Brussels and *April* at the group show at the Barc de Boutteville gallery in November 1892. The artist was also apparently unconcerned with keeping the panels together, selling *October Evening* to a Monsieur Poujaud after the Indépendants and, in December, selling *April*, *July*, and *September* to the dealer Ambroise Vollard for the sum of 400 francs.[4]

All of this contrasts with Denis's behavior three years later, when he exhibited another set of panels for the decoration of a young girl's bedroom at Siegfried Bing's Maison de l'Art Nouveau (see cat. 19–24). Denis exhibited these later panels under a single catalogue number. He also despaired at the thought of having to break up the Bing ensemble, indicating that this frieze needed to be kept whole for its meaning to remain intact. Perhaps Denis did not feel that the earlier panels needed to act as a unified whole and did not intend them to hang end-to-end as a frieze, but rather to "decorate" four separate walls.[5] These indications that Denis did not envision his 1891–92 works as a strictly narrative series have not deterred scholars from trying to interpret them according to a specific thematic order. But ultimately their success as both Symbolist and decorative works lies in their rich, evocative imagery, which invites multiple readings under the broader epithet "stages of a young woman's life."[6]

Denis may have intended two distinct pairings within the group, which he then linked together. *April* and *July* each represents a brightly lit scene of women gathering flowers, strolling, or playing by a river or in a forest clearing and each is divided by and organized around a diagonal element: a path (*April*) and a tree (*July*). They both employ emphatic, undulating lines and arabesques to define figures and landscape (a characteristic mocked by at least one critic, who compared the wavy branches of the bush in the foreground of *April* to an octopus).[7] The snaking path dividing *April*'s composition may well have encouraged the young Belgian artist-designer Henry Van de Velde (who would have known of Denis's work through the exhi-

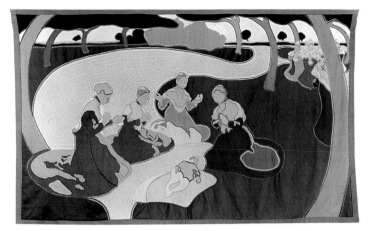

FIG. 1
Henry Van de Velde. *Angels'
Watch*, 1893. Tapestry, appliquéd
embroidery, wool on linen,
outlines in silk; 140 x 233 cm.
Museum Bellerive, Zurich.

bitions of the Indépendants) to create his celebrated appliquéd tapestry, *Angels' Watch* (fig. 1), based on a similar bipartite composition.[8] Compositionally, *July* and *April* are more daring and abstract than the other two panels. Jean Paul Bouillon even suggested affinities between Denis's exuberant and high-keyed *July* and the simplified figural types and brilliant coloration found in later, modernist works, such as Vasily Kandinsky's *Composition II* (1910; Solomon R. Guggenheim Museum, New York) and Henri Matisse's *Joy of Life* of 1905–06 (Watkins, fig. 20).[9]

September Evening and *October Evening* can be paired as well, since they share a stagelike composition bordered on either side by trees and anchored by women pushed to the foreground in friezelike fashion. They also feature larger and more static figural types, as opposed to the more delicate, sinuous females in *April* and *July*. Absent are the dynamic diagonal lines that pierce and define the compositions of the other two panels. Instead, the oblique and arabesque lines are straightened, resulting in a picture plane organized around right angles.

Unlike Denis's later series of seven panels commissioned by Bing (see cat. 19–24), which was intended for a specific destination—a bedroom exhibition space in Bing's gallery—and was inspired by Robert Schumann's 1840 song cycle *The Love and Life of a Woman*, these earlier, more colorful canvases share no unifying palette or theme. The Bing cycle begins with young girls dancing, moving on from engagement and purity to maternity and fulfillment, reflecting developments in Denis's personal realm. The earlier panels, made before Denis's marriage, suggest instead the cycles of life for a young woman *prior* to motherhood. When unencumbered by children, women for Denis

personified a virginal state. As art critic Gustave Geffroy put it, these are scenes of "delicate gaiety, slow dances, obsessive gestures, frail hands picking flowers, pale dresses, a dark park, the pink countryside."[10]

Both these panels and those for Bing's Maison de l'Art Nouveau were intended as bedroom decorations, but only the later panels actually depict a bedroom and convey its significance as the symbol of fulfillment—home, birth, and family.[11] Although these earlier images are clearly intimate, they show woman in relation to the natural rather than domestic realm, emphasizing her connection to flowers, trees, and water. In the Bing series three years later, Denis repositioned woman in what he believed to be her equally natural role as wife and mother within the home.[12]

In this way, the four early decorative panels evoke what was happening in Denis's life at the time, namely his courtship of Marthe Meurier, just as the later Bing panels reflect the artist's reaction to his marriage in 1893 and the birth and premature death of his first child in 1894–95. It was precisely in 1891–92, as his romance was blossoming, that Denis made what was for him a momentous personal discovery—that carnal and spiritual love could exist side by side, and in fact must exist for joy and creativity to be possible.[13] Broadly interpreted, these panels suggest the evolution of this discovery as it impacted Marthe's life—youth, with its lack of moral responsibilities (*July*); decision-making (picking flowers in *April*); expectations (*September*); and engagement (*October*, whose imagery of a woman carrying the bouquet of the fiancée suggests the acceptance of the rituals inherent to a woman's life).[14] Clearly, Denis was struggling to find his own path at this time. In his journal entries from mid-1891 to mid-1893, known as "Les Amours de Marthe," he embarked on a confessional journey through the stages of his struggle with and final triumph over the question of spiritual and secular love. After a metaphorical wrestling, Denis, who referred to himself as the knight, or *chevalier*, returns to hearth and home. His love message to Marthe, "The knight did not die on the crusades," is visually expressed in *September Evening,* where a woman is shown waiting expectantly, yet calmly, on a balcony (which resembles the terrace at St.-Germain-en-Laye where Denis and Marthe would host their wedding lunch in June 1893), while in the background horsemen ride by. In *September Evening*, and in what can be considered its pendant, *October Evening*, Denis introduced a male

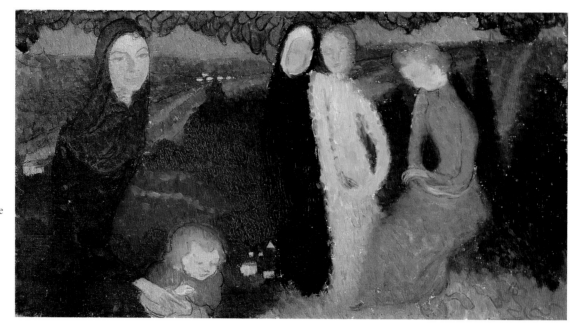

FIG. 2
Maurice Denis. *The Muses*, or
Les Fioretti, 1891. Oil on canvas;
22 x 39 cm. Petit Palais—Musée
d'Art Moderne, Geneva.

presence. In the former, he is one of the riders in the distance; in the latter, he is suggested as the intended of the bouquet-bearing fiancée.

A smaller panel, *The Muses*, or *Les Fioretti* (fig. 2), is similar in composition and palette to *October Evening* (probably serving as a study for the final panel) and alludes more specifically to Denis's struggle to resolve the conflict between the flesh and the spirit.[15] While the scene takes place in the same parklike surround and is similarly framed at the top by chestnut-tree branches, the woman who accompanies the fiancée of *October Evening* is now a nun, wearing a black veil and close-fitting, white wimple. Perhaps symbolizing the spiritual path, she leans into and seems to support the younger woman, who, although she wears the same pinkish dress as in *October Evening*, no longer holds the bouquet of a fiancée. Another woman at the left also wears a dark veil but lets a curl of hair fall forward and holds on to a child in red. The latter, who appears to be trying to break away from the woman's touch, may suggest the ultimate responsibility of the path the fiancée has chosen. In the final decorative panel, however, Denis appears to have avoided the tension between physical and spiritual love altogether, showing the young woman on the cusp of matrimony. In many ways, he resolved this conflict only in his "Bing" panels three years later.

The significance of this early series of panels—little talked about during Denis's lifetime, since they were immediately dispersed after the Indépendants exhibition in March 1892—is less as an ensemble for a par-

ticular interior than as a highly sophisticated quartet painted during what the artist's journals indicate was a critical turning point in his life. With this series, loosely connected in subject and composition, Denis introduced (and in some cases reworked) the theme of a young woman gathering flowers and awaiting her beloved that he would return to regularly in paintings such as *Orchard of the Wise Virgins*, *Princess in a Tower* (1893 and 1894, respectively; both Daniel Malingue Collection, Paris), and *Figures in a Springtime Landscape* (cat. 25, fig. 2).

CAT. 14

MAURICE DENIS

Ladder in Foliage, or *Poetic Arabesques for the Decoration of a Ceiling,* 1892

Oil on canvas, mounted on cardboard
235 x 172 cm (92 ½ x 67 ¾ in.)
Musée Départemental Maurice Denis "Le Prieuré,"
St.-Germain-en-Laye

I N HIS 1914 INVENTORY OF DENIS'S DECORATIVE projects, Achille Segard began his account of Denis's meteoric rise to fame with the purchase in 1891 by the artist's painter friend Henry Lerolle of Denis's 1890 painting *Catholic Mystery* (1890–99 Intro., fig. 8) and Lerolle's commission, the following year, of

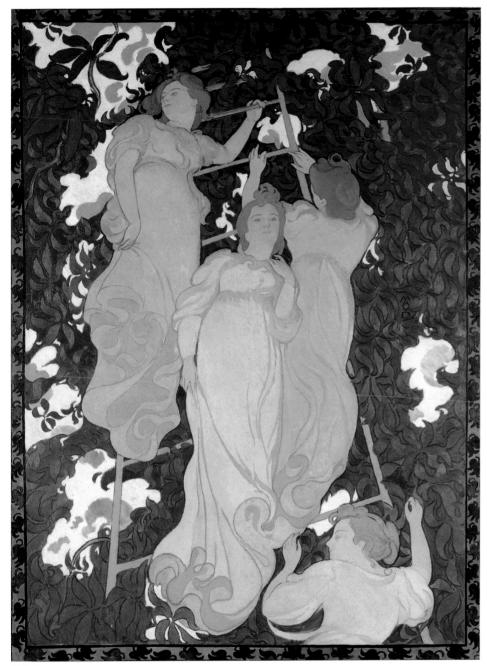

CAT. 14

confidence in someone so young and inexperienced. Denis in fact took only several weeks to complete the ceiling painting.[3] Unpublished correspondence between Lerolle and Denis, moreover, suggests that, while Denis discussed his ideas with Lerolle, he submitted no preliminary studies. "I'm happy that you have thought about it," Lerolle wrote Denis in June 1892, "and from what you tell me I anticipate something beautiful."[4] Lerolle's only specific demands were that Denis match the dimensions of the painting to the ceiling and that he specify the cost of the project.[5] As Lerolle indicated in the diagram that he included in this letter (fig. 1), the painting needed to fit a narrow space on one end of a large, rectangular room. Now mounted on cardboard, the canvas would have originally been attached directly onto the ceiling, using a specific glue and a technique called *marouflage*.

Denis's final composition ingeniously addresses the problem of different vantage points. *Ladder in Foliage* works, on the one hand, as a ceiling painting (*peinture plafonnant*), lit from below to emphasize the spiraling line of the women who levitate toward the pockets of blue-and-white sky. It works equally well, on the other hand, as an easel painting, hung vertically as it is now presented at the Musée Départemental Maurice Denis. Indeed, for his first effort at ceiling painting, Denis looked not to the Italian Renaissance masters (as he would do subsequently), but to his own highly original poster design, recently completed for Arthur Huc, director of the newspaper *La Dépêche de Toulouse* (fig. 2).[6] The poster shows a woman in a similarly big-sleeved and flowing gown, holding the newspaper headlines like a banner. Her ascension is made clear by the people who stand below her and by her conspicuously exposed feet, which dangle in the air.[7] (In the ceiling painting, Denis hid the women's bare feet under long, swirling robes.) Denis borrowed the levitating gesture of the woman in the poster for his ceiling painting and then decided to show the women ascending, or descending, a ladder nestled into dense foliage. The clouds that dot the sky in the poster reoccur in the painting as blue-and-white arabesques, which break through the greenery in decorative shapes. Coloristically, too, the overall palette of bright yellows, greens, and blues in *Ladder in Foliage* suggests the bold, flat colors found in color lithographs and posters.

Far more than a representation of reality, this is—as Denis's original title *Poetic Arabesques* (*Arabesques poétiques*) implies—a poetic and ornamental evocation of reality. The women do not actually climb the ladder

this ceiling painting.[1] This *décoration*, on a grander scale than anything Denis had undertaken thus far, launched the artist's career as a painter-decorator, since it was for Lerolle's extended family that he would paint "decorations" in 1893, 1894, 1896, and 1898 (see cat. 15–16; cat. 16, fig. 2).

It seems that Lerolle may have originally planned to commission Aristide Maillol, a recent addition to the Nabi circle, to paint this ceiling decoration, but apparently he changed his mind once he saw Maillol's sketches for the project.[2] Lerolle then turned to the relatively unknown Denis, displaying a remarkable

FIG. 1

FIG. 2

FIG. 1

Letter from Henry Lerolle to
Maurice Denis, 2 June 1892.
Musée Départemental Maurice
Denis "Le Prieuré," St.-
Germain-en-Laye.

FIG. 2

Maurice Denis. Poster for
La Dépêche de Toulouse, 1892.
Lithograph in four colors; 56 x
44 cm. Musée Départemental
Maurice Denis "Le Prieuré,"
St.-Germain-en-Laye.

FIG. 1

FIG. 2

but rather hover in front of it, and the trees have been transformed into an almost solid tapestry of leaves, with very few branches and no fruit. The insistence on the arabesque, or S-curve, in both the original French title of this work and in the painting's composition reflects the importance of this ornamental and musical concept for Denis and his circle. For his subject, Denis chose images that resonate with secular and biblical references, suggesting both the theme of fruit picking and that of Jacob's ladder. As Segard commented in 1914, a very similar figural type—characterized by dignified and solemn gestures freighted with religious and secular associations—recurs throughout Denis's work.[8]

The woman in the painting, who is essentially repeated four times in *Foliage*, clearly resembles the full-faced and full-figured Marthe.[9] The fact that the decorative border of *Ladder in Foliage* was painted by Marthe and signed with her initials, moreover, reinforces her likely role as model, as well as assistant, in the creation of this work.

The picture was shown in the fall of 1892 at the Château de St.-Germain-en-Laye. Although it was described in the catalogue of this exhibition as "decoration for a ceiling painting," it was probably hung on a wall with other easel paintings, as was usual for ceiling paintings shown at the Salons. In a letter to Lerolle, written shortly after the close of this exhibition, Denis voiced his concern about the way the painting would actually look in Lerolle's interior. The older artist's encouraging and fatherly response is worth citing at length for what it reveals about the protector-patron role that he played in Denis's life:

I understand your hesitations at the moment of installing your work in its definitive place—not that I might not judge it very beautiful—but I have been there and I think that we have all passed through that stage. To be completely free from these hesitations and doubts about what one has done, one must have great pride, which is not always a bad thing in art, or else be one of those phonies who couldn't care less about things. . . .

I'm delighted that your ceiling painting will soon arrive. . . .

We will try to install it, and we'll talk about it. But I feel the need to tell you right now, how much I found it [the painting] beautiful the two times that I've seen it, at your home and at the exhibition. . . .

Of course, it will not have the same effect at my home that it did at the exhibition, being less elevated and in a smaller space, but we will see to all that. . . .

You have made something beautiful—I thank you.[10]

CAT. 15

MAURICE DENIS

The Muses: Decorative Panel, 1893

Oil on canvas
171.5 x 137.5 cm (67 ½ x 54 ⅛ in.)
Musée d'Orsay, Paris

FOLLOWING THE SUCCESSFUL INSTALLATION OF the ceiling painting *Ladder in Foliage* (cat. 14) in the home of Henry Lerolle, Denis executed wall decorations for Lerolle's brothers-in-law Arthur Fontaine (1860–1931), a high-level government official, and Ernest Chausson (1855–1899), the distinguished composer.[1] Denis painted *The Muses* for Fontaine and exhibited it at the Indépendants in 1893 (along with five other works), prior to its installation in his home. In 1932, *The Muses* was purchased by the French nation and placed on public display at the Musée du Luxembourg, Paris, thus becoming one of Denis's best-known works.

The commission from Fontaine, then Chief Engineer of Mines and future Minister of Labor, was another coup for Denis, who was at that point in his early twenties. Like Lerolle and Chausson, Fontaine was a conservative Catholic. He would later join forces with Denis to found *L'Occident*, a literary review promoting Western (and, in particular, Catholic) art.

The catalogue for the 1893 Indépendants exhibition lists the work followed by the phrase "à Madame A[rthur] F[ontaine]" (to Madame Fontaine). It is unclear whether this phrase indicates actual ownership, as in the expression "appartient à Madame Fontaine" (belongs to Madame Fontaine) or simply that the work was dedicated to Marie Fontaine, perhaps as a gift from Arthur Fontaine to his wife. It is even possible that Marie Fontaine, apparently an artist herself,[2] commissioned the work after having seen *Ladder in Foliage* (cat. 14) at her sister's home.

The Muses is set in the forest of St.-Germain-en-Laye; the golden, horizontal band in the background suggests the famous terrace in front of the Pavillon Henri IV, where Denis was to hold his wedding luncheon on 12 June 1893, only a few months after completing this work. Denis's fiancée, Marthe Meurier, served as the model for the three figures in the foreground, each in a different pose and costume

(in a day dress, in evening wear, and in a black veil, possibly for church or mourning). Marthe symbolizes not only the three muses, but also what Denis scholar Jean Paul Bouillon termed the artist's belief in the "trinity" of "art, love and religion."[3]

The yellow-on-yellow, patterned dresses of two of the "muses" evoke the wallpapers of William Morris and are similar to a printed dress that appears in Denis's portrait of France Ranson, also exhibited at the Indépendants in spring of 1893.[4] Indeed, the gestures of Madame Ranson and two of the women in *The Muses* (the former holds a teacup and the latter a pencil and a book) share a similar hushed, quasi-spiritual quality. In *The Muses*, the radiant yellow-gold of the dresses of all but three of the women is echoed by the seated figure in the distance, who is bathed in a golden light that seems to emanate from the far-off terrace. A mysterious aura, moreover, envelops the strolling female couples, who seem wedded compositionally to the trees and leafy pathways. In this Baudelairian "temple of living pillars,"[5] Denis mixed pagan elements (the woman in a long black tunic at left), Christian imagery (the young women in white and the black-veiled woman possibly reading the Bible), and contemporary references (the women's hairstyles and the wrought-iron chairs ubiquitous in French parks).

The reviewers of the Indépendants exhibition noted the similarity of Denis's offerings that year, all of which, with the exception of the portrait of Madame Ranson mentioned above, featured the artist's fiancée. In these, Marthe-as-muse-and-model appears in various roles: a virgin in an enclosed garden in *Orchard of the Wise Virgins* (1893; Daniel Malingue Collection, Paris), a communicant in *Easter Procession* (1894; private collection, Paris), and a bride with entourage in *March of the Betrothed* (1894; private collection, Paris). It is also possible that she appeared in a work identified in the exhibition catalogue as *Notre Dame*, whose current location is unknown.[6]

Critic Roger Marx remarked on the secular and profane possibilities of these "images of calm, meditation, and compassion."[7] His words aptly capture the aura emanating from the female figures in *The Muses*, whose passionless gestures and expressions suggest ritual and religion. For the critic of *Le Coeur*, there was no doubt that this and the five other paintings Denis exhibited were replete with hermetic and symbolic images conceived by a "mystic par excellence."[8]

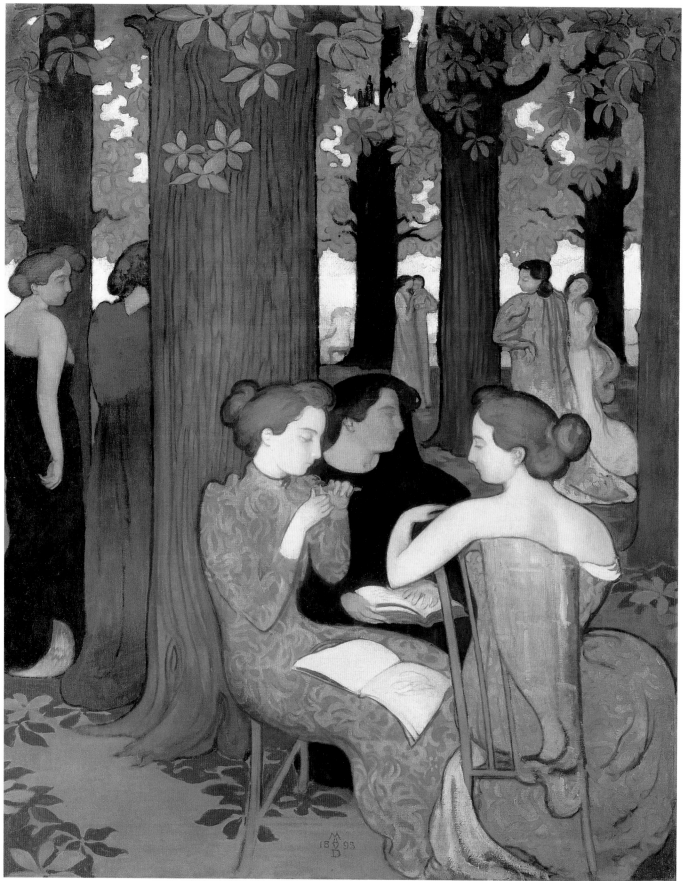

CAT. 15

FIG. 1

FIG. 1
Maurice Denis. *Women in a Park*, 1893. Oil on canvas; 51 x 33 cm. Musée Léon Dierx, St.-Denis de la Réunion.

FIG 2
Edouard Vuillard. *Chat at the Fontaines*, 1904. Oil on board; 63 x 62 cm. Private collection.

FIG. 2

Other critics commented at the time on the "decorative" aspects of this work. Edmond Cousturier, while critical of its repetitive figural types, admired the artist's rhythmic orchestration of trees and his use of the arabesque.[9] His acceptance, indeed endorsement, of the painting as an independent *panneau décoratif*, in keeping with the Nabis' intentions for a specific type of painting, was in marked contrast to complaints by other critics and artists around this time. This group (which included critic Camille Mauclair and painter Camille Pissarro) could not accept the Nabis' claim that an easel painting, albeit "decorative," could constitute a *décoration*, which they felt to be an artwork physically dependent upon the architectural context of which it is part.[10]

The aesthetic (rather than physical) differences between *tableau* and *décoration* in the artistic debates of the time become clear in comparing *The Muses* to a smaller, and presumably earlier, study by Denis, *Women in a Park* (fig. 1), where Denis included an older woman, a possible chaperone or grandmother, who confers to the scene a more definite narrative element than presented in *The Muses*. The trio of "muses" in the foreground of *Women in a Park* are differentiated females, rather than, as in the larger work, Marthe repeated three times. The more monochromatic (brown, gray, black), small picture is also more conventional in its treatment of space: the figures are set slightly back to allow for "breathing" room between the viewer's realm and that of the image. *The Muses*, by contrast, displays a deep spatial recession, mitigated by the frieze of women in the foreground and by the unifying and flattening effect of a highly controlled palette of yellows, browns, and copper and the recurring leaf pattern. Denis's eminently decorative use of the horse-chestnut leaf motif in the ground shadows and as a pattern on the women's dresses is the factor that most clearly gives *The Muses* the quality of *décoration* rather than that of a large, framed *tableau*.

Immediately after the Indépendants exhibition, Denis wrote to Fontaine that the "large canvas" would be sent to his home.[11] No documents or photographs exist, unfortunately, to show how the painting looked in the Fontaines' first Paris apartment, at 6, rue Greffuhle, in the seventh arrondissement. By 1905, the Fontaines were divorced. Although Marie Fontaine (who eventually became Madame Abel Desjardins) remained friendly with Denis, the painting that was initially listed in her name stayed with her ex-husband in their home on avenue de Villars, where the Fontaines

had moved sometime around 1901/02.[12] Vuillard's 1904 painting of the interior of the Fontaines' salon (fig. 2) suggests how Denis's panel functioned in the Fontaine home at least by that time. Encased in a heavy, gold frame and hung on the wall closest to the large windows, *The Muses,* while not designed for this specific interior, looks as if it had been. Many years after its completion, Denis wrote to Fontaine, proposing to "clean your decorative panel." Denis's offer attests not only to the special characteristics of this kind of painting—typically left unvarnished and unglazed—but also to his ongoing commitment to his patron and friend.[13]

As Vuillard's painting indicates, *The Muses* was hung to be seen by the seated couple and their guests while they pursued their discussions of art, music, and literature. Like Lerolle's interior, which Vuillard felt emanated a "sense of calm,"[14] the Fontaines' salon provided an intellectual and artistic retreat that was perfectly reflected in Denis's *The Muses.*

CAT. 16

MAURICE DENIS

April, 1894
Oil on canvas
Diam.: 200 cm (78 ¾ in.)
Private collection

THE COMPOSER AND MUSICIAN ERNEST Chausson was undoubtedly introduced to Denis through his brother-in-law Henry Lerolle, for whom Denis had painted a ceiling *décoration* in 1892 (cat. 14). By 1893, Denis was friendly enough with Chausson to invite him to his wedding that June.[1] A few months later, Chausson commissioned this work, the first of three ceiling paintings Denis was to create for his private residence, at 22, boulevard Courcelles.

While fifteen years Denis's senior, Chausson shared similar personal circumstances with the artist—the Chaussons were young parents, as the Denis were expecting to be—that sealed their relationship on a more intimate level. In Chausson, Denis found an enthusiastic patron and a friend, and the two maintained a close relationship until Chausson's untimely death in 1899.

All three of Denis's ceiling paintings for Chausson have spring as their basic theme, although the first (cat. 16) is more allegorical (and therefore Symbolist) than the last two (*Spring* [1896; private collection]; and fig. 2).[2] Just as Denis was given complete artistic freedom while executing his ceiling painting for Lerolle, he apparently received little or no input from Chausson concerning *April.* Chausson, in fact, only saw the painting for the first time when it was exhibited publicly in April 1894:

I went to the Indépendants the very day of my arrival. I was very anxious to see your ceiling painting. It is completely delicious and will go admirably with the white paint of the gallery. I'm very happy to possess such a beautiful thing, which, however, will not prevent me from wanting others from you.[3]

The circular panel, for which Chausson paid 1,000 francs, was installed in early June by Denis with the help of the more experienced Lerolle and a Monsieur Binan, a specialist in the *marouflage* technique.[4] Denis's choice of a very muted palette—like that of Pierre Puvis de Chavannes, dominated by turquoise-blues, ochers, and off-whites—was no doubt dictated by the white walls of Chausson's salon. In contrast to the decors of Denis's other clients at this time—the William Morris wallpaper employed by Lerolle or the Renaissance-inspired wallpaper used by Arthur Huc—which reflected prevailing notions of good taste, an all-white salon was a novelty that would not come into vogue until the beginning of the twentieth century (with the move away from excessive ornamentation). The dainty feminine forms of *April* painted in soft, pastel tones are radically different from the bright, posterlike colors of *Ladder in Foliage* (cat. 14) or the deep greens and browns of the door panels Denis later executed for Arthur Huc, *Forest in Spring* and *Forest in Autumn* (cat. 17–18). It is possible that the composition and palette of this tondo were in response to Chausson's white walls and to earlier "Rococo" panels Lerolle painted for the Chausson residence.[5]

In *April,* Denis subverted the tradition of seventeenth- and eighteenth-century ceiling painting, in which decorative motifs encircle a central area that is left empty or open to signify sky. Instead, the largest female figure fills the center of the composition, leading a procession of spiraling white-robed women bearing baskets of flowers on their heads. Compositionally, the painting works both horizontally, as a ceiling painting, and vertically (as it would have been hung at the Indépendants), as a wall decoration. When

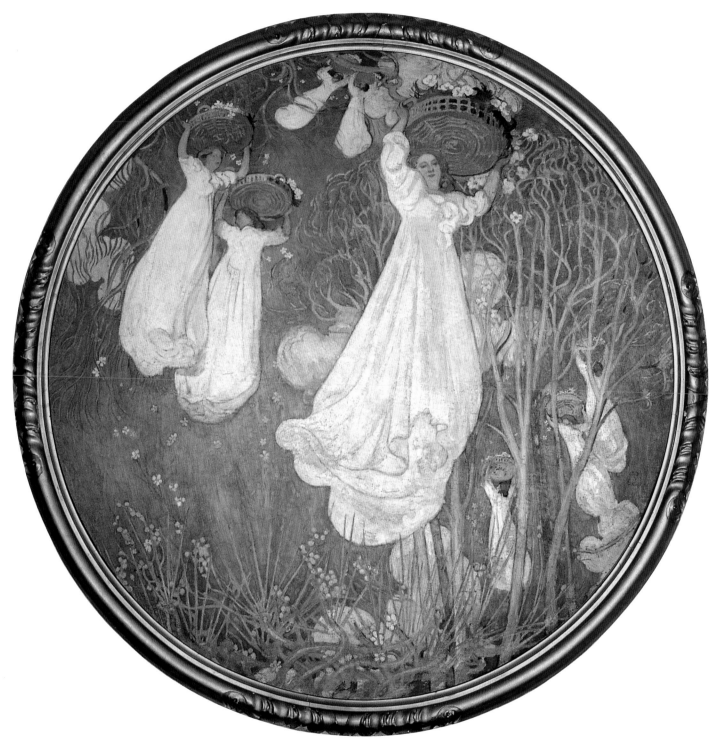

CAT. 16

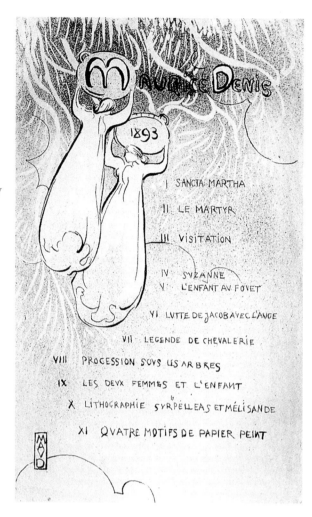

Text within figure:

Maurice Denis

1893

I SANCTA MARTHA

II LE MARTYR

III VISITATION

IV SUZANNE
V L'ENFANT AU FOUET

VI LUTTE DE JACOB AVEC L'ANGE

VII LEGENDE DE CHEVALERIE

VIII PROCESSION SOUS LES ARBRES

IX LES DEUX FEMMES ET L'ENFANT

X LITHOGRAPHIE SUR PELLEAS ET MELISANDE

XI QUATRE MOTIFS DE PAPIER PEINT

it is viewed as a wall painting, the female figures seem to ascend and circulate around the tondo along a sinuous, arabesqued line associated with the nascent Art Nouveau movement. When the panel is hung as a ceiling painting, however, the women appear to spiral upward, in columnlike fashion, toward a circular portal in the sky (or ceiling). Like Denis's ceiling decoration for Lerolle, which was inspired by an earlier poster he designed, the basket-carrying and floating females of *April* are based on a lithograph by the artist (fig. 1), used to advertise his solo exhibition at the Barc de Boutteville gallery, Paris, in 1893. This transposition of motifs from graphic art to large-scale decorative painting is something Bonnard did as well, emphasizing the belief of the two men in a new kind of art that would blur the boundaries between high and applied art and techniques.[6]

Although the painting was exhibited at the Indépendants as a ceiling, no critic remarked upon its intended destination. Few in fact paid any special attention to the work, which Denis exhibited along with several other Symbolist and religious canvases: *Supper at Emmaus* (1894; private collection), *Annunciation* (1894; formerly Mellerio collection), and *Princess in a Tower* (1894; Daniel Malingue Collection, Paris).[7] Writing in *La Plume*, Jules Christophe commented that all four paintings share a particular feminine type unique to Denis: "woman with a round face, innocent, gentle and intelligent, who is highly appealing, by turns, a muse, virgin, or Maeterlinck's fairy princess."[8]

Just as Chausson's *Mélodies*, or art songs based on Symbolist poetry, were evocative and suggestive without indicating specific meaning, the decorative and expressive women in Denis's tondo invite multiple interpretations. Guy Cogeval saw them as floating "princesses" who cast down a rain of flowers that, like stars, are metaphorically fixed in the sky. Thus, they are the little sisters of the fairy in Stéphane Mallarmé's early poem "Apparition" (1883): "Who when I lay in the gentle sleep of a spoiled child / Passed by, always letting fall from her loosely closed hands / White flowers like a snow of sweet-scented stars."[9] Such an underlying meaning is plausible, since this same year Denis executed a three-color lithographic cover for the musical adaptation of the Mallarmé poem.[10]

Clearly the rhythmic sequence of these ethereal young women refers, as does the position of the women in *Ladder in Foliage* (cat. 14), to the crescendos and diminuendos of musical scores. Writing about this tondo, Jean Paul Bouillon expanded this musical analysis, citing an entry from Denis's journal in which he quoted verbatim from Paul Verlaine's "Parsifal": "For a ceiling: lo these children's voices singing in the cupola!"[11] Bouillon posited that Denis ingeniously alluded not only to the poem, with its reference to the opera of Richard Wagner, but also to Parsifal's temptation by the far-off echo of the voices of the "girl-flowers" (*filles-fleurs*). In *April*, these are the floating young girls holding flowers and circling upward.[12]

For both Cogeval and Bouillon, the women exist, appropriately for a ceiling painting, in a celestial realm. But could not the aqua-blue surround, with its coral-like vegetation, also be seen as an underwater paradise in which the women float upward like weightless sea anemones, bringing their baskets of sea pearls and stars to the surface?[13] Like successful Symbolist poetry, Denis's *April* resonates with highly suggestive imagery in a way that the succeeding two ceiling panels for the

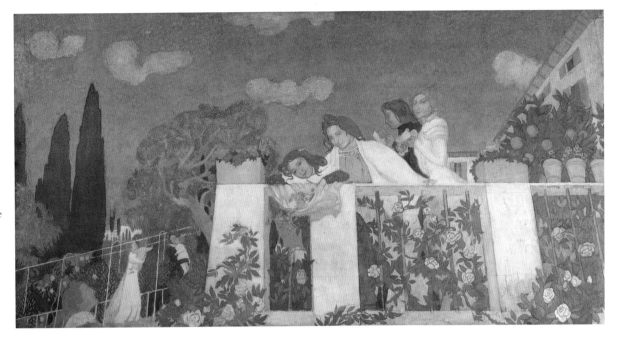

FIG. 2
Maurice Denis. *The Chausson Family, Villa Pariniano*, 1898. Oil on canvas; 127 x 244 cm. Private collection. Photo: Courtesy of Achim Moeller Fine Art.

Chausson residence do not. *Spring*, for example, painted two years later, has a more literal setting, the pergola in the terraced garden of the Chaussons' rented villa at Fiesole. Unlike *April*, in which Denis reused feminine types from his earlier paintings and graphic works, *Spring*[14] is strongly indebted to the work of Albert Besnard, whose ceiling murals for the Ecole de Pharmacie in Paris, the Salle des mariages of the town hall of Paris's first arrondissement (Watkins, fig. 3), and the Berck Sanatorium in Normandy Denis admired. Denis's last ceiling painting for the Chaussons, *The Chausson Family, Villa Pariniano* (fig. 2), is quite different in character and composition. Executed after Denis's visit to the Chaussons' Fiesole villa in November–December 1897, it includes portraits of the Chaussons at their property.[15] In this way, the work overtly displays its indebtedness to the Italian tradition of incorporating patrons' portraits into murals depicting their estates or palaces (in this case, that of the Chaussons).[16] The Symbolist and evocative qualities of Denis's first *décoration* for Chausson are not found in this final commission.

Perhaps because the second Chausson ceiling painting, *Spring*, had been rejected at the Salon, Denis wrote to his patron to ask whether he should exhibit this third ceiling painting at the Indépendants.

Chausson's generous response reveals the casual nature of their friendship and the support that the composer continued to provide:

If you think that it will be interesting for you in any way, send *Pariniano* to the Champ-de-Mars without a second thought. If not, let's get it glued on, my friend; that will be the punctuation mark bweeen the final stained-glass windows. And what a shame, when the decorative scheme is finally completed. At least, until I can find, as I hope, another place to be decorated.[17]

Less than three months later, Chausson was dead. When, several years afterward, Madame Chausson returned to the decorative agenda that she and Ernest had set out for their home, Denis was not among the artists she considered.[18] In 1902, she turned to Odilon Redon—the older artist had often played the violin with her husband at the salon of their mutual friend Berthe de Raysaac—to paint a series of five vertical panels for the loggia of a "vast music room."[19] Even with an artist of Redon's stature, Madame Chausson was more specific in her demands than her husband had ever been with Denis. According to one eyewitness, Redon originally executed a figure in the central panel which she then asked him to paint out. The result was a composition of "flowering vegetation, half-real, and half-idealized,"[20] a description that could aptly describe the dreamlike quality of Denis's *April*.

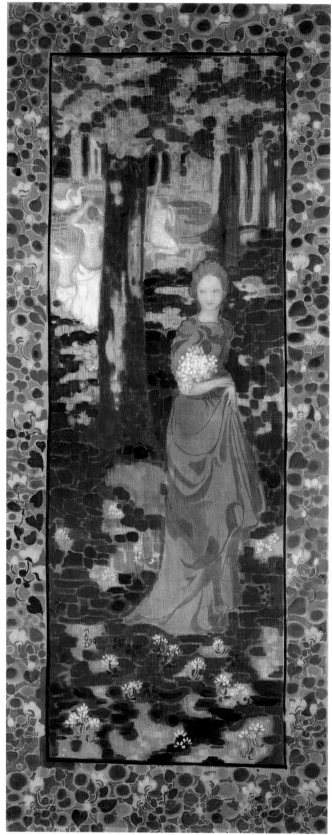

CAT. 17

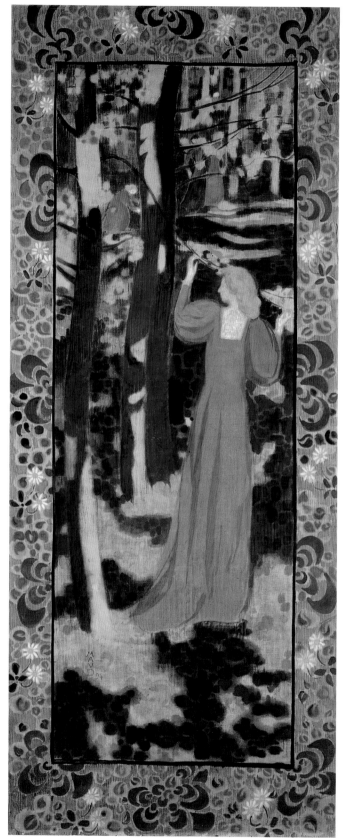

CAT. 18

CAT. 17–18

MAURICE DENIS

17 *Forest in Spring*
1894
Oil on canvas
230 x 100 cm (90 ½ x 39 ⅜ in.)
Tom James Co./Oxxford Clothes

18 *Forest in Autumn*
1894
Oil on canvas
230 x 100 cm (90 ½ x 39 ⅜ in.)
Tom James Co./Oxxford Clothes

THESE MONUMENTAL PANELS, IMITATING TAP-estries and symbolizing spring and autumn, were commissioned from Denis by Arthur Huc (1854–1932), director (or perhaps coeditor) of the newspaper *La Dépêche de Toulouse*.[1] Apart from a brief period immediately after their completion during which they were installed in *La Dépêche*'s offices (in an exhibition of works by the Nabis and others), the panels were not exhibited during Denis's lifetime. Soon after this 1894 exhibition, they were installed as door panels in the dining room of Huc's home, where they remained until a few years ago.[2]

FIG. 1
Maurice Denis. Studies for *Forest in Spring* and *Forest in Autumn*, 1894. Oil on canvas; each panel, 44 x 16 cm. Private collection.

The nearly eight-foot-high canvases are the result of Denis's intense but short-lived relationship with Huc. Between 1891 and 1894, Huc commissioned a variety of projects from Denis, including a portrait of himself and another of his mother; a calendar for his newspaper, *La Dépêche de Toulouse*; a poster for *La Dépêche* advertising an exhibition of the work of Denis and his contemporaries (see cat. 14, fig. 2); a version of that poster painted in oil; and these two large panels, *Forest in Spring* and *Forest in Autumn*, originally commissioned by Huc as "door drapes" or *portières*.[3]

Huc's patronage of Denis was marked by two important events: his appointment to a major post at *La Dépêche de Toulouse* (which also had a Paris office) sometime in 1890; and his marriage at age forty, in the summer or fall of 1894. Before joining the newspaper, Huc had led a relatively uninspired life as a civil servant, holding several minor political positions in smaller towns.[4] In June 1891, soon after his appointment to *La Dépêche* (and probably following the Indépendants exhibition), Huc wrote to Denis that he was one of his "admirers," and asked him for a sketch or small study.[5] A little more than a month later, Huc made an appointment to visit Denis at his rue Pigalle studio, where he selected one of Denis's paintings, possibly *The Fairies* (1891; private collection) or *Breton Dance* (1891; private collection, Switzerland).[6] This initial visit triggered Huc's interest in Denis's career and in the Nabis in general.

Huc's involvement with Denis and his circle coincided with his plans to expand the contents of *La Dépêche*. As he explained to Denis in a letter of September 1891, his goal was to cover not only regional and international events and politics, but also literature and art, in the style of the well-regarded moderate newspaper *L'Echo de Paris*.[7] In August of that same year, Huc had asked Denis to send information on the upcoming exhibition of Denis's group at the Première Exposition annuelle des beaux-arts in St.-Germain-en-Laye so that he could write something about it for the paper suited to Denis's taste. But in the end he wrote nothing about the exhibition, promising instead to "publish—shortly—a study on the new artistic schools."[8]

In a subsequent letter Huc commissioned what was to be Denis's unique poster design (cat. 14, fig. 2). The image, originally intended in 1891 to symbolize the newspaper's newly expanded goals, was not published until three years later. At that time it was used to

FIG. 2
Pierre Bonnard. *Nude against a Background of Foliage*, 1895. Oil on canvas; 140 x 60 cm. Private collection. Photo: Dauberville, vol. 1, p. 137, no. 73.

advertise an exhibition of the work of Bonnard, Denis, Toulouse-Lautrec, and Vuillard.[9] The poster's importance for Huc is underscored by the fact that soon after its commission he asked Denis to make another version of the same design on "canvas glued to board."[10]

Unlike Denis's other patrons—Chausson, Fontaine, and Lerolle—all of whom were involved in the arts and were collectors themselves, Huc was a newcomer to contemporary painting. His family home, which he shared with his mother, was a model of fin-de-siècle eclecticism, featuring "Romanesque capitals, Italian Renaissance sculptures, and tapestries side by side."[11] Denis's two panels, although temporarily hung in the offices of *La Dépêche* in Toulouse, were immediately thereafter installed on the dining-room doors in this museumlike interior.[12] In contrast to the relatively laissez-faire attitude of Denis's earlier patrons (see cat. 14–16), Huc took an active role in the project he commissioned. Writing on 17 April 1894, Huc informed Denis that he had visited a color merchant and seen canvases "with the same grain, painted in imitation of tapestry and that weren't too bad. You can [go there] and see the process for yourself."[13] Huc acknowledged the difficulties of finding and painting a very large canvas to imitate a textile, and allowed Denis to use smaller canvases to make decorative panels instead of *portières*. Huc said he would find a place for these smaller panels, but renewed his request for door curtains, offering to send Denis larger, wide-grained canvases.[14]

How Denis, who by 1894 was already a well-respected *peintre-décorateur*, felt about such a specific, if not rigid, request is not known. He seems to have responded to his client by not responding, so that a week later Huc wrote, asking, "What have you decided for the *portières*? Have you found another method?"[15] Perhaps by this time Denis had already sent Huc two studies for the panels showing a woman and bathers (*Spring*) and a woman and children (*Autumn*) situated in forested areas and surrounded by floral borders (fig. 1), which are in most respects very close to the final version of the panels.

The final eight-foot canvases are splendidly conceived and rank among Denis's most successful decorations. Although at first glance they are tapestrylike, they have little in common with the commercially manufactured "paintings in imitation of tapestry" popular at the time. These were painted on specially treated canvases whose grains resembled the coarse weave of tapestry, and were in the style of earlier medieval or Renaissance tapestries.[16] Instead, Denis assimilated certain general characteristics of medieval tapestry—floral border, richly modulated color patterns, and simple figurative outlines—to create works that are highly decorative, personal, and sophisticated.

The woman depicted in the two panels has sometimes been identified as Marthe, who also appears gathering flowers in *April*, or *Anemones* (1891; private collection),[17] and in multiple poses in the forest of St.-Germain-en-Laye, in *The Muses* (cat. 15). It is more likely, however, that the willowy female in *Forest in Spring* and *Forest in Autumn* was inspired by a younger model, such as Yvonne Lerolle, Henry Lerolle's daughter, whose triple portrait Denis would paint in 1897 (cat. 19–24, fig. 5), one year before she married. The bathers in the background of the *Spring* panel are Puvis-like in their gestures and classical drapery. Comparing these chaste nudes in a lush, forested setting to Bonnard's much more audacious, near-life-sized nude in a decorative panel of 1895, *Nude against a Background of Foliage* (fig. 2), reveals the aesthetic and ideological gap between the two artists and among the Nabis in general that was becoming increasingly significant at this time. Denis's nude bathers represent rebirth and purity, and echo the widespread belief in woman's affiliation with nature. Bonnard's shimmering and naked woman, by contrast, is a modern Venus, completely self-absorbed in a near-hallucinatory relationship (much like a female Narcissus) with her own body and the foliage that surrounds her. Whereas Bonnard had moved dramatically away from the clever linearity and caricatural mode of his *Women in a Garden* (Watkins, fig. 14) to a new concern for the female body on a grand scale dissolved into backdrops of color abstractions, Denis's stylistic development was more evolutionary than revolutionary—achieving variations on a theme, rather than making a definite break with earlier subjects and styles.

Indeed, Denis used here a number of motifs that appear in other works by him of the period. One can find the same setting and trees depicted with the same mottled surface in his decorative border (*encadrement lithographié*) for Mallarmé's poem "Petit Air," published in the December 1894 issue of *L'Epreuve*.[18] Revisited also is the compositional device of women strolling amid slender trees with decorative patterning, such as in *The Muses* (cat. 15) and in *Procession under the Trees* (1892; Mr. and Mrs. Arthur G. Altschul, New York).[19] For the first time, however, Denis was faced with

extremely tall, narrow panels. Instead of an expansive space divided by trees, he painted a narrow patch of landscape that rises unbroken by horizon line or sky.

Denis apparently ignored Huc's request for images on a coarse canvas that would seem woven when painted upon. Instead, he chose a very fine linen, upon which he thinly applied diluted oil pigments. The canvas, left unprimed in certain areas, serves as a neutral ground for his color harmonies. The wide, patterned borders enhance the sensation of dense foliage, with repetitive leaf patterns that are different in each panel according to the season represented: stylized fruit-tree blossoms for spring, wildflowers for autumn. These decorative elements mirror both the content and the style of the composition, affirming Denis's earlier comments that painted borders should harmonize rather than vie with the picture within.[20]

The short time separating Huc's letter recommending the tapestrylike canvas and the delivery of the panels one month later suggests Denis's enthusiasm and complete absorption in the challenge posed by the panels' large scale and unusual format. It also reflects Denis's customary, quick, and decisive way of working. What arrived on 14 May, one day before the opening of the exhibition, however, was neither a set of panels—in the strict sense of framed canvases to be fitted into an existing area—nor door curtains. In a letter written to Denis shortly after receiving the so-called tapestries, Huc voiced his surprise. Expecting door curtains, he found instead unframed, but stretched, full-length canvases, which he considered far too beautiful to waste as *portières*.[21] The panels immediately went into the lobby of the *Dépêche* offices, and were on view for the exhibition of lithographs and paintings by the Nabis and others, which opened on 15 May.[22] Writing under the pseudonym Homodei,

Huc called Denis "the most surprising and most original decorator of the age," and referred specifically to "the two remarkable tapestries that decorate the center panel of the gallery."[23] At the close of the exhibition, Huc installed the panels into the framework of wooden moldings (*boiserie*) of his dining-room doors, where they were held in place by narrow strips of wood, painted a shade of burgundy, and set off with a fine, gold thread.[24] While it is uncertain whether Denis's original conception took into account this destination, Denis's palette of muted green, brown, and ocher would have harmonized perfectly with the dark green wallpaper with an ocher and beige pattern of Huc's formal dining room.[25]

Huc's marriage in 1894 provided one of the last occasions for a commission from Denis.[26] Huc requested that Denis illustrate the "marriage missals" for the wedding ceremony. Once installed, the *Spring* and *Autumn* panels were apparently never photographed. In Toulouse, far from the capital, they did not receive the critical attention given to Denis's other decorative projects, such as those for Baron Denys Cochin (1890–99 Intro., figs. 16–18), Charles Stern, and Gabriel Thomas (1900–30 Intro., fig. 5).[27]

In 1924, after a twenty-year silence, Denis wrote to Huc requesting a list of his works in Huc's collection with the aim of borrowing them for an upcoming retrospective at the Musée des Arts Décoratifs. Huc's response shows how distanced the two men had become, but also suggests Huc's continued belief that Denis's panels in a sense fulfilled his original request for tapestries: "Most importantly," he wrote, "I have two tapestries on Gobelins canvas: but it will be impossible for me to send them. They are inserted in the double doors of the salon."[28]

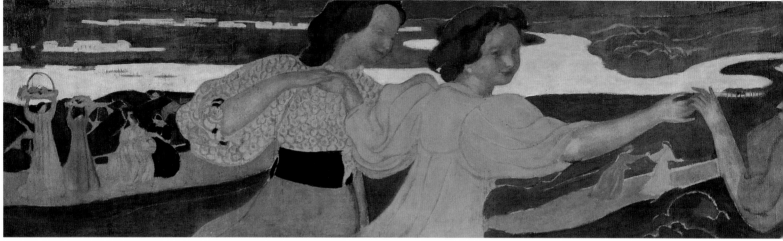

CAT. 19

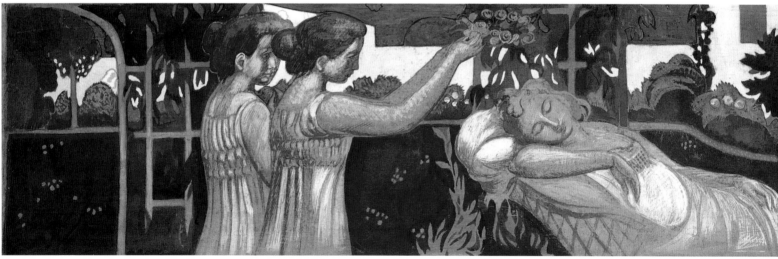

CAT. 20

CAT. 19–24

MAURICE DENIS

Decorations for the Bedroom of a Young Girl
1895–1900

19 *Farandole*
1895
Oil on canvas
48 x 205 cm (18 ⅞ x 80 ¾ in.)
Private collection

20 *Sleeping Woman,* or *Crown of the Betrothal*
1897/99
Distemper on canvas
53 x 219 cm (20 ⅞ x 86 ¼ in.)
Musée Départemental Maurice Denis "Le Prieuré,"
St.-Germain-en-Laye

21 *Birth*
1897/99
Distemper on canvas
53 x 196 cm (20 ⅞ x 77 ⅛ in.)
Musée Départemental Maurice Denis "Le Prieuré,"
St.-Germain-en-Laye

22 *White Roses*
1897/99
Distemper on canvas, mounted on wood
43 x 96 cm (16 ⅞ x 37 ¾ in.)
Private collection, Paris

23 *Young Goats*
1897/99
Distemper on canvas, mounted on wood
43 x 96 cm (16 ⅞ x 37 ¾ in.)
Private collection, Paris

24 *Doves*
After July 1900
Distemper on canvas
53 x 85 cm (20 ⅞ x 33 ½ in.)
Musée Départemental Maurice Denis "Le Prieuré,"
St.-Germain-en-Laye

IN 1895, DENIS FINISHED A BEDROOM DECOR that had been commissioned by Siegfried Bing for the inaugural exhibition of his Maison de l'Art Nouveau. Seven panels, originally exhibited as a frieze placed high on a wall around the entire bedroom, summarized and encapsulated Denis's philosophical, spiritual, and aesthetic beliefs—beliefs that he would hold dear throughout his life. Inspired by Robert Schumann's 1840 song cycle *Frauenliebe und Leben* (*The Love and Life of a Woman*), the story of a woman's love and life depicted in this frieze also unmistakably refers to the women in Denis's own life. This frieze, however, was but one part of the history of this theme for Denis. Although he was obliged to break up the ensemble after the exhibition, he subsequently painted a similar frieze for the bedroom he shared with his young wife, Marthe, at Villa Montrouge in St.-Germain-en-Laye. He retained this second version throughout his life, installing it in the two houses later inhabited by him and his family, and altering it to fit the new interiors. Until recently, the seven panels in the Musée Départemental Maurice Denis "Le Prieuré"[1] have been identified as the original frieze made for Bing's exhibition. From documents and correspondence, however, it is now clear that the works in the museum's collection consist of five panels from the second version, painted sometime between 1897 and 1899 (cat. 20–21, figs. 7, 9, 11), and two related panels, *Doves* (cat. 24) and *Prayer* (fig. 10), painted sometime after July 1900, as is discussed later in the essay.[2] Indeed, only one of the six panels included in this exhibition, the one known as *Farandole* (cat. 19), and now in a private collection, is part of the original "Bing" frieze. The remaining five (cat. 20–24), three from the Musée Départmental Maurice Denis and two from a private collection, represent repetitions and variants of the "Bing" frieze. In these, Denis revised the compositions to fit not only new interior configurations but new personal circumstances as well.

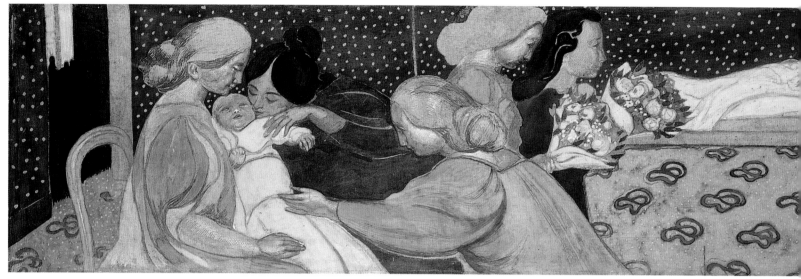

THE "BING" FRIEZE, 1895

In order to appreciate fully the deeply personal nature of these panels, one must return to the original seven-panel frieze for a bedroom ensemble made for the opening on 26 December 1895 of Bing's Maison de l'Art Nouveau. Bing's ambitious and controversial enterprise is discussed here by Nicholas Watkins as a venue that brought together a variety of styles in painting, decorative objects, and architecture under the larger banner of Art Nouveau (see Watkins). Denis had originally become acquainted with Bing when he was commissioned, along with a number of his Nabi colleagues, to create designs for stained-glass windows to be executed by Louis Comfort Tiffany (see cat. 29–30, 34).[3] In this opening exhibition, Denis was well represented as an *artiste-décorateur*, not only by the decorative frieze under discussion, but by the three pieces of furniture listed under the name Eugène Pinte in the exhibition's catalogue and described as "*Furniture prototypes for a bedroom* executed after designs by Maurice Denis."[4] Perhaps Bonnard's designs for a dining-room ensemble, submitted to the competition held by the Union centrale des arts décoratifs three years earlier, prompted Denis to undertake a bedroom suite.[5] Bing had been interested, as shown in a letter to Denis from August 1895, in Denis's opinions on the general design of the bedroom, including its color, feeling, and decorative details, seemingly more concerned with creating an integrated ensemble than with the content or theme of the panels.[6] It would appear, however, that Denis's decision actually to design the furniture himself went far beyond Bing's expectations and, in the same letter to Denis, he expressed his surprise and misgivings. Rather pointedly, Bing alluded to Bonnard's previous attempts at furniture design, warning Denis that "pieces that would show a certain roughness in the style of Bonnard—while eminently artistic as they might be—would, all things considered, be out of their element in the milieu which is in formation at the time at L'Art Nouveau."[7] As an alternative to Bonnard's stylistic eccentricities, he encouraged the young artist to look at the marquetry furniture of the better-known artist and designer Emile Gallé.

Denis forged ahead with his ideas for bedroom furniture and submitted rudimentary designs that were subsequently fabricated by Eugène Pinte (who had been chosen by Bing) as models for a "bed, a chair, and a console table to be placed between the two windows."[8] Unfortunately, as Pinte related to Denis, Bing "saw fit to drape the head of the bed with awful blue hangings and to enclose the poor armoire in a green fabric that's even worse."[9] According to critics, the results were funereal, prompting them to say that Denis's bedroom resembled a tomb, a "crematorium with a catafalque,"[10] or, in Camille Pissarro's words, "a lugubrious bedroom for a young girl! furniture resembling tombs and everything the gray of goose-shit!!!"[11] The critic Camille Mauclair, while critical of the pieces of furniture, which he found "unformed and truly ugly in their austere pretentiousness and their false 'Gothic character,'" justly remarked

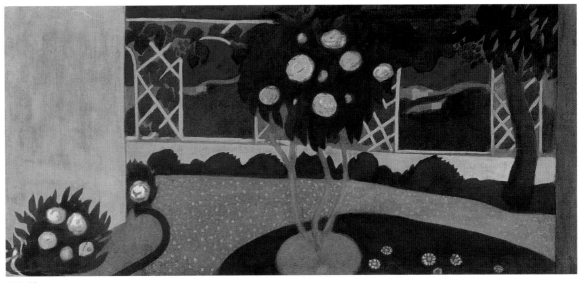

CAT. 22

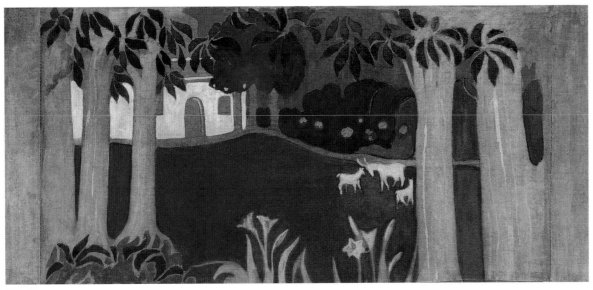

CAT. 23

CAT. 24

upon the "harmonies of green and pink" of the frieze.[12] The greenish palette may also indicate the artist's melancholy during this period. In February 1895, his first child, Jean Paul, died at only a few months of age.

The unanimous opposition to the heaviness of Denis's furniture contrasted with the largely positive reaction to his painted frieze, which was admired for its decorative qualities and for its spiritual charm, an aspect of Denis's work consistently praised by critics at the time. Writing for *La Revue blanche*, Edmond Cousturier called it "a kind of calendar of feminine existence," where "one finds the qualities of grace and restraint, the ecclesial charm that is given off by all of his compositions."[13] Gustave Geffroy specified the frieze's decorative character, insisting on its identity as both ornament and wall painting:

As regards the frieze, he follows the logic of his style and the evolution of his taste for ornamentation, by depicting a stream of images along the *muraille* in a veiled clarity, all the sweet figures of young girls, women, mothers as represented in scenes of betrothals, marriages, visits to a new mother, all conceived in supple lines and attenuated colors.[14]

THE LOVE AND LIFE OF A WOMAN

Robert Schumann's song cycle *Frauenliebe und Leben* (hereafter referred to as *The Love and Life of a Woman*) is based on poems of the same title written by Adelbert von Chamisso in 1830. The songs tell the story of a young woman's voyage through love, marriage, and motherhood.[15] Like Schumann, who incorporated only the first eight of the nine poems into his composition, Denis, in his panels devoted to the theme, omitted the tragic conclusion of the poem cycle, which describes the woman's pain at the death of the man she loves. The painter proposed his own interpretation, eschewing a literal illustration of the text, reflecting his conception of illustration, which he had already applied in illustrating his friend André Gide's *Le Voyage d'Urien* (1892). Denis's panels loosely interpret Schumann's *lieder*, picking up the themes that were most personally significant to the painter in this bittersweet tale of love and loss. Themes relating to the transition between girlhood and womanhood and the transforming power of love had a special importance for Denis. Indeed, he had already incorporated them in a suite of paintings on the seasons of 1891–92 (cat. 10–13), made during his courtship of the woman he married, Marthe Meurier.

Schumann's *lieder* were familiar to the painter, and he had certainly heard them at musical soirées at the home of his patron Henry Lerolle, perhaps performed by Madame Lerolle or by her sister Jeanne Chausson, wife of the composer Ernest Chausson. Marthe Meurier also sang them in the early days of her acquaintance with Denis. In a passage dated October 1891 from a section of his *Journal* entitled "The Loves of Marthe," Denis noted the perfect accord between Marthe's and his burgeoning love for each other and the mood of Schumann's two famous song cycles:[16] "With the background of music—like a décor—of the Dichterliebe, where there is sadness and irony—and the first three songs of the Frauenliebe, the consoling ones, our souls inclined toward each other in slow movements."[17] *Nos Ames, en des gestes lents (Our Souls, in Slow Movements)* is the title of one of the twelve lithographs assembled in Denis's album *Amour*, based on a long poem by the artist, an almost day-by-day account of his growing love in the weeks preceding his engagement.[18] Essentially, the themes of *Amour* are the same as those in *The Love and Life of a Woman*. The lithographs, published in 1899 by Ambroise Vollard, were actually made by Denis in 1897, the same year that he supposedly began his second version of the frieze.[19] In their entirety, Denis's panels for Bing consisted of *Farandole, Sleeping Woman, Crown, Bouquet, Toilette, Birth,* and *Fruit.* Today, unfortunately, with the exception of *Farandole* (cat. 19) and *Toilette* (fig. 2), the panels for Bing are known only from the photographic documentation ordered by Julius Meier-Graefe around 1899 for both the German and French editions of his new periodical, *Dekorative Kunst* (fig. 1).

In February 1896, Bing and Denis had a quarrel; Bing, who had paid almost 2,000 francs for the installation of the bedroom and the execution of the furniture, hoped to sell the frieze, but Denis had already found a buyer for *Farandole*.[20] Even though he had an opportunity to sell the panel, however, Denis was reluctant to break up the set, believing strongly that there was an internal logic to this series and that the panels functioned as a unified frieze, as evidenced by a letter of January 1896 to Henry Lerolle. Faced with a willing buyer for one of the panels and with Bing's irritation, the artist sought Lerolle's advice, telling him that he wanted to exhibit the entire frieze at the Salon de la nationale, and that he would be grief-stricken if he had to break up his "poor bedroom."[21] In a letter

FIG. 1(a)

FIG. 1(b)

FIG. 1(c)

FIG. 1(d)

FIG. 1(e)

FIG. 1(A–G)
Photographs, c. 1899, made for
Julius Meier-Graefe of the
seven-panel "Bing" frieze, the
only surviving documentation
of the entire frieze in its
original form: (a) *Farandole*,
(b) *Sleeping Woman*, (c) *Crown*,
(d) *Bouquet*, (e) *Toilette*, (f) *Birth*,
(g) *Fruit*. Denis family archives,
St.-Germain-en-Laye, and
archives of the Musée Départe-
mental Maurice Denis "Le
Prieuré," St.-Germain-en-Laye.

FIG. 1(f)

FIG. 1(g)

FIG. 2

FIG. 3

FIG. 2
Maurice Denis. *Toilette*, or
Young Girl, 1895. Oil on canvas;
49 x 33.5 cm. Private collection.
This was formerly in the collec-
tion of Adrien Mithouard.

FIG. 3
Maurice Denis. Photograph,
1898/99, of Denis's studio at
Villa Montrouge, showing two
children posing for the decorative
mural *Glorification of the Cross*,
completed in 1899 for the
Collège de Ste.-Croix in Vésinet
(now in Musée des Arts Déco-
ratifs, Paris, on deposit from the
Musée d'Orsay, Paris). In the
background are panels from
the first "Bing" frieze, *Birth*
and *Fruit*. Denis family archives,
St.-Germain-en-Laye.

FIG. 4
Photograph, c. 1903, of the
dining room of Count Harry
Kessler, Weimar, showing part
of the panel *Fruit* by Maurice
Denis. Bildarchiv Foto Marburg,
Germany.

FIG. 4

of 11 February 1896, the buyer, Gabriel Trarieux, an
old friend of Denis's, expressed his sympathy with the
artist's dilemma:

> Dear friend. You know that we would take your farandole with
> pleasure (at 700 francs, I think). But I don't want there to be
> any misunderstanding. If that would entail your renouncing a
> sale of the whole thing that you would find preferable, and if
> there's still time for this [to be concluded], I'd much prefer to
> wait for another occasion that also suits you. Otherwise, keep
> the painting, as you say, until I come by. And would you like to
> have it framed? So there's our agreement. You don't even have
> to answer me.[22]

Denis sold *Farandole* to his friend the same month.[23]
The fact that this panel had been left unframed by
Denis shows that the artist saw the panels as a frieze, as
an entity, a wall ornament. Even in Denis's own bed-
room, the later series of panels formed a frieze and
remained unframed, surrounded simply by moulding.
Another panel from the "Bing" frieze, known as
Toilette (fig. 2), was sold to Adrien Mithouard the fol-
lowing year.[24] The remaining five paintings were
taken back by Denis. A small photograph made by the
painter himself shows *Birth* and *Fruit* on the walls of
his studio at Villa Montrouge, where the Denis family
lived until July 1900 (fig. 3). The five panels remained
in Denis's possession until Vollard acquired them in
1904 for the sum of 2,200 francs, as shown by Denis's
mention of them as the "five canvases (of Bing)" in his
notebook of gifts and sales in the Denis family
archives. Four of these were sold later that year to
Count Harry Kessler, one of Denis's most ardent sup-
porters during the first decade of the century, and
were installed in a dining room in Kessler's new
Weimar mansion, the interiors of which were over-
seen by Henry Van de Velde.[25] The four panels were
placed high on the wall within paneling painted
"white and blue against a pink ground" (see fig. 4).[26]

Farandole
1895 (CAT. 19)

In 1896, Denis sold both the original panel of
Farandole to Gabriel Trarieux and the one he
described as a "double" or second version of the same
subject (*Farandole*, 1895; private collection) to his
friend Ernest Chausson.[27] Did Chausson ask for the
double after seeing the frieze at Bing's exhibition, or
was he aware of the panels beforehand, perhaps even
requesting the painting while Denis was still working
on the series?[28] Whatever the details behind the com-

FIG. 5

FIG. 5

Maurice Denis. *Triple Portrait of Yvonne Lerolle*, 1897. Oil on canvas; 170 x 110 cm. Private collection. Photo: Lyons 1994, p. 177, cat. 52.

FIG. 6

Maurice Denis. *Visit to the Violet Bedroom*, c. 1899. Oil on canvas; 46 x 55 cm. Galerie Berès, Paris.

mission, it is clear that the subject of the frieze was of particular interest to Chausson, as the friendship and artistic sympathy of the two men occasioned exchanges and sometimes shared inspiration during this period. To cite one example, Chausson composed a song dedicated to Marthe, "Les Couronnes," which not only shares a similar title with panels from both the first and second versions of the frieze (see below), but also a similar theme. In his song, Chausson set to music a poem by Camille Mauclair, creating a melancholy ballad about a young girl waiting for her *beau chevalier* (handsome knight).[29] No doubt the two men discussed aesthetic questions with each other, including their mutual admiration for Schumann, whom Chausson called "the true poet of the human heart."[30] While Chausson probably felt an affinity for the Schumann-inspired theme of *Farandole*, he may also have noted that this panel, which represents in the far-left background two women in flowing white dresses carrying baskets of flowers on their heads, had a motif similar to that of his ceiling tondo *April*, which Denis had painted for him in 1894 (see cat. 16).

Farandole represents a type of popular dance still performed at weddings and family celebrations— what we may call a line dance as opposed to a round or circle dance. This panel, with its girls dancing and

gathering flowers, echoes panels Denis painted in 1892 "for the bedroom of a young girl," especially *April* and *July* from that series (see cat. 12–13). Whereas the earlier ensemble dealt only with the life of a woman before marriage, *Farandole* already shows signs of a change, foreshadowing the transformation from carefree maiden to fulfilled bride. This is reflected in the image of the young girl turning her head away, referring to a line in Chamisso's first poem: "The games of my sisters I want to share no more."

While Marthe moved forward into fulfillment and motherhood, Denis turned to new models to express the uncertainty and anticipation of female life before marriage that Marthe had embodied for him only a few years earlier. Thus, much of the imagery of this panel seems to have been inspired by Henry Lerolle's daughter Yvonne. In his triple portrait of Yvonne from 1897 (fig. 5), painted shortly before her marriage,[31] Denis showed the three stages of transformation of a young girl into a woman: Yvonne holding roses close to her face, Yvonne picking up a rose, and Yvonne walking away toward a new life. Shown on the terrace of the Château de St.-Germain-en-Laye (where Denis himself was married), Yvonne stands out against the river Seine, which divides the landscape into two sections—the same landscape that Denis had rendered in a panoramic format in the frieze panel of *Farandole* (cat. 19). The portrait, which shares the blue and green palette of the frieze panels, also features in the far background a group of women dancing the farandole, an activity Yvonne had enjoyed.

The Frieze for Marthe's Bedroom
1897/99 (CAT. 20–24)

Having partially dispersed the "Bing" frieze, Denis decided, toward the end of 1896, to paint another set of panels for Marthe's bedroom at Villa Montrouge. The birth of Denis's daughter Noële on 30 June 1896 may have been a decisive factor here, sparking a renewed interest in the themes of birth and motherhood that he had introduced in the original frieze. This new series of *The Love and Life of a Woman* is bluer in tonality than the Bing version. It was painted not in oil but in distemper (*à la colle*), and quickly, as this medium requires, giving the work its fresh and velvety quality. The frieze matches the dark blue walls, verging on violet, of the bedroom, as can be seen in the artist's contemporary easel paintings of this room,

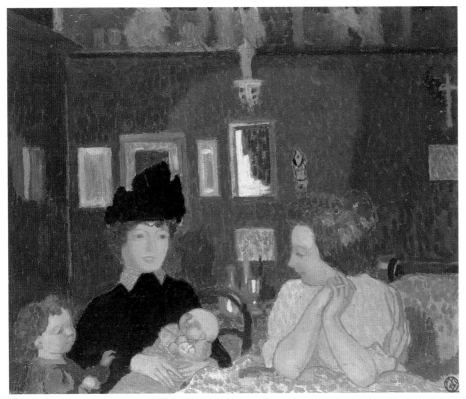

FIG. 6

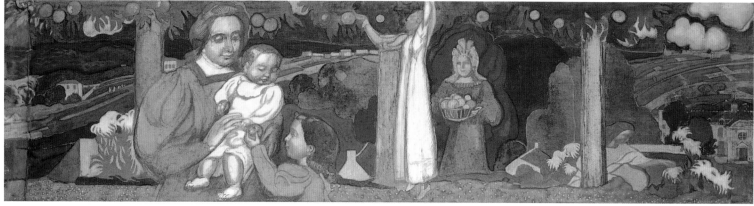

FIG. 7

FIG. 7
Maurice Denis. *Fruit*, or *Infancy*, 1897/99. Distemper or canvas; 53 x 200 cm. Musée Départemental Maurice Denis "Le Prieuré," St.-Germain-en-Laye.

FIG. 8
Maurice Denis. *Two Cradles*, c. 1900. Oil on cardboard; 44 x 50 cm. Private collection.

such as *Visit to the Violet Bedroom* (fig. 6). This canvas, depicting a visitor to Marthe and the infant Bernadette, born April 1899, also shows that the new frieze was already painted by that time, as a portion of it is visible at the top.

For three of the panels, *Sleeping Woman* (or *Crown of the Betrothal*; cat. 20), *Birth* (cat. 21), and *Fruit* (or *Infancy*; fig. 7), Denis retained the compositions almost exactly from the previous set. He replaced *Farandole* with another horizontal panel known as *Woman Embroidering* (or *Embroidering by the Sea*; fig. 9), which shows a woman (Marthe) waiting on an expansive shoreline. Presumably, the young woman's beloved will come to her from the sea, borne by the sailing ships on the horizon. But, taking into account Marthe's pregnancies at this time, it seems that she might also be

FIG. 8

waiting for an expected birth. Denis did not include the small panel, *Toilette* (fig. 2), in this new frieze for Marthe's bedroom. Instead, he completed the ensemble with two small panels, *White Roses* (cat. 22) and *Young Goats* (cat. 23). The neutral subject of these panels and the simplicity of their compositions suggest that these were intended as overdoors, meant simply to harmonize with and fill out the frieze. But above all, the biggest change Denis made was to combine the imagery of *Crown* (fig. 1c) and *Bouquet* (fig. 1d) to form a single and much longer panel, known as *Annunciation*.

When Denis moved his family to a larger residence on rue de Mareil in 1900, he kept five of the Villa Montrouge panels (two of which, *Birth* and *Fruit,* are shown in the painting *Two Cradles* [fig. 8], installed as pendants in the new violet bedroom), but replaced the two overdoors with two other panels, *Doves* (cat. 24) and *Prayer* (fig. 10). The latter two are twenty centimeters high, undoubtedly made to match the dimensions of the other frieze panels. They also have more overtly religious imagery than the overdoors; *Doves* symbolizes the Holy Spirit, and *Prayer* shows Noële with her mother, learning to make the sign of the cross.

Sleeping Woman
1897/99 (CAT. 20)

The sleeping woman (*dormeuse*) was a particularly significant theme for Denis; it was one that he had taken up several years before, during his courtship of Marthe, and that he included in both versions of the frieze. In 1892, Denis designed the stage sets for a play written by his friend Gabriel Trarieux, *Songe de la belle au bois (Dream of Sleeping Beauty)*,[32] which plunged the artist into the atmosphere of this fairy tale. He

FIG. 9

began a series of *dormeuses* with white skin whose beautiful features are those of Marthe.[33] *Sleeping Woman* may also echo the sentiments expressed in the fourth poem of Chamisso's *Love and Life of a Woman*, in which he described the condition prior to love as a form of sleeping or dreaming:

> My dream had come to an end,
> Childhood's peaceful, lovely dream,
> I found myself lonely and lost
> In an empty, infinite space.

The anguish of uncertainty preceding the future feeling of "realness" was a sentiment well understood by Denis, as attested by his journal at the time. His fear and trepidation about life, however, were put to rest through the love he shared with Marthe: "Here is the end of all doubt, it is the will to live. . . . Oh the joy of living outside of dreams!"[34] Finally asleep, the young girl in the frieze would soon be crowned by love, symbolized by the garland of roses brought by her friends. As in Denis's lithographic series *Amour*, mentioned above, she will soon be embraced by her knight (see, especially, the lithograph *The Knight Did Not Die on the Crusades*).[35]

FIG. 9
Maurice Denis. *Woman Embroidering*, or *Embroidering by the Sea*, 1897/99. Distemper on canvas; 53 x 232 cm. Musée Départemental Maurice Denis "Le Prieuré," St.-Germain-en-Laye.

FIG. 10
Maurice Denis. *Prayer*, after July 1900. Distemper on canvas; 53 x 94 cm. Musée Départemental Maurice Denis "Le Prieuré," St.-Germain-en-Laye.

FIG. 10

Birth and *Fruit*
1897/99 (CAT. 21 AND FIG. 7)

The panels *Birth* (cat. 21) and *Fruit* (*Infancy*; fig. 7) were personally significant to Denis, because he considered children to be the precondition of the happiness of a household and its lifeblood. As Chamisso expressed in the seventh poem of his cycle: "Only a mother can know / What it means to love and to be happy." Denis never grew weary of painting domestic love and maternal tenderness, returning to these themes with the birth of each of his nine children. Both versions of *Birth* (cat. 21 and fig. 1f) are inspired by his *Visit to the New Mother* (1895; private collection), which was painted at the birth of his first son, Jean Paul, but their format is adapted for the frieze. The scene is set in Denis's family environment, in the bedroom with violet walls in Villa Montrouge.[36] In the background, a young mother, fatigued by the effort of labor, languishes in bed while a maid moves away to the right. In the middle ground, two flower-bearing friends enter the room to visit the mother, and in the foreground, a baby appears clothed, pampered, and embraced by three other young women.

In a notebook (called "du Prieuré"),[37] Denis entitled the last panel *Fruit*, equating an infant with the fruit of a tree. It can be seen as an allegorical extension of the panel *Birth*; the child becomes the "fruit of thy womb" of the Catholic Hail Mary prayer. The apple presented to the infant by the young girl in the foreground is an ancient symbol of fecundity, but the gathering of fruit also signifies knowledge. Denis thus expressed his allegory of life and eternal new beginnings, a subject to which he would return again in later works such as *The Unchanging Orchard*, or *Harvest* (1898; Kröller-Müller Museum, Otterlo), and his ensemble for Gabriel Thomas called *Eternal Spring* (see 1900–30 Intro., fig. 5).

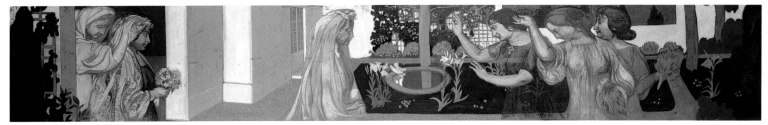

FIG. 11

Annunciation
1897/99, 1922 (FIG. 11)

The biggest change Denis made to the "Bing" original series was to combine the imagery of *Crown* (fig. 1c) and *Bouquet* (fig. 1d) to form a single and much longer panel. In the original frieze, these paintings, together with *Toilette* (fig. 1e), could be linked to form a triptych alluding to a woman's (Marthe's) spiritual engagement. The themes of annunciation, vocation, and purification are conflated in this panel, often called *Marriage* and entitled *Annunciation* in Denis's "du Prieuré" notebook. The gesture of the two bridesmaids on the right and their bow of respectful greeting designate the chosen one, in a way that echoes the traditional "annunciation" subject. Chamisso wrote in his third poem, "How could he from among all others / Have exalted and blessed poor me?" and in the second poem, "Only the worthiest of all / May your choice make happy / And I will bless the noble one." The bride given in marriage, trimmed with flowers and wearing a veil, symbolizes the concept of vocation. Although Denis did not include the subject of *Toilette* in this panel, he referred to the theme of purification, by representing a basin surrounded by lilies—symbols of purity and virginity—and doves, also symbols of purification, who drink from the basin.

In 1919, Marthe died after a long illness. Several years later, on 2 February 1922, Denis married Elisabeth (called Lisbeth) Graterolle. At that time, Denis repainted three faces in *Annunciation*, endowing them with the features of his new wife (two of the attending women at right, and the bride being crowned and holding a bouquet of flowers at left). Thus, as he added a new chapter to his life, he added his new bride's image to this "frieze of life."

The inventive iconography of *The Love and Life of a Woman*, which evolved over a number of years, represents a synthesis of Denis's life experience and spirituality. From the frieze's inception as a commission for a bedroom designed for public viewing, to its rebirth as ornamentation of his own bedroom, Denis reworked, altered, and adapted the original concept to reflect his changing circumstances, while never abandoning the idea that this be foremost a decorative ensemble. Loath to have it broken up in 1896, he quickly painted a second frieze that he could personalize even further and that would be a constant in his interior décor. The decorative concept for the bedroom, which is profoundly linked to its symbolic significance as a "frieze of life," corresponds to the Nabis' aspirations. Denis, moreover, created a work consistent with Bing's avant-garde definition of the industrial arts in his report *La Culture artistique en Amérique* (1896): "The strict subordination of questions of ornament to those of organic structure; the inner conviction that every useful object should draw its beauty from the rhythmic ordering of lines, which, before all other considerations, is subject to the practical function to be fulfilled."[38]

THÉRÈSE BARRUEL

FIG. 11
Maurice Denis. *Annunciation*, or *Marriage*, 1897/99; reworked 1922. Distemper on canvas; 53 x 341 cm. Musée Départemental Maurice Denis "Le Prieuré," St.-Germain-en-Laye.

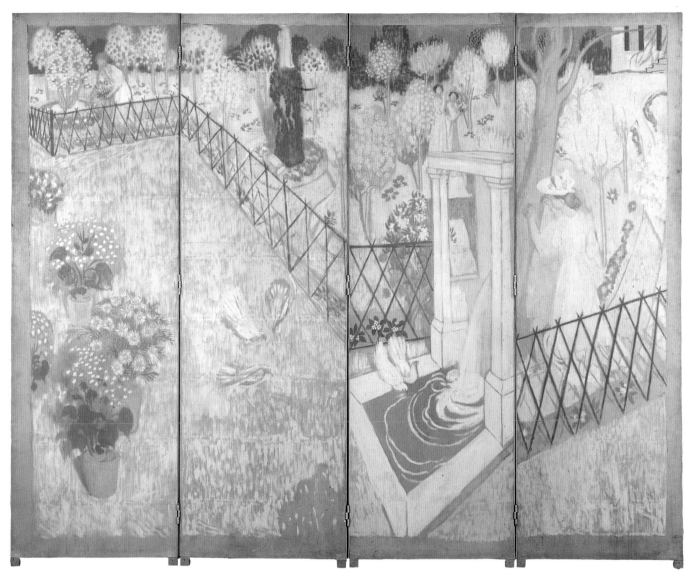

CAT. 25

CAT. 25

MAURICE DENIS

Screen with Doves, c. 1896

Oil on canvas
Four-panel screen: each panel, 164 x 54 cm
(65 x 21 ¼ in.)
Private collection, Paris

THE FOUR-PANELED *SCREEN WITH DOVES* IS the earlier of only two folding screens in Denis's oeuvre. While the artist made this first screen for his own personal use and never exhibited it during his lifetime, the second was part of a larger decorative ensemble commissioned by Charles Stern

in 1905 for his Paris mansion.[1] Denis's limited foray into decorative screens is surprising, given the fascination of the Nabis, especially Bonnard and Vuillard, with this art form (see, for example, cat. 1, 6, 80), and the high esteem in which these multipaneled paintings—whether antique, Asian, or contemporary—were held by progressive art collectors.[2]

However Denis may have rated the screen genre within his oeuvre, *Screen with Doves* demonstrates that he was as competent in this format as he was in the other decorative arts—ceramics, fans, costumes, wallpapers, stained-glass windows—he undertook in the 1890s. Indeed, *Screen with Doves* brilliantly demonstrates Denis's complete understanding of the compositional possibilities inherent in working on a flat surface that could be folded and shifted to create mul-

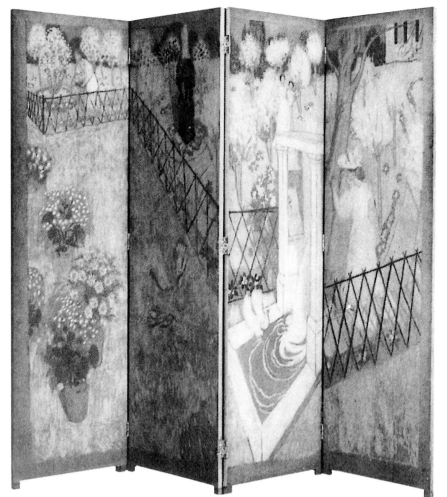

FIG. 1
Maurice Denis. *Screen with Doves* (cat. 25), folded. Photo: Frèches-Thory and Terrasse 1990, p. 170.

By using the trellis-work fence to divide foreground from background, as well as to link the four panels, Denis introduced the illusion of space and distance. Unlike Bonnard's *Nannies' Promenade* (cat. 6), and Vuillard's four-panel screen showing Stéphane Natanson and Misia Natanson (1890–99 Intro., fig. 13), whose flat, empty spaces are strongly influenced by Japanese art, Denis's screen design creates a sense of deep recession. On the other hand, both Bonnard's and Denis's screens share the conceit of a continuous frieze (of carriages in the first, and of flowering trees in the second) to delineate the horizon and create a decorative top edge. For a free-standing screen, which was generally placed on the floor with furniture around it, such a design was both aesthetic and practical, since it required decoration in the upper portion that could be seen above the furnishings and seated guests.

As is true of many of Denis's large-scale decorative works and easel paintings after 1895, the palette of *Screen with Doves* is radically different from the warm, jewel-like color schemes favored by Vuillard (see cat. 31, 35–39) or the monochromatic hues preferred by Bonnard (see cat. 5). Indeed the clear, pastel shades used by Denis in this case would have been difficult to integrate within the dark, richly patterned color schemes of a typical late nineteenth-century interior. More than a wall or ceiling painting, whose elevated position within a room can distinguish it from its environs, a folding screen must compete more actively with upholstered furniture, rugs, wallpapers, and other interior accessories on the same level. Given its light blue, mauve, ocher, and white colors, *Screen with Doves* probably was not intended for a more public area of Denis's house, but rather for a boudoir or woman's bedroom. Denis executed this screen one year after Siegfried Bing commissioned from the artist a seven-panel frieze on the love and life of a woman for "the bedroom of a young girl" (cat. 19–24) on the occasion of the inaugural exhibition of his Maison de l'Art Nouveau in 1895. Perhaps Denis conceived of the screen, which, like the frieze, has a palette dominated by blue-greens, pinks, and whites, as an extension of the earlier project, complementing the second set of panels on the theme that he created for and installed in his own bedroom. This would also explain the imagery of the screen, which, like that of the Bing frieze, is highly personalized on a number of levels.[4]

The screen shows women picking flowers and strolling through a tree-filled garden or orchard. In the

tiple viewpoints. The entire composition is anchored by the elegant grilled fence that runs diagonally across the panels from left to right and from top to bottom. Denis had first used this compositional device in 1892 in the decorative painting *April* (cat. 12), part of a suite of paintings of the seasons. However, the effect is much more dramatic on a four-part, movable surface. The fence introduces a dynamic element into an otherwise soft and delicate image by interacting with the folding screen. As Michael Komanecky pointed out, the fence shifts directions several times, precisely at the breaks between the screen panels.[3] When the screen is folded, as it would be in a domestic interior (fig. 1), the image's space is activated in a way that echoes the zigzag progression of the fence from the left background to the right foreground. The artist further accentuated this alternating rhythm by filling the foreground of the first and third panels (with potted plants and a fountain) and leaving the foreground empty in the second and fourth panels.

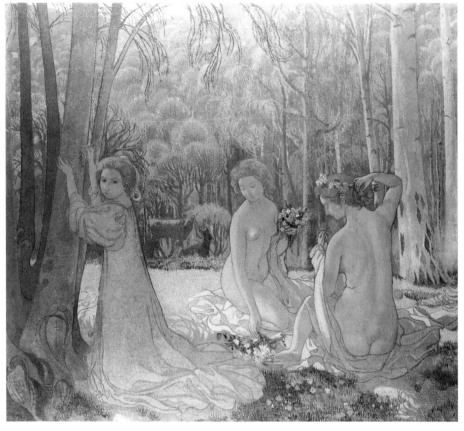

FIG. 2
Maurice Denis. *Figures in a Springtime Landscape*, or *The Sacred Wood*, 1897. Oil on canvas; 157 x 179 cm. The State Hermitage Museum, St. Petersburg.

my dove."[6] The mystical and highly figurative language of the Song of Solomon appealed to Denis, who mentioned it several times in his journal during this period.

On another level, the subject of *Screen with Doves* embodies the artist's love for his wife. The screen is one of a number of images inspired by "Les Amours de Marthe," Denis's visual and literary journal, dating from mid-1891 to mid-1893, in which he charted the early stages of his courtship of Marthe.[7] For example, *Figures in a Springtime Landscape,* or *The Sacred Wood* (fig. 2), which the artist exhibited in 1897 at the nineteenth Salon de la nationale, uses a trio of women—all identifiable as Marthe—to signify the three stages of a romantic relationship—love, betrothal, and marriage—a theme Denis had featured in his aforementioned frieze for Bing's Maison de l'Art Nouveau. Love is symbolized by a woman who has just carved the artist's initials, "MAVD," into a tree;[8] betrothal by the woman wearing a crown of flowers; and marriage by the woman who picks flowers for her wedding bouquet.[9] So too in *Screen with Doves*, the figure poised to carve initials (most probably Denis's) into a tree is certainly Marthe, whose action here perhaps symbolizes her love for and reaffirms her claim to Denis, as a man and as an artist.[10]

The two doves drinking from the fountain offer both sacred and profane significance. From his Catholic upbringing and his Lycée Condorcet education, Denis would have been aware of the multiple meanings of the dove. In the Middle Ages, it represented chastity, innocence, and conjugal fidelity. In Greek mythology, however, the dove was one of Venus's birds, and thus stood for love and voluptuousness.[11] The action of the young woman carving (her lover's) initials into a tree could thus be interpreted as symbolizing her betrothal, her spiritual union with another in the eyes of God, and the commencement of her sexual life.

One of Denis's early studies for the screen shows that he originally intended to emphasize more strongly the differences between the two areas on either side of the fence (fig. 3).[12] In the sketch, he placed the potted plants on cobblestones, suggesting beyond the fence a road or the front courtyard of another residence, a secular world that contrasts with the secluded garden. In the screen, Denis extended the pale grass to both sides of the fence, perhaps to avoid introducing yet another pattern of circular motifs that would interrupt a visual progression into the distance.

fourth panel, a female figure, apparently carving something into the bark of a tree, stands behind a fountain at which two doves drink. *Screen with Doves*, like many of Denis's works dating to just before and after his marriage to Marthe Meurier, affirms his belief in the compatibility of spiritual and secular themes. The enclosed garden, an age-old metaphor for virginity; the fountain, representing purity or rebirth (as in the ritual of baptism); and the doves, symbolic of Christ or of the Holy Spirit, all suggest that these are Christian women, chaste and isolated from the outside world. Their seclusion is evoked as well by the convent- or chapel-like edifice with long narrow windows at the upper right of the fourth panel.[5] As Guy Cogeval remarked, the entire scene seems to refer obliquely to the second chapter of the Song of Solomon, which is a lover's declaration of physical passion for his betrothed that has traditionally been interpreted as an allegory of Christ's love for the Church. Cogeval also drew attention to a contemporary drawing by Denis for the periodical *L'Art décoratif*, featuring doves and a fountain and bearing a paraphrase of a part of the Song of Solomon: "Arise, my beloved, my fair one and be

FIG. 3
Maurice Denis. Sketch for
Screen with Doves, c. 1896. Pastel
on paper; 48.6 x 61.7 cm.
Private collection.

He may also have intended to increase the ambiguity of the scene by erasing clear-cut distinctions between sacred and profane.

It has been noted that the asymmetry of the composition of *Screen with Doves*, dramatically embodied in the zigzagging fence, is highly unusual in Denis's work. As Werner Hofmann recently observed, *Screen with Doves* seems to be the one exception to Denis's Catholic sense of order—the aspect of his personality that made it impossible for him to continue with the blurred outlines and the more unstructured and "chaotic" compositions of his Nabi years. This screen is in fact unique to Denis's art, not only because it is one of his rare attempts to paint in this format, but also because it lacks a centralized perspective. The multiple entry points into the space of the picture are compositionally so radical that they prompted Hofmann to describe the work as a precursor of the multiple viewpoints and visual realities of Cubism (an interpretation that Denis would probably not have appreciated).[13]

Unlike the majority of Nabi screens, which have been dismantled and remounted as wall panels, *Screen with Doves* retains its full impact as both decorative surface and functional object. Made during the time of Denis's most intense examination of love's transforming power, it can also be seen as a semi-autobiographical statement. Since the artist kept it with him throughout his life, one can only presume that for him this screen had great personal and artistic significance.

KER XAVIER ROUSSEL

26 *The Seasons of Life* (first version)
1892/93
Oil on canvas
58 x 123 cm (22 ⅞ x 48 ⅜ in.)
Musée d'Orsay, Paris

27 *The Seasons of Life* (second version)
1892/93
Oil on canvas
60 x 130 cm (23 ⅝ x 51 ⅛ in.)
Private collection

AROUND THE TIME VUILLARD COMPLETED six overdoor panels for Léonie and Paul Desmarais (see 1890–99 Intro., figs. 11–12; cat. 31, fig. 1), Roussel conceived several canvases of similar format and size on the theme of women in public parks and landscapes, including these two, known as *The Seasons of Life* (here called "first version" and "second version" for ease of reference, although their actual relationship is unknown).[1] Because Roussel dated and exhibited so few of his works (destroying more than he kept), it is difficult to know with certainty the date and purpose of these overtly decorative panels. Apparently made without a specific destination in mind, the two paintings, like many by Roussel, were only discovered in the artist's studio after his death in 1944. Because so little information is available about these works, they have been interpreted variously: as mural decorations for a city hall, as pendants "unhappily separated" (*malheureusement separés*), and as unrelated, single-panel experiments that share a horizontal format and friezelike composition.[2]

The different dimensions of the two panels, however slight, suggest that they may be independent endeavors. Also, despite the title that the two now share, the symbolic conceit of the seasons mirroring the different stages of human life is only really illustrated in the "first version" (cat. 26). In it, an older woman (perhaps symbolizing the "winter of life") is included as one of four female figures, whereas in the "second version" (cat. 27), all of the women depicted are youthful. Despite the specific symbolism that the two may or may not share, they both are evocations of a theme—a modernization of the traditional, religious subject

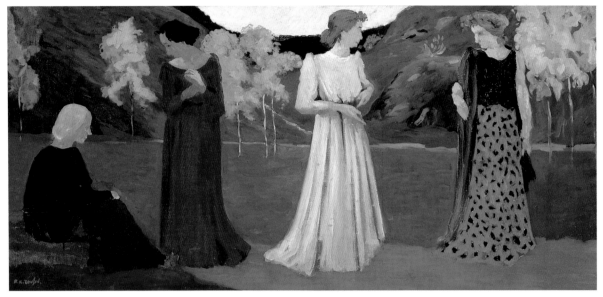

CAT. 26

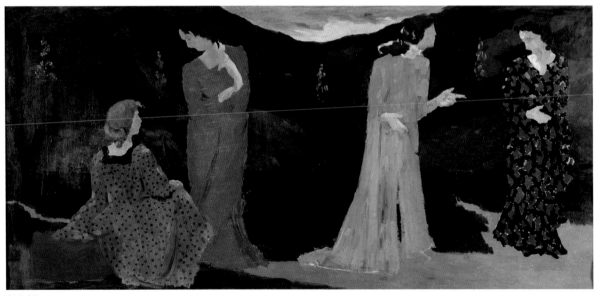

CAT. 27

known as a "sacred conversation"—so popular in the art of the Nabis at this time.

Both panels show women attired in the long, loose, quasi-medieval robes seen in paintings by Denis (see cat. 17–18) and Vuillard (see cat. 31) at this time. Roussel's choice of fashion and his decision to place figures on a shallow ledge parallel to the picture plane may have been partly inspired by his awareness of costume and set designs for puppet shows. We know that his friends Denis, Ranson, Sérusier, and Vuillard and his future wife, Marie Vuillard, all took part in puppet-theater productions around this time.[3]

In both versions of *The Seasons of Life*, the women stand in front of, rather than exist within, the landscapes depicted, although the landscapes themselves differ in their treatment. In the "first version," for example, the landscape is decorative, but at the same time naturalistic, with identifiable trees and a sloping horizon creating a sense of real space, just as the colors used to define the forms seem appropriate and objectively observed. This is not the case with the slightly larger "second version," in which the landscape is reduced to a flat, decorative backdrop. Trees and topographical details are eliminated. Instead, the women

FIG. 1
Paul Sérusier. *Fabric Vendor*, 1892. Oil on canvas; 73 x 92 cm. Petit Palais—Musée d'Art Moderne, Geneva.

are lined up against a dark-green curtain of hills (perhaps another allusion to the puppet theater), which slopes gently in the center, allowing a bit of bright sky to break the otherwise enclosed and stagelike space.

Gisela Götte suggested that, like Vuillard and Denis at this time, Roussel was greatly influenced by the small, horizontal predella panels by Quattrocento masters Fra Angelico and Perugino. Roussel would have been familiar with them from his visits to the Musée du Louvre, as well as from a trip to London in November 1892 with Vuillard, where the two admired the paintings of Fra Filippo Lippi and Fra Angelico, among others, in the National Gallery.[4] Both Roussel's and Vuillard's paintings at this time show the influence of these Italian Renaissance works in their strongly horizontal formats and the placement of figures close to the viewer. Roussel also shared with Vuillard a more immediate source of inspiration—Vuillard's mother's dress shop. The colorful, patterned dresses in Roussel's panels are very close to those worn by the women in Vuillard's exuberant *Dressmaking Studio I* (cat. 31). There is no reason to doubt that Roussel was also familiar with Madame Vuillard's sewing workshop, with its infinite varieties of patterns and fabrics, and continual female interaction.[5]

The simplicity of these figures has direct connections to Denis's work in the early 1890s as well. The old woman seated on the left in the first version of *The Seasons of Life* is very similar to the static, seated female figures in Denis's *September Evening* and *October Evening* (cat. 10–11). Unlike Denis and Vuillard, however, Roussel did not consistently flatten and distort his subjects for decorative effect. As Götte pointed out, in Roussel's "Nabi phase"—that is, the years from 1892 to 1895 when he was most influenced by Nabi theories—the artist experimented with and vacillated between the depiction of flat and illusionistic space.[6] Thus, just as he varied his treatment of the landscape in each panel, Roussel treated his figural types either as pure, flat profiles (the first figure on the left in the "first version") or as volumetric forms (the third figure from the left in the "first version").

It is possible that one of these panels was exhibited at the Barc de Boutteville gallery's exhibition of Impressionists and Symbolists in 1893 under the title *Women Talking (Femmes causant)*. Reviewing Roussel's submissions to this show, Léon Paul Fargue praised the indecisive and ambiguous qualities that make Roussel's paintings so difficult to categorize iconographically and formally:

The expression of youthful pleasures, of the experience of a new and beautiful gown, of the anxiety not to ruin it, of the candid and serious charm of a young woman to whom springtime comes once again, of the beginning of a summer holiday—of all that produces an unexpected calm after a vague change in the air . . . and what have you. Paintings dryly and richly decorated, with the opaque sparkle of woven and lacquered dresses.[7]

The current title these two panels share, indicating the symbolic significance of the seasons in terms of the stages of human life, dates from after the artist's death and suggests a different reading from Fargue's. Most probably the "second version," in which all of the figures are youthful, was exhibited at Barc de Boutteville. If instead it was the "first version," Fargue, a Symbolist writer attuned to nuance and poetry, would surely have commented on the woman with white hair dressed in black, easily seen as an allegorical representation of the "winter of life" within the larger theme. For this old woman, Roussel seems to have borrowed rather than created a figural type—in this case the Breton women from the Pont-Aven paintings and lithographs by Paul Sérusier and Emile Bernard.[8]

Compare, for example, this white-haired figure with the old women in Sérusier's *Fabric Vendor* (fig. 1), exhibited in 1893 at the same Barc de Boutteville exhibition reviewed by Fargue. Roussel's seated woman has a bulbous nose similar to that of Sérusier's women (as well as to the younger girl seen in profile at left), and her white hair wraps her head like the traditional headgear worn by Breton women and known as a *coiffe*. The comparison between Sérusier and Roussel can be extended to the subject as well, since both Roussel's frieze and Sérusier's image of Breton women of different ages clustered around an aged figure can be seen as symbolic representations of the life cycle.[9]

Roussel's two panels reflect his experimentation with Nabi themes, compositions, and formats—all of which he would reject by the end of the decade. In 1893, he is thought to have submitted another pair of paintings to a mural competition for the city hall at Bagnolet (cat. 28; cat. 28, fig. 1). Although similar in format and subject (women conversing in a parklike setting), Roussel executed these later panels in a palette reminiscent of that of Pierre Puvis de Chavannes and included architectural details that anchor the compositions in real time, perhaps in an effort to render them appropriate for a public space. The two *Seasons* panels, on the other hand, are more personally significant, made when Roussel was looking for an artistic as well as spiritual path and—like Vuillard at this time—a working philosophy. Compared to the panels for the Bagnolet competition, these are more tentative, the result of Roussel's interest in Nabi principles of distortion and color theories. Because of this, they are also more derivative, compiled rather than composed, and drawn from the past (the Quattrocento) and from the works of Bonnard, Denis, Sérusier, and, most importantly, Vuillard. While falling short of Vuillard's fully conceived and confident panels for the Desmarais interior, Roussel's *Seasons of Life* mark the most decidedly Nabi-like phase of the artist's evolution. By 1895, he had embarked on paintings and pastels of the landscapes of Arcadia with which he would be most closely associated after 1900.

CAT. 28

KER XAVIER ROUSSEL

Conversation on a Terrace, 1893

Oil on canvas
39.5 x 60 cm (15 ½ x 23 ⅝ in.)
Private collection

CONVERSATION ON A TERRACE SHARES WITH *Meeting of Women* (fig. 1) a horizontal format organized around an architectural grid, as well as a palette dominated by chalky blue and salmon. They have always been considered maquettes for a decorative mural, because both compositions contain blank rectangular areas indicating the openings of doors or windows that would have had to be accommodated by the finished mural. Only recently have the two panels been identified as Roussel's submissions for a mural competition for the *mairie*, or town hall, of Bagnolet, a suburb southeast of Paris.[1]

As Nicholas Watkins notes in his essay for this book, mural competitions for public buildings and churches were part of the Third Republic's program to create a visual language of Republican citizenship and also provide a healthy forum for its younger artists. If Roussel had succeeded in winning the competition, he would have been one of the only Nabis to gain an official public commission. Although Denis painted murals for churches beginning in the mid-1890s, it was not until 1912 that he, along with Vuillard and Roussel, was asked to paint decorations for the Théâtre des Champs-Elysées (see 1900–30 Intro.). But even this establishment, while certainly accessible to a great public, was privately owned and thus exempt from the state's system of public competitions and awards.

Albert Aurier's important article "Beaux-Arts: Les Symbolistes," published in 1892, compares Roussel's intellect, vision, and sensibilities to those of Pierre Puvis de Chavannes, and concludes that if Roussel fulfilled his early promise, he would become "a marvelous decorator" (*un merveilleux décorateur*).[2] Roussel and others in his circle admired Puvis, and it is indeed probable that Roussel's choice of palette and large, monumental figure types in these mural studies, stems, at least in part, from the artist's desire to echo the muralist.[3]

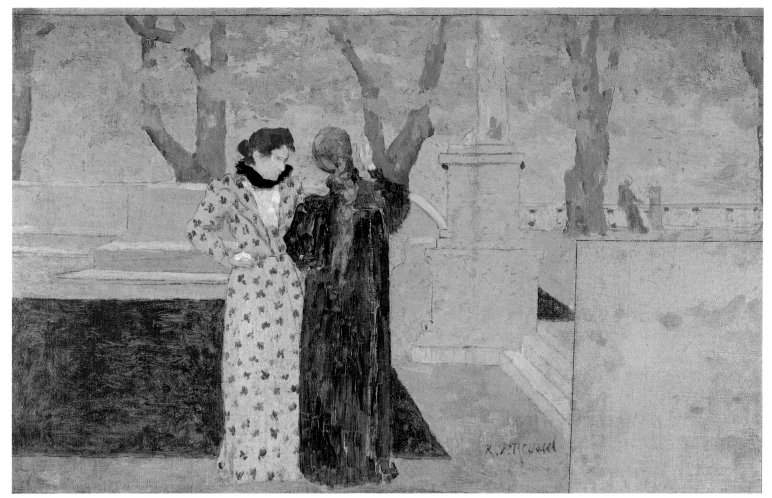

CAT. 28

These panels are especially close in spirit to Puvis's mural *Inter artes et naturam* (fig. 2), which had been commissioned for the Musée des Beaux-Arts, Rouen, and exhibited in 1890 (before its final installation) at the Salon de la nationale (often called the Salon de Champ-de-Mars to distinguish it from the official Salon on avenue des Champs-Elysées). It is also similar to oil studies painted in 1892 by Puvis's student Alexandre Séon for a mural for the town hall of Montreuil.[4] Although ultimately rejected by the jury, Séon's studies were exhibited at the second Salon de la Rose + Croix in the spring of 1893, where Roussel may have seen them.[5] Although Séon's idyllic mural studies are much closer in spirit to Puvis's works (featuring men and women in semi-antique garb in an enclosed garden), Roussel's studies share with Séon's the same pastel tints, flattened space, emphasis on line over modeling, and matte surface characteristic of Puvis's decorative aesthetic. Roussel, however, was less interested in classical resonance, insofar as his figural

types were concerned. While Puvis and Séon created female types alluding to the allegorical nature of decorative painting, Roussel's figures wear the by-now-familiar kimono-inspired, or "quasi-medieval" (as in Roussel's *Seasons* [cat. 26–27]), gowns that, while different from Parisian fashions of the 1890s, would have been decidedly contemporary in feeling at the time they were painted. Thus the conversation of the women in both of Roussel's panels (cat. 28 and fig. 1) would have seemed a real encounter and the viewing of this exchange an intrusion on something happening not in a distant past, but in the present moment.

The panels, with their intimate yet ambiguous subjects, were neither up-to-the-minute records of Bagnolet society, nor remote evocations of another time and place, and indeed were not appropriate to the function of a mural as a patriotic, uplifting, or even moralizing backdrop for the general public. This point is obvious when one compares Roussel's works to those of the winner of the Bagnolet competition,

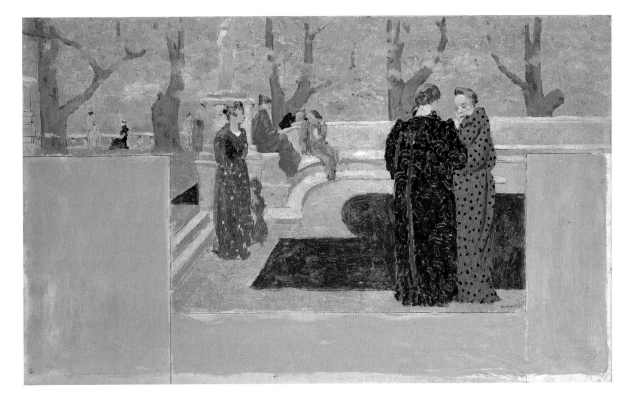

FIG. 1
Ker Xavier Roussel (French;
1867–1944). *Meeting of Women*,
1892/93. Oil on canvas;
44 x 73 cm. Norton Simon
Art Foundation, Pasadena.

FIG. 2
Pierre Puvis de Chavannes.
Inter artes et naturam, 1890.
Oil and wax on canvas; 295 x
830 cm. Musée des Beaux-Arts,
Rouen.

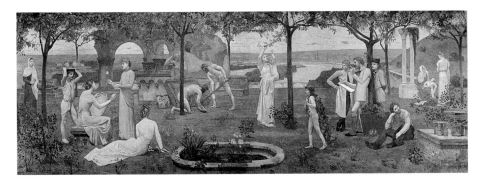

Pierre Vauthier, whose mural entitled *Summer, The Festival of Bagnolet, The Day of the Crowning of the Rose Queen* (Watkins, fig. 4) shows a contemporary event, and thus mirrors the daily life of the city for which it was made, or even to Puvis's murals, whose draped figures and fragments of temples suggest the ancient past. The critic Arsène Alexandre, in his account of the competition, praised the ambiguous qualities in Roussel's studies, while recognizing that it was unlikely they would win the competition:

Among the projects that we should point out one finds first off M. Roussel's [mural design], of great nobility and simplicity, and at the same time, of a rarefied harmony. But it is so much outside of the type generally admitted, that we do not feel that we are wrong in predicting that the jury will not choose it.[6]

Roussel chose to set the scenes of his mural designs in a city park, or *jardin public*, near the apartment of Vuillard, whose sister he married in 1893 (the stone terrace is probably the famous "Terrasse des Tuileries," looking south toward the Seine near the Pavillon de Flore, the westernmost wing of the Louvre).[7] Vuillard would use the same backdrop the following year in his nine-panel ensemble for Alexandre Natanson, *Public Gardens* (cat. 32–33), but with a much different effect. In his panels, Vuillard evoked the Tuileries and Luxembourg gardens with their lively groups of women and children, seen amidst regularly aligned trees with canopies of chestnut leaves. The women in Roussel's panels, in contrast, do not play games, or attend children, but are instead engaged in solemn, perhaps sacred, conversations. The monumental and hieratic figural types act as visual analogues to the heavy and severe architecture that surrounds them. Roussel's women converse in a setting emphasizing the older features of the park, whereas Vuillard's chatting women and gamboling children move among wrought-iron chairs and benches, the decorative qualities and modern implications of which Vuillard used to complement the fashionable striped blouses and skirts of his female cast.[8]

Within the carefully composed, man-made spaces of Roussel's panels, nature intrudes in the green

FIG. 3
Ker Xavier Roussel. *Chat in a
Garden*, 1893. Lithograph after
an original drawing, repr. in
Revue blanche 5, 23 (15 Sept.
1893). Photo: Paris 1993, p. 237,
cat. 97.

patches of lawn and in the decorative fringe of trees.
The latter not only connects one panel to the next,
but creates a pattern against the brilliant blue sky. With
their delicate, cloudlike leaf patterns, the trees con-
tribute a further oriental accent to these females
dressed in kimono-inspired garments decorated with
patterns borrowed from Japanese prints.[9]

A drawing and subsequent lithograph (fig. 3), pub-
lished in *La Revue blanche* in September 1893 as *Chat
in a Garden*, may have been the first idea for these
mural projects.[10] In the lithograph, the architecture is
even more dominant and the women shown are
engrossed more actively in conversation. The *japonist*
intentions here are apparent, not only in the vertical
(*kakemono*) format and the tree that divides the image
with an elegant S-curve, but also in the tight, linear
composition that unites figures with architecture
and nature.

Although Roussel's paintings do not generally
include recognizable models, as do Denis's works of
this period, the woman with the braided hair seen
from behind in *Conversation on a Terrace* may well be
Marie Vuillard. Most photographs and paintings show
Marie with her hair up, but there is one very curious
and daring painting by Vuillard showing him embrac-
ing his sister, in which Marie's thick, reddish-brown
braid dominates (*Self-Portrait with Sister*, c. 1892; Phila-
delphia Museum of Art). She is perhaps pictured again
in *Meeting of Women*, this time with her long hair slung
over one shoulder. Here she speaks to an older
woman, perhaps an evocation of Madame Vuillard,
who was for Roussel (whose parents were divorced) a
second mother. Given her daughter's impending mar-
riage to Roussel, Madame Vuillard would have been
particularly involved in their lives at this time.[11]

It is difficult to know exactly why Roussel, seem-
ingly the least ambitious and aggressive of the Nabis,
chose to embark upon such a patently official project.
Mural painting on a grand scale (outside of theater and
puppet show décors) was a dreamed of, but uncertain,
possibility among the Nabis in the early 1890s. The
upcoming catalogue raisonné on this artist will un-
doubtedly give a better idea of Roussel's artistic evolu-
tion and scope, and help to clarify the intent of these
two panels.[12] In the meantime, this unsuccessful mural
project eloquently illustrates the challenge faced by
Roussel, Vuillard, and Bonnard (and to a lesser extent
Denis) when forced to make public and on a grand scale
their preference for Symbolist and intimist subjects.

CAT. 29–30

KER XAVIER ROUSSEL

29 *Women in the Countryside*
c. 1893
Pastel on paper
42 x 26 cm (16 ½ x 10 ¼ in.)
Private collection, courtesy Galerie Hopkins-
Thomas-Custot, Paris

30 *Garden*
1894
Oil on cardboard, mounted on Japanese paper,
mounted on honeycomb panel
121 x 91.4 cm (47 ⅝ x 36 in.)
Carnegie Museum of Art, Pittsburgh, gift of Mr. and
Mrs. John F. Walton, Jr., 1969

THESE TWO DESIGNS FOR STAINED-GLASS
windows were executed during a period in
which Roussel, along with a number of his
Nabi colleagues, was experimenting with the genre.
From the beginning, the Nabis were attracted to
stained glass for the formal opportunities it offered
(divided colors and forms) and for its association with
the medieval period, one of the golden eras of *décora-
tion*. *Women in the Countryside* (cat. 29) was probably
made by Roussel as an independent exercise, as no
commission or intended destination for the work is
known. *Garden* (cat. 30), however, is known to have
been among the cartoons commissioned by Siegfried
Bing in 1894 to serve as models for stained-glass win-
dows produced by the American designer Louis
Comfort Tiffany.[1] The windows that resulted from the
1894 commission, exhibited at the 1895 Salon de la
nationale and Bing's Maison de l'Art Nouveau in
December 1895, in many ways represent the apex of
the Nabis' involvement with the burgeoning stylistic
movement of Art Nouveau.

Women in the Countryside is probably somewhat
earlier than *Garden* in date, since it is close in spirit to
other works by Roussel of around 1893, such as the
paintings, lithographs, and charcoals of women in
forested settings typical of the artist's most Symbolist
phase.[2] The figures, set within a landscape of tended
fields, massive rocks, and spiky fir trees, are engaged in
activities that defy clear interpretation. The woman in
the left foreground, for example, gestures mysteriously

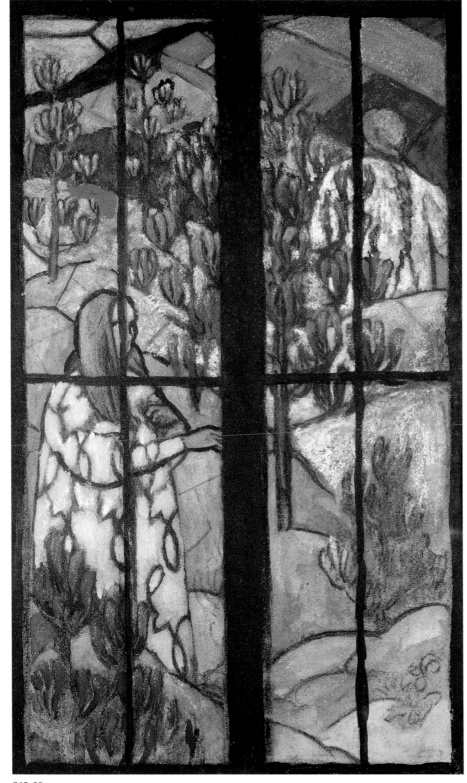

CAT. 29

and is oblivious to the woman with the long braid at top right (who is very similar to a figure in a decorative mural project also from this time [cat. 28]). The women wear heavy, unstructured housedresses (in marked contrast to the body-hugging, kimonolike robes of the women in Roussel's decorative panels) that also resemble the "missionary" dresses worn by Paul Gauguin's Tahitians (see, for example, his *Young Christian Girl*, 1894; Sterling and Francine Clark Art Institute, Williamstown, Mass.). In *Women in the Countryside*, the heavy, unrevealing dresses and the solemnity of the women's gestures suggest that Roussel may have had a religious setting in mind for the final window (which was never realized). Also contributing to this feeling are the heavy black lines that divide the composition, indications of the window bars that would transect the actual stained-glass window. These bars, however, seem as if they were laid over a pre-existing drawing, giving the window an experimental quality. Roussel does not seem to have altered the style of the composition to accommodate the demands of the medium of stained glass as much as he would in *Garden*.

When Siegfried Bing, Tiffany's collaborator, called upon the Nabis and their circle to submit window designs,[3] Roussel created in *Garden* something very different in composition and subject. Roussel's brother-in-law, Vuillard, and the artist Henri Ibels played a major role in getting their friends involved. Writing to Denis in the summer of 1894, Vuillard voiced his approval of a proposed plan to work with the revolutionary glass designer:

Here is a proposition that comes from Ibels. He has made the acquaintance of Bing, the merchant of curios who would like to present, in France, with the help of artists/decorators, a special type of colored glass where one can achieve all kinds of color, including gradations in the same color while the glass remains transparent. . . . Ibels has told him about all of us and Bing is waiting to show us samples. He would take it upon himself to have our sketches executed because the fabrication itself is a secret, which they will not divulge. Would you like to come to see it? It might interest you. All of us have made an appointment at about 3 p.m. in my studio. Come, since it should interest you and Bonnard most of all.[4]

The artists submitted designs (see cat. 30, fig. 1; cat. 34) that were sent to Tiffany in late fall of 1894, and thirteen were returned as stained-glass windows by mid-April 1895 in time to be exhibited at the Salon de la nationale.[5] Although one cannot know how they were installed in the section of "art objects," the effect was

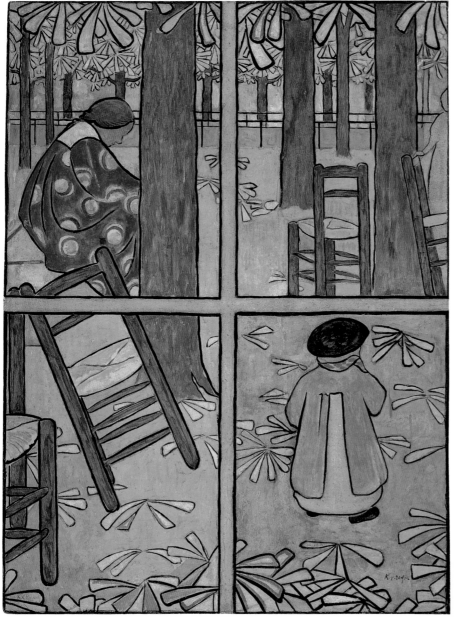

rich. We cannot help dreaming of the magic of these windows with the sun shining through them in the privacy of our own homes, brightening the monotony of daily life with their exuberant gaiety, the enchantment of their glistening colors.[7]

The reviewer admired the windows as a means of vivifying dreary and airless interiors by allowing light and art to play a natural role in the embellishment of private domestic space. This seems to have been the goal of Bonnard (see Watkins, fig. 15), Roussel (cat. 30), and Vuillard (cat. 34), all of whom chose to depict simple scenes of women and children in parks, intimate subjects that were very different from the sophisticated and posterlike *Parisians* presented by Félix Vallotton (see fig. 1) and Henri de Toulouse-Lautrec in their designs.[8]

No specifics are known about the negotiations between the Nabis and Bing that Vuillard mentioned in his letter to Denis. One can only speculate that the artists were given instructions on how to render their designs to take into account the special properties of Tiffany's glass, created using pieces of opaque, opalescent glass, streaked and marbleized with boldly contrasting hues. These pieces were layered over one another and combined in complex patterns to add dramatic and mysterious effects.[9] The artists used heavy, black lines (which recall the *cloisonniste* technique of Louis Anquetin and Emile Bernard) to outline and define elements of their compositions and to serve as a guide to the glass cutter, and to the person who would pour the lead that would be used to attach the pieces together.

Roussel chose a composition highly suitable to Tiffany's technique, albeit one very uncharacteristic of Roussel's works from the 1890s. Using a simple palette, he introduced heavy outlines and large, rounded forms that he further simplified into cut-out shapes.[10] The resulting composition is consistently flat with boldly defined, stylized shapes that were undoubtedly conceived to facilitate the glassmaker's process. The angled, straw-seated chairs are a very clever device to break up and animate the composition, as well as give it a suggestion of recession into depth. The resulting Tiffany stained-glass window is even more appealing than Roussel's preparatory design—made up of variegated greens, turquoises, and pinks that further enhance the false-naive, but in effect highly sophisticated, imagery (fig. 2).[11]

Although the critic for *L'Art moderne* rejoiced at the contribution these windows would make to the

sufficiently impressive to enthuse a number of critics. These included Roger Marx, who praised their jewel-like qualities; Jacques Emile Blanche, who called Tiffany the "hero of the exhibition";[6] and an anonymous reviewer for the Belgium-based *L'Art moderne*, who commended the initiative wholeheartedly:

As we know, the artists chosen all have a special gift for creating the most ingenious harmonies by the juxtaposition of a few flat colors. They have already proved their talent in posters, wallpaper, tapestry, and illustration: their work is original, simplified, unexpected, and new. It was an excellent idea to ask them to design stained glass. M. Tiffany has created an exquisite series of works: his colored glass is velvety in texture, soft to the eye, warm, and

FIG. 1
Félix Vallotton (Swiss; 1865–1925). *Parisians*, cartoon for a stained-glass window, 1894. Oil on canvas, 128.5 x 60 cm. Collection Madame Barbier-Müller, Geneva. Photo: Paris 1993, p. 390, cat. 214.

average home, and looked optimistically to future collaborations by these artists with the American impresario, the Bing–Tiffany project was not repeated. Indeed, it seems to have marked the end of the Nabis' active participation in the ambitious decorative-arts revival launched by Bing's highly controversial Maison de l'Art Nouveau. Out of the thirteen designs made into stained-glass windows by Tiffany and exhibited at the April 1895 Salon de la nationale, only seven windows were shown in Bing's shop for its inaugural opening that December, including those by Bonnard, Ibels, Ranson, Roussel, Toulouse-Lautrec, Vallotton, and Vuillard. Bing's architect Louis Bonnier apparently redesigned Bing's pre-existing gallery of Far-Eastern art to accommodate the seven windows, and placed Toulouse-Lautrec's at the top of the rue Chauchat doorway to diffuse light as visitors headed up the stairs.[12]

The stained-glass windows received little notice from reviewers commenting on the Maison de l'Art Nouveau exhibition, perhaps because they were so unobtrusively installed within specially designed rooms. It is unfortunate that more written accounts of the windows are not available, since with the exception of three (by Bonnard, Roussel, and Toulouse-

Lautrec), all of them have disappeared, so that the full impact of these beautiful decorative objects, which Roger Marx compared to precious stones, jade, and marble, has been lost.[13]

Lost too, perhaps, were the motivation and enthusiasm that enabled Vuillard to assemble on short notice his artist friends to share in a collaborative project. While the critic for *L'Art moderne* believed these artists' future endeavors would involve the enhancement of the modern interior, it was not to be. It was as if, having accomplished their mission, they were satisfied to return to a more traditional format. Or perhaps, without the economic support of Tiffany and Bing, there was no longer a sufficient incentive to undertake similar projects.

Additionally, the medium of stained glass itself was perhaps not entirely suited to the Nabis' styles or to the needs of their patrons. For smaller Parisian interiors in which light was at a premium, the veil of colors resulting in a finished window would be seen as an obstruction to what little light there was. Moreover, stained glass, a medium closely aligned with the medieval revival, would have appealed more to a small group of Neo-Catholics than to the Nabis' other patrons, who ranged all along the religious and political spectrum.

While Roussel's and Vuillard's park scenes (cat. 30, 34) and Bonnard's image of a mother and child (Watkins, fig. 15) would have been perfectly suited to the format of small oil paintings, as larger images in stained glass they may have seemed too intimate for the public spaces in which they were exhibited. Only Denis pursued this medium after 1895, utilizing classical and Christian themes, in commissions for churches and for immense *hôtels privés* of collectors such as Jacques Rouché and Baron Denys Cochin.[14]

As previously stated, Bonnard, Roussel, and Vuillard eventually abandoned their interest in making decorative objects, to concentrate solely on paintings, decorative ensembles, and (in the case of Roussel) pastels. In the end, however, the simplified, stylized character of these stained-glass projects, more so than folding screens, ceramics, or even painted murals, underscored the early message and goal of the Nabis, expressed famously by Denis as the covering of flat surfaces with forms and colors.

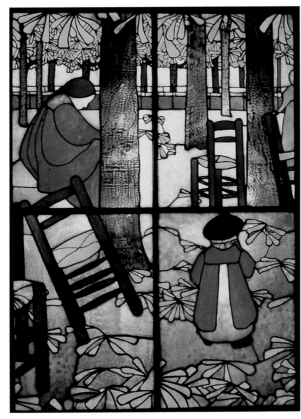

FIG. 2
Tiffany and Co., New York. *Garden*, stained-glass window after a design by Ker Xavier Roussel, 1895. Marbled glass; 124 x 93 cm. Private collection, Paris. Photo: Paris 1993, p. 389, cat. 213.

CAT. 31

EDOUARD VUILLARD

Dressmaking Studio I (first version), 1892
Oil on canvas
47 x 115 cm (18 ½ x 45 ¼ in.)
Private collection

VUILLARD'S FIRST MAJOR COMMISSION (APART from the theater décors he executed for little or no money)[1] was to paint six overdoor panels for what Paul Ranson described as the "very chic salon" of Paul Desmarais, a cousin by marriage of the Natanson brothers, Alexandre, Thadée, and Alfred.[2] Their cousin Stéphane Natanson, a member of the *Revue blanche* circle, may well have encouraged and perhaps even arranged the commission for his sister Léonie and her husband, Paul. Ten years after the panels were first installed at the Desmarais' Paris home, at 43, rue de Lisbonne (or possibly their country estate, near Chantilly), Stéphane, an architect, designed for his sister and her husband a fashionable mansion on avenue de Malakoff. The new house included a room that functioned as both study and dressing room, and that was especially tailored to fit Vuillard's horizontal panels.[3]

Paul Ranson, writing around 1892 to the painter Jan Verkade, applauded Vuillard's decor: "Vuillard has finished the large panels for the Natansons' [Desmarais'] salon. I think all six are very good. What an effort, what a task for Vuillard."[4]

Ranson's opinion of the panels was seconded by the critic Roger Marx, who described them in August 1892 as works "of the freshest inspiration, and the most ornamental originality."[5] The commission for the wealthy industrialist seems to have marked a coming of age for Vuillard, who up until then had found patrons among a particular milieu made up of artists and men of letters (especially associated with *La Revue blanche*). The Desmarais, however, represented that faction of the newly wealthy that Denis had appealed to in an article published in February 1892. There, he pleaded for enlightened consumers and patrons to support the creation of *décors* (decorative ensembles), freeing artists from the necessity of making more traditional easel paintings: "Where is the industrialist who would wish to be associated with these decorators, to take up some of the time they spend making too many paintings?"[6]

While details about the commission are few, it is possible that Paul Desmarais viewed Vuillard's project as both a social and a financial investment, since by 1892 the Nabis were beginning to be mentioned in the major press. What is known is that before completing the final panels, which can be paired by subject (figures in public gardens, dressmakers in workshops, and women on a terrace [1890–99 Intro., figs. 11–12]),

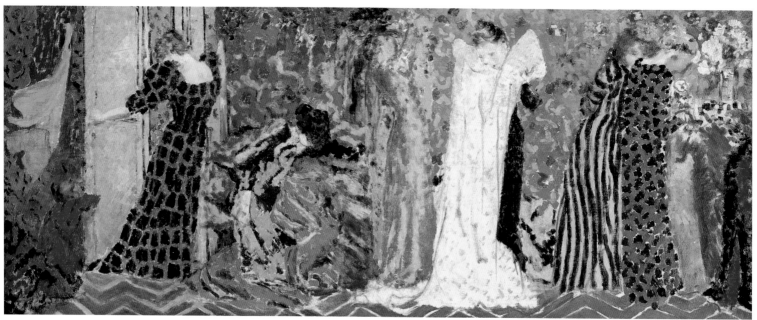

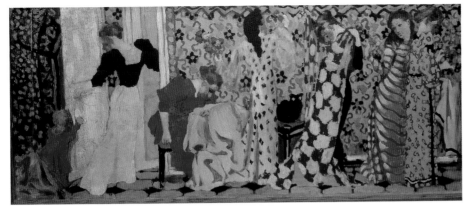

FIG. 1
Edouard Vuillard. *Dressmaking Studio I*, 1892. Oil on canvas; 48.5 x 117 cm. Desmarais Collection, Paris.

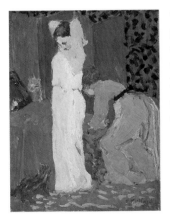

FIG. 2
Edouard Vuillard. *Actress in Her Dressing Room*, 1892. Oil on canvas; 24 x 18 cm. Musée des Beaux-Arts de la Ville de Reims.

Vuillard painted smaller oil studies, which he kept for himself.[7] He also executed this full-scale study for *Dressmaking Studio I* (cat. 31), so close in scale, palette, and composition to the final work (fig. 1) that it could be considered a variant rather than a study.

The theme of seamstresses appeared early in Vuillard's oeuvre as a means of exploring mystery in the familiar. He drew on the dressmaking workshop of his mother (who was registered as a corset maker, but was also a dressmaker) and the many years he had spent casually observing the workshop's activities—the cutting, measuring, sewing, and fitting of handmade garments. The theme of dressmaking and the subject of the seamstress in particular dominated his entries to the second exhibition at the Barc de Boutteville gallery, Paris, in spring 1892, when critic Albert Aurier admiringly described his images of women bent over their work in gas-lit interiors as possessing "the charm of the unexpected," and expressing "the bittersweet emotions of life and the tenderness of intimacy."[8] The depiction of the dressmaking workshop in the panels for the Desmarais, however, evidences little of the ritualistic and Symbolist underpinnings seen in Vuillard's contemporaneous lithographs and easel paintings of seamstresses.[9] Instead, Vuillard concentrated on the ornamental patterning created by the forms of the female workers, whose curving and graceful figures seem directly related to the arabesques of the nascent Art Nouveau style and its sources in the patterns of oriental porcelains and tapestries.

In these panels, Vuillard transformed the reality of a mundane place of business into a lively arena where seamstresses are indistinguishable from their clients. Indeed, the scene in both the finished version of *Dressmaking Studio I* and the study is so animated that it could easily be seen as the backstage dressing room of a Symbolist theater, with actresses in dressing gowns trying on costumes inspired by medieval and Japanese fashions (see fig. 2).[10]

While this earlier version of *Dressmaking Studio I* clearly resembles the final one, the differences between them are significant. Not only is the first of these more daring and audacious in its palette of hot pinks and reds, but it also shows a greater interest in pattern and texture than in the clarity of forms. Whereas the final panel emphasizes the delineation of figures in the service of the work's overall harmony and readability, the figures in the study are less legible and thus less narrative, creating a seamless frieze, as if a piece of patterned fabric has been cut from its bolt. One needs the final version, in fact, to "read" the study properly. In the final Desmarais panel, for example, the interaction of the two women at the far right is easily comprehensible: one looks away while the other examines fabric pulled from a drawer in a small table. In the variant, by contrast, the women on the right are camouflaged within a wonderfully dense concentration of wallpaper, fabric, and flowers. The mysterious swath of fabric at the far left of the study, moreover, is clearly identifiable in the final panel as curtains held back with a tie. Likewise, the vertiginous patterning of the fabric-strewn floor in the study has been toned down in the definitive composition, the rick-rack ornament relocated to the cornice trim of the wallpaper. In the latter, the wallpaper itself is more legible, characterized by an identifiable floral motif instead of the hot brown- and red-spattered background of the variant.

As an ensemble or series, the Desmarais overdoor paintings represent a shift in direction for Vuillard toward large-scale decorative paintings linked to one another by palette and theme. These panels may indeed be considered a decorative interpretation of his expressive Symbolist works of the early 1890s. In this lively variant, even more than in the final work, Vuillard combined the mystery and vague figural types of his smaller paintings of lamp-lit interiors with a new interest in audacious colors and bold compositions. The fact that Vuillard kept this canvas (along with the smaller oil studies for the Desmarais panels) in his studio until his death suggests its importance as a source of inspiration for his future work.

EDOUARD VUILLARD

Public Gardens, 1894

32 *First Steps*
Distemper on canvas
213.4 x 68.5 cm (84 x 26⅞ in.)
Tom James Co./Oxxford Clothes

33 *Under the Trees*
Distemper on canvas
214.6 x 97.7 cm (84 ½ x 38 ½ in.)
The Cleveland Museum of Art, gift of the Hanna
Fund, 1953.212

IN EARLY 1894, VUILLARD RECEIVED A COM-
mission from Alexandre Natanson, the eldest of
the three Natanson brothers, for nine decorative,
near life-sized panels for his home, at 60, rue du Bois
de Boulogne. For Vuillard, whose only commissioned
project thus far had been the six overdoor panels for
Paul and Léonie Desmarais (see cat. 31), this was a
momentous opportunity and challenge. In his journal
entry summarizing the events of 1894, Vuillard listed
this as his primary artistic activity that year.[1] Indeed,
this ambitious undertaking, known as *Public Gardens*
(*Les Jardins publics*), sealed Vuillard's reputation as a
painter-decorator.[2] Five of the nine decorative panels
are now in the collection of the Musée d'Orsay, Paris:
a triptych consisting of *Nursemaids*, *Conversation*, and
Red Sunshade; and the pendants *Little Girls Playing* and
Asking Questions (see fig. 3).[3] The two other "pairs,"
Two Schoolboys (fig. 1) and *Under the Trees* (cat. 33), and
Promenade (fig. 2) and *First Steps* (cat. 32), are dispersed
among four other collections.[4] Since all but one, *First
Steps*, are in public collections, these nine panels are
today the best known of Vuillard's decorative ensembles.

Vuillard had painted women and children in parks
in a number of earlier compositions—two of the panels
from the 1892 Desmarais series, a large painting
known as *The Park* (1893–94; private collection, New
York),[5] and a number of smaller graphic and painted
works—but this was the first time he sustained the
theme in such a monumental undertaking, and using
the difficult distemper (*à la colle*) technique. Scholars
have compared these panels to a variety of other
works, including Georges Seurat's life-sized park scene
A Sunday on La Grande Jatte—1884 (cat. 52–54, fig. 2),

the pastel-hued murals of Pierre Puvis de Chavannes
(see Watkins, fig. 5), and even the painted panoramas
so popular in late nineteenth-century France.[6] Perhaps
the analogy to Seurat's masterwork is the most apt, for
like Seurat, Vuillard began by observing real park
denizens, and appropriated and exploited the different
social and economic "types" he found for the purpose
of decorative expression. But unlike Seurat, who situ-
ated his image in a particular place (celebrated in the
work's title), Vuillard chose to combine features of sev-
eral different Paris parks, most obviously the Jardin des
Tuileries and the Bois de Boulogne.

In the pair *Two Schoolboys* (fig. 1) and *Under the
Trees* (cat. 33), for example, Vuillard painted the
Tuileries gardens, which Baedeker's guide to Paris at
the time called "the especial paradise of nursemaids
and children."[7] For Vuillard, whose family lived from
1893 to 1898 a few blocks from the garden on rue St.-
Honoré, the Tuileries was a familiar place of passage
en route to the Louvre or a destination in and of
itself.[8] Like the eighteenth-century painter Antoine
Watteau, whose favorite park was the Jardin du
Luxembourg, Vuillard was inspired by the pictorial
possibilities of the public life he witnessed in these
urban gathering places. As described by art historian
T. J. Clarke, the public life of the Tuileries was both
"narrow and definite," in contrast to the Bois de
Vincennes to the east and Parc Buttes-Chaumont to
the south, which were frequented by the Parisian
working classes.[9] The Tuileries was the destination of a
more exclusive and more outwardly uniform group of
social types, since the *petit bourgeois* and middle classes
conformed to the standards of their upper-class com-
patriots with whom they shared the park. Dressed
fashionably in lace-collared dresses or soft, woolen hats
and knickers, the children in Vuillard's "Tuileries"
compositions seem to adhere to the unofficial dress
code of this once-royal garden.

In contrast to the two "Tuileries" panels, *Two
Schoolboys* and *Under the Trees*, which are topped by the
densely patterned chestnut-leaf foliage characteristic
of that park, the remaining panels evoke the spacious-
ness of the Bois de Boulogne, lying just outside the
city walls of Paris. The Natansons' home was located
near the Bois de Boulogne, at the end of the long
avenue of the same name, making it a very accessible
location for Vuillard. Since its opening in the 1860s, the
21,000-acre park, which included the racecourse of
Longchamps celebrated by the painters Edouard Manet

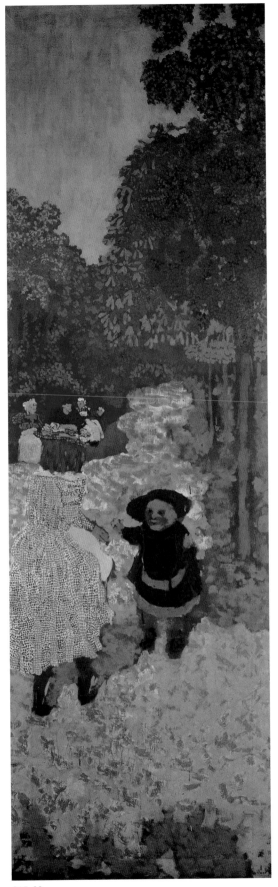

CAT. 32

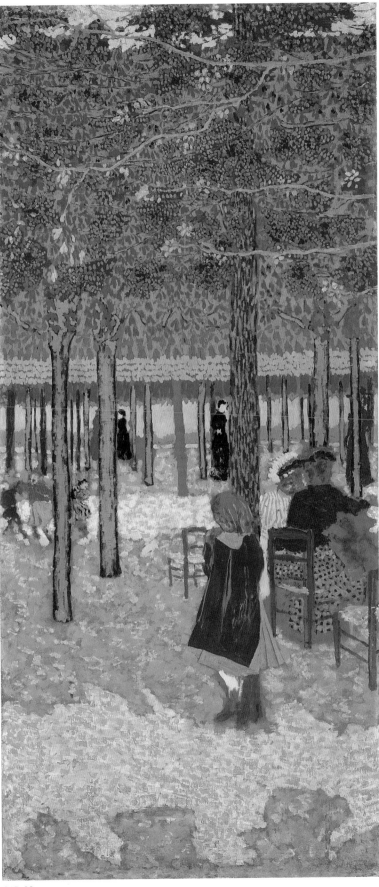

CAT. 33

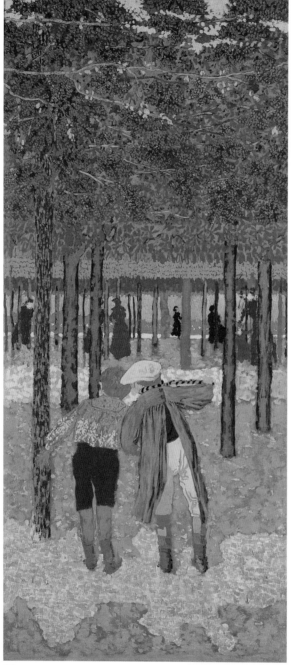

FIG. 1

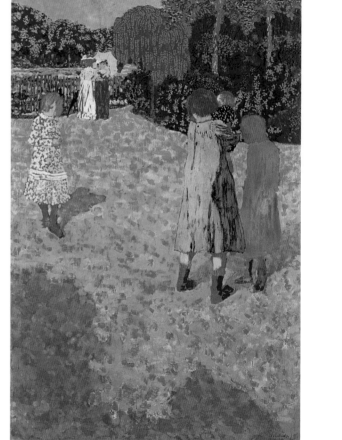

FIG. 2

and Edgar Degas, was a popular leisure site.[10] Vuillard focused, however, on the interaction of women and children: women scolding and comforting, whispering and gossiping on a bench; and children playing, holding babies, and planning a prank. In other words, Vuillard created a world devoid of the masculine signs of business and industry associated with modern (and capitalist) Paris. The child was one of the Nabis' favorite motifs during the 1890s, especially Vuillard

and Bonnard. The latter's *Nannies' Promenade, Frieze of Carriages*, first painted in 1894 (see cat. 6, fig. 1), shares with Vuillard's series similar female groupings centered around children. It was a world in which the artist, unrestrained by full-time employment, could freely mingle and make observations.

In the panels *First Steps* (cat. 32) and *Promenade* (fig. 2), Vuillard presented another subtle narrative. While the "Tuileries" panels illustrate Parisian children

FIG. 3
Photograph, before 1908,
showing *Asking Questions* (1894;
Musée d'Orsay, Paris) installed
in the home of Alexandre
Natanson at 60, rue du Bois
de Boulogne, Paris. Salomon
archives, Paris.

being mischievous or playing hide and seek, these two images depict girls of different social classes and their respective responsibilities. In *Promenade*, for example, the little girl wearing a fancy blue-and-white dress seems to address hesitantly more modestly attired girls who, together with the baby they hold, stand together in the right foreground of the picture. This group contrasts not only with the well-dressed little girl but also with the women wearing decorative hats and holding parasols, who wait in the background. In *First Steps*, by contrast, a little girl with white gloves and hat is not guardian of her toddler sibling (as is the older girl in *Promenade*), but merely amuses herself with the tentative walking efforts of the younger child, decked out in a matching ensemble.

These panels reflect Vuillard's general interest in children as a subject for his art, but he may have found a more immediate source of inspiration in the Natanson children; Alexandre had three young daughters by 1894 (Evelyn, Bolette, and Georgette). It is conceivable, indeed, that Vuillard designed the project to appeal as much to the Natanson girls as to their parents.

On 21 August 1894, Vuillard received eight hundred francs from Alexandre, enabling him to buy the large pieces of canvas required for the series.[11] The panels were installed by the end of 1894, and inaugurated in February 1895 with a lavish soirée for three

hundred people at which Henri de Toulouse-Lautrec served particularly lethal "American" cocktails.[12] According to the available evidence, the panels were installed on the ground floor (*rez-de-chaussée*) in a combination dining room and salon.[13] A sketch by Vuillard of this room with the dimensions of each work indicates that the artist intended the panels to be grouped in three pairs separated by windows, doors, and possibly a fireplace, with the triptych placed on the long unbroken wall.[14] The panels, installed with edges almost touching, were grouped according to their decorative elements, which linked them visually, if not physically. Works such as *First Steps* and *Promenade*, for example, are paired by background foliage that is carried across the panels (when they are placed side by side with *Promenade* on the left and *First Steps* on the right), as well as by the similar, wavelike patterning of the gravel and sand pathways.

The combination dining room and salon in which the panels were installed was itself unusual. Compared to another room in Alexandre's house, the traditional white-and-gold salon depicted in Bonnard's portrait of the Natanson daughters painted in 1908 (1890–99 Intro., fig. 6), the setting for Vuillard's panels was decidedly less formal. A contemporary photograph of the installation of *Asking Questions* (fig. 3) shows the decoration hung in a room with unpaneled walls that were painted or papered a solid, light color. The panel was simply banded with a narrow, wood frame and affixed to the wall about three and a half to four feet off the ground, and flanked by large door draperies (*portières*). In addition to the nine primary panels of this series, Vuillard also created more generalized overdoor panels.[15] Two of these are just visible above the door draperies in this photograph, which illustrates how they were meant to be adjacent and complementary to, but not dependent on, the primary decorations.

The panels for the *Public Gardens* series were reinstalled twice—once, with Vuillard's help, in 1908, when the Natansons moved to avenue des Champs-Elysées; and again, apparently without his assistance, in 1914, when the family moved to rue de Courcelles near Parc Monceau. In 1929, all nine panels (but no overdoors) were put up for auction in the sale of Alexandre's collection and, ultimately, dispersed.[16]

Although Vuillard never returned to the theme of public gardens for a decorative project, this series for Alexandre Natanson was a significant achievement, as it was larger and more ambitious than anything he, or

any of the other Nabis, had undertaken to date. The panels' tapestrylike surfaces, rich patterns, and soft hues of sea greens and sky blues, together with their relatively formal structure, would have provided a modern yet "classic" décor for the Natansons to show off to their friends. The series also created a delightful environment for the Natanson daughters—one that mirrored their own world. With the dispersal of the individual panels, the magic of that environment is irrevocably lost, but it is a tribute to Vuillard's talent that paintings such as *First Steps* and *Under the Trees* are still able to stand alone as complete and entirely satisfactory works of art.

CAT. 34

EDOUARD VUILLARD

Chestnut Trees, 1894/95
Distemper on cardboard, mounted on canvas
110 x 70 cm (43 ¼ x 27 ½ in.)
Private collection

THIS DESIGN FOR A STAINED-GLASS WINDOW IS a result of an 1894 commission for cartoons to be executed in an innovative kind of stained glass by Louis Comfort Tiffany. The project, which was organized by Siegfried Bing, involved the Nabis and others in their circle and is discussed more thoroughly earlier in this book (see cat. 29–30). The finished stained-glass windows were exhibited at the 1895 Salon de la nationale and some of them were shown again later that year at Bing's Maison de l'Art Nouveau. Vuillard was instrumental in getting his friends involved in this endeavor, which represents the height of their involvement in the Art Nouveau movement.

Vuillard's design *Chestnut Trees* (cat. 34), which depicts women and children in a street or courtyard almost completely obscured by the leafy boughs of trees, is typical of his work from this period in terms of subject matter. The *Public Gardens* (cat. 32–33) decorations he was working on at the time, for instance, also illustrate the interactions of women and children in verdant, yet obviously urban, settings. The bird's-eye view that Vuillard adopted for the window design is one that he would reuse in later decorative paintings of city squares, especially the panels known as *Place Vintimille* (cat. 75–79).

Whereas Vuillard drew on some of the most enduring themes in his oeuvre for the subject of this design, its execution is quite different from anything else he was making at the time. The crisp, linear style of *Chestnut Trees*, which had to be translated into glass and lead by Tiffany, is unlike the more painterly and dabbed handling Vuillard usually employed. He no doubt altered his manner to accommodate the unique properties of stained-glass windows, and Tiffany's process in particular, which discouraged naturalistic detailing. The result is a faceted, "primitive," almost crude image, unlike any other work in his career.

The style that Vuillard adopted was perfect for Tiffany's stained-glass method, since it was insistently flat and did not require shading or modeling to remain legible. A comparison of *Chestnut Trees* to Félix Vallotton's *Parisians* (cat. 29–30, fig. 1) makes this point clear. Unlike Vuillard's patch-work scene of tiny figures embedded in an overall faceted composition, Vallotton's design, featuring women in stylish fashions, required a more complicated linear treatment and some modeling to make them readable. It was windows of this latter type that René de Cuers condemned in his 1899 study "Domestic Stained Glass in France," when he concluded that France had the potential to make wonderful things in stained glass, but was thwarted by artists who did not understand how to make designs that could be translated into the medium.[1] The stained-glass window by Vuillard, however, met with de Cuer's praise in the same article. The author saw in Vuillard's window a lively, interesting scene, perhaps a "courtyard of a boarding school, shaded by big trees, with an indefinite sort of house . . . the figures of some pupils and, in the distance, the cap of a sister of mercy who is praying against the doorway, heedless of the laughter and the gambols of the girls under her charge."[2]

Unfortunately, the stained-glass window resulting from Vuillard's cartoon has been lost, and one can only imagine the panoply of colors that would have been possible with such a logical and accommodating design. Although Vuillard, as shown here, was highly adept at modifying his style to the special needs of stained glass, he never undertook a decorative project of this sort again.

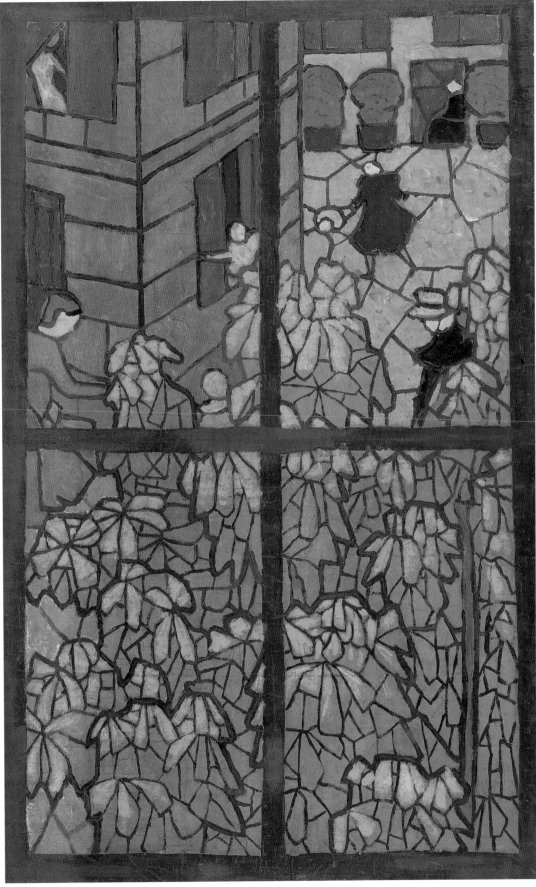

CAT. 34

EDOUARD VUILLARD

Series of Five Decorative Panels Known as "Album," 1895

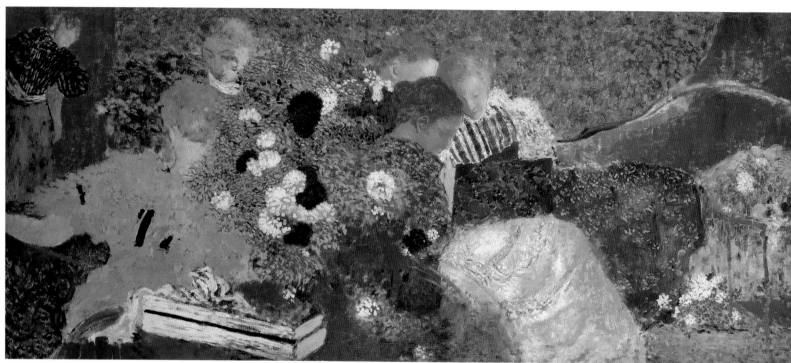

CAT. 35

35 *Album*
Oil on canvas
67.8 x 204.5 cm (26 ¹¹⁄₁₆ x 80 ½ in.)
The Metropolitan Museum of Art, New York, The
Walter H. and Leonore Annenberg Collection,
partial gift of Walter H. and Leonore Annenberg,
2000 (2000.93.2)
NEW YORK ONLY

36 *Embroidering by a Window,* or *Tapestry*
Oil on canvas
177.7 x 65.6 cm (70 x 25 ⅞ in.)
The Museum of Modern Art, New York, estate of
John Hay Whitney

37 *Stoneware Vase,* or *Conversation*
Oil on canvas
65.5 x 114.5 cm (25 ¾ x 45 ⅛ in.)
Private collection, courtesy Nancy Whyte Fine Arts

38 *Vanity Table*
Oil on canvas
65 x 116 cm (25 ⅝ x 45 ⅝ in.)
Private collection

39 *Woman in a Striped Dress*
Oil on canvas
65.7 x 58.7 cm (25 ⅞ x 23 ⅛ in.)
National Gallery of Art, Washington, D.C.,
Collection of Mr. and Mrs. Paul Mellon (1983.1.88)

THADÉE AND MISIA NATANSON PLAYED A
major role in Vuillard's social and professional
development throughout the 1890s. They
promoted him through *La Revue blanche* (in whose
offices he was given his first one-person exhibition)
and by recommending him to others, including their
relatives the Desmarais (see cat. 31) and Thadée's
brother Alexandre (see cat. 32–33). That same year,
Thadée and Misia also purchased from the artist for

their apartment on rue St.-Florentin a large, decorative panel known as *The Park*.[1] But it was their request the following year for five decorative panels that resulted in one of Vuillard's most beautiful, yet least-known, series of paintings (cat. 35–39), entitled collectively *Album*, after the largest work in the group.[2]

These five paintings, depicting domestic interiors filled with young women and flowers, were also the first of Vuillard's decorative paintings to be seen publicly. A month after Vuillard completed them in November 1895, they were shown in what was described as "a small antechamber" for the inaugural exhibition of Siegfried Bing's Maison de l'Art Nouveau. At that time, they went relatively unnoticed, perhaps because they were overshadowed in the eyes of the critics by other, more controversial works. Writing for *La Revue blanche*, Edmond Cousturier referred to the panels only as "scenes of women in interiors" of "muted and subtle harmonies."[3] Arsène Alexandre commended the panels as "discreet and harmonious," but complained that they were hung in a small room, adjoining an oval salon, lit badly by an "absurd chandelier where giant flies turn, illuminating us with their transparent *derrières*."[4]

Also exhibited at Maison de l'Art Nouveau were selections from the ninety-six-piece table service that Vuillard had decorated for Jean Schopfer, a member of the Natanson's circle and one of the artist's earliest patrons.[5] These were displayed in a dining room designed by Belgian artist and architect Henry Van de Velde. The designs consisted of full- or half-length female figures in the center of plates or platters, with borders of floral motifs or striped and stippled patterns derived from the figures' blouses and dresses (see 1890–99 Intro., fig. 10). The effect of this daintily decorative, but at the same time dizzying and crowded, painted porcelainware was similar to that of the *Album* series, where young women and flowers vie with the floral patterns of the wallpaper behind them.

The *Album* panels are of varying dimensions, and lack many of the linear and textural elements that linked the artist's earlier ensembles (see cat. 31–33). All five panels, however, share a palette and style, even if only two exhibit the same format: *Stoneware Vase* (cat. 37) and *Vanity Table* (cat. 38). Within the series, the three panels that are most thematically and compositionally similar, *Album*, *Stoneware Vase*, and *Vanity Table*, show a profusion of chrysanthemum-like blossoms from which young women with striped, stippled, and

CAT. 36

CAT. 37

checked blouses seem to emerge. All three share the *repoussoir* device of an exaggeratedly inclined table, laden with objects, in the foreground, whose recession back into space is blocked by the flatness of the all-over patterned surface. Any sense of spatial depth is negated by the absence of modeling and of differentiation between the colors and textures of animate and inanimate objects. The heads of the women in the second plane are obscured by large vases and floral bouquets, while the women at either side are radically cut off by the edges of the canvas.

In these congested interiors, the women are neither participants in the narrative nor entirely subordinate to it. Seen from behind (in *profil perdu*, the least personal of poses), or with heads bent and shadowed, they make no contact with the viewer. Their importance is equal to that of the objects in their midst, and both objects and figures are embedded in their surroundings. Some may see this as a visual expression of the way nineteenth-century women were, with few exceptions, defined by their environment. The association of women with nature and especially with flowers

was a standard subject in paintings, posters, and illustrations of the day. Vuillard's young women, however, are not merely decorative embellishments of domestic space, but purveyors of a feeling of sensuous abundance. Their very ethereality contrasts with and underscores the palpable existence of the objects around them.

It is conceivable that Vuillard's choice of format (and subject for the largest panel, showing women looking at a large book or album) drew on the general idea of an album or portfolio arrangement of diverse prints with a general rather than particular connection. It is most likely, however, that these congested and richly textured panels of varying formats and sizes were meant to be a reflection of the home for which they were intended: Thadée and Misia Natanson's apartment on rue St.-Florentin. The interior of this modest apartment off Place de la Concorde, called the "Annex" since it so often served as an alternative office for the contributors and subscribers to *La Revue blanche*, was decidedly unconventional. Thadée and Misia lived in a rented apartment of unusual arrangement. Whereas

CAT. 38

most residences of the time had separate rooms and distinct areas for reception and private activities, the Natansons' quarters consisted of one relatively large and open space (serving as an informal salon, parlor, and music room), adjoined by several small alcove areas, as seen in contemporary photographs and in Vuillard's famous portrait of the "Annex," *Room with Three Lamps* (1890–99 Intro., fig. 4). In a period when the world of the bourgeois (non-working) woman and wife was defined by the place assigned to her caretaking, the Natansons' home was unusual in its lack of clear distinctions between traditionally masculine spaces (office, library, and den) and feminine ones (kitchen, dining room, boudoir, and nursery).[6]

Before her marriage to Thadée, Misia had lived alone in apartments in London (1887) and in Paris (1889–90), both of which she decorated with bright wallpapers and rattan furnishings purchased on installment from department stores. From these experiences, she acquired a taste for decorating and for the cluttered but comfortable informality characteristic of certain English interiors. Indeed, although Misia claimed to

have been influenced by the Belgian Van de Velde,[7] the rue St.-Florentin apartment, like her previous ones, reflected an eclectic personal style that drew upon the English Arts and Crafts Movement. Her use here of patterned floral wallpaper in bright yellow-orange and blue and loud floral and paisley fabric applied to all available surfaces and upholstery is reflective of the English style that had been popularized and disseminated internationally by William Morris by the late 1880s. Vuillard's *Room with Three Lamps* gives an indication of the eclectic decorating aesthetic that prevailed in the Natansons' home. The artist's wide-angled sweep encompasses three brass oil lamps with fringed shades, decorative ferns, flowers in a *jardinière*, rustic pottery on the mantelpiece, firescreens, a bentwood rocker, a cushioned sofa, and a grand piano draped with a Spanish shawl in front of a large decorative tapestry.

Even with contemporary photographs of the interior of the Natansons' home in the 1890s, it is not easy to reconstruct how the five *Album* panels would have been installed to best advantage in this seemingly unstructured, if not haphazardly organized, interior.

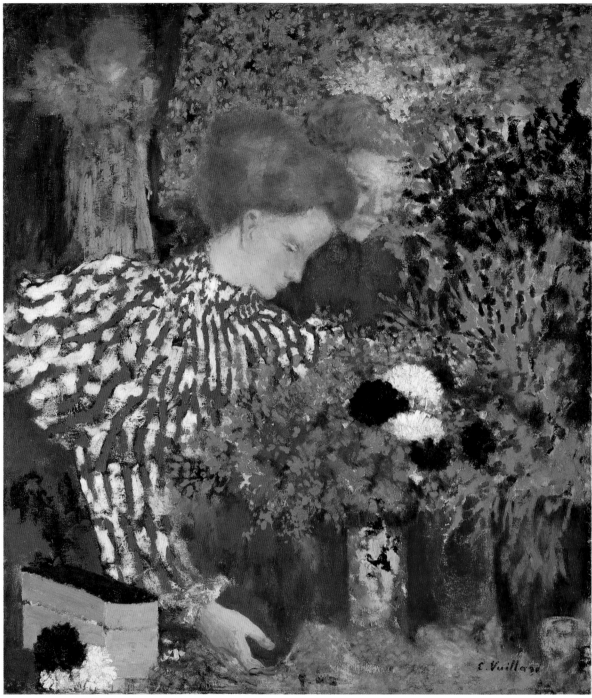

CAT. 39

Unlike the earlier panels for the Desmarais mansion, described as overdoors intended for Léonie Desmarais's dressing room (see cat. 31), or the suite of nine panels for Alexandre Natanson's home, which were installed in a space that served as both dining room and salon (see cat. 32–33), the *Album* panels were left unframed and informally placed or hung on top of wallpaper.[8]

A photograph of Misia (fig. 1) standing beside a sideboard in what would have been the pantry alcove shows the unframed vertical panel *Embroidering by a Window* (cat. 36) not so much hung as resting upon the plinth forming the baseboard. In this casually posed view, the panel seems to be a temporary fixture, a decorative foil for Misia, whose striped housedress

FIG. 1

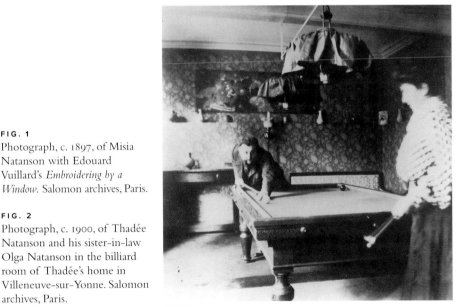

FIG. 2

and polka-dot bow reflect the unusual tastes in fashion that so fascinated Vuillard and the other artists in her circle. Even the two very similar and seemingly frieze-like panels, *Stoneware Vase* (cat. 37) and *Vanity Table* (cat. 38), were apparently never hung side by side. Vuillard seems to have been captivated by this informality, and executed a number of paintings featuring these deco-

rative panels in the background. In Vuillard's portrait of Misia at the piano with her half-brother, Cipa (cat. 40), one can make out *Album* (cat. 35) hung on the wall adjacent to the piano over a large tapestry seen in the painting *Room with Three Lamps* mentioned above. This indicates that the panels did not remain in fixed positions while the Natansons owned them, but rather were moved and rearranged like the other decorative objects in the room. In many ways, the panels functioned more like portable wall hangings or tapestries than as permanent and integral murals. Indeed, these panels are stylistically similar to tapestries. Although executed in oils, they share with tapestries a feltlike quality resulting from densely patterned compositions and the use of closely ranged tonalities that fuse the figures to other objects, as if they were woven into the background.[9]

Because Vuillard's canvases were easy to rearrange, they fulfilled Lucien Muhlfeld's 1893 recommendation that *décorations* be portable and movable to accommodate the changing needs of the apartment dweller.[10] The panel *Album* (cat. 35) seems also to have been relocated not only within the Natansons' Paris apartment, but also to their summer homes at Valvins (near Fontainebleau), and after 1897, at Villeneuve-sur-Yonne. In a photograph from around 1900 (fig. 2) showing Thadée with his sister-in-law Olga (Alexandre's wife), one sees *Album* hung unframed over a shelf in the billiard room of the Villeneuve residence. Even in this seasonal home, Misia's decorating mania is evident in the English-style floral wallpaper and ornamental vases, making the environment for the painting similar to that of the busily patterned "Annex."

By 1903, the Natansons' cushioned and lamplit environment had been radically and irreversibly altered. In that year, the *Revue blanche* office closed its doors, and Thadée and Misia, now separated, were involved in divorce proceedings. Vuillard's evocations of women at their needlepoint work or reading, surrounded by flowers and painted in earthy browns, tawny burgundies, and yellows, would have fit less happily into the formal woodwork of Misia's subsequent residences (as Madame Alfred Edwards) on rue de Rivoli and quai Voltaire, or in Thadée's apartment in the seventh arrondissement, where he was listed as an "industrialist."[11]

It is likely the panels remained with Thadée until they were auctioned along with the rest of his collection in 1908; at that time, they entered different interiors to fulfill entirely new aesthetic functions.[12]

EDOUARD VUILLARD

Cipa Listening to Misia at the Piano, 1897/98
Oil on cardboard
63.5 x 56 cm (25 x 22 in.)
Staatliche Kunsthalle Karlsruhe, Germany

VUILLARD'S STUNNING PORTRAIT OF MISIA Natanson at the piano with her half-brother, Cipa Godebski, standing behind her takes its palette and congested composition from the *Album* series executed a few years earlier for the Paris apartment of Misia and her husband, Thadée (cat. 35–39). Although *Cipa Listening to Misia at the Piano* is not generally considered to be a decorative painting, it is informed by many of the same principles as Vuillard's work in this mode. It also serves to illustrate how one of Vuillard's ensembles was hung in a particular interior, as it includes within its composition a somewhat generalized depiction of the panel *Album* (cat. 35) hanging in the Natansons' apartment. It is seen here against the floral wallpaper behind Misia, creating a painting-within-a-painting conceit that makes it difficult to distinguish what is "real" and what is painted decoration. In contrast to the *Album* panels, which feature anonymous and generic images of women involved in domestic activities, *Cipa Listening to Misia at the Piano* is an intimate double portrait. Although Vuillard did not clearly depict the physiognomies of his sitters, his image gives insights into their essential characters.

Misia was the youngest, and only girl, of three children from sculptor Cyprien Godebski's marriage to Sophie Gervais. According to her dramatic and breathless biography, her mother died giving birth to her at the end of an arduous trip to St. Petersburg after having discovered her husband's infidelities.[1] Her father's remarriage shortly thereafter to Matylda Natanson (an aunt of Misia's future husband Thadée) brought with it two step-siblings and resulted, much to Misia's joy, in the birth of her half-brother, Cipa.[2] Three years younger than his half-sister, Cipa (and later Cipa's two children) would be for Misia a source of stability in a life that included three marriages and many unresolved relationships. Although Misia, a protégé of the composer Gabriel Fauré, was the family's musical prodigy, by the time of her marriage in April 1893 she

had abandoned her thoughts of a serious musical career and was content to perform informally.[3] It was Cipa, the more reserved and passive of the two, who pursued his passion for music with true determination. In 1905, Cipa met the young composer and pianist Maurice Ravel, who became a frequent visitor to the Godebski household, composing special songs for Cipa's children.[4]

In the 1890s, however, when Vuillard knew him most intimately through Misia and Thadée, Cipa was unmarried and apparently without plans for his future. Writing to Félix Vallotton in the fall of 1897 from the Natansons' summer home in Villeneuve-sur-Yonne, Vuillard hinted at Cipa's idiosyncratic nature: "As for Cipa, I'll tell you some preposterous stories. He is becoming more and more epic."[5] Cipa's portly frame and dark, bushy beard appear in many interior portraits by Vuillard and his friends at this time, where he functions as a kind of shadowy alter ego to Misia. In *Woman Seated in a Garden* (1890–99 Intro., fig. 15), a large decorative panel from the summer of 1898, Cipa appears directly behind his sleeping half-sister, camouflaged by the green trees and foliage from which he seems to emerge. In *Misia and Cipa at Lunch* (fig. 1), in which Misia appears to be conversing with him, he presents a hulking figure composed of solid browns and black in opposition to the otherwise bright and airy scene accented by vibrant wallpaper, fiery paintings, and his sister's characteristic checked housedress. Noticeable in this painting is Vuillard's use of the paintbrush handle to scratch into Misia's hair, dress, and other areas of the painting, creating alternative patterns and textures that further contrast with Cipa's heavier, monolithic form.

In *Cipa Listening to Misia at the Piano*, Vuillard again used Cipa as a foil for Misia. His looming figure is analogous in palette and heft to the piano and to the sewing table upon which is laid a tea service. Thus Cipa seems to belong to the realm of the furnishings and inanimate objects that fill the room, rather than the lively patterns that define Misia and her immediate surroundings. Misia's form merges with the brilliant yellow-and-orange wallpaper, the profusion of flowers in the painting on the wall behind her, and the oil lamp that sits atop the piano.[6] Her head, slightly bent in concentration, is illuminated by this single light source, although its position in relation to her is difficult to discern. The light from the lamp, which adds dark and light contrasts, contributes to distinguishing this composition, as does its narrative subject, from Vuillard's more strictly decorative works of the period.[7]

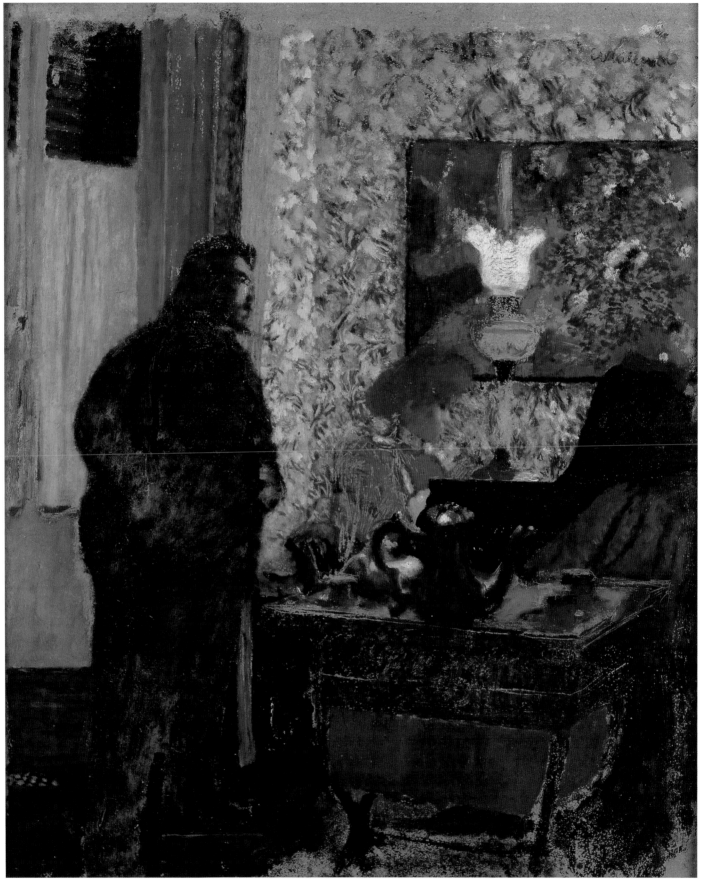

CAT. 40

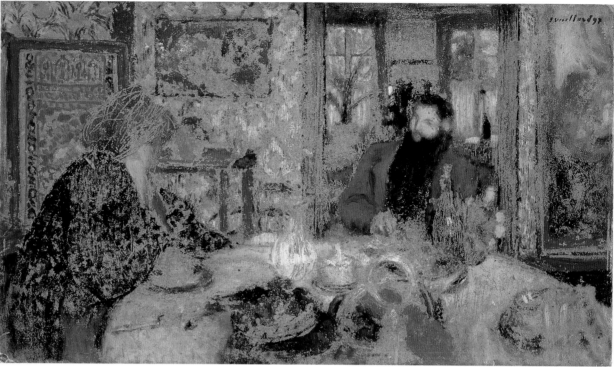

FIG. 1

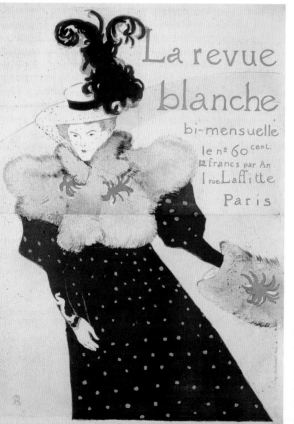

FIG. 2

In this double portrait, Misia is connected coloristically and compositionally to the painting behind her, a loosely interpreted depiction of *Album* (cat. 35), representing women looking at albums and arranging flowers in an explosion of oranges, mauves, and vermilion. By exaggerating the color of Misia's dress (which Vuillard also incised with the end of his brush to suggest a checkerboard effect) and by increasing the orange color of her normally auburn hair, Vuillard matched Misia to her counterparts in the background panel. The exaggerated hue of Misia's hair also reflects her public persona at this time. In 1896, for instance, she appeared in Henri de Toulouse-Lautrec's poster for *La Revue blanche* with hair as bright orange as the polka dots sprinkling her dark blue mantle (fig. 2).

Cipa Listening to Misia at the Piano can be seen as an embodiment of the Baudelarian concept of "synaesthesia," wherein one sensory experience evokes and stands in for another. In this case, the vivid, rich colors that fill the canvas serve as an expression of the music Misia plays, visually creating a "harmonious" image. Here Vuillard created a painterly relationship that makes the "visible intangible" but at the same time seems to make it "audible in the form of colored sound."[8] Most importantly, however, this painting serves as an intimate double portrait, a telling image of two siblings whose lives were intertwined in part through their shared love for music.

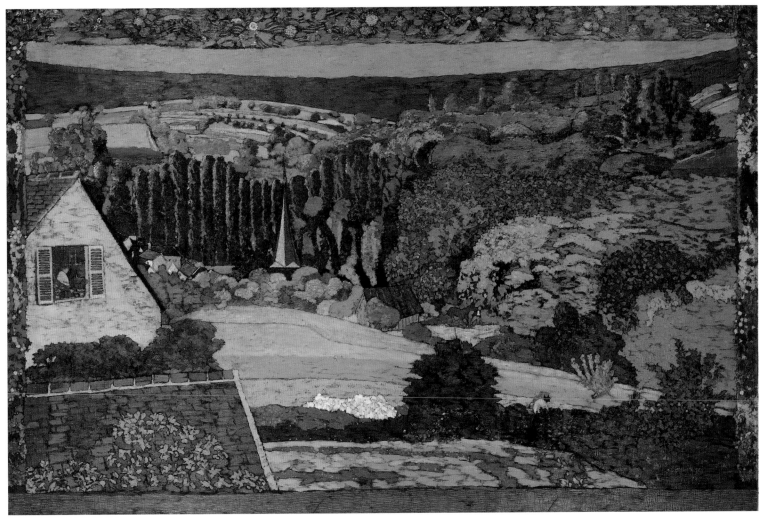

CAT. 41

CAT. 41

EDOUARD VUILLARD

Window Overlooking the Woods, 1899

Oil on canvas

249.2 x 378.5 cm (98 ⅛ x 149 in.)

The Art Institute of Chicago, L. L. and A. S. Coburn Fund, Martha E. Leverone Fund, Charles Norton Owen Fund, and anonymous restricted gift

WINDOW OVERLOOKING THE WOODS **AND** *First Fruits* (fig. 1) are known collectively in the Vuillard literature as the "Ile-de-France Landscapes."[1] These pendants represent two of the largest *décorations* of Vuillard's career and constitute the last project Vuillard executed for the Natanson family. Vuillard was commissioned by the patriarch of the family, Adam Natanson, probably at the prompting

of his son Thadée and Thadée's wife Misia, for whom the artist had already completed a decorative ensemble (cat. 35–39). In 1899, at the time the panels were completed, Thadée and Misia were temporarily housed in Adam's *hôtel privé* on rue Jouffroy.[2] According to his granddaughter Annette Vaillant, Adam was a straight-laced conservative with tastes "typical of that generation: walls loaded with gilt frames, art objects of dubious value."[3] Widowed shortly after he had brought his family of boys to Paris from Poland in 1878, Adam derived pleasure as a retired banker acquiring real-estate properties to which he transplanted his family for short periods of time. These included the eighteenth-century Château de Méréville, a "small château" at Longchamp, an estate at Ranville in Normandy, and another near Cannes.[4]

These two monumental scenes of an undistinguished landscape near Paris, however, had little to do with Adam's pretensions or properties. Just as Vuillard's

135

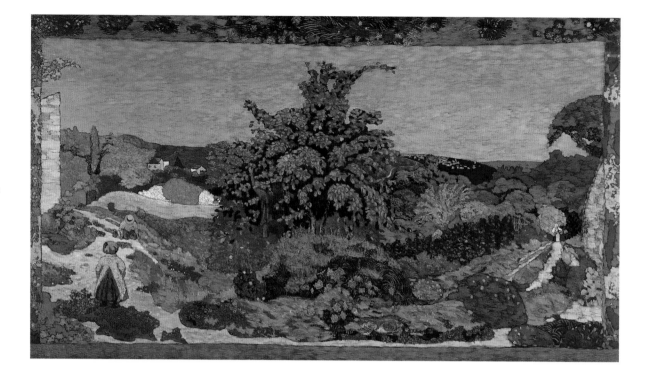

FIG. 1

Edouard Vuillard. *First Fruits*, 1899. Oil on canvas; 248 x 432 cm. The Norton Simon Foundation, Pasadena.

decoration for Jack Aghion, *Walking in the Vineyard* (cat. 42), was inspired by an excursion in the vineyards around Thadée's and Misia's country home, his choice of landscape for the Ile-de-France pendants was personal in nature. They were inspired by his extended stays at L'Etang-la-Ville, a hillside suburb six miles west of Paris where his sister, her husband (the painter Roussel), and their one-year-old daughter Annette (born November 1898) had recently rented a house. Writing to Félix Vallotton in July 1899, Vuillard noted his progress on the works:

In the end I'm very much preoccupied by the paintings I am making for rue Jouffroy. I now see them more clearly. For the past week, the long promenades in the good weather and a torrid heat which I find tolerable, has made me have renewed interest in things, the skies, the trees, the little flowers, especially when one is looking at them with the head down and I am thinking of finding something in nature to exploit."[5]

Many of the specific topographical details that Vuillard noticed on his walks through the lush landscape were reproduced in his sketches and easel paintings from the time.[6] In the two finished panels, Vuillard incorporated recognizable landmarks of the area, but subordinated specific details to the overall decorative effect.[7]

The view in *Window Overlooking the Woods* includes in the foreground a yellow house with an open window that reveals a woman (possibly Vuillard's sister, Marie) watering her geraniums. Also in the foreground of this panoramic landscape, at lower right, is a tiny figure picking grapes. The only other person in this verdant countryside is the man walking his horse in the middle ground, forming a small, bright speck amidst dense, green foliage. To the right of the roof line of the yellow house, the white-stucco structures of the little town tucked in between the hills are lit by an unseen sun, an effect that enlivens and opens up the otherwise tightly constructed and banded landscape. In the center of the composition next to the steel-gray church steeple, a stand of midnight-blue trees creates a cavernous surround. With the exception of this deeper spatial illusion and the spire piercing the middle ground, the composition is basically a series of softly rounded, overlapping, green tiers. The construction of these deceptively simple bands creates a landscape that can be read both as a flat backdrop and as a curving panorama that gives one the sense of being surrounded and enveloped by the landscape rather than looking at it.[8]

The larger pendant, *First Fruits* (fig. 1), represents the same rolling terrain. Like *Window Overlooking the Woods*, it eschews complicated illusionistic devices in favor of flat, decorative schemes, but it is more traditionally conceived than its pendant, with a giant tree anchoring its symmetrical composition. Simple in design and airy in feeling, it is a fitting complement to the densely packed and airless construction of its pendant.[9]

The garland border that decorates the top horizontal edge and the vertical edges of each of these panels

distinguishes these decorative paintings from all others in Vuillard's oeuvre. A study for *First Fruits* shows that Vuillard had already decided at an early stage to include the border.[10] In contrast to Denis's *Forest in Spring* and *Forest in Autumn* (cat. 17–18), which also rely on borders to confirm their tapestrylike character, Vuillard included the garland decoration on only three sides, adding to the fourth a clay-colored "ledge" to suggest a third dimension—that of the interior from which the landscape is viewed.[11]

No doubt Vuillard's choice of borders reminiscent of French Renaissance and Flemish tapestries was a means of connecting his decorative vision to his patron's tastes.[12] Adam Natanson owned several *verdures* (North European tapestries representing wooded landscapes), and the various tapestries that appear in Vuillard's paintings and photographs of Thadée and Misia's rue St.-Florentin apartment (see 1890–99 Intro., fig. 4) may well have come from his collection. As Achille Segard noted, in making these panels Vuillard did not create images that closely reflected the realities of the rural landscape and those who labor in it, but rather an intellectualized metaphor for nature. Rhetorically (since Segard knew very well for whom the paintings had been conceived), he continued:

One feels that the work has been painted in a large town and for a metropolitan apartment. . . . The vision of nature that M. Vuillard presents for us is the possible reward of an intellectual work that one engages upon in its viewing and contemplation. It is the reward associated with the state of mind of a city-dweller.[13]

As already noted, the destination for these panels was indeed a large metropolitan home on rue Jouffroy,

near Parc Monceau. Although no documents exist of their installation, the panels were probably attached by their stretcher bars to wooden moldings. The twenty-one-inch difference between the widths of *First Fruits* (fig. 1) and the smaller *Window Overlooking the Woods* (cat. 41) was likely calculated to fit exact wall measurements. In 1904, Adam sold his house to move into his son Alfred's nearby apartment at 92, boulevard Malesherbes. Based on photographs of the installation of the panels in this residence, it appears that they were hung in different rooms. A photograph taken about 1906 shows Marthe, Alfred's actress wife, seated in a bentwood rocker in the library of this apartment at a heavy oak table facing *Window Overlooking the Woods* (fig. 2). Another from the same period shows *First Fruits* hung in the dining room.[14] These photographs indicate that the panels were placed so that the bottom edge would match the eye level of a person seated at a table, thus giving the viewer a sense of being surrounded by a landscape that could only be partially taken in. Certainly for Alfred's daughter, Annette Vaillant, who grew up with the panels in her parents' apartment, the paintings were tantamount to a living storybook. Recalling her childhood impressions, she wrote of the fairy-tale world that *Window Overlooking the Woods* evoked for her as a little girl:

That immense panel in which I lose myself to my daydreams, unconscious of the fact that my grandpapa Natanson—always so sober and severe—had commissioned it from Vuillard. . . . Paying no attention to my grandpapa, I amuse myself by pushing my detestable spinach with my fork and finally, I escape into the painted landscape which is more real than real, absolutely actual, and unlimited—with its poplars and its hillsides. The pointed steeple of the little church, and in the middle ground a little white house. . . . House of the Ogre or House of little Red Riding Hood, its window is bathed in a fuller light and opens to a woman who tends her geraniums. Is it me she calls or that laborer at work—the happy man of the country whose thirst is quenched with a glass of red wine.[15]

Although their large size made them difficult to hang as pendants,[16] the panels as Segard described them, were "easily adapted to the wall like a tapestry that one fixes with four nails and that seems to have been placed there permanently at whatever place one installs it."[17] As Vaillant's description of *Window Overlooking the Woods* reveals, the panels lend themselves to a wide range of interpretations. While Adam Natanson, who commissioned them, probably valued their formal, tapestrylike qualities, his granddaughter saw in them a magical world of escape, steeped in mystery and a sense of endless possibility.

FIG. 2
Alfred Natanson. Photograph, c. 1906, of *Window Overlooking the Woods*, installed in the library of his apartment at 92, boulevard Malesherbes. Salomon archives, Paris.

EDOUARD VUILLARD

Walking in the Vineyard, or *Promenade*
1899/1900

Oil on canvas
260.5 x 249 cm (102 ½ x 98 in.)
Los Angeles County Museum of Art, gift of Hans de
Schulthess

LIKE VUILLARD'S TWO MONUMENTAL paintings for Adam Natanson (see cat. 41), this nearly square painting was among the artist's last large-scale decorative landscapes painted in oil, rather than distemper.[1] The history of the two larger panels is well known since the paintings were owned by the Natansons and then by a friend of the Natansons until the 1970s. By contrast, the story of *Walking in the Vineyard* (cat. 42)—which was commissioned by a peripheral member of the *Revue blanche* circle and later became the primary decorative object in an interior designed by Henry Van de Velde in Hagen, Germany—is as fascinating as it is little known.[2]

Walking in the Vineyard was originally commissioned by the Egyptian-born, Oxford-educated, and independently wealthy collector Jack Aghion. Aghion was married to one of the two sisters of Josse and Gaston Bernheim, whose Galerie Bernheim-Jeune (so called to distinguish it from the gallery of their father, Alexandre) would soon officially represent Vuillard, Bonnard, and Vallotton. Vuillard's involvement with Aghion coincided with the latter's peak activity (1899–1902) as a collector of and novice dealer in modern art. In 1901, for example, when the Bernheim-Jeune gallery mounted a retrospective of Vincent van Gogh, Aghion lent six paintings. His collection also included works by Nabi artists Bonnard, Vuillard, Denis, and Roussel, as well as paintings by the Impressionists Boudin, Caillebotte, Pissarro, Renoir, and Sisley.[3] While Aghion was a well-known figure at this time, the exact circumstances of this commission are not known (as is true of so many of Vuillard's commissions, especially those executed before he began in 1907 to keep day-by-day journal entries). What we do know, from a letter Vuillard wrote in July 1900, is that he made at least two additional (unidentified) panels for the room in which this painting was installed and that other Nabi artists were to contribute works to an overall decorative ensemble:

We have installed the Aghion panels, and you know that you and Ranson are going to be asked if you want to make *décorations* for the two extremities of the room—which will echo the shades of the paintings and give an overall decorative cohesion to this wonderful room.[4]

Vuillard's enthusiasm for the decorative project shows his confidence in his future with Aghion. Unfortunately, the room, which was to be a joint endeavor, a kind of Nabi pantheon, was apparently never completed. This may have been due at least in part to Aghion's mental instability. Félix Vallotton, who married the other Bernheim sister in 1899, described him that year as "very rich," with "not much else to recommend him."[5] By 1908, he was bankrupt and forced to sell part of his collection. It was at this time that *Walking in the Vineyard* was sold to Jos Hessel at the Bernheim-Jeune gallery.[6] Aghion's mental state eventually led to his commitment to an asylum in Switzerland around 1912.

Like the large-scale landscapes inspired by L'Etang-la-Ville that Vuillard painted in 1899 for Adam Natanson (see cat. 41), *Walking in the Vineyard* also represents a recognizable place—the vineyards around the Natansons' property at Villeneuve-sur-Yonne. In the fall of 1899, Vuillard wrote to Vallotton, urging him to visit him there so that "we can speak together about the pretty virgin red ivy that covers the barn, and [we can] make some studies of this beautiful landscape with its supple lines and burgundy tones."[7]

The painting is difficult to read as a result of Vuillard's palette of closely related colors, devoid of value contrasts, ranging from olives, ochers, and yellows to hotter oranges and mauves, presumably chosen to blend with the color scheme of Aghion's interior. These colors, applied thinly in short, regular strokes, fuse men, women, and children into a seamless, almost woven surface. Despite the suggestions of intimacy and conversation between the figures, the men grouped together do not truly interact nor do the women's gestures give a clue to their relationship with the younger girls. The overall feeling is one of suspended animation. This quality stems in part from Vuillard's use of photographs, taken during an excursion around the Natansons' home in 1898 or 1899 (figs. 1–2), as a source for the composition.

One of these photographs (fig. 1), in which the shadow of Vuillard taking the picture can be seen at the lower right, is especially close in composition and subject to the finished painting. The little girl in the photograph with the hat, capelet, and long braid is

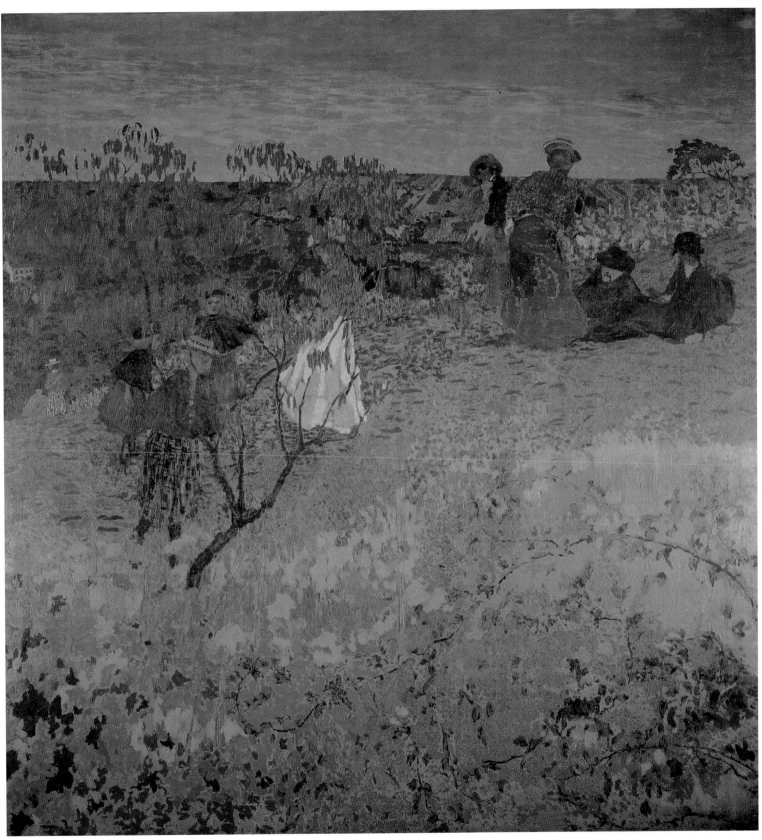

CAT. 42

FIG. 1

FIG. 2

represented at left of center in the painting. The woman in the white skirt, partially obscured by the tree in the painting, is also derived from the photograph. Even small details from the photographs made their way into the painted work. For example, the vertical supports for the plants in the vineyards, visible in the background of the photographs, are included in the painting as tiny dashes at the upper right. Vuillard added a number of elements to the painting that are lacking in the photographs, however, giving it a lower vantage point, adding a tree, and introducing other changes that add to the work's visual interest.

The casual, unposed nature of the photographs makes it difficult to identify the subjects conclusively. It has been suggested that the photographs of the outing represent Vallotton and his wife, Gabrielle; Misia and Thadée; their writer friend Romain Coolus; and possibly Roussel and his wife, Marie,[8] all of whom have been generalized in the painted panel for the sake of ornament. The seated gentleman with red hair

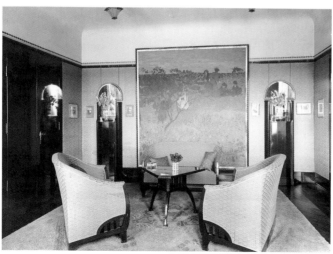

FIG. 3

and bushy beard at far right in the painting may be an approximation of the artist himself. The trio of young girls might be Thadée's nieces, the daughters of Olga and Alexandre Natanson, or Aghion's own daughters, Janine, Germaine, and Marie Louise, aged five, eight and eleven respectively in 1899. Vuillard would hold a fatherly affection for these girls long after their eccentric father's death in 1918.[9] Not surprisingly, the most recognizable figure, based on gesture and attire, is Misia. In the painting, she is seen from the back hovering over the seated gentlemen at upper right, and in another photograph of the outing (fig. 2) she faces front in a similar half-turned pose, wearing her characteristic checked blouse with a large, floppy bow.[10]

Before the end of 1908, *Walking in the Vineyard* was sent to Bernheim-Jeune and purchased by Henry Van de Velde on behalf of Karl Ernst Osthaus. The painting was to serve as an integral part of a larger interior decorative scheme Van de Velde was creating for Osthaus's home in the small town of Hagen, in Westphalia. There, it became the prime architectural ornament and artwork for the *Salonkultur*, or music room. Osthaus's home, called Hohenhof, featured other specially designed rooms, including an entrance hall with a mural by Swiss Symbolist Ferdinand Hodler, and a winter garden with a ceramic-tile mural by Henri Matisse. A photograph of *Walking in the Vineyard* taken before 1920 shows how rich the total effect was in Osthaus's home (fig. 3). The upholstery, designed by Van de Velde, echoed the regular brush strokes of the painted canvas, while the tapestry rug repeated the arabesques and diagonals of the composition. One can only assume that these interior ornaments would have been in chromatic harmony with the muted and subtle palette of Vuillard's decoration.

Interestingly, *Walking in the Vineyard* was probably better integrated into this setting than it was in Aghion's interior, the one for which it was specifically commissioned. At Aghion's, the painting may well have been relegated to a secondary role and overshadowed by the collection of artwork and traditional, aristocratic furnishings. At Hohenhof, Vuillard's dreamlike landscape became the primary feature of a totally integrated design. In many ways, the German setting for *Walking in the Vineyard* fulfilled Denis's earlier call for the integration of contemporary painting with other artworks of "noble appearance, of rare and fabulous beauty," to create a modern interior that would be "clear, simple, and pleasing."[11]

Catalogue

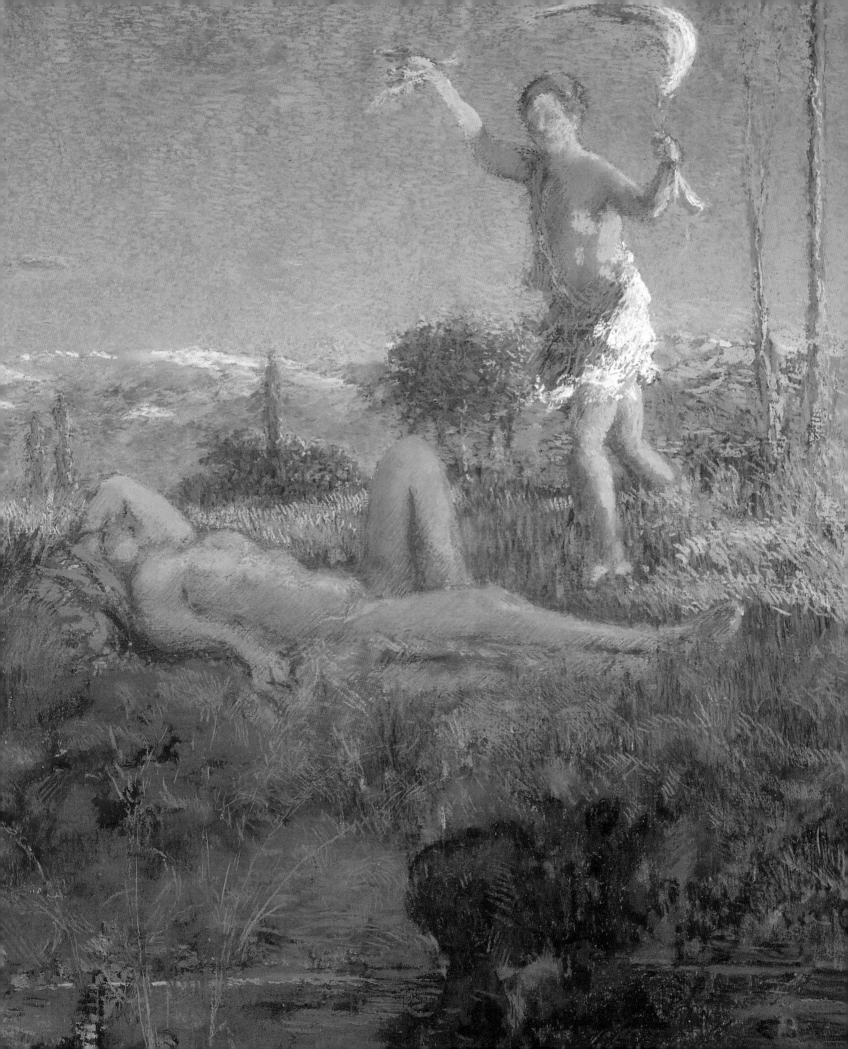

Into the Mainstream: Decorative Painting, 1900–30

S THEY ENTERED THE TWENTIETH CENTURY, Bonnard, Vuillard, Denis, and Roussel continued to share a long-standing friendship, as well as many artistic connections: dealers, patrons, exhibitions, and teaching responsibilities at the Académie Ranson, Paris. But they also increasingly evolved along distinct and independent lines—especially in the case of Denis—pursuing their common decorative goal in ways that were mediated by temperament, ideology, and patronage opportunities. Moreover, as more stridently avant-garde developments—such as Fauvism, Cubism, abstraction, Dada, and later Surrealism—hogged the critical limelight, their art increasingly was seen as conservative. As Nicholas Watkins notes in this book, the revolutionary implications of these artists' work—which they executed quietly and without fanfare during these years—were in many respects not clearly felt until after World War II. The activities of this group of artists have thus remained largely outside the standard accounts of this period in modern art. It is one of the goals of this essay to begin to fill this gap by reconstructing the circumstances, both factual and theoretical, around their major decorative projects after 1900. Special importance will be given to the role of particular patrons and to the complex relationship with Henri Matisse, the one exponent of a decorative aesthetic whose work was always regarded as part of the avant-garde.

Between 1900 and 1930, the four artists featured here reached their full artistic maturity and achieved international reputations: Bonnard, with complex and coloristically dazzling landscapes and scenes of domesticity; Denis, with ambitious mural projects for private patrons and especially for religious institutions; Roussel, with exquisitely crafted small panels and pastels, as well as enormous murals for both public and private patrons; and Vuillard, with large-scale decorations, as well as with a hybrid of portraiture and decoration that remains largely unique in the history of twentieth-century art. In a period of incredible stylistic diversity and theoretical extremism, all four artists were appreciated or condemned for their constancy, and for renewing their art without losing, as will be shown, the sense of belonging to a uniquely French tradition.

TOWARD STABILITY AND RECOGNITION

In April 1900, another "Modern School" exhibition, smaller than the one of 1899 discussed earlier in this book (see 1890–99 Intro.), and consisting of works by the former Nabis Bonnard, Denis, Hermann-Paul, Ibels, Maillol, Ranson, Roussel, Sérusier, Vallotton, and Vuillard, took place at Galerie Bernheim-Jeune. The gallery, run by two young brothers, Josse and Gaston Bernheim, who had recently taken over the business of their father, Alexandre, at 8, rue Laffitte (adding the "Jeune" to the gallery's name to distinguish their enterprise from their father's),[1] soon forged a significant relationship with the four artists under discussion. Only Vuillard would officially sign a contract with the gallery (it remained valid at least until 1912, when he opted to be represented instead by the Bernheims' cousin Jos Hessel). Bonnard would show there annually between 1906 and 1913 and less regularly until 1946, and Roussel and Denis participated in group shows and were given important solo exhibitions there throughout the gallery's first decade.[2]

In many ways, the gallery run by the Jewish Bernheims appealed to a milieu of young artists and intellectuals similar to that of *La Revue blanche*, which would cease publication in April 1903. By 1906, when the art historian and critic Félix Fénéon joined the Bernheim-Jeune gallery, it represented most of the artists who had shown in the 1899 "Modern School" exhibition, including, as Fénéon wrote to the Belgian architect and designer Henry Van de Velde in 1906, Bonnard, Denis, Roussel, and Vuillard, in addition to Lucie Cousturier, Cross, Luce, van Rysselberghe, Signac, and other "bons peintres."[3]

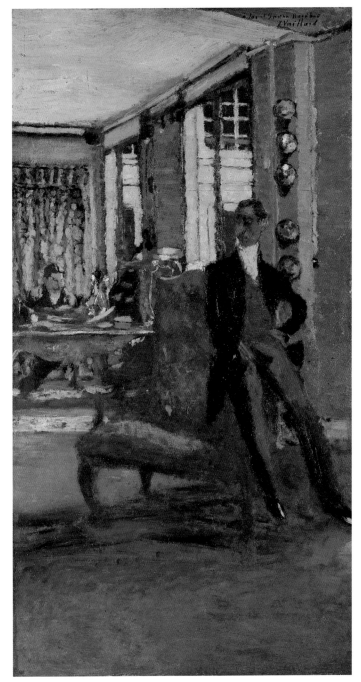

FIG. 1
Edouard Vuillard. *Portrait of Josse and Gaston Bernheim*, 1907–08. Oil on canvas; 73.2 x 66 cm. Marion Koogler McNay Art Museum, San Antonio, Texas, bequest of Frances Cain.

work and contracts during purely social events) that the painter deplored several times in his journal.[4] Vuillard's portrait of the Bernheims (fig. 1) portrays them as elegant, assured, and slightly rapacious, as if waiting in their sumptuously appointed gallery for the next customer. It was here that many of Vuillard's decorative cycles were showcased and purchased, or, in the case of commissioned works, shown before installation in a specific interior. Bonnard, on the other hand, enjoyed a much looser arrangement (based only on a verbal agreement), and while good friends with both brothers, remained, owing to his peripatetic lifestyle, at a certain distance from the "business" of art. Denis's exclusive relationship with the Bernheims lasted only until 1907, when he was given an important solo exhibition. After this, although he remained cordial with the gallery and occasionally showed in group exhibitions, he switched allegiances to the more established Galerie Druet. Another important dealer for the four artists was Ambroise Vollard, who showed their works on paper and commissioned several lithographic albums from the artists. Vollard was a particularly strong supporter of Bonnard and Roussel.[5]

By 1907, Denis's writings and paintings revealed his devotion to an art of decoration that no longer accepted the ideal he had himself so eloquently articulated in 1890 of a pure transposition of reality into a subjective expression on canvas.[6] The kind of art he now advocated required a vigorous reassertion of traditional formal values to achieve a universal rather than personal expression. Denis's art had indeed moved along a different path from that of his artist friends. The gap he had pointed out in 1899 between "Latin" and "Semitic" tastes within the group had only grown wider, although long-standing friendships still held. This paradox was explained by Vuillard to Count Harry Kessler, a German collector and important patron of Denis, during the count's visit in December 1902: "You see, within our so-called group, Maurice Denis, Bonnard, Roussel and me, we are very close and we exhibit together; but we want totally different things [of art]. On the other hand, we are always searching for something of a truly formal interest in our works [*un intérêt vraiment plastique*]."[7]

As shown, despite the divisiveness of the Dreyfus Affair and Denis's own anti-Dreyfus stance, Denis remained close friends with pro-Dreyfusards Bonnard, Vuillard, and Roussel.[8] As adults with new responsibilities (by 1900, all but Vuillard were married, although

Although professionally it was Fénéon who was the glue that bound the group to the gallery, the Bernheim brothers would play an important role as well, since they were socially well connected, rich, and financially savvy. They were particularly close to Vuillard, whose intense friendship with Lucie Hessel (the wife of Jos Hessel) tied him to the Bernheim family. Indeed, the brothers' role took the form of a personal involvement in Vuillard's life (visiting his studio, commenting on works in progress, bringing up

Bonnard would not officially marry Marthe de Méligny until 1925), their circumstances had greatly changed from the time of their youthful bohemian gatherings in Ranson's studio. With the gradual breakup of the Nabis as a group, Denis no longer wrote on their behalf, but continued his personal campaign to make his own art known. In his writings, Denis, the only politically engaged artist of the four (especially so after 1905, when the French government separated church and state, which pushed him closer to the monarchists), insisted on the superiority of both French (Christian) and classical (Latin) culture.[9] Through his patrons, who included administrative officials and well-connected artists of the Third Republic, many of whom were actively involved with public mural projects (the critic Roger Marx, the artist Albert Besnard, and the entrepreneur Gabriel Thomas) and church commissions, his career rise was steady and sure. Bonnard, Vuillard, and particularly Roussel followed less obvious but nonetheless effective routes to financial security and public renown.

The differences in both their art and personalities were acknowledged and respected within the group. In 1910, Denis, already lauded as successor of Pierre Puvis de Chavannes, accepted without hesitation the title of Chevalier of the Legion of Honor. Vuillard, who with Bonnard and Roussel would refuse the honor two years later out of solidarity with Claude Monet and others who were never offered it, wrote a congratulatory note, reminding Denis how much he admired and liked him: "Moreover, you've known for a long time, I think, about the confidence, admiration, and affection I have had toward and for you."[10]

Of the four friends, Vuillard was the most permanently situated in Paris, continuing to live with his mother until her death in 1928. Although trips and summers with the Hessels took him periodically out of the city, he was, in the end, a city-dweller, unlike the other three, who mostly lived outside the capital. Denis remained in the western suburb of St.-Germain-en-Laye, where in 1914 he purchased a former convent (Le Prieuré), which five years later would become the Ateliers d'art sacré (a school of religious art); Roussel settled at L'Etang-la-Ville, where by 1906 he had bought a permanent residence, La Jacanette (named for his children, Jacques and Annette); and Bonnard, although keeping an apartment and studio for much of his life in Paris, rented and eventually purchased homes in Normandy and in the Midi.

Until World War I, which dispersed them to different locales, the four artists remained closely connected to one another. One of their gathering places was the Académie Ranson, which opened its doors in 1908 on rue Henri-Monnier. Billed as an "Academy of Painting, Sculpture, and Decorative Art," it boasted a faculty of the former Nabis Bonnard, Denis, Lacombe, Maillol, Ranson, Roussel, Sérusier, Vallotton, and Vuillard, and the Neo-Impressionist artist Théo van Rysselberghe. The school was originally conceived as a means of helping Paul Ranson's financial situation. When Ranson died suddenly in February 1909, it was continued as an homage to the artist under the direction of his widow. In operation for the next ten years, the school enjoyed a prestige equal to that of two other Paris establishments, the Académie Julian and the Académie de la Grande Chaumière.[11]

The schedule and requirements for the teachers were loosely defined. Each artist contributed according to his temperament and availability.[12] Indeed, by this time, their personalities were as publicly known as their works: Denis, the devout Catholic, gifted teacher, and acknowledged master of the mural-painting tradition; Roussel, the painter of Virgilian subjects who read poetry to his students; Bonnard, the surprisingly inventive and unclassifiable observer of modern life; and Vuillard, the painter of the interior realm, whose decorative works, as the writer André Gide had described them in 1905, "spoke almost in a whisper."[13]

DECORATION AND THE LURE OF THE MEDITERRANEAN, 1900–14

The activities and goals of the Académie Ranson may be compared to the short-lived Académie Matisse, which had opened a few months earlier, in January 1908, on rue de Sèvres and closed in March 1911. Patterned in part after the conservative and academic training program that Matisse had received (in Adolphe Bouguereau's studio), this school taught a mainly international group of students. Matisse showed up weekly in the beginning, and less often after 1909, to correct, advise, or just lecture informally. His method of teaching, by motivating rather than directly instructing his students, paralleled the efforts of Bonnard, Roussel, and Vuillard, whose weekly involvement at the Académie Ranson also decreased after the first year or so. With the exception of pedagogically gifted artists, such as Denis and Paul Sérusier,

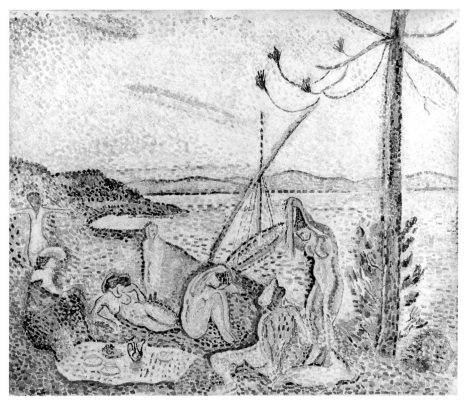

FIG. 2

Henri Matisse. *Luxe, calme et volupté*, 1904. Oil on canvas; 98.3 x 118.5 cm. Musée d'Orsay, Paris.

through its colors, which calm us. The colors obviously are not composed haphazardly, but expressively. A painting on a wall should be like a bouquet of flowers in an interior.[16]

Matisse's remarks sound close to Denis's own call in 1895 for an arrangement of colors and forms on canvas "for the pleasure of the eyes."[17] Likewise, Matisse's notion of composition (defined in his 1908 "Notes of a Painter") as "the art of arranging in a decorative manner the various elements at the painter's disposal for the expression of his feelings" seems analogous to Denis's famous definition of a painting as "a flat surface covered with colors arranged in a certain order."[18] Matisse's belief in painting as "an art of balance, of purity and serenity devoid of troubling or depressing subject matter" and its role for modern life as a restorative, "a mental soother, something like a good armchair,"[19] similarly appears to reinforce Denis's 1892 "dream" of an interior with paintings of a "rare and extraordinary beauty" that "contribute to the poetry of man's inner being."[20]

Shared too was their interest in a return to the classical world associated with the Mediterranean coastal region of France, which both Matisse and Denis had discovered in 1904 and 1906, respectively. As Jean Paul Bouillon pointed out, Matisse and Denis represented two facets of an artistic moment characterized by a renewed interest in the sense of balance, harmony, and purity associated with antiquity and the Mediterranean. But Matisse and Denis pursued this goal in very different ways. Matisse's *Luxe, calme et volupté* invokes the indolent, sensuous, and liberated spirit of antiquity with garishly colored figures in an equally intense landscape. Denis's paintings, such as *Beach with Small Temple* of 1906 (cat. 60), are imbued instead with a restraint and discipline that hark back to a time when order and simplicity, intellect and art reigned. Moreover, as Bouillon rightly asserted, Denis's deep religious convictions and his belief that art should express universal, spiritual values made it impossible for him to accept what he perceived to be Matisse's purely hedonistic and individualistic response to nature.[21]

The lure of the Mediterranean was a crucial feature in the work of other artists as well. By 1900, Roussel was already forging an iconography based in myth and classical poetry. With few stylistic changes (Roussel's paintings from around 1900 are often indistinguishable from those painted in the 1930s), his art increasingly revolved around variations on certain mythological or classical themes—in images such as

who taught on a regular basis and who enjoyed communicating their techniques and ideas about painting, most of the artists were there to provide support and encouragement. More significant than the actual teaching practices, however, was the fact that both the former Nabis and Matisse, despite their aesthetic differences, felt the need to organize and have an impact on future generations of artists.[14] The notion of painting and decoration was of particular concern to both schools. (Sérusier taught a special course in decorative painting.) Indeed, while Matisse's *Luxe, calme et volupté* (fig. 2), exhibited at the 1905 Salon d'Automne and heralding the advent of Fauvism, was visually antithetical to Denis's Puvis-like *Trellis (Decorative Panel)*, shown at the Salon de la nationale that spring, both artists agreed on the importance of the decorative to their work.[15]

For Matisse, who would make even larger decorative paintings over the next seven years, the decorative was intimately related to the interior. As he stated as late as 1945:

The Decorative is an extremely precious thing for the work of art. It is an essential quality. To say that the paintings of an artist are decorative does not detract [from them]. All the French primitives are decorative. The character of modern art is to participate in life. A painting in an interior spreads joy around it

The Abduction of the Daughters of Leucippus (cat. 65), *Triumph of Bacchus* (cat. 64), and *The Sleep of Narcissus* (cat. 66). Roussel's interest in such subjects was reinforced by trips to St.-Tropez in 1904 and again along the Estérel (the coastal region between Cannes and St.-Tropez) with Denis in 1906. During the latter trip, the two artists visited Cézanne, Cross, Renoir, and Signac, all of whom were evolving a style and palette that evoked the south and its antique past. Bonnard similarly became fascinated with the special quality of southern light and with classical motifs around 1908, following a trip to St.-Tropez. Bonnard's decorative cycle for Misia Natanson Edwards (she married the very wealthy Alfred Edwards in 1905), for example, painted between 1906 and 1910 (see cat. 45–47), features toga- and tunic-clad men and women, and bucolic southern landscapes that are unlike anything he had done before.[22] In reexamining the art of antiquity, Bonnard, Roussel, and Denis joined Matisse, Maillol, Derain, and later Picasso, among others, who were also to develop a modern type of painting based on antique models.

Not surprisingly, in this context, nudes took on new significance, especially between 1907 and 1913, when exhibitions of works by these artists were dominated by depictions of the female nude in various guises—mythological (Roussel), classical (Denis), classicizing yet modern (in the interiors of Bonnard).[23] The importance of Cézanne, whom, as mentioned above, Denis and Roussel visited in 1906 in his studio at Les Lauves, cannot be discounted.[24] In his writings, Denis singled out Maillol as the successful heir to Cézanne's solemn and heroic nudes, because he considered Maillol's sculptures, based on Greco-Roman and modern ideals, to be an antidote to Matisse's unbridled colors and subjects. For Denis, Maillol best represented the spirit of *latinité* (order, balance, clarity, and harmony of proportions) that he sought to universalize through his writings and art.[25] For many of these artists, "Mediterranean" became a catch-all word during the first decade of the twentieth century, resonating with moral and aesthetic connotations.[26] In 1903, Maillol began work on the seated female sculpture that would become known as *Mediterranean* and that seemed to embody the simplicity, clarity, and heroism of antiquity, as did the figures of Denis's *Terre Latine* (1907; Musée Départemental Maurice Denis "Le Prieuré," on loan from Musée du Petit Palais, Paris), a three-panel ensemble for the home of Jacques

Rouché.[27] Denis's "antique" period—that is, when mythological or overtly classical themes predominated in his work (see for example *Beach with Small Temple* [cat. 60] and *Eurydice* [cat. 59; cat. 59, fig. 1])—spanned the years 1900 to 1914 and culminated in the series of six panels on the theme of Nausicaa, exhibited at the Druet gallery in 1914 and purchased by Marcel Kapferer in 1919 (see cat. 61–62).[28]

Bonnard's borrowings from the past are less obvious, both in his choice of style and in his treatment of Mediterranean subjects. Stylistically, he favored the softer, looser brushwork of the Impressionists over the linear definition espoused by Denis. Thematically, he evoked the past through the mood of his works rather than through pointed allusions to antiquity. His three panels for the Russian collector Ivan Morozov (cat. 50), for example, exhibited in 1911 at the Salon d'Automne, are set in contemporary times. What is "southern" about them is not so much a set of specific references to the classical past as the artist's association of his Mediterranean subject with relaxation, luxuriant well-being, and an overwhelming sense of warmth and tranquility. Like Matisse, Bonnard alluded to the civilizing effect of the distant past with a color scheme and composition that suggest internal order, calm, and a cohesion of parts within the whole.

Of the four artists featured here, Vuillard remained the only one not drawn to the Midi. Although he made small landscape paintings of Cannes, which he visited in 1901, and accompanied Roussel to St.-Tropez in 1904, he did not incorporate the Mediterranean landscape or light into his large-scale decorative works. On the contrary, he seems to have discovered the decorative potential in urban motifs, as evidenced in the number of his works between 1908 and 1915 (the same years in which the nude played such an important role in the art of his friends) that focus on the streets and squares of the city (see cat. 73–81, 83).

Vuillard's response to the classicizing trend of the period and his renewed appreciation of qualities typically associated with drawing (coinciding with and possibly a result of his involvement with the Académie Ranson) are best represented by a monumental decorative painting of 1911 known as *The Library* for Marguerite Chapin (fig. 3), one of his most fascinating efforts in this genre. Destined for a grand interior (probably the salon of Chapin's apartment at 110, rue de l'Université), it is replete with references to

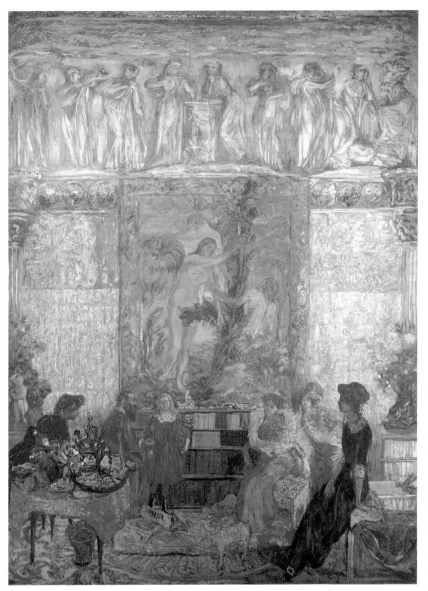

FIG. 3
Edouard Vuillard. *The Library*, 1911; repainted 1912–13, 1936. Distemper on canvas; 400 x 300 cm. Musée d'Orsay, Paris.

Salon d'Automne. Commissioned by Sergei Shchukin, this painting might also have been known to Vuillard from a visit, one month after he had begun *The Library* (October 1910), to Matisse's studio in the suburb of Issy-les-Moulineux. In his journal he remarked only on Matisse's students and the "grisaille by Puvis" in the artist's atelier.[31] Perhaps this visit inspired his own use of this older technique in *The Library*, but there the analogy between these two contemporaries ends. Compare, for example, Matisse's *Red Studio* (fig. 4), finished the same year. Matisse's large, uncommissioned decorative painting is a shocking assault on the senses, while remaining clear and open in composition. The room itself is defined by the objects in it, as floor and walls merge into the seductive, all-encompassing red that gives the work its name. Vuillard's canvas, by contrast, is painted in a limited range of silvery blues, and organized according to a highly detailed three-tiered structure. Every inch of Vuillard's large-scale canvas is devoted to rendering in considerable detail the people, artworks, and objects within, down to the overflowing wastepaper basket to the left of center.

Denis would undoubtedly have felt that both Matisse's and Vuillard's works inadequately met the goals of decorative art: the one being too "hedonistic," the other too "prosaic" (as he referred to Vuillard's paintings in 1907) in its emphasis on the material rather than the poetic.[32] Denis's basic problem with Matisse, Vuillard, and many other artists whose decorative works were exhibited at the Salon d'Automne during these years was their inability to subordinate their vision to what he considered to be the universal rules of color, harmony, and line, rules entrenched in French tradition and classicism. It may have been that Denis equated suppression of one's individual temperament in art to a more universal concept of subordination, community, and humility, grounded in Christian virtue. In 1907, Louis Rouart, a member of the Catholic right-wing intelligentsia (and husband of Henry Lerolle's daughter Christine, whose likeness appears in Denis's *Terre Latine*), implied this in an article praising Denis's decorative paintings. For Rouart, Denis's sensibilities and his popularity as a decorative painter for private homes and churches would not have been possible in the nineteenth century, which he saw as marked by the triumph of individualism, a trait opposed to art that occupies "a restrained place, . . . a spot fixed in advance within a harmonious ensemble," and that is based "upon a common goal."[33]

past art. The frieze at the top, for example, shows the well-known *Sarcophagus of the Muses* (150 B.C.), which Vuillard copied in the Salle des Antiquités at the Musée du Louvre.[29] References to the Renaissance (the band of decorative medallions below the classical frieze) and to the Baroque (the tapestry based directly on Titian's *Adam and Eve* and on the Rubens copy after it, which hung together in the Museo del Prado, Madrid) are also embedded in this scene of modern life.[30]

The "order" imposed on this composition is altogether different from the kind Denis or even Matisse had in mind. Vuillard probably knew the latter's monumental *Dance II* (1910; The State Hermitage Museum, St. Petersburg), when it was exhibited at the 1910

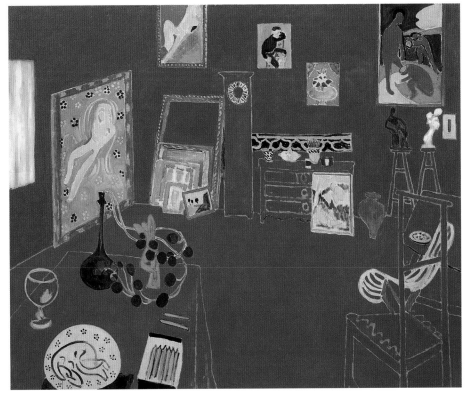

FIG. 4
Henri Matisse. *The Red Studio*, 1911. Oil on canvas; 181 x 219.1 cm. The Museum of Modern Art, New York.

DIFFERENT STROKES: PERSONALITY, IDEOLOGY, AND DECORATION, 1900–14

As noted in the preceding section, the four artists under discussion evolved highly distinct expressions of the decorative ideal they held in common. These variables included not only the differences in their response to classicism, but also broader differences in "spirit, taste, inventiveness, poetry," and "technique," to use the words of one of the Nabis' major patrons, Count Harry Kessler. His journal comments following the Salon d'Automne of 1910 deserve to be quoted at some length for their insight into some of the primary distinctions between Denis, Bonnard, and Vuillard. Examining Denis's irregularly sized decorative panels for the vaulted octagonal cupola of Charles Stern's mansion in Paris, Kessler concluded that they "leave me surprisingly cold; if I ask my conscience, they do not give me any joy whatsoever. Maybe he does too much, his art is too complete, a too complete materialization of his thinking; no more secrets, nothing remains."[34] Quite the contrary was his reaction to Bonnard's tawny, brown-orange panels for Misia Edwards's dining room (see cat. 45–47), which he felt were less complete, more awkward, but so much more fascinating! His [Bonnard's] works really give joy; one is always looking for-

ward to the new, the exceptions. Unlimited abundance in taste and inventiveness, drawing, color. It is not at all possible to compare in parallel terms Denis and Bonnard, and not in the least with regards to spirit, taste, inventiveness, poetry; only in technique, in execution, does Denis stand above Bonnard, but even then, you wonder whether this is an advantage.[35]

For Kessler, Denis's palette was "gracious but academic," whereas Bonnard's was "poetic" and "ingenious" (but he conceded that Bonnard's decorative work was probably not up to the standards of his easel painting), and Vuillard's was "natural."[36]

These differences were sensed by the artists as well. In April 1906, Denis recorded a recent conversation with the painter Marc Mouclier about Vuillard's paintings exhibited at the Indépendants that spring: "Mouclier says that the paintings by Vuillard at the exhibition are very good but that they have the appearance of dancing in front of the canvas. That's a funny way of saying that there is an affectation in the carelessness of his execution. It flits and flickers [*ça papillotte et ça papillonne*]."[37] Denis's remarks point to one of the major divisions in the group as early as 1898, concerning the importance of current work by the Impressionists (a term that was then understood to include artists like Cézanne, Degas, Monet, and Renoir even at the end of their careers, art that we now refer to as Post-Impressionist). On a personal level, all four artists respected and were friendly with the older artists. Denis and Roussel, as noted, visited Cézanne in the Midi; Vuillard visited Degas shortly before his death in 1917; and Bonnard, Vuillard, and Roussel were regular visitors to Monet's studio at Giverny. In their art, however, only Bonnard and Vuillard looked closely at their Impressionist predecessors, especially at their treatment of contemporary city and suburban scenes shown from a fragmentary viewpoint. They also adapted the Impressionists' broken brushwork to their subtle color modulations, but significantly departed from them in their choice of scale, format, and in the relative importance of figure to ground. As Bonnard remarked at the end of his life, "When my friends and I wanted to pursue the Impressionists' experiments and try to develop them further, we looked to transcend their naturalist viewpoints and color. Art is not nature. We were more serious about composition. There was also a lot more to be gained with color as a means of expression."[38]

For Vuillard, the search for the potential of color involved experimenting in distemper. In 1907, after a six-year hiatus, he returned to the distemper (or *à la*

FIG. 5

Photograph of Maurice Denis's *The Musicians* (left), and *Coronation of the Virgin* (right), both 1908. They are seen here installed in the dining room of Gabriel Thomas's home in Bellevue, outside Paris. Both are now in the Musée Départemental Maurice Denis "Le Prieuré," St.-Germain-en-Laye. Photo: Bouillon 1993, p. 129.

colle) technique for two decorative, large-scale paintings, which he showed at the Bernheim-Jeune gallery in February 1908.[39] That same year, Vuillard attended the inauguration of Denis's decorative panels for Gabriel Thomas, a cousin of the painter Berthe Morisot, and an inventor and engineer who would be instrumental in the creation of the Théâtre des Champs-Elysées (1910–13). The suite of mural and overdoor panels that Vuillard would have seen in Thomas's formal and mirrored dining room was collectively entitled *Eternal Spring* and depicted allegorical and religious scenes such as the *Coronation of the Virgin* (see fig. 5), with the likeness of Thomas's wife and children substituted for the biblical protagonists. Vuillard, however, made no note of Denis's curious blending of religious iconography and modern portraiture, commenting only on the use of grisaille and on the "rich bourgeois world" that was its setting.[40] Two days later, Vuillard saw Denis's decorative paintings for the vestibule of Rouché's mansion near Parc Monceau. The *décorations* by Denis, Besnard, and Georges Desvallières (who would become with Denis a notable religious artist) for this residence were a major social and artistic event, showcased in the popular press of the period. This time, Vuillard's assessment was more critical: "Pretty colors [but] no expression. Irritation and discomfort among this society, ugly wall

paintings by Besnard, . . . good memories of Alexandre Natanson."[41] The fact that Vuillard visited two decorative projects by Denis within a short period of time also suggests the degree to which commissioned, large-scale paintings by well-known artists of whatever school had become popular and irresistible status symbols for a certain economic and social echelon. Indeed, by the time of the Salon d'Automne of 1908, *la peinture décorative* no longer needed an apology or explanation. As Charles Morice, observing the variety of decorative paintings by artists of widely different styles, remarked: "Decoration is the goal, the purpose, and the sanction of all efforts concerning art."[42] What Morice was referring to was not merely site-specific and commissioned works, but an increase in paintings in general that combined the aesthetic and physical characteristics of decoration—large, open compositions displaying an increasing tendency toward abstraction and a palette of closely related hues, whether bright or muted, on canvases of any format for exhibition and sale.

By mid-decade, Vuillard had developed a hybrid of portraiture and decoration that he would use throughout his career. In the majority of his large-scale decorative works created after he returned to distemper in 1907, his style was characterized by a greater naturalism. This was achieved at times through the use of photographic sources, or aides-mémoire, as well as by the dissolution of distemper to an almost wash-like consistency or, conversely, by its application in dense, cementlike layers. This tendency was also reinforced by a preference for Impressionist themes of modern streets, squares, and suburban or summer homes.[43]

Bonnard, by contrast, had no single decorative style. Content to experiment during the 1890s, he was not commissioned to paint for specific interiors until after 1905. By this time, he had developed several different ways of approaching a decorative painting. In the 1907 *In the Country* panels (cat. 48–49) for the Kapferer residence, for example, he relied on a fairly traditional vertical format and a subject and palette that hark back to eighteenth-century pastoral painting. For Misia Edwards, he created a set of four panels (see cat. 45–47) whose brilliant disarray and disregard for any one theme or meaning matched his patron's own eccentric and passionate personality. In other words, he adapted his style and imagery, as Kessler pointed out, to the color scheme of the interior, the character of his client, or other requirements of the work's destination.

Roussel's decorative style, unlike Bonnard's, varies little in theme and palette from that of his smaller canvases. The big difference between his decorative and non-decorative works was his adoption of Vuillard's preferred *à la colle* (distemper) method for the former, resulting in the matte, thick, and crusted surface that is readily seen in his works for Jean Périer (cat. 70) and that is markedly distinct from the oil surface of his earlier decorative paintings *Triumph of Bacchus* (cat. 64) and *Triumph of Ceres* (cat. 64, fig. 1), acquired by Morozov.

The choice of distemper by both Vuillard and Roussel is significant. In the first place, it tempered the facility with which they could blend colors or paint wet on wet to smooth over previous painted passages. With distemper, mixing on the canvas is not possible, since the paint (made up of dry pigments and melted glue) dries quickly. For Vuillard and Roussel, it represented a more stable, durable medium, one that they thought (erroneously, as it turned out) would not fade or discolor and would remain as hard as cement.[44] In a letter to Hans or Werner Reinhart, regarding Roussel's decorative murals for the Kunstmuseum in Winterthur, Switzerland (cat. 67–68), Roussel explained how the wavy lines in the canvas (presumably referring to the results of having sent rolled, unstretched canvases from his studio in L'Etang-la-Ville) could be eliminated when the canvases were stretched and sponged gently from the back. He went on to praise the *à la colle* technique for its durability, which made retouching easy and which was more colorfast than oil painting, since paint was applied to a canvas coated with glue combined with pigment for ground color.[45] What is now clear to conservators and owners of paintings executed in this medium is that colors applied with this hot rabbit-glue method are light sensitive, and that the losses (*trous*) in the paint surface are not easily retouched.[46] In many of the canvases—including Vuillard's paintings for Jean Schopfer (1890–99 Intro., figs. 14–15), which could not travel to the exhibition occasioning this catalogue because of paint losses—these flakes of paint cannot be replaced. The surface is indeed better left as is, since it is impossible to achieve the exact color and consistency of the original paint layer.[47]

Whereas Bonnard, Roussel, and Vuillard remained steadfastly "secular" in their chosen themes, Denis's pursuit of universal principles and Christian iconography linked him to other groups of artists, such as the Société de Saint Jean, with whom he exhibited begin-

ning in 1907. This, and his switch that same year to the Druet gallery, further distanced him from his close friends. The bond expressed in his most famous easel painting, *Homage to Cézanne* (Denis bio., fig. 2), exhibited at the Indépendants in 1901 as a tribute also to fellow Nabi painters and to Odilon Redon, seemed less clear by mid-decade. Although Denis continued to admire Redon (writing an "homage" to him for the magazine *La Vie* in 1912), he saw the older artist's art through the lens of Christianity. In 1911, when Denis asked Redon to contribute a Christ figure to the Exposition internationale de l'art chrétien moderne for the Société de Saint Jean in Paris, Redon refused, saying that his Christs were not like those of Denis, since they were only sacred in the same way as the Buddhas, Venuses, and Apollos he also painted.[48] Redon, whose own decorative and large-scale painting owed a major debt to Denis and the Nabis, astutely noted in his journal that Denis's artistic talents were limited only by religion: "With his gifts, he could raise himself to higher things, instead of landing up in a dead end. He is [however] too upright ever to become narrow."[49]

Bonnard, Vuillard, and Roussel, like Redon, did not seek to impose their views. While Denis warned the world of the "dangers of abstraction" in the art of Matisse and the Fauves,[50] his friends quietly slipped away from the Paris avant-garde to develop their own personal styles. While not actively engaged in current artistic issues, they maintained a presence at the Salon d'Automne, the Bernheim-Jeune gallery, and at international exhibitions in Berlin, Brussels, London, and Munich, among others.[51] At the 1911 Salon d'Automne, Bonnard was certainly aware of the gulf between his triptych *Mediterranean*, destined for the Morozov residence in Moscow (cat. 50), which drew Apollinaire's disapproval, and the Cubist paintings of Pablo Picasso and Georges Braque, which elicited his praise. In an interview published in 1942, Bonnard remained typically nonjudgmental and generous to other movements: "Cubism has been a dead end to those without training. It has been useful to those who already possessed such a thing."[52]

PATRONS, OLD AND NEW

As shown, in the 1890s Bonnard, Vuillard, Denis, and Roussel were just beginning their careers as painter-decorators. By July 1914, when Achille Segard pub-

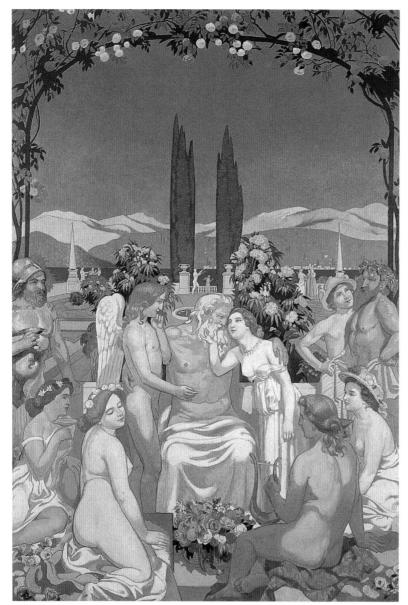

FIG. 6
Maurice Denis. *Jupiter in the Presence of the Gods*, 1908. Oil on canvas; 399 x 272 cm. Fifth and last panel of the cycle *History of Psyche* for the music salon of the Morozov mansion, Moscow, showing Maillol as Bacchus, at far right, and Marthe Denis as Venus, at lower left. The State Pushkin Museum, Moscow. Photo: Albert Kostenevich, *Bonnard and the Nabis* (Bournemouth, Eng./St. Petersburg, 1996), p. 195.

lished *Peintres d'aujourd'hui: Les Décorateurs*, the first major survey of contemporary French decorative painting, these artists' reputation had experienced a major boost. Segard included Vuillard and Denis in his book, among other officially recognized painters. The latter included Henri Martin, the well-established decorator of the Capitole de Toulouse and of the Sorbonne, Paris (1909); Edmond Aman-Jean, whose decorative panels could be viewed at the Musée des Arts Décoratifs, Paris; and Besnard, the muralist for the Ecole de Pharmacie in Paris and Berck Sanitorium in Normandy, who has already been mentioned as one of the Nabis' exemplars. By this time, Bonnard was also known as a painter of large-scale murals. His panels for

Misia Edwards (cat. 45–47) and Morozov (cat. 50), exhibited at the Salon d'Automne of 1910 and 1911, respectively, had been written about and reproduced in the major art journals of the day. Roussel's credentials had been based until 1911 on his exquisite pastels and small oil paintings of nymphs and fauns shown regularly at the Bernheim-Jeune gallery. But his reputation rose when he exhibited, at the 1911 Salon d'Automne, the large-scale *Triumph of Bacchus* and *Triumph of Ceres*. Two years later, his decorative painted curtain for the Théâtre des Champs-Elysées was viewed by a wide public.[53]

While the renown of these artists grew steadily from the 1890s onward, other aspects of their careers remained fairly stable. In particular, the broad divisions in patronage between Catholic intellectuals and non-Catholic (Jewish and Protestant) intellectuals (see 1890–99 Intro.) persisted into the twentieth century for these artists. The exceptions to these broad categories, however, which included some surprising crossovers and additions to established patronage circles, attest, as we will see, to a gradual change in the climate for decorative painting.

～ ～ ～

Vuillard, who lived with his mother, never owned a home, and was constantly worried about money, seems to have been the most dependent upon his friends to compensate for his bachelor status and the attendant feelings of isolation. His involvement with the Natansons' circle had been one of friendship first, art second. This attractive, professional relationship seemingly changed when he agreed to new commercial arrangements offered by the Bernheim-Jeune gallery, arrangements that apparently obligated him to produce and exhibit a certain number of works per year. Between 1901 and 1907, for example, Vuillard made no decorative paintings, which may indicate that he was working on a quota system to please his new dealers. Or perhaps he had not spelled out the terms for commissioned work in his contract and thus was uneasy about accepting projects. Matisse, who had no fewer than five contracts with the Bernheims during the period 1909–26, seems to have made special provisions that allowed him total freedom when it came to portraits and commissioned decorative works. In all five contracts, he clearly defined what was intended by "decoration": "paintings of irregular format and whose dimensions are strictly determined by the

architecture of the location for which they are destined." Interestingly, he distinguished "decorative" canvases, such as *The Red Studio* (fig. 4), from site-specific paintings, such as *Dance II*, which Shchukin commissioned for his stairwell. Financially, the importance of Matisse's definition was that he could accept full payment for site-specific *décorations* or for portraits, without giving the Bernheims a percentage. However, if the commission for either art form came about through the Bernheims, the gallery was owed as much as twenty-five percent of the sale price.[54]

Vuillard's contract with the Bernheims was probably less specific than Matisse's, but likewise subject to adjustments, which Vuillard seems to have made at least once, in 1908 and perhaps again in 1910, before leaving the gallery for Hessel's representation around 1912.[55] Bonnard, although attached to the Bernheim gallery for a much longer period than Vuillard, had no written contract at all, but only a loose, oral agreement.[56]

Whatever their particular arrangement with the gallery, Vuillard, Bonnard, and Roussel were introduced by the Bernheims and Hessels to an international and worldly group of collectors, whose importance is discussed later in this essay. Nonetheless, some of their earlier patrons continued to provide support, as they had in the 1890s. In 1908, Jean Schopfer commissioned Roussel to paint large panels on the themes of Nausicaa and the Fall of Icarus, measured to fit over the bookcases in his new home on rue de Bac.[57] Henri Vaquez, who had earlier commissioned Vuillard's four panels showing women in interiors (1890–99 Intro., figs. 20–21), not only acquired two large, horizontal paintings showing Place St.-Augustin (see cat. 81; cat. 81, fig. 1), but also purchased violin-shaped panels, showing Place Vintimille (private collection, Japan), that had been commissioned and then rejected by Vuillard's client Henri Laroche (see below).[58]

Misia Edwards (who, by 1920, would be married a third time, to José Maria Sert) continued to be a major player in the lives of Bonnard and Vuillard. Newly rich and at the peak of her social status (by now painted at least four times by Renoir), she commissioned four decorative panels from Bonnard on the theme of exotic lands, voyages, trips, and pleasure (see cat. 45–47). Not only did these panels receive much publicity when they were exhibited at the 1910 Salon d'Automne (in part owing to the notoriety of the commissioner), but they were fêted with a black-tie evening party at Misia Edwards's quai Voltaire apartment. Misia's fortunes, however, moved as fluidly as did her husbands, and by 1915 she was forced, either because of financial need or lack of space, to sell the ensemble. All four panels entered the collection of Henri and Marcel Kapferer, brothers from a Jewish family who would become important new patrons of Bonnard, Denis, and Vuillard.

~ ~ ~

Denis's supporters continued to be drawn largely from the circle surrounding Cochin, Henry Lerolle, and *L'Action française*, although at times Denis's clients intersected with those of Bonnard, Vuillard, and Roussel. This was true of one of their most important new patrons, the wealthy Russian collector Ivan Morozov, who commissioned *The History of Psyche* from Denis, a series of five panels that are perhaps the most blatantly Ingresque works of Denis's career. Denis's *Jupiter in the Presence of the Gods* (fig. 6), for example, recalls Ingres's *Napoleon on His Imperial Throne* (1806; Musée du Louvre, Paris) and his *Apotheosis of Homer* (Watkins, fig. 2). Unlike Shchukin, who had begun collecting modern French art slightly earlier, Morozov was not a discoverer of unknown talents but a buyer of blue-chip artists. His purchases of art by the former Nabis were restricted to the work of Bonnard, Denis, Roussel, and Vuillard, all of whom, with the exception of Vuillard, would be represented in his Moscow mansion by large-scale decorative works: Denis, by the *Psyche* cycle mentioned above, which eventually totaled nine panels (along with sculptures by Maillol, to whom Morozov had been introduced by Denis); Bonnard, by an over thirteen-foot-high triptych entitled *Mediterranean* (cat. 50), commissioned in 1911 and installed in 1912; and Roussel, by *Triumph of Bacchus* (cat. 64) and *Triumph of Ceres* (cat. 64, fig. 1), installed in 1913.[59]

The international circle of collectors that became interested in these artists included royalty, or so-called royalty. The Romanian princes Antoine and Emmanuel Bibesco, friends of Proust whom Vuillard met through Jean Schopfer, purchased at the time of Schopfer's divorce in 1903 the two panels he had commissioned from Vuillard in 1897, *Woman Reading on a Bench* and *Woman Seated in a Garden* (1890–99 Intro., figs. 14–15). Both Bibesco brothers held sinecurial positions in the Romanian embassy in Paris, but like the Polish-born banking family the Natansons,

FIG. 7

Maurice Denis. *The History of Music* (detail), 1912–13. Oil on canvas; entire frieze, 372 m in length. Théâtre des Champs-Elysées, Paris. Photo: Société immobilière du Théâtre des Champs-Elysées, Paris.

and the Swiss-born Schopfer (whose father was also a banker), their main interests revolved around vanguard theater, literature, and art. The youngest heirs of a noble family (descended from the twelfth-century Prince of Wallachia) and cousins of such aristocrats as the de Noailles, the Caraman-Chimays, and Prince George Bibesco, the Bibesco brothers moved effortlessly between the different social registers of old and new France.[60] Like Bernstein and Schopfer (whose marriage and divorce from the wealthy American Alice Wetherbee received widespread attention), they enjoyed publicity (Antoine was an aspiring playwright) and their tastes reflected their enthusiasm for artists such as Paul Gauguin (in 1899 Emmanuel bought six paintings from the artist without ever having seen the works or met the man, who was in Tahiti) and Redon (whose paintings decorated an entire room of the brothers' London apartment), as well as for Bonnard and Vuillard.[61]

For a while both Vuillard and Bonnard were close friends of these eccentric brothers, accompanying them on an art and architecture sightseeing trip to southern Spain and Portugal, recorded in photographs showing artists and collectors at various sites.

Although they were less directly connected after the war (Emmanuel committed suicide in 1917; Antoine married Elizabeth Asquith, daughter of Lord Asquith, in 1919), Antoine continued to be a loyal supporter of Vuillard's art. In 1921, he commissioned a portrait of his wife in their golden-walled salon on quai Bourbon. In this apartment he kept, until the end of his life, the two Vuillard pendants originally commissioned by Schopfer in 1898. As with so many of the decorative paintings intended for one site and reinstalled in another, these panels took on new life. Indeed, when the American professor Mina Curtiss visited Bibesco's apartment shortly before his death in 1951, she noted "a room so beautiful that it took my breath away with the full-length Vuillard panels obviously painted to fit the wall."[62]

~ ~ ~

On the whole, Vuillard and Denis seem to have been the most conscientious about their commissioned projects. Roussel sometimes took years before finishing a project, or, as in the case of his decorative painting for the Bernheims' summer home, Bois-Lurette, never completed it at all, so that when the house was

sold in 1933, yards of canvas were discovered that the Bernheims had put aside in anticipation of the project. Bonnard was also casual about his commitments. He worked on his ensemble for Misia Edwards for over four years (see cat. 45–47), and another four years on the panels for the vestibule of the Bernheims' home on avenue Henri-Martin (see cat. 52–54).

Even in cases when a project went wrong, Vuillard was apparently quick to forgive his patrons and, perhaps because of being a bachelor, which, as his journal indicates, often made him feel lonely, was loathe to end his relationship with them. This was the case when Marguerite Chapin suddenly married the Italian Prince of Bassiano and rejected (at her husband's bidding) Vuillard's *Library* (fig. 3). After only a few months on the walls, it was returned to Vuillard's studio, where it remained until 1938, when it was purchased by the French nation. In another instance, one of Vuillard's clients, Henri Laroche, refused to pay for the violin-shaped canvases he had commissioned as decorative door panels (*trumeaux*), on which Vuillard had worked for over eight months.[63]

As mentioned, large-scale decorative paintings were sometimes purchased directly from the gallery or artist and made to fit into an existing interior. This was the case with Roussel's decorative pendants *Triumph of Bacchus* and *Triumph of Ceres*, exhibited at the Salon d'Automne in 1910 and purchased afterward by Morozov. After learning that his works would be seen in Moscow alongside paintings by Matisse, Roussel "updated" the palette of these canvases before he shipped them to Russia. Unlike Denis, who traveled to Russia to see his *History of Psyche* panels and to work on additional panels for the series, Roussel never saw his works' final destination. He thus had no idea whether or not the changes he made were for the better or (as Morozov concluded) for the worse (see cat. 64).

On the one hand, commissioned paintings allowed the artist freedom from exhibitions; on the other, they came with expectations and rules that were not always convenient. Having miscalculated the dimensions of the wall for which he was commissioned to paint a decorative mural in the home of the Hahnloser family in Lausanne, Bonnard ended up having to produce another, smaller panel (*Summer*, 1917; Fondation Maeght, St.-Paul de Vence). Preferring to work on an unstretched canvas and let the composition determine the final format, he must have felt particularly constrained when he had to paint vertical panels (cat. 50)

to fit between the columns at the top of Morozov's staircase, which he could see only in photographs.

Denis too seems to have had relations and proposals that were unsatisfactory. In 1906, for example, Anna Boch, sister of van Gogh collector Eugène Boch (who was immortalized in van Gogh's portrait *The Poet— Eugène Boch*, 1888; Musée d'Orsay, Paris), wrote several letters to Denis requesting him to paint murals for her new home outside Brussels. Herself a painter, she described the kind of mural she wanted and the money she would be able to pay. The result, it seems, was an unfinished or perhaps never-started project, even though, by this stage, Denis could afford assistants.[64] On other occasions, as with the five panels he painted for the music room of Kurt von Mutzenbecher, director of the opera and theater of Wiesbaden, Denis himself was disappointed by the installation and surrounding furnishings.[65]

～ ～ ～

In 1912, Vuillard, Denis, and Roussel received their first commission for a "public" decorative project, a part of the decorative program for the most progressive theater complex to date, the sumptuous and architecturally daring Théâtre des Champs-Elysées on avenue Montaigne.[66] Denis was an early participant in this project, starting with the initial discussions about a new building between the musician Gabriel Astruc and Denis's friend and patron Gabriel Thomas. The theater, which opened on 10 March 1913, was a huge success, and the reputations of all three artists were enhanced by the artworks they contributed to it.

For this commission, the three artists turned to what they knew best. Not surprisingly, given Denis's reputation as the modern Puvis, he was awarded the most important assignment, to paint a 372-meter circular frieze for the ceiling of the theater on the theme of the history of music (see fig. 7).[67] Roussel was asked to create a large, painted curtain (7.54 x 8.12 meters) for the smaller of the two theaters, the Théâtre de Comédie, for which he chose a neoclassical subject linked to the origins of theater, *Procession of Bacchus* (also called *The Birth of Tragedy*), and one already familiar from his other decorative works (see cat. 64, fig. 2). Vuillard, among the last to receive a commission (other artists participating in the project were the sculptor Antoine Bourdelle, and the painters Henry Lebasque, Jacqueline Marval, and Sem),[68] was assigned the foyer of the Théâtre de Comédie, for which he

FIG. 8

Photograph, 1912, of Edouard Vuillard's *Sunny Morning*, 1910. Distemper on canvas; 203 x 142 cm. Private collection, London. The photograph shows the work in a stage set for *La Prise de Berg-op-Zoom*, a comedy by Sacha Guitry, Théâtre de Vaudeville, Paris. Photo: *Théâtre* 332 (Oct. 1912), p. 10.

created a narrow horizontal panel, three vertical panels, and two larger, mural-like panels. For the two latter works, he turned to subjects of contemporary relevance, Tristan Bernard's bourgeois farce *Le Petit Café* and Molière's *Malade imaginaire*, both of which were currently running in Paris.

In his frieze for the ceiling of the main performance space, Denis painted four long panels (interspersed with smaller tondos): *Greek Music, Opera, Symphony,* and *Lyric Drama.* The latter includes past and present-day composers, represented by one or more of their works in the actual mural painting. Wagner's Parsifal is at center holding the Grail (and looking every bit as hieratic as Denis's Jupiter in the Morozov panel), surrounded on the left by the heroines of the Romantic composers (Berlioz, Chopin, Liszt) and on the right by figures identifying the classic (Massenet, Strauss) and modern composers (Debussy, Duparc, Franck, d'Indy, among others). Denis's early friend and patron Ernest Chausson is represented by Madame Chausson herself, while on the extreme right, the Ballets Russes by the dancing figures of Nijinsky and Karsavina.[69] This was an ambitious project with a complicated iconography that was worlds removed from Vuillard's much smaller panels,

showing contemporary theater performances. Vuillard, however, was generous with his praise, noting that Denis's cupola was "an enormous work, well done." Vuillard's approval seems to have meant a great deal to Denis, who remarked in his journal that he had received compliments "even from Vuillard."[70]

DECORATIVE PAINTING DURING THE WAR

In 1912, perhaps because of their work for this public commission and their increased notoriety in general, Bonnard, Roussel, and Vuillard, all in their mid- to late-forties, were nominated to become Chevaliers of the Legion of Honor. As stated above, they turned down the offer. While they did this quietly, "their gesture was a manifesto," in the opinion of one critic.[71] Such modesty, and their refusal to be officially recognized, was in keeping with their temperaments. (Vuillard, for example, agreed to allow Claude Roger-Marx to write his biography, but only on condition that it be published after the artist's death.) Despite their indifference to official recognition, however, their art was perceived as quintessentially French, epitomizing the "grace," "harmony," and "restraint" synonymous with French culture.[72] Vuillard, in particular, had become a household name among the comfortably well-off. At the same time that he was painting scenes based on Bernard's play *Le Petit Café*, theater-goers were admiring his decorative painting *Sunny Morning* on the stage of another contemporary bourgeois farce, *La Prise de Berg-op-Zoom* (*The Capture of Berg-op-Zoom*), by his friend the actor Sacha Guitry (see fig. 8). This painting (showing Lucie Hessel and her niece Denise Natanson in the gardens at the Hessels' country home, Les Pavillons, in Villerville) had earlier been shown as part of the "bourgeois" décor in another comedy by Guitry, *Un Beau Mariage* (*A Beautiful Marriage*). As one critic described it, in an article entitled "Décor d'un *Beau Mariage*," Guitry went to the Bernheim-Jeune gallery, where he selected "the flowers of Bonnard, a figure of van Dongen, the nymphs of Roussel, and two works by Vuillard, including a large distemper painting *Sunny Morning*." When the same critic asked Gaston Bernheim how an actor could afford such expensive accoutrements, he replied:

Lysés [Charlotte Lysés, Guitry's actress wife] and Sacha create the principal characters, Bonnard and Vuillard create a pleasant atmosphere around them.[73]

FIG. 9

Pierre Bonnard. *Factory*, 1916.
Oil on canvas; 243 x 340 cm.
Private collection, Switzerland.
Photo: Dauberville, vol. 4, p. 381,
no. 02112.

The goal of creating a "pleasant atmosphere" is significant at this moment in pre-war France. The art of the mainstream theater—the bourgeois farce—and of the up-to-date wealthy Parisian, as exemplified in the decorations of these four artists (depicting scenes from modern life, pastoral poetry, mythology, and Christianity), was reassuring on the eve of conflict in a way that most vanguard art was not. As Kenneth Silver asserted, in the years prior to and after World War I, there was a sea change in attitude among critics and the avant-garde. Art was no longer a matter of intellectual discussion and "isms," but a necessary component of France's struggle to maintain its identity as a culturally superior nation. In many ways the climate was similar to the situation after the Franco-Prussian War of 1870–71, which spawned a rash of government commissions for mural painting (see Watkins). Now President Raymond Poincaré's *union sacrée* was the buzzword for a cessation of differences between political parties in the name of one concerted effort against the enemy. Patriotism demanded the abandonment of individuality. In this ideological climate, the circle of Denis and his conservative Catholic intellectuals around *L'Action française* grew in influence. The political differences between leftists and conservatives were overridden by a common national cause, as "members of the left tried to make themselves look more zealously patriotic."[74]

For many it was a call to order, a *rappel à l'ordre*, as artist and art critic André Lhôte termed it in 1919.[75] This meant an overarching concern for order, reserve, and discipline, and in the arts a return to traditional standards of composition, organization, and subject matter. For Denis, there was no ideological break.[76] The general pre-war climate only underscored Denis's longstanding belief in dutiful work, self-discipline, and social harmony. In art these goals could be achieved through the continuation of classical ideals, translated into correct, ordered, universal standards of art, mediated by the Christian and Latin tradition. And here one might remember Denis's earlier criticism of Vuillard as an artist who "flits and flickers."[77] For in 1914 it was no longer enough to make art that showed subtlety and "extreme elegance," words used to describe the art of Bonnard, Vuillard, and others by the critic Henry Bidou in a 1910 review of the Salon d'Automne.[78] Art needed to express a sense of resolve and restraint.

In the eyes of many, France had fallen prey to the frivolous, cosmopolitan, amorphous, and undefined, and hence, as in 1871, was on the verge of being defeated again by the same enemy. It needed to return to its great tradition and show itself "victorious, masterful, hierarchical, rooted, measured, fully conscious."[79] All four artists under consideration here were certainly rooted in France, both in their choice of subjects and in the importance they accorded to the French tradition of *décoration*, and they were certainly not practitioners of abstract art. They nevertheless experienced the onset of war not only with a heightened sense of reality and obligation, but also as a call for change in their own art.[80] Part of this probably had to do with their situations at this time.

With the exception of Denis, who was mobilized in October 1914 (and served until March 1915, when he was sent home after the birth of his son François),[81] Bonnard, Vuillard, and Roussel were too old to fight and experienced the sense of powerlessness that other non-combatant artists like Matisse felt during the war years. Roussel, after contemplating enlistment, suffered a nervous breakdown, which put him in a Swiss asylum during much of the war.[82] Bonnard, after a brief sojourn in Vernon, spent much of this period in St.-Germain-en-Laye. He was particularly anguished by what he saw as his faulty technique and lack of discipline. In a c. 1915 interview with his nephew Charles Terrasse, he remarked that he needed to begin again and so renewed his efforts at drawing and composition.[83]

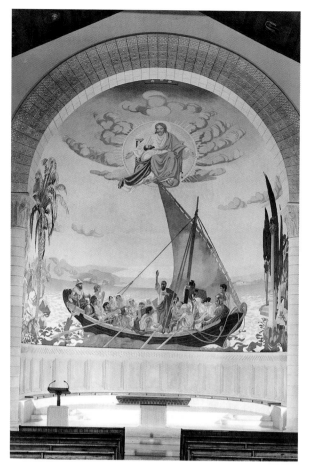

FIG. 10
Photograph showing Maurice
Denis's mural decoration for the
apse of the church of Saint-Paul,
Geneva, Switzerland. Photo:
Paroisse de Saint-Paul, Genève
(Guide des monuments suisses).

the Seine (cat. 54), begun in 1916, are both expressions of a grim reality from the view of non-combatants in wartime Paris.[88] Throughout the war, Denis published articles on French art, defending it against that of Germany.[89] He traveled between his home at St.-Germain-en-Laye, where he worked on the windows, furniture, frescoes, and painted murals for the chapel of Le Prieuré (now Musée Départemental Maurice Denis), and Geneva, Switzerland, where he worked on the murals and stained-glass windows for the Church of Saint-Paul (see fig. 10).

Roussel, as mentioned, was hospitalized. As he later told his first biographer, Lucie Cousturier, he was not able to reconcile what he termed "the thought of yesterday with the reality of today."[90] A lifelong admirer of German poetry and philosophy, he must have been acutely aware of his mixed loyalties. The Bacchic imagery prevalent in his decorative and smaller canvases, inspired by the writings of Friedrich Nietzsche and the music of Richard Wagner, must have seemed doubly indulgent, if not heretical, in a period calling for self-denial, self-abnegation, and nationalist loyalty.[91] This conflicted state of mind may have been partly responsible for Roussel's obsessive need to alter forms, composition, and perspective in the murals for the Kunstmuseum Winterthur, a project that preoccupied him from 1915 to 1926 (see cat. 67–68).[92]

In 1918, Vuillard and Bonnard both painted large-scale landscapes, often referred to as *verdures* because of their emphasis on foliage (cat. 84, 55). Begun in summer 1918, when the possibility for peace seemed imminent, these works reflect the sweetness of life (*la douceur de vivre*) and celebrate the rich vegetation and civilized country living synonymous with France. Although Impressionist in sensibility, they are also tightly structured and restrained. Vuillard's composition is centered on a massive oak tree, while Bonnard contructed an unfolding landscape with tablecloth stripes and chair railings subtly serving as ingenious foils, or *repoussoirs*. These and other ambitious decorations made during the war years, including *"Le Grand Teddy" Tea Room* (cat. 63, fig. 1), an elliptical painting commissioned from Vuillard in 1918 by the owner of the fashionable *thé-dansant* of the same name, reflected their reality. It was a different reality from that of a non-civilian, but one Fénéon described in a letter to the painter Maximilien Luce when the war broke out: "Paris, gloomy the first days [of the war], is regaining a fairly lively and likeable character."[93] In other words,

Although all four artists certainly sought solace in their art, they did not hide from the present. Vuillard immediately enlisted in the army as a non-combatant and was made a railway-crossing guard at Conflans-Ste.-Honorine, outside Paris, but left this post after four months.[84] In 1916, Bonnard and Vuillard visited the battlefields of the Somme. Both artists painted large decorative panels of wartime factories (see fig. 9).[85] The resulting "decorations" are unusually somber and schematic. Such restraint is due to the subject itself, but may also reflect their resolve to combat their own tendencies toward the refined and elegant, which were out of place in what Vuillard described in his journal as a world of "engineers, of active, ambitious figures, and raging conflicts."[86] Equally foreign was the world Vuillard discovered at the army base at Gérardmer in the Vosges, where he served as an official war artist for three weeks in February 1917.[87]

Vuillard's scene of men working in Place Vintimille, begun in 1915 (see cat. 83), and Bonnard's *Workers on*

while greatly affected by the tragedy of war, all of these artists, perhaps Roussel most of all, found solace in their art and a continuing market for large-scale decoration.

THE LATE DECORATIONS, 1918–30

After the war, Bonnard, Vuillard, Denis, and Roussel continued to take an active interest in one another's careers and exhibited together at the Bernheim-Jeune gallery in 1921. But geography and ill health (Denis had begun to have serious eye trouble about 1916, which worsened by 1918) kept them apart. Bonnard only infrequently visited Paris, because he found he could not work there.[94]

Although Bonnard undertook fewer decorative projects after 1920, the "decorative" dominated the large-scale landscapes he executed in Normandy and, after 1926, at Le Cannet near Cannes, where he purchased a home called Le Bosquet. Bonnard stamped each of these full-blown panoramas of brilliant color with a particularity of nature or details of his home, without being overly realistic. In this way, he could generalize the specific regardless of geography. It is possible that Bonnard took his canvases from place to place and that he did not necessarily complete them in front of the "motif."[95] This seems to be true, for example, of *The Terrace at Vernon* (cat. 57), with its peculiarly southern light. As mentioned, unlike Denis and Vuillard, Bonnard did not have a decorative style that is easily and consistently grasped.

This is particularly clear in four panels commissioned as an ensemble in 1916 for the entryway of the Bernheims' mansion at 107, avenue Henri-Martin (cat. 52–54). Completed over the course of four years, these panels combine a variety of earlier themes drawn from both southern and northern climates. Stylistically, they differ radically. In *Monuments* and *Workers on the Seine*, Bonnard emphasized form and drawing, while in *Earthly Paradise* and *Pastoral Symphony*, he created more elaborately harmonized and Impressionist views of Normandy. The Renoiresque nude in *Earthly Paradise* may constitute an homage to Renoir, who died in 1919, and whose late works relate to Bonnard's art. Clearly Bonnard's figure would have fit well with the Bernheims' renowned collection of Renoirs (eighty in their grand salon alone).[96]

Bonnard's personal life around this time was accented by an affair with a young and statuesque artist and model, Renée Monchaty (see cat. 52–54). The relationship intensified in 1921 when Bonnard traveled to Rome to meet her parents and spent two weeks with her. But he could not bring himself to cut his ties with Marthe de Méligny, his companion for nearly thirty years. Less than one month after Bonnard married Marthe (on 13 August 1925), Monchaty committed suicide (on 9 September).[97] Another important relationship for the artist was his growing friendship with Matisse, his neighbor in the south of France and the source of a rich correspondence. Certainly paintings such as *The Terrace at Vernon* (cat. 58) owe something to Matisse's vibrant line and sharp emphasis on forms. Bonnard continued to pursue an art that, in Antoine Terrasse's words, could be taken in only slowly, not at a glance, as Terrasse believed was true of Matisse's work. Bonnard could nonetheless admire Matisse for his continual struggle to renew his art, which for both men was a lifelong quest.[98]

Denis—whose wife, Marthe, died after a long illness in 1919—became more and more entrenched in the Ateliers de l'art sacré, the school of religious painting he officially founded at Le Prieuré along with Georges Desvallières in 1919. (In 1921, for example, he ceased teaching at the Académie Ranson in order to devote himself to his new school.) Seldom did he accept secular projects, and when he did (in 1925 for the cupola of the Petit Palais, Paris, and in 1937 for the Palais des Nations, Geneva), they were for public, not private institutions. One exception was the 1923 commission (see below) from Marcel Kapferer, who, along with his brother, Henri, was among the small number of patrons who ordered decorative paintings from Denis after the war. The Kapferers' fortunes were assured during the conflict when Marcel, employed by Royal Dutch and Shell Oil, negotiated a contract to supply British military forces (and subsequently the French army) with a new, lighter-weight petroleum product produced in Borneo. His brother, listed as a civil mining engineer in 1914, became a leading figure in the new field of aerodynamics.[99] Bachelors until their forties, the two brothers lived together at 26, avenue de Clichy, at which time they seemed to have commissioned, or acquired, two decorative paintings by Bonnard (see cat. 48–49). By 1916, both brothers were married. Marcel, now residing on rue Charles-Lamoureux, purchased from the Druet gallery the six-panel *History of Nausicaa* by Denis (see cat. 61–62), which had been exhibited that year.

FIG. 11

FIG. 11
Edouard Vuillard. *The Dining Room*, 1912. Oil on board; 72.4 x 99.1 cm. Private collection. Photo: Courtesy of Wildenstein and Co., Inc., New York.

FIG. 12
Edouard Vuillard. *Portrait of Marcel Kapferer*, 1926–27. Oil on canvas; 117 x 89 cm. Private collection. Photo: Courtesy of Wildenstein and Co., Inc., New York.

FIG. 13
Photograph, c. 1923, showing a fragment of Edouard Vuillard's frieze *Little Girl Feeding Chickens*, 1923. Distemper on canvas; 75 x 253 cm. Private collection. The frieze, installed around the bedroom of Marcel Kapferer and his wife, at 64, avenue Henri-Martin, Paris (demolished 1968), is seen here with Odilon Redon's pastel *Buddha* partially visible below it. Photo: Courtesy of Wildenstein and Co., Inc., New York.

FIG. 12

Up until his purchase of the Denis panels, Marcel's collection was dominated by Redon, including the large-scale *Perseus and Andromeda* (1910/13; private collection, New York), shown leaning against the wall in a c. 1920 photograph (cat. 61–62, fig. 1). Other works by this artist he owned include *Buddha*, a large pastel and his first purchase (1906–07; Musée d'Orsay, Paris), *Homage to Gauguin* (1903–05; Musée d'Orsay, Paris), and the pastel *Flower Clouds* (1903; The Art Institute of Chicago). Also featured were paintings by Bonnard, Cézanne, Charles Cottet, Renoir, Roussel (a sketch for the curtain of the Théâtre des Champs-Elysées [private collection, Paris]), Signac, and van Gogh (including *Three Pairs of Shoes* [Fogg Art Museum, Cambridge, Mass.]). Vuillard was the Kapferer family portraitist. In 1912, he painted a double portrait of the bachelor brothers in the dining room of their avenue de Clichy apartment (fig. 11) and four years later he painted their mother in an antimacassared armchair at the family home (1914; private collection).[100] Shortly after Marcel's move in 1920 to a much larger apartment on avenue Henri-Martin, Vuillard painted Marcel's wife in front of the large Redon *Buddha* (Musée Marmottan, Paris). Denis, too, was asked to paint a group portrait showing the Kapferer children, Alice and Yvette, in this new, lighter, and airier home, with the parents reflected in the mirrored doorways (c. 1923; private collection, Paris). One of Vuillard's last portrait commissions for the family showed the fifty-four-year-old Marcel in Vuillard's studio, seated in front of Bonnard's lithographic screen, *Nannies' Promenade* (fig. 12; see cat. 6).[101]

Unfortunately, no photographs exist to show how the completed *History of Nausicaa* series looked in these more expansive and modern interiors. As revealed by the photographs showing the panels in the first interior (cat. 61–62, fig. 1), the series was fit within the existing space of a curiously crammed salon/office.[102] What seems significant is Marcel's eclecticism, which easily accommodated both Denis and Vuillard, despite their substantial differences. In 1916, for example, following the sudden death of publisher Emile Lévy while Vuillard was still finishing the large *Place Vintimille* he had commissioned (the version showing workers replacing the sidewalk), Marcel stepped in to purchase it (see cat. 83).

In 1923, Marcel commissioned not only four more Denis panels on the Nausicaa theme, but also a frieze by Vuillard, showing his daughters on the grounds of their country home at Versailles. This six-panel frieze,

FIG. 13

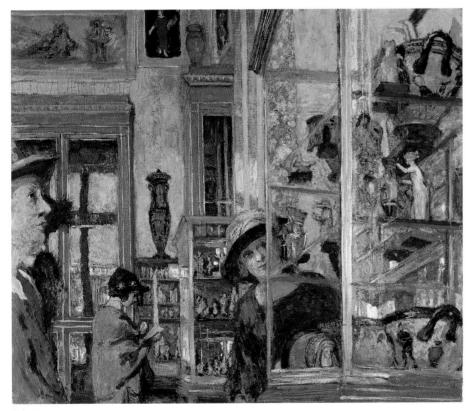

FIG. 14

FIG. 14
Edouard Vuillard. *The Medieval Gallery (La Salle Clarac)*, 1922. Distemper on canvas; 97.2 x 114.9 cm. Toledo Museum of Art, Toledo, Ohio.

which wrapped around the parents' room on the second floor of the avenue Henri-Martin residence, can be considered Vuillard's last full-scale decorative project for a private residence (see fig. 13). In conceiving the design, Vuillard returned to a concept he had developed with the Schopfer panels in 1898, that is, naturalistic settings combined with photography-aided likenesses. Alice Clément, the eldest daughter of Marcel, remembered posing for Vuillard, but also remembered the photographs that were used to complete the series.

Apart from the Kapferer commission, Vuillard did many fewer decorative projects after World War I, especially for private patrons. In 1920, the Musée du Louvre, after having been closed during the war and then renovated, was reopened. For Vuillard, like many artists, it was cause for celebration and nostalgia, resulting in a series of paintings for the Basel residence of Swiss collector Camille Bauer.[103] In these sensitive and winning scenes of the well-known Salle des Caryatids, Salle La Caze, Salle Clarac (fig. 14), and Galerie de Sculpture, Vuillard painted the act of looking. The art that the scene's protagonists, Annette Roussel and Jacques Salomon, admire is also what we admire. Their viewpoint, as they move around the glass cases, becomes our experience. It is one of Vuillard's more personal and touching comments on how important the art of the past was for his decorative sensibilities.

Roussel, although still plagued by his neurasthenic, anxiety-prone nature, was more productive after the war than before. Perhaps his airy, but "classically informed" canvases, such as *Fountain of Youth* and *Bacchus*, or his variations on the Mallarméan *Afternoon of a Faun* (cat. 70), appealed to the post-war need for comfort and reassurance.[104] From his studio at L'Etang-la-Ville, he produced large-scale paintings for newly wealthy industrialists such as the family of Marcel Monteux, owner of Chaussures Raoul, the first mass-produced shoe chain, and Lucien Rosengart, a manufacturer of luxury automobiles.[105] In 1919/20, Roussel painted six panels (see figs. 15–16) for the dining room of the Monteux residence at 25, avenue Marceau. These were followed in 1923/24 by more decorations for the dining room of the mansion of Marcel's father in Cap d'Antibes.[106] For the Rosengart mansion, Roussel made large (3.58 meters high) panels on the seasons. *Summer* and *Winter* were destroyed during World War II, but *Autumn* and *Spring*, which were based on photographs of Roussel's grandchildren Antoine and Catherine, are

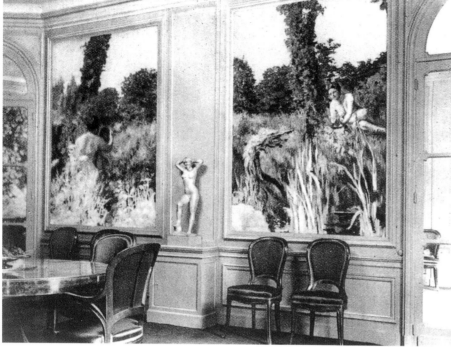

FIG. 15

FIG. 15
Photograph, c. 1930, showing
Ker Xavier Roussel's panels *The
Infancy of Jupiter* (fig. 16) and *The
Garden of the Hesperides* (c. 1924;
The Detroit Institute of Arts).
They are installed in the dining
room of the mansion of Marcel
Monteux, at 25, avenue Marceau,
Paris. Photo: Werth 1930, fig. 20.

FIG. 16
Ker Xavier Roussel. *The Infancy
of Jupiter*, 1920/24. Distemper on
canvas; 211.8 x 152.4 cm. The
Dayton Art Institute, gift of Mr.
Walter P. Chrysler, Jr., 1960.28.

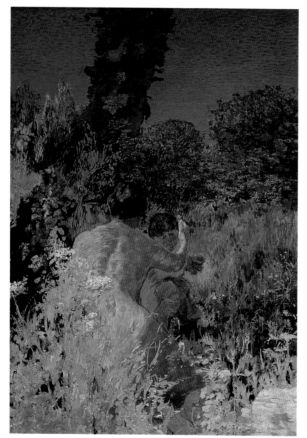

FIG. 16

still in the family's possession. The visual impact of these brilliantly hued works (judging by the palette of *The Infancy of Jupiter*) would have been reinforced by the palatial residences in which they were seen.[107]

In the late 1920s, Roussel joined contemporary artists Raoul Dufy and Pierre Laprade in creating decorations for the Hessels' Château des Clayes. One of the most elegant private residences in France at the time, this Renaissance mansion, between Versailles and Port Marly, had been acquired by the Hessels in 1925. Roussel was commissioned to paint two large canvases for the billiard room. The panels, destroyed along with other works during World War II, were considered among Roussel's masterpieces by the French collectors who moved in Hessel's circle. Their loss is indeed still felt by Roussel's descendants to be one of the most serious of many problems that have plagued appreciation of Roussel's place in the history of art.[108]

By the 1920s, Roussel's easily accessible references to Virgilian and mythological themes, painted in vibrant, clear pigments, fulfilled a post-war need to reaffirm French values, and served as appropriate backdrops for the work of the most popular furniture-makers of the 1920s, Louis Süe and André Mare, whose furniture is seen in a photograph of the Monteux dining room (fig. 15). Both Süe and Mare were important players in the move to generate a "French Style" that, as shown in the Monteux interior, was both luxurious and traditional. In general, by the second decade of the century, interiors were lighter and less heavily concentrated around richly patterned surfaces than pre-war interiors such as Marcel Kapferer's apartment on avenue Charles-Lamoureux. By 1925, after a period of self-sacrifice and restoration, France was again ready to raise the issue of developing a distinctly French kind of interior decoration.[109]

The Exposition internationale des arts décoratifs et industriels was a huge international showcase held in 1925 from April to October in the heart of Paris. Devoted to modern design, the Exposition took place in official French buildings, commercial pavilions, and structures created by the twenty-one participating countries. Germany, not surprisingly, was excluded. Sponsored by the Minister of Commerce, it was explicitly intended to advertise French decorative and industrial arts, and implicitly, to announce France's successful post-war reconstruction and recovery. Featured were artists, architects, furniture-makers, glassmakers, ceramists, and sculptors, all working in

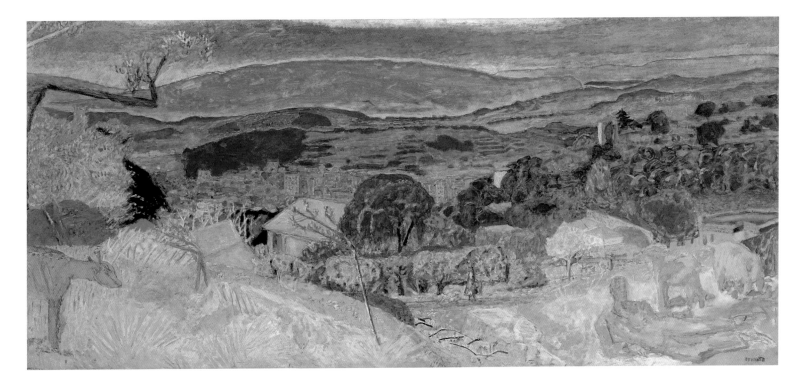

FIG. 17

Pierre Bonnard. *Landscape at Le Cannet*, 1928. Oil on canvas; 123 x 275 cm. Private collection, Chicago. Photo: Courtesy of Richard L. Feigen and Co.

tandem with commercial ventures, such as Paris department stores, or for installations in temporary buildings such as the Ambassade de France and the Hôtel d'un Collectioneur (created by the famous furniture-maker Emile Jacques Ruhlmann).[110] Bonnard's works, for example, were shown at the pavilion-studio of Editions Bernheim-Jeune, as well as at the new Bernheim-Jeune gallery at 83, rue du Faubourg-St.-Honoré (where the gallery is still located).[111]

Significantly, decorative painting was present everywhere, as each establishment enlisted groups of artists to create murals relating to a French institution or region. The style for these monumental works varied from a realism that evoked the historical murals of the academic painter Jean Paul Laurens to styles that drew heavily on Puvis de Chavannes and Denis in their emphasis on figurative, clear, and easily legible imagery (see, for example, the work of Gustave Jaulmes, a noted muralist and tapestry-maker). Some of these decorations were executed directly on cement, the new fashion in building material. Indeed, the place of site-specific, educational, and aesthetically pleasing decorative painting as a link to France's traditions and future seemed secure. As critic Arsène Alexandre observed in the conservative *Renaissance de l'art français*, the new architecture, with the massive, vaulted ceilings and large scale that cement afforded, offered more and bigger expanses for artists to decorate.[112]

For Franz Jourdain (painter, architect, and president of the Société du Salon d'Automne), however, the exhibition pointed out another important change in aesthetics and lifestyle. In a July 1925 interview published in *Formes nouvelles et programmes nouveaux: L'Art décoratif moderne*, Jourdain made this clear. When asked, "Will the architect and *décorateur* work in concert as it seems they should? Or does the evolution of interior décor answer to special rules?" Jourdain responded that in the future the notion of a *décoration fixe*, that is, a work fitted into the wood moldings of an interior, would be abandoned. He went on to explain that, since a *décoration* was essentially intended to harmonize and fit the proportions of a specific place, it would no longer be viable in a world that had become more mobile and changeable. For Jourdain, painting as decoration would continue to be an important public enterprise, but in the domestic interior it would be replaced by paintings that are both moveable and intimate.[113]

DECORATIVE PAINTING AND ITS LEGACY

Indeed, as we have seen, the decorative paintings created by Bonnard, Vuillard, Denis, and Roussel over the four decades included in this study were often victims of the vicissitudes of the fast-changing society for which their works were intended. With the exception of the six overdoor panels Vuillard painted in 1892 for

the Desmarais family (see 1890–99 Intro., figs. 11–12; cat. 31, fig. 1) and his decorative frieze for the Kapferers (fig. 13), none of the ensembles, series, or pendants created by these artists has remained with the original owner and not one is still *in situ*. (Denis's cycle for Denys Cochin, the *Legend of Saint Hubert*, has only recently left the Cochins' home to become part of the Musée Départemental Maurice Denis "Le Prieuré," St.-Germain-en-Laye; see 1890–99 Intro., figs. 16–18). More typically, these *décorations* were sold and dispersed during the artists' lifetimes. Bonnard's panels for Misia Natanson Edwards, seemingly works that were highly personalized and particular to the textures of her dining-room interior, were soon divided between various private collections. In certain instances the artists seemed to have worked on speculation, exhibiting panels that were uncommissioned, with the goal that these would be acquired and made to fit a particular room. Vuillard's works, especially, seemed to have suffered the vagaries of his clients' changing circumstances. Sometimes the projects were rejected before they were paid for. At other times he was asked to modify the shape to make what was once a site-specific painting or series of paintings more marketable. In 1936, Schopfer's widow requested that he cut the seven-foot-long *Luncheon in Vasouy* (1901; Tate Gallery, London) in half to facilitate its sale. At about this same time, he added to and repainted several panels from the Bernheims' Bois-Lurette series (see cat. 82) to facilitate their sale.

Jourdain's comments about the death of fixed or site-specific decoration seem particularly applicable to these artists, who worked for the rich, both old and new, French and foreign. Perhaps Vuillard's five panels known as *Album* (cat. 35–39) come closest to fulfilling Jourdain's call for mobile and intimate works. Small, appealing, and easily transportable from the Natansons' city apartment to their country house, they fit within a variety of spaces (overdoors, friezes, on the doors) and thus remained undemanding, regardless of location.

By the 1920s, the art of Bonnard, Vuillard, Denis, and Roussel was regarded, by both detractors and supporters, as embodying a distinctly French tradition in painting. The first group saw these artists as having made a cautious, conservative choice that lacked the intellectual rigor of newer movements, such as abstraction and Surrealism. The second praised them for upholding the essential greatness of French art.

Ultimately, however, as we have tried to show throughout this study, the four painters can be regarded as latter-day Impressionists only to the degree that they adhered to a personal response to nature. Their art never crossed the line into complete abstraction. Nature, however freely interpreted or overlaid with mythical or symbolist overtones, always remained the foundation, the essential reference point of their work. Their achievement resides in their ability to infuse large-scale or unconventional formats with personal content and mood, so that the resulting works remained intimately connected to their own experience or to that of the patron for whom the works were created.

By around 1930, the endpoint of this examination of the decorative paintings of these four artists, they had ceased, with only a few exceptions, to produce works on commission for private individuals. This was at least in part due to the fact that their decorative precepts had by then become integral to all their work, whatever its scale or purpose. This is demonstrated by Bonnard's monumental *Landscape at Le Cannet* of 1928 (fig. 17), which was not commissioned. Related to mural painting by its scale, this work is a compelling visual summation of the tenets that Bonnard and his colleagues contributed to vanguard painting from the 1890s onward. A man, perhaps the artist himself (or an artist in general), lounges casually in front of a panorama replete with references to the Midi. The continuous, rolling landscape creates the sense of a vast space and yet retains the integrity of the picture's surface through elaborate patterning. The patterns are achieved through the application of color, color that is harmonized in order to establish the mood of the work and unify the composition. Like the master decorations of old, Bonnard's painting draws us into a world of infinite possibilities, a realm we know to be fiction but we want to be true.

As Nicholas Watkins demonstrates here (see Watkins), many crucial characteristics of decorative works such as this—the emphasis on surface, flat forms, non-narrative content, and large-scale or unusual formats—were absorbed after World War II into avant-garde painting. Indeed, the artistic values Bonnard, Vuillard, Denis, and Roussel forged in the 1890s and quietly promoted in subsequent decades were essential to setting the stage for the most advanced painting of the post-war period.

1. Alexandre Bernheim's gallery had been highly successful, representing for example Courbet, the Barbizon School, and Corot; see Groom 1993, p. 147.

2. Roussel was given a solo exhibition in 1906, Denis in 1907. Vuillard, who was under contract, exhibited almost annually between 1900 and 1913, with solo exhibitions in 1906, 1908 (in both February and November), 1909, 1912, and 1913. Bonnard had numerous solo exhibitions beginning in 1906: annually, between 1909 and 1913; and then in 1917, 1921, 1922, 1926, 1933, and 1946.

3. Félix Fénéon to Henry Van de Velde, 4 Nov. 1906, in Jean Paul Morel, ed., *Correspondance, 1906–1942: Félix Fénéon et Jacques Rodrigues-Henriques* (Paris, 1996), p. 14, letter 2

4. See, for example, Groom 1993, pp. 165–66. Vuillard's discomfort with the Bernheims may have stemmed in part from his relationship with Lucie, whose husband Jos broke away from the gallery in 1912. Writing in his journal, 15 June 1912, Vuillard worried, "[There is the] question of my ties with the Bernheims, as opposed to the interests of Jos [Hessel]" ("Question de mes liens avec les Bernheim, opposés aux intérêts de Jos"); Vuillard, Journals, MS 5397.

5. For Vollard's patience with Roussel, from whom he commissioned a set of lithographs in 1910 that were not completed by 1938, when the dealer died, see Stump 1972, pp. 153–56.

6. Denis 1890.

7. Count Harry Kessler's journal entry, 24 Dec. 1902, in Schäfer 1997, p. 197, no. 7. To this Kessler added an explanatory note: "He means with that, as he explained, the pure harmony and the pure rhythm, without looking at the subject, and an understanding of these principles for both music and visual arts" (ibid.).

8. Bonnard refused to sign documents either for or against the Jewish officer. Vuillard signed a pro-Dreyfus petition in Georges Clemenceau's radical newspaper *L'Aurore*; see Thomson 1988, p. 60.

9. Bouillon, in Lyons 1994, p. 102.

10. See Vuillard to Denis, 22 May [1910], MS char.6.H. [written in ink], Musée MD: "Du reste, vous savez [depuis] longtemps je pense, la confiance, l'admiration et l'affection que j'ai eu vers et pour vous."

11. See Sandrine Nicollier, "L'Académie Ranson de 1908 à 1918," unpubl. Ph.D. thesis, Ecole du Louvre, Paris, 1998. This recent study brilliantly examines why the academy was so successful and how each of the former Nabis participated in it. See also her essay on Vuillard at the Académie Ranson, in St.-Tropez, Musée de l'Annonciade, *Edouard Vuillard: La Porte entrebâillée*, exh. cat. (2000), pp. 63–75.

12. Nicollier, in St.-Tropez (note 11).

13. Denis, a natural teacher, was especially enthusiastic about the academy's potential; see Gaston Diehl, *Peinture d'aujourd'hui: Les Maîtres* (Paris, 1943), p. 7, cited in Nicollier (note 11), p. 18. André Gide, "Promenade autour du salon," *Gazette des beaux-arts* 47, 3, 34 (1 Dec. 1905), tr. in Russell 1971, p. 96.

14. Characteristically, Roussel would take from his pocket a volume of Charles Baudelaire's poetry, or that of some other author, and read to his students; see Stump 1972, p. 96, citing Salomon 1968, p. 48, and Thadée Natanson, *Peints à leur tour* (Paris, 1946), p. 349. For profiles on these artists and their different approaches to teaching, see Nicollier (note 11), pp. 73–100. For Matisse's pedagogical goals, see Martina Padberg, "Matisse als Lehrer—Originalität und Intuition in der Künstlerausbildung," in Kunst-Museum Ahlen, *Die grosse Inspiration: Deutsche Künstler und der Académie Matisse: Hans Purrmann, Oskar und Marg Moll, William Straube*, exh. cat. by B. Leismann (1997), pp. 37–45.

15. Denis's painting is listed as no. 403, "*Le Treille* (panneau décoratif)" in the catalogue of the Salon de la nationale, 15 Apr.–30 June 1905. The current location of the picture, commissioned by a Dr. Wolff in Berlin, is unknown.

16. Matisse, in Léon Degand, "Matisse à Paris," *Lettres françaises* (6 Oct. 1945), p. 7.

17. See Denis's 1895 review, "Préface de la IXème exposition des peintres impressionnistes et symbolistes," repr. in Denis 1993, p. 27. In this regard, one should keep in mind Pierre Auguste Renoir's belief that a painting should be likeable, joyous, and pretty; see Watkins.

18. Matisse, "Notes d'un peintre," 1908, tr. in Chipp 1968, p. 132; and Denis 1890, p. 540, tr. in Chipp 1968, p. 94.

19. Matisse (note 18), tr. in Chipp 1968, p. 135.

20. Maurice Denis [Pierre Louis, pseud.], "Notes sur l'exposition des Indépendants," *Revue blanche* 2, 7 (25 Apr. 1892), p. 232.

21. See Bouillon 1993, p. 122.

22. As is discussed later in this essay, Roussel's and Bonnard's interpretations of the Midi, however, were indebted to Impressionism, a style that by the early twentieth century was no longer considered avant-garde.

23. See Sasha Newman, in Washington, D.C. 1984b, p. 15.

24. It is worth remembering here that Cézanne served as a major source for opposing trends in early twentieth-century art. While inspiring artists like Denis and Maillol to a greater classicism, Cézanne also spurred artists like Georges Braque and Pablo Picasso to develop Cubism.

25. See Jean Paul Bouillon, "Maillol et Denis: 'Fraternité artistique' et moment historique," in Lausanne, Musée Cantonal des Beaux-Arts, *Aristide Maillol*, exh. cat. (1996), pp. 127–43.

26. Today there is a renewed interest in this phenomenon, as witnessed by two forthcoming exhibitions: one entitled *Méditerranée: De Courbet à Matisse*, opening at the Grand Palais, Paris, on 22 Sept. 2000; and another devoted to Signac, opening at the same institution in February 2001.

27. See Barazzetti-Demoulin 1945, p. 151 n. 1; and Lyons 1994, p. 357.

28. Commenting on Denis's *Nausicaa*, exhibited at the Indépendants, the poet Guillaume Apollinaire remarked that Denis was "not at home" with Homer and that he was better when he interpreted a Catholic miracle; "Watch Out for the Paint!" *Intransigeant*, 18 Mar. 1910, repr. in Leo C. Breunig, ed., *Apollinaire on Art: Essays and Reviews, 1902–1918* (New York, 1960), p. 68.

29. Vuillard chose the side of the sarcophagus depicting the nine Muses, who preside over the arts and sciences. Not copied was the scene on the lid showing the Bacchanale of Maenads and aging Satyrs, which was described in a contemporary guidebook as alluding to the "joys of future life"; see Groom 1993, p. 184.

30. See Groom 1993, pp. 182–88. The painting's "failure" was due to a number of factors: it was complicated by too many ideas and allusions to past cultures and perhaps by Vuillard's feelings toward his young and lovely client. See Vuillard's numerous journal comments about both project and patron, in Groom 1993, pp. 179–81, 195–99.

31. Vuillard, Journals, [Nov. 1910], MS 5397. For more on this visit, see Groom 1993, pp. 184, 242 n. 42.

32. Denis, speaking to Kessler about Vuillard's exhibition at the Bernheim-Jeune gallery in June 1907, remarked that Vuillard's painting was "becoming prose. He is working too much in front of nature; he's no longer using his memory enough. Bonnard, too, works often in front of nature; but he has so much imagination, so much fantasy, that it [nature] does not extinguish him: there's always an element of transposition"; Kessler's journal entry, 10 June 1907, in Schäfer 1997, p. 211, no. 35. Interestingly, however, although Denis may have written and spoken ill of Vuillard's technique in an informal conversation, in his published writings, especially his *Théories*, which appeared in 1912, he had only good things to say about Vuillard; see Denis 1993.

33. See Louis Rouart, "Les Oeuvres de Maurice Denis (à la Galerie Bernheim)," *Grande Revue* 9 (10 May 1907), p. 530.

34. Kessler's journal entry, 8 Oct. 1910, in Schäfer 1997, pp. 229–30, no. 76. Denis's panels for the cupola of Stern's mansion are seen in his oil painting on cardboard entitled *Florentine Evening, Projective View* (c. 1910; private collection), illustrated in Lyons 1994, p. 280, cat. 124. The ensemble for a cupola, consisting of four large panels, *Bathers*, *Cantata*, *Poem*, and *Dances*,

complemented by smaller decorative panels, was inspired by Boccaccio's *Decameron*. *Bathers*, *Cantata*, and *Poem* are in the Musée du Petit Palais, Paris; *Dances* and the smaller panels are lost.

35. Kessler's journal entry, 8 Oct. 1910, in Schäfer 1997, pp. 229–30, no. 76.

36. Ibid. In a journal entry of 9 Oct. 1910, Kessler again compared Bonnard to Denis: "One could picture everything in a different color scheme as well (as in wallpaper), for example, if Stern had chosen different colors for his carpet or curtains; in this case, Denis could have used the same figures, the same bushes, the same flowers, the same compositions and just used a different color scale. That would be unthinkable with Bonnard, since his compositions and colors are influenced by one another; a different color scale would change his imagination, his forms, his inventions"; cited in Schäfer 1997, p. 230, no. 77.

37. See Denis, *Journal*, vol. 2, p. 36. See also Groom 1993, p. 237 n. 104.

38. Bonnard, cited in Jean Bouret, *Bonnard: Séductions* (Lausanne, 1967), p. 44.

39. The paintings *Alley* (Musée d'Orsay, Paris) and *Haystack* (Musée des Beaux-Arts, Dijon) show his increased naturalism, to the extent that he based them directly on snapshots taken during a visit to Normandy with the Hessels and playwright Tristan Bernard. See Juliet Bareau, "Edouard Vuillard et les Princes Bibesco," *Revue de l'art* 4 (1986), pp. 37–46. See also Groom 1993, p. 159.

40. Vuillard, Journals, 10 Oct. 1908, MS 5397 ("monde bourgeois riche").

41. Ibid.: "Jolies couleurs. Aucune expression. Irritation gêne de ce monde. Peintures laides au murs de Besnard . . . bons souvenirs d'Alexandre Natanson." For more on this mansion, see E. Bellerville, "Un Hôtel particulier à Paris," *Art décoratif* 10, 19 (Aug. 1908), p. 41; and Groom 1993, p. 161.

42. Charles Morice, "Revue de la quinzaine," *Mercure de France* 76 (1908), p. 1.

43. When Vuillard did waver from this successful formula, as in *The Library* (fig. 3), the result was less satisfying.

44. See Jacques Salomon, *Auprès de Vuillard* (Paris, 1953), p. 73, citing Vuillard on the merits of distemper.

45. Roussel, cited in Stump 1972, app., letter VI, [n.d.], pp. 306–07.

46. An example of color change due to light can be seen not only in the works executed on paper (where the paper itself is light sensitive), but also in works totally covered in distemper, such as Vuillard's *Under the Trees* (cat. 33), where the difference in color between the image and the canvas covered by the frame is considerable. I am grateful to Marcia Steele, Conservator at the Cleveland Museum of Art, for having allowed Art Institute Conservator of Paintings Faye Wrubel and me to examine this painting in the laboratory.

47. Retouching, in fact, especially when applied with another type of glue or varnish, radically compromises the surface, both aesthetically and physically. I am grateful to Faye Wrubel, who has succeeded in replicating the *à la colle* technique and has shared with me the results of her research into this challenging medium. Ms. Wrubel has recently finished treatment on one of the Art Institute of Chicago's large-scale portraits by Vuillard, *Madame Guérin* (1914), which manifested many of the conservation problems that Roussel assured his patron would not occur.

48. See Denis, "Hommage à Odilon Redon," *La Vie* 41 (30 Nov. 1912), p. 129; and unpublished letter from Redon to Denis, 4 July 1911, Denis family archives, St.-Germain-en-Laye. I am grateful to Claire Denis for allowing me to excerpt this letter.

49. Redon's journal entry, 1909 (*A Soi-même, journal, 1867–1915: Notes sur la vie, l'art et les artistes* [Paris, 1922; repr. 1961], p. 116). He also wrote, "Maurice Denis burdens his [art] with social and religious messages; he dabbles in politics, and what a shame it is."

50. In an article entitled "La Réaction nationaliste," *Ermitage* 16, 5 (May 1905), Denis mentioned the "dangers of abstraction" that he saw in paintings like Matisse's *Luxe, calme et volupté*; see Roger Benjamin, "Fauves in the Landscape of Criticism: Metaphor and Scandal at the Salon," in Los Angeles County Museum of Art, *The Fauve Landscape*, exh. cat. (1990), p. 246.

51. All four artists exhibited internationally, beginning with their submissions to the Libre Esthetique exhibition in Brussels in 1904 (and in 1908, 1909, and 1910). In 1911 and 1912 they were represented in St. Petersburg (Centennial Exhibition). For full listings of international exhibitions, see London 1998, pp. 256–63; Lyons 1994, pp. 362–67; St.-Tropez 1993, pp. 120–21; and Paris 1968, pp. 207–09.

52. Guillaume Apollinaire, "Les Cubistes," *L'Intransigeant*, 10 Oct. 1911; and untitled article in ibid., 12 Oct. 1911, repr. in *Apollinaire on Art: Essays and Reviews, 1902–1918* (New York, 1972), pp. 183–85. For Bonnard on Cubism, see *7 Jours*, 11 Jan. 1942, cited in Antoine Terrasse, "Matisse and Bonnard: Forty Years of Friendship," in Jean Clair and Antoine Terrasse, eds., *Bonnard/Matisse: Letters between Friends*, tr. by R. Howard (New York, 1992), p. 19.

53. Roussel exhibited a *panneau décoratif* as early as 1905 at the Salon d'Automne (no. 1368), which has not been identified. In 1908, he painted two decorative panels for Jean Schopfer, but these were private rather than public projects. In 1911, he also exhibited the large panel *The Abduction of the Daughters of Leucippus* (cat. 65, fig. 1) destined for the carriage entrance (*porte cochère*) of the Bernheims' home on avenue Henri-Martin, Paris.

54. These contracts have been published in Guy Patrice and Michel Dauberville, *Matisse: Henri Matisse chez Bernheim-Jeune* (Paris, 1995), vol. 1, pp. 26–47. See also Malcolm Gee, *Dealers, Critics and Collectors of Modern Painting: Aspects of the Parisian Art Market between 1910 and 1930* (New York, 1981), app. E, pp. 11–13.

55. For Vuillard's concern about the conflicting interests of the Bernheim brothers and Jos Hessel, see note 4 above.

56. See André Fermigier, *Pierre Bonnard* (London, 1987), p. 26.

57. For the general décor of the residence to which Schopfer moved after his remarriage to Clarise Langlois in 1908, see Groom 1993, pp. 117, 119.

58. Thomson 1988, p. 122, pl. 110. These have since been transformed into vertical panels.

59. For the story of Ivan Morozov's collection until 1914, see Albert Kostenevich, "Russian Collectors of French Art," in Essen 1993, pp. 35, 92–114.

60. On the Bibescos, see Groom 1993, pp. 148–51.

61. Emmanuel Bibesco offered to buy all of Gauguin's Tahitian works at prices higher than those offered by his dealer, Ambroise Vollard, in return for the exclusive right to purchase everything Gauguin produced. This was an offer that even Gauguin, however destitute, could not accept; see Jean Loize, *Les Amitiés du peintre Georges Daniel de Monfreid et ses reliques de Gauguin* (Paris, 1951), p. 147, no. 448, cited in Groom 1993, p. 149.

62. Mina Curtiss, *Other People's Letters: A Memoir* (Boston, 1978), pp. 82–83.

63. Vuillard worked on them from May 1917 to Feb. 1918; see Thomson 1988, p. 122, pl. 110.

64. See Anna Boch to Denis, 26 Mar. [1903 or 1904] and 2 Apr. [1903 or 1904], MS 1055, Musée MD.

65. Denis noted in his journal, after seeing the panels, "my disillusion; ridiculous surroundings for my panels"; Denis, *Journal*, vol. 2, p. 59. He received the commission through Kessler. See Barazzetti-Demoulin 1945, pp. 149–50; and Kessler's journal entry, 21 Aug. 1904: "I have been dealing with him [Denis] regarding Mutzenbecher's commission," in Schäfer 1997, p. 203, no. 17. The Mutzenbecher panels were probably not installed until 1907; see, for example, Kessler's journal entry, 31 Jan. 1906, in Schäfer 1997, p. 207, no. 26. A screen (see Montreal 1998, pp. 75 [ill.], 101, cat. 77) is the only surviving work from this commission.

66. As Stump (1972, p. 104) described it: "It is still one of the most comfortable and important of Paris theaters, and is considered to be an authentic masterpiece of early twentieth-century French architecture."

67. What is surprising is that this was also Denis's first public commission (outside of religious projects).

68. For other artists, see Groom 1993, p. 245 n. 9.

69. See Lyons 1994, pp. 311–12. In the study for this frieze (ibid., p. 313, cat. 176), Denis included the names of the composers on the bottom edge of the mural. The three-dimensional model for the ensemble is still preserved in the Musée d'Orsay, Paris (repr. in Bouillon 1993, p. 145). As one critic put it, this panel resembles the curtain call at the end of a spectacle, when all the players, including those with minor roles, come out on stage; see Jean Louis Vaudoyer, "La Décoration" (part of larger article entitled "Le Théâtre des Champs-Elysées"), *Art et décoration* 33 (Apr. 1913), p. 120.

70. Vuillard, Journals, 13 Dec. 1912, MS 5397; and Denis, *Journal*, vol. 2, p. 147.

71. "Echos: Les Rubans dédaignés," *Gil Blas*, 25 Oct. 1912.

72. As early as 1910, Henry Bidou, writing on the Salon d'Automne (where, in fact, Bonnard exhibited his panels for Misia Edwards [cat. 45–47]), summed up their work as embodying a new emphasis on grace: "While the foreign artists, still dazzled by the palettes of the preceding age, send us remakes that grate on us a little, we remain above all contemporaries of Debussy, Boylesve, Denis, Bonnard, of the subtle masters"; see Henry Bidou, "Le Salon d'Automne," *Gazette des beaux-arts* 52, 4, 4 (Nov. 1910), p. 383.

73. "Echos: Décor d'un *Beau Mariage*," *Gil Blas*, Nov. 1911, cited in Groom 1993, p. 204.

74. See Silver 1989, p. 26: "Proust, Gide, Rodin and Apollinaire were all wartime subscribers to *Action française*."

75. See Nathalie Reymond, "Le Rappel à l'ordre d'André Lhôte," in Colloque d'histoire de l'art contemporain, *Le Retour à l'ordre dans les arts plastiques et l'architecture, 1919–1925* (St.-Etienne, 1975), p. 222 n. 9. As Reymond pointed out, the phrase *rappel à l'ordre* came into widespread use at this time. Lhôte used it in 1919 in connection with a Braque exhibition at the Léonce Rosenberg gallery, Paris; Jean Cocteau later made it the title of a collection of critical writings published in 1926.

76. In 1912, he was a member of the editorial board of the virulently patriotic (and anti-Semitic) magazine *L'Indépendance*, a board that also included Georges Sorel, Vincent d'Indy, Maurice Barrès (who with Léon Daudet had edited *L'Action française* around the time of the Dreyfus Affair), and Paul Bourget. See Silver 1989, pp. 197–98.

77. See note 37.

78. See note 72.

79. Silver 1989, p. 29.

80. Matisse was also all too aware of this change. Silver compared Matisse's pre-war painting *The Red Studio* (1911; fig. 4) to his wartime *The Piano Lesson* (1916; The Museum of Modern Art, New York), to illustrate Matisse's newly applied "restraint"

and response to duty and family. See Silver 1989, pp. 34–37. For more on Matisse's feelings about being a civilian in wartime, see Catherine C. Bock, "Henri Matisse's *Bathers by a River*," *The Art Institute of Chicago Museum Studies* 16, 1 (1990), pp. 44–55.

81. Stump 1972, p. 129.

82. Fénéon described Roussel as being in treatment at Territet (Lake Geneva) "for acute neurasthenia"; see Fénéon to Jacques Rodrigues, 1 Oct. 1915, in Morel (note 3), p. 51, letter 29. Taking his family to Lausanne to stay near relatives of Vallotton, Roussel placed himself under the care of Dr. Auguste Widmer, a Swiss specialist (and Marcel Proust's doctor) at Maison Lambert. See Lausanne, Musée Cantonal des Beaux-Arts, *La Collection du Dr. Henri-Auguste Widmer au Musée Cantonal des Beaux-Arts de Lausanne*, exh. cat. by Jörg Zutter and Catherine Lepdor (1998), p. 41. Zutter and Lepdor, however, referred to this facility as the "Clinique Valmont."

83. Bonnard's comments to Charles Terrasse, repr. in Charles Terrasse, *Bonnard* (Paris, 1927), pp. 126–30.

84. See Thomson 1988, p. 119.

85. For Bonnard the result of visiting the Somme was what Timothy Hyman called "a sad little picture on his return," known as *The Armistice*, recently redated to 1916 instead of 1918, and probably showing the flag-waving crowds at the 14 July celebrations that year; Hyman 1998, p. 109, fig. 83. Vuillard's wartime pictures include *The Forge* (1917; Musée d'Art Moderne, Troyes).

86. Vuillard, cited in Thomson 1988, p. 119.

87. Nicollier, in St.-Tropez (note 11), p. 75 n. 41.

88. Bonnard and Vuillard also contributed illustrations to *Album national de la guerre*, published in 1915 by the Comité de la fraternité des artistes. Other contributors included Degas, Monet, Renoir, and Signac. See London 1998, p. 260.

89. For example, in his essay for the Kunsthaus Zürich exhibition *Französische Kunst des XIX und XX Jahrhunderts* (1917), published in the original French (even though the rest of the catalogue was in German), Denis lauded the "revolutionary spirit" in French art, but also the intelligence behind it, the enlightened collectors who had made it possible, and the genius of the French race: "You need to be French to understand them [the artists], since their qualities, intrinsic to the genius of our race, largely transcend the classifications of a purely rational critique" (p. 8).

90. Lucie Cousturier, *K.-X. Roussel* (Paris, 1927), p. 63, cited in Stump 1972, p. 132.

91. One can also imagine Roussel's sense of betrayal when reading in 1915 Léon Daudet's and Charles Maurras's article "Hors du joug allemand: Mesures d'après-guerre," in *L'Action française*, which stresses that the "devotion to Wagner is costly . . . because he denationalizes the French in the manner of a Kant or a Hegel or a Schopenhauer," cited in Silver 1989, p. 23.

It is also possible that the overly sensitive Roussel "may have blamed himself for his faith in the ideas of Nietzsche, and perhaps realized that he had not understood the political implications of the *surhomme*"; Stump 1972, p. 131.

92. For Roussel's struggle with these murals, see Stump 1972, pp. 132–33. See also below, cat. 67–68.

93. Fénéon to Maximilien Luce, 18 Aug. 1914, in Morel (note 3), p. 24, letter 28. In this letter, Fénéon described the confusion the outbreak of war precipitated: "Vuillard is guarding a bridge, I don't know where. Bonnard is at 29, route des Andelys, in Vernon, Eure. Roussel, probably at l'Etang[-la-Ville]. The Pankiewiczs [Bonnard's friends from the Midi, pictured in *Conversation in Provence*, cat. 51] exiled from Collioure, are now broke, in Barcelona."

94. "I hardly ever spend more than two months a year in Paris. I return for a certain exposure to the atmosphere, to compare my paintings with others. In Paris I am a critic, I can't work there. There is too much noise, too much distraction. I know that other painters get used to that life [this probably refers to Vuillard]. For me, it has always been difficult"; Bonnard, in Pierre Courthion, "Impromptus—Pierre Bonnard," *Nouvelles littéraires* (24 June 1933), cited in Terrasse (note 52), p. 21.

95. Nicholas Watkins, in conversation with the author, 20 June 2000.

96. For works by Renoir in the Bernheim-Jeune collection, see Henry Dauberville, *La Bataille de l'impressionnisme* (Paris, 1967), pp. 209–26, 549–50.

97. For the facts surrounding Monchaty's death, see Nicholas Watkins, "The Death of Renée Monchaty, Bonnard's Model and Lover," *Burlington Magazine* 140, 1142 (May 1998), p. 327.

98. Terrasse (note 52), pp. 34–35. For Matisse's respect for Bonnard, see Watkins.

99. "Note de Monsieur Marcel Kapferer, ancien Directeur de la Sté les Fils de A. Deutsch," May 1961, unpubl. typescript, Francine Kapferer archives, Paris. For Henri's profession, see *Tout Paris* (Paris, 1914), n.pag.; and *Bottin mondain* (Paris, 1923), n.pag. I am grateful to Francine Kapferer, granddaughter of Marcel, and to Alice Clément, Martine Martin, and Claude Weill, the daughters of Marcel and Henri, for their interest in this project and willingness to provide information on their parents' history. I am also indebted to Marina Ferretti for her diligent research on this family.

100. Vuillard's *Portrait of Mother Kapferer* is illustrated in Jacques Salomon, *Vuillard admiré* (Paris, 1961), p. 127.

101. Among the small, unstretched canvases seen pinned to the wall in *Portrait of Marcel Kapferer*, the lowest one is a version of a painting by Vuillard (c. 1917; The Minneapolis Institute of Arts) of his mother at their summer home at Vaucresson. As mentioned, Vuillard, like

Bonnard, worked on unstretched canvas, but never on the scale of Bonnard, who would sometimes spread a roll of canvas and make multiple works on it.

It is not well known that Marcel was a particularly important collector of former Nabis, including Bonnard (he owned this artist's *Dessert*, c. 1920, The Cleveland Museum of Art; *At the Casino*, 1924, Pacquemont collection, Paris; and *After the Luncheon*, c. 1920, Kreeger collection, United States), among others.

102. Photographs of the new home published in *L'Art et décoration* in 1920 show the walls covered with works by Redon; see Pierre Lahalle, "Notre Enquête sur le mobilier moderne: Lucet, Lahalle et Levard," *Art et décoration* 38 (July–Dec. 1920), pp. 122–23.

103. According to Salomon (note 100), p. 137, the two had met while Vuillard was on guard duty at Conflans-Ste.-Honorine. For Vuillard's decorative series, see Charlotte Thornton, "Au Louvre: A Study of Edouard Vuillard's Creative Process," M.A. thesis, University of Texas at Austin, 1986.

104. Roussel was sought after not only in France as a painter-decorator, but also abroad for his easel paintings, and he was awarded a second prize for painting at the 1926 Carnegie International, Pittsburgh, for *Faun and Nymph on a Tree*; see Stump 1972, pp. 141–42.

105. See Jean Dauberville, *En encadrant le siècle* (Paris, 1967), pp. 536–37.

106. Marcel Monteux's wife, Simone, in conversation with the author, 9 Sept. 1982, claimed that Roussel painted the Paris murals directly on the walls. This description is similar to that of Jacques Guérin, Marcel's half-brother. Guérin, however, claimed that the murals were never completed and that they remained in the state of black-and-white sketches in 1932 when the family moved. Apparently, the Monteux lost everything through bad business deals and pillage by the Germans during World War II (Simone Monteux, in conversation with the author, 24 Nov. 1982). In contrast to these eyewitness accounts, the published sources on these works traditionally cite the Paris murals as dating to 1919/20, followed by the ensemble (1923/24) at Cap d'Antibes. Vuillard's journal refers to the "grands panneaux Monteux" in entries of 1 July 1920, 25 July and 17 Sept. 1921, and 2 Mar. 1923, all MS 5396, without, however, specifying whether or not they were for the Monteux children or father.

107. For another view of the Monteux dining room, showing the panel *Fountain of Youth*, see Werth 1930, fig. 23. For another view of the Rosengart interior, showing the panel *Bacchanale*, see ibid., fig. 24.

108. See Stump 1972, p. 151; and Jacques Roussel, in conversation with the author, Feb. 1998.

109. Guillaume Janneau, *Formes nouvelles et programmes nouveaux: L'Art décoratif moderne* (Paris, 1925), p. 44.

110. Paradoxically, although many critics saw this exhibition as proof that the reign of individuality and of excessive stylistic mannerisms had given way to a clear, logical, and elegant style, the exhibition was criticized as elitist, since it targeted only the upper bourgeoisie. For more on the exhibition and its implications for modern art, see Silver 1989, pp. 362–74 passim.

111. Editions Bernheim-Jeune was inaugurated around 1900 to produce monographs on artists; Guy Patrice Dauberville, in conversation with the author, Oct. 2000. For a description of the Bernheim-Jeune pavilion built expressly for the 1925 exposition, see Bernheim-Jeune, *Les Galleries et editions d'art Bernheim-Jeune* (Paris, [c. 1930]), pp. 32, 35.

112. Arsène Alexandre, "Les Peintres à l'Exposition," *Renaissance de l'art français* 8, 8 (Aug. 1925), p. 337.

113. Franz Jourdain, quoted in Janneau (note 109), p. 44.

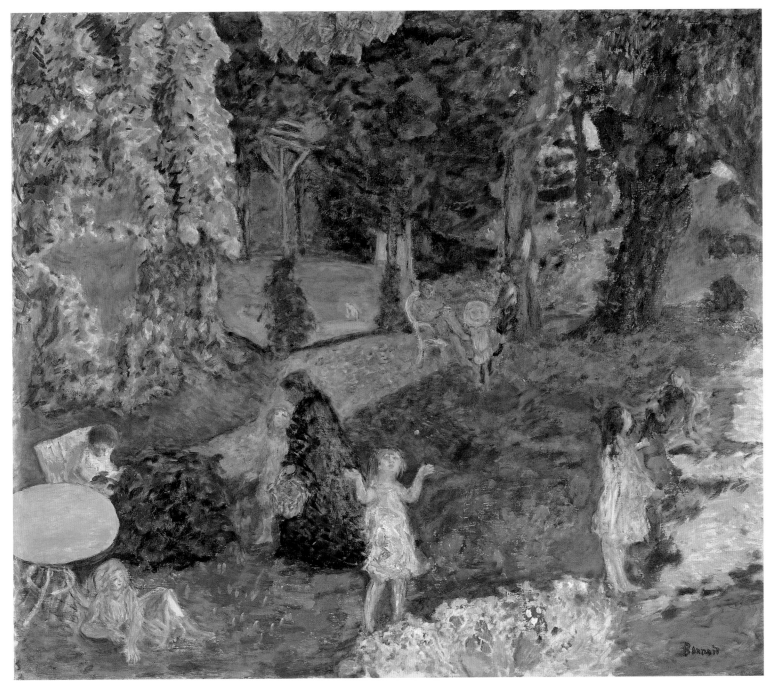

CAT. 43

CAT. 43

PIERRE BONNARD

Family in the Garden (Le Grand-Lemps)
c. 1901
Oil on canvas
109.5 x 127.5 cm (43 ⅛ x 50 ¼ in.)
Kunsthaus Zürich

FAMILY IN THE GARDEN IS ONE OF BONNARD'S many uncommissioned decorative composi- tions inspired by summers spent at his family home, Le Clos, at Le Grand-Lemps, in the Dauphiné region of France. It differs substantially, however, from his earlier treatments of his family in this setting: *Twilight* (cat. 5) with its richly modulated patchwork of colors; and the tapestrylike, almost monochromatic scenes of the surrounding orchards painted between

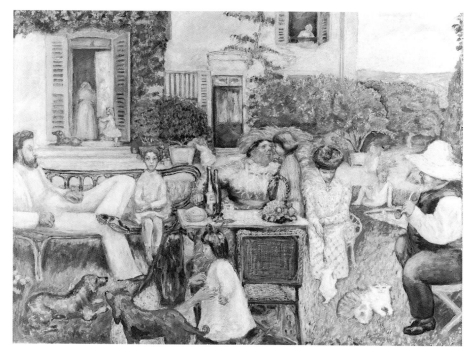

Pierre Bonnard. *Bourgeois Afternoon*, 1900. Oil on canvas; 139 x 212 cm. Musée d'Orsay, Paris.

1895 and 1899 (cat. 7–9). In many ways, *Family in the Garden* heralds Bonnard's move away from a Nabi aesthetic, characterized by nuanced hues and straightforward, intimist subjects, to the works that would define his art in the next four decades, with its explosive color and complex spatial construction.

Bonnard undertook this freely brushed and chromatically brilliant family scene around 1901, shortly after having shown a very different representation of his family, *Bourgeois Afternoon* (fig. 1), at the Indépendants that spring. As Nicholas Watkins pointed out, in many ways, the two paintings show dramatically different views of Bonnard's family.[1] In *Bourgeois Afternoon*, the artist employed a gray and somber palette and a friezelike composition of figures in two horizontal registers; the depictions of the artist's relatives are portraitlike, if not caricatural. In *Family in the Garden*, Bonnard created a more distant and visually pleasing image. Using a green and golden palette, he dotted the landscape with simplified and abstracted figures and adopted a higher viewpoint. It is as if Bonnard felt that the portrayal of his family in *Bourgeois Afternoon* was too intimate; and in *Family in the Garden*, he appears to have retreated to a psychologically safer distance.

This panel shows how Bonnard's compositional strategies had evolved since his earliest Nabi paintings of Le Grand-Lemps. The differences between *Family*

in the Garden and an earlier, much larger, work, *The Terrasse Family in the Garden* of 1896 (fig. 2), illustrate this point. The artist set both scenes in a clearing in the forested area of his grandmother's property, used approximately the same bird's-eye viewpoint, and featured the same gazebolike structure in the background. In the later panel, however, he shifted his emphasis from people and perspective to color and design.[2] The earlier work, painted on paper mounted on wood, is thought to have been intended originally as a four-panel screen.[3] Indeed, it is compositionally similar to Bonnard's earlier painted screen *Nannies' Promenade* (cat. 6, fig. 1); both feature a continuous decorative and unifying element across the top and similar groupings of women, children, and dogs. While Bonnard carefully structured *The Terrasse Family in the Garden* to accommodate the screen format (allowing for shifts of perspective between screen panels, for instance), he defined the space in *Family in the Garden* more loosely. Likewise, the earlier image presents a more legible narrative: children play with a dog while their mother looks on, their grandmother strolls under the trees, and their father is busy at work in the gazebo at the left. The family members in the later composition, in contrast, seem to hover between bourgeois complacency and chaotic fragmentation. Indeed, compared to the relative clarity and calm Bonnard achieved in the 1896 painting, in *Family in the Garden* he seems to have wished to subvert any sense of spatial and narrative consistency.[4]

In *Family in the Garden*, the figures—Bonnard's grandmother in black, Claude and Andrée Terrasse, and their five children, plus two additional youngsters—are scattered, seemingly at random, throughout the verdant landscape. Closer inspection, however, reveals a more subtle arrangement in which the figures revolve around the little girl at the center of the canvas who is gazing at the ball she has tossed into the air. Her outstretched arms direct the viewer's eye upward to the group of Claude Terrasse and two children. The eye then moves counter-clockwise along the brightly lit path to the dark form of the grandmother, on to the figures around the golden-orange table, and then, following an arc along the bottom of the canvas, past a flowerbed, to the figures on the edge of the lemon-yellow patches of light on the far right.

Equally important to the liveliness of this composition are the two circular areas of brilliant orange-gold that brighten the landscape: the flowerbed at bottom

right, and at far left, a round table underneath which a little girl reclines. The striking flowerbed, painted in heavy impasto and dotted with pinks, greens, and oranges, seems almost luminous, and the front of the little girl with raised arms seems to glow in response. Likewise, the thinly painted and smoothly contoured table on the left appears to radiate a kind of golden energy that is reflected by the surrounding figures. The young girl beneath the table is not hidden in shadow, as one might expect, but rather enveloped in a warm orange-yellow.

Here Bonnard's use of color patches is less dogmatic, less subservient to the notion of painting as pattern and decoration than in earlier paintings, such as *Twilight* (cat. 5). It reveals Bonnard's commitment to the type of handling of brilliant color found in Impressionist paintings, but now in the service of an all-over design and a near-negation of spatial depth. *Family in the Garden* shows how far Bonnard had traveled since the tufted and tightly interlocked forms of *Twilight*.

FIG. 2
Pierre Bonnard. *The Terrasse Family in the Garden*, 1896. Oil on paper, mounted on wood; 220.4 x 313.7 cm. Staatliche Museen Preussischer Kulturbesitz, Berlin. Photo: Kunsthaus Zürich, *Bonnard*, exh. cat. (1984), p. 101.

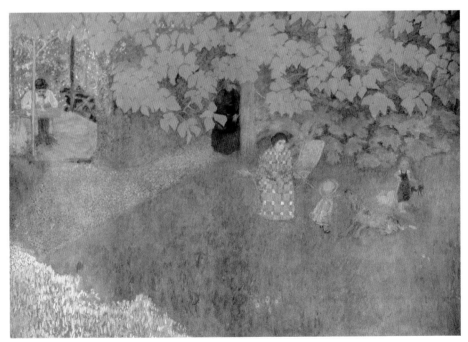

CAT. 44

PIERRE BONNARD

Screen with Rabbits, 1902/06

Oil on paper, mounted on canvas
Six-panel screen: each panel, 161 x 45 cm
(63 ⅜ x 17 ¾ in.)
Musée Départemental Maurice Denis "Le Prieuré,"
St.-Germain-en-Laye

THIS LARGE, SIX-PANEL SCREEN SEEMS TO have been the last of Bonnard's numerous experiments with the screen format.[1] *Screen with Rabbits* (cat. 44) is also one of the most personal of his works in that genre and was probably not intended for public viewing, as it was never exhibited during Bonnard's lifetime and stayed in his family after his death. Rococo in palette and subject, the panels are divided horizontally into two distinct sections: the bottom two-thirds of the work features frolicking rabbits (paired off in five of the six panels), while the upper third depicts vignettes of cavorting satyrs (sometimes called fauns) and nymphs, interspersed with glimpses of country houses and snowy landscapes.[2] These scenes are set off by the deep indigo of the irregularly shaped background.[3]

The themes of this screen are fecundity, symbolized by the rabbits, and eroticism, reflected in the sexual activity of their human counterparts. Pairs of rabbits were popular motifs in Japanese art (as tricksters and symbols of fecundity)[4] and were especially favored by Katsushika Hokusai and Kitao Masayoshi, whose graceful, calligraphic line drawings Bonnard would have known from illustrations in Siegfried Bing's periodical *Le Japon artistique* (see fig. 1). Rabbits were also among Bonnard's favorite subjects, appearing (usually in playful, but chaste, pursuits) early on in his work.[5] But the initial inspiration most likely came from experiences of nature at the Bonnard family home at Le Grand-Lemps. *Screen with Rabbits* links Bonnard's predilection for domestic fauna (rabbits, chickens, roosters, cats, and dogs) with a new passion for Arcadian themes.

Typically dated 1902/06, this screen may have evolved out of two commissions for lithographic illustrations he received in 1900 and 1901: for an edition of Paul Verlaine's *Parallèlement*, a series of love poems emphasizing the ideals of Greek paganism, published

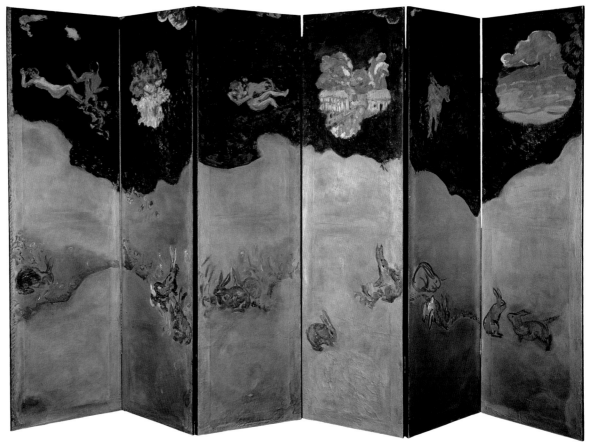

CAT. 44

FIG. 1
Kitao Masayoshi (Japanese;
1766–1824). *Cats—Various
Animals* (detail), late eighteenth
century. Photo: *Japon artistique 2*,
24 (1890), pl. BFI.

in September 1900; and, more specifically, for a new edition of Longus's *Daphnis et Chloé*, published in 1902 (see Watkins, fig. 21).[6] *Daphnis et Chloé*, a pastoral romance by the third-century A.D. Greek writer Longus, recounts the innocent love of a young goatherd and shepherdess on the island of Lesbos. The story, which is the classical equivalent of a modern romance novel in its descriptive eroticism, mingles pagan myths with details of Arcadian life.[7] The mood

of eroticism in Longus's poem inspired several of Bonnard's bronze sculptures from this period, including a series of nymphlike nudes and an oval-shaped centerpiece datable to 1902, also titled *Daphnis and Chloe*. This centerpiece features a number of images of the two protagonists lying languidly among flowers and vines (fig. 2).[8]

In his 1902 lithographs for Longus's story, Bonnard created mythological scenes in which he combined classical figures and the informal landscapes of the Ile-de-France and the Dauphiné region of his childhood. This fusion of a pastoral and classical theme with a contemporary setting appears as well in *Screen with Rabbits*, in which features of northern France (and possibly, in the last panel, of the snow-covered Dauphiné) are juxtaposed with the temporally and geographically remote satyrs and nymphs.[9]

The nymph depicted in various vignettes on the screen embodies Bonnard's longtime mistress and future wife, Marthe. She reclines seductively and allows herself to be taken by the satyr, perhaps an allu-

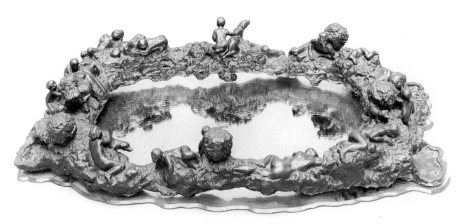

PIERRE BONNARD

Decorative Ensemble, 1906–10

45 *After the Flood*
Oil on canvas
250 x 450 cm (98 ⅜ x 177 ⅛ in.)
Ikeda Museum of Twentieth-Century Art, Ito, Japan

46 *Landscape Animated with Bathers,* or *Pleasure*
Oil on canvas
251.5 x 464.7 cm (99 x 183 in.)
The J. Paul Getty Museum, Los Angeles

47 *Pleasure: Decorative Panel,* or *Games*
Oil on canvas
246 x 300 cm (96 ⅞ x 118 ⅛ in.)
Collection Paule and Adrien Maeght, Paris

FIG. 2
Pierre Bonnard. *Daphnis and Chloe*, 1902. Bronze centerpiece; 15 x 83 x 50 cm. Musée d'Orsay, Paris.

sion to the artist, who had earlier portrayed himself as a spying faun (1890–99 Intro., fig. 3). Their playful physical interaction is underscored by the innocent scenes of rabbits in the abstract landscape suggested by leaf and flower shapes.[10]

The seemingly unrelated vignettes of seduction and the landscape scenes at the top of the screen can be seen as Bonnard's reflection on the peripatetic life he shared with Marthe. Between 1901 and 1910, Bonnard (with Marthe in tow) worked each spring in various locations in the Seine valley: Montval (near Marly-le-Roi), L'Etang-la-Ville, Vernouillet, and Médan. The couple continued to spend the summer and early autumn in Le Grand-Lemps, after which they returned to Paris for the winter.[11] Bonnard could easily have seen himself as a satyr, periodically carrying his mistress (the nymph) off with him to various locales.

Unfortunately, no known photographs exist to document what function the screen played in the artist's home or studio. Perhaps the uncharacteristically subdued deep-blue and silvery tones of the screen were intended, like Denis's ensemble on the *Love and Life of a Woman* (cat. 19–24), to evoke the nocturnal realm of the bedroom and thus to fit within that kind of interior. This possibility is reinforced by the private imagery (perhaps the artist's meditation on his relationship with Marthe) incorporating themes of particular interest to Bonnard: references to his abiding admiration for Japanese art, to his newfound appreciation of mythological and pastoral themes, and to his own modern-day studio sites. Like the sensual illustrations for *Daphnis et Chloé*, which were meant to be enjoyed privately, *Screen with Rabbits* invites close and intimate viewing.[12]

THESE THREE MONUMENTAL PANELS, ALONG with *Water Game*, or *Voyage* (fig. 1), were commissioned by Misia Natanson Edwards in 1906 as a decorative ensemble for her dining room at 21, quai Voltaire, but were not completed until four years later. They were finished in time for the 1910 Salon d'Automne, where they were shown under the generic title "*Decorative paintings forming an ensemble* (mounts by Dantant)"[1] and were praised for their uniqueness, not only in relation to decorative painting in general at that time, but also to Bonnard's own oeuvre. Even Louis Vauxcelles, the critic who five years earlier had railed against the garish and savagely painted Fauvist works of Henri Matisse and his group, admired these paintings for their surprising color combinations and inventiveness:

M. Bonnard is fantasy, instinct, ingenuous spontaneity, French charm, both tender and mischievous. He delights the eye with attenuated color harmonies suggesting the tones of faded tapestries, and iridescent, pearly skin in semidarkness. His panels depict a thousand stories as entertaining as the thousand and one nights, portrayed with energy.[2]

Bonnard's habit of leaving his works untitled or letting others assign titles to them, some more accurate than others,[3] makes it difficult to determine his intention and leaves much room for interpretation. The general unifying theme of the panels would seem to be pleasure or pleasurable pastimes, suggested by titles and

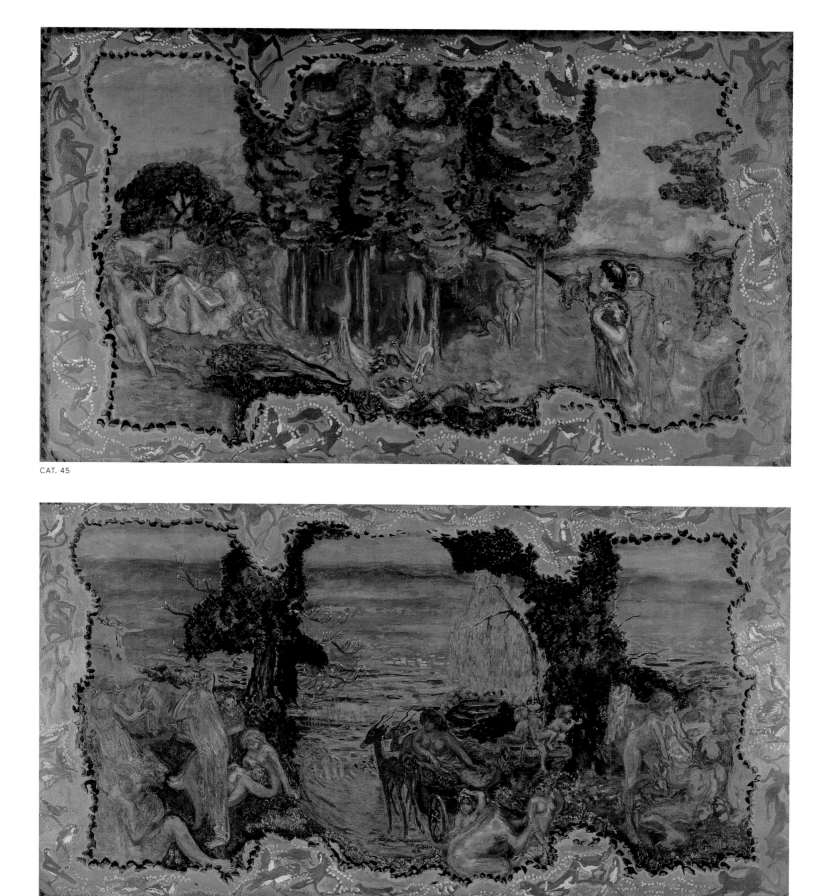

CAT. 45

CAT. 46

174

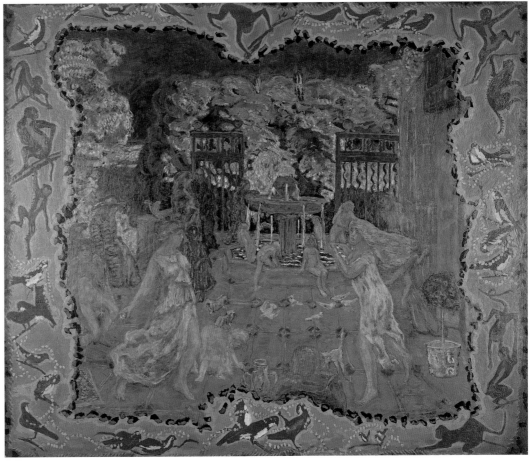

CAT. 47

subtitles such as *Pleasure* and *Games* (even *After the Flood* has hopeful overtones). The panels depict figures engaged in idle pursuits: women playing ball and children bathing (cat. 47), shepherds and nymphs in an earthly paradise replete with exotic animals (cat. 45), women and children at play in an idealized country-side devoid of males in which "a kind of Queen of Sheba lets herself be carried in a chariot pulled by antelope"[4] (cat. 46), and Rubenesque sirens riding on the backs of aquatic beasts (fig. 1).

The four panels represent eccentric variations on the theme of Arcadian happiness and earthly paradise, which Bonnard had begun exploring around 1905, as he expanded his repertoire for decorative art. Sources for individual elements within the paintings reflect a broader group of interests, however, and reveal Bonnard's incredible capacity for drawing upon varied themes and making them his own. In *Pleasure* (cat. 47), for instance, Bonnard returned to subjects inspired by his family home. The scene centered on the fountain, for example, recalls numerous paintings dating around

1900 of his nieces and nephews bathing in a fountain at the family estate at Le Grand-Lemps. And the potted tree at the far right recalls a similar motif in *Child with Pail* (1894–95; Musée d'Orsay, Paris), the now-detached fourth panel of his screen *Ensemble Champêtre* (1894/96; Museum of Modern Art, New York), also inspired by his bucolic family home.[5] The imagery in *Landscape Animated with Bathers* and *After the Flood*, on the other hand, develops further the Virgilian pantheon that Bonnard first introduced in his illustrations for *Daphnis et Chloé* in 1902 (see Watkins, fig. 21). The robust sirens in *Water Games*, however, may also be a nod to the river goddesses in Peter Paul Rubens's *Embarkation of Marie de' Medici* from the *Life of Marie de' Medici* cycle (1621–25), which Bonnard would have seen at the Musée du Louvre, Paris.[6]

While the classically inspired subject of these four panels is reflective of many elements in Bonnard's work at the time, their unusual borders set them apart from anything the artist had done previously or would do thereafter. The lively, frenetic, undulating border

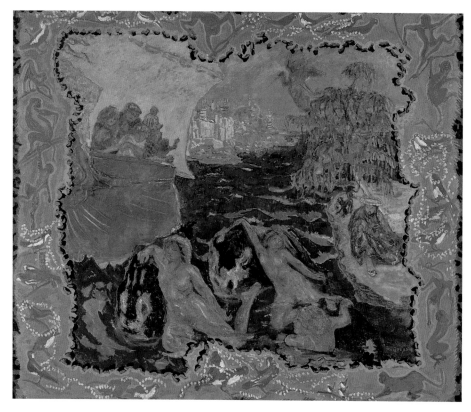

FIG. 1

Pierre Bonnard. *Water Game*, or *Voyage*, 1906–10. Oil on canvas; 250 x 300 cm. Musée d'Orsay, Paris.

decoration, filled with acrobatic monkeys and birds (perhaps magpies) entwined with strings of pearls, functions like the meandering marginalia in medieval manuscripts. The irregular, "cut-out" shapes of the borders are also unique. In opposition to the recommendations of Denis, Alphonse Germaine, and others who advocated a close relationship between painted frames, or borders, and image, Bonnard's feather-and-fur borders represent a new species altogether, having little in common with the images they frame.[7]

Bonnard's convoluted, exotic, and baroque imagery in these panels, so different from that of his other work from this period (see cat. 48–50), can be understood as a concession to his patron's personal tastes. To appreciate fully the barely restrained exuberance of this ensemble, one must look to Misia Edwards and her complex personal situation at the time. Bonnard began work on the panels in August 1906, after having traveled to Belgium and Holland the month before with Misia and her husband, Alfred Edwards, aboard their yacht, *Aimée*.[8] Edwards, a physically unattractive and arrogant millionaire, who owned the newspaper *Le Matin* as well as two theaters, had spared no expense in convincing Misia to leave her newly bankrupt first husband, Thadée Natanson, to become one

of the wealthiest and most powerful women in Paris.[9] After her divorce in February 1904, Bonnard (who was close to Natanson) remained her best friend, confidant, and frequent traveling companion. Thus it was to Bonnard, and not to her longtime friend and admirer Vuillard, that Misia turned for the decoration of her dining room.[10]

By 1906, only one year after agreeing to marry Edwards (who had pursued her since 1900), Misia's fortunes turned, as she suffered the humiliation and pain of her husband's infidelity with a young actress, Geneviève Lantelme. In her memoirs, Misia recorded how she confronted her rival and was told, "My dear, if you really want him you can have him—on three conditions: I want the pearl necklace you're wearing, one million francs—and you"(whereupon Misia, taken aback, abruptly cut off negotiations).[11] The gossip that followed this exchange and her husband's continuing relationship with Lantelme led eventually to Misia and Edwards's divorce in 1909 and to his marriage to Lantelme later that year, All of this caused Misia much anguish, which she must have shared with Bonnard.[12] It is possible that Bonnard alluded to this extraordinary tale when he painted birds that look like magpies—traditional symbols of gossip, magpies are also known to steal bright objects—surrounded by strands of pearls and cavorting monkeys, which have been associated with lewdness and ugliness (perhaps referring to Edwards's character and appearance).[13]

Perhaps Bonnard wished to create an exotic visual escape for his friend, who for those years lived almost as a prisoner of her overbearing, violently jealous, and at the same time philandering, husband.[14] Within the paintings' borders, which may also have been modeled after eighteenth-century *chinoiseries* (Chinese-inspired motifs of animals and birds), are images of pastoral calm (*After the Flood, Landscape Animated with Bathers*) and joyous activity (*Pleasure, Water Game*).[15] Moreover, Bonnard included figures from a time and place far removed from Misia's everyday life, figures that he no doubt hoped would appeal to her adventurous and easily bored nature.[16] This somewhat melancholy vision of Misia is suggested by Bonnard's somber portrait of her, *Misia Godebska* (fig. 2), painted one year before her divorce from Edwards. Ensconced in the luxury of her apartment on quai Voltaire (Bonnard's studio at this time was on the same street), she is set against a background reminiscent of *Landscape Animated with Bathers*. The classical figures of this background deco-

ration suggest the seventeenth- and eighteenth-century tapestries that Misia owned and that Bonnard's paintings were intended to complement.[17]

Finally, Bonnard may have inserted himself into this fantasy world. In the foreground of *Pleasure* is a curious masculine profile. While situated within the decorative border, the man seems to belong to the world of the viewer, observing the scene along with us. This figure may well depict the artist himself, as it is similar to the profile presumed to be a self-portrait in Bonnard's later decorative painting *Earthly Paradise* (cat. 52).

The dimensions for the four panels are similar but not identical, suggesting that they were measured to fit the unequal wall spaces of Misia's dining room. Jean Godebski, Misia's nephew (the second child of Cipa and Ida Godebski), remembered the walls of his aunt's apartment as being dark green, which the panels' deep brown-green-orange tonalities would have complemented.[18] Bonnard's unusually muted color harmonies

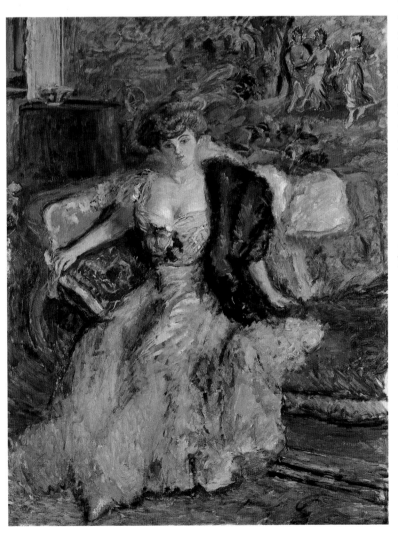

were noted by contemporary critics, who justified this anomaly in his oeuvre by referring to their final destination as part of Misia's interior décor:

The four panels for Madame Godebska reveal nothing however of his new concern for color. All of the ornamental motifs of these vast surfaces are supposed to play a discreet and decorative role upon the walls, like wall hangings and antique furniture. That's why Bonnard, instead of throwing himself into these immense fields with resounding tones, values, and clashing colors, instead of exalting the local tints, doesn't indicate these at all, except in the most minimal way.[19]

The official inauguration of the panels was a black-tie event, referred to by Vuillard as an "evening party for Bonnard's panels,"[20] held on Christmas day 1910. There, the ensemble would have been seen by Misia's circle of friends, which by that time included, in addition to many painters, the composers Maurice Ravel, Richard Strauss, and Igor Stravinsky; the ballet impresario Serge Diaghilev;[21] and writers such as André Gide and the young Jean Cocteau. Those seated at the dining-room table were surrounded by these fantastical landscapes, whose somber tones would have been made even more dramatic by candlelight. Marcel Proust, who uncharacteristically mustered up enough energy to visit the quai Voltaire apartment, remarked upon this sparkling, underwater realm, which was in part due to Bonnard's murals: "In the submarine salon of Mme Edwards / Sparkle the Bonnards, the ficusplants, and the quartz."[22]

The ensemble moved with Misia to 29, quai Voltaire in 1914; Gide recalled seeing the "charming decorations by Bonnard" installed in the grand salon of this residence when he went to dinner there in November 1915.[23] By 1916 or 1917, however, when Jean Hugo (great-grandson of writer Victor Hugo) visited Misia during one of his military leaves, they seem already to have been sold and dispersed.[24]

One can only imagine the effect these paintings had on the writers and musicians who frequented Misia's apartment. The panels were in many ways like Misia herself—passionate, voluptuous, and frenetic. Based on what Gustave Coquiot called "disciplined disorder" (*désordre discipliné*), they are radically different from anything Bonnard painted before or would execute after. Like Vuillard's 1898 decorative panel *Woman Seated in a Garden* (1890–99 Intro., fig. 15), which was, in many ways, an homage to Misia, these panels are highly personalized testaments of Bonnard's close friendship with this remarkable woman.

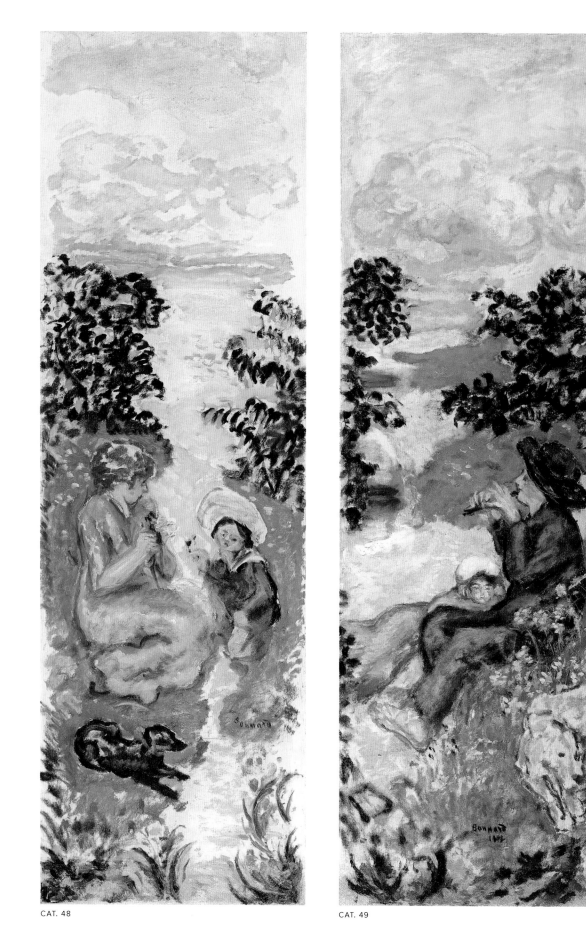

CAT. 48

CAT. 49

CAT. 48–49

PIERRE BONNARD

48 *In the Country I: Mother and Little Boy*
1907
Oil on canvas
100 x 32 cm (39 ⅜ x 12 ⅝ in.)
Joan and Nathan Lipson, Atlanta

49 *In the Country II: Father and Little Girl*
1907
Oil on canvas
100 x 32 cm (39 ⅜ x 12 ⅝ in.)
Joan and Nathan Lipson, Atlanta

FIG. 1
Pierre Bonnard. *The Hunt*, 1908.
Oil on canvas; 109 x 126 cm.
Göteborgs Konstmuseum,
Sweden.

THESE TWO NARROW PANELS, KNOWN COL-lectively as *In the Country*, are unique to Bonnard's decorative career in the twentieth century because of their small scale and their overt references to eighteenth-century pastorals. They were first owned by Henri Kapferer, an aerodynamics expert, inventor, and Shell executive, who may have commissioned them from the artist. Henri, along with his brother, Marcel, was an important collector of the works of Bonnard, Vuillard, Denis, and Roussel (see

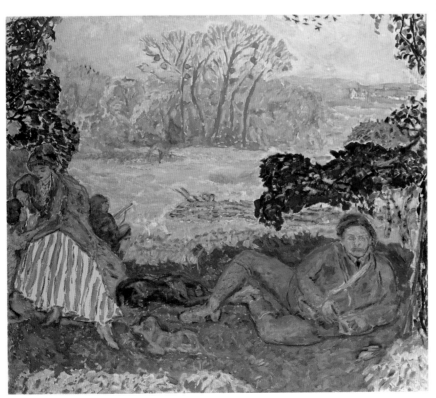

1900–30 Intro.). Painted in muted grays, greens, and yellows, these pendants are loosely, almost sketchily, executed. Their status as finished works, however, is confirmed by Bonnard's signature on both panels and the date of 1907 on *In the Country II*.

Like his equally muted *Screen with Rabbits* (cat. 44), these narrow, vertical panels, depicting a mother and son and a father and daughter relaxing in a bucolic landscape, signal Bonnard's fascination not only with Arcadian and pastoral subjects, but also his interest in borrowing and updating art-historical themes and styles.

The setting of *In the Country* recalls the delicate and lighthearted depictions of rural life popularized by François Boucher and Jean Honoré Fragonard in the first half of the eighteenth century. In another large work from this period, *The Hunt* (fig. 1), Bonnard applied a similar palette and handling of paint to a more narrative subject, resulting, as Nicholas Watkins pointed out, in a softened and atmospheric variation on the realist hunting scenes of Gustave Courbet.[1] Both *The Hunt* and these smaller pendants are difficult to classify, since they fall between various genres: fantasy, pastorals, costume pieces, and themes pertaining to the aristocratic ideals of wealthy landowners.

In many ways, the *In the Country* pendants and *The Hunt* are transitional works that fall outside Bonnard's more overtly mythological, Arcadian scenes inspired by Vernouillet (where he moved in spring 1907), such as *Faun*, or *Rape of the Nymph* (1907; private collection) or *The Beginning of Spring, Small Fauns* (c. 1909; The State Hermitage Museum, St. Petersburg).[2] Their suggestion of a pastoral past is tempered by Bonnard's inclusion of references to modern life, such as the contemporary dress of the figures. The domestication and modernization of Arcadian subject matter is especially apparent in *In the Country II*. Here, Bonnard transformed the traditional figure of the flute-playing Pan or shepherd—a subject that had appeared in his 1902 illustrations for *Daphnis et Chloé*, in a number of works by Roussel from this period, and in Henri Matisse's *Pastoral* (fig. 2)—into a country gentleman.[3] In this respect, the two panels reflect Bonnard's interest at this time in the interplay between opposites—between the themes of city and country, the contemporary and the timeless.[4] Bonnard must have regarded these transitional works as more than experiments, however, since he exhibited *The Hunt* in 1909 at the Bernheim-Jeune gallery.[5] A decade later he

returned to similar pastoral subjects—in *Pastoral Symphony* (cat. 53) and in a large horizontal, allegorical scene *Landscape at Le Cannet* (1900–30 Intro., fig. 17).

Not only the iconography, but also the format, of these pendants evokes the Rococo, especially decorative wood panels (*boiseries*) from that period, which were often narrow and vertical in format.[6] It may well have been the panels' lighthearted, airy, Rococo quality that Henri Kapferer admired. While it is not certain that they were actually commissioned by this avid collector, the fact that they were never exhibited and that Henri is the first documented owner suggest that they were intended for his rue de Clichy apartment, which, until he married in 1914, he shared with his brother.[7]

While it is not known how the panels were installed in Henri's and Marcel's rue de Clichy apartment, it is known that, after his marriage, Henri moved to 8, rue Pomereau, where they were installed on either side of a fireplace. In this location, they served as decorative complements to a larger painting by Bonnard, *Wise Children* (c. 1906; private collection, France), which hung over the mantel.[8]

As with so many of Bonnard's decorative paintings, such as his green, tapestrylike canvases from 1895/99 (cat. 7–9), there remain many unanswered questions concerning the origins, intended destination, and meaning of these unusual panels. While the artist revisited the idea of a modern allegory in his later paintings for the foyer of Josse and Gaston Bernheim's apartment (cat. 52–54), he seems never to have returned to this small, readily portable, and expressly decorative format nor to such an overtly eighteenth-century composition.[9]

FIG. 2
Henri Matisse. *Pastoral*, 1906. Oil on canvas; 45.7 x 55.2 cm. Musée d'Art Moderne de la Ville de Paris.

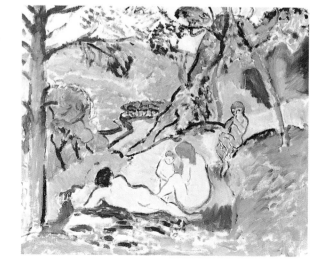

CAT. 50

PIERRE BONNARD

Mediterranean, 1911

Oil on canvas
Triptych: center and left panels, 407 x 152 cm (160 ¼ x 59 ⅞ in.); right panel, 407 x 149 cm (160 ¼ x 58 ⅝ in.)
The State Hermitage Museum, St. Petersburg

THIS TRIPTYCH WAS COMMISSIONED BY THE Russian collector Ivan A. Morozov in January 1910 for his Moscow residence. Over thirteen feet high, it represents the pinnacle of what Henri Focillon referred to as Bonnard's "luminous Mediterranean fables," a group of paintings the artist began in 1909 following his first extended encounter with the south of France.[1] In its sunny depiction of the idyllic and indolent rhythms of the south, this work seems to have functioned as a kind of counterpart to two other panels commissioned by Morozov around the same time, the densely peopled, horizontal street scenes *Morning in Paris* and *Evening in Paris* (1911; The State Hermitage Museum, St. Petersburg).[2] Whereas the latter evoke the energy and congestion of the French capital, the triptych depicts the lazy play of mothers and children on a terrace overlooking the Mediterranean. The dimensions of the triptych were clearly determined by its future destination in the Morozov mansion, where they were installed between pre-existing half columns on a wall at the top of a grand stairway (figs. 1–2).[3]

Bonnard's inspiration for the ensemble may have been a view from the painter Henri Manguin's garden overlooking the sea at his home in St.-Tropez. After his stay with Manguin in June 1909, Bonnard painted *View of St.-Tropez* (fig. 3), showing the same landscape found in the Morozov triptych. Against the lush and sunny backdrop of the Mediterranean, painted in what poet Guillaume Apollinaire called a "savory ragout of colors,"[4] Bonnard depicted a woman, most likely Marthe (based on her dress and pose, which resemble those of figures for which she was clearly the model in other works), at the left playing with a cat; another, more generalized woman holding a parrot at the right; and several scantly dressed children at the center and right, reminiscent of the nieces and nephews Bonnard had included in works more than a decade earlier.

180

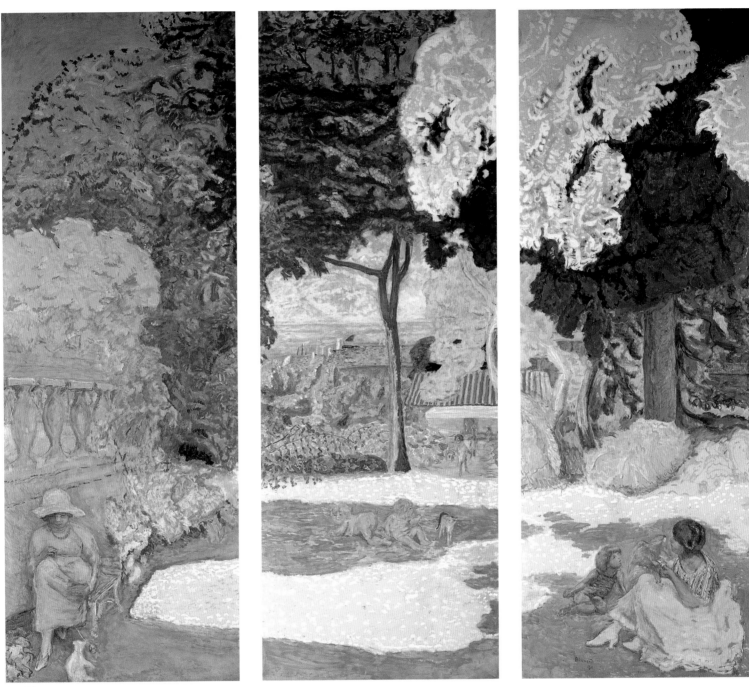

CAT. 50

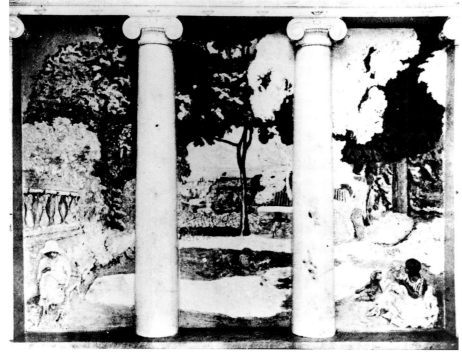

FIG. 1

FIG. 1
Photograph, late 1920s, of *Mediterranean* installed between terracotta half-columns in the Moscow residence of Ivan A. Morozov. Photo: Galerie Bernheim-Jeune, Paris.

FIG. 2
Photograph, late 1920s, of *Mediterranean* installed in Ivan A. Morozov's mansion, Moscow. The State Hermitage Museum Archives, St. Petersburg. Photo: Albert Kostenevich, *Bonnard and the Nabis* (Bournemouth, Eng./St. Petersburg, 1996), p. 50.

FIG. 2

The blond palette and sleepy mood of the triptych seem a far cry from Bonnard's initial impressions of the south, which he likened in a 1910 letter to his mother to a "spectacle from *A Thousand and One Nights.*"[5] Indeed, his perception of the south as exotic, even fantastic, is more appropriately linked to paintings such as his brilliant *Woman with a Parrot* (1910; Wildenstein Collection, Paris) and the exuberant decorative cycle for Misia Edwards he also completed in 1910 (see cat. 45–47).[6] In the same letter to his mother, however, Bonnard wrote that he was discovering the more mundane details of the south—the clay shingles, the olive and oak trees—all of which he would include in *Mediterranean.*[7] The striped pattern of clay roof tiles, for example, spreads across the center and right panels and is repeated in the clay-colored stripes of the blouse worn by the woman holding the parrot in the foreground of the right panel. Indeed, landscape motifs such as the oak trees that fill the top of the center panel and the vineyards visible in the distance seem to be as much the focus of the composition as the figures embedded within it.

Bonnard probably conceived the separate panels as one large canvas so that the perspective of the landscape and the scale of the figures would be proportionately correct. While Bonnard's first biographer, François Fosca, viewed this work as a failed decorative ensemble "without any composition whatsoever,"[8] Bonnard clearly attempted to unify the panels through the patterning of foliage and shadows and by balancing various elements within each of the three sections. For instance, as framing devices he used the inward-turning diagonal of the balustrade in the left panel and the woman seated in profile in the right panel, who is turned to face the center of the design. Camouflaged within the blue-yellow shadows, the children in the center, set against an expanse of land and sea, accentuate the openness and spaciousness of this southern idyll.

Bonnard took into consideration the pre-existing, one-foot-wide, terracotta half-columns that would separate the panels in creating this composition, so that the scene is clearly legible only when the panels are separated and not when they are placed edge to edge. It is probable that Bonnard, who by this time typically worked on an unstretched canvas tacked to a wall, began the composition as a huge landscape, which he then cut into three segments, leaving spaces for the columns. Perhaps his decision to move to a new studio at 21, quai Voltaire in 1910 and to a larger

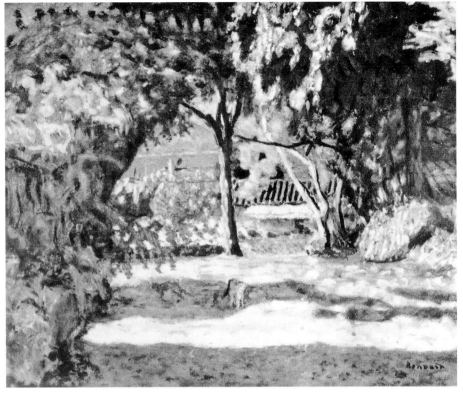

FIG. 3
Pierre Bonnard. *View of St.-
Tropez*, 1910. Oil on canvas;
53.5 x 63 cm. Collection
Hans R. Hahnloser, Berne.
Photo: Dauberville, vol. 2,
p. 154, no. 545.

aim here. While the triptych has a certain formality because of its grand scale, its composition and theme are intentionally informal. Bonnard knew from photographs that the panels were to be installed in a public, formal area of Morozov's home, but he nevertheless conceived this monumental decorative scheme as an intimate view of women and children "absorbed pantheistically into the atmosphere of the gardens."[13]

Mediterranean was completed in time for Bonnard's 1911 solo exhibition at the Bernheim-Jeune gallery, where Vuillard saw it and remarked admiringly in his journal on its "tender blues and novel freshness."[14] The triptych was then exhibited at the 1911 Salon d'Automne, where each segment was described as a "panel between columns," as if to indicate not only the panels' ultimate destination but also why they did not, in fact, precisely "fit" together.

The unstretched panels were then sent to Moscow, where they were simply glued (without stretcher bars) to the wall at the top of the grand staircase (fig. 2). The height at which they were installed, about three feet above the floor, would have put the bright patches of sunlight marking the lower third of the composition at eye level. Thus, these open spaces were what visitors would have seen immediately as they climbed the staircase and then, from what appears in the photograph to be a rather shallow distance, they would have been able to take in the entire panorama.

That Morozov was apparently pleased with the results is indicated by an undated letter from Bonnard in which the artist voiced his happiness that the triptych pleased the Russian and asked for a photograph of the work in situ.[15] The collector quickly commissioned two more panels based on the seasons, *Early Spring in the Country* and *Autumn, Fruit Harvest* (1912; The State Pushkin Museum, Moscow), to complement the summery *Mediterranean*.[16] Bonnard's considerable fee for these panels, however, initially caused Morozov to rethink the commission, and it was only after some delay that he agreed to let the artist proceed.[17]

In many ways, *Mediterranean* and the other paintings that Bonnard executed for Morozov between 1910 and 1912 are representative of the varied themes that preoccupied the artist at the time. Although they were made to fulfill Morozov's plans for his own interior, they reflect Bonnard's personal concerns and his preferred sites of memory and creation: city and country; north and south; Paris, Normandy, and the Mediterranean.

studio at 22, rue Tourlaque in 1911 was in part to accommodate such an enormous canvas.[9]

Bonnard used splotches of blue-orange and yellow to suggest the effects of sunlight and shade on the terrace grounds and to further unify the three panels. In this regard, the artist may have borrowed from Vuillard's *Public Gardens* panels (see cat. 32–33), in which variegated and irregular patches of blue, mauve, and yellow suggest pebble and dirt paths and create continuous patterns that unite the separate panels.[10] Although leading to similar results, the two artists' working methods were different. While, as we have seen, Bonnard probably worked from a large canvas that he cut down into three panels, Vuillard conceived the *Public Gardens* series from the start as nine separate panels, which could be grouped to form an uninterrupted panoramic triptych and three groups of pendants.[11]

In addition to criticizing Bonnard's composition, Fosca also attacked him for not taking into consideration the architectural setting of the panels' final destination and for failing to include a decorative border to enclose the long verticals of the columns, thus creating the effect of "fragments of canvas glued to a wall."[12] Fosca seems to have misunderstood Bonnard's radical

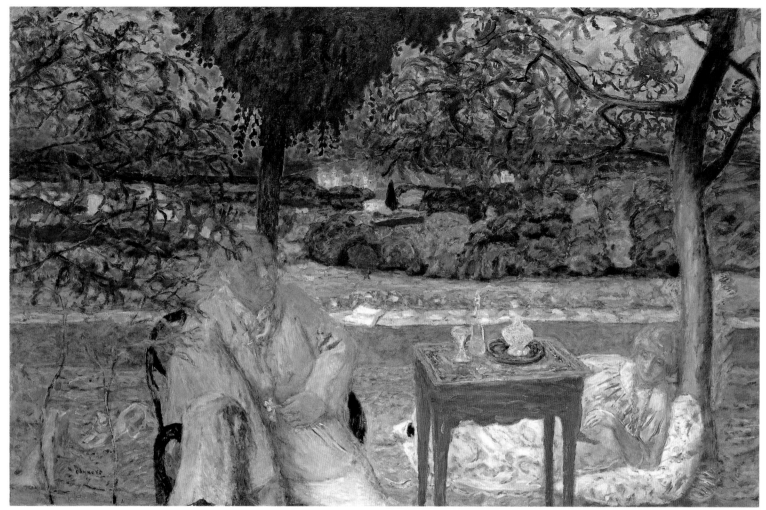

CAT. 51

CAT. 51

PIERRE BONNARD

Conversation in Provence, 1912/13;
reworked 1927

Oil on canvas
129.5 x 202 cm (51 x 79 ½ in.)
Národní Galerie, Prague

CONVERSATION IN PROVENCE HAS THE unique distinction of being the only work by Bonnard to have been included in the famous 1913 Armory Show in New York.[1] Organized by Walt Kuhn, Elmer MacRae, Walter Pach, and others, the Armory exhibition was modeled after prominent European exhibitions such as the Sonderbund exhibi-

tion in Cologne and the Post-Impressionist exhibitions conceived by Roger Fry in London in 1912. The organizers hoped both to create a market in the United States for contemporary American paintings and to introduce Americans to prevailing trends in modern European art. In comparison to the works by Braque, Duchamp, Matisse, Picasso, and even Cézanne that so shocked American audiences, *Conversation in Provence* must have looked relatively tame, as it was not commented upon by the highly critical press.

The painting, which belonged to the important publisher Eugène Fasquelle at the time of the Armory Show, was lent through the Bernheim-Jeune gallery and listed with a price of 2,700 francs. When it failed to sell, it was returned to the gallery and then presumably to Fasquelle, who eventually sold it back to the Bernheims in 1917.[2] Indeed, the painting was either a

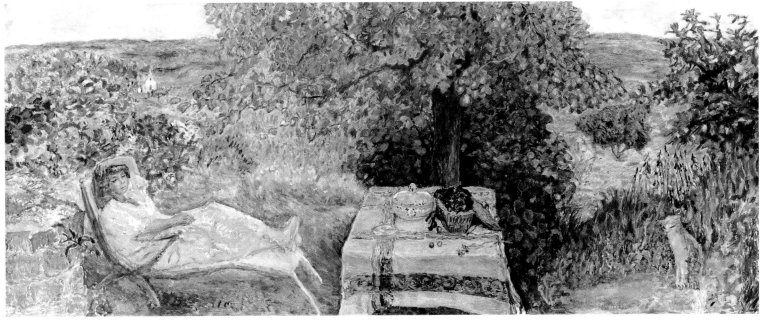

FIG. 1

FIG. 1
Pierre Bonnard. *Resting in the Garden*, c. 1914. Oil on canvas; 100.5 x 249 cm. Nasjonalgalleriet, Oslo.

FIG. 2
Henri Matisse. *Tea in the Garden*, or *Tea*, 1919. Oil on canvas; 140.2 x 211.3 cm. Los Angeles County Museum of Art.

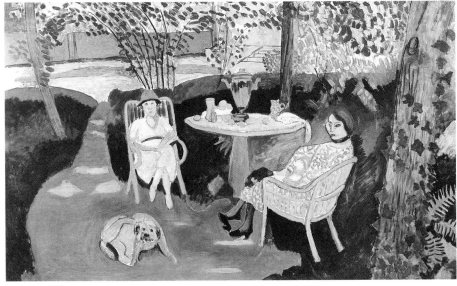

FIG. 2

favorite of the gallery or one of their problem pieces, since it returned several times to their ownership before its final acquisition in 1931 by the Národní Galerie, Prague.

In the past twenty years, *Conversation* has been redated by the Národní Galerie from 1911 to 1913/14, based on its stylistic affinities with several works, most particularly *Evening*, or *Resting in a Garden in the South of France* (Musée des Beaux-Arts, Bern), and *Resting in the Garden* (fig. 1), both of which Bonnard painted around 1914.[3] Its inclusion in the 1913 Armory Show,

however, means that it must have been painted in 1912/13 at the latest. Preceding these other works, *Conversation in Provence* served Bonnard as a model for placing reclining or seated figures in the foreground of a long, horizontal landscape consisting of parallel, layered bands of color, a compositional strategy he would employ for the decorative panel *Earthly Paradise* (cat. 52), commissioned by the Bernheim brothers in 1916.

The dating of *Conversation* is further complicated by the fact that the painting, dominated by rich blues and ochers, was apparently repainted by Bonnard in 1927, no doubt to freshen or modernize it for its upcoming sale at auction in 1928.[4] One wonders whether Bonnard decided to reinvigorate the palette of his canvas at this later date (as Roussel did for his *Triumph of Bacchus*, cat. 64) by adding or intensifying the blues. If so, this would explain the incongruity between its title, which suggests the sun-drenched south, and its cool, bluish palette, which Bonnard often used to suggest Normandy and the north. Indeed, *Conversation* seems far removed from the insistently blond palette Bonnard usually employed for his "southern paintings," such as *Mediterranean* (cat. 50). By 1930, when the Bernheims lent a photograph of the painting to André Fontainas for an article on the artist, it bore the more generic title *Au jardin*, perhaps in recognition of the dramatic color changes Bonnard may have made to the original, which made it a less convincing vision of the south.[5]

Compositionally, *Conversation* presents some affinities with *Mediterranean* in its adoption of a similar progression into depth: figures in the foreground, a bright horizontal patch in the middle ground, and houses and sea in the background. Both works are framed by tall trees, whose tops are cropped by the edges of the composition, and both show a woman playing with a cat (at left in the triptych and at right in *Conversation*). *Mediterranean* and *Conversation* were indeed both inspired by St.-Tropez, which Bonnard visited in 1909–10 and on numerous occasions before 1913. The seated man in *Conversation* has been identified as the Polish artist Józef Pankiewicz, whom Bonnard had met through André Gide in 1908 and whose home in the south, Villa Joséphine, he frequented between 1910 and 1920.[6] Wearing an artist's smock and blue trousers, the burly Pankiewicz is shown seated in a bentwood chair meditatively holding a wildflower. The female figure remains unidentified, but she may have been inspired by Marthe, or by the woman with similar striking, thick blonde hair with bangs who is depicted in *Resting in the Garden* (fig. 1). The setting for these figures is possibly Pankiewicz's garden.[7]

Conversation was chosen for the French section of the Twelfth International Exhibition of Art in Venice, held in spring 1920. Paul Signac, who organized the French section, seems to have shown a preference for up-to-date artists whose paintings evoked the Midi—the Mediterranean aspect of French culture—in keeping with a preference at the time for Latin and Mediterranean themes (see 1900–30 Intro.).[8] *Conversation* would have been seen there within the context of other landscapes and figural subjects, such as Matisse's *Tea in the Garden* (fig. 2). The two works share a similar terrace or garden theme and composition, but Matisse's strikingly linear, Cubist-influenced style is very different from the soft, iridescent, and vague forms of Bonnard's terrace view. Bonnard would briefly assimilate some of Matisse's love for blocks of color defined by line (see cat. 58), but here he was still wedded to an Impressionist sense of light and color.

The lush and enigmatic *Conversation in Provence* has its origins in Bonnard's rediscovery of the south around 1909 and looks forward to the more allegorical, "earthly paradise" of the painting he would do several years later for the foyer of the Bernheims' apartment (cat. 52).

PIERRE BONNARD

52 *Earthly Paradise*
1916/20
Oil on canvas
130 x 160 cm (51 ⅛ x 63 in.)
The Art Institute of Chicago, estate of Joanne Toor Cummings; Bette and Neison Harris and Searle Family Trust endowments; through prior gifts of Mrs. Henry C. Woods, 1996.47

53 *Pastoral Symphony*
1916/20
Oil on canvas
130 x 160 cm (51 ⅛ x 63 in.)
Private collection, courtesy Galerie Bernheim-Jeune, Paris
CHICAGO ONLY

54 *Workers on the Seine*
1916/20
Oil on canvas
130 x 160 cm (51 ⅛ x 63 in.)
The National Museum of Western Art, Tokyo, donated by the heirs of Mr. Tomijiro Kakinuma, P.1992–1

IN 1916, BONNARD WAS COMMISSIONED TO MAKE four decorative panels for the vestibule of Josse and Gaston Bernheim's home at 107, avenue Henri-Martin.[1] The paintings, well under way by mid-June 1917 when Vuillard admired them in Bonnard's Paris studio,[2] were not completed until 1920, after which they were exhibited at the Bernheim-Jeune gallery. Although they have been given various titles throughout the years, at this first exhibition Bonnard titled them *Countryside* (cat. 53), *Cityscape* (cat. 54), *Monuments* (fig. 1), and *Paradise* (cat. 52)—short, telegraphic titles that indicate the divergent themes of the panels, from ancient to modern, from rural to urban. With the exception of *Monuments*, the paintings have subsequently been known by more poetic (*Earthly Paradise* and *Pastoral Symphony*) or narrative (*Workers on the Seine*) titles.[3]

The visit Vuillard made to Bonnard's Paris studio at 56, rue Molitor on 12 June prompted him to describe his friend's "paintings from the Midi" as "golden age" panels, and to commend their "clarity and gaiety, always an element for my admiration."[4] Visiting again

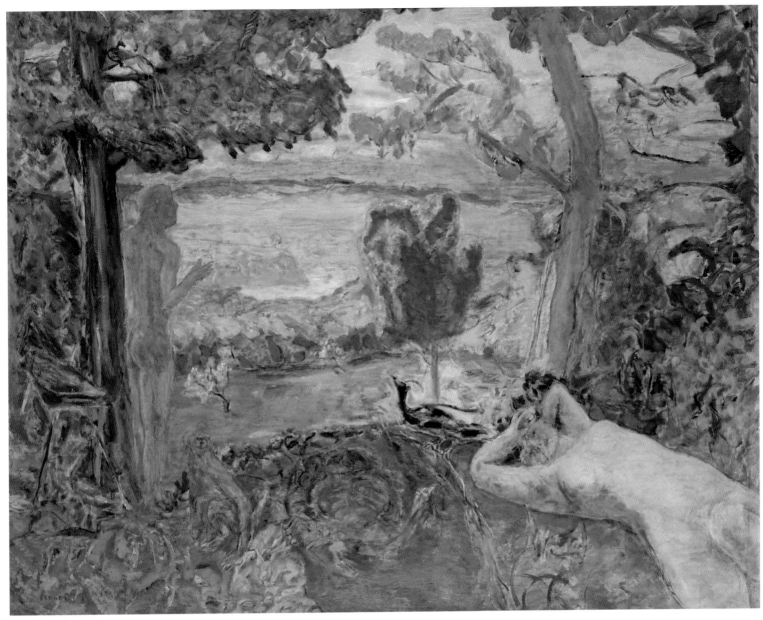

CAT. 52

in early September, Vuillard remarked on the "four panels, Golden Age, Paradise, etc. that charm me—unity, general harmony of tones."[5] Although Vuillard admired the "unity" of these works, the panels in fact represent antithetical themes—city and country, work and leisure, the man-made and the natural, north (with its more anecdotal nature) and south (with quotations from the antique), the contemporary and the timeless. Together they also reflect the artist's travels during this time to Cannes, St.-Tropez, and Le Cannet in the south; and to Paris, St.-Germain-en-Laye, and his home Ma Roulotte in Vernon in the north. In fact, of all Bonnard's decorative projects, these are the most

loosely connected, unified only by their identical scale and by compositions structured around foreground figures set against an infinite vista. The effect is stage-like, with a proscenium arch formed by tall trees on both sides of the composition in *Pastoral Symphony* and *Earthly Paradise*, by billowing smoke in *Workers on the Seine*, and by a stone archway in *Monuments*.

Unlike the set of four panels that Bonnard completed for Misia Edwards in 1910 (see cat. 45–47), which, while thematically diverse, are linked formally by palette and composition, the panels for the Bernheims stand alone as four distinct inventions. It is likely that, just as Vuillard and Roussel were allowed

187

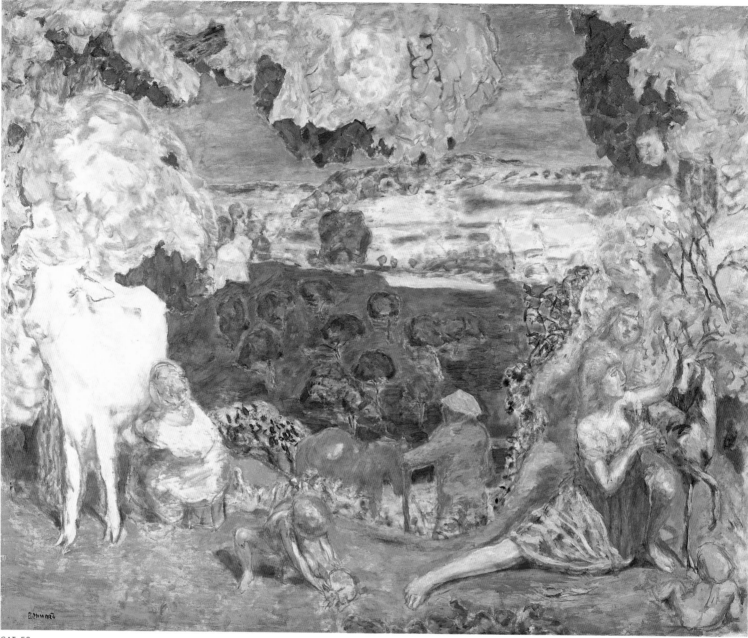

CAT. 53

free rein when they were commissioned to make dec-
orations for the Bernheims' city and country homes
(see cat. 82 and 65–66, fig. 1, respectively), Bonnard
was given carte blanche in terms of choosing the sub-
ject for his decorative series.[6] The fact that the project
extended over four years, however, may indicate his
changing ideas on these themes. In some ways, the
panels are a summation of subjects that he had devel-
oped in previous years, now fitted together as a sweep-
ing statement, perhaps his reflection on civilization in
the face of World War I: *Pastoral Symphony*—Arcadian

and pre-civilized innocence; *Earthly Paradise*—loss of
innocence; *Monuments*—classical, refined civilization;
and *Workers on the Seine*—the modern world and the
degradation of the individual.

Pastoral Symphony (cat. 53) offers a view of a
bucolic countryside filled with lush vegetation that
evokes Arcadian themes. The idyllic scene depicts chil-
dren playing, a woman milking a cow, and a farmer
leading his horse down the valley. Nymphs and a stag
in the right foreground introduce a mythological ele-
ment (perhaps an allusion to Diana the Huntress) into

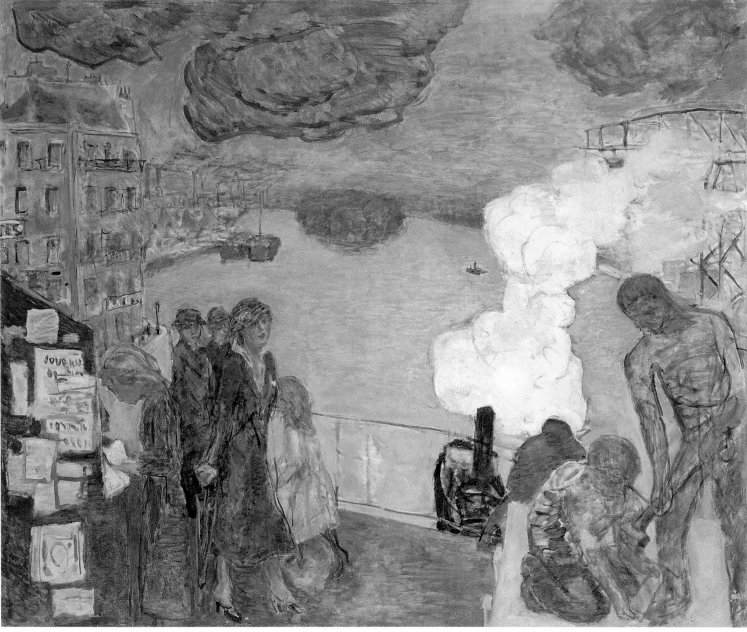

CAT. 54

an otherwise mundane scene. The children who play in the red clay at the center and right are also ambiguous; they may be understood as farmers' offspring, or as otherworldly cherub*s*, or *putti*. *Pastoral Symphony*, despite these ambiguous elements, is set in a contemporary landscape, the rich, verdant mountains, plains, and forests of the Dauphiné region around Bonnard's family home at Le Grand-Lemps, which the artist often associated with cows and children at play.[7]

While *Pastoral Symphony* suggests a kind of rural innocence, the panel to which it is most closely linked by color and figural types, *Earthly Paradise* (cat. 52), seems to depict the loss of innocence, the aftermath of Adam and Eve's fall from grace. This panel is the most stylistically Impressionistic of the four, suggesting a long-lost, Edenic land where monkeys, birds of paradise, rabbits, turkeys, and a great blue heron (at the far left, foreshortened in such a way that it resembles an artist's folding table) coexist peacefully. The evil serpent that tempted Adam and Eve in the biblical garden is also present, but reduced to a harmless garden variety, entwined around the branch of a bush above

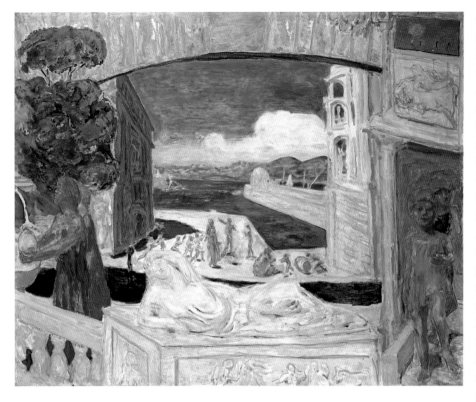

FIG. 1
Pierre Bonnard. *Monuments (Mediterranean)*, 1916/20. Oil on canvas; 130 x 160 cm. Private collection. Photo: Courtesy of Galerie Bernheim-Jeune, Paris.

Eve's hip. Of the four paintings, this image seems the most autobiographical. Like the lecherous faun in a painting of 1899 (1890–99 Intro., fig. 3) who seems to share certain physiognomic traits with the artist, the man leaning against a tree at the left may well serve as a stand-in for Bonnard. The detachment and physical estrangement between the male and female in *Earthly Paradise* is seen in a more obvious self-portrait by Bonnard, *Man and Woman* (1900; Musée d'Orsay, Paris).[8] While in *Earthly Paradise* the male figure aligns himself with the erect tree in the middle ground and contemplates the distant horizon, Bonnard's Renoir-esque Eve, painted with iridescent blues and mauves, dominates the foreground.[9] It is possible that this woman is Renée Monchaty, the tall, big-boned, aspiring artist with whom Bonnard was romantically involved from about 1920 to 1923, when his loyalties to his longtime mistress, Marthe de Méligny, forced him to end the affair.[10] If the female figure is indeed a depiction of Renée, the analogies between her pose and Bonnard's representation of Marthe, lying in bed in a similar pose of post-coital abandon, *Indolence* (1899; Musée d'Orsay, Paris),[11] make this interpretation of the Creation story all the more complex, fascinating, and, thematically at least, anti-decorative.

Monuments (fig. 1) most accurately fits Vuillard's description of these panels as representing a golden age. It is also, in many ways, the panel most removed geographically, temporally, and thematically from Bonnard's own experience. Set in antiquity, it recalls one of his earlier decorative panels for Misia Edwards, *Pleasure* (cat. 47), with its blending of classical and modern elements into a fantastical environment. In the decorative panels for the Bernheims, however, the effect is more static and controlled. The blond light of the Mediterranean is juxtaposed with the brilliant blues of sea and sky, creating a dreamlike atmosphere that is accentuated by the statue of a reclining female (no doubt inspired by a second-century B.C. *Sleeping Ariadne* in the Musée du Louvre) atop an ancient sarcophagus.[12] To the left of the statue, two women gather water from a fountain, and at the right two children, reminiscent of Quattrocento *putti*, descend a darkened stairway. The arch patterned to suggest Roman stonework and the ancient bas-relief on the right frame the distant scene of a Mediterranean port bordered by palaces and featuring a jetty that juts dramatically into the sea. Adolescents from another age play in this sun-bleached place, their movement and vivacity contrasting the immovable, sculpturesque figures in the foreground. The whole is permeated with a strange quality in many ways analogous to that of works exhibited in Paris between 1912 and 1914 by the Italian artist Giorgio de Chirico, such as *The Silent Statue* (1913; Kunstsammlung Nordrhein-Westfalen, Düsseldorf), and *The Soothsayer's Recompense* (1913; Philadelphia Museum of Art).[13]

In contrast to the timeless quality of the three other panels in the series, *Workers on the Seine* (cat. 54) presents a picture of modern-day life in all its grittiness. Set in the working-class Parisian suburb of Asnières, this is the most anti-decorative of the panels, as it functions as a commentary on the modern condition and man's need to work to survive. Here Bonnard translated the energy of the "modern city" (one of its subsequent titles) into a chaotic scene in keeping with the multiple activities represented. Only the woman at the newsstand at the left stands still in contemplation. The remaining protagonists, women who enter from the left in suits and hats, a little girl who passes in the other direction, and two workers who toil with sledgehammers at the right, are caught in motion.

The obvious contrast between men and women, workers and non-workers (or perhaps "blue-collar" and "white-collar" workers), is not confrontational but presented on different planes, both metaphorical and physical. Using what seems to be a bird's-eye view, Bonnard

workers replacing sidewalks around Place Vintimille (cat. 83), Bonnard was struck by the nature of wartime labor, much of which was carried out by those too old or otherwise ineligible to enlist. As mentioned (see 1900–30 Intro.), Bonnard and Vuillard visited the battlefields of the Somme region and both of them executed large paintings of the munitions factory run by Thadée Natanson in Oulins, near Lyons (see 1900–30 Intro., fig. 9). It may well have been Bonnard's fascination with and revulsion for the kind of heavy, demanding labor he saw there that inspired *Workers on the Seine.*

It has been suggested that in *Workers on the Seine* Bonnard transformed Georges Seurat's famous representation of bourgeois leisure, *A Sunday on La Grande Jatte—1884* (fig. 2), set on the island visible in the distance in Bonnard's canvas, into a parody of or perhaps a damning statement on urban life.[16] In his work Bonnard depicted the modern city as a world of dull, gray skies in which threatening, black clouds clash with the billowing smoke from tugboats and factories.

Of the four panels, *Workers on the Seine* has clearly the least resonance with the theme of the "golden age" that Vuillard commented upon and that was increasingly in vogue during the war years (see 1900–30 Intro.). Whereas the other three panels represent themes removed from the war, characterized by innocence, clarity, and beauty, *Workers on the Seine* is a straightforward view of modern realities. Although Vuillard's journal comments in 1917 mention *four* decorative panels, one wonders whether *Workers on the Seine* was actually among these or if it was a later addition. It is also possible that Bonnard reworked the canvas after Vuillard saw it, creating the ambivalent scene we have today. Vuillard's interest in these panels underscores his deep admiration for Bonnard's art, which had evolved so differently from his own. In his paintings for the Bernheims' country home, Bois-Lurette (see cat. 82), Vuillard mirrored the *douceur de vivre* of the high society in which the Bernheims lived. Bonnard, however, chose subjects with broader historical and philosophical resonance.

actually assumed a position that encompasses multiple vantage points in a way that is typical of his work at this time. At first glance, all of the figures appear to be situated on the same picture plane, but upon more careful observation it is apparent that the workers on the right are on a raised platform above the passers-by. They are thus both spatially removed from and less clearly defined than the female figures to the left.[14] While Bonnard made an effort to describe the features of the women, the male workers appear to be anonymous.

This is a departure from Bonnard's exclusive focus on elegant women crossing well-known Paris bridges in works he did over a decade earlier.[15] In this portrayal of city life, he included male workers who are muscular symbols not of health and progress, but rather of back-breaking work and resignation. During the war years, Bonnard, after having served briefly as a war artist, spent much of his time in and around Paris. Although he did not live in working-class Asnières, his travels to St.-Germain-en-Laye or to his home in Normandy would have taken him past this suburb. Perhaps, like Vuillard, who painted the construction

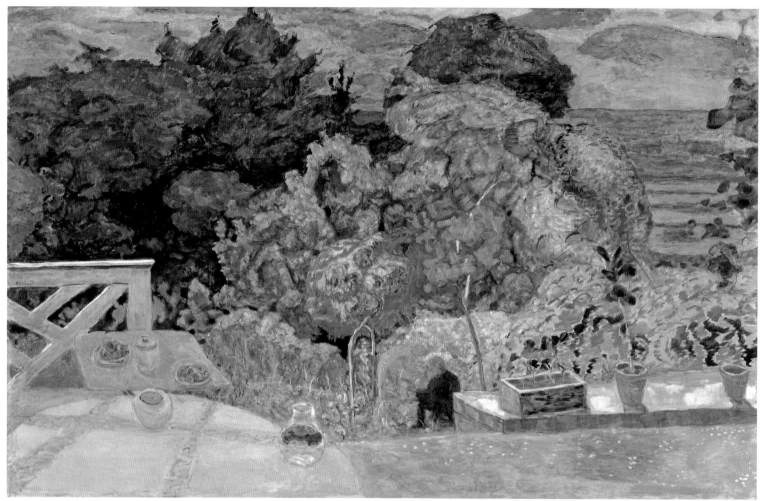

CAT. 55

CAT. 55

PIERRE BONNARD

The Terrace, 1918
Oil on canvas
159 x 249 cm (62 ¾ x 98 ¼ in.)
The Phillips Collection, Washington, D.C.

THIS IS THE FIRST OF THREE LARGE, DECO-
rative canvases (see cat. 57–58) featured here
that depict the view from the terrace of
Bonnard's small house, known as Ma Roulotte, in
Normandy, in the town of Vernon. After purchasing
the brick, two-story home in 1912, Bonnard kept the
traditional nickname of the building, meaning "cara-
van," since it seemed to fit his own very nomadic life,
which ranged between Normandy, the south of
France, and the capital. As was often the case with

Bonnard's country homes, Ma Roulotte had a bal-
cony, which ran along the upper story of the house's
façade (see fig. 1).[1] This balcony led to a large terrace
adjacent to the house, which, as Nicholas Watkins put
it, provided Bonnard with a stagelike observation
deck, "a platform overlooking a subject that he found
endlessly fascinating: the Seine and the immense, usu-
ally cloud-filled sky."[2] Although stairs led from the
lush land surrounding the house up to the terrace,
they are not pictured in this painting. Rather, they are
merely suggested by the space between the edge of
the wooden balcony railing at left and the brick wall
at right, so that the foreground seems to plummet into
the middle ground of the garden without visible tran-
sition. In this narrow, middle register, two figures,
probably Marthe de Méligny and the artist himself,
work in the garden. Rising behind them is dense
greenery and, at the far right, the more distant horizon
of the Seine valley.

FIG. 1

FIG. 1
Photograph, 1910/15, of Marthe
de Méligny with her dog, Black,
at Ma Roulotte. Musée d'Orsay,
Paris.

FIG. 2
Pierre Bonnard. *Marthe and
Her Dog*, 1918. Oil on canvas;
117.5 x 70 cm. Galerie Jan
Krugier, Ditesheim & Cie,
Geneva.

FIG. 2

Bonnard painted *The Terrace* in the summer of 1918, probably after a trip during July and August to the health spa Uriage-sur-bains near Grenoble, where, as he wrote to Vuillard, he was studying and thinking intensely about foliage, and hoping that Vuillard was also was enjoying the seasonal greenery of his own summer residence.[3] The results of Vuillard's summer were incorporated into a large decorative painting that he referred to as *Foliage* (cat. 84). Bonnard too painted several vertical decorative paintings inspired by summer scenery (see fig. 2) and commissioned by the textile industrialist Richard Bühler for the paneled dining room of his home in Winterthur, Switzerland. In these, the figures occupy only a small corner of the composition, which is otherwise taken up by large, leafy trees and surrounding vegetation.[4]

Lush foliage can also be considered the primary subject of *The Terrace*, which was exhibited at the 1919 Salon d'Automne as *The Wild Garden*.[5] In this panoramic view from Bonnard's Normandy home, the cloudlike foliage of tall trees painted in majestic greens and blues is contrasted with the highly civilized scene in the foreground: a round table covered by a pink-and-white tablecloth, bowls of fresh fruit and sugar on a rectangular tray-table nearby, and cultivated plants in pots lined up along the top of the terrace wall. The orthogonals of the railing's wooden slats mirror similarly oriented stripes of the tablecloth. As in so many of Bonnard's after-lunch scenes, the table serves as a focal point; one can follow either the cloth's horizontal pink stripe along the sunny terrace to the potted plants or the more vertical stripes up into the lush, untamed foliage and then down to the man and woman in the middle distance.[6] The couple is linked spatially and psychologically, as the two figures appear to be both engaged in a shared activity, the female perhaps bending to pick some flowers from the cultivated garden, the male seated close by, assisting her. The play between natural and artificial in the painting is further intimated by what may be an ornamental trellis in the exact center of the canvas made of twisted branches and enclosing a plant or tall flower accented with bright touches of yellow. This suggestion of nature bent and shaped by humans links the civilized scene in the foreground with the untamed landscape beyond. This distinction between cultivated and uncultivated land may be more of an invention of Bonnard's than a faithful representation of the view from his terrace. Unlike his friend Claude Monet, who lived nearby in Giverny and lovingly tended and

painted the ponds, trellis-lined *allées*, and floral islands of his earthly paradise, Bonnard was no great gardener. He preferred to order nature through his art rather than through any physical intervention, perhaps because his peripatetic life kept him from settling down permanently and making the land his own.

Bonnard's composition leads us around the rambling landscape, as if we are actually wandering through planted and uncultivated lands, and eventually to amorphous cloud formations of blue, orange, and yellow, tinted by the early evening light. As Watkins pointed out, Bonnard may have chosen this time of day for its stillness, in order to "communicate the quiet pastoral feeling of being at one with nature. The light is fading fast, and the warm colors are caught in a residual glow uniting foreground and background in receding bands of warm and cool tones."[7]

As a counterpoint to this richness, Bonnard added the solid blue-black form of the man's coat, which arrests the eye and helps to anchor the sweeping composition to the middle plane. Marthe's bending gesture is echoed by the L-shaped form of Bonnard, who seems to be in perfect harmony with his companion and with the task in which they are engaged together. The pervasive feeling of tranquility is not unlike that of Vuillard's *Foliage* (cat. 84). Neither canvas merely captures a moment in time, but rather provides a sense of reassuring permanence. In *The Terrace* this permanence seems internalized and is underlined by the "civilized" realm of fresh food, a carafe, and neatly arranged plants, flanked by the rich forests and plains.

Like Vuillard, who repeatedly painted Place Vintimille from his window in Paris, finding new compositions and capturing different evocations of the same place (see cat. 75–80, 83), Bonnard continually rediscovered a wealth of artistic possibilities from the vantage point of his terrace. In this painting and in subsequent scenes inspired by his Normandy home (cat. 57–58), Bonnard complicated his earlier compositions on similar themes of summer leisure and comfort, such as *Conversation in Provence* (cat. 51) and *Resting in the Garden* (cat. 51, fig. 1), in which figures sit or recline in the foreground of clearly readable landscapes. In the panoramas from his terrace, Bonnard introduced a marked contrast between foreground and background, resulting in space that is both open and compressed, restrained (as in the civilized vignette of the table on the terrace) and expansive.[8]

PIERRE BONNARD

The Abduction of Europa, 1919

Oil on canvas
117.5 x 153 cm (46 ¼ x 60 ¼ in.)
The Toledo Museum of Art, purchased with funds from the Libbey Endowment, gift of Edward Drummond Libbey, 1930

THIS PAINTING IS ONE OF THE LAST OF Bonnard's works on Arcadian themes, paintings in which he combined reality, in the form of an authentic "observed" landscape, with mythical, dreamlike subjects. Other canvases in this genre include three of the four panels for the Bernheims' decorative ensemble from around the same time (see cat. 52–54). After 1920, Bonnard's subjects were more rooted in his daily reality: monumental nudes in baths, landscapes with shifting perspectives and dazzling colors, and the poignant series of self-portraits that mark the end of his life.

In this five-foot-long canvas, Bonnard pictured the myth of Europa, daughter of the king of Phoenicia, whose beauty so enchanted Zeus that he decided to abduct her, disguising himself as a bull so as not to attract the attention of his wife, Hera, and make her jealous. Zeus carried Europa on his back across the sea to Crete, where she bore him several sons.

Probably painted during Bonnard's stay on the Mediterranean coast in the winter of 1918–19, this work can be seen as a variant on his painting *Monuments* (cat. 52–54, fig. 1), which also features in the foreground figures set against a deep expanse of sea. Here he presented the coastal area between Cannes and St.-Tropez known as the Estérel, which he had painted earlier in smaller formats (see fig. 1). Bonnard's contemplation of the white rocks of the Mediterranean coast may have led him to interpret them in terms of the Europa myth, for the solid, boulderlike bull of his painting resembles the form of the large rock jutting from the sea in the middle ground.[1] Indeed, if one is not looking for the narrative, the figure of Europa may be read as sitting on a large white boulder rather than a roaring bull, which thrusts his head back to form a living saddle for his prize.

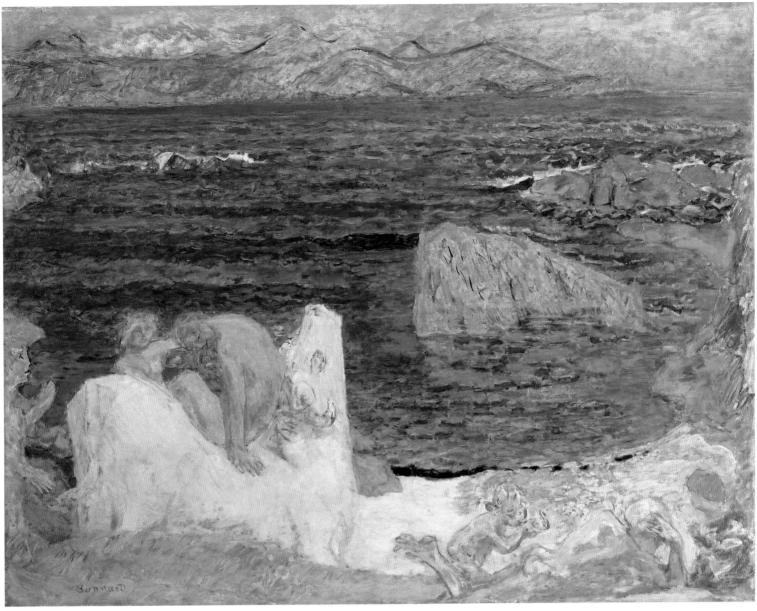

CAT. 56

Other figures in this unusual painting are not tradi-
tional participants in the myth and are perhaps better
understood as part of a personal imagery with special
significance for Bonnard. A man reclines in the right
foreground, almost completely camouflaged against the
sandy beach. The figure may be a kind of self-portrait
of the artist, much like the standing nude male in
Earthly Paradise (cat. 52) or the lounging and fully
dressed figure in the later *Landscape at Le Cannet*
(1900–30 Intro., fig. 17). Reclining, with his head rest-
ing on his hand, he seems to listen to a flute-playing
faun and is tended to by a vaguely defined figure at the

far right wearing a green cap. It is possible to read this
vignette, inserted into a mythological scene of tempta-
tion and lust, as a commentary on Bonnard's personal
relationships at the time. Caught between the faun, a
symbol of lust and a kind of alter-ego for Bonnard (see
1890–99 Intro., fig. 3), and the figure with the green
cap, perhaps his longtime mistress, Marthe de Méligny,[2]
the reclining figure may feel the desires that fueled
Zeus's aggressive action with Europa. At this time
Bonnard was torn between his loyalty to Marthe and
his desire for the much younger Renée Monchaty,
with whom he would become involved in 1920.

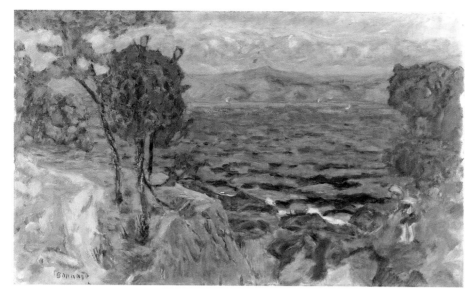

PIERRE BONNARD

The Terrace at Vernon, or *Décor at Vernon*
1920/39

Oil on canvas
148 x 194.9 cm (58 ¼ x 76 ¾ in.)
The Metropolitan Museum of Art, New York, gift of
Mrs. Frank Jay Gould, 1968

THE TERRACE AT VERNON, SOMETIMES CALLED *Décor at Vernon*, is one of three large-scale paintings Bonnard executed showing the terrace and garden vista at his Normandy home, Ma Roulotte (cat. 55, 58).[1] Bonnard is thought to have begun this composition in 1920, but seems not to have resolved it until many years later, finishing it only in 1939.[2] Even then the painting must have held a particular fascination for the artist, as it remained in his studio until his death in 1947.

The most interesting question raised by the unusual dating of this work regards the extent to which Bonnard may have reworked the painting over the years. The canvas's loosely painted areas of foliage and soft, buttery brushwork are closer to those of *The Terrace* (cat. 55) of 1918 than to the more tightly painted and linear *The Terrace at Vernon* (cat. 58) of 1928. *The Terrace at Vernon* (cat. 57) also resembles the decorations Bonnard executed for the Bernheim family in 1916/20 (see cat. 52–54), in its mixture of contemporary life with quotations from the antique and in its combination of a northern landscape and a southern palette. The work's intense, hot oranges and mauves are the colors of the Midi and of his home there, Le Bosquet, in Le Cannet, where the artist established himself more or less permanently in 1926. But the view depicted here is actually that from the terrace of Ma Roulotte, his residence in Normandy.

Although it shows the same vista out onto the garden as do the other two terrace paintings, the Metropolitan Museum's *Terrace at Vernon* is more figurative. The large-scale, almost monumental figures introduce a sense of uneasiness to an otherwise bucolic scene, as they suggest an enigmatic and perhaps unresolved narrative. The image shares many elements with Impressionist outdoor dining scenes, such as *The Luncheon* (c. 1873; Musée d'Orsay, Paris) by Bonnard's

FIG. 1
Pierre Bonnard. *Landscape of the Midi*, or *Pine Trees and Blue Sea*, or *L'Estérel*, 1914. Oil on canvas; 85 x 66 cm. Ny Carlsberg Glyptotek, Copenhagen.

What at first appears to be a straightforward illustration of the myth indeed presents numerous ambiguities. Did the artist represent here a moment of playful flirtation or one of resignation,[3] in which Europa sadly contemplates her fate with the triumphant bull?[4] The choice of narrative may also be an indirect reference to the ravages of World War I, which Bonnard had witnessed with Vuillard in the Somme valley. The figure of Europa could embody a kind of Marianne (symbol of the French Republic), tormented and raped by the German "bull."[5] The figure at the extreme left who voices alarm, for example, is strikingly similar in profile to one of the sketchy figures in Bonnard's painting known erroneously as *The Armistice* (1916; private collection), a work dating to the height of the war's devastation.[6]

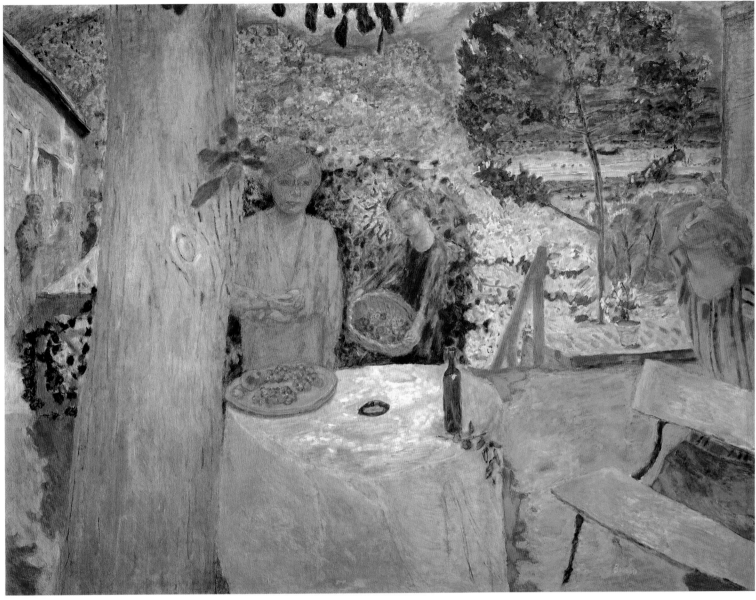

CAT. 57

neighbor Claude Monet, who lived across the river at Giverny. Bonnard's version of this traditional subject, altered through color and gesture, offers a Symbolist twist on the theme.

Instead of Monet's unified expression of a specific moment in time—the aftermath of a bourgeois luncheon in a garden—Bonnard presented fragments of the same moment, or rather three events happening simultaneously (figures conversing casually, a woman and a young helper near the table, and a woman rushing in from the right). The space itself is structured like a stage, with the purplish tree trunk at the left dividing the two women in the central foreground from the incidental

"offstage" interaction of conversing figures at the far left, and a garden bench creating a separate zone for the female at the right. A woman in a yellow-orange dress at the center, traditionally identified as Marthe, is illuminated by the waning evening light. This light, which seems to emanate from the glowing foliage over her head (similar to the lamplights over tables in Bonnard's early interiors), also defines the younger girl in blue carrying a basket of plums. A statuesque, columnar figure holding a golden apple, Marthe is presented as a kind of Pomona, the Roman goddess of fruit. The young servant behind her thus becomes the goddess's handmaiden, offering her more gifts from nature.

FIG. 1

FIG. 2

are also stylistically close to Pablo Picasso's antique-inspired subjects, which he began around 1920.[4]

The pairing of Marthe with a servant girl holding a basket appears in two preparatory sketches for an earlier work, *Bowl of Milk*,[5] although the final painting of the subject (fig. 1) includes only one figure. In both the final version of *Bowl of Milk* and the large terrace scene, Marthe's figure appears to echo in pose and dress a type of pre-classical Greek female statue (*kore*), wearing a Dorian peplos, that he could have seen in the Musée du Louvre.[6] The stance of the two women is strikingly similar: each is rigidly frontal, with one arm held stiffly against her columnar body while the other holds an object, a bowl of milk or a piece of fruit.

Bonnard's treatment of Marthe in relation to the racquet-wielding woman is all the more interesting in light of facts that have recently become known about Bonnard's psychologically complex life. Painted in part during his tragic love affair with Renée Monchaty—she committed suicide in 1925, two years after Bonnard had broken off their relationship and less than a month after he married Marthe—this work can be viewed as a multilayered and complex commentary on the artist's involvement with the two women.[7] The golden-haired tennis player (a figural type unique to his oeuvre) bears a resemblance to the only image that the artist clearly identified as Renée, in *Young Women in the Garden* (fig. 2), where she is golden, radiant, and fresh-cheeked. Marthe is also depicted in this work, but only as a dark-haired profile lurking in the right foreground. In *The Terrace at Vernon* (cat. 57), Bonnard created another scenario, one that he may have worked on throughout his relationship with Renée and finished years later, showing Renée as Marthe's aggressor. The latter stands indifferently, holding out the golden apple (or perhaps a tennis ball), seemingly unaware of or ignoring the attack. Indeed, Marthe's dulled, unthreatened, and unfathomable expression may well be the key to understanding this very ambivalent painting: she is the cold and distant mistress of the house, while Renée is the passionate intruder.[8]

As already noted, the landscape, aflame with color, that surrounds these enigmatic figures, has more in common with the southern light and hills of Le Cannet than with the valleys around Vernon.[9] It is conceivable that Bonnard simply rolled up and carried this canvas with him, working on it over a period of years and incorporating in it qualities stemming from the various places he traveled to throughout France.

The statuesque female, bathed in golden light, who enters from the right with her arm raised was possibly inspired by the depiction of Orestes attacking his foes on an ancient Roman bas-relief known as *Iphigenia in Tauris*, which Bonnard may have seen at the Musée du Louvre.[3] Bonnard's figure, however, wields what is thought to be a tennis racquet in place of a sword. Her expression, gesture, and exaggerated sculptural form

Since the extent of Bonnard's reworkings cannot be determined (he was known for subtracting from, rather than adding to, works-in-progress),[10] one can only speculate about the evolution of this strange and beautiful work, which is so different, in both mood and meaning, from his other two works on this subject (cat. 55, 58). While the painting may have initially evolved according to purely painterly and aesthetic concerns, it is likely that over the years Bonnard used it as a way to express his own very personal and changing preoccupations.

CAT. 58

PIERRE BONNARD

The Terrace at Vernon, 1928
Oil on canvas
242.5 x 309 cm (95 ½ x 121 ⅝ in.)
Kunstsammlung Nordrhein-Westfalen, Düsseldorf

BY 1925, BONNARD HAD PURCHASED A HOME called Le Bosquet in Le Cannet, overlooking the Mediterranean, but he still kept his apartment and studio in Paris and his home, Ma Roulotte, in Normandy. This painting is the last and largest of three large-scale decorative panoramas inspired by the terrace at Ma Roulotte featured here (see cat. 55, 57). It is also the most insistently "northern" in feeling. Unlike the version of this theme dating to 1920/39 (cat. 57), in which he combined salient elements of his Normandy house with a bright, southern light and monumental, seemingly antique, figures, *The Terrace at Vernon* most purely embodies the spirit of Normandy and most faithfully reflects an actual setting. In two of his previous canvases, the Seine, which flowed behind Bonnard's residence, either is omitted completely (cat. 55) or appears as a small sliver of mauve (cat. 57). The season depicted is not full summer (as in the other two) but spring, so that the trees are not yet completely filled out with foliage hiding the river's presence. Thus in *The Terrace at Vernon* the Seine sparkles in the sunlight, becoming a dominant band of color dividing the canvas into thirds.

Compositionally, the work is close to *The Terrace* (cat. 55), in which the terrace is but a narrow band overlooking an expansive countryside. This painting, some ten years earlier, is insistently horizontal, with bands of landscape stretching across the canvas, layered to indicate the rolling terrain from the terrace. In the later painting, Bonnard added strong vertical elements, so that the whole is organized around right angles formed by the horizontal railing of the terrace and ocher banks of the Seine, as they intersect with the tree trunks and foliage in the center and the house and tree that frame the composition on either side.

The two women in *The Terrace at Vernon*, who are separated by the dense block of foliage at the center, are also differentiated stylistically and thematically. The woman at the right (probably Marthe, who is often shown wearing such a straw hat in photographs; see cat. 55, fig. 1) ascends the steps wearing a blue-green and red-dotted dress, which camouflages her form within the dark green and blue foliage. Her hat has a blue-yellow tint, which is echoed in the patch of light on yellow-blue leaves directly to the left, thus relating her to the natural environment around her. In contrast to her is the blonde woman on the far left, her back to the viewer, who wears an orange top with white edging, which repeats the color of the home's brick walls, accented by white wood trim. Standing rigidly, she seems in complete harmony with the architectonic elements on the left side of the canvas. She is aligned with architecture and the man-made instead of uncontrolled nature.[1] In a recent analysis of this work, Joachim Kaak suggested that with this painting Bonnard summed up two different attitudes toward art and nature, distinguishing between those who look at nature analytically and seek spatial illusion (left side), and those who look solely from an aesthetic viewpoint and seek unity (right side).[2]

By the time Bonnard was working on this painting, he had resolved his earlier struggle to reevaluate his art in light of the need for stronger drawing, or linear elements. *The Terrace at Vernon* grew out of many pencil drawings, particularly one of the trees, foliage, and dynamic geometric shapes of this terrace view (fig. 1). This notebook sketch already contains all the lights, darks, and specific elements of scenery that appear in the final composition, except for the female figures.[3] Looking at the evolution from small sketch to finished painting, one is reminded of Bonnard's paradoxical conclusion that "drawing is sensation, color is reasoning."[4]

Bonnard was reluctant to part with this work, keeping it in his studio until 1938, which suggests that,

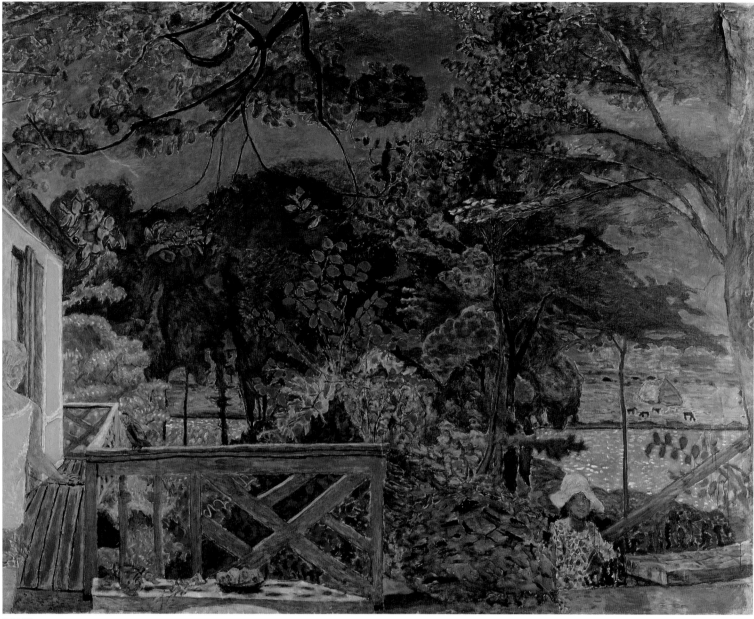

CAT. 58

like *The Terrace at Vernon* (cat. 57), it held special significance for him. It also points to his renewed appreciation of the art of Henri Matisse, who was then living in Nice (close to Bonnard's new home at Le Cannet) and with whom he began a regular correspondence.[5] The brilliant and contrasting blues and oranges and the more linear delineation of individual leaves in *The Terrace at Vernon* have more in common with the way Matisse incorporated brightly colored motifs into his interiors and landscapes of the south than with the puffy, soft, blurred, iridescent foliage seen in Bonnard's earlier terrace pictures.[6] Even the clarity of this gentle landscape—the sharp lines describing the figure of the woman at the left and the easily readable architectural and spatial divisions—suggests the influence of Matisse, whose intense colors and accessible subjects (however sophisticated stylistically) imbue his canvases with an immediacy that Bonnard's works, which are usually absorbed and understood only gradually, generally lack.[7]

This new concern in Bonnard's work for the logical ordering of nature was noted by André Lhôte, who remarked, after seeing Bonnard's exhibition of landscapes at the Bernheim-Jeune gallery in the fall of

FIG. 1
Pierre Bonnard. *The Terrace at Ma Roulotte*, c.1928. Pencil on paper; 27.5 x 30.5 cm. Private collection. Photo: Watkins 1994, p. 146.

1928, that the artist was "increasingly spurning the impressionistic fragmentation of objects . . . to integrate them into the architectural forms that normally surround them."[8] Perhaps because this painting represented a monumental experiment for the artist and employed new conceptual techniques that would become increasingly important for his future art, Bonnard retained the work for himself.

In 1938, René Huyghe, chief curator of the Musée du Louvre, convinced Bonnard to lend it to a three-year touring exhibition (August 1939–October 1941) to various venues in North and South America. It is possible that Bonnard was not finished with this work at the time, since it remains unsigned. It was Bonnard's custom to work on a canvas unstretched and pinned to a wall, often stopping and rolling it up for later completion. This painting shows evidence of such a working system. Originally, for instance, Bonnard continued the decorative foliage at the top edge in a strip of vegetation about eight to ten centimeters wide. At some point, however, he decided to cover the strip, perhaps to accommodate stretcher bars or perhaps because he felt the composition worked better without it.[9]

Although it ultimately made its way into a European collection, *The Terrace at Vernon* was never exhibited in France during Bonnard's lifetime. It was, however, the work by which he was represented in cities throughout the New World: Buenos Aires, Montevideo, Rio de Janeiro, São Paolo, San Francisco, New York, Chicago, Los Angeles, and Portland, Oregon.

CAT. 59

MAURICE DENIS

Eurydice, c. 1905

Oil on canvas
85 x 111 cm (33 ½ x 43 ¾ in.)
Staatliche Museen zu Berlin, Nationalgalerie, on permanent loan from the Ernst von Siemens Foundation, Munich

MAURICE DENIS EXHIBITED *EURYDICE* IN Weimar at the February 1905 exhibition of Neo-Impressionists organized by his friend Count Harry Kessler.[1] According to the artist's records of gifts and sales, it was purchased at that time for 4,000 francs, but unfortunately Denis did not or could not identify the purchaser.[2] *Eurydice* then dropped out of view until recently, when it was lent permanently to the Nationalgalerie, Berlin. Coincidentally, another, much larger version of the same subject, signed and dated 1906, has also only recently reappeared (fig. 1),[3] so that now the significance of these paintings, their unusual iconography, and their place in Denis's oeuvre can be properly reassessed.

Both belong to the "mythological beaches" (*plages mythologiques*) that Denis painted frequently in the first decade of the twentieth century, culminating in the decorative cycle on the theme of Nausicaa commissioned by the dealer Eugène Druet in 1914 (see cat. 61–62). Although Denis's interest in classicism began in 1898, with his reevaluation of Renaissance art while in Rome with André Gide, he only began to paint scenes of the Brittany coast rendered as if bathed in Mediterranean sunlight,[4] such as *Eurydice*, around 1904. In that year Denis exhibited a *Scène mythologique* at the Salon de la nationale. Two years later he showed the Homeric subjects *Polyphemus* (1906; The State Pushkin Museum, Moscow), *Calypso* (1906; Finnish

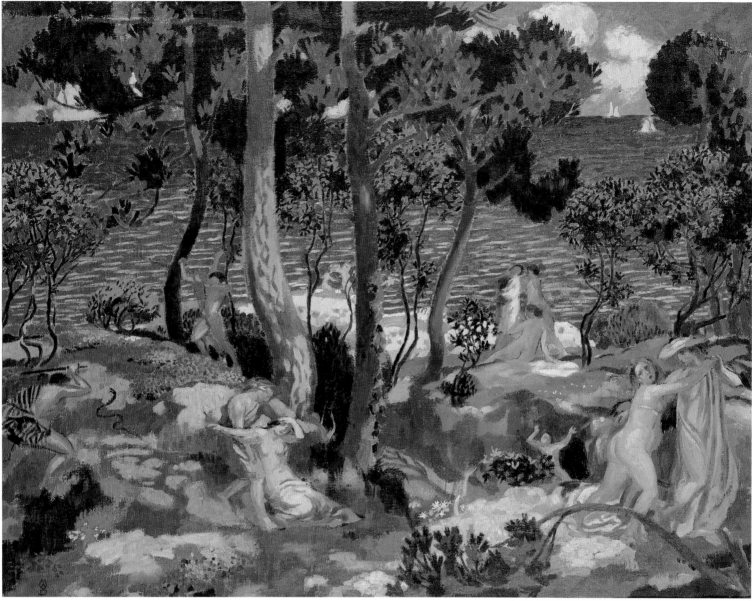

CAT. 59

National Museum, Helsinki), and *Nausicaa* (1906; private collection, Japan).[5]

In many ways, these overt references to Greek mythology represent a departure from Denis's customary treatment of these themes, which usually combined nymphs and shepherds of ancient lore with images of his wife, Marthe, and other contemporary "Venuses" and their maternal charges (see cat. 60, fig. 2).[6] In these, Denis fused the sacred with the profane, relying on the seascape as a multivalent symbol, associated with birth (Venus rising from the waves), with the timeless, and with purification (the water used in the rite of baptism). In these works, sculptural and highly finished figures dominated the landscape.

This is not the case in the *Eurydice* canvases, however, in which small, wriggling figures seem to grow out of the rocky, forested area leading to the sea. In this sense, the *Eurydice* paintings may be Denis's response to the *paysage historique*, or fictionalized landscape depicting the heroic or mythic past, which had been reinvigorated by Pierre Puvis de Chavannes in the last decades of the nineteenth century and which continued to inform the works of artists as diverse as Jules Cazin, René Ménard, and L. O. Merson.[7] But for Denis the *Eurydice* paintings represent perhaps his only two essays in this genre.

Denis's reasons for painting these two versions of the Eurydice subject—first as a full-scale painting

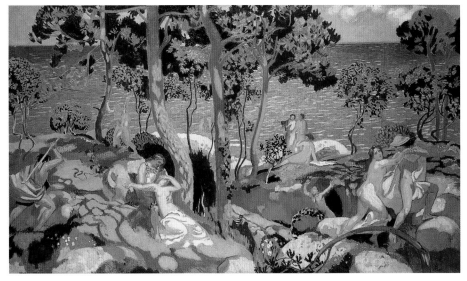

(cat. 59) and again as a much larger (nearly six-foot-long), horizontal composition (fig. 1)—are not clear, as they are not believed to have been commissioned. The subject may have appealed to Denis for personal reasons. Several scholars have pointed to Denis's choice of the theme of death and rebirth as a response to his own recent personal crises—the death of Marthe's sister, Eva, in 1901 and the near-death of his first daughter, Noële, from acute appendicitis in 1903.[8] The myth, which Denis would have known from Ovid's *Metamorphoses* or Virgil's *Georgics*, relates how, soon after her wedding to Orpheus, the beautiful Eurydice received a lethal snakebite while she was trying to escape the amorous overtures of the shepherd and beekeeper Aristaeus. Orpheus followed her to the underworld in an attempt to free her, and was granted permission to lead her out on the condition that he not look back at her. When he gave in to temptation, he lost her forever. Denis alluded to this tragic incident in numerous vignettes. At the far left, a man in a striped tunic kills the snake that bit Eurydice; to his right, Orpheus (whose identity is suggested by his laurel leaves) holds his wounded love; while at the far right, a scene of seduction may well allude to Aristaeus's lustful approaches, which ultimately led to Eurydice's death. The figure in the chasm could be Eurydice flailing her arms in agony as she is pulled back into the underworld or perhaps Orpheus, who is being thrown out of Hades after having failed to fulfill his promise. The relationship of other vignettes to the main story is more obscure. The two men fighting at the left, for example, could suggest not only the conflict between Aristaeus and Orpheus, but also Orpheus's

struggle with temptation, a struggle he ultimately lost. They could also refer more generally to the theme of fighting youths taken from Greek vase painting, which Denis later incorporated into canvases to suggest not only the Mediterranean past, but also the ancient ideal of youth and sport.[9] The women in various stages of undress in the right background may also be connected to the myth, representing Eurydice's companion nymphs who gesture in alarm at her plight. Finally, the three bathing figures just visible behind the central tree allude to the sea nymph Cyrene, mother of Aristaeus, and her companions. Both groups of nymphs play a part in the Eurydice story: after her death, Eurydice's companion nymphs, in an act of revenge, destroy Aristaeus's bees, after which, Aristaeus himself seeks revenge with help from Cyrene.[10]

As Richard Thomson pointed out, *Eurydice* presents a landscape loaded with references to the incident and its consequences,[11] so that the overall effect, despite the serene palette of pinks and blues and the peaceful seaside setting, is one of impending and actual horror. Denis's usual Christian message about good and evil, redemption and salvation, is less evident in this scene of violence and death than in most of his works. It is as if Denis had taken Henri Matisse's decorative composition *Luxe, calme et volupté* (1900–30 Intro., fig. 2) and through this ancient myth invested it with troubling emotional overtones. Tempering and countering the intensity of the legendary past, however, is the recognizable landscape of pine trees around Noirmoutier, an island just south of Brittany. In 1903, Denis had used the same setting in a pastoral scene (fig. 2) that most likely served as a model for *Eurydice* two years later.[12]

In a manner that recalls his treatment of forests in his Nabi works of the 1890s (see cat. 15), Denis emphasized in *Eurydice* the phalange of parasol pines placed rhythmically across the canvas. The sinuous curves of the tree trunks are a decorative strategy that harmonizes them with the horizontal movement of the waves and undulating shapes of the rocks, but it may also evoke the Orpheus legend; Orpheus's lyre music was said to be so compelling that it caused trees to relax their branches and even rocks to soften.[13]

Although the two versions of the subject are almost identical in composition, the larger *Eurydice* (fig. 1) is more daringly colored. As Jean Paul Bouillon pointed out, Denis infused the landscape of Noirmoutier with the light of the Mediterranean, perhaps in response to his trip with Roussel to the coastal region of the Estérel

to visit the painters Cross, Renoir, Signac, and Valtat in January 1906.[14] There Denis encountered the intense sunlight of the south, which seems to drench the landscape with a sense of unreality. The experience is reflected in Denis's electrified palette of hot pinks and oranges in the larger *Eurydice*.[15] Although this landscape, with its schematized figural types, is perhaps the closest that his compositions would come to Matisse's modern mythologies from the years 1904–06, in its emphasis on a unified color harmony, it is at the opposite extreme from Matisse's palette of strongly contrasting primary colors.[16]

The *Eurydice* paintings represent transitional and unique experiments in Denis's evolving "classical style." In his subsequent beach scenes, light is used as a decorative device and unifier, but is never again so artificially construed. Although he would use contemporary landscapes (the beaches along the Golfe du Morbihan, and after 1909, at Perros-Guirec) as settings for later large-scale, mythological, decorative compositions, the landscape itself would never again play such a leading role in his works. Whereas the two *Eurydice* canvases depict a mythological story in which vignettes are integrated within and subordinated to the landscape around them, his later beach scenes feature monumental, sculptural, classical figures, often bearing portraitlike resemblances to members of his family (see cat. 61–62, fig. 2).

MAURICE DENIS

Beach with Small Temple, 1906

Oil on canvas
114 x 196 cm (44 ⅞ x 77 ⅛ in.)
Musée Cantonal des Beaux-Arts, Lausanne, acquired with the support of the Association des Amis du Musée

THIS LARGE DECORATIVE PAINTING WAS FIRST exhibited at the Salon de la nationale in 1906 under the generic title *Bathers* (*Baigneuses*), although it was sold through Galerie Druet a year later as *Beach with Red Hat*.[1] Perhaps the first title (presumably the artist's preference, as it dates from a time the work was still in his possession) was Denis's way of paying homage to Paul Cézanne, whose *Large Bathers* (fig. 1) he had seen in January of that year during a visit to the older artist's studio at Les Lauves, near Aix-en-Provence.[2] Neither of these early titles for Denis's work, however, suggests the mythological and classical connotations evoked by its current appellation, *Beach with Small Temple*.

The combination here of women and children in various stages of undress in a generalized beach setting is similar both to Denis's early scenes of families bathing in Brittany, such as *Bathers, Beach at Le Pouldu* (fig. 2), and to the large decorative compositions based on Homeric subjects he produced between 1904 and 1914 (see cat. 61–62). Although *Beach with Small Temple* does not represent a specific myth, the posture and gestures of the figures suggest a kind of narrative, as if the women were expecting something or someone to approach or emerge from the water. Three of the women look toward the ocean. One in particular, a white-robed woman who sits on a rock at left gazing out to sea with a resolute but perhaps resigned expression, suggests the mythical figure of Penelope, who waited for years for her husband, Ulysses, to return from the Trojan War. This sense of the antique is reinforced by the Greek temple directly behind her.

It was probably the open-ended subject of this work, with its vaguely mythical connotations, that appealed to Belgian painter and collector Eugène Boch,[3] who purchased this work, along with Denis's *Nausicaa* (fig. 3), shortly after both had been exhibited at the 1906 Salon de la nationale.[4] *Nausicaa* depicts a

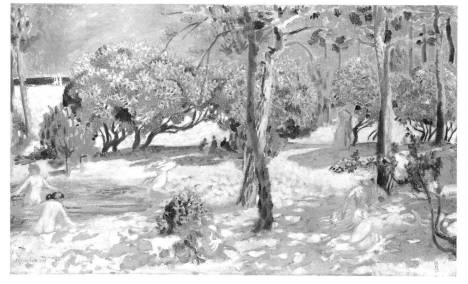

204

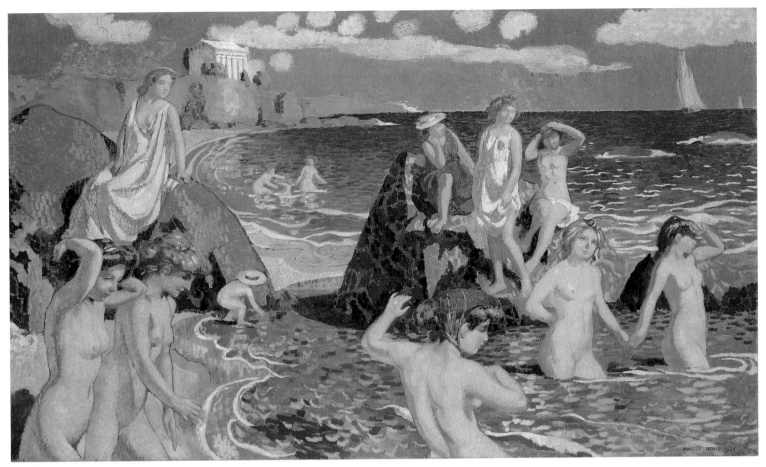

CAT. 60

clearly identifiable story from the Odyssey, a scene Denis also depicted in his 1914 *The Awakening of Ulysses* (cat. 62). In *Beach with Small Temple*, however, the narrative seems secondary to a sense of classical order and is subsumed within a harmonious, decorative whole. This mythological aura is also tempered by the addition of seemingly contemporary figures, such as the woman sporting a red dress and straw hat (*canotier*) at the center and the little child crouching at the left of center, who also wears a *canotier*. These modern-day references reflect the artist's desire to suggest parallels between past and present. The result is a composition that unites ancient Greece with Denis's experience of a summer's day with his family in the Brittany coastal town of Le Pouldu.

Just as mythological and contemporary elements are combined in *Beach with Small Temple*, its sacred and profane aspects are similarly entwined. It has been suggested that the women wading in the water and those in the distance with a small child between them evoke the baptismal rite of purification to which

Denis alluded in a number of his works (see cat. 25). The woman in red draws attention to the veined and variegated triangular rock on which she sits at the center of the canvas (posing like Melancholy in Albrecht Dürer's famous engraving of that name), which may also refer to Denis's faith.[5] In keeping with Denis's goal of infusing even works of general appeal with references to his beliefs, the rock may be seen not only as a decorative feature, but also as alluding to an altar, its triangular shape perhaps indicating the three aspects of the Holy Trinity.[6] The work may also contain a hidden reference to Cézanne's *Large Bathers* (fig. 1). Here too female nudes are distributed across the foreground of a horizontal composition, and bending trees create a pyramidal area enclosing the nudes and two figures who advance from afar. Denis may have admired the strict geometry of Cézanne's composition and executed it in reverse: where Cézanne constructed an empty triangle defined by trees, Denis created a solid triangular form surrounded by open space. Denis also placed several small

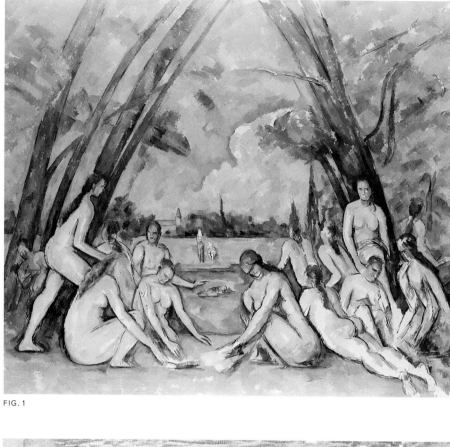

FIG. 1

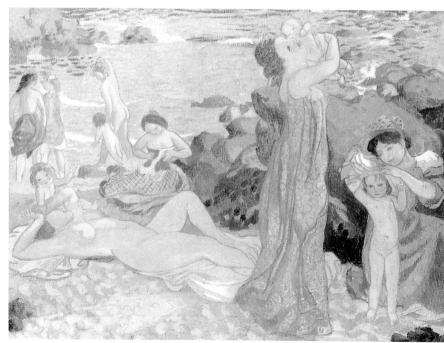

FIG. 2

figures—the two women leading a child into the sea in the far background—in almost the same location in his picture as Cézanne had in *Large Bathers*.

The rock serves an overtly decorative purpose, as well as a symbolic one. Its distinctive markings recall the strong patterning often found in the Nabis' earlier works, such as Vuillard's *Dressmaking Studio* (cat. 31), Roussel's *Seasons of Life* (cat. 26–27), and Denis's *Muses* (cat. 15). The cobalt and copper marbling of the rock's surface contrasts brilliantly with the patterning of the waves (themselves reminiscent of Denis's wallpaper designs from the 1890s), creating an image of ornamental complexity as well as hidden symbolism.

Denis visited numerous European beaches during this period, including those on the Naples coast (1904); Andalusia (1905); and the Estérel, between Cannes and St.-Tropez (1906). Nonetheless, he returned to Le Pouldu as the setting for this work. However, instead of including the Brittany landmark Maison du Pendu, as he did in the background of *Nausicaa* (fig. 3), Denis depicted the Temple of Neptune at Paestum, which he had visited in 1904.[7] As in his two *Eurydice* paintings (cat. 59; cat. 59, fig. 1),[8] Denis used the generalized topography of the Brittany coast to create a "mythologized" landscape that lent itself to the tenets of decorative painting as he understood them. By this time, he firmly believed in the need for clarity, purity of line and color, timelessness, and harmony in his works.

Jean Paul Bouillon pointed out that Denis's discovery of the art of Hellenistic Greece around 1904–05 converged with his interest in and encouragement of the younger artist Aristide Maillol. While Denis in many ways informed the direction of Maillol's art, he was himself influenced by the sculptor's simplified, Hellenized statues of women standing, crouching, or sitting, such as the famous bronze *Mediterranean* (1900–05; Fondation Dina Vierny, Musée Maillol, Paris).[9] Denis and Maillol both utilized similar figural types of small-breasted and narrow-shouldered "contemporary" women infused with an aura of antiquity.

Around the same time that Matisse's *Luxe, calme et volupté* (1900–30 Intro., fig. 2) was shown along with other Fauvist works at the 1905 Salon d'Automne, Denis voiced his allegiance to Maillol and to an art that stood in direct opposition to the Fauves' instinctual, expressive use of line and color:

His [Maillol's] art is essentially an art of synthesis. Without having been led by any particular theory, by that which is other

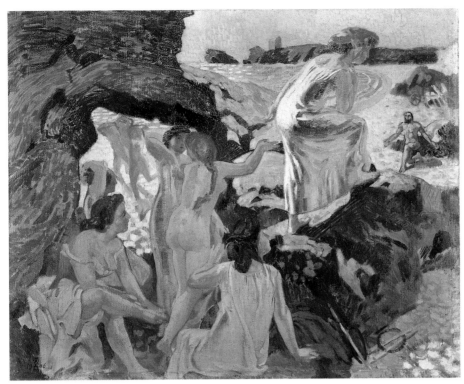

FIG. 3

FIG. 3

FIG. 1
Paul Cézanne (French;
1839–1906). *Large Bathers*, 1906.
Oil on canvas; 210.5 x 250.8 cm.
Philadelphia Museum of Art,
purchased with the W. P.
Wilstach Fund.

FIG. 2
Maurice Denis. *Bathers, Beach at
Le Pouldu*, 1899. Oil on canvas;
70 x 99 cm. Musée du Petit
Palais, Paris.

FIG. 3
Maurice Denis. *Nausicaa*, 1906.
Oil on canvas; 73 x 85 cm.
Private collection, Japan.

than his own instincts, he has taken part in the neoclassical movement, which has its origins in the art of Cézanne and Gauguin.... The ideal for art is to condense, to summarize in a small number of clear and concise forms the infinite and varied connections that can be perceived in nature. It is to reduce to the essential our most specific sensations, to simplify that which is complicated.[10]

Beach with Small Temple is Denis's affirmation of these ideals—a harmonious, simplified image in which there is no disjunction between expression, subject, and technique. At the same time, as seen in the indirect symbolism of the altar-rock and water rites, this large decorative painting reflects the artist's enduring Christian belief in family, children, and the salvation to be found through faith, so that his modern-day Venuses look for fulfillment not only to the sea and to nature, but also to their maternal duties.

MAURICE DENIS

61 *Washerwomen's Games*
1914
Oil on canvas
160 x 386.1 cm (63 x 152 ¼ in.)
Private collection

62 *The Awakening of Ulysses*
1914
Oil on canvas
160 x 285 cm (63 x 114 in.)
Private collection

THESE TWO PANELS ARE THE LARGEST IN A series of works Denis devoted to the story of Nausicaa, a subject he found to be an inexhaustible source of inspiration over a period of many years. At the Salon de la nationale in the spring of 1914, Denis exhibited them, together with four additional panels on the theme of Nausicaa, as belonging to "M. Druet." Like the ensemble *History of Psyche* that he had painted for Ivan Morozov and exhibited four years earlier, Denis grouped the six works under one heading (*Nausicaa*) but gave each canvas a separate title in the catalogue.[1] The panels featured here, *Washerwomen's Games* and *The Awakening of Ulysses*, share a horizontal format, although *Washerwomen* measures three feet longer than the nearly eight-foot-long *Awakening*. The remaining four panels, *Chariot* (location unknown), *Bathers* (location unknown), *Tennis*, and *Tennis Players* (both formerly known as *Ball Game* and now in the Musée National du Sport, Paris), are vertical in format. The varying dimensions and orientations suggest that Denis tailored the panels to fit a specific interior.

Although often thought to have been purchased by Marcel Kapferer from the Druet gallery immediately following the 1914 exhibition, the panels were probably executed specifically for the home of gallery owner Eugène Druet, where they remained until they were acquired by Marcel Kapferer around 1919.[2] Although it is not known how the panels were installed in the Druet residence, in the Kapferer home on rue Charles-Lamoureux they were hung in the living room (see fig. 1), where they remained until 1922/23. At that time the six panels were reinstalled in the dining room of Marcel Kapferer's new mansion at

CAT. 61

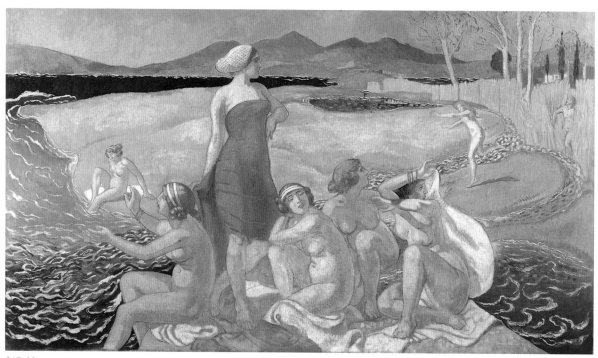

CAT. 62

64, avenue Henri-Martin. Denis then augmented the ensemble, most probably in response to the needs of the new location, creating at least four new works, including two large panels (see fig. 2) and two small overdoors painted in trompe l'oeil to resemble bas-reliefs.[3]

For Denis, who spent every summer, beginning in the late 1890s, at the beach of Perros-Guirec in north-ern Brittany, the story of the Phaeacian princess Nausicaa, from Homer's *Odyssey*, fit naturally with the theme of women on the seashore that characterized both his mythological and secular works at this time. The Homeric tale begins with Nausicaa dreaming that she must hurry to wash all her garments in preparation for her approaching marriage. After she awakens,

she is given permission by her father to take her virgin attendants and a wagon to a faraway beach to perform this task. Based on its title, it is likely that the painting *Chariot* depicted this first part of the story; one can imagine Nausicaa in a wagon laden with food and wine, surrounded by her handmaidens. The tale continues as Nausicaa and her attendants complete the washing, spread the garments on the shore to dry, bathe, and sit down to enjoy their meal, after which they amuse themselves with a game of ball.[4] These events are depicted in a generalized fashion in *Washerwomen's Games* and in the smaller vertical *Ball Game* panels. *The Awakening of Ulysses* takes up the next sequence of events. The weak, shipwrecked Ulysses who, unbeknownst to the women, was sleeping in a thicket nearby, is awakened by their cries when the goddess Minerva causes their ball to splash into the water. Half-dead, unclothed, dirty, and helpless, Ulysses staggers out of the thicket to find himself in the presence of young and beautiful women. Denis represented the critical moment when one of the young women, terrified at the sight of this naked stranger, runs screaming toward the princess and her

entourage. Nausicaa, unlike the handmaidens around her, remains calm, having been endowed by Minerva with "courage and discernment."[5] Denis set the princess apart both physically and emotionally from her attendants. The only clothed figure, she stands nobly in the center of a bevy of nude and cringing females and confronts the foreigner heroically. Whereas the hero Ulysses himself is disoriented and almost feral, Nausicaa takes center stage as a symbol of equanimity and intelligence.

In *Washerwomen's Games*, which can be considered the pendant to *The Awakening of Ulysses* (at least in its installation in Marcel Kapferer's first apartment), Nausicaa is either excluded from the scene or not distinguished from her handmaidens. Although she is said to have sung to her companions as they played at the seaside, Denis chose to focus on a group of undifferentiated young women and children (probably modeled after those in his own family of five), who amuse themselves with the garments they have come to wash. This painting's generalized scene of play on the beach contrasts with the more faithful rendering of the myth in *The Awakening of Ulysses*. *Awakening* is

FIG. 1
Photograph, c. 1920, showing Marcel Kapferer and his daughter Alice in the living room of their apartment on rue Charles-Lamoureux, with *Washerwomen's Games* and *The Awakening of Ulysses* visible on the wall behind them. Francine Kapferer archives, Paris.

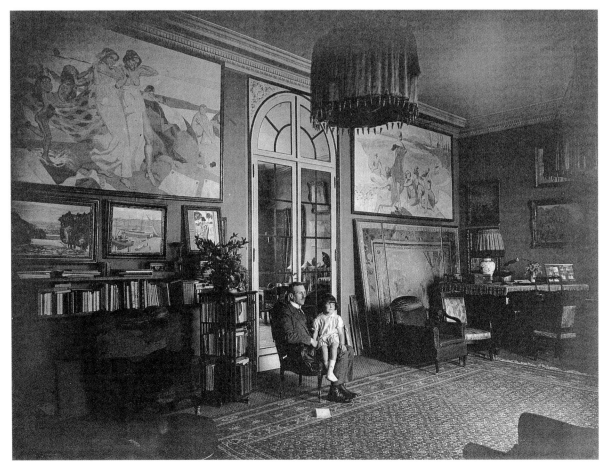

more explicitly fraught with sexual embarrassment and tension. Children are absent, and the women, with the exception of Nausicaa, are nude, emphasizing their helplessness in the face of an intruder who has been sleeping in their midst.[6]

It is interesting to consider Denis's treatment of the confrontation between Ulysses and Nausicaa in light of the political situation at the time. In this work, exhibited just months before the outbreak of war against Germany, Nausicaa bravely confronts a perceived danger, whereas in Denis's earlier version of the subject, *Nausicaa Discovering Ulysses* (1909; private collection), the emphasis is more on Ulysses slumbering in the foreground than on Nausicaa, who draws back in fear upon discovering him.[7] Another version of the subject, from 1906 (cat. 60, fig. 3), depicts the princess more centrally, but as a much more cautious and tentative figure. While one can simply view the 1914 depiction of Nausicaa as a new approach to a story that Denis found continually fascinating, it is also possible to see Nausicaa, in this 1914 materialization, as embodying the French Revolutionary heroine Marianne.

Marcel Kapferer's interest in Denis's art seems to have begun around the time of his purchase of the *Nausicaa* series. Although Vuillard had met Marcel and his brother, Henri, as early as 1912 (when he referred to the two brothers as "the young bachelors"),[8] Denis's involvement with Marcel seems not to have begun much earlier than 1919. As shown in the photograph of Marcel with his eldest daughter, Alice, in

their living room (fig. 1), the panels formed but one tier of interest in an interior filled with smaller canvases and other large-scale works, such as Odilon Redon's *Perseus and Andromeda* (1910/13; private collection, New York), leaning against the wall at the right.[9] Unfortunately, no photographs exist to show how Denis's panels looked in the dining room of Marcel Kapferer's subsequent residence on avenue Henri-Martin, where they were presumably installed as the exclusive décor. At that time (1923), Denis painted portraits of the Kapferer daughters and four additional panels loosely based on the theme of Nausicaa. Interestingly, Denis chose not to complete the cycle with the ending of the myth, which has Nausicaa taking Ulysses to her father for aid, Ulysses setting off again on his adventure, and Zeus punishing the Phaeacians for helping the hero. Instead, Denis elaborated upon and updated themes already illustrated in the 1914 series. One of the new panels, for instance, known as *Ball Game*, but more properly called *Ancient Corsica* (fig. 2), is also set on the beach at Perros-Guirec and filled with figures of women and children.[10] Here, however, the women wear modern bathing suits, sundresses, and fashionable toques. Seated at right is Elizabeth Graterolle, whom Denis had married in February of the previous year. Elizabeth offers fruit to several adolescent girls (possibly representations of Denis's daughters) and is hugged by an infant (who may be an allusion to the impending arrival of her first child with Denis, Jean Baptiste, in July 1923).[11]

Although *Ancient Corsica* is almost completely bereft of overt references to classical times, it touches upon the same themes of play found in the 1914 *Nausicaa* panels that it was meant to complement. Denis also added elements not found in the original ensemble, such as the theme of maternity and nurturing so important to his oeuvre, here embodied in the fulsome figure of Elizabeth in the foreground.[12]

Marcel Kapferer's request that Denis add to the existing series of panels suggests that the artist continued to interest this eclectic collector some four years after he first acquired the works. Unlike the overdoor panels that Vuillard was asked to paint to supplement his *Public Gardens* series (see cat. 32–33), Denis's second set of panels for Marcel Kapferer was not a true addition. Rather these works represented new chapters, only loosely related to the Nausicaa myth, in a narrative that now alluded to his own life.

CAT. 63

CAT. 63

MAURICE DENIS

Bacchanale, 1920

Oil on canvas
99.2 x 139.5 cm (39 x 55 in.)
Bridgestone Museum of Art, Ishibashi Foundation,
Tokyo, acc. WP-65

THIS PAINTING IS A VERSION OF A SUBJECT treated on a much larger scale (about three times larger) in response to a commission received in 1920 by a Monsieur Neubert. The director of a fur shop in Geneva called Le Tigre Royal, Neubert asked Denis to paint a large decorative mural for his

store. Denis's response was a nearly thirteen-foot-long composition showing a frenetic and orgiastic bacchanalia. The mural remained in its original installation until 1944. In 1984, it was purchased by a wealthy New York collector, who cropped it at the top and sides to fit it into her residence.[1] It is thus the smaller version (cat. 63) that today most accurately documents this commission.[2]

The Bridgestone Museum painting, which is highly finished, signed, and dated, could be the *maquette*, or model, Denis presented to Neubert before transferring the composition to the larger canvas, or it may be a reprise after the final version.[3] Denis exhibited the definitive large-scale mural painting at the Salon d'Automne in 1920, where it was considered, at least by a critic writing in the *Gazette des beaux-arts*, to be a

strange departure for the artist, one that went beyond his usual choice of subject matter. He found the "agitation of submissive tigers and seductive women" to be a far cry from the religious scenes that dominated Denis's oeuvre at this time.[4]

Denis probably met Neubert on one of his many trips to Geneva, where he received a number of commissions for religious art. From 1916 until 1923, he worked on a mural and stained-glass windows for the Church of Saint-Paul (see 1900–30 Intro., fig. 10), and in 1917, he executed windows depicting the four evangelists for the Church of Notre Dame, endeavors that required him to stay entire months in the city. Denis's increasing interest in religious painting after the war even lead him to taper off his teaching responsibilities at the Académie Ranson in 1919 (where he had been deeply involved since 1909) and to quit entirely in 1921 in order to devote himself more fully to the Atelier de l'art sacré, which he founded in 1919 with the artist Georges Desvallières.

The fact that Denis chose to be represented publicly in 1920 by this monumental pagan subject, painted in brilliant and intense oranges, greens, and reds, and not by his religious decorations, generally executed in softer pastel shades, suggests that as much as he personally valued religious subject matter, he welcomed a different perspective on his work, or perhaps a broader audience for it. In its novelty (an artistic undertaking for a commercial enterprise), *Bacchanale* can be compared with one of Vuillard's few ventures into the commercial world from a few years earlier, a large oval mural painted for a fashionable Paris tea room called Le Grand Teddy (fig. 1). Whereas Denis responded to his commission with an exotic subject (perhaps dictated to him by Neubert) only tangentially related to the business for which it was made, Vuillard painted the tea room's chic patrons, so that they are both the painting's subject and audience.

Denis seems to have drawn on a variety of sources for this unusual image, especially High Renaissance and Baroque paintings. Works such as Nicolas Poussin's *Triumph of Flora* (fig. 2) and Titian's *Bacchus and Ariadne* (1522–23; National Gallery, London) also present exotic or mythological figures in a grand processional, set in a lush landscape.[5] Denis might also have looked to the orientalist fantasies of Eugène Delacroix, especially the writhing and contorted figures in *Death of Sardanapalus* (1826; Musée du Louvre, Paris), as well as to dance performances at the Théâtre des Champs-Elysées of the Ballets Russes and other groups known for their exotic scenery and costumes and their complex modern choreography.[6]

However, even within this seemingly chaotic scene of debauchery, so unique for Denis, there is the sense of clarity and absolute balance that always marks his work. As Jean Paul Bouillon rightly observed, this balance is achieved by the division of the composition into smaller pyramidal groupings: for instance, the central triangle composed of a dancing bacchante with grapes, a small boy, and a rearing tiger; and on the right the woman steadying a child on a goat, the woman bearing a basket of fruit, and the figure play-

FIG. 1
Edouard Vuillard. *"Le Grand Teddy" Tea Room*, 1918–19; reworked from 1930. Distemper on oval canvas; 150 x 290 cm. Petit Palais—Musée d'Art Moderne, Geneva.

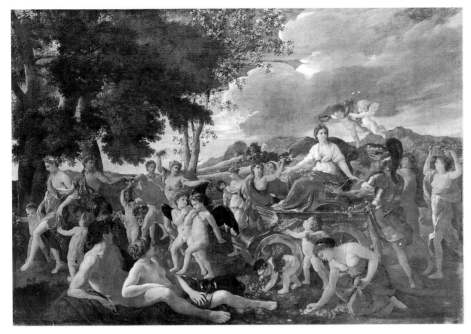

natives. This story is not evoked in paintings of Bacchus as often as the god's triumphal entry into his native Crete.[9]

Apart from the four additional panels of the *Nausicaa* series painted in 1923 for Marcel Kapferer (see cat. 61–62), *Bacchanale* represents one of Denis's last purely secular commissions, with the exception of his work for the Salle des Nations in Geneva and the project for the Théâtre de Chaillot in Paris in 1937. Indeed, his election to the position of vice-president of the religious-art section of the Société nationale des beaux-arts in 1920 made official the political and religious stance he had early on embraced in his art. With *Bacchanale*, Denis, under the aegis of a shop decoration for a foreign city, indulged in re-creating the hedonistic world he had long renounced.

CAT. 64

KER XAVIER ROUSSEL

Triumph of Bacchus, or *Mythological Scene*
1911; reworked 1913

Oil on canvas
166.5 x 119.5 cm (65 ½ x 47 in.)
The State Hermitage Museum, St. Petersburg

THIS IS ONE OF TWO WORKS THAT ROUSSEL exhibited under the title *Scène mythologique* at the Salon d'Automne of 1911 and that would later be acquired by the Russian collector Ivan A. Morozov in 1913.[1] The subject of both of Roussel's panels, now known as *Triumph of Bacchus* (cat. 64) and *Triumph of Ceres* (fig. 1), is typical of Roussel's repertoire at this time, which largely focused on joyous processions of dancing nymphs and fauns. As early as 1896, Roussel had painted a similar subject, *Drunkenness at Twilight* (Musée des Beaux-Arts André Malraux, Le Havre), featuring dancing nymphs and cymbal-playing Dionysian characters set into the rolling landscape of L'Etang-la-Ville that also forms the setting of these two panels.[2] These later panels, however, show Roussel's newfound interest in larger, more volumetric figures, seen as well in others of his decorative canvases at this time (see cat. 67–68). Gisela Götte ascribed this new interest to a change in Roussel's working method, which involved his use of

FIG. 2
Nicolas Poussin (French; 1594–1665). *Triumph of Flora,* 1628. Oil on canvas; 165 x 241 cm. Musée du Louvre, Paris.

ing cymbals behind them.[7] The vignette of the woman, child, and goat recalls Denis's *maternités,* or paintings of mothers and infants, inspired by his own family and executed in the mid- to late-1890s.[8] This woman even bears some resemblance to Marthe, who had died in August of the previous year. The little boy who walks alongside the woman with grapes, pulling the goat and looking back at the Marthe figure, has features similar to blue-eyed Dominique, Marthe's last child.

Although Denis's subject recalls the Bacchus and Silenus canvases Roussel painted beginning in 1906 (see cat. 64), *Bacchanale,* crowded with different kinds of figures and animals, is more specifically related to the myth than are Roussel's treatments of the theme. Denis included an arsenal of attributes typically ascribed to the god of wine, dance, and fertility: vines laden with grapes; mothers and babies; delirious bacchantes with tambourines; and the god himself, a handsome youth carrying a staff topped by a pine cone, a symbol of fertility. The exotic animals that fill the canvas were standard in the sixteenth- and seventeenth-century iconography of this subject, as Bacchus's chariot was thought to have been pulled (according to different versions of the myth) by a panther, a tiger, or a goat. The inclusion of an elephant in the background, as well as various wild cats, indicates that Denis wanted to suggest the god's lesser-known adventures, the so-called Indian Bacchanale, or the triumph of Bacchus in India, where he converted the

Vollard recalled that Edgar Degas saw *Triumph of Bacchus* in his gallery in 1913, just before it was sent to Morozov, and commented, "It's noble!"[4] What Vollard did not mention is that the work that Degas admired in 1913 was far different from the one Morozov saw in 1911 at the Salon d'Automne and perhaps at the Bernheim-Jeune gallery. The painting and its pendant, which Morozov had purchased for 10,000 francs, were radically repainted by Roussel (without Morozov's knowledge) before they were sent to Moscow, and Roussel himself never actually saw them in their final location. He transformed the original grayish brown tonalities of both panels into a riotous combination of reds, oranges, and acidic greens.[5] According to B. N. Ternovetz, the first curator of the Morozov collection after its nationalization, Roussel revised his palette after finding out that the panels were to hang in the same room in Morozov's mansion as works by Henri Matisse, in an attempt to integrate them better into their future setting. He then signed and redated them accordingly. Apparently, Morozov, by all accounts a conservative and methodical amateur who put together his collection "masterpiece by masterpiece, as if he were stringing a necklace,"[6] was unimpressed and even shocked by Roussel's dramatic transformation of the paintings. He may have felt the brilliant palette did not suit the subject matter or style of the pendants, although he was apparently not displeased enough to return them to Vollard.[7] Instead, they remained installed at the Morozov mansion, although it is unclear how they were displayed. As the two "triumph" panels are only loosely linked thematically and compositionally, they could have been hung in various ways: as flanking pendants, as separate panels, or as a diptych.[8]

Roussel's decision to alter his paintings to match works by Matisse (perhaps the "Moroccan" triptych, commissioned by Morozov, which Roussel could have seen at the Bernheim-Jeune gallery in 1913) seems unusual, given the fact that Roussel normally remained personally and professionally outside of modernist circles in Paris.[9] It is possible that his friendship with Henri Cross and Henri Manguin throughout the first decade of the century made him more aware of Matisse's radical colors and formal simplifications, leading him to intensify his own characteristically soft and dreamy painting style.

Of course, Roussel's repainting of the works for Morozov may be seen simply as an example of his normal working practice; he was notorious for radically altering and repainting his works. In his mono-

mannequins as models for frozen poses of figures seen in action.[3]

Rather than invoke the specific details of the Thracian god's life, *Triumph of Bacchus* gives a generalized vision of the joy of song and dance, of wine and abundant food. While it is indebted to earlier paintings of mythological festivals by artists such as Jordaens, Poussin (see cat. 63, fig. 2), Rubens, and Titian, Roussel's panel does not depict the god's traditional entourage of exotic animals and ecstatic and scantly clad young women, but is limited instead to four male figures.

FIG. 1
Ker Xavier Roussel. *Triumph of Ceres*, 1911; reworked 1913. Oil on canvas; 166.5 x 119.5 cm. The State Pushkin Museum, Moscow. Photo: *Art Décoratif* 26 (5 Nov. 1911), p. 222.

FIG. 2
Photograph of Ker Xavier Roussel's scene curtain *Procession of Bacchus*, 1912–13, as it looks today in the Théâtre des Champs-Elysées, Paris. Société immobilière du Théâtre des Champs-Elysées, Paris.

FIG. 1

FIG. 2

graph on the artist, Jacques Salomon commented with humor on his father-in-law Roussel's propensity, almost compulsion, to rework his paintings: "Beware, never let Roussel retouch one of his works—you won't recognize it . . . from the sea, he makes a field of wheat!"[10] The Bernheims recognized this need and even provided the artist with a special room where, for over thirty years, he retouched and repainted canvases held by their gallery.[11]

It is also possible that Roussel's reworking of *Triumph of Bacchus* and *Triumph of Ceres* was influenced by his involvement at that time with a major decorative undertaking—the scene curtain (*rideau de scène*) that he had been commissioned to paint in early 1912 for the Théâtre des Champs-Elysées.[12] Completed in 1913, this curtain (fig. 2), known variously as *Dance*, *Procession of Bacchus*, or *Birth of Tragedy*, also exploits the theme of the bacchanale, which was so predominant in Roussel's work of the pre-war years. This commission was not only the most important he had received to date, but also the most challenging in terms of function and installation. The scene depicted is similar to that shown in *Triumph of Bacchus* (cat. 64). Both works feature figures bearing baskets of fruit and dancing on a path amidst green patches of shadow.[13] In the curtain painting, Bacchus flings above him a garland of grapes, while in the panel he holds cymbals, referring to the birth of music.

More interesting in terms of Roussel's repainting of the two "triumph" panels is the fact that he also wrestled with and ultimately altered the palette of the curtain. Lucie Cousturier related Roussel's tale of his year-long struggle to bring this enormous *rideau de scène* to fruition. Having conceived the painting in his studio at L'Etang-la-Ville to accommodate the reddish lights of the theater, Roussel was anguished to find that the theater lights hit his work in a scattered rather than direct manner, so that the painting had "holes" caused by the uneven lighting, which undermined the intended unity of the composition. In the end, Roussel worked at the site itself, overpainting the distemper with deeper emerald greens, oranges, and reds so that the painting emerged glowing "like the skin of nectarines."[14]

The final curtain, which was unveiled a few months after the official opening of the theater on 31 March 1913, was a critical success. Gabriel Mourey wrote that Roussel's work revealed "a Greek soul united with a completely French sensibility in an incomparable seduction" executed in "very warm

tonalities . . . harmonized with a perfect art."[15] Paul Jamot praised the curtain's brilliantly colored landscape as complementing perfectly the ecstatic celebration depicted.[16] The importance of this curtain to Roussel and the positive response he received to his repainting of it may have had some bearing on his decision to repaint the Morozov panels that same year.

Roussel put great effort into integrating *Triumph of Bacchus* and *Triumph of Ceres*, as well as the monumental stage curtain for the Théâtre des Champs-Elysées, into their intended surroundings. Unfortunately, both of these attempts were ultimately frustrated. Morozov was dissatisfied, as discussed above, and the director of the Théâtre des Champs-Elysées, Louis Jouvet, eventually decided that the colors that Roussel had worked so hard to achieve were too bright. He removed Roussel's monumental curtain in 1920–21, because he believed its vibrant and glowing colors made the stage sets look dull by comparison.[17]

CAT. 65–66

KER XAVIER ROUSSEL

65 *The Abduction of the Daughters of Leucippus*
1912/15
Oil on canvas
171 x 75 cm (67 ⅜ x 29 ½ in.)
Private collection, Paris

66 *The Sleep of Narcissus*
1912/15
Oil on canvas
171 x 75 cm (67 ⅜ x 29 ½ in.)
Private collection, Paris

THESE PANELS STAND OUT IN ROUSSEL'S oeuvre for their unusual pairing of contrasting subjects and for their expressive handling. They were commissioned by the dealer Jos Hessel (see 1900–30 Intro.) for the dining room of his Paris apartment,[1] and they have been variously dated between 1910 and 1918. But they were most likely begun around 1912, after Roussel had completed a monumental decorative painting on the same subject as one of the Hessel panels, *The Abduction of the Daughters of Leucippus* (fig. 1), for the carriage entrance of the Paris home of Hessel's cousins Josse and Gaston Bernheim.

The pendants for Hessel were probably completed by the first months of 1915, when Roussel took his family to Switzerland, where he would be hospitalized for much of the war.[2]

Roussel worked for over four years on the nearly eleven-foot-high painting for the Bernheims, exhibiting it at the Indépendants in 1910 and again in his solo exhibition at the Bernheim gallery in late March 1911.[3] According to the story, the two daughters of Leucippus were abducted on the day of their marriage to the two sons of the king of Messenia by the twins Castor and Pollux.[4] In the Bernheim version, Roussel tamed the tragedy by showing the moment before the violent abduction, when the women are just emerging from their bath and look up to see horsemen approaching in the distance. The work's title provides the only suggestion of impending terror in a composition characterized by an idyllic profusion of dainty flowers in the trees, bushes, and fields (reminiscent of Denis's scenes from the 1890s of young women amidst carpets of flowers), and framed by a garlanded border. Indeed the horsemen themselves are half hidden by the flowering tree and are turned in a way that suggests their surprise at catching sight of the two bathers, rather than their intention of intruding on them.

In contrast to this detailed, fairyland setting, the Hessel pendant on this subject contains only a sketchy suggestion of vegetation and is painted in a much rougher, more impulsive, and heavily impastoed manner. This handling renders the figures and setting somewhat hard to read and underscores the tumultuous and violent episode represented. In the Hessel panel, Roussel eschewed a toned-down and prettified version of the myth, showing instead the brutal abduction of one daughter. Wearing bright red drapery, the attacker is positioned at the apex of a triangle. At the lower left, the other sister runs with arms outstretched from her own pursuer, who leaps toward her from the lower right. In this Baroque and agitated composition, the violence is not impending, but actually happening. The horses—symbolizing Castor's abilities as a trainer and his performance of chivalric deeds, for which, paradoxically, he was also well known—are absent. The women are helpless, trapped by their pursuers, in what amounts to a surprisingly direct and brutal interpretation of the legend.[5]

Equally surprising, as suggested above, is Roussel's schematic and at the same time densely painted rendering of this composition. The violence is under-

CAT. 65

CAT. 66

FIG. 2

FIG. 1

woman looks up from the rock where she has spread her clothes for bathing, and raises her arms in horror. Roussel captured her shock at discovering that her sister is being abducted, but did not imply that she too would necessarily suffer the same fate.[6]

The pendant to the Hessel version of *The Abduction of the Daughters of Leucippus* depicts a completely different mythological subject. For this work, Roussel turned to another mythic hero, the handsome and pink-cheeked Narcissus. Asleep in a pose probably borrowed from Poussin's celebrated *Echo and Narcissus* (c. 1625; Musée du Louvre, Paris), he is approached by two figures, perhaps shepherds or the woodland nymphs who admired him. Narcissus reclines horizontally across the canvas, in a pose that is the compositional and spiritual antithesis to the upward thrust of the pendant's rape scene. It is possible that the pairing was intended to create contrasts of style (Baroque versus classical) and subject (violence versus calm), while maintaining unity through similar technical execution.

Both panels include someone who is spying on or observing the story's main protagonists, whether the motivation is benign, as in the Narcissus panel (where figures admire the handsome god), or malevolent, as with the bathing maidens. In his spring 1911 exhibition at Bernheim-Jeune, Roussel exhibited not only the earlier Bernheim version of *The Abduction of the Daughters of Leucippus* and several variants, but also two other works relating to the "male gaze" and aggression: *The Abduction of Proserpina* and *Nymphs Observed*.[7] Roussel's fascination with the notion of the secret observer and with nature as a participant in the drama (as sheltering woods or revealing fields) suggests affinities with the work of his older friend Odilon Redon. At this time, Redon was likewise experimenting with representations of damsels in distress, suggesting a mood of terror and sexual tension tempered by the mythological setting. These include images of Andromeda chained and awaiting rescue, or of women trapped in nature and spied upon by males, culminating in the disturbing and fascinating *Cyclops* of 1912 (Kröller-Müller Museum, Otterlo, The Netherlands).[8]

Precisely how these panels may have been installed in the Hessels' dining room remains uncertain. Vuillard, who often dined there on the invitation of Jos's wife, Lucie, offered no description of these narrow panels, which may easily have served as door panels or as *trumeaux* on either side of an entrance.[9]

scored by the quick strokes of red, yellow, and purple used to describe the protagonists. Even the figure closest to the viewer is rendered indistinctly, in splotchy patches of yellow and gray-yellow. The result is a highly expressive and agitated scene, which seems at odds with the work's function as dining-room decoration. In his choice of subject and handling, it is possible that Roussel was reflecting to some degree Hessel's own preferences. Indeed, in other paintings of similar subjects, such as the large Bernheim composition and a work customarily entitled *The Abduction* (fig. 2), Roussel employed a more detailed, naturalistic landscape and a smoother surface that allows an easier reading of the scene. *The Abduction* features two women, but only one man. A woman in white is forcefully carried off by her seducer. The remaining

CAT. 67–68

KER XAVIER ROUSSEL

67 *Autumn*

1915

Oil on paper, mounted on canvas

100 x 65 cm (39 ⅜ x 25 ⅝ in.)

Neffe-Degandt, London

68 *Spring*

1915

Oil on paper, mounted on canvas

100 x 65 cm (39 ⅜ x 25 ⅝ in.)

Neffe-Degandt, London

IN 1915, ROUSSEL WAS COMMISSIONED TO PAINT two murals for the stairway of a new municipal museum for the city of Winterthur, just outside Zurich, Switzerland.[1] He made numerous studies for these murals, including these two oil sketches, *Autumn* and *Spring*. Signed and dated 1915, they are among the earliest studies Roussel executed for this project, which was installed in 1918 and then completely repainted by Roussel on site in 1926 (fig. 1).[2]

Roussel stayed out of Paris during most of World War I. Torn between a sense of duty and a conviction of the absurdity and senselessness of the war, he had a breakdown.[3] In 1915, he left his family near Lausanne with friends of the Vallotton family and committed himself to the care of a Swiss specialist in mental disorders, Dr. Auguste Widmer, at the Maison Lambert, located between Geneva and the mountain range of Glion-Montreux.[4] It was here that he received the commission for the murals for the new museum (still under construction) from art patrons Hans and Werner Reinhart, who had been encouraged to select Roussel by the artist's Nabi colleagues Bonnard, Maillol, and Vallotton. All three had close ties to important Swiss collectors and thought that the commission would occupy their troubled friend.[5] When the museum opened to the public in January 1916, however, Roussel's paintings were still not in place. After he returned to his studio in L'Etang-la-Ville in the summer of 1917, he resumed his work on the panels, finally sending them to the museum sometime in 1918.

Roussel, having been a firm believer in and admirer of German philosophy and music, found it difficult to come to grips with the reality of the war.[6]

As he wrote to Marcel Guérin, he struggled to reconcile the "thought of yesterday and the reality of today."[7] The commission may indeed have provided an outlet for him, a therapeutic and meaningful escape from his inner turmoil.[8] The obsessiveness with which he worked on study after study (many of which share the same scale and medium as *Autumn* and *Spring*), experimenting with a variety of spatial relationships and compositions, may be attributed at least in part to his disturbed emotional state at this time.

The murals that were finally installed in the museum were painted in distemper, and although Roussel executed his studies in oil, he obtained the matte surface characteristic of the distemper technique by working on absorbent paper, rather than canvas, and by leeching out the oil from his paints.[9] Many of these small works (those featured here) should rightfully be called "versions" rather than "studies," since they bear little resemblance to the final murals. The early studies *Autumn* and *Spring* feature dense compositions painted in a sketchy fashion, but maintain a sense of compositional and spatial stability. In some of his later studies, he adopted a highly expressionist and mannered style, so that the objects and figures are seemingly stretched and pulled into the center of the canvas (see fig. 2).[10] In the murals, Roussel retained these figural and spatial distortions. Seeing the arched tops of the architectural space where these panels were to hang, Roussel may have been reminded of apse decorations and may even have looked to Denis's mural, completed in the fall of 1916, for the apse of the Church of Saint-Paul in Geneva (see 1900–30 Intro., fig. 10). As Jeanne Stump has asserted, it is possible that Roussel was trying to create the same visual effect of Denis's mural, which was painted on a curved surface, by placing strong orthogonals in the foreground and leaving the background relatively flat so that the composition would seem to curve into the center.[11]

When Roussel returned to Winterthur in 1926, he was so dissatisfied with the exaggerated spatial illusionism and elongated figure types of his murals that he completely repainted them in situ. With its more logical construction of space, the repainted version (fig. 1) harks back to earlier studies such as *Autumn* and *Spring*. The revised compositions achieve a much greater overall balance and no longer present the spatial distortions of their predecessors. *Autumn* and *Spring*, while similar in composition to the 1926

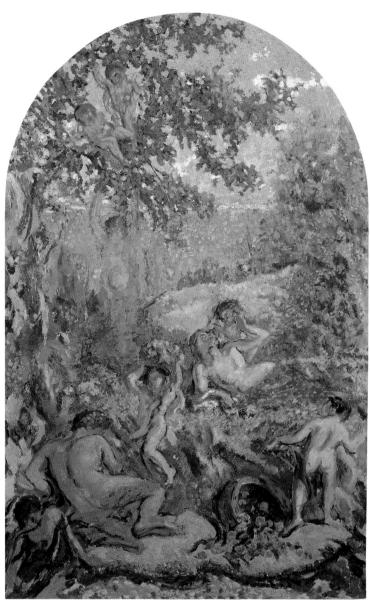

CAT. 67

CAT. 68

murals, differ stylistically. Dating from the war and the time of Roussel's greatest instability, they display a nervous, quivering energy, especially in the contours and edges of his figures and forms. The sense of agitation may reflect Roussel's psychological state during the war, when he had a recurring nightmare about being unable to stop the "stupid accident" of the conflict.[12] This agitation is even more pronounced in the 1918 murals. When he reworked the panels in 1926, however, he produced works of simplicity and clarity, situating the figures in a legible space, surrounded by decorative foliage and flowers.

The compositions of the panels featured here are each organized around a pyramidal grouping of figures

balanced by *putti* in the trees and the inverted blue wedge indicating Lake Geneva, bordered delicately by the Vaud and Valois mountains. The final panels were to be installed side-by-side, with *Autumn* on the left and *Spring* on the right. With this in mind, Roussel unified these studies through a number of compositional strategies: they share a similar mass of foliage (at the right in *Autumn* and at the left in *Spring*) and a tree that curves along the top of each panel, functioning as a framing device, as the two trees stretch toward each other. The seasons are differentiated from each other by variations in the landscape and plant life, with apples ripening on the trees and spilling from baskets in *Autumn* and blossoming foliage in *Spring*.

FIG. 1
Ker Xavier Roussel. *Autumn* and *Spring*, decorative murals for the Kunstmuseum Winterthur, 1916–18; reworked 1926. Distemper on canvas; each, 517 x 346 cm. Kustmuseum Winterthur, Switzerland.

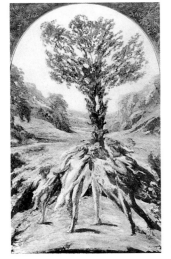

FIG. 2
Ker Xavier Roussel. *Spring*, 1916/18. Location unknown. Photo: *Art et décoration* 39 (Jan.–June 1921), p. 95.

Compositionally, *Spring* is similar to a type of painting featuring processions of mythical figures that has a long tradition in Renaissance and Baroque art (see cat. 63, fig. 2). The female figure here perhaps represents Ceres, goddess of agriculture, presiding over budding trees and wearing a cape of what appear to be woven flowers. She is approached by an old man wearing animal furs and holding a black cane, perhaps a personification of Winter, whom she has conquered. The figure of an older male among youthful figures also appears in the 1926 version of *Spring* at the Winterthur museum (fig. 1); it may suggest the idea of transition or passage, or simply the triumph of the new and youthful over the old.

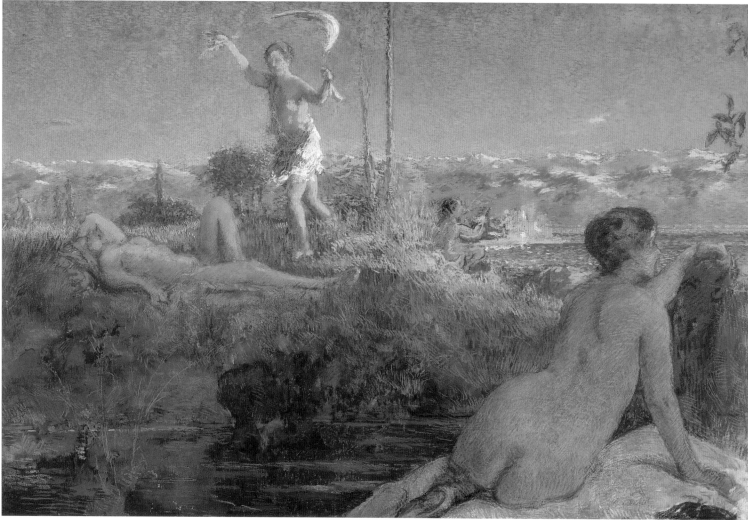

CAT. 69

CAT. 69

KER XAVIER ROUSSEL

The Cape of Antibes, c. 1928
Pastel, distemper, and charcoal on paper, mounted on canvas
86 x 127 cm (33 ⅞ x 50 in.)
Private collection, Paris

THIS PAINTING IS ONE OF SEVERAL WORKS that may have been loosely inspired by Stéphane Mallarmé's poem *Afternoon of a Faun* (1874) about a faun's encounter (or dream of an encounter) with two nymphs lying naked in a woodland (see cat. 70). Mallarmé's narrative was popularized by the tonal music of the same name that Claude Debussy wrote in 1894. This in turn inspired the ballet choreographed and danced by Vaslav Nijinsky, a *succès de scandale* in Paris in 1912. In all of these incarnations, the subject was steeped in a sense of sensuality and eroticism, a feeling that also permeates the mythical scene depicted here. Roussel—like Renoir, Boucher, Titian, and Giorgione before him—was a master at evoking, by means of figural types and gestures, the sensuous undertones of a summer's day in Arcadia. Here, the scene is inspired by the southernmost tip of the peninsula between Nice and Cannes called Cap d'Antibes, a resort area known for its rocky beaches and pine forests. Roussel painted this view from the marshes by the shore, looking east toward the sea and the foothills of the Alps, visible, cloudlike, in the distance.[1]

In 1928, the date traditionally ascribed to this painting, Roussel was continuing to enjoy the rela-

222

tively good health that had allowed him to undertake important commissions for wealthy industrialists between 1919 and 1926, including dining-room ensembles for the Paris residences of Marcel Monteux and Lucien Rosengart (see 1900–30 Intro., figs. 15–16), and the decoration of the salon of Gaston Monteux, Marcel's father, at Cap d'Antibes.[2] While Roussel may have visited Gaston's property while working on his project, *The Cape of Antibes* is probably not a commissioned work. Begun as a pastel over charcoal and built up with small, even strokes of distemper applied in parallel lines, the surface has a textured, woven quality. While smaller in scale than the artist's panels for the Monteux and Rosengart residences, *The Cape of Antibes* may have been an attempt to achieve a mural-like surface in an easel painting, using the distemper technique (pigments dissolved in hot glue) to reinforce the chalkier medium of pastel.[3] Also suggestive of mural decorations is the composition, based on a sweeping diagonal, and the figure pushed up to the right foreground.

Thematically, *The Cape of Antibes* represents an amalgam of motifs that Roussel had favored in his work from the beginning of the century. As Gisela Götte pointed out, Roussel both assimilated figural types from old master paintings (Poussin's, for example) and drew repeatedly on figures belonging to his personal repertoire.[4] The Rubenesque reclining female in the right foreground, for instance, was a staple in Roussel's oeuvre, appearing in smaller works such as *Venus by the Sea* (1908; Musée d'Orsay, Paris) and the pastel *Jupiter and Amalthea* (c. 1927; private collection, St.-Germain-en-Laye).[5] Also taken from earlier works is the reclining figure, in the left middle ground, with

one bent leg. This androgynous sleeping figure (perhaps one of the nymphs of Mallarmé's poem) appears numerous times in Roussel's oeuvre: for example, in a vertical oil painting of similar scale, *Spring in L'Etang-la-Ville* (c. 1928; private collection), and an early version of *Afternoon of a Faun* (c. 1914; private collection).[6] The triumphant figure waving a scarf or banner is drawn from bacchanales and other procession scenes and is also found in *The Sleep of Narcissus* (cat. 66). Even the smaller figure sitting on the banks of the water, to the right of the two trees that divide the canvas, is reminiscent of the flute player and drinker from the fountain of youth, often seen in Roussel's works on this subject starting around 1920.[7]

As in so many of his paintings, Roussel was not as interested here in delineating a legible narrative as he was in creating a visually pleasing work evocative of the sensual pleasures of life. It is possible that the scene represents the faun surprising one of the sleeping nymphs of Mallarmé's poem, but it is perhaps just a more generalized Arcadian scene. In what is considered an earlier composition (fig. 1), Roussel's standard types—seated nude, sleeping nymph, and banner-bearing male—also appear, but they do not play as prominent a role, as they are interspersed among many other figures.[8]

By the mid-1920s, Cap d'Antibes was a popular upper-class tourist resort, enhanced by the presence of wealthy socialites like Frank Jay and Florence Gould and F. Scott and Zelda Fitzgerald. Although Roussel undoubtedly made at least one visit to the Monteux mansion in this area, he left no journal entries or descriptions of his trip that would indicate the importance of this region to his aesthetic sensibilities. Certainly he would have been aware of the marked changes the landscape was undergoing due to the influx of Americans and wealthy Europeans drawn to the sun-filled beaches. This scene, however, makes no contemporary allusions. In characteristic fashion, Roussel's topography—lush grasslands, small inlets leading out to a wave-capped sea—evokes a land outside of time, undisturbed by commerce or tourism, a realm whose natural beauty is underscored by human forms that are equally unblemished.

FIG. 1

Ker Xavier Roussel. *Arcadian Scene*, c. 1910. Oil on canvas; 88 x 181 cm. Private collection, Paris. Photo: Kunsthalle Bremen, *Ker-Xavier Roussel*, exh. cat. (1965), p. 63, cat. 34.

CAT. 70

KER XAVIER ROUSSEL

Afternoon of a Faun, c. 1930
Distemper on canvas
200 x 320 cm (78 ¾ x 126 in.)
Musée Départemental de l'Oise, Beauvais

ROUSSEL PAINTED THIS LUMINOUS ARCADIAN scene for the Cap Ferrat villa of the famous French baritone Jean Périer, best known for his role as Pélleas in the 1902 production of Debussy's opera *Pélleas et Mélisande*.[1] By the time of this commission, Roussel had already proven himself as a theatrical designer. He had executed four different stage sets for a production of René Fauchois's *Penelope*, which had opened at the Théâtre des Champs-Elysées in May 1913.[2] In 1920, long after the other former Nabis had ceased their involvement with theatrical work, Roussel designed the scenery for *Les Scrupules de Sganarelle*, a three-act play by the Symbolist poet Henri de Régnier, which opened at the Théâtre de l'Oeuvre in February 1921.[3]

Roussel was by this time also a sought-after painter for the châteaux and mansions of the very wealthy. From 1924 to 1926 he worked on a four-panel ensemble for the dining room of car manufacturer Lucien Rosengart, and between 1925 and 1930 he completed two monumental canvases for Jos and Lucie Hessel's Château des Clayes, near Versailles.[4] Roussel's introduction to Périer could easily have taken place at one of the elaborate weekend parties that the Hessels threw in which fine conversation and food mingled with gambling and billiard-playing, Jos's particular passions in addition to art.[5] Roussel, having painted a decorative ensemble for the Cap d'Antibes villa of Gaston Monteux, must have been a relatively well-

CAT. 70

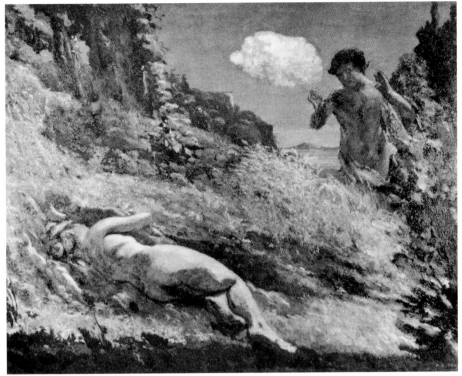

FIG. 1

Ker Xavier Roussel. *Nymph and Faun*, or *Afternoon of a Faun*, 1919. Oil on canvas; 171 x 221 cm. Private collection. Photo: London, Marlborough Fine Art, Ltd., *European Masters: Roussell—Bonnard—Vuillard*, exh. cat. (1954), cat. 19.

Roussel, whose own life included a long-standing affair with Berthe de Waad, which has been only hinted at in the Roussel literature to date.[6] Perhaps just as Bonnard sometimes identified with the faun (see 1890–99 Intro., fig. 3), Roussel here too aligned himself with the mythological figure, who is tempted by the forbidden.

Roussel's numerous pastels and paintings on this theme may also have been a response to Vollard's suggestion that he illustrate a new edition of Mallarmé's poem. According to Vollard, Roussel was very receptive to the idea, although it never came to fruition. Roussel was, however, able to realize, at least in part, another project in a similar vein around 1910, when the dealer asked him to make lithographs to illustrate Maurice de Guérin's *Le Centaure* (1833) and *La Bacchante* (1840). Roussel lingered over this project, and it remained unfinished.[7]

Within the group of works by Roussel loosely inspired by Mallarmé's poem (see cat. 69), the decoration for Jean Périer, with its blond palette, even light, and tufted surface (resulting from the distemper technique), is the most mural-like.[8] In a smaller, 1919 version of the subject, Roussel placed a nymph on a rocky hillside near the sea (fig. 1) and invested the work with more obvious erotic overtones. The faun is shown nearly frontally, his body tensed as if ready to pounce, while the nymph lies unaware, her naked body stretching langorously across the foreground. Like the sleeping woman in Redon's disturbing image of female powerlessness, *The Cyclops* (c. 1914; Kröller-Müller Museum, Otterlo),[9] she is oblivious to her fate.

For the larger decorative work under discussion, Roussel developed a calmer setting with less aggressive imagery. One nymph is bathing; the faun is half-hidden by tall grasses and reeds, arrested in a pose that could indicate either surprise or aggression. The other nymph appears to be running for cover, adding a note of alarm to the scene and bringing the viewer back to the confrontation between faun and bathing nymph and to the prospect of violation. In a charcoal sketch for this composition, the figures are agitated and the effect more disquieting; the faun is shown in calculated pursuit of the bathing nymph, rather than as an innocent intruder.[10]

known talent among the elite in these resort towns, whose light-filled homes were the perfect backdrops for Roussel's idealized Arcadian landscapes.

As in so many of Roussel's decorative works, the conditions for the commission remain unclear. Roussel returned to a subject that had become a favorite of his beginning around 1919—Mallarmé's poem *L'Après-midi d'un faune* (*Afternoon of a Faun*), in which a faun finds (or dreams that he finds) two naked nymphs asleep in a wood. In this treatment of the theme, however, Roussel departed from the original poem (made famous by Debussy's tone-poem of 1894 and by Nijinky's ballet performance as the faun in 1912). Instead of showing the nymphs lying chastely under the faun's spying eye, he instead has one nymph swimming in a pond while the other is seen in the background diving into the bushes.

In many ways, the story of the nymphs (who, as the poem continues, are ravished by the faun) is analogous to another of Roussel's favorite themes, that of the abduction of Leucippus's daughters, who are also watched and eventually carried off by intruders (see cat. 65). The combination of dramatic action (the moment when the faun encounters the sleeping nymphs) and intense emotion (his excitement at the discovery) might have held special meaning for

In his various treatments of the subject, Roussel adjusted the characters for dramatic effect (creating a sense of greater agitation or calm) and also played with the setting. While the reeds and marshy areas of

Afternoon of a Faun suggest the pond for which L'Etang-la-Ville was named,[11] the work also includes a mountain in the distance that signals the Midi.[12] This strategy allowed Roussel to create a series of paintings without relying on the nature-bound strategies used by artists such as Monet. Relying on landscape motifs inspired by his home and travels, he created subtle variations on a theme that was dear to Symbolist poets, painters, and composers—one that Roussel, as the acknowledged poet among the Nabis, seems to have found particularly seductive.

CAT. 71

EDOUARD VUILLARD

In the Garden, at the Vallottons, 1900
Oil on cardboard
26.8 x 111 cm (10 ½ x 43 ¾ in.)
Staatsgalerie Stuttgart

IN THE HISTORY OF VUILLARD'S DECORATIVE career, *In the Garden, at the Vallottons* remains difficult to categorize. Falling between large-scale decoration and intimate genre scene, it seems to have been a one-time experiment inspired by the artist's visit to the Château de la Naz, the summer home rented by Félix Vallotton and his wife, Gabrielle, in the small hillside town of Romanel near Lausanne, Switzerland. By 1893, Vallotton was an integral part of the *Revue blanche* circle and his woodcuts were a regular feature of the periodical. A bachelor, he was particularly close to the unmarried Bonnard and Vuillard and, through them, to Misia and Thadée Natanson, whose summer home he frequented between 1895 and 1898. Vuillard's many letters to Vallotton during these years reveal their close friendship, which became even more important to Vuillard as his other friends moved away or married.[1] Writing in 1897, Vuillard let Vallotton know how much he cherished his "splendid letter," which had made him feel even more acutely the support and encouragement of his friends: "After all, one must live where one can best live and with whom one can best breathe."[2]

In May 1899, however, Vallotton married Gabrielle Rodrigues-Henriques, sister of the gallery owners Josse and Gaston Bernheim, and sister-in-law of Jack Aghion, for whom Vuillard had painted *Walking in the Vineyard* (cat. 42) a short time earlier. Vallotton probably announced his marriage immediately to Vuillard, but in July of that year the latter still chose to write to Vallotton of his discomfort at a recent wedding of a mutual friend: "Bachelors are rare these days and these kinds of spectacles are made for cutting them to the quick."[3] Vallotton himself recognized that Vuillard was disgusted (*estomaqué*) by his marriage to the thirty-six-year-old widow and mother of three, but hoped that Vuillard would feel differently after meeting the new bride.[4] Indeed, while Vuillard was apparently upset by the marriage of his closest single friend, he was not willing to lose him. Writing to Vallotton in September, he announced his plan to visit Félix and Gabrielle: "We will have a lot to talk about—to start over again, almost."[5]

Vuillard not only came to accept Vallotton's marriage, he also learned to appreciate (in some ways better than Vallotton) the unartistic and not particularly attractive Gabrielle, whose children, Max, Jacques, and Madeleine, would remain a mystery for the non-paternal Vallotton. In late August 1900, after much procrastination, Vuillard joined the Vallottons at the Château de la Naz. There he and Vallotton walked the hilly landscape around Romanel and Lausanne. Most of Vuillard's paintings from that summer depict the rolling countryside and Lake Léman, near Lausanne.[6] These expansive views reflect his renewed interest in landscape, which had been ignited by the large panoramas he painted at L'Etang-la-Ville the previous year (see cat. 41).

It is unclear how long Vuillard stayed with the Vallottons, but by mid-September he was in Basel, Switzerland, as an escort to Misia Natanson. Just before leaving Misia in Basel, Vuillard wrote to Vallotton: "I'm starting to get a little bit tired and I'm anxious to be in Paris again to ruminate tranquilly over all of my very good memories of Romanel."[7] A few days later, he wrote to Vallotton that he was enjoying fond memories of life at La Naz: "calm pleasures, or good Burgundy wine among the faces of friends."[8]

Vuillard's painted response to those "calm pleasures" is this intimate scene of a family at the luncheon table, a theme that had permeated his work in the 1890s, now situated out-of-doors and made to fit a long, narrow, horizontal strip of cardboard. Vallotton, wearing his characteristic soft hunter's cap, appears at

CAT. 71

the far right in profile. Unlike the other figures, who are seated in bright sunlight on the patio or terrace, Vallotton seems to hover in the shadows closer to the viewer. Although not all of the figures can be identified definitively, certain physiognomic traits hint at the cast of characters. The older, gray-haired woman seated closest to Vallotton has sometimes been identified as Lucie Hessel, wife of the dealer Jos Hessel (Gabrielle's cousin) and Vuillard's future muse and confidante, but she is more likely Louise, Jos Hessel's gray-haired sister, who is known to have visited that summer.[9] Barely legible at left, as a mound of dark brown hair above the rattan chair, is probably Marthe Mellot, the actress-wife of Alfred Natanson and also one of the invitees. At far right are two blond figures, one of whom, wearing a dark tie, is almost certainly Jacques Rodrigues, Gabrielle's second son (around ten

years old at this time). The figure seen in profile with hair seemingly coiled into a chignon is most likely Dithée (Daisy) Vallotton, wife of Félix's brother, Paul. At the center of the composition is Gabrielle, wearing a straw hat. Although it seems odd that a mature woman and mother of three would be wearing her hair down, a photograph (probably taken by Paul Vallotton) during this same summer holiday, shows Gabrielle wearing the same hat and dress with her hair hanging loosely around her shoulders (fig. 1).[10] She grins and looks happily toward the far right, where Vallotton himself is barely discernible, his head and habitual hunter's cap cropped by the picture plane. It is quite possible that Vuillard, who would rely on photographic sources for his works more consistently after 1900, used similar candid shots for his casual record of the Vallottons and guests.

The photograph of Gabrielle also helps decode the painting's setting. The blocks and bands of gray, ocher, and cream that flatten the composition, negating any sense of deep space, are revealed in the photograph as identifiable elements of the actual courtyard. The column-like form at the center is legible as the tree behind Gabrielle in the photograph, while the brighter square of yellow to the right of the tree is in fact a sealed-up window. All of these elements are pushed to the painting's foreground, underscoring the friezelike arrangement of the family.

The friezelike character of the work is also due in large part to its unusual dimensions. Although Vuillard painted many horizontal compositions, he usually employed a height-to-width ratio of around 1:2 (see cat. 37–38) and not 1:4, as he did here. Longer than an overdoor panel, *In the Garden, at the Vallottons* is more appropriate to cornice trim, a wallpaper-like sliver made to decorate the topmost portion of a wall.

FIG. 1
Photograph, 1900, of Gabrielle Vallotton in the courtyard of the Château de la Naz, Romanel, Switzerland. Archives Fondation Félix Vallotton, Lausanne.

227

Like most of Vuillard's decorative paintings, which tended to offer generalized images of figures rather than specific portraits, the identities of the sitters for this work would have been known only to his most intimate circle. In this way, it is similar in many respects to an earlier, large horizontal painting by Vuillard that Vallotton owned, *Large Interior with Six Figures* (fig. 2).[11] This work also features one man surrounded by women in a complicated space, in this case a richly carpeted and upholstered study. A comparison of these two compositions also serves to show how much Vuillard's technique changed in a few short years. Instead of richly applying paint to merge patterns with figures as he did in *Large Interior*, Vuillard dabbed the cardboard surface of *In the Garden* with patches of pigment, creating a mosaic effect that breaks up the scene, conferring to it an almost abstract quality. The resulting work, which pairs a genre subject with decorative surface and spatial distortions, looks forward to Vuillard's many later works on paper in distemper.[12]

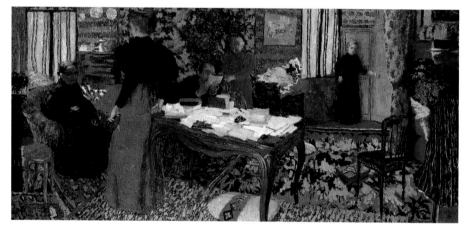

FIG. 2
Edouard Vuillard. *Large Interior with Six Figures*, 1897–98. Oil on canvas; 88 x 193 cm. Kunsthaus Zürich.

CAT. 72

EDOUARD VUILLARD

Florist's Garden, or *View from the Artist's Window, Rue de la Tour,* 1906/08
Distemper on paper, mounted on canvas
71.5 x 157.7 cm (28 ⅛ x 62 ⅛ in.)
Milwaukee Art Museum, gift of Mrs. Harry Lynde Bradley, M1956.20

IN OCTOBER 1904, VUILLARD MOVED TO 123, rue de la Tour in the Paris district of Passy. For Vuillard, who was, with few exceptions, a lifelong resident of the right-bank neighborhood of Batignolles, this was a major geographical change. His stay in Passy would last less than four years and would result in works that have no equivalent in his career. At first, Vuillard was delighted with the different scenery. Writing to Thadée Natanson after signing the lease on his new residence, Vuillard voiced his satisfaction at having left behind the dark, cramped courtyards of his apartment on rue Truffaut, featured in a painting known as *Courtyard in Autumn* (fig. 1). Now, he wrote, he was in a newer and larger apartment, with "windows that I couldn't have hoped for, giving onto open spaces occupied by flower shops and greenhouses, and bordered in the distance by big trees. These greenhouses, the people unrolling straw mats and the palm trees remind me of Cannes."[1]

In the large, apparently uncommissioned panel *Florist's Garden*, Vuillard expressed in paint his summery view of the Passy neighborhood. The flower shops that he mentioned in his letter to Natanson have been transformed here into a barely legible patchwork of colors bordered at the back by a large apartment building and at the sides by smaller and lower structures and shops. The low, tilted roofs Vuillard painted in a palette of silvery pinks, whites, and blues could easily depict glass *serres*, or greenhouses. Interestingly, at the turn of the century, a large part of the Passy neighborhood just south of rue de la Tour (near Parc de la Muette) was occupied by the municipal florists. These gardens, which were the exclusive supplier of flowers to public cemeteries, schools, parks, and squares, were transferred to the Porte d'Auteuil in 1898.[2] Judging from Vuillard's letter to Natanson and from his paintings, the area still

CAT. 72

retained a number of smaller florists and gardens. At the time he was living there, for instance, a widow named Madame Jessin was listed as a "private florist" living directly across from the artist at 122, rue de la Tour.[3]

This painting is one of the first Vuillard painted in the distemper technique on plain paper of a series inspired by the streets and squares of the Passy district. He exhibited six of these under the rubric "Paris" in his important retrospective exhibition at the Bernheim-Jeune gallery in November 1908.[4] Now known as *Florist's Garden*, this work was probably among these, under the title *Par la fenêtre*. Also listed under "Paris" were *Square Lamartine* and four other panels showing

Passy streets (see cat. 73–74, figs. 1–2). The last four were purchased by the playwright Henry Bernstein (see cat. 73–74), who also commissioned from Vuillard a four-panel ensemble in 1908 (see cat. 75–79).

By choosing to paint views from his window, Vuillard was clearly drawing upon the Impressionist tradition made famous by Monet, Pissarro, and Caillebotte, all of whom painted the urban landscape from a similar vantage point.[5] Bonnard, too, had taken up this subject beginning in the mid-1890s, creating an album of lithographs published in 1899 entitled *Some Aspects of Life on the Streets of Paris* and executing a variety of works in the first decade of the twentieth century on that subject.[6] In 1906, Vuillard wrote to Félix Vallotton about Bonnard's move to a studio on rue de Douai and how much he admired the street scene Bonnard was working on. Describing Bonnard's work as "a fragment of Paris seen from the windows . . . with the bustling, crowded, boulevard de Clichy at the bottom," Vuillard went on to write, "All of this enchants me always and pleases me enormously."[7] In works such as *Florist's Garden* and *Florist's Garden, Rue de la Tour* (fig. 2),[8] Vuillard could explore the Passy landscape from the vantage point of his apartment in a way that he had not been able to do in his previous residence, which looked out onto the "small, cramped courtyards" of the Batignolles quarter.

229

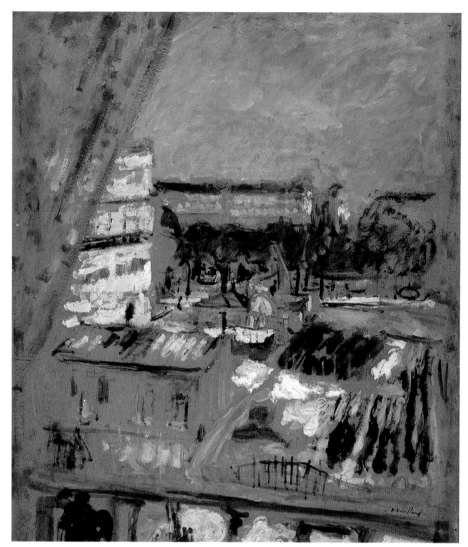

FIG. 2
Edouard Vuillard. *Florist's Garden, Rue de la Tour*, c. 1908. Distemper on paper, mounted on canvas; 52.5 x 46 cm. Private collection, Paris. Photo: Courtesy of Salomon archives, Paris.

Florist's Garden distinguishes it from the soft, pastel-like tones of many of Vuillard's other works, also executed in distemper and exhibited in 1908, such as his Brittany landscapes and his vertical views of Passy (see cat. 73–74, figs. 1–2). Perhaps the unusually vivid hues of this lush and sunny scene reflect his initial enthusiasm for his new surroundings.

Within a short time, however, Vuillard's feelings changed. The "Cannes-like" atmosphere and suburban tranquility of this area, along with its distance from the city's center, soon became oppressive for the artist, accustomed as he was to being psychologically and geographically connected to his friends. His slightly later, vertical views of Passy streets can even be interpreted as a subtle indictment of the area (see cat. 73–74). In 1908, Vuillard moved back to the Clichy district (near his old Batignolles neighborhood), where he was to paint from his window the ever-changing Place Vintimille (see cat. 75–80, 83).

CAT. 73–74

EDOUARD VUILLARD

73 *Avenue Henri-Martin*
c. 1908
Oil on paper, mounted on canvas
198.1 x 50.8 cm (78 x 20 in.)
Grace Hokin, Palm Beach, Fla.
NEW YORK ONLY

74 *Bois de Boulogne*
c. 1908
Oil on paper, mounted on canvas
198.1 x 50.8 cm (78 x 20 in.)
Grace Hokin, Palm Beach, Fla.
NEW YORK ONLY

In *Florist's Garden, Rue de la Tour* (fig. 2), the balcony railing visible along the bottom and the swag of curtain at the left give a sense of perspective. Vuillard used a similar, but less obvious, device in *Florist's Garden*, a hazily defined strip of reddish brown at the bottom of the composition, which acts as a ledge or windowsill, helping to identify the vantage point of the panoramic view. In this way, the painting is similar to another large landscape view by Vuillard, *Window Overlooking the Woods* (cat. 41), which also incorporates the conceit of window ledge or roof top. In *Florist's Garden* this ledge orients the viewer and creates a sense of depth (as do the gently angled orthogonals formed by the roofs of the buildings and shops at the sides of the composition), even as the decorative patches of color throughout simultaneously create a flattened effect. The fiery pink-and-orange palette of

WHEN VUILLARD LIVED BRIEFLY IN THE Passy area of Paris, from about 1904 to 1908, he documented the streets near his apartment in a number of studies. Two of these studies, *Avenue Henri-Martin* and *Bois de Boulogne*, executed in oil on paper, apparently were never exhibited. They are closely related, however, to a group of four tall (over six-foot-high), narrow panels (see figs. 1–2) that were exhibited in November 1908 at the Bernheim-Jeune gallery under the general heading "Paris," and

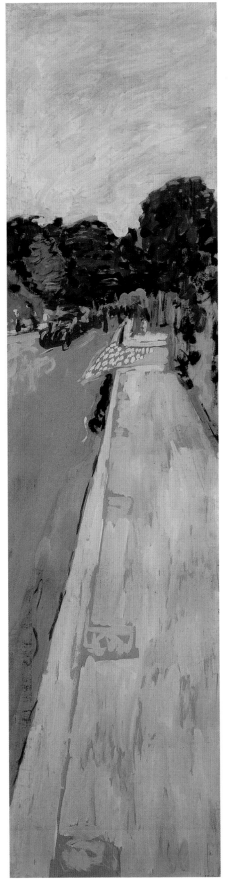

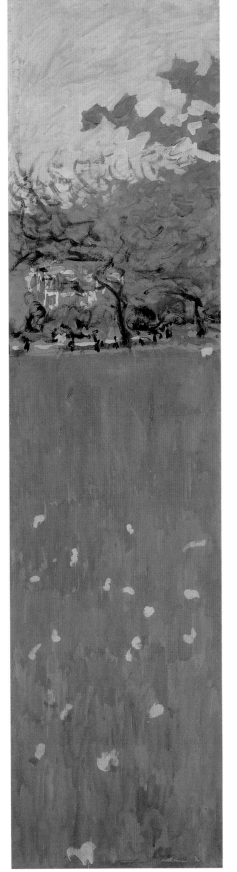

CAT. 73

CAT. 74

were purchased at that time by Henry Bernstein, a Jewish playwright whose provocative play *L'Israël* opened that year at the Théâtre Réjane.[1]

Avenue Henri-Martin and *Bois de Boulogne* share with the Bernstein panels the compositional formula of a relatively empty foreground with buildings or trees pushed to the background. In *Avenue Henri-Martin*, the lines of a sidewalk and street bisect the picture vertically at a slight angle and create a sense of deep perspective. The street level vantage point of the artist contributes to the picture's immediacy.

The street series offers few indications that Passy was a high-rent, exclusive neighborhood, since there are few signs if any of its monied inhabitants. *Bois de Boulogne* and *Avenue Henri-Martin* are completely devoid of human presence, while the child in *Child Playing in a Gutter* (fig. 2) and the portion of a woman's coat just visible in the foreground of *The Eiffel Tower* (fig. 1) give only very generalized indications of the life in the area. Unlike the panels commissioned by Bernstein in 1908 to complete the series, which document the activity of a popular middle-class Paris square, Place Vintimille (see cat. 75–79), the Passy scenes are generic and anonymous. Indeed, Vuillard chose to focus not on the suburban activities and sophistication of this area, but on its spatial and natural aspects. In *Avenue Henri-Martin*, for example, he presented the grand, divided boulevard, with its island of stately chestnut trees, completely devoid of elements such as horses, people, and dwellings that would help to humanize the scene and orient the viewer.

Bois de Boulogne, a panel whose identical size and technique make it a likely pendant to *Avenue Henri-Martin*, is equally devoid of such details. Here, however, Vuillard shifted his viewpoint from a sidewalk to an expansive green lawn. Instead of the rushing orthogonals of *Avenue Henri-Martin*, here he presented a frontal view of a private home or luxury apartment building seen through tree branches and foliage. White splotches of paint in the foreground indicate flowers studding the grass and help situate the artist and viewer. The title suggests that the scene is a section of the fashionable public park known as the Bois de Boulogne, which bordered the Passy area.[2]

In these two works, Vuillard insisted on the naturalistic aspects of the muted, unpicturesque, and relatively abandoned street and park, giving them a melancholy mood. Unlike the lively *Place Vintimille* panels (see cat. 75–79) painted to complete this series

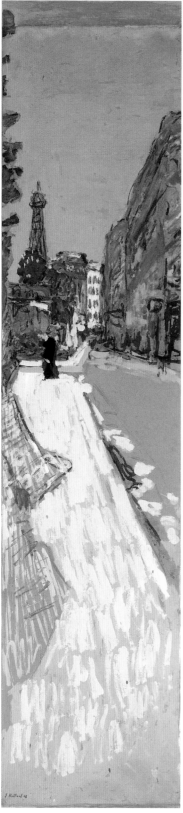

in 1909/10, which reflect Vuillard's contentment at being back in a familiar neighborhood, it is possible to read the Passy panels as revealing the painter's discomfort in an alien one. He felt too removed from his intimate circle of friends (Bonnard, Misia Edwards, Lucie Hessel, and Thadée Natanson), who lived closer to the city center. While he now resided near his dealers, Josse and Gaston Bernheim, who lived on avenue Henri-Martin, and his customers, he noted in his journal more than once during this period his disdain for the *haut bourgeois* community in which he now lived but to which he did not belong.[3] Instead of functioning as a *flâneur*, who takes in everything and is himself part of what he observes, Vuillard positioned himself as a disinterested *documentaliste*, noting in schematic fashion the effects of a walk through these recently developed suburban avenues.[4]

Because these paintings were not commissioned, Vuillard may well have felt freer to assume the role of outside observer and to employ a looser technique than in his commissioned decorative paintings. In these more personal works, he did not have to tailor his style or choice of subject matter to a patron's taste. The lighter palette, the bold, almost violently brushed surfaces, and the cheap paper support (later glued to canvas) are similar in spirit to his smaller, airy, seaside landscapes such as *Promenade in the Port, Le Pouliguen* (Musée d'Orsay, Paris), painted in the summer of 1908 and exhibited that fall with the Bernstein panels.[5] Indeed, these street scenes and related marine paintings allowed Vuillard to explore unknown territory with a directness and freedom that were new to his work, being outside the limitations of commissioned decorative works and of portraiture.

FIG. 1
Edouard Vuillard. *The Eiffel Tower*, 1908. Distemper on paper, mounted on canvas; 194 x 65.1 cm. Private collection.

FIG. 2
Edouard Vuillard. *Child Playing in a Gutter*, 1908. Distemper on paper, mounted on canvas; 194 x 65 cm. Private collection.

FIG. 1

FIG. 2

CAT. 75

EDOUARD VUILLARD

Place Vintimille, 1909/10

75 Study for *Rue de Calais*

Distemper on paper, mounted on canvas

165.1 x 47 cm (65 x 18 ½ in.)

The Armand Hammer Collection, UCLA, at the Armand Hammer Museum of Art and Cultural Center, Los Angeles

76 Study for *Place Vintimille*

Distemper on paper, mounted on canvas

196 x 69 cm (77 ⅛ x 27 ⅛ in.)

Kunsthandel Wolfgang Werner, Bremen/Berlin

Kunsthandel Sabine Helms, Munich

CHICAGO ONLY

77 Study for *Place Vintimille*

Distemper on paper, mounted on canvas

196 x 69 cm (77 ⅛ x 27 ⅛ in.)

Kunsthandel Wolfgang Werner, Bremen/Berlin

Kunsthandel Sabine Helms, Munich

CHICAGO ONLY

78 *Place Vintimille*

Distemper on cardboard, mounted on canvas

200 x 69.5 cm (78 ¾ x 27 ⅜ in.)

Solomon R. Guggenheim Museum, New York, Thannhauser Collection, gift of Justin K. Thannhauser, 1978

NEW YORK ONLY

79 *Place Vintimille*

Distemper on cardboard, mounted on canvas

200 x 69.9 cm (78 ¾ x 27 ½ in.)

Solomon R. Guggenheim Museum, New York, Thannhauser Collection, gift of Justin K. Thannhauser, 1978

NEW YORK ONLY

IN 1908, THE PLAYWRIGHT HENRY BERNSTEIN purchased four panels by Vuillard depicting the streets surrounding the artist's apartment on rue de la Tour in the Passy district of Paris (see cat. 73–74). He then commissioned four more panels of a similar vertical format to complement the earlier ensemble, by then installed as door panels in his dining room.[1] Vuillard worked on the commission over the next several years, executing numerous studies (cat. 75–77) of

233

CAT. 76

CAT. 77

the view of Place Vintimille from his apartment. The final paintings, comprising three different views of the square itself forming a loosely defined triptych (cat. 78–79 and fig. 1) and a view of Vuillard's street (fig. 2), were finally installed in 1910.

The subject of the Place Vintimille series was no doubt prompted by the artist's change in residence from the up-scale (but in Vuillard's mind, much too quiet) Passy district to 26, rue de Calais, just off Place Vintimille (now Place Adolphe-Max) and close to the Vuillards' previous residence on rue Truffaut. On 18 July 1908, Vuillard noted in typical telegraphic style his relief at making the final move to his old neighborhood and a new fourth-floor apartment:

Got up at 9:30, the move all ready. Telephoned the Bernheims. Leave rue de la Tour at 11:30 with the intention of never returning to their neighborhood. Pleasure at being again at Clichy. . . . Apartment pleases me. Still not discouraged.[2]

Even before moving, while thoroughly scouring the neighborhood for a place, he had begun to make sketches, if not paintings, of the streets around the square. His apartment on rue de Calais was situated on a corner, offering him multiple views onto the square, as well as onto rue de Vintimille, which ran perpendicular to rue de Calais.

It was the bustling life animating this busy square that formed the subject of the three triptychlike panels known as *Place Vintimille* (cat. 78–79 and fig. 1). Although these works are often referred to as a triptych because of their shared dimensions and their seemingly continuous, panoramic view of the square, they were probably more loosely connected, as indicated by their different horizon lines and variations in style.[3] Unlike the first set purchased by Bernstein, which presents open and empty streets rendered in cool blues and whites, the Place Vintimille panels show a variety of middle-class Parisians in a lively area largely painted in warm browns and grays. Executed during the winter of 1909–10, they feature hues evocative of the climatic conditions of that time of year, a season the French term *morne* and *maussade* (morose and melancholy). Vuillard's many works related to this project (pastel and painted sketches, full-scale preparatory paintings [cat. 76–77], and the definitive panels themselves) reveal his interest in the subtle variations of light and shadow and in the quality of the sky at this time of year.[4]

Vuillard's concern with capturing different aspects of the changing scene outside his window is especially interesting in light of some of the comments he wrote

CAT. 78

CAT. 79

in his journal after a visit he made with Bonnard to Monet's home and studio at Giverny in December 1909. Noting their host's grace and hospitality, Vuillard also remarked upon the paintings he saw there and Monet's "newness still for me." Writing two days later, Vuillard seemed to relate his visit to Monet and the work he had seen there to the Place Vintimille project: "Project for the Bernstein paintings. Memories of Monet. General ideas. Difficulty to finish."[5] Vuillard's interest in the older artist must have been piqued by this visit, during which he could have seen (perhaps for the second time) many of the forty-eight *Paysages d'eau* (water-lily paintings) exhibited the previous May and June at the Durand-Ruel gallery.[6] He may also have seen and studied Monet's highly atmospheric *Tugboats by Charing Cross Bridge* (1904; Mr. and Mrs. Werner E. Josten, United States), which was in Bernstein's collection at that time.

As if encouraged by the master Impressionist, Vuillard began noting regularly his temperament and the weather conditions, both of which affected his work on the panels. On 14 December 1909, he wrote: "Beautiful weather. Moving along. Spend my time at the window. Small pastels for Bernstein's panels. Somewhat feverish intoxication and awkwardness. No rapid progress." On 11 January 1910: "Decided to make Bernstein's fourth panel. Pastel cloud has just begun to take shape, a day shut in, excited"; and on 18 January 1910: "Return to the rue de Calais sketch. Pastel effect of the rain. Corner of the square." A month later, on 13 February 1910, he noted work on the "houses in the sun."[7] His execution of the project (and comments about it) continued right up to the week before he was to deliver it to Bernstein: "Raise my eyes to have another look. Touching up the fire[?] to finish. Beautiful weather. Idea of harmony."[8]

The climatic differences Vuillard wrote about in his journal are more noticeable in the full-scale studies for the left and right panels of the "triptych" (cat. 76–77).[9] In the left panel, the sun breaking through the clouds is dramatically indicated by a brilliant lemon-yellow wedge of light, which falls across the foreground, illuminating the street. The row of houses in the background is also illuminated, while the right panel is mostly in shadow. In the final panels (cat. 78–79), Vuillard paid even greater attention to the play of sunlight on the clouds above and on the street below. He decreased the sharp contrasts between light and shadow, however, perhaps in an effort to harmonize the panels as a group.

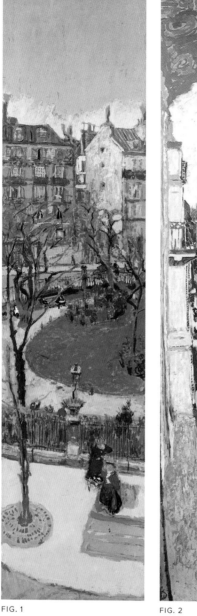

FIG. 1 FIG. 2

The studies for the left and right panels of the "triptych" are on a scale similar to that of the finished works, but are bolder, less detailed, and sketchier in handling. In the studies, Vuillard was primarily concerned with establishing the panels' main forms and color relationships. The artist used a wide brush to divide the surface into large areas of color, to which he added smaller accents with a narrower, pointed brush, in the form of scrawls, hatchings, and sweeping lines.[10] Interestingly, no such worked-up study exists for the central panel (fig. 1), which has a different canvas weave, a slightly different palette, and a less atmospheric sky than the flanking panels, thus supporting the idea that they were not necessarily conceived as a unified view of the square.[11] Indeed, all three panels present slightly varying views and perspectives, so that it is hard to imagine them fitting together edge-to-edge in a triptych format. Perhaps Vuillard approached each composition from a slightly different angle, or perhaps these shifts in perspective are due to his use of photographic aids. For the final paintings, he used the same palette, but employed tighter, more flickering brushwork (except for the central panel, which is more freely brushed and less precisely detailed than the flanking panels). The tighter execution confers a greater sense of activity and detail to this city park, with its nannies and their wards, old women seated on benches, horse-drawn carriages, men reading newspapers, and couples *en promenade*.

The fourth panel for Bernstein (fig. 2) features a view from Vuillard's corner window of rue de Vintimille, running almost perpendicular to rue de Calais. For this work as well, Vuillard made a full-scale study, or perhaps what could be considered another version, given its high degree of finish (cat. 75). This study was cut down by approximately one foot at a later date, presumably to suit the needs of a subsequent installation in a private residence.[12] In the final work, Vuillard included a section of the balcony on the story above him as well as the heavy stonework that marked the building's corner.

On 26 March 1910, Vuillard arrived with the panels, newly mounted on canvas, at the Bernstein residence, and was shocked to be greeted by Bernstein in his bathrobe. The artist, rather conservative by nature, left, "unnerved, wanting almost to cry."[13] Unfortunately no photographs or descriptive accounts exist to suggest how the six-foot-tall views of Paris streets and squares fit into Bernstein's bachelor apartment on boulevard Haussmann, described variously as having stark, white lacquered walls trimmed in black, or arranged *à la japonaise* in beige silk.[14] Bernstein's daughter and biographer listed the eight panels Vuillard executed as having been inserted in the "double doors facing into the salon on one side and into the dining room on the other," an arrangement that would have undermined the spatial relationships between the three panels depicting the square.[15]

Bernstein's collecting interests were most intense between 1909 and 1910; he not only bought and commissioned works by Vuillard, but purchased most of his collection, including examples by Renoir, Matisse, and Picasso. In June 1911, following the fallout from his

scandalous play *Après moi*, which had opened in February 1911 and closed in March, Bernstein liquidated his collection at Hôtel Drouot, selling works by Bonnard, Cézanne, Renoir, and Vuillard, but keeping the eight decorative panels. The panels remained with Bernstein when he and his wife (as of 1915) moved with their daughter to Pau in 1917 and then returned after World War I to Paris, where they were reinstalled in the dining room of their apartment at 110, rue de l'Université.[16] They subsequently traveled with the Bernsteins when they escaped to the United States at the beginning of the German occupation. In 1948, all eight panels were sold to Justin Thannhauser. Ten years later, Thannhauser sold six—including the central panel of the "triptych"—to a private collector, thus breaking up the ensemble.

Just as his earlier *Public Gardens* series had marked a turning point in Vuillard's career as a young Nabi artist (see cat. 32–33), the Passy and Place Vintimille panels demonstrate Vuillard's new sensibility toward the minutely observed, which resulted in decorative works with decidedly realist aims. While his exploration of the cityscape of Passy was isolated, Vuillard returned to the subject of Place Vintimille in other ambitious decorative projects, including the five-panel screen executed in 1911 for the American Marguerite Chapin (cat. 80) and the monumental view of Place Vintimille under construction, commissioned in 1915 by the industrialist Emile Lévy (cat. 83).

CAT. 80

EDOUARD VUILLARD

Five-panel Screen for Miss Marguerite Chapin: Place Vintimille, 1911

Distemper on paper, mounted on canvas
Five panels: each panel, 230 x 60 cm (90 ½ x 23 ⅝ in.)
National Gallery of Art, Washington, D.C., gift of Enid A. Haupt, 1998.47.1

THIS FIVE-PANEL SCREEN OF A SUN-FILLED day on Place Vintimille in Paris represents Vuillard's last effort in the screen format. It was commissioned by the young American Marguerite Chapin, whose apartment, at 110, rue de l'Université, Vuillard visited frequently between 1910 and 1912.[1]

Vuillard had first met Chapin on 11 March 1910, when he was invited, along with Bonnard and the Romanian prince Emmanuel Bibesco, to her home for lunch. Their meeting led to Vuillard's infatuation with Chapin and to a series of important commissions. The following month, he began work on an intimate portrait of his patron in the interior of her aunt's home on avenue d'Iéna (1910; Fitzwilliam Museum, Cambridge).[2] By October 1910, Chapin had commissioned the thirteen-foot-tall panel in distemper known as *The Library* (1900–30 Intro., fig. 3), which is perhaps Vuillard's most enigmatic and least appreciated *décoration*. His work on the project lasted a little over six months. *The Library* was installed on 5 May 1911, at which time Vuillard noted modestly, "not a bad impression of my painting."[3]

Apparently Vuillard had already been commissioned to paint the five-panel screen (cat. 80) by this time, since a week later he recorded in his journal that he was "taking up again" work on the screen.[4] Unlike the monumental *Library*, for which Vuillard made many sketching trips to the Louvre and executed a full-scale study in distemper,[5] the Place Vintimille screen was completed rather quickly. Charcoal underdrawing visible in some areas of the screen, for instance, supports the theory that Vuillard did not use a full-scale preparatory study for this image, which he instead drew directly onto the paper support. His rapid progress can be explained by his familiarity with the subject; he had already created a four-panel ensemble depicting Place Vintimille for Henry Bernstein in 1909/10 (see cat. 75–79). By the end of June, the Chapin screen was ready to be mounted onto a wood support and backed with wallpaper.[6]

Whereas the heavily encrusted *Library* (retouched in 1912–13 and 1936) features multiple and seemingly disjointed themes, the screen is a freely brushed celebration of one subject: the teeming life of a Paris square. Vuillard no doubt relied on photographs of Place Vintimille he took from a single spot but in slightly different directions. A photograph of the view of the left half of the square (fig. 1), for instance, was taken from almost the exact vantage point and angle that Vuillard used for the left half of the screen. While he clearly utilized photographs to capture accurately details of the scene, he was not completely bound by them. It is clear, for example, that he manipulated the space of the composition for decorative effect, organizing it so that the joints of the screen appear exactly at divisions in the fence around the square (such as the

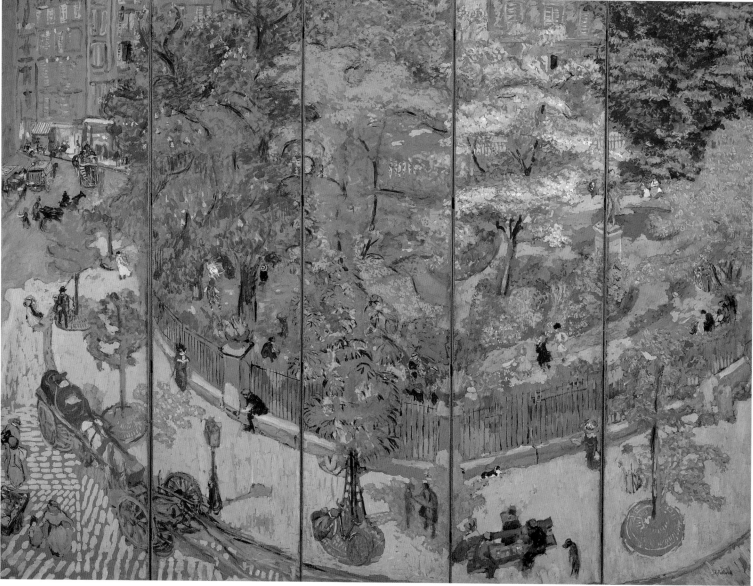

CAT. 80

stone marker at the right side of the third panel from the left, which is literally bisected by the vertical fold).

In contrast to the gray, almost shadowless, wintery day depicted in the Bernstein panels (see cat. 75–79), the bright day scene here allowed Vuillard to create greater contrasts between light and shade and to let the deep shadows cast by lampposts, benches, trees, and people create additional patterns in this animated scene. The paper Vuillard employed as the neutral ground color for this work (as he had for the Bernstein panels) has reddened with age and exposure to light. While this darkening of the support creates a rich and satisfying image, it also compromises the intended harmony between what was originally a pale beige backdrop, the light green-and-yellow foliage, and the pale peach paving stones and sidewalk.

Like Bonnard's street scenes from the 1890s, which are replete with anecdotal vignettes of life on the street, Vuillard's screen is nearly caricatural in its renderings of Parisians at work and play. In the center panel, for example, behind the tree with its iron scaffolding against which a bicycle leans, one sees the curled-up legs of a reclining figure wearing blue pants, possibly a worker but also quite possibly a *clochard* (a homeless person), whose presence clashes with the otherwise productive activities on view. As Claude Roger-Marx remarked, Vuillard's all-inclusive treatment of this urban scene is analogous to his care-

FIG. 1

FIG. 1
Edouard Vuillard. Photograph,
1911/12, of Place Vintimille.
Salomon archives, Paris.

FIG. 2
Photograph, c. 1980, of cat. 80
as a folding screen. Photo: *House
and Garden* 157, 9 (Sept. 1985),
p. 129.

FIG. 2

fully observed and transcribed portraits—especially
the representations of his mother:

In this tiny square, similar to so many others, with its railings, its
paths, its bushes, its imprisoned chestnut and plane trees, its
lamps and its statue, all Paris is resuméd as a son's affection is
resuméd by the traits, similar to so many others and yet incom-
parable, by that immense and limited universe, which is the face
of the mother.[7]

Although he probably conceived the composition as
one continuous surface, Vuillard ingeniously calculated
the many permutations that this scene could take
given the folding-screen format. As seen in a photo-
graph of the screen as it looked in its last private inte-
rior, (fig. 2), the shifting angles of the folds counteract
the effects of deep space and surface decoration,
negating the panoramic expanse and creating the
visual experience of scenes that can be read vertically
as well as horizontally.[8]

It is not known how the screen fit into Chapin's
ground-floor apartment. Vuillard recorded several
times the effect of *The Library* in that residence, hung
in a room opening onto a garden designed in the sev-
enteenth century by André Le Nôtre, but made no
mention of the screen's destination. Just three short
months after delivering the screen, however, it was *The
Library* that weighed heavily on Vuillard's mind, since
Chapin had returned it to him. The reason for this
about-face seems to have been her rather sudden
engagement to the Italian noble Roffredo di Caetani,
Prince of Bassiano, who apparently could not accept
the larger-than-life vision of this *féerie bourgeoise*, or
bourgeois fairy-land, as decoration.[9]

The screen, however, was not among the casualties
of the Chapin-Bassiano marriage; it moved from the
family's rue de l'Université home to Villa Romaine at
Versailles, to Rome (during the war), and back to
Versailles, where it remained until Marguerite, who
had by then shifted her art interests to the Italian
Futurists and to Surrealism, sold it to Albert Henraux.[10]

CAT. 81

CAT. 81

EDOUARD VUILLARD

Place St.-Augustin, or *Little Carts in June:*
Seltzer Bottle, 1912–13

Distemper on paper, mounted on canvas
156 x 193 cm (61 ⅜ x 76 in.)
Private collection, London

THIS PICTURE BELONGS TO ONE OF VUILLARD'S
most compositionally complex decorative
projects, which also happens to be one of his
least known. It is one of two panels depicting Place
St.-Augustin (see also fig. 1) exhibited in 1913 simply
as "decorative panels" for no specific patron or inte-
rior. Jacques Salomon stated that the panels were com-
missioned by Henri Vaquez, the cardiologist for whom
Vuillard had painted four panels known collectively as
Figures in an Interior in 1896 (see 1890–99 Intro., figs.
20–21).[1] In 1914, however, a year after they were first
exhibited, Achille Segard correctly listed them in his

FIG. 1

FIG. 2

FIG. 1
Edouard Vuillard. *Place St.-Augustin*, or *Little Carts in June: Woman with Rose*, 1912–13. Distemper on paper; 154.9 x 194.3 cm. The Minneapolis Institute of Arts, bequest of Putnam Dana McMillan.

FIG. 2
Pierre Bonnard. *Place de Clichy*, 1912. Oil on canvas; 139 x 205 cm. Musée des Beaux-Arts et d'Archéologie, Besançon, gift of Georges and Adèle Besson.

inventory of Vuillard's decorative art under "works executed without destination," as they were in fact acquired by the Bernheims and then by Jos Hessel before Vaquez purchased them in 1920.[2] Certainly this Impressionist subject of people crossing a public square, reminiscent of Degas's *Place de la Concorde* (c. 1876; The State Hermitage Museum, St. Petersburg),[3] would have seemed to Vaquez an appealing counterpart to the densely patterned interiors Vuillard had painted for him in 1896. The views of Place St.-Augustin in the eighth arrondissement would also have held personal significance for the doctor, who lived until 1928 just down the street from the square at 27, rue du Général-Foy.

Vuillard himself had reasons for painting this section of the city. In 1909, he began renting a large studio at 112, boulevard Malesherbes, which intersected with the square. As a part-time resident of this neighborhood, Vuillard was also geographically close to Thadée Natanson, who lived a block away from Place St.-Augustin on rue de Laborde, and whose second wife, Reine, Vuillard painted around this time.[4] Lucie Hessel also lived nearby, at 33, rue de Naples, and her husband's gallery, with which Vuillard had recently become associated, was located on rue La Boétie, which also intersects Place St.-Augustin.

According to Vuillard's journal references, he started to work on the paintings in May or June of 1912, but stopped when he began a more pressing commission for the Théâtre des Champs-Elysées.[5] On 12 April 1913, he returned to the St.-Augustin panels, finishing them in June, the month he retained as part of their early shared title.[6] As Salomon pointed out, Vuillard

positioned himself at a sidewalk café that allowed him multiple views of the intersection. After having painted numerous images of Place Vintimille from the vantage point of his apartment in the winter of 1909–10 (see cat. 75–79), he now assumed, in spring of 1913, a street-level position just inside the restaurant, so that he could incorporate the patterned awning of the sidewalk café into a decorative border. In conceiving this stagelike setting of a busy urban intersection, Vuillard relied on a strategy he was using at the same time for his murals for the Théâtre des Champs-Elysées, *Le Malade imaginaire* and *Le Petit Café*, both of which were framed at the top by a painted border suggesting the stage curtain of the theater itself. He undoubtedly also knew Bonnard's large-scale decorative painting *Place de Clichy*, commissioned in 1912 for the dining room of the art critic Georges Besson (fig. 2), which presents a similar stagelike setting topped by a decorative border resembling an awning.

The second panel depicting Place St.-Augustin (fig. 1), with its elegant foreground figure silhouetted against a bright and massive yellow building (formerly a military barracks, known as the Caserne de la Pépinière), is spiritually close to Bonnard's scene of Parisians passing by a café lit by a bright summer sun.[7] Both artists turned to the Impressionists' theme of life on the street. In *Place de Clichy* Bonnard painted a friezelike and flattened view from the inside of a café, whereas Vuillard opened up his composition to include much deeper space, allowing a wide-angle vista of the Place St.-Augustin intersection.

The result, in fact, is not unlike Caillebotte's famous view of a radial intersection of Paris streets,

Paris Street; Rainy Day (1876–77; The Art Institute of Chicago). Like the Caillebotte painting, the St.-Augustin panels invite closer observation of the myriad details that lead the eye further and further into the scene, while at the same time retaining their decorative effect. But Caillebotte's insistent, smooth rendering contrasts with Vuillard's broadly brushed patches of color, which serve both to create a sense of depth and to function as ornamental surface patterning.

In the *Seltzer Bottle* panel (cat. 81), Vuillard eschewed one-point perspective, instead constructing space using several orthogonals that do not converge, but lead off beyond the buildings onto rue La Boétie (slightly right of center) and boulevard Haussmann (at the far right). At the center of the composition stands a flower cart from which a woman wearing an ivory-collared navy-blue dress and a large feathered hat and accompanied by a small brown-and-white dog, makes a purchase. This one vignette among many is unique in being the only one that is carried over into the second panel (fig. 1). This pendant seems to represent a subsequent moment in time, when the woman, having completed her transaction, strides briskly away from the flower cart while her dog lags behind, sniffing the ground. Vuillard also repositioned himself for this second painting in order to take in the other side of the square, with boulevard Malesherbes at the left and the smaller avenue César-Caire at lower right running behind the woman with the roses.

The effect of these panels is cinematic, as Vuillard, in the role of director, used the tilt of chairs and the angle of carts, carriages, buildings, and streetlights to steer the viewer into and around this animated thoroughfare and through different moments in time. As Claude Roger-Marx described it, Vuillard presented the square as a stage set or a track on which "circulate all sorts of vehicles, market-carts, dogs, cyclists, pedestrians, and motor-buses."[8] Placed side-by-side, these panels present a fish-eye view of the entire square. Vuillard was not, however, thinking panoramically (as in his *Place Vintimille* panels; cat. 75–79), but rather presenting with equal emphasis related incidents separated spatially and temporally.

A little over a year after these panels were completed, the sense of confidence, stability, and bustling productivity they convey would be dramatically shaken by the outbreak of war.

CAT. 82

EDOUARD VUILLARD

Tea in a Garden at the Water's Edge, 1913; reworked c. 1934

Distemper on canvas
192.1 x 234.3 cm (75 ⅝ x 92 ¼ in.)
Private collection, courtesy Galerie Bernheim-Jeune
NEW YORK ONLY

THIS PANEL IS FROM A SERIES OF AT LEAST nine large paintings commissioned in 1911 by Vuillard's dealers, Josse and Gaston Bernheim, for their sumptuous summer home, Bois-Lurette, in Villers-sur-mer, Normandy. Two of the panels from this series, *Woman and Child on a Veranda* (1912; location unknown) and *Two Women Embroidering on a Veranda* (1912; Musée d'Orsay, Paris), were exhibited at the Bernheim-Jeune gallery in April 1912 as an *encadrement de porte*, or door surround.[1] Five more panels, *Two Women under an Awning* (fig. 1), *Tea in a Garden at the Water's Edge* (cat. 82), *Woman at a French Window* (1912; private collection, London), *Woman in Blue Embroidering before a Window* (1913; private collection), and *People Seated around a Set Table* (1912; private collection, Washington, D.C.), were exhibited at the same gallery the following year under the rubric "Five Decorative Panels for the Vestibule of a Villa," before they were installed in the Bernheims' country home.[2] Another panel from this series, *The Pavilions of Cricqueboeuf; In Front of the House* (1913; private collection), has recently come to light; it may have been exhibited at Vuillard's 1938 retrospective along with the rest of the ensemble.[3] The ninth major panel from this series may be an unidentified painting of two women in an interior, seen to the right of *Tea in a Garden at the Water's Edge* in a 1913 photograph of the panels installed at Bernheim-Jeune (fig. 2).[4] In addition to these larger works, Vuillard also executed two long and thin horizontal panels representing foliage.[5]

For Vuillard, the Bois-Lurette panels were a major undertaking in what was already a very fertile moment in his decorative career. He had recently completed a commission for a decorative portrait showing the surgeon Dr. Gosset in his operating room (*Surgeons*, 1912; reworked 1936; private collection, Paris), which he also showed at the Bernheim-Jeune exhibition in 1913.[6] In fact, this exhibition included

242

CAT. 82

several significant decorative works—the five Bois-Lurette panels, two of the six panels commissioned by Gabriel Thomas for the foyer of the Théâtre de Comédie in the architectural complex known as the Théâtre des Champs-Elysées, and the two large Place St.-Augustin panels (cat. 81; cat. 81, fig. 1).

The most personalized and architecturally specific of these various decorative undertakings were those for Bois-Lurette. Not only did many include in clearly identifiable portraits people of interest to the patrons (see fig. 1), but they were also carefully measured to fit the dimensions of the Bernheims' sitting room, in

between windows and doors and along the staircase wall. Whereas Denis frequently painted panels to fit particular architectural spaces (such as his 1912 commission for the curved ceiling of the Théâtre des Champs-Elysées; see 1900–30 Intro., fig. 7), this was Vuillard's first attempt at creating decorative paintings that had to fit irregular spaces.[7]

The photograph of two of the unframed paintings as they were exhibited in 1913 (fig. 2) reveals that *Tea in a Garden* was originally painted on a trapezoidal canvas in order to fit the incline of the stairway it was designed to decorate. Around 1934, when the Bern-

243

FIG. 1

FIG. 2

heims' villa was sold, Vuillard added a triangular piece of canvas to the top of the work, in order to regularize its shape, and partially repainted it.[8]

The majority of the panels for the Bernheims did not depict their own home or its immediate surroundings, but rather the Hessels' summer home, Les Pavillons, located in nearby Villerville. By 1911, Vuillard was a frequent visitor to Jos and Lucie's home, and their less extravagant abode served as a setting for many of his paintings from this time, such as *Sunny Morning* (1910; private collection, London).[9] Like *Tea in a Garden,* this earlier work also shows Lucie Hessel and Alexandre Natanson's daughter Denise.[10] By using a different setting from that of his patrons, Vuillard was repeating a thematic strategy for decorative painting that he had introduced in 1898 with panels for Jean Schopfer (1890–99 Intro., figs. 14–15). These do not represent Schopfer's property, but rather that of his friends Misia and Thadée Natanson at Villeneuve-sur-Yonne, where Vuillard had spent the previous summer. Schopfer and his wife appear only in the third and final panel for the project, completed in 1901.[11] Vuillard's intention for both the Schopfer and Bernheim commissions seems to have been to create representations of a parallel social world that would have been recognizable and of interest to his patrons, rather than simply to mirror their own surroundings.

In the Bois-Lurette series, for example, Vuillard included specific references to the Bernheims only in

Two Women under an Awning (fig. 1), which shows the celebrated beauties Mathilde and Suzanne Adler (sisters who were wives to Josse and Gaston, respectively) standing on what can easily be identified as the large front porch of Bois-Lurette.[12] Like *Tea in a Garden*, this picture features figures around a table, in what appears to be the lazy aftermath of a meal. In the former, the seated gentleman in a blue shirt (probably Jos Hessel) reads his newspaper and avoids interacting with the figures assembled around the table, including another seated male, whose presence is suggested by the crossed legs emerging from the lower right.[13]

While the Bois-Lurette panels are of different sizes and have widely varying palettes, ranging from yellow-orange (*People Seated around a Set Table*) to an almost monochromatic bluish white (*Woman and Child on a Veranda*), they are unified by their setting within the landscape of the Calvados region of Normandy, described by Claude Roger-Marx as "half field, half garden, impregnated with the smell of the sea."[14] The variations may be a result of Vuillard's careful observation of the ambient light of the rooms for which he was painting the panels and the modification of his palette to complement it.[15]

The dull, yellowish sky in *Tea in a Garden*, for example, suggests an overcast day and is mirrored in the muted, soft blues, greens, grays, and ochers that make up the scene. Of all the panels, this is the most Impressionist in subject matter and in the attention

paid to the effects of light and shadow. In September 1913, Vuillard made note in his journal of a lunch at Bois-Lurette with Claude Monet.[16] It is conceivable that this interaction influenced Vuillard's composition and treatment of light, which is so reminiscent of Monet's early works of Argenteuil and Bennecourt.

According to Emile Gruet, a longtime employee at the Bernheim-Jeune gallery, Vuillard's works functioned as summertime replacements for the more valuable easel paintings that filled the Bernheims' Paris home.[17] It would not have been considered safe to have expensive works at their Normandy residence, because they stayed at Bois-Lurette only once a year, and because of the less-than-ideal weather conditions of the Normandy coast.[18]

The panels—several of which had been been given a more regular shape and repainted by the artist by the time of his 1938 Paris retrospective—have, over the years, been dispersed. It is thus no longer possible to view as an ensemble these scenes of women and children (and occasionally men) eating, taking tea, writing, or sewing. But it is not hard to imagine that in their original format they served as a quintessential evocation of the *douceur de vivre* of pre-war France.

CAT. 83

EDOUARD VUILLARD

Place Vintimille, or *Berlioz Square,* 1915–16; reworked 1923

Distemper on canvas
162.6 x 228.6 cm (64 x 90 in.)
The Metropolitan Museum of Art, New York, promised gift of Anonymous Donor
NEW YORK ONLY

FOUR YEARS AFTER COMPLETING THE FIVE-panel screen for Marguerite Chapin depicting Place Vintimille (cat. 80), and some five years after his four-panel ensemble on the same subject (see cat. 75–79), Vuillard began what was to be his final grand statement on this Paris square, a site he found continually fascinating. The thematic, technical, and compositional changes Vuillard made to this last reprise of the subject reveal not only his increased familiarity with the scene, but also his new desire for a more defined and solid structural foundation in his

works.[1] Vuillard's vantage point was also different—in October 1913, he had moved from his fourth-floor apartment at 26, rue de Calais (from which he painted the first two decorations) to the second floor of the same building—resulting in a more direct engagement with the square.

The story behind this panel is both fascinating and disheartening. Vuillard began this decorative project for Emile Lévy in early June 1915, at the same time that he was completing a decorative frieze for this patron depicting a kind of allegory of the arts.[2] *Place Vintimille* was to be hung in Lévy's printmaking office at 73, rue Claude-Bernard. By the end of the second week of July, Vuillard had completed both a pastel maquette (private collection, Dallas) and a full-scale distemper-on-paper study (Musée des Beaux-Arts, Metz), with the aid of photographs (some of which are preserved in the Salomon archives, Paris) and quick sketches, such as one showing the right side of the panel (fig. 1).[3] Adding to the immediacy of the closer viewpoint was the urban drama taking place on the square itself—construction workers tearing up and rebuilding the sidewalk. In Vuillard's earlier images of Place Vintimille, the elliptical pavement between the street and the iron fence enclosing the square was occupied by dainty trees enclosed in iron grillwork, and a variety of animals and pedestrians. Here, casual passers-by and people using the park are secondary to the scene of men laboring in the foreground. If, as Claude Roger-Marx proposed, Vuillard's Place Vintimille compositions functioned analogously to the portraits he did of his favorite muses, such as his mother, whom he never tired of painting,[4] then this view of the square is a portrait of the artist's metropolitan muse, after she has lost her youthful looks and innocence. It is conceivable that Vuillard, who was probably given his usual *carte blanche* for this project, chose this spectacle not only for its significance to the immediate neighborhood, but also in order to allude to the labor in the trenches of the ongoing war. Too old to fight, he was engaged only briefly as a railroad crossing guard, and in 1917, as a wartime artist.[5] Perhaps he conceived this decorative mural as a kind of open-air trench in the heart of the Batignolles district.

In this image Vuillard combined a realist subject with the Impressionists' concern for atmospheric effects, while at the same time creating a tightly organized composition anchored by the wooden supports of the exposed sidewalk. Indeed, as Antoine Salomon pointed out, a shift had taken place in the

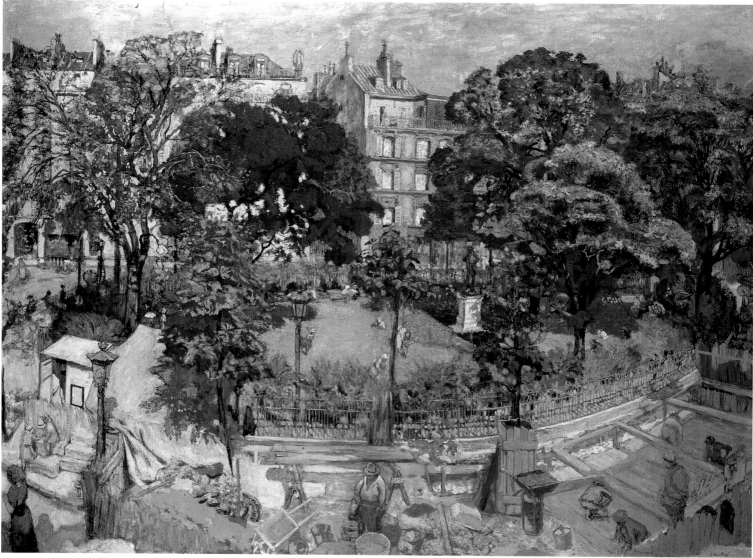

CAT. 83

treatment of the subject since his screen for Marguerite Chapin: "the nervous, sinuous linearity that so charmingly animates the screen's composition has been superceded in the later panel by an imposing formal design."[6] Vuillard centered the composition around a standing worker in a dirty white shirt who is aligned with a small tree directly behind him and a yellow apartment building through the trees in the background. The overall tone is solemn, almost resigned, as men (those who were unable to serve in the military) work quietly or contemplate their labors, heads lowered.[7] After watching the bourgeois spectacle of Place Vintimille for almost eight years and making it the subject of at least two highly successful decorative projects, it is interesting that Vuillard chose to show such a different face of the square in this dusty and sobering view. By choosing an overall blond

palette and by creating with glue-based distemper a chalky, thickly layered surface texture, Vuillard evoked the white of the cement, the grittiness of the foundation trenches, the patches of dirt where the grass had been worn down, and beyond this the bright yellow façade of the building in the background.

From the beginning, the project itself appeared difficult if not doomed. On 11 September 1915, Vuillard recorded in his journal a "visit from E. Lévy [who was] disappointed in the way the large painting looks now."[8] Lévy died suddenly on 23 January and Vuillard was left with the large, still-unfinished panel. He completed it by March 1916, when it was shown at Galerie Georges Petit.[9] Seemingly unable to find a buyer, the artist kept it in his possession. Probably for this reason, Vuillard was willing to let it travel to a number of exhibitions—to Zurich in 1917, to Pitts-

246

FIG. 1
Edouard Vuillard. *Place Vintimille*, c. 1915. Pastel on paper; 52 x 60 cm. Private collection. Photo: Paris, L'Oeil galerie d'art, *Vuillard et son kodak*, exh. cat. by Jacques Salomon and Annette Vaillant (1963), p. 11.

FIG. 2
Photograph, 1929, of Vuillard's panel *Place Vintimille* (cat. 83) installed in the Musée du Luxembourg. Photo: *Revue de l'art ancien et moderne* 55 (Jan.–May 1929), p. 143.

FIG. 1

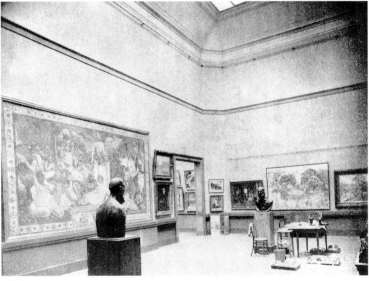

FIG. 2

Probably as a result of the exposure the painting received while on view at the Musée du Luxembourg, the French state considered acquiring it at this time. In a letter of 18 February 1929 to the Consulting President of the National Museums, a Monsieur Koechlin, Vuillard voiced his hesitation about being represented in the Luxembourg by this rather than another picture.[12] In a subsequent letter, Vuillard was even more direct: "Permit me to be frank—as I told you in my first letter, I'd prefer to be represented in an official museum by a different kind of painting than *Place Vintimille*."[13] Having established his position, Vuillard went on to add that his relationship with Kapferer, the work's current owner, motivated his resistance to this purchase. He then pointed out in jest that he (Vuillard) was still alive, and that there would be other opportunities for the state to purchase a work by him.[14] Apparently Koechlin insinuated in his response to this letter that Vuillard might well use the same excuses again at a later date, causing the artist to respond tersely in a subsequent letter that the official obviously did not understand the situation motivating his decision.[15] While one cannot know exactly what kind of work Vuillard wanted the state to purchase instead of *Place Vintimille*, it is possible that he preferred to be represented by the types of paintings that had given him his greatest success, such as his much-touted decorative portraits of the 1920s or his earlier Nabi compositions. One month later, the problem of Vuillard's official representation was solved when the state purchased three of his *Public Gardens* panels (see cat. 32–33) from the sale of Alexandre Natanson's collection in 1929.

Although the triptych from the *Public Gardens* series also depicts Paris parks, it is clearly more conventional in content than the *Place Vintimille* project, as it features the picturesque subjects of women and children relaxing and playing in a leafy surround. Possibly the aborted commission and the resulting panel, which remained for many years in Vuillard's studio, held enough negative significance for the artist that he was reluctant to have it stand officially for his entire career. Nevertheless, it remains an intriguing and beautiful document of a particular moment and place. Roger-Marx, who wrote fulsomely about the rare qualities of this work, regarded it as a remarkable and innovative "portrait" of a place. Clearly it is that aspect, over and beyond its function as decoration, which makes this work so fascinating and compelling today.

burgh in 1922, and back to Paris in 1923—before he finally sold it to Marcel Kapferer.[10]

Although the painting joined Kapferer's prestigious collection on avenue Henri-Martin, its fate remained unresolved. In 1928, Marcel lent the painting to the Salon d'Automne. A year later, he lent it to the Musée du Luxembourg for its reopening on 25 February 1929 as the "Musée des Artistes Vivants," featuring French art of the past forty years. There it hung in Gallery Five alongside works by Denis, René Piot, Roussel, and Toulouse-Lautrec, among others (fig. 2).[11]

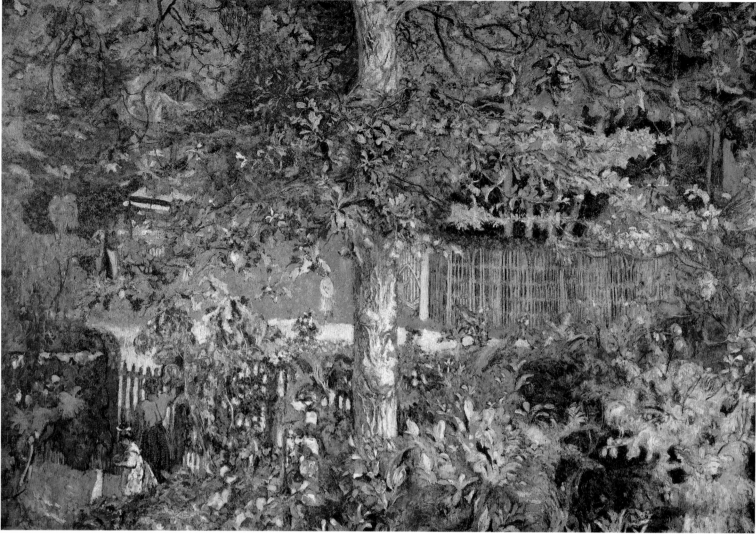

CAT. 84

CAT. 84

EDOUARD VUILLARD

Foliage: Oak Tree and Fruit Seller, 1918
Distemper on canvas
193 x 283.2 cm (76 x 111 ½ in.)
The Art Institute of Chicago, a Millenium Gift of
Sara Lee Corporation, 1999.373

AFEW YEARS AFTER VUILLARD COMPLETED
the decorative ensemble for Josse and Gaston
Bernheim's villa Bois-Lurette (see cat. 82),
another art dealer and friend of Vuillard, George
Bernheim (no relation), commissioned a decorative
mural for his Paris residence. Vuillard variously referred
to this work as "a scene of a fruit seller" (*scène de la
fruitière*) or as "foliage, oak tree and fruit seller" (*verdure

chêne et fruitière*), but it actually shows the grounds of
Closerie des Genêts at Vaucresson (a western suburb of
Paris, near Versailles), which the Vuillard family rented
every summer from 1918 to 1925. The *closerie,* or
enclosed property, of Genêts was situated on a tiny, L-
shaped, dead-end street in the oldest section of the vil-
lage.[1] There Vuillard vacationed along with his
mother; his brother, Alexandre, and his family; and
probably his sister, Marie, and her children, Annette
and Jacques. Vuillard may have been motivated to rent
a summer home here by the presence of his close
friends Lucie and Jos Hessel, who had rented since
1917 a property called Villa Anna in the same village.

The details of George Bernheim's decision to
commission this large panel from Vuillard are not
known. Vuillard's journal indicates that he began mak-
ing pencil sketches for the project at Closerie des
Genêts on 20 July 1918.[2] Five days later, he drew the

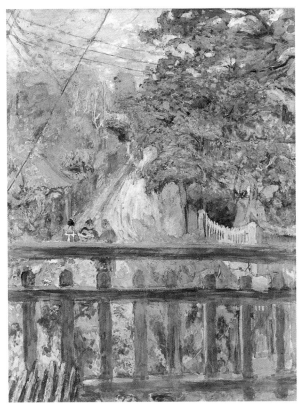

FIG. 1

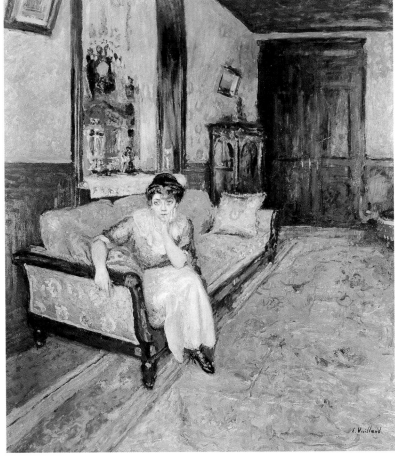

FIG. 2

projected composition, and on the next day ordered the over-nine-foot-wide canvas he intended to use for the painting to be delivered to his studio in Paris.[3]

For this work, Vuillard adopted the vantage point from his mother's second-floor window in the villa. Another, smaller canvas from around this time, *Countryside at Vaucresson* (fig. 1), shows the same view looking down onto the gated garden and through tree branches up the road. This street, barely discernible through the overhanging branches and foliage of the central oak tree in both the smaller easel painting and the *décoration*, is clearly legible in an unpublished photograph of the scene taken by Vuillard at this time.[4] In the final decorative painting, Vuillard enlivened the scene with more human elements, such as the cart and female fruit seller (probably one of the itinerant farmers common during the war) in the left middle ground and the women and children visible in the foliage throughout the composition.[5]

Vuillard's direct, close-up view of the property around the villa reveals a lush jungle of trees, bushes, and flowers. The foliage, which seems at once to cascade down from the top of the composition and rise from the bottom, nearly obscures the fruit seller, the woman and child at the gate, the child in the street directly to the left of the tree, and the woman, just discernible over foliage at the right, carrying a baguette. The spreading oak tree, which bisects this highly symmetrical composition, gives structure to the riotous greenery and serves as a vertical support and focal point around which the scene is organized.

On 12 August 1918, Vuillard returned to Paris and sketched the composition onto the canvas, which he began painting five days later.[6] His journal entries over the next months show that he divided his time between his Paris studio on boulevard Malesherbes, where he painted, and Vaucresson, where he continued sketching and making notations to incorporate into the final work. In many ways, this is an updated and more "Impressionist" version of the views from a window of the rolling hillsides of L'Etang-la-Ville he painted for Adam Natanson in 1899 (cat. 41; cat. 41, fig. 1). Devoid of the tapestrylike floral borders of these earlier works, *Foliage* is less overtly decorative. The distemper technique employed in the later painting, however, enhances the surface quality and veils the subject in thickly impastoed patches of soft green and blue, suggesting fresco paintings or murals.

At this time, Bonnard was also increasingly interested in rendering the effects of foliage and greenery,

249

executing his verdant *The Terrace* (cat. 55) in 1918. He wrote to Vuillard of his endeavors, and in response Vuillard informed his friend that he too had undertaken "a kind of *verdure* for which I have need of your way of lighting up the greens and blues, which I am only just discovering!"[7] The subject of Vuillard's letter then switched from painting to patriotism, as he seemingly associated his progress and enthusiasm for his work with his hope for the end of the war: "I'll work on it [*Foliage*] again with pleasure next week. Everyone around me is doing well and we are allowing ourselves to be carried away by hopeful dreams (*beaux espoirs*)." By late August, Vuillard and all of France had reason to be optimistic. The Germans' last attempt to win the war had been thwarted by Allied forces and, with the arrival of American troops, the end of the conflict seemed imminent. Vuillard was in his studio retouching *Foliage*, in fact, when the announcement of the signing of the Armistice reached Paris.[8]

Vuillard continued to work on the canvas, only considering it sufficiently finished to go to Bernheim at the end of December. The uneven and encrusted surface of this painting speaks to his numerous deliberations—painting and repainting the foliage, and altering and refining the light and shadow. Especially noticeable is the odd, riverlike swath of darker blue-green at upper left, possibly a later addition, which seems to interrupt the street as it curves to the left of the canvas.[9] Perhaps Vuillard's many reworkings were due to his lack of confidence in dealing with a new patron. If this was the case, Vuillard's concern may have been justified, as the reception of the work by the patron was volatile. On 29 December 1918, the day before Vuillard delivered the panels, Vuillard recorded a "terrible scene with George Bernheim apropos of the *verdure*."[10] It is uncertain in what respect the patron deemed the painting inadequate. Was the painting too large? Too confused? It should be mentioned that at this time, Bernheim's professional artistic tastes tended toward the Paris school, and his gallery represented Chagall, Derain, Dufy, and Utrillo, as well as Matisse and Picasso.[11] In contrast to the strong, brilliantly colored surfaces and accessible subjects that characterize the contemporary work of these artists, Vuillard's heavily encrusted painting relies on harmonious, delicate, and closely ranged tonal values that obscure and diffuse the subject. On the other hand, Bernheim's personal artistic tastes seem to have drawn him to Vuillard. Two years later, for instance, he asked Vuillard to paint a life-sized oil portrait of his wife, seated pensively on the edge of the sofa in their salon (fig. 2). Despite Bernheim's initial reaction to *Foliage,* it remained in his collection over the next two decades, and was shown in the Vuillard retrospective in 1938 with him listed as owner. There it hung alongside other decorative panels, including *Place Vintimille* (cat. 83) and *The Forge* (1917; Musée d'Art Moderne, Troyes).[12] The latter was part of a commission from the munitions factory owner Monsieur Lazare-Lévy for large murals depicting his largely female workforce lifting stacks of bombs and operating heavy machinery. It was a world foreign to Vuillard's experience and sensibilities, one he found disorienting and fascinating.[13] Both *The Forge* and *Foliage* show a wartime world largely devoid of men: the former depicts women taking on the traditional role of men and engaging actively in the war effort, the latter the more familiar world of women performing the duties of motherhood and thus of *la patrie.*

CAT. 85

EDOUARD VUILLARD

Morning in the Garden at Vaucresson, 1923; reworked 1937

Distemper on canvas
151.2 x 110.8 cm (59 ½ x 43 ⅝ in.)
The Metropolitan Museum of Art, New York,
Catharine Lorillard Wolfe Collection, Wolfe Fund, 1952

UNLIKE BONNARD AND DENIS, WHO OWNED homes outside Paris where they stayed and painted for long periods during the year, Vuillard never had his own property. His Paris apartment was rented, and during the summer months he generally stayed in the country (usually accompanied by his mother) with friends such as Jos and Lucie Hessel. Between 1918 and 1925, Vuillard and his mother rented the villa known as Closerie des Genêts in Vaucresson, near the Hessels' rented Villa Anna and their subsequent home, Clos Cézanne. This large panel, showing an intimate view of Clos Cézanne, reflects the close relationship Vuillard enjoyed with the Hessels and his familiarity with their property, which is the setting for numerous works from this period.

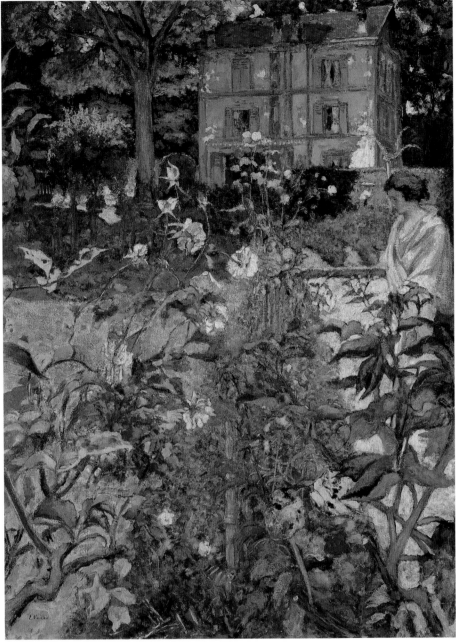

CAT. 85

Vuillard began this composition in 1923, and it remained in his collection for many years. He repainted it around 1937 (in preparation for his 1938 retrospective), long after the Hessels had moved in 1926 from Clos Cézanne (so-called because it was purchased with the proceeds of the sale of a Cézanne painting in 1920) to a fourteenth-century baronial mansion known as the Château des Clayes.[1]

In contrast with the grand Château des Clayes, Clos Cézanne (seen in the background of Vuillard's painting) was a modest, three-story, stucco-and-brick building surrounded by an enclosed garden. Apart from the rows of rosebushes and the rigidly pruned shrubbery in the background, the garden appears disordered in Vuillard's painting, with flowers and vines spilling over the fence railing and engulfing the figures working in it. Just visible behind the tangle of pink roses at the center is a woman, most likely Lucie Hessel, dressed in blue and wearing a sun hat, who is stooping to tend to the flowers. The younger woman in a bathrobe who looks on has not yet been identified, although she may be Tristan Bernard's niece Madeleine, whom Vuillard painted at Villa Anna in 1919.[2] Standing on the gravel path on the other side of the garden fence in a pink robe that echoes the delicate petals of the blooming plants, she is, in her casual beauty and youth, the human counterpart of the flowers.

Vuillard's subordination of the figures to their flowery surroundings in this work is markedly different from his practice in large-scale, decorative portraits set outdoors, such as *The Garden at Vaucresson* (fig. 1).[3] In these, Vuillard made an effort to create identifiable likenesses of his sitters situated in decorative surroundings. Rather, the anonymous character of the two women in *Morning in the Garden at Vaucresson* is similar to that of the female figures in the artist's earlier *Album* series (cat. 75–79) and in *Foliage: Oak Tree and Fruit Seller* (cat. 84).

Like so many of Vuillard's paintings after World War I, this work looks back to the Impressionist landscapes of Monet and even Renoir, whose vertical decorative panel *Garden on Rue Cortot, Montmartre* (fig. 2) uses a similar strategy of screening figures with riotous flowers in the foreground, inspired by Chinese and Japanese panels and screens (see cat. 1, fig. 2). Vuillard indeed showed a greater interest in surface than subject in this picture. The painting itself probably evolved from small pencil sketches made on the spot, later worked up and reworked in his studio, based on what we know of his working habits at this time. In *Morning in the Garden at Vaucresson*, Vuillard ultimately subordinated the observation of nature to decorative cohesion.

The painting remained in Vuillard's possession until 1938, allowing him, as noted, to rework it before his retrospective that year. It was then purchased by Jos Hessel along with *The Garden at Vaucresson* (fig. 1), a large, square decorative canvas showing Lucie Hessel and Alfred Natanson seated in a formal and more expansive area of the garden at Clos Cézanne.[4] Hessel

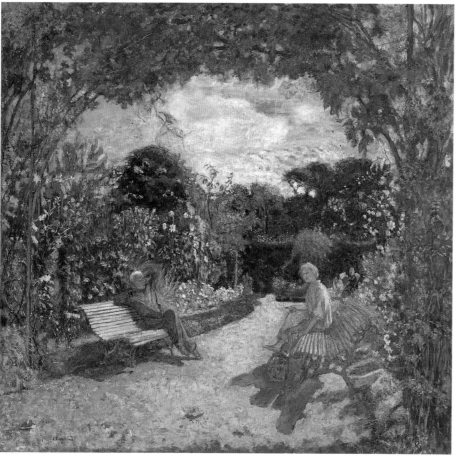

FIG. 1

FIG. 2

lent both to the New York World's Fair in 1939, perhaps considering the two roughly contemporaneous works to be pendants. Indeed, while the paintings both depict the grounds of the same residence, they complement each other through their very marked differences. Whereas *The Garden at Vaucresson* (fig. 1) depicts a view through an arched trellis onto an expansive vista of open fields, entry into the vertical *Morning in the Garden at Vaucresson* is blocked by a screen of voluptuous flowers in the foreground and by the house and hedges that form a seemingly impenetrable wall in the background. Moreover, in *The*

Garden at Vaucresson Vuillard positioned two clearly-defined figures in a classically balanced composition invoking a formal residence. In *Morning in the Garden at Vaucresson*, by contrast, he emphasized the closed, hushed and intimate quality of this summer residence, giving us a view of a young woman admiring a fragment of nature in casual interaction with an older woman who works in it—a scene that has all the spontaneity and casualness of a *plein-air* interior.

Pierre Bonnard

PIERRE EUGÈNE FRÉDÉRIC BONNARD WAS BORN on 3 October 1867 in Fontenay-aux-Roses, a suburb of Paris. He spent his childhood at Le Clos, in the village of Le Grand-Lemps, in the Dauphiné region and visited there regularly until 1925. Bonnard earned a degree in law, and simultaneously attended art classes at the Académie Julian, where he met Denis and Vuillard, as well as Ibels, Ranson, Roussel, and Sérusier, all future Nabis. He subsequently enrolled at the Ecole des Beaux-Arts. After winning the poster competition for France-Champagne in 1889, Bonnard abandoned law for a career as an artist. He produced numerous posters, and illustrations for books and sheet music, and contributed lithographs frequently to the avant-garde literary journal *La Revue blanche*. In 1891, he shared a studio in Montmartre with Denis, Vuillard, and actor Lugné-Poë. In 1893, Bonnard began a life-long relationship with Maria Boursin, who called herself Marthe de Méligny; they married in 1925.

From 1891 to 1899, Bonnard exhibited with the Nabis, during which time his interest in Japanese prints strongly influenced his work. Bonnard had his first solo exhibition at the Durand-Ruel gallery, Paris, in 1896, and exhibited annually at the Bernheim-Jeune gallery from 1906 to 1913 (and less regularly until 1946), as well as at the galleries of Vollard, Druet, and Le Barc de Boutteville. Over the years, he traveled to Algeria, Belgium, England, Germany, Holland, Italy, Portugal, Spain, Tunisia, and the United States. He spent his later years in Vernon, Normandy, where he owned a home from 1912 to 1939, and in Le Cannet, on the Mediterranean coast, where he purchased a second home in 1926, while maintaining a studio-apartment in Paris. During his stays at Le Cannet, he began a friendship and regular correspondence with Matisse, who lived nearby in Nice. His important patrons (in chronological order) included Misia Natanson Edwards, Marguerite Chapin, Ivan Morozov, Josse and Gaston Bernheim, Henri and Marcel Kapferer, and Arthur and Hédy Hahnloser. After Marthe's death in 1942, Bonnard remained mostly in Le Cannet. He died there on 23 January 1947.

Maurice Denis

MAURICE DENIS WAS BORN ON 25 NOVEMBER 1870 in Granville in Normandy. The family soon moved to St.-Germain-en-Laye, a suburb of Paris, where Denis lived for the rest of his life. Starting in 1884, he kept a journal that revealed his fervent belief in Catholicism and his dedication to religious imagery. Denis's religious convictions influenced his art and theoretical writings throughout his career. Denis attended the Lycée Condorcet in Paris in 1882 with Roussel and Vuillard. In 1888, he studied at the Académie Julian—where he met future Nabis—and also at the Ecole des Beaux-Arts under academic artists Jules Lefebvre and Lucien Doucet. A founding member of the Nabis, Denis continually promoted their efforts. His article "Définition du néo-traditionnisme," which became the manifesto of the Nabis movement, includes the famous statement: "It is well to remember that a picture—before being a battle horse, a nude woman, or some anecdote—is essentially a plane surface covered with colors assembled in a certain order" (Denis 1890). Denis married Marthe Meurier in 1893; they had seven children. He purchased homes in Perros-Guirec in Brittany in 1908 and in St.-Germain-en-Laye in 1914. Denis spent several years restoring his home in St.-Germain-en-Laye, a former convent known as Le Prieuré, which is now a museum devoted to his work and that of the Nabis. Marthe died in 1919 after many years of illness. In 1922, Denis married Lisbeth Graterolle, with whom he had two more children.

Denis exhibited at the galleries of Bernheim-Jeune, Le Barc de Boutteville, and Druet, who became Denis's primary dealer in 1904. He traveled to Canada, Germany, Russia, Spain, Switzerland, and the United States, and repeatedly to Italy. His important patrons (in chronological order) included Henry Lerolle, Arthur Fontaine, Ernest Chausson, Baron Denys Cochin, Gabriel Thomas, Ivan Morozov, and Henri and Marcel Kapferer, in addition to numerous religious and public institutions. In his later years, Denis suffered from ocular arthritis. He died in a tragic accident—he was run over by a car—on 13 November 1943.

FIG. 1
Maurice Denis, c. 1900.
Photo: Lyons 1994, p. 15.

FIG. 2
Maurice Denis. *Homage to Cézanne*, 1900. Oil on canvas; 180 x 240 cm. Musée d'Orsay, Paris. From left to right: Redon, Vuillard, Mellerio, Vollard, Denis, Sérusier, Ranson, Roussel, Bonnard, and Marthe Denis.

FIG. 3
Denis with Marthe and their daughters Noële and Bernadette, 1908. Musée Départemental Maurice Denis "Le Prieuré," St.-Germain-en-Laye. Photo: Bouillon 1993, p. 130.

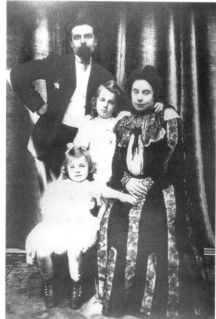

254

FIG. 1
Alfred Athis (Alfred Natanson).
Photograph, July 1897, of Ker
Xavier Roussel (left) and
Edouard Vuillard. Salomon
archives, Paris. Photo: Paris
1993, p. 15.

FIG. 2
Roussel in his studio at
L'Etang-la-Ville, 1930/40.
Salomon archives, Paris. Photo:
Albert Kostenevich, *Bonnard and
the Nabis* (Bournemouth, Eng./
St. Petersburg, 1996), p. 136.

FIG. 3
Roussel seated, Pierre Bonnard
and his dog, c. 1932. Salomon
archives, Paris. Photo: Lyons
1990, p. 99.

Ker Xavier Roussel

KER XAVIER ROUSSEL WAS BORN ON 10 December 1867 in the small town of Chêne near Lorry-les-Metz in Lorraine. The family moved to Paris after the Franco-Prussian War of 1870–71. Along with Vuillard and Denis, Roussel attended the Lycée Condorcet, where the Symbolist poet Stéphane Mallarmé taught English. He studied at the Académie Julian and joined the Nabis in 1889. In 1893, Roussel married Vuillard's sister, Marie. They had two children and, in 1906, purchased a home in L'Etang-la-Ville, a western suburb of Paris, which remained Roussel's life-long residence.

Roussel's first solo exhibition, of pastels, lithographs, and drawings, took place in 1894 at the offices of *La Revue blanche*. He exhibited at the galleries of Le Barc de Boutteville, Durand-Ruel, Druet, and regularly at Bernheim-Jeune. Like the other Nabis, he exhibited often at the gallery of Ambroise Vollard, for whom he produced numerous lithographs. In 1914, Roussel considered enlisting for military service, but suffered a nervous breakdown and spent most of the war years in a psychiatric hospital in Switzerland. He traveled to Belgium, England, Holland, Italy, and frequently to the south of France. Throughout his career, mythological scenes, inspired by Roussel's home in the Ile-de-France and his many travels to the Mediterranean, dominated his work. His important patrons (in chronological order) included Jos Hessel, Josse and Gaston Bernheim, Ivan Morozov, Marcel and Gaston Monteux, and Lucien Rosengart. His public works included commissions for the Théâtre des Champs-Elysées (1913); Kunstmuseum Winterthur, Switzerland (1916–18; reworked in 1926); the League of Nations, Geneva (1936); and the Théâtre du Palais de Chaillot (1937). Roussel died in L'Etang-la-Ville on 5 June 1944.

Edouard Vuillard

CHARLES EDOUARD VUILLARD WAS BORN ON 11 November 1868 in the small town of Cuiseaux in the Saône-et-Loire. In 1877, the Vuillard family moved to Paris, where he attended the Lycée Condorcet with Denis and Roussel. Influenced by Roussel, Vuillard gave up the idea of following his father and brother into the military and instead attended the Académie Julian. He studied at the Ecole des Beaux-Arts with history painter Jean Léon Gérôme. Like Denis, Vuillard kept a journal, beginning in 1888. Vuillard never married, living with his mother, Marie Michaud, until her death in 1928. Her dressmaking studio in the family apartment became the subject of many of Vuillard's early works.

Vuillard joined the Nabis in 1889. He had his first solo exhibition at the *Revue blanche* offices in 1891. Vuillard exhibited at the galleries of Le Barc de Boutteville, Vollard, Durand-Ruel, Druet, and regularly at Bernheim-Jeune between 1900 and 1913; Jos Hessel became his primary dealer in 1912. Vuillard traveled to Austria, Belgium, England, Holland, Italy, Scotland, and Spain. His important patrons (in chronological order) included Paul and Léonie Desmarais, Thadée and Misia Natanson, Alexandre Natanson, Jean Schopfer, Henri Vaquez, Jack Aghion, Jos and Lucie Hessel, Josse and Gaston Bernheim, Henry Bernstein, Emmanuel and Antoine Bibesco, and Henri and Marcel Kapferer. In addition to lithographs, domestic ensembles, and portraiture, Vuillard created numerous public works, including theater sets and public murals. At the beginning of World War II, he retreated from the German army to the Hessels' home in La Baule. He died in the hospital there on 21 June 1940. Roussel, as executor of his brother-in-law's estate, bequeathed fifty-five of Vuillard's works to the French nation.

CAT. I

PIERRE BONNARD

Ducks, Heron, and Pheasants
(*Canards, héron, et faisans*)
1889
Distemper on red-dyed cotton fabric
Three-panel screen: each panel, 159.5
x 54.5 cm (62 ¾ x 21 ½ in.)
Signed with monogram on center
panel at lower left, and on right panel
at upper right: *PB*
Tom James Co./Oxxford Clothes

PROVENANCE: Pierre Bonnard; André
Bonnard, before Sept. 1890; by descent,
to her daughter Madame Vivette Floury,
the artist's niece; private collection, Paris;
sold through Galerie Hopkins-Thomas-
Custot, Paris, to present owner.

NOTES:

1. Another source for the imagery could
be Japanese fabrics that had arrived in
Europe for the Exposition universelle
of 1867, fabrics with designs of branches
and flowers, bamboo, waves, and birds;
see Perucchi-Petri 1976, p. 53.

2. Jean de La Fontaine's *Fables*, origi-
nally published in three successive
collections from 1668 to 1694, deal
with traditional moral issues, as well as
addressing contemporary social and
political events using the Aesopic
model of animals as protagonists.

3. See Jean de La Fontaine, *Fables* (with
engravings by Jean Baptiste Oudry)
(Paris, 1992), vol. 1, book 3, fable 4.

4. This information comes from an
unpublished manuscript by Antoine
Terrasse, grandnephew of Pierre Bonnard
and grandson of Andrée Terrasse.

5. For a discussion of the bamboo motif
in Japanese art and eighteenth-century
chinoiserie, see Siegfried Wichmann,
*Japonisme: The Japanese Influence on
Western Art in the Nineteenth and
Twentieth Centuries* (New York, 1981),
pp. 84–85.

6. Ibid., pp. 93–94.

7. See La Fontaine (note 3), vol. 2,
book 7, fable 4.

8. Paul Gauguin, *Avant et après: Paul
Gauguin's Intimate Journals*, tr. by Van
Wyck Brooks (New York, 1921), p. 33.
Gauguin supposedly based his painting
Clay Jug and Iron Jug (1880; The Art
Institute of Chicago) on a La Fontaine
fable of the same title, which under-
scores the importance of knowing one's
true nature and remaining consonant
with it; see Brettell 1999, pp. 48–50,
cat. 12.

9. See Brussels, *6ème Exposition des
Vingt*, exh. cat. (1889), no. 7.

10. Bonnard offered both to the eight-
een-year-old Andrée in 1889; she mar-
ried the composer Claude Terrasse in
1891; this information was provided to
me by Antoine Terrasse in letters of 24
June 1999 and 20 July 2000.

11. For this letter, see cat. 6.

CAT. 2–3

PIERRE BONNARD

2. *Women in a Garden: Woman in a
Polka-dot Dress* (first version)
(*Femmes au jardin: Femme à la
robe à pois blancs*)
1890/91
Distemper over charcoal, pencil,
and white chalk on paper, mounted
on canvas
154 x 47 cm (60 ⅝ x 18 ½ in.)
Estate stamp at lower left: *Bonnard*
Kunsthaus Zürich, Society of
Zurich Friends of Art, with a
contribution in memory of
Ernst Gamper

PROVENANCE: Pierre Bonnard
Estate; to Alice and Marguerite
Bowers, Boulogne-sur-Seine; private
collection, Belgium; sold, Galerie
Koller, Zurich, 12 Nov. 1982, nos.
5111–12, to Kunsthaus Zürich.

3. *Women in a Garden: Woman in a
Checked Dress* (first version)
(*Femmes au jardin: Femme à la
robe quadrillée*)
1890/91
Distemper over charcoal, pencil,
and white chalk on paper, mounted
on canvas
154 x 47 cm (60 ⅝ x 18 ½ in.)
Estate stamp at lower left: *Bonnard*
Kunsthaus Zürich, Society of
Zurich Friends of Art, with a
contribution in memory of
Ernst Gamper

PROVENANCE: Same as cat. 2.

NOTES:

1. See Paris, *7ème Salon des artistes
indépendants*, exh. cat. (20 Mar.–27 Apr.
1891), where the four panels are listed
as *Panneaux décoratifs 1, 2, 3, 4*, along
with *L'Après-midi au jardin, Portrait, Le
Bon Chien, L'Exercice*, and *Etude de chat*
(nos. 120–28). In December, Bonnard
included the four panels in the Nabis'
first exhibition of "Impressionists and

Symbolists" at the Barc de Boutteville
gallery (nos. 13–16). The panels
acquired the general title *Femmes au
jardin* and individual panel titles only
later. This is also true of the titles under
which the two Zurich studies featured
here are sometimes published, *Harmonie
rouge* and *Harmonie verte*, which are no
longer used by Kunsthaus Zürich,
according to a letter from curator
Christian Klemm, of 4 Aug. 1999. The
four final panels are now in the Musée
d'Orsay, Paris.

2. Jean Passé, "Impressionnistes et sym-
bolistes," *Journal des artistes* (27 Dec. 1891),
p. 390.

3. See Bonnard to Lugné-Poë, [Nov.–
Dec. 1890], in Lugné-Poë 1930, p. 243.

4. See Bonnard to his mother, 13 Mar.
1891, partially published in Terrasse
1988, p. 21.

5. This goal was acknowledged by critics
at the time; see Adolphe Retté, "Septième
Exposition des artistes indépendants,"
Ermitage 2, 5 (May 1891), p. 298: "All of
these painters, instinctively, are headed
toward the abolition of the easel paint-
ing." See also Watkins's essay for more
on the various factors affecting the
Nabis' attitude toward mural decora-
tion, easel painting, and art objects.

6. Watkins 1994, p. 29.

7. See Siegfried Wichmann, *Japonisme:
The Japanese Influence on Western Art in
the Nineteenth and Twentieth Centuries*
(New York, 1981), p. 156, citing Roger
Goepper, *Schatten des Wu-T'ung Baumes*
(Munich, 1959), p. 35.

8. See Dauberville, vol. 1, p. 19, no. 13,
and above, note 3, for Bonnard's refer-
ence to a "tableau sérieux." This is the
only portrait from this period in the cat-
alogue raisonné of Bonnard's work suffi-
ciently large to be considered "serious."

9. For a discussion of the panels as
representations of the seasons, see
Perucchi-Petri 1976, pp. 45–46; idem,
"Les Nabis et le Japon," in *Japonisme in
Art: An International Symposium* (Tokyo,
1980), p. 24. See also Frèches-Thory
and Terrasse 1990, p. 94.

10. See the discussion of the impor-
tance of the arabesque in cutting
through space and enhancing the
"mural" effect of decorative paintings,
in Bouillon 1985, p. 45.

11. Christian Klemm, *Museum of Fine
Arts, Zurich*, tr. by Phillip Weller
(Zurich, 1992), p. 68.

12. This thick-featured woman appears
in other caricatural drawings at this
time, such as *Mischievous, Old Pink, Piece
for Piano* (1895), Bonnard's design for

sheet music by Francis Thomé; see New
Brunswick 1988, pp. 147–48, no. 158.

13. It is possible that Bonnard was aware
of the successful quartet of decorative
and posterlike panels by the master
poster designer Jules Chéret that was
offered for sale in 1891 as wall panels for
use in the home. Published as large-
sheet chromolithographs, each shows an
exuberant young woman, or *chérette* (as
the artist's youthful females have been
called), representing Dance, Pantomime,
Comedy, and Music. Termed both
"hanging wall panels" (*panneaux de ten-
tures*) and "decorative engravings"
(*gravures décoratives*), they were to serve,
as one reviewer puts it, "as simulated
frescoes," evoking eighteenth-century
trumeau (the wall between windows)
decorations and forming "a veritable
ensemble" within a domestic setting.
In order to achieve the effect, one critic
recommended they be hung on white
walls and either left unframed or framed
by simple gold borders that would serve
as a "natural transition between the ani-
mated colors of the compositions and
the whitening of the woodwork." See
Raoul Sertat, "Quatres Panneaux déco-
ratifs par Jules Chéret," *Revue des arts
décoratifs* 12 (1891–92), pp. 208–09.
Bonnard may have conceived his four,
printlike panels similarly.

14. See Félix Fénéon, "Catalogue: Sur
les Murs," *Chat noir* 10, 490 (6 June
1891), p. 1760; and Lugné-Poë 1930,
p. 192.

CAT. 4

PIERRE BONNARD

Poodles, or *Two Poodles*
(*Caniches*, or *Deux Caniches*)
1891
Oil on canvas
37 x 39.7 cm (14 ¼ x 15 ½ in.)
Signed and dated at upper left:
P Bonnard/1891
Southampton City Art Gallery,
England

PROVENANCE: O. Bateman Brown,
London; sold, Sotheby's, London, 23
Nov. 1960, no. 81, to Arthur Jeffress,
London; bequeathed to Southampton
City Art Gallery, 1963.

EXHIBITIONS: Paris, Pavillon de la
Ville de Paris, *8ème Salon de la Société
des artistes indépendants*, 19 Mar.–27 Apr.
1892, no. 171, as *Caniches*. Toulouse,
offices of *La Dépêche de Toulouse*,
*Exposition de peinture de "La Dépêche
de Toulouse*," 15 May–end of June 1894,
no. 4.

NOTES:

1. See Bonnard to Lugné-Poë, [late 1890], in Lugné-Poë 1930, p. 243.

2. While we do not know definitively whether the design for the furniture ensemble or the oil painting was completed first, the fact that *Poodles* was not exhibited until March 1892 argues for its later execution.

3. The cost of realizing the bedroom was not to exceed 2,500 francs. For specifics of this contest, see Paris 1993, pp. 361–63, cat. 182; and Giambruni 1983, p. 102.

4. J. R. de Brousse, "Chronique locale: L'Exposition de *La Dépêche*," *Impartial* 421 (1894); and Gustave Geffroy, "Les Indépendants, 29 mars 1892," in Geffroy 1892–1903, p. 373. Both are cited in Paris 1993, p. 117, cat. 7. Dogs continued to play a role in Bonnard's iconography, as street mutts (see, for example, the lithograph *Le Marchand des quatre saisons*, c. 1897, and the lithographic screen of 1891/92, formerly in the collection of Louis Carré) and, more often, as portraits of pets.

5. Bonnard's project for a dining-room ensemble, made in 1895 for another competition at the Union centrale des arts décoratifs, was also rejected; see Paris 1993, p. 363.

CAT. 5

PIERRE BONNARD

Twilight, or *Croquet Game*
(*Crépuscule,* or *La Partie de croquet*)
1892
Oil on canvas
130 x 162.5 cm (51 ⅛ x 64 in.)
Signed and dated at upper left:
Bonnard 1892
Musée d'Orsay, Paris, gift of Daniel Wildenstein through the Société des Amis du Musée d'Orsay, RF 1985-8

PROVENANCE: Pierre Bonnard Estate; Alice and Marguerite Bowers; private collection, U.S.A.; private collection, Paris; gift of Daniel Wildenstein to Musée d'Orsay, Paris, through the intermediary of the Société des Amis du Musée d'Orsay, 19 Apr. 1985.

EXHIBITIONS: Paris, Pavillon de la Ville de Paris, *8ème Salon de la Société des artistes indépendants,* 19 Mar.–27 Apr. 1892, no. 173, as *Crépuscule.* Paris, Galeries Durand-Ruel, 1899, no. 8. Paris, Grand Palais, Exposition de la Société des artistes indépendants, *Trente Ans d'art indépendant,* 1926, no. 390, as *Scène de jardin.*

NOTES:

1. Watkins 1997, p. 15.

2. Married in September 1890, Claude Terrasse and Andrée Bonnard had six children (see cat. 7–9 n. 9). See Heilbrun and Néagu 1988, p. 14.

3. Guy Cogeval in Lyons 1994, p. 136.

4. *Scène de jardin,* in Paris, Grand Palais, Exposition de la Société des artistes indépendants, *Trente Ans d'art indépendant,* exh. cat. (1926), no. 303.

5. Cogeval 1993, p. 20.

6. Among the numerous titles, one can cite Paul Verlaine's poem "Crépuscule du soir mystique" from *Poèmes saturniens* (1866, repr. in 1889, at which time it won wider approval from Symbolist writers such as Stéphane Mallarmé and Charles Marie René Leconte de Lisle); Jules Massenet's composition *Crépuscule: Pour Flûte, violon, violoncelle* (1872, 1892); and Edouard Dubus's poem "Crépusculaire," which appeared in *Mercure de France* 1, 2 (1890), p. 39.

7. James Kearns, "The Writing on the Wall: Descriptions of Painting in the Art Criticism of the French Symbolists," *Artistic Relations: Literature and the Visual Arts in Nineteenth-Century France,* ed. by Peter Collier and Robert Lethbridge (New Haven/London, 1994), pp. 239–52.

8. Geffroy 1892–1903, vol. 2, p. 372. Ursula Perucchi-Petri compared the twilight imagery of *Crépuscule* to that of Paul Verlaine's "Nuit de Valpurgis classique" (1866), in which the branches of a tree act as protagonists against the moonlight and, in Verlaine's words, "dance very slowly in a circle"; see Perucchi-Petri 1976, p. 69.

9. See Pierre Larousse, *Grand Dictionnaire universel du XIX siècle* (1869, repr. Geneva/Paris, 1982), vol. 5, p. 586.

10. Natanson 1951, p. 216.

11. For *Young Woman in a Landscape,* see Dauberville, vol. 1, p. 112, no. 37.

12. Watkins 1994, pp. 21–22.

13. Ursula Perucchi-Petri, "Les Nabis et le Japon" in *Japonisme in Art: An International Symposium* (Tokyo, 1980), p. 262.

CAT. 6–6A

PIERRE BONNARD

6. *Nannies' Promenade, Frieze of Carriages*
(*Promenade des nourrices, frise de fiacres*)
1895/96
Lithograph in five colors on paper
Four-panel screen: each panel,
149.9 x 47.9 cm (59 x 18 ⅞ in.)
Signed with monogram at lower right of third panel: *PB*
Private collection
CHICAGO ONLY

PROVENANCE: Sir Rex de C. Nan Kivell, London; sold, Sotheby's, London, 4 Oct. 1977, to the Trustees of the British Rail Pension Collection; Libbie Howie, London, 1986; to current owner.

6a. *Nannies' Promenade, Frieze of Carriages*
(*Promenade des nourrices, frise de fiacres*)
1895/96
Lithograph in five colors on paper
Four-panel screen: each panel,
149.9 x 47.9 cm (59 x 18 ⅞ in.)
Signed with monogram at lower right of third panel: *PB*
Private collection, New York
NEW YORK ONLY

NOTES:

1. The screen was published in an edition of 110 by Galerie Laffitte (under its owner, Lucien Molines). See *Estampe et affiche* 1 (15 Mar. 1897), p. 24, cited in Paris 1993, p. 368, cat. 188. As separate panels, the lithographs would be similar to Jules Chéret's chromolithographed wall decorations, published in 1891 (see cat. 2–3 n. 13).

2. Bonnard, cited in Washington, D.C. 1984a, p. 143.

3. Vuillard to Vallotton, Valvins, 1 July 1898, in Guisan and Jakubec 1973–75, vol. 1, p. 175, letter 117. The date of this letter cannot be trusted, since it was written from Valvins, the Natansons' summer home until 1897, when they moved to Villeneuve-sur-Yonne. See New York 1994, p. 84, for a citation of the announcement and illustration of the lithographic screen in *Studio* 9, 43 (Oct. 1896), pp. 67–68. Colta Ives stated that the prints could have been made as early as 1895; idem, "City Life," in New York 1989, p. 115. For further early published references to the screen, see also Paris 1993, pp. 368–69, cat. 188.

4. It is reasonable to believe that this is the *paravent* (no. 32) in the catalogue for the inaugural exhibition of Bing's Maison de l'Art Nouveau (Dec. 1895), and one of two *paravents* mentioned by Gustave Geffroy in *Le Journal* (1 Jan. 1896), repr. in Geffroy 1892–1903, vol. 6, p. 296. See also New York, The Museum of Modern Art, *Masterpieces from the David and Peggy Rockefeller Collection: Manet to Picasso,* exh. cat. by Kirk Varnedoe (1994), p. 85. Varnedoe suggested that the painted screen might well be a work by Bonnard called *Promenade,* belonging to Thadée Natanson and listed as no. 49 in Paris, Galeries Durand-Ruel, *Exposition P. Bonnard,* exh. cat. (1896). He went on to postulate that the lithographic version was one of the screens listed simply as *Paravent* (no. 52) in the print category of this exhibition.

5. Letter cited in Terrasse 1988, pp. 44–45. The unsuccessful "ducks and leaves" screen that Bonnard mentioned in the letter has not been identified. It is possible that he was referring to his screen *Ducks, Heron, and Pheasants* (cat. 1); this screen, however, is considered to be very early (1889) and is not known to have been exhibited at the time (Antoine Terrasse to author, 24 June 1999). There also exists what appears to be a study for a screen panel featuring a woman surrounded by ducks and foliage; see London, Christie's, *Impressionist and Post-Impressionist Art including Scandinavian Art,* sale cat. (27 June 2000), p. 122, no. 198.

6. The cropped sprigs of greenery on the far right of Bonnard's screen also reveal the Japanese influence on this work; they were a motif Bonnard had used previously in his painting *Poodles* (cat. 4). In the painted version of *Nannies' Promenade* (fig. 1), the leaves are more numerous and are conceived as extensions of the frame that Bonnard designed and painted himself (burning his name into the fourth frame segment). But in the printed screen, minus the decorative frame, they have been reduced to a single, strictly ornamental feature.

7. Vuillard's *Little Girls Playing* (1894; Musée d'Orsay, Paris), the pendant to *Asking Questions,* shares similar attributes, although here the Parisian (wearing the same batlike cape as Bonnard's female) is seated and the children, who play behind her, are not necessarily hers; Groom 1993, p. 52, pls. 81–82.

8. See New Brunswick 1988, pp. 27, 53–58.

9. Bonnard, in fact, most likely saw Georges Seurat's monumental painting at the 1892 Indépendants; see Reff 1981, p. 66, no. 1082.

CAT. 7–9

PIERRE BONNARD

7. *Apple Gathering*
(*La Cueillette des pommes*)
1895/99
Oil on canvas
169 x 104 cm (66 ½ x 41 in.)
Virginia Museum of Fine Arts, Richmond, Millenium Gift of Sara Lee Corporation

PROVENANCE: Thadée Natanson, Paris; Galerie Pierre Colle, Paris; Galerie H. Knoedler, Paris; private collection, Paris; sold, Christie's, London, 14 Apr. 1970, no. 23, to R. B. Davies; M. Knoedler and Co., Inc., New York; Nathan Cummings Collection, Chicago; Sara Lee Corporation, Chicago, 1984; gift to the Virginia Museum of Fine Arts, Richmond, 2000.

EXHIBITIONS: Paris, Galerie Charpentier, *Jardins de France,* 1943, no. 311, as *Jardin de Provence.*

8. *Apple Gathering*
(*La Cueillette des pommes*)
1895/99
Oil on canvas
169 x 131 cm (66 ½ x 51 ½ in.)
Signed at upper right: *Bonnard*
Pola Museum, Tokyo

PROVENANCE: Mr. and Mrs. G. B. [Georges Besson?]; Baron Rollin, Brussels; sold, Christie's London, 29 June 1981, no. 31; Tsuneschi Suzuki, Pola Cosmetics, Tokyo.

9. *Children Playing with a Goat*
(*Enfants jouant avec une chèvre*)
1895/99
Oil on canvas
168 x 130 cm (66 ⅛ x 51 ⅛ in.)
Pola Museum, Tokyo

PROVENANCE: Sold, Galerie Charpentier, Paris, 12 Mar. 1956, no. 32; private collection, New York, 1958; Tsuneschi Suzuki, Pola Cosmetics, Tokyo.

NOTES:

1. *Plum Harvest* is reproduced in Dauberville, vol. 1, p. 216, no. 204.

2. Other dates have also been suggested without any documentation. See, for example, Paris, Grand Palais, *Art contemporain*, exh. cat. (1963), n. pag., where the Pola Museum's *Apple Gathering* is illustrated and listed as *Enfants dans un jardin ramassant des fruits* and dated to 1912. Two of the paintings in this group, *Apple Gathering* and *Children Playing with a Goat* (cat. 8–9), share almost exact dimensions and are organized around the same type of strongly diagonal compositional element.

3. Bonnard to his brother Charles in Bonnard 1944, p. 77. This letter is part of a 1944 publication by Bonnard in which he gathered a number of early letters from the 1890s, written by himself, his mother, and his maternal grandmother Mertzdorff, accompanied by new illustrations he made. For the origins and significance of this unusual publication, see Rebecca Rabinow, "The Creation of Bonnard's *Correspondances*," *Print Quarterly* 15, 2 (June 1998), pp. 173–85.

4. For information on these panels, see Dauberville, vol. 4, p. 109, no. 1691.

5. Natanson 1951, p. 152. Interestingly, Natanson made no mention of the earlier *Apple Gathering* panel, which, purportedly, he owned.

6. The sketchbook is in a private collection and is discussed in Frèches-Thory 1986, pp. 425, 430 n. 18. See also the color lithograph *Orchard* (*Le Verger*) of 1899, in Bouvet 1981, pp. 72–73, no. 56. *Orchard* is reproduced in Dauberville, vol. 1, p. 159, no. 113, where it is listed as belonging to the Norton Simon Collection. However, according to Gloria Williams, Curator of European Painting at the Norton Simon Museum of Art, Pasadena, Calif., it has never been in the Norton Simon Collection (letter to author, 17 July 2000).

7. The two canvases most similar to *Large Garden*, *Apple Gathering* (cat. 7), and *Plum Harvest* have been published with both earlier and later dates.

Richard Brettell dated the Richmond panel to 1899 on the basis of photographs from around 1899 that show the Terrasse children picking apples, although he acknowledged that his findings are inconclusive. See Brettell 1999, p. 8, cat. 2. See also Paris 1993, p. 366, cat. 186.

8. Frèches-Thory 1986, p. 425. See also entry for the panel *Child with a Pail* (*L'Enfant au seau*) (1894–95; Musée d'Orsay, Paris) in Paris 1984, p. 52, cat. 2.

9. Bonnard's nieces and nephews were Jean (1892–1932), Charles (1893–1982), Renée (1894–1985), Robert (1896–1966), Marcel (1897–1898), and Eugènie "Vivette" (1899–c. 1998).

10. See photographs in Jean François Chevrier's, "Bonnard and Photography," in Paris 1984, pp. 83–103.

11. See Philippe Huisman and M. G. Dortu, *Lautrec by Lautrec*, tr. and ed. by Corinne Bellow (New York, 1964), p. 215. I am grateful to Anne Roquebert for the identification of and iconographical references to this curious character in Lautrec's life.

12. Gustave Coquiot, *H. de Toulouse-Lautrec: Nombreuses Illustrations la plupart inédites avec des souvenirs* (Paris, 1913), p. 148; and M. G. Dortu, *Toulouse-Lautrec et son oeuvre* (New York, 1971), vol. 6, p. 797, no. D.4.441.

13. Thadée Natanson's ownership of this work is presumed on the basis of Dauberville, vol. 1, p. 221, no. 209, but has not been supported so far by any independent evidence.

14. Although not an official exhibitor with the Nabis, Lautrec was part of the Natanson circle at the *Revue blanche* offices and a member of the intimate group of friends that vacationed at the Natansons' summer homes at Valvins in July 1895, and at La Grangette at Villeneuve-sur-Yonne in spring 1896, summer 1897, and September 1898. See "Chronology" in Lucien Goldschmidt and Herbert Schimmel, eds., *Unpublished Correspondence of Henri de Toulouse-Lautrec: 273 Letters by and about Lautrec Written to His Family and Friends in the Collection of Herbert Schimmel*, with intro. and notes by Jean Adhémar and Theodore Reff (London, 1969), pp. 309–14.

15. I am grateful to Richard Thomson for his insights (Thomson to author, 12 July 1999), even though he saw only very weak, second-generation photographs of the drawings.

16. See Ambroise Vollard, *Recollections of a Picture Dealer*, tr. by Violet M. Macdonald (London, 1936), pp. 17–18, where he referred to the work by Lautrec as both a "silhouette drawing" and a "charcoal drawing," depicting "a little guy" (*un petit bonhomme*) on the back of a "study" (*étude*) by Bonnard. Unfortunately, he did not describe the work further. See also Giambruni 1983, p. 331 n. 63. If the drawings were added

right after the panel was completed, and if they are actually by Lautrec, the panel and caricatures could date from before the end of 1899, at which time he became so weak that he could not have achieved the sharp, confident lines of these charcoal drawings. Viaud, although mentioned in Lautrec's correspondence as early as 1892, only became part of the artist's daily life in 1899; see "Chronology" in Goldschmidt and Schimmel (note 14), p. 313.

17. Of course, this interpretation depends on whether or not the painting was in Thadée Natanson's possession in the 1890s, when he was living with Misia. It is also possible that Thadée persuaded his father to commission or purchase Bonnard's "green" canvas, just as he did Vuillard's *Verdures* (see cat. 41; cat. 41, fig. 1). *Apple Gathering* was not listed among the works in the 1908 sale of Thadée's collection (Hôtel Drouot, Paris, 13 June 1908).

18. The caricature depicting Lautrec on the verso of *Apple Gathering* does resemble one drawn by Bonnard in his sketchbook *The Painter's Life* of c. 1910 (see Watkins, fig. 1).

CAT. 10–13

MAURICE DENIS

Suite of Paintings on the Seasons
1891–92

10. *September Evening*, or *September: Women on a Terrace*
(*Soir de Septembre*, or *Septembre: Femmes sur la terrasse*)
1891
Oil on canvas
38 x 61 cm (15 x 24 in.)
Signed with vertical monogram and dated at lower right: *MAVD 91*
Musée des Arts Décoratifs, Paris

PROVENANCE: Sold by the artist to Ambroise Vollard, Paris, 1892; Guy de Cholet Collection, Paris; bequeathed to the Société des Amis du Luxembourg, 1916; left to the Musée des Arts Décoratifs, Paris, upon the dissolution of the society, 1985.

EXHIBITIONS: Brussels, *9ème Exposition des Vingt*, 1892, no. 4, as *Soir de septembre*. Paris, Pavillon de la Ville de Paris, *8ème Salon de la Société des artistes indépendants*, 19 Mar.–27 Apr. 1892, no. 354, as *Septembre*.

11. *October Evening*, or *October*
(*Soir d'octobre*, or *Octobre*)
1891
Oil on canvas
37.5 x 58.7 cm (14 ¾ x 23 ⅛ in.)
Signed with vertical monogram and dated at lower right: *MAVD 91*
Mr. and Mrs. Arthur G. Altschul, New York

PROVENANCE: Sold by the artist to P. Poujaud, 1892; Galerie Druet, Paris, 1929; Mr. and Mrs. Arthur G. Altschul Collection, New York, 1967.

EXHIBITIONS: Brussels, *9ème Exposition des Vingt*, 1892, no. 5, as *Soir d'octobre*. Paris, Pavillon de la Ville de Paris, *8ème Salon de la Société des artistes indépendants*, 19 Mar.–27 Apr. 1892, no. 355, as *Octobre*. Paris, Pavillon de Marsan, Union centrale des arts décoratifs, *Maurice Denis, 1888–1924*, Apr.–May 1924, no. 33, as *Octobre*.

12. *April*
(*Avril*)
1892
Oil on canvas
37.5 x 61 cm (15 x 24 in.)
Signed with vertical monogram and dated at lower left: *MAVD 92*
Kröller-Müller Museum, Otterlo, The Netherlands

PROVENANCE: Sold by the artist to Ambroise Vollard, Paris, 1892; Eugène Blot; sold, Hôtel Drouot, Paris, Eugène Blot Collection, 10 May 1906, no. 25, to Eugène Druet; sold to Kröller-Müller Museum, Otterlo, 1913.

EXHIBITIONS: Paris, Pavillon de la Ville de Paris, *8ème Salon de la Société des artistes indépendants*, 19 Mar.–27 Apr. 1892, no. 352, as *Avril*. Paris, Le Barc de Boutteville, *3ème Exposition des peintres impressionistes et symbolistes*, Nov. 1892, no. 28, as *Avril*. Düsseldorf Kunsthalle, *Sammlung der Frau H. Kröller-Müller den Haag*, Aug.–Sept. 1928, no. 41, as *April*.

13. *July*
(*Juillet*)
1892
Oil on canvas
38 x 60 cm (15 x 23 ⅝ in.)
Signed with vertical monogram and dated at lower right: *MAVD 92*
Fondation d'Art du Docteur Rau, Embrach-Embraport, Switzerland

PROVENANCE: Sold by the artist to Ambroise Vollard, Paris, 1892; Dr. Ducroquet Collection; sold, Christie's, London, 28 Nov. 1972, no. 116, to Fondation d'Art du Docteur Rau, Embrach-Embraport, Switzerland.

EXHIBITIONS: Paris, Pavillon de la Ville de Paris, *8ème Salon de la Société des artistes indépendants*, 19 Mar.–27 Apr. 1892, no. 353, as *Juillet*.

NOTES:

1. Paris, *8ème Salon de la Société des artistes indépendants*, exh. cat. (19 Mar.–27 Apr. 1892), no. 351, repr. in Reff 1891, p. 25. The generic title *Sujet poétique* is followed by individual numbers and titles: *Avril*, no. 352; *Juillet*, no. 353; *Septembre*, no. 354; and *Octobre*, no. 355. What is confusing is that *Sujet poétique*

was assigned a number (351), as were the four individual panels (nos. 352–55).

2. Ibid. Also see Bouillon 1993, pp. 36ff.; and Paris 1993, p. 154.

3. See Bouillon 1993, p. 36, who cited but gave no further description of this "sketchbook sheet" (*feuille de croquis*).

4. Montreal 1998, p. 97.

5. This was the case of three paintings exhibited at the Indépendants by José Engel that year with the title *Les Enfants: Frise décorative*; see Reff 1981, p. 29, nos. 428–30.

6. Guy Cogeval and Thérèse Barruel concurred that they refer to stages of a woman's life in terms of cycles of nature, but they have differed in their conclusions as to what those cycles symbolize. Cogeval sequenced the panels as *September* (waiting); *October* (renunciation); *April* (choosing a path); and *July* (decision or fulfillment); see Lyons 1994, p. 156, and Montreal 1998, p. 97. Cogeval compared Denis's allegory of fulfillment to the Germanic concept of *Erfüllung* (erroneously spelled *Erfühlung* in Lyons 1994) and to Arnold Böcklin's images of the 1870s—an odd choice given the carnality of the women the Swiss artist used to express ideas about love and fertility and the innocence of Denis's child-women. Barruel posited that the series begins with *April*, as the "gathering" season; followed by *July*, representing the "carefreeness" of a summer's games; *September*, the "waiting" period; and ending with *October* and its invitation to the young woman and to nature to rest—before reawakening in spring. See Thérèse Barruel, "L'Amour et la vie d'une femme," unpublished MS. Interestingly, for Cogeval, fulfillment is expressed by young, carefree women, while for Barruel, it is found in the panel suggesting the woman as fiancée.

7. *Le Journal* of 26 Nov. 1892 featured *April* in a group of cartoon caricatures of certain works from the Barc de Boutteville exhibition; see Mauner 1978, p. 103 and fig. 9.

8. Both compositions in fact owe a debt to Paul Gauguin's *Vision After the Sermon* (Watkins, fig. 18) and Puvis de Chavannes's *Poor Fisherman* (1881; Musée d'Orsay, Paris).

9. See Bouillon 1993, p. 38, and 1890–99 Intro.

10. See Geffroy 1892–1903, vol. 2, p. 372, cited in Paris 1993, p. 154.

11. For a brief discussion of the importance of the bedroom in Denis's art, see Jean Paul Bouillon, "Denis, Matisse, Kandinsky," in *Maurice Denis, 1870–1943: Fin-de-Siècle und Neue Klassik: Internationales Kolloquium im Wallraf-Richartz-Museum/Museum Ludwig, 1995*, special ed. of *Wallraf-Richartz-Jahrbuch* 57 (1996), p. 267.

12. Jeanne Stump described *April* and a contemporary drawing by Roussel as representing a "sisterhood, intimately related to nature"; see Stump 1972, p. 198.

13. See Denis's journal entry, Midnight Mass, Christmas 1891, repr. and tr. in Lyons 1994, p. 346: "There is no need to give up the idea of bringing together what is called flesh with what is called spirit, their reconciliation is the essential object of our efforts."

14. While this ordering seems to correspond to Denis's personal life, it does not follow the chronology in which Denis painted and signed the four canvases, nor does it adhere to the order of the months mentioned in the works' titles.

15. *Fioretti* (Italian for *Little Flowers*) is the title of a compilation of stories and vignettes, dating from the late thirteenth to early fourteenth century, on the life of Saint Francis of Assisi (1182–1226).

CAT. 14

MAURICE DENIS

Ladder in Foliage, or *Poetic Arabesques for the Decoration of a Ceiling* (*L'Echelle dans le feuillage*, or *Arabesques poétiques pour la décoration d'un plafond*)
1892
Oil on canvas, mounted on cardboard
235 x 172 cm (92 ½ x 67 ¾ in.)
Signed with vertical monogram and dated at center right: *MAVD 92*; inscribed in lower-left corner of border with Marthe Meurier's initials: *MM*
Musée Départemental Maurice Denis "Le Prieuré," St.-Germain-en-Laye

PROVENANCE: Sold by the artist to Henry Lerolle (d. 1929), 1892; Lerolle family, 1929–38; sold back to the artist, 1938; by descent, to the artist's son Dominique Denis; given to the Musée Départemental Maurice Denis "Le Prieuré," St.-Germain-en-Laye, 1976.

EXHIBITIONS: St.-Germain-en-Laye, Château National, *2ème Exposition annuelle des beaux-arts*, 14 Aug.–16 Oct. 1892, no. 102, as "*Arabesques poétiques pour la décoration d'un plafond* (App. à M. H. Lerolle)."

NOTES:

1. Segard 1914, vol. 2, p. 140. Unpublished correspondence suggests that the relationship between Lerolle and Denis began at the exhibition of the Indépendants in spring 1891. There, Lerolle purchased one of two pendants, *Souvenir de soir II* (*Evening Souvenir II*) for 150 francs. For this little-known work, dated Apr. 1890 and now in a private collection, see Lyons 1994, p. 135, cat. 15. See also Lerolle to Denis, 13 Apr. 1891, Musée MD, MS 6971.

2. Maillol's failed candidacy for this commission is mentioned in the most recent Denis publications (Paris 1993, p. 165 n. 1; Lyons 1994, p. 157, cat. 34) without documentation.

3. Segard 1914, vol. 2, p. 162.

4. Lerolle to Denis, 2 June 1892, Musée MD, MS 6977: "Je suis heureux que vous y ayez pensé et ce que vous m'en dites, me fait espérer une jolie chose."

5. Ibid.: "Car, quand nous avons un peu parlé d'un prix de ce petit plafond, nous avons été très vagues, tous les deux."

6. See below, cat. 17–18, for more on this commission.

7. Arthur Huc would later point out that Denis had given the woman in the poster two left feet. See Huc to Denis, 27 Apr. 1894, Musée MD, MS 5622, and cat. 17–18.

8. Segard 1914, vol. 2, p. 211. Perhaps, as Bouillon suggested, the painting evokes Jacob's dream of a ladder "set up on earth and the top of it reached to heaven and behold the angels of the god ascending and descending"; Bouillon 1993, p. 42; and Genesis 28:12.

9. See Denis's triple portrait of Marthe of 1892; St.-Germain-en-Laye 1980, p. 27, cat. 78. Denis's *Triple Portrait of Yvonne Lerolle* (cat. 19–24, fig. 5), painted five years later, shows instead a sleeker, more angular physical type.

10. Lerolle to Denis, Thursday, [after 6 Oct.] 1892, Musée MD, MS 6975:

Je comprends vos hesitations au moment de placer votre oeuvre à sa place définitive—non pas que je ne la trouve très jolie—mais, j'ai passé par là et je crois que nous avons tous passé, par là. Pour être exempt de ces hésitations et de ces doutes sur ce qu'on a fait, il faut avoir un grand orgueil, ce qui n'est pas toujours mauvais en art, ou bien être de ces farceurs qui se fichent de tout....

Je suis ravi de voir arriver votre plafond....

Nous l'essaierons en place, nous en causerons. Mais je tiens à vous dire; dès maintenant, combien je l'ai trouvé joli les deux fois que je l'ai vu, chez vous et à l'exposition....

Assurément, il ne fera pas chez moi le même effet qu'à l'exposition étant moins élevé et dans un endroit plus petit, mais nous verrons cela....

Vous avez fait une très jolie chose—je vous en remercie.

CAT. 15

MAURICE DENIS

The Muses: Decorative Panel (*Les Muses: Panneau décoratif*)
1893
Oil on canvas
171.5 x 137.5 cm (67 ½ x 54 ⅛ in.)
Signed with vertical monogram and dated at lower center: *18 MAVD 93*
Musée d'Orsay, Paris

PROVENANCE: Sold by the artist to Arthur Fontaine (d. 1931), 1893 (perhaps as a gift for Madame [Marie] Fontaine, under whose name it was listed when exhibited at the 1893 Salon des indépendants); sold, Hôtel Drouot, Paris, 13 Apr. 1932, no. 37, as *Dans le parc*, to the French nation for the Musée du Luxembourg, Paris; transferred to the Musée d'Art Moderne, then to the Musée d'Orsay, Paris.

EXHIBITIONS: Paris, Pavillon de la Ville de Paris, *9ème Salon de la Société des artistes indépendants*, 18 Mar.–27 Apr. 1893, no. 366, as "*Les Muses: Panneau décoratif*, à Madame A[rthur] F[ontaine]." Paris, Union centrale des arts décoratifs, Pavillon de Marsan, *Maurice Denis, 1888–1924*, Apr.–May 1924, no. 38, as *Les Muses*.

NOTES:

1. Fontaine and Chausson were married to sisters of Madeleine Escudier, Lerolle's wife.

2. In a letter, Denis asked Arthur Fontaine if there was anything he could do to help Madame Fontaine with "her debut at our salon" ("ses débuts à notre salon"); Denis to Fontaine, n.d. (but before 1903, and referring to the Indépendants or possibly the Salon d'Automne), Institut Néerlandais, Paris, MS 1973–A249.

3. See Bouillon 1993, p. 47, where the work is described as a *conversation sacrée* and a *composition trinitaire*.

4. For an illustration of Denis's portrait *Madame Ranson with Cat* (c. 1892; Musée Départemental Maurice Denis "Le Prieuré," St.-Germain-en-Laye), see Bouillon 1993, p. 41.

5. George Mauner, "The Nature of Nabi Symbolism," *Art Journal* 23, 2 (winter 1963–64), p. 97.

6. The exhibition catalogue lists these works as follows: "no. 365, *Le Verger des vierges sages*, à M. H[enry] L[erolle]; no. 368, *Procession pascale*, à M. R[oger] M[arx]; no. 369, *Marche des fiançailles*, à Madame A[rthur] F[ontaine]; no. 370, *Notre Dame*."

7. Roger Marx, "Les Indépendants," *Voltaire*, 28 Mar. 1893, p. 1, cited in Paris 1993, p. 167.

8. Tipheret, "L'Art," *Coeur* 1, 1 (Apr. 1893), p. 7. In 1932, however, when *The Muses* was sold as part of Fontaine's estate, it was listed under the title *In the Park*, which emphasizes the familiar setting. More recently, the title and subject have been further secularized by relating the work specifically to the Jardin du Luxembourg, where "the modern muses are young women preparing for exams"; Mathieu 1990, n. pag. Bouillon, however, refuted the identification of the site as the Jardin du Luxembourg by noting those features that point clearly to the terrace at St.-Germain-en-Laye; Bouillon 1993, p. 47.

9. Edmond Cousturier, "Notes d'art," *Entretiens politiques et littéraires* 6 (10 May 1893), p. 429.

10. Camille Mauclair complained about Denis's framed *décorations* in 1894; see Camille Mauclair, "Choses d'art," *Mercure de France* (Dec. 1894), p. 384. Camille Pissarro had raised this objection as early as 1892 in a letter to his son Lucien, 20 Oct., cited in Rewald 1972, p. 204. For specific characteristics of a *décoration* as understood by the Nabis, see 1890–99 Intro.

11. Denis to Fontaine, [Apr. 1893], Institut Néerlandais, Paris, MS 1973-A204.

12. On Denis's friendship with Madame Fontaine, see Denis to Chausson, Oct./Nov. 1894, in Barruel 1992, p. 68, letter 7; and Denis to Fontaine (note 2).

13. Denis to Fontaine, 25 Nov. 1909, Institut Néerlandais, Paris, MS 1973-14224.

14. See Vuillard, Journals, entry, 7 Nov. 1894, MS 5396.

CAT. 16

MAURICE DENIS

April
(*Avril*)
1894
Oil on canvas
Diam.: 200 cm (78 ¾ in.)
Signed with round monogram entwined in a circular format at lower right: *MAVD*
Private collection

PROVENANCE: Ernest Chausson, Paris; several private collections.
EXHIBITIONS: Paris, Palais des Arts Libéraux, *10ème Salon de la Société des artistes indépendants*, 7 Apr.–27 May 1894, no. 208, as "*Avril*, plafond. Appartient à M. E. G. [*sic*]." Paris, Pavillon de Marsan, Musée des Arts Décoratifs, *Le Décor de la vie sous la IIIème République, de 1870 à 1900*, Apr.–July 1933, no. 117, as "*Plafond*, 1898."
NOTES:

1. The biographical details for this entry are drawn from Barruel 1992. For Chausson's negative reply to Denis's wedding invitation, see ibid., p. 66.

2. *Spring* is reproduced in Bouillon 1993, p. 78.

3. Chausson to Denis, late April 1894, in Barruel 1992, pp. 67–68, letter 3.

4. Chausson originally remembered 600 francs as the agreed-upon price of the painting, but ended up paying 1,000 francs (see Barruel 1992, p. 68, letter 3); for the installation, see Chausson to Denis, [June 1894], in ibid., p. 68, letter 4.

5. For more on Lerolle's panels, described as depicting airy figures set into animated space, see Denis 1932, p. 24. The current location of the panels is unknown.

6. See Bouillon 1993, p. 63.

7. For reproductions of these works, see Bouillon 1993, pp. 57, 61, 74.

8. Jules Christophe, "Les Salons," *Plume*, 1 June 1894, p. 234.

9. Lyons 1994, p. 158, cat. 35.

10. For Chausson's ownership of this illustrated cover for André Rossignol's musical setting for the poem, see Barruel 1992, p. 74, no. 4.

11. However, Denis did not credit Verlaine in his journal entry, entitled "Pictorial observations of a honeymoon trip" ("Notes picturales d'un voyage de noces"); see Denis, *Journal*, vol. 1, p. 102. Verlaine's "Parsifal" was published in his compilation of poems *Amour* in 1888 and republished in 1892.

12. Bouillon 1993, p. 69.

13. For the late nineteenth-century fascination with aquariums and underwater life, see Gloria Groom, "The Late Work," in Chicago 1994, p. 314.

14. *Spring* was also called the "Rondinelli" ceiling painting, after the villa at Fiesole that the Chaussons rented from Oct. 1894 to Mar. 1895. I am grateful to Thérèse Barruel for this information.

15. Writing in March 1899, Denis told Chausson that he had finished the work except for the portraits and added, "because it's a family scene, it would be better if the figures were sufficiently true to life. And so it will be useful if I can have those involved come here, if only for an hour or two: (Madame Chausson, Etiennette, Annie, Michel, Marianne)"; see Barruel 1992, p. 73, letter 35.

16. Denis's interest in the Italian tradition even prompted him to propose that Chausson compose a dedication for the painting inspired by that given by Andrea Mantegna to his famous mural *Bridal Chamber* (c. 1473; Palazzo Ducale, Mantua); see Barruel 1992, p. 76, no. 15. Denis's decision to include real portraits followed on the heels of his successful nine-panel series of 1897 for Baron Denys Cochin, which features members of the Cochin family at their estate (1890–99 Intro., figs. 16–18).

17. Chausson to Denis, Mar. 1899, in Barruel 1992, p. 73, letter 36.

18. Madame Chausson's reasons for choosing other artists to complete the interior are not clear, especially since she continued to be close to Denis on a personal level. Perhaps she simply preferred decorations without figures, which were Denis's strongest subject.

19. See Groom (note 13), p. 311.

20. Ibid.

CAT. 17–18

MAURICE DENIS

17. *Forest in Spring*
(*La Forêt au printemps*)
1894
Oil on canvas
230 x 100 cm (90 ½ x 39 ⅜ in.)
Signed with vertical monogram and dated at lower left: *MAVD 94*
Tom James Co./Oxxford Clothes

PROVENANCE: Arthur Huc, Toulouse (d. 1932); Huc family; Galerie Odermatt-Cazeau, Paris, by 1994; Japan Maruko, Inc.; private collection, Japan; Galerie Waring-Hopkins-Thomas-Custot, Paris, 1999; Tom James Co./Oxxford Clothes.
EXHIBITIONS: Toulouse, offices of *La Dépêche de Toulouse*, *Exposition de peinture de "La Dépêche de Toulouse,"* 25 May–end of June 1894. Not in catalogue.

18. *Forest in Autumn*
(*La Forêt en automne*)
1894
Oil on canvas
230 x 100 cm (90 ½ x 39 ⅜ in.)
Signed with vertical monogram and dated at lower left: *MAVD 94*
Tom James Co./Oxxford Clothes

PROVENANCE: Same as cat. 17.
EXHIBITIONS: Same as cat. 17.
NOTES:

1. Huc held the post of *sous-préfet* in Soissons and Bonneville before assuming his post at *La Dépêche*. Surprisingly little has been written about this interesting patron of the Nabis. Laura Morowitz provided important biographical information, but used it to stress Huc's anti-Semitism; see "Anti-Semitism, Medievalism, and the Art of the Fin-de-Siècle," *Oxford Art Journal* 20, 1 (1997), pp. 44, 49 n. 103. Huc's position at *La Dépêche* is not entirely clear; Morowitz stated that he joined the paper as a correspondent (ibid., p. 44). In Frèches-Thory and Terrasse 1990, p. 114, however, he is described as the paper's coeditor, and in Bouillon 1993, p. 67, as director.

2. Denis himself seems not to have remembered the Huc panels when he compiled a list of decorative projects for Achille Segard's otherwise comprehensive *Peintres d'aujourd'hui: Les Décorateurs* (1914), and they are not mentioned in Barazzetti-Demoulin 1945, a biography of Denis that features a chapter on his decorative projects.

3. *Portrait of M. Huc* (1892; Barber Institute of Fine Arts, University of Birmingham); Lyons 1994, p. 173, cat. 49. The locations of the calendar and oil version of the poster are unknown.

4. See note 1 above.

5. All references to correspondence between Huc and Denis are from the archives of the Musée MD. I am grate-ful to Mme Dellanoy for allowing me to consult this heretofore unpublished correspondence. Denis to Huc, 7 June 1891, Musée MD, MS 5598.

6. See letters of 10 July 1891 and 20 Mar. 1924, Musée MD, MSS 5599, 5637. In the latter, Huc listed the works he owned by Denis.

7. Huc explained his hopes for expansion in a letter to Denis of 19 Sept. 1891, Musée MD, MS 5601.

8. Huc to Denis, 20 Aug. 1891, and 19 Sept. 1891, Musée MD, MSS 5600–01. In the latter, Huc complained that the organizers of the St.-Germain show were going to charge him for entry to the exhibition and for publicity if he tried to review the show, and he therefore decided not to.

9. Huc to Denis, 19 Sept. 1891, Musée MD, MS 5601. At the same time Huc commissioned a calendar, the subject of which Huc left up to Denis's "fantasy": "Il y aurait toute latitude pour votre fantaisie." A year and a half later, on 3 Jan. 1893, Huc asked Denis to let Edouard Ancourt (the printer used by Bonnard and Toulouse-Lautrec, among others) know that the calendar image would be used in 1894; see Huc to Denis, Musée MD, MS 5612.

10. Huc to Denis, 21 Apr. 1892, Musée MD, MS 5610: "Voulez-vous si vous avez quelque loisir vous occuper du travail dont je vous ai entretenu: la reproduction de l'affiche sur toile pour panneau?" In the 1924 letter cited above (note 6), Huc listed this painting as having been "done from memory" (*fait de souvenir*).

11. Frèches-Thory and Terrasse 1990, p. 115.

12. It is not clear whether the panels were originally conceived for the offices or for Huc's residence. Information supplied by Thérèse Barruel states that they were originally made to go in the lobby of the *Dépêche* office, but Huc acquired them and took them home. She did not, however, offer any specific details on the transaction, and it is just as likely that the panels, which were not listed in the catalogue of the 1894 *Dépêche* exhibition, were conceived for permanent installation in Huc's residence. There was also talk of a commission, which apparently never came to fruition, to decorate Huc's billiard room; see Huc to Denis, 27 May 1892, Musée MD, MS 5611: "I hope to have the pleasure of offering you several other commissions, among them the decoration of a billiard room—but nothing [is] decided yet" ("J'espère aussi avoir le plaisir de vous donner encore quelques autres commandes, entr'autres la décoration d'une salle de billard—mais rien de décidé encore").

13. Huc to Denis, 17 Apr. 1894, Musée MD, MS 5621: "Les toiles de même grains peintes en imitation de tapisserie

et qui n'étaient pas trop mal. Vous pourrez vous informer du procedé."

14. Ibid.: "If the canvas is not usable for the *portières*, reduce it to those proportions that seem most harmonious to you and make panels of them. I will always find a place for them. In this case I will provide you for the *portières* a larger, wide-grained canvas that will work better" ("Si la toile n'est pas utilisable pour les portières, réduisez-là à telles proportions qui vous paraîtront les plus harmonieuses et faîtes en des panneaux. Je leur trouverai toujours une place. Dans ce cas je vous fournirais pour les portières de la toile à gros grains qui a plus de largeur et qui conviendrait mieux").

15. Huc to Denis, 27 Apr. 1894, Musée MD, MS 5622: "Qu'avez-vous décidé pour les portières? Avez-vous trouvé un procédé quelconque?"

16. Julien Godon, *Painted Tapestry and Its Application to Interior Decoration: Practical Lessons in Tapestry Painting with Liquid Color*, tr. by B. Buckhall (London, 1879). The vogue for decorative tapestries and wall paintings had reached a peak by the 1890s. The 1896 edition of the *Annuaire-Almanach du commerce et de l'industrie* advertised numerous painting supply shops under the categories *peintres en décors* and *peintres-décorateurs*, specializing in paintings imitating ancient tapestries and in all sizes; see Groom 1993, p. 231 n. 51. For more on the vogue for painted tapestries as *portières* in late nineteenth-century France, see *Autour du fil: L'Encyclopédie des arts textiles*, 2d ed. (Bagnolet, 1991), p. 27.

17. Paris 1993, pp. 144–45, cat. 33.

18. Bouillon 1993, p. 54.

19. Ibid., p. 35.

20. Maurice Denis [Pierre Louis, pseud.], "Notes sur l'exposition des Indépendants," *Revue blanche* 2, 7 (Apr. 1892), p. 233.

21. Huc to Denis, 14 May 1894, Musée MD, MS 5623: "I received your tapestries this morning. It [*sic*] is absolutely superb. Truly it is a shame to make *portières* of them, and I really wish to use them as panels" ("Reçu ce matin vos tapisseries. C'est absolument superbe. Vraiment il est dommage d'en faire des portières et j'ai grande envie de les utiliser pour les panneaux").

22. The date for this exhibition remains unclear, since the catalogue is very rare. Patricia Boyer described the exhibition as featuring seventeen original lithographs by a variety of artists; see New Brunswick 1988, p. 39, cat. 175, figs. 55–58. In his review of the exhibition, Huc divided the exhibiting artists into three categories: "Néo-réalistes" (Anquetin, Hermann-Paul, Ibels, and Toulouse-Lautrec), "Néo-traditionalistes" (Bonnard, Denis, Ranson, Roussel, Sérusier, and Vuillard), and others who were considered outside these two approaches (Maufra, Rachou, Ranft, and Vallotton). See Arthur Huc [Homodei, pseud.], "Nos Expositions: Les Oeuvres," *Dépêche de Toulouse*, 21 May 1894, p. 2.

23. See Huc (note 22).

24. Frèches-Thory and Terrasse 1990, p. 117.

25. The dining room also featured a false fireplace (*fausse cheminée*) in the form of a Renaissance altar; ibid., p. 115.

26. See Huc to Denis, 14 May 1894, Musée MD, MS 5623. One of the last of Huc's commissions was for designs for porcelain plates to be created by a *faiencier*, or maker of faience porcelain, in Martres, near Toulouse; see Huc to Denis, 20 Dec. 1895, Musée MD, MS 5639.

27. For Denis's work for Charles Stern, see cat. 25 n. 1. For his commission from Gabriel Thomas, see 1900–30 Intro., fig. 4.

28. Huc to Denis, 20 Mar. 1924, Musée MD, MS 5637: "J'ai d'abord deux tapisseries sur toile des Gobelins: mais il me serait impossible de les envoyer. Elles sont insérées dans une porte de salon à deux grands battants."

CAT. 19–24

MAURICE DENIS

Decorations for the Bedroom of a Young Girl, 1895–1900

19. *Farandole*
(*La Farandole*)
1895
Oil on canvas
48 x 205 cm (18 ⅞ x 80 ¼ in.)
Private collection

PROVENANCE: Sold by the artist to Gabriel Trarieux for 700 F, 1896. Private collection.

EXHIBITIONS: Maison de l'Art Nouveau, Paris, *Premier Salon de l'art nouveau*, 26 Dec. 1895–Jan. 1896, no. 71, as "*Frauenliebe und Leben*, frise en 7 panneaux pour une chambre à coucher."

20. *Sleeping Woman*, or
Crown of the Betrothal
(*La Dormeuse*, or
La Couronne de fiançailles)
1897/99
Distemper on canvas
53 x 219 cm (20 ⅞ x 86 ¼ in.)
Musée Départemental Maurice Denis "Le Prieuré," St.-Germain-en-Laye

PROVENANCE: Collection of the artist (d. 1943); by descent, to the artist's daughter Bernadette Denis; gift to the Musée Départemental Maurice Denis "Le Prieuré," St.-Germain-en-Laye, 1976.

21. *Birth*
(*La Naissance*)
1897/99
Distemper on canvas
53 x 196 cm (20 ⅞ x 77 ⅛ in.)
Musée Départemental Maurice Denis "Le Prieuré," St.-Germain-en-Laye

PROVENANCE: Collection of the artist (d. 1943); by descent, to the artist's daughter Bernadette Denis; gift to the Musée Départemental Maurice Denis "Le Prieuré," St.-Germain-en-Laye, 1976.

22. *White Roses*
(*Le Rosier blanc*)
1897/99
Distemper on canvas, mounted on wood
43 x 96 cm (16 ⅞ x 37 ¾ in.)
Private collection, Paris

PROVENANCE: Collection of the artist (d. 1943); by descent, to his granddaughter Claire Denis.

23. *Young Goats*
(*Les Chevreaux*)
1897/99
Distemper on canvas, mounted on wood
43 x 96 cm (16 ⅞ x 37 ¾ in.)
Private collection, Paris

PROVENANCE: Collection of the artist (d. 1943); by descent, to private collector, Paris.

24. *Doves*
(*Les Colombes*)
After July 1900
Distemper on canvas
53 x 85 cm (20 ⅞ x 33 ½ in.)
Musée Départemental Maurice Denis "Le Prieuré," St.-Germain-en-Laye

PROVENANCE: Collection of the artist (d. 1943); by descent, to the artist's daughter Bernadette Denis; gift to the Musée Départemental Maurice Denis "Le Prieuré," St.-Germain-en-Laye, 1976.

NOTES:

1. In 1976, the Yvelines district's purchase of Le Prieuré, Denis's home in St.-Germain-en-Laye, and an important gift from the Denis family created the Musée Départemental Maurice Denis "Le Prieuré." The museum opened in 1980. Among the many works of art in the donation is Denis's bedroom frieze. In addition to works of art, the benefaction included many documents, such as most of the correspondence received by the artist (e.g. letters from Bing to Denis), which are now in the museum's archives. Some of the documents, however, including Denis's notebook records of gifts and sales, are still in the Denis family archives.

2. None of the panels from this second series was exhibited during his lifetime. It is difficult, therefore, to ascribe precise dates to them. Since paintings exist from 1899 that depict the panels on the walls of Denis's bedroom in Villa Montrouge (see fig. 6), they must have been completed by then, although exactly when they were begun is more difficult to establish. Denis signed and dated (*MAVDJANVIER 22*) the panel *Annunciation*, or *Marriage*, in 1922, when he added images of his second wife, Lisbeth. A detailed discussion of all of these works is included later in this entry.

3. For the genesis of the commission from Bing and Tiffany, see Thérèse Barruel, "L'Amour et la vie d'une femme, la chambre à coucher de Maurice Denis," unpublished MS, Aug. 1999, pp. 2–3. The stained-glass windows manufactured by Tiffany after designs by Bonnard, Vuillard, and Roussel (cat. 30; cat. 30, fig. 1; cat. 34), among others from the Nabi circle, were shown for the second time that year at the Maison de l'Art Nouveau, Paris, having first been presented eight months earlier in Paris at the Salon de la nationale to great acclaim. Fabricated by Tiffany, Denis's window, *Paysage (Landscape)* (current location unknown; but it is worth noting that one of the versions of *Women at a Stream* [*Femmes au ruisseau*], in the Musée Départemental Maurice Denis "Le Prieuré," St.-Germain-en-Laye [inv. 976.1.98], was squared for transfer and thus might have served as the model), was featured at the Salon de la nationale, but not included in Bing's show, perhaps because it had already been purchased. See Paris, *17ème Salon de la Société nationale des beaux-arts*, exh. cat. (1895): "Tiffany (Louis C.): no. 391: "*Paysage*, vitrail d'après un carton de Maurice Denis." See also corresponding entry in one of Denis's notebook records of sale under 1894: "Vitrail à Bing—Tiffany, 200 F." For a brief discussion of Denis's window designs for Bing, see Lyons 1994, pp. 333–34.

4. Paris, Maison de l'Art Nouveau, *Premier Salon de l'art nouveau*, 26 Dec. 1895–Jan. 1896, no. 524: "*Maquette de mobilier pour une chambre à coucher* d'après les dessins de Maurice Denis." "*Frauenliebe und Leben*, frise en 7 panneaux pour une chambre à coucher," is listed as no. 71.

5. See Watkins. See also cat. 4.

6. In a letter to Denis, 30 Aug. 1895, Bing stressed the importance of all of the elements of the ensemble working in concert with Denis's paintings. He asked Denis to submit: "1. the disposition of your panels or sections of a frieze, 2. the range of colors, 3. your ideas about the rest of the decoration and about the relationship between the colors and the materials to be employed and their disposition." He also explained that "perfect homogeneity should exist in each room. . . . The ensemble will

also have to form a harmonious whole." Cited in Weisberg 1986, pp. 56, 53, respectively. Weisberg misread the date of this letter as April.

7. Bing to Denis, 30 Aug. 1895, cited in ibid., pp. 55–56.

8. Unpublished letter from Eugène Pinte to Denis, 26 Nov. 1895, Musée MD: "Il m'a commandé le lit, une chaise et une table-console pour mettre entre les deux fenêtres."

9. Unpublished letter from Eugène Pinte to Denis, 30 Dec. 1895, Musée MD: "Je viens d'aller voir Monsieur Bing. Les maquettes ont vécu: figurez-vous qu'il avait trouvé très intelligent de faire draper la tête du lit avec une tenture bleue d'un effet repoussant et enfermer la pauvre armoire dans une étoffe verte encore plus ignoble."

10. Gabriel Lefeuve, "Choses d'art, L'Exposition Bing," *Le Siècle*, 5 Jan. 1896: "Alas! We quickly exited, in spite of its pretty paintings, the bedroom by M. Denis, a kind of crematorium with a catafalque."

11. Camille Pissarro to his son Lucien, 3 Jan. 1896, in Camille Pissarro, *Correspondance*, vol. 4, p. 143.

12. Camille Mauclair, "Choses d'art," *Mercure de France* 17, 74 (23 Feb. 1896), p. 268.

13. Edmond Cousturier, "Galeries S. Bing, Le Mobilier," *Revue blanche* 10 (1896), p. 93.

14. Gustave Geffroy, "L'Art d'aujour-d'hui—Ameublement et décoration," *Le Journal* (3 Jan. 1896), pp. 1–2. *Muraille* referred to a decorative painting whose effect remains on the surface of the wall (through the use of soft colors) as opposed to trompe-l'oeil decorative painting, in which a sense of recessive or projecting space is created. See George Manning Tapley, Jr., *The Mural Paintings of Puvis de Chavannes* (Ann Arbor, Mich., 1981), pp. 56–57.

15. All citations of the poems by the French-born Adelbert von Chamisso come from Robert Schumann, *Frauenliebe und Leben: A Cycle of Eight Songs*, tr. by Edith Braun and Waldo Lyman (New York, 1954). In the first of the eight *Lieder*, or songs, the young woman meets the man of her dreams and becomes filled with a longing for him and a dissatisfaction with the care-free life among her friends she had for-merly found so appealing. The second two *Lieder* express the woman's painful expectations as she hopes to be chosen by the man she adores and her amaze-ment and joy when her love is requited. The fourth song describes her betrothal, and the fifth the joy of her wedding, tempered by her sadness at leaving her old life behind. The sixth and seventh songs focus on the bliss of married life and the ultimate fulfillment of mother-hood. The eighth and final song describes the woman's pain at the death of the man she loves. At Lycée Condor-cet, Paris, Denis read Chamisso's novel

Peter Schlemihl's Remarkable Story (1814), the tale of a man who sells his shadow; see Denis, *Journal*, vol. 1, p. 47.

16. The second cycle to which Denis referred is Schumann's *Dichterliebe* (*Poet's Love*, 1840), based on texts by Heinrich Heine and Joseph Freiheir von Eichendorff.

17. Part of the passage in question, written in Oct. 1891, is published in Denis, *Journal*, vol. 1, p. 88, but not these lines, which are cited and translated in Lyons 1994, p. 346.

18. *Amour* actually comprises twelve lithographs and a cover illustrated by Denis. The lithographs bear the follow-ing titles: *Allegory* (*Allégorie*), *The Postures Are Relaxed and Chaste* (*Les Attitudes sont faciles et chastes*), *Morning Bouquet, Tears* (*Le Bouquet matinal, les larmes*), *This Was a Religious Mystery* (*Ce fut un religieux mystère*), *The Knight Did Not Die on the Crusades* (*Le Chevalier n'est pas mort à la croisade*), *Twilight Has the Gentleness of Old Paintings* (*Les Crépu-scules ont une douceur d'anciennes peintures*), *She Was More Beautiful than a Dream* (*Elle était plus belle que les rêves*), *And It Is the Caress of His Hands* (*Et c'est la caresse de ses mains*), *Our Souls, in Slow Movements* (*Nos âmes, en des gestes lents*), *On a Pale Gray Sofa* (*Sur le canapé d'ar-gent pâle*), *Life Becomes Precious, Discreet* (*La Vie devient précieuse, discrète*), *But My Heart Is Beating Too Fast* (*Mais c'est le coeur qui bat trop vite*).

19. Denis mentioned the lithographs in his notebook record of gifts and sales under 1897 ("12 estampes d'Amour, 1200 F à Vollard") and in a 1909 list of his prints ("Amour, 1897").

20. Bing to Denis, 3 Feb. 1896, repr. in Weisberg 1986, p. 273 n. 26: "After having done everything to meet your demands, after having spent nearly 2,000 francs as you well know, after having reserved a place for your paint-ings that all of Paris passed by, a collec-tor [*amateur*] emerged from the public who was taken with your work. How-ever, if, in the absence of any written documents between us, you consider yourself absolved from any responsibil-ity to me, it's your business; but I must go on record that this is your point of view."

21. See unpublished letter from Denis to Henry Lerolle, postmarked Jan. 1896, Musée MD:

Bing asks me very cooly to take back my panels. . . . However, one of my friends wishes to buy Farandole; I would be very happy to have the money, but it is really too early for me to part with my work. . . . Do you think that I could find a way to sell the ensemble? . . . Truthfully, I fear doing this, but I would prefer to sell the whole thing than to break up my poor bedroom. (Bing me prie très sèche-ment de reprendre mes panneaux. . . . Or un de mes amis veut m'acheter la Faran-dole, je serais bien content d'avoir l'ar-gent, mais c'est vraiment trop tôt pour

me séparer de mon oeuvre. . . . Croyez-vous que je ne trouverai pas à vendre le tout? . . . J'en ai peur, à la vérité, mais j'aimerais faire tout plutôt que de détailler ma pauvre chambre.)

22. See unpublished letter from Gabriel Trarieux to Denis, 11 Feb. 1896, Musée MD: "Cher ami. Vous pensez si nous prenons avec plaisir votre farandole (à 700 fr. je crois.) Je ne voudrais pour-tant pas un malentendu. Si cela vous fait renoncer à une vente en bloc que vous préfériez, et s'il en est temps encore, j'aime bien mieux attendre une autre occasion qui nous soit également agréable. Dans le cas contraire, gardez le tableau, comme vous dites jusqu'à mon passage. Et voulez-vous le faire encadrer? Voilà qui est bien convenu. Vous n'avez même pas besoin de me répondre."

23. See entry under 1896 in Denis's notebook record of gifts and sales: "700 F. La Farandole à Trarieux."

24. See Denis's notebook record of gifts and sales, second part of entry for 1897: "300 F. *Jeune fille* (*chambre Bing*) à Mithouard."

25. See unpublished letter from Count Harry Kessler to Denis, 11 Mar. 1904, Musée MD, MS 6088: "You might be interested to learn that I have just acquired the four decorative panels you made for Bing" ("Il vous sera peut-être intéressant d'apprendre que je viens aussi d'acquérir les quatres panneaux décorat-ifs que vous aviez faits pour Bing").

26. According to Denis's account of his 1909 visit to Weimar; see Denis, *Journal*, vol. 2, p. 110: "Kessler's house, very well arranged by Van de Velde for my paint-ings . . . white and blue on a pink back-ground for my Bing panels."

27. See entry under 1896 in Denis's notebook record of gifts and sales: "700 F. La Farandole (en double) à Chausson." For drawings related to the Bing frieze owned by Chausson, see Barruel 1992, p. 74.

28. Although the unusual description of Chausson's copy of *Farandole* as a "dou-ble" would seem to indicate that it was painted *after* the version in the Bing series, it is also signed by Denis and dated 1895, leading one to believe that it was either worked on at the same time as the "Bing" panels or that Denis back-dated the final painting, as it is unlikely that he produced it in the few days between the opening of the exhibition in late December and the new year.

29. "Les Couronnes," dated 5 Sept. 1896 and dedicated to Marthe Denis, is one of Chausson's *Trois Lieder*; see Barruel 1992, p. 69, letters 16, 19.

30. Chausson, cited in Jean Gallois, *Ernest Chausson* (Paris, 1994), p. 64. Chausson also admired the otherworldly aspect of Schumann's music: "With him, form seems not to exist"; ibid.

31. The marriage of Yvonne Lerolle and Eugène Rouart, one of the sons of the famous collector Henri Rouart, took

place on 24 Dec. 1898. In her diary, Julie Manet offered an account of her friend's engagement party at Henri Rouart's home: "While beautiful music was being played, we took delight in examining the Corots. Yvonne was charming in a dress with silver spangles"; see Julie Manet, *Journal, 1893–1899*, 2d ed. (Paris, 1988), p. 150.

32. *Songe de la belle au bois*, a fairy tale in five acts, was published in 1892 by the Librairie de l'art indépandant, Paris.

33. Works on this theme include *Sleeping Woman*, the verso of *Boat Races at Perros* (1892; private collection), *Sleeping Beauty in Autumn* (1892; private collection), *Sleeping Woman on a Black Balcony* (1892; Galerie Berès, Paris), and *Sleeping Woman* (1892; Musée Bonnat, Bayonne).

34. Denis, *Journal*, vol. 1, p. 86.

35. See note 18.

36. It is interesting to note that in this panel, as well as in *Prayer*, Denis, perhaps for decorative reasons, depicted the walls of the bedroom at Villa Montrouge covered with white, starlike dots, whereas contemporary easel paintings of the bedroom, such as *Visit to the Violet Bedroom* (fig. 6) and *Two Cradles* (fig. 8), show plain, violet walls.

37. The notebook is named after Denis's final residence, an old seventeenth-cen-tury hospital built by Madame de Montespan in St.-Germain-en-Laye; it now houses the Musée Départemental Maurice Denis "Le Prieuré."

38. Siegfried Bing, *La Culture artistique en Amérique* (Paris, 1896), p. 108; tr. by Benita Eisler and repr. in Samuel [*sic*] Bing, *Artistic America, Tiffany Glass, and Art Nouveau*, intro. by Robert Koch (Cambridge, Mass., 1970), p. 185.

CAT. 25

MAURICE DENIS

Screen with Doves
(*Paravent aux colombes*)
c. 1896
Oil on canvas
Four-panel screen: each panel,
165 x 54 cm (65 x 21 1/4 in.)
Private collection, Paris

PROVENANCE: Maurice Denis (d. 1943); by descent, to his family.
NOTES:

1. Maurice Denis, *Eternal Summer Screen* (1905; private collection); see Lyons 1994, p. 308, cat. 169.

2. Roussel also made at least five designs for screens, although none was realized. Screens played a role in Denis's own décor: in 1891, he wrote to Aurélien Lugné-Poë that he had received from the wife of his friend Gabriel Trarieux "a splendid Japanese folding screen," and in 1908 he purchased several Asian screens for his home in Montrouge; see Denis to Lugné-Poë, 23 Jan. 1891, in Lugné-Poë 1930, p. 266.

3. Washington, D.C. 1984a, p. 149.

4. It does not explain, however, why the screen was not mentioned in Achille Segard's 1914 inventory or in Barazzetti-Demoulin 1945, which includes a chapter on Denis's decorative projects.

5. This is possibly the convent at St.-Germain-en-Laye, which appears in Denis's 1892 painting *Garden in a Convent* (formerly in the collection of the artist's son Dominique; its present location is unknown). Dominique Denis identified the convent in that painting in a letter of 18 Mar. 1893, which is cited in Washington, D.C. 1984a, p. 150.

6. This variation on Song of Solomon 2: 9–14 is cited in Lyons 1994, p. 161. Seven years later, Denis returned to the motifs of doves and a purifying fountain in a stained-glass window for the ambulatory of the Church of Ste.-Marguerite in Vésinet. In this composition, called *Ego flos campi*, he made the message more explicit by adding another Christian symbol, a chalice, to the entablature of the fountain; see Washington, D.C. 1984a, p. 152.

7. "Les Amours de Marthe," which is reproduced in Denis, *Journal*, vol. 1, pp. 84–101, resulted in an 1899 lithographic suite of the same title; see cat. 19–24 and cat. 19–24 n. 18.

8. Guy Cogeval suggested that the carving of the monogram in *Figures in a Springtime Landscape* refers to Denis's meditation on his fame at that moment; see Lyons 1994, p. 240.

9. In the upper right of the *Bouquet* panel (cat. 19–24, fig. 1d), for example, white figures approach the Gothic door of a chapel. Denis seems to have introduced the idea of a goal, or path to a higher plateau, in his earlier *Easter Mystery* (1891; The Art Institute of Chicago), where he made the entry of souls into a sacred building even more explicit.

10. In *Screen with Doves*, the woman who is about to carve into the tree is also distinguished from the others: she is the only female wearing a hat and is closest to the fountain, which is not enclosed but rather flanked by the garden fence. Is she the chosen one, the one who will marry and yet remain pure, even outside the garden's protective walls?

11. See Louis Réau, *Iconographie de l'art chrétien*, vol. 1 (Paris, 1955), pp. 80–81.

12. Interestingly, Denis drew his first idea for the screen on the back of a letter of 5 Dec. 1895 he received from Maison de l'Art Nouveau; see Michael Komanecky, "A Perfect Gem of Art," in Washington, D.C. 1984a, p. 85. Although Komanecky did not make the connection, it is this letter that has led to the redating of the work from 1902 to 1896.

13. Werner Hofmann, "Was ist ein Bild? Maurice Denis antwortet," in *Maurice Denis, 1870–1943: Fin-de-Siècle und Neue*

Klassik: Internationales Kolloquium im Wallraf-Richartz-Museum/Museum Ludwig, 1995, special ed. of *Wallraf-Richartz-Jahrbuch* 57 (1996), p. 296.

CAT. 26–27

KER XAVIER ROUSSEL

26. *The Seasons of Life* (first version)
(*Les Saisons de la vie*)
1892/93
Oil on canvas
58 x 123 cm (22 ⅞ x 48 ⅜ in.)
Estate stamp at lower left: *K. X. Roussel*
Musée d'Orsay, Paris

PROVENANCE: Collection of the artist's son, Jacques Roussel, Paris; to Musée d'Orsay, Paris, 1990.

27. *The Seasons of Life* (second version)
(*Les Saisons de la vie*)
1892/93
Oil on canvas
60 x 130 cm (23 ⅝ x 51 ⅛ in.)
Private collection

PROVENANCE: Collection of the artist (d. 1944); by descent, to Mlle Marceline Roussel, Paris; private collection.

EXHIBITIONS: Possibly Paris, Le Barc de Boutteville, *5ème Exposition des peintres impressionistes et symbolistes*, 1893, no. 162, as *Femmes causant*.

NOTES:

1. See also *Woman and Child Walking* (*Femme et enfant au promenade*, 1892/93; private collection, France) in Paris 1990, cat. 78, which is even closer in spirit to the park scenes in Vuillard's panels for the Desmarais.

2. See London, Marlborough Gallery, *Roussel, Bonnard, Vuillard*, exh. cat. (1954), p. 15, no. 2, where one is titled *Décoration pour une mairie*; Frèches-Thory and Terrasse 1990, p. 107; and St.-Germain-en-Laye 1994, p. 7, cat. 11, where they are described as pendants.

3. These included Maurice Maeterlinck's macabre *Sept Princesses* and a medieval play in modern French, *La Farce du pâté et de la tarte,* performed at the home of the State Counselor (*Conseiller d'Etat*) François Coulon in the spring of 1892. See Agnes Humbert, *Les Nabis et leur époque, 1888–1900*, pref. by Jean Cassou (Geneva, 1954), pp. 106–10. See also St.-Germain-en-Laye, Musée Départemental Maurice Denis "Le Prieuré," *Paul Elie Ranson: Du symbolisme à l'art nouveau,* exh. cat. (1998), pp. 76–77.

4. Götte 1982, vol. 1, p. 115. For information on the trip to London, see Vuillard to Verkade, Nov. 1892, in Mauner 1978, p. 283, app. 13.

5. Interestingly, unlike Denis, who focused on his fiancée, Marthe, as the major theme of his works of 1892–93,

Roussel painted no known portraits of Marie, nor did he allude in his works to their upcoming nuptials. Whereas Denis created seasonal panels relating to the stages of life and to Marthe specifically, Roussel seems to have treated the theme without investing it with personal significance.

6. See Götte 1982, vol. 1, p. 112.

7. Léon Paul Fargue, "Peinture chez Le Barc de Boutteville," *Art littéraire* 13 (Dec. 1893), p. 49.

8. Roussel's borrowing from Bernard is particularly evident in the two vertical panels of old women that he exhibited at the Barc de Boutteville gallery, Paris, in Dec. 1891–Feb. 1892 as *Paysan* (nos. 60–61).

9. Mauner 1978, pp. 243–44, interpreted these as the four seasons, from right to left:

Spring, with her mottled dress; Summer, bright, full and closest to the center; Fall, darkly clad, in shadow and looking down at seated Winter, white-haired and most passive. Spring and Summer look at each other, forward and backward, as it were; Autumn looks at Winter, who does not return the glance, but rather looks back toward the floral robe of Spring.

CAT. 28

KER XAVIER ROUSSEL

Conversation on a Terrace
(*Conversation sur la terrasse*)
1893
Oil on canvas
39.5 x 60 cm (15 ½ x 23 ⅝ in.)
Signed at lower right: *K. X. Roussel*
Private collection

PROVENANCE: Galerie André Maurice, Paris; private collection.

NOTES:

1. The competition for the mural decoration of the Salle des fêtes of the town hall of Bagnolet (completed 1891) was opened to artists on 9 June 1893. For further details, see Paris 1986, p. 237.

2. Albert Aurier, "Beaux-Arts: Les Symbolistes," *Revue encyclopédique* 2, 32 (1 Apr. 1892), p. 485; cited in Paris 1993, p. 224, cat. 87.

3. As early as 1890, Denis wrote to Aurélien Lugné-Poë of a plan to visit Puvis, "who will be useful to us." See Denis to Lugné-Poë, [early Nov. 1890], in Lugné-Poë 1930, p. 254.

4. For Séon's mural studies, *The Ephebes* and *The Maidens* (both 1892; Musée du Petit Palais, Paris), see Paris 1986, pp. 230–31, 275, cat. 95–96.

5. See Jean Da Silva, *Le Salon de la Rose + Croix, 1892–1897* (Paris, 1991), p. 123 n. 48. Roussel also could have known about Séon's mural aesthetic and achievement through Alphonse Germain's complimentary article on the artist,

"Un Peintre idéaliste idéiste," *Art et idée* (20 Feb. 1892), p. 34.

6. Arsène Alexandre, "La Décoration de la mairie de Bagnolet," *Eclair*, 8 Nov. 1893, p. 3; cited in Paris 1993, pp. 226–27.

7. I am grateful to David Van Zanten, art and architectural historian at Northwestern University, Evanston, Ill., for this identification.

8. See, for example, Vuillard's painting known as *The Park* (1894; private collection, New York), in which stripes, both fabric and metal, play a major role; see Groom 1993, p. 42, pl. 63.

9. See Giambruni 1983, p. 87, who pointed out this characteristic in Bonnard's works.

10. The lithograph was reproduced in *Revue blanche* 5, 23 (15 Sept. 1893) and again in the *La Petite Suite de La Revue blanche*, 1895. For the original drawing (*La Terrasse*, or *Deux Femmes conversant*), see Paris 1990, cat. 79; and Paris 1993, p. 237, cat. 97.

11. The Philadelphia painting is illustrated in Houston 1989, p. 15, no. 5. Roussel became part of the Vuillard household after his parents' separation in 1879; see Stump 1972, p. 50. In 1894, Roussel made yet another work focused on two women of differing ages, a lithograph entitled *Women in a Wood (Femmes dans un bois),* for the catalogue of the exhibition held at the offices of *La Dépêche de Toulouse* in May of that year. In that lithograph, Marie is recognizable by the hunched-over posture that characterizes her in many of Vuillard's dressmaking images. See Frèches-Thory and Terrasse 1990, p. 236 (ill.).

12. The Roussel archives are owned by the artist's great-grandson, Antoine Salomon, Paris. The catalogue raisonné for Roussel is expected to follow that of Vuillard, which Salomon is currently preparing with Guy Cogeval and the Wildenstein Foundation for publication in 2001.

CAT. 29–30

KER XAVIER ROUSSEL

29. *Women in the Countryside*
(*Femmes dans la campagne*)
c. 1893
Pastel on paper
42 x 26 cm (16 ½ x 10 ¼ in.)
Signed at lower right: *K.X.R.*
Private collection, courtesy Galerie Hopkins-Thomas-Custot, Paris

PROVENANCE: J[acques] Salomon; E. J. Wisselingh and Co., Amsterdam; private collection, The Netherlands; E. J. Van Wisselingh and Co., Naarden; private collection.

30. *Garden*
(*Le Jardin*)
1894
Oil on cardboard, mounted on
Japanese paper, mounted on hon-
eycomb panel
121 x 91.4 cm (47 ⅝ x 36 in.)
Signed at lower right: *K. X.*
Roussel
Carnegie Museum of Art,
Pittsburgh, gift of Mr. and Mrs.
John F. Walton, Jr., 1969

PROVENANCE: Edouard Vuillard,
Paris. Jacques Roussel, Paris; Dr. Walter
Feilchenfeldt, Zurich; Carnegie Museum
of Art, Pittsburgh, gift of Mr. and Mrs.
John F. Walton, Jr., 1969.
NOTES:
1. The previous title and date of what
we here call *Garden* (cat. 30), was *The
Window*, 1900, based on information
provided by the dealer from whom the
Carnegie Museum acquired the work
in 1969. Stump 1972, p. 73, mentioned
the existence of another stained-glass
window design by Roussel known as
The Window, apparently made as a
replacement for a broken window in
Vuillard's studio around 1900, thus fur-
ther confusing the issue. However, since
there is no further evidence to suggest
that Roussel executed, some five years
later, a near-exact copy of the stained-
glass window that is known to have
been made by Tiffany in 1895, the cura-
tors at the Carnegie Museum have
agreed that the work should be titled
Garden and dated 1894.
2. See, for example, *Composition in a
Forest* (1890; Musée Départemental
Maurice Denis "Le Prieuré," St.-
Germain-en-Laye), in St.-Germain-en-
Laye 1994, p. 6, no. 9; *Symbolist Scene*
(1890–92; Orléans, Musée des Beaux-
Arts), in Montreal 1998, p. 57, cat. 110;
and *Chivalric Scene* (1890–92; private
collection), in ibid., p. 197, no. 107.
3. Although a complete list of the artists
who submitted designs to Tiffany is
unavailable, we know that Tiffany
returned windows in 1895 based on
designs by Besnard, Denis, Ibels, Isaac,
Ranson, Roussel, Sérusier (who
designed three windows), Toulouse-
Lautrec, Vallotton, and Vuillard.
4. Vuillard to Denis, 30 May 1894,
Musée MD, tr. in Weisberg 1986, p. 49.
5. I am grateful to Thérèse Barruel for
providing me with information on the
Tiffany–Bing project, which will be
discussed more fully in her forthcoming
publication on Denis's decorative cycle
on *The Love and Life of a Woman*.
6. Jacques Emile Blanche, "Les Objets
d'art I, au Salon du Champ-de-Mars,"
Revue blanche 8, 43 (15 May 1895), p. 466.
7. "Le Salon du Champ-de-Mars," *Art
moderne* 15, 22 (2 June 1895), p. 173,
cited and tr. in Frèches-Thory and
Terrasse 1990, p. 187.

8. The cartoon for Lautrec's composi-
tion, *Papa Chrysanthème* (1894), is in the
Philadelphia Museum of Art; see
Weisberg 1986, p. 47, pl. 8. Surprisingly,
given his usual repertoire, Denis was
represented by a landscape (*Paysage*).
Thérèse Barruel suggested that this
design for a window may be a work
known as *Women at a Stream* in Musée
MD (see cat. 19–24 n. 3).
9. See David Wilkins, "Ker Xavier
Roussel's 'The Window,' " *Carnegie
Magazine* 52 (Dec. 1978), pp. 17–19.
10. Roussel's drawing differs slightly
from the stained-glass window. The
crouching woman at upper left wears a
dress of a solid blue in the window,
instead of the polka-dot dress that
Roussel indicated in his preparatory
design, perhaps owing to limitations in
the Tiffany technique.
11. Not all of Roussel's contemporaries
approved of the design, however. One
commentator found Roussel's window
oversimplified, "very primitive" and
"childish," consisting of "a few trees, a
chair, and a small boy," remarkable for
the "artlessness of the impression felt
[that] makes one smile and forgive";
René de Cuers, "Domestic Stained
Glass in France," *Architectural Record* 9
(Oct. 1899), p. 137.
12. This special architectural design
could explain why all of Tiffany's pro-
duction was not included in this second
venue. It is also possible that the
stained-glass windows by Denis,
Besnard, Isaac, and Sérusier were sold
during or shortly after the Salon de la
nationale. For more on Bing's interior,
see Weisberg 1986, pp. 57–73.
13. The three surviving windows were
purchased by Galerie Bernheim-Jeune,
Paris, at the Bing sale, Paris, Hôtel
Drouot, 26 May 1909; see Paris 1993,
p. 390.
14. For Baron Cochin's dining room,
Denis designed a large triptych, *The
Presentation at the Temple at Fiesole*, 1898,
executed by professional glass maker
Henri Carot; see Frèches-Thory and
Terrasse 1990, pp. 187–90. The cartoon
and the final window are in the collec-
tion of the Musée Départemental
Maurice Denis "Le Prieuré," St.-
Germain-en-Laye. In 1907, Denis
designed a stained-glass window, *Nude
at a Mirror* (*Nue au miroir*), for the
vestibule of the home of the director of
the Théâtre des Arts, Jacques Rouché;
see Segard 1914, vol. 2, p. 146.

CAT. 31

EDOUARD VUILLARD

Dressmaking Studio I (first version)
(*L'Atelier de couture I*)
1892
Oil on canvas
47 x 115 cm (18 ½ x 45 ¼ in.)
Private collection

PROVENANCE: Estate of the artist,
Paris; Wildenstein & Co., Inc., New York;
Mrs. Charles Stachelberg (formerly
Mrs. Walter Ross), New York; by descent,
to her family; sold, Christie's, New York,
30 Apr. 1996, no. 40, to present owner.
NOTES:
1. For information on Vuillard's theater
décors, see Russell 1971, pp. 31–32.
2. Ranson to Verkade, [July 1892], in
Mauner 1978, p. 280, app. 7.
3. For color reproductions of the six
panels and for further information on
this commission, its installation, and
the Desmarais family, see Groom 1993,
pp. 19–34, pls. 24–29.
4. Ranson to Verkade, [probably Oct.–
Nov. 1892], cited in Mauner 1978,
p. 282, app. 11.
5. Roger Marx, "L'Art décoratif et les
'symbolistes,' " *Voltaire*, 23 Aug. 1892,
excerpted and tr. in Claude Roger-
Marx 1946, p. 205 n. 7. Since there is no
indication that the panels were ever
exhibited, it is likely that Marx saw
them in Vuillard's studio.
6. Maurice Denis [Pierre Louis, pseud.],
"Pour les Jeunes Peintres," *Art et critique*
90 (20 Feb. 1892), p. 94.
7. In 1946, for example, Claude Roger-
Marx considered the originals lost:
"What has become of the *trumeaux* and
screen Vuillard created for Madame
Desmarais in 1892? We have lost knowl-
edge of them except for an article in *Le
Voltaire* and the fairly finished oil stud-
ies that the artist has kept for himself."
Roger-Marx 1946, p. 120. See Groom
1993, pp. 21, 31, pls. 22, 43–44, for oil
sketches related to the Desmarais series.
8. Albert Aurier, "Beaux-Arts: Les
Symbolistes," *Revue encyclopédique* 2, 32
(1 Apr. 1892), p. 485. *Sewing*, a wash
drawing by Vuillard showing two
females in a radically abstract composi-
tion, illustrates the article.
9. See Groom 1993, pp. 28, 30, pls.
38–39, 42.
10. See also ibid., p. 28, pl. 36, for a com-
parison of the dressmaking panels with
a print by Kitagawa Utamaro showing
women preparing fabrics for dresses.

CAT. 32–33

EDOUARD VUILLARD

Public Gardens, 1894

32. *First Steps*
(*Les Premiers Pas*)
Distemper on canvas
213.4 x 68.5 cm (84 x 26 ⅞ in.)
Signed and dated at lower right:
E. Vuillard 94
Tom James Co./Oxxford Clothes

PROVENANCE: Alexandre Natanson,
Paris; sold, Hôtel Drouot, Paris, 16 May
1929, no. 119, as *Les Premiers Pas*, to
Gaston Hemmendinger, Paris; Nazi
"spolia," 1940–45. Recovered by Gaston
Hemmendinger, 1947/48; private collec-
tion, Switzerland, from 1958; Wilden-
stein and Co., Inc., New York; Tom
James Co./Oxxford Clothes.
EXHIBITIONS: Paris, Galerie
Bernheim-Jeune, *Exposition Vuillard*,
19 May–26 June 1906, no. 26, as one
of *Neuf Panneaux décoratifs*.

33. *Under the Trees*
(*Sous les arbres*)
Distemper on canvas
214.6 x 97.7 cm (84 ½ x 38 ½ in.)
Signed and dated at lower right:
E. Vuillard 94
The Cleveland Museum of Art,
gift of the Hanna Fund, 1953.212

PROVENANCE: Alexandre Natanson,
Paris; sold, Hôtel Drouot, Paris, 16 May
1929, no. 122, as *Sous les arbres*, to
Georges Bénard, Paris; sold, Hôtel
Drouot, Paris, "vente G. B.," 9 June
1933, no. 90, as *Le Jardin du Luxembourg
sous les arbres*, to Henri Blum, Paris;
Hector Brame, Paris; César de Hauke,
New York; Knoedler & Co., New York,
May 1953 (stock # A5278); The Cleve-
land Museum of Art.
EXHIBITIONS: Paris, Galerie
Bernheim-Jeune, *Exposition Vuillard*, 19
May–26 June 1906, no. 26, as one of
Neuf panneaux décoratifs. Paris, Galerie
des Beaux-Arts, *Les Etapes de l'art con-
temporain II: Gauguin, ses amis, L'Ecole
de Pont-Aven et l'Académie Julian*, 1934,
no. 165. Paris, Chez Bolette Natanson
(Les Cadres), *Exposition des peintres de
La Revue blanche*, 12–30 June 1936, no.
79, as one of "*Deux des neuf panneaux
commandés par Alexandre Natanson en
1894 pour la décoration murale d'un salon.
App. à M. Henri Blum*." Paris, Musée
des Arts Décoratifs, *Exposition E. Vuillard*,
May–July 1938, no. 34b, as *Sous les arbres*.
NOTES:
1. Vuillard, Journals, MS 5397.
2. Individual titles were probably given
to these panels at the time of the sale of
Alexandre Natanson's collection in
1929. The only time the panels were
exhibited before 1929 was in 1906,
when they were referred to as *Neuf
panneaux décoratifs*; see *Exhibitions* for
cat. 32–33.

3. See Groom 1993, pp. 50, 52, pls. 76–78, 81–82.

4. *First Steps* (cat. 32) is particularly important to the series and to this exhibition. Although it was actually returned to its owner in 1947/48 after having been pillaged by the Nazis in World War II, it was generally thought to have been destroyed during the war, and only resurfaced in the Vuillard literature in 1999.

5. For the Desmarais panels (*Nursemaids and Children in a Public Park* and *A Game of Shuttlecock*) and *The Park*, see Groom 1993, pp. 22–23, pls. 26, 29, and p. 42, pl. 63.

6. The most thorough discussions of this series can be found in Claire Frèches-Thory, "*Les Jardins publics* de Vuillard," *Revue du Louvre* 4 (1979), pp. 305–12; Emily Ballew, "Edouard Vuillard's 'Jardins publics': The Subtle Evocation of a Subject," M.A. thesis, Rice University, Houston, 1990; William Robinson, "Vuillard's *Under the Trees* from the Nabi Cycle *The Public Gardens*," *Bulletin of the Cleveland Museum of Art* 79, 4 (Apr. 1992), pp. 111–27; and Groom 1993, pp. 47–65.

7. Karl Baedeker, *Paris and Environs* (Paris, 1891), p. 151.

8. In a journal entry of 1894, Vuillard mentioned visiting the Musée du Louvre and the Jardin des Tuileries several times; see Groom 1993, pp. 52, 218 n. 56.

9. T. J. Clark, *The Painting of Modern Life: Paris in the Art of Manet and His Followers* (New York, 1985), pp. 64, 279 n. 102. See also Groom 1993, pp. 51–52.

10. The park also included the eighteenth-century pavilion of the Bagatelle with the stunning art collection of Sir Richard Wallace, several fancy cafés, and boat rides, among other activities.

11. "Reçu l'argent d'Alex. Toile 9m 50 en 2m 40 de large à 3,80 = 36f 10, lin 1f 10, encre de chine, 60 total, 375f 80"; Vuillard, Journals, entry, 21 Aug. 1894, MS 5396.

12. See Giambruni 1983, p. 199; and New York, Wildenstein and Co., *La Revue blanche: Paris in the Days of Post-Impressionism and Symbolism*, exh. cat. by George Bernier (1983), pp. 28–33.

13. For the varying descriptions of this room, see Groom 1993, pp. 61–62.

14. This sketch and other studies for the series are located in the Salomon archives, Paris. See Groom 1993, pp. 60–61, pls. 100–03.

15. See Segard 1914, vol. 2, p. 320; and Juliet Bareau, "Edouard Vuillard et les Princes Bibesco," *Revue de l'art* 4 (1986), p. 46. Vuillard made a second set of overdoors, around 1908, for the family's new apartment on avenue des Champs-Elysées.

16. The triptych component of this series, consisting of the panels

Nursemaids, Conversation, and *Red Sunshade,* was purchased for 200,000 francs by the Musée du Luxembourg, Paris (now Musée d'Orsay), and was the first of Vuillard's decorative paintings to enter a French museum.

CAT. 34

EDOUARD VUILLARD

Chestnut Trees
(*Les Marronniers*)
1894/95
Distemper on cardboard, mounted on canvas
110 x 70 cm (43 ¼ x 27 ½ in.)
Private collection

PROVENANCE: Siegfried Bing; sold to Gallery Bernheim-Jeune, Paris "Vente Bing," 26 May 1909, no. 17454, as *Le Carton aux 8 personnages*; sold, Hôtel Drouot, Paris, 22 Dec. 1941, no. 111; private collection, France (?); sold, Hôtel Drouot, Paris, 19 June 1956, no. 57, to Galerie Percier, Paris; Galerie Berri-Lordy, Paris; sold, Hôtel Rameau, Versailles, 14 June 1980, no. 41; Galerie Marcel Bernheim, Paris; private collection.

EXHIBITIONS: Paris, Champ de Mars, *17ème Salon de la Société nationale des beaux-arts*, from 25 Apr. 1895, no. 390, as "Tiffany, *Marronniers; vitrail exécuté d'après un carton de Vuillard.*" Paris, Maison de l'Art Nouveau, *Premier Salon de l'art nouveau*, 26 Dec. 1895–Jan. 1896, no. 490, as "Tiffany, *Marronniers; vitrail exécuté d'après un carton de M. Vuillard.*"

NOTES:

1. René de Cuers, "Domestic Stained Glass in France," *Architectural Record* 9 (Oct. 1899), p. 141.

2. Ibid., pp. 137–38.

CAT. 35–39

EDOUARD VUILLARD

Series of Five Decorative Panels Known as "Album," 1895

35. *Album*
(*L'Album*)
Oil on canvas
67.8 x 204.5 cm (26 ¹¹⁄₁₆ x 80 ½ in.)
Signed at lower left: *E. Vuillard*
The Metropolitan Museum of Art, New York, The Walter H. and Leonore Annenberg Collection, partial gift of Walter H. and Leonore Annenberg, 2000 (2000.93.2)
NEW YORK ONLY

PROVENANCE: Thadée and Misia Natanson, Paris, from 1895; sold, Hôtel Drouot, Paris, 13 June 1908, no. 51, as *La Table de toilette*; Viennot (?); Walter H. and Leonore Annenberg; The Metropolitan Museum of Art, New York, The Walter H. and Leonore Annenberg Collection, 2000.

EXHIBITIONS: Paris, Maison de l'Art Nouveau, *Premier Salon de l'art nouveau*, 26 Dec. 1895–Jan. 1896, no. 210, as "*Décoration en cinq panneaux. Appartient à Mme Thadée Natanson.*"

36. *Embroidering by a Window,* or *Tapestry*
(*Les Brodeuses,* or *La Tapisserie*)
Oil on canvas
177.7 x 65.6 cm (70 x 25 ⅞ in.)
Signed at lower right: *E. Vuillard*
The Museum of Modern Art, New York, estate of John Hay Whitney

PROVENANCE: Thadée and Misia Natanson, Paris, from 1895; sold, Hôtel Drouot, Paris, 13 June 1908, no. 54, as *La Tapisserie* to Galerie Bernheim-Jeune, Paris; Jacques Emile Blanche, Paris; John Hay Whitney Collection, New York; The Museum of Modern Art, New York.

EXHIBITIONS: Same as cat. 35.

37. *Stoneware Vase,* or *Conversation*
(*Le Pot de grès,* or *La Conversation*)
Oil on canvas
65.5 x 114.5 cm (25 ¾ x 45 ⅛ in.)
Signed at lower left: *E. Vuillard*
Private collection, courtesy Nancy Whyte Fine Arts

PROVENANCE: Thadée and Misia Natanson, Paris, from 1895; sold, Hôtel Drouot, Paris, 13 June 1908, no. 52, as *Le Pot de grès,* to Jos Hessel, Paris; sold, Christie's, New York, 18 Nov. 1998, no. 38, to private collector.

EXHIBITIONS: Paris, Maison de l'Art Nouveau, *Premier Salon de l'art nouveau*, 26 Dec. 1895–Jan. 1896, no. 210, as "*Décoration en cinq panneaux. Appartient à Mme Thadée Natanson.*" Zürcher Kunsthaus, *Französische Kunst des XIX und XX Jahrhunderts,* 5 Oct.–14 Nov. 1917, no. 354, as *La Femme dans les fleurs.* Bristol, Royal West of England Academy, *French Modern Art Exhibition,* 31 May–14 June 1930, no. 95, as *Conversation.* New York, Jacques Seligmann & Co., *Exhibition of Paintings by Bonnard, Vuillard, Roussel,* 6–25 Oct. 1930, no. 30, as *Conversation.* Paris, Pavillon de Marsan, Palais du Louvre, *Le Décor de la vie sous la IIIème République de 1870 à 1900,* Apr.–July 1933, no. 341, as *Conversation.* Paris, Musée des Arts Décoratifs, *Exposition E. Vuillard,* May–July 1938, no. 37b, as *Conversation.* Buenos Aires, Museo Nacional de Bellas Artes, *La pintura francesa de David a nuestros días,* July–Aug. 1939, no. 202b (dated 1893), traveled to Montevideo, Rio de Janiero, São Paolo, San Francisco, New York, Chicago, Los Angeles, and Portland, Oregon, 1939–41, with varying titles.

38. *Vanity Table*
(*La Table de toilette*)
Oil on canvas
65 x 116 cm (25 ⅝ x 45 ⅝ in.)
Signed at lower right: *E. Vuillard*
Private collection

PROVENANCE: Thadée and Misia Natanson, Paris, from 1895; sold, Hôtel Drouot, Paris, 13 June 1908, no. 53, as *La Table de toilette,* to Jos Hessel, Paris; De Hauke & Co., Inc., New York; private collection, Japan; sold, Christie's, New York, 14 Nov. 1989, no. 55, to private collector.

EXHIBITIONS: Paris, Maison de l'Art Nouveau, *Premier Salon de l'art nouveau*, 26 Dec. 1895–Jan. 1896, no. 210, as "*Décoration en cinq panneaux. Appartient à Mme Thadée Natanson.*" Zürcher Kunsthaus, *Französische Kunst des XIX und XX Jahrhunderts,* 5 Oct.–14 Nov. 1917, no. 355, as *La Femme dans les fleurs.* Paris, Hôtel de la Curiosité et des Beaux-Arts, *Cent Ans de peinture française,* 15 Mar.–20 Apr. 1922, no. 161, as "*Panneau décoratif* (appartient à M. Hessel)." Bristol, Royal West of England Academy, *French Modern Art Exhibition,* 31 May–14 June 1930, no. 94, as *Amidst the Flowers.* New York, Jacques Seligmann & Co., *Exhibition of Paintings by Bonnard, Vuillard, Roussel,* 6–25 Oct. 1930, no. 31, as *Dans les Fleurs.* Kunsthaus Zürich, *Pierre Bonnard, Edouard Vuillard,* 1932, no. 124. Paris, Pavillon de Marsan, Palais du Louvre, *Le Décor de la vie sous la IIIème République de 1870 à 1900,* Apr.–July 1933, no. 339, as *Dans les fleurs.* London, Arthur Tooth & Sons, Ltd., *Paintings and Pastels by E. Vuillard,* 7–30 June 1934, no. 5, as *Dans les fleurs.* Paris, Musée des Arts Décoratifs, *Exposition E. Vuillard,* May–July 1938, no. 37a, as *Dans les fleurs.* Amsterdam, Stedelijk Museum, *Parijsche Schilders: Bonnard, Braque, Léger, Matisse, Picasso, Rouault, Utrillo, Vuillard,* Feb.–Apr. 1939, no. 136. Buenos Aires, Museo Nacional de Bellas Artes, *La pintura francesa de David a nuestros días,* July–Aug. 1939, no. 202a, traveled to Montevideo, Rio de Janiero, São Paolo, San Francisco, New York, Chicago, Los Angeles, and Portland, Oregon, 1939–41, with varying titles.

39. *Woman in a Striped Dress*
(*Le Corsage rayé*)
Oil on canvas
65.7 x 58.7cm (25 ⅞ x 23 ⅛ in.)
Signed at lower right: *E. Vuillard*
National Gallery of Art, Washington, D.C., Collection of Mr. and Mrs. Paul Mellon (1983.1.38)

PROVENANCE: Thadée and Misia Natanson, Paris, from 1895; sold, Hôtel Drouot, Paris, 13 June 1908, no. 55, as *Le Corsage rayé,* to M. Escher. George Herbert Dietze Collection, Frankfurt, by 1964; Wildenstein & Co., London

and New York, 1966; Mr. Paul Mellon, Upperville, Va., from 1966; gift from Mr. Paul Mellon to the National Gallery of Art, Washington, D.C., 1983.

EXHIBITIONS: Paris, Maison de l'Art Nouveau, *Premier Salon de l'art nouveau*, 26 Dec. 1895–Jan. 1896, no. 210, as "*Décoration en cinq panneaux*. Appartient à Mme Thadée Natanson." Leipzig, Kunstverein Museum, *Moderne Kunst aus Privatbesitz*, 1922.

NOTES:

1. See Groom 1993, p. 42, pl. 63, and pp. 44–45.

2. Since Vuillard referred to the paintings in his journal only as the "panels for Thadée," and they were exhibited in 1895 only as *Décoration en cinq panneaux*, I have adopted the individual titles used in the catalogue accompanying the sale of Thadée's collection on 13 June 1908. The collective title *Album*, based on the subject of the largest work in the series, seems to have been introduced informally around the same time. The text for this expanded entry is drawn directly from chapter four of Groom 1993, pp. 67–90.

Part of the reason this commission is infrequently mentioned in the Vuillard literature is that the panels were the first of the artist's decorative projects to be sold and later dispersed (1908). Segard's 1914 inventory lists them as having been "separated into diverse collections," notably those of the dealer Jos Hessel and the artist Jacques Emile Blanche. See Segard 1914, vol. 2, p. 20. Blanche actually purchased *Embroidering by a Window* from the Bernheim-Jeune gallery, which had bought it at the sale of Thadée's collection.

3. Edmond Cousturier, "Galeries S. Bing: Le Mobilier," *Revue blanche* 10, 51 (15 Jan. 1896), p. 93.

4. Arsène Alexandre, reviewing Bing's exhibition for *Figaro*, 28 Dec. 1895; cited in Victor Champier, "Les Expositions de l'art nouveau," *Revue des arts décoratifs* 16 (Jan. 1896), p. 16.

5. For Schopfer's role in Vuillard's career, see Groom 1993, pp. 99–119 passim.

6. This loftlike expanse, in which the Natansons lived for almost a decade, was devoid of the pretensions of Misia's artistic but solidly *haut bourgeois* family home in the fashionable Parc Monceau district; see Gold and Fizdale 1980, pp. 22–23. The home of Thadée's father, on rue Jouffroy in the same neighborhood, was also conservatively furnished in the Bourbon Louis style (see cat. 41).

7. Misia later credited Van de Velde with introducing her to the principles of modern painting and design; see Misia Godebska Sert, *Misia* (Paris, 1952), p. 36.

8. On the vogue for unframed paintings, see Groom 1993, pp. 86–87, 89.

9. The panels today are varnished differently, and some have been overcleaned

so that the original unity of surface patterns and finish is irreparably lost.

10. Lucien Muhlfeld, "A propos de peintures," *Revue blanche* 4, 20 (June 1893), p. 460. Muhlfeld recommended the use of the screen format and pulleys (presumably to move the works up and down like shades, or across as curtains) to give *décorations* greater flexibility.

11. See *Bottin mondain* (Paris 1903), where Thadée is listed at 23, rue de Constantine.

12. From the sale, the two "pendants" (cat. 37–38) were purchased by Jos Hessel and have, until recently, remained in his family's collection.

CAT. 40

EDOUARD VUILLARD

Cipa Listening to Misia at the Piano
(*Cipa écoutant Misia au piano*)
1897/98
Oil on cardboard
63.5 x 56 cm (25 x 22 in.)
Signed at upper right: *E. Vuillard*
Staatliche Kunsthalle Karlsruhe,
Germany

PROVENANCE: M. E. Hoogendijk, Amsterdam; sold, F. Muller & Cie, Amsterdam, 22 May 1912; Sir Alexander Korda, London; sold, Sotheby's, London, 15 June 1962, no. 33; O'Hanna Gallery, London; Marlborough Fine Art Gallery, London; sold to Staatliche Kunsthalle Karlsruhe, 1965.

NOTES:

1. See Gold and Fizdale 1980, pp. 12–14.

2. See ibid., p. 19. Misia's biography makes little mention of her brothers Ernest and Franz.

3. In 1892, shortly before her marriage, Misia performed at the café Le Chat Noir in honor of its eccentric and handsome owner, Maurice Rollinat. There she was hailed as a budding young artist by Lucien Muhlfeld, music critic for *La Revue blanche*; see his "Notes dramatiques," *Revue blanche* 2, 5 (15 Feb. 1892), p. 128.

4. Gold and Fizdale 1980, p. 100.

5. Vuillard to Vallotton, 7 Nov. 1897, in Guisan and Jakubec 1973–75, vol. 1, p. 170, letter 110; repr. in Gold and Fizdale 1980, pp. 71–72.

6. See Robert Burnard, *La Vie quotidienne de 1870 à 1900* (Paris, 1947), pp. 124–26, for the appearance of the oil lamp around 1890 and its significance as light source and decoration.

7. Compare, for example, this painting to the *Album* series (cat. 35–39) and to one of Vuillard's panels for Dr. Henri Vaquez, which also shows a woman playing the piano (1890–99 Intro., fig. 21).

8. Siegmar Holsten, "Von der Impression zur Befreiung der Farbe:

Französische Malerei im Aufbruch der Moderne," *Staatliche Kunsthalle Karlsruhe: Die Sammlung der Moderne* (Heidelberg, 1993), p. 11.

CAT. 41

EDOUARD VUILLARD

Window Overlooking the Woods
(*La Fenêtre sur le bois*)
1899
Oil on canvas
249.2 x 378.5 cm (98 ⅛ x 149 in.)
Signed and dated at lower right:
E. Vuillard 99
The Art Institute of Chicago,
L. L. and A. S. Coburn Fund,
Martha E. Leverone Fund,
Charles Norton Owen Fund, and
anonymous restricted gift

PROVENANCE: Adam Natanson (d. 1906), Paris, from 1899; by descent, to his son Thadée Natanson, Paris; sold, Hôtel Drouot, Paris, 13 June 1908, no. 64, to Alexandre Natanson; sold, Hôtel Drouot, Paris, 16 May 1929, no. 127, to Léon Blum, Paris (d. 1950); by descent, to Robert Blum, Paris (d. 1974); M. Knoedler's, New York, 1974; sold, Sotheby's Parke-Bernet Gallery, New York, 23 Oct. 1974, no. 216, to John Samuels; sold, Sotheby's Parke-Bernet Gallery, New York, 22 Oct. 1980, no. 60a, to Herman Shickman; sold to The Art Institute of Chicago, 1981.

EXHIBITIONS: Probably Paris, Grand-Palais, *2ème Salon d'Automne*, 15 Oct.–15 Dec. 1904, no. 1287 or 1288, as *Verdure*. Paris, Musée des Arts Décoratifs, *E. Vuillard*, May–June 1938, no. 69, as *Paysages de l'Ile de France*.

NOTES:

1. The Ile-de-France consists of the region between the Seine, Oise, and Marne rivers. It includes the suburbs St.-Germain-en-Laye, where Denis lived, and L'Etang-la-Ville, where Roussel lived.

2. See Groom 1993, p. 230 n. 18.

3. See Annette Vaillant, *Le Pain polka* (Paris, 1974), p. 56. For an expanded discussion of the subject in this entry, see Groom 1993, pp. 121–34.

4. See Groom 1993, p. 124.

5. Vuillard to Vallotton, 26 July 1899, in Guisan and Jakubec 1975, p. 15.

6. See *Hillside of L'Etang-la-Ville* (c. 1899; Kunstmuseum Winterthur, Switzerland) and *Sunny Road* (c. 1899; private collection, Paris), in Groom 1993, pp. 126–27, pls. 201, 204.

7. An early postcard, for example, shows the church of L'Etang-la-Ville, which in *Window Overlooking the Woods* is reduced to a swordlike object peeking through the trees; see Groom 1993, p. 130, pl. 209.

8. I owe this observation to discussions in front of the work with Nicholas Watkins.

9. Examination of the surface of *Window Overlooking the Woods* suggests that Vuillard worked quickly and repainted little. This process, however, is in marked contrast to Vuillard's laments about the amount of time consumed by the pendants; Vuillard to Vallotton, 23 Nov. 1899, in Guisan and Jakubec 1975, p. 19.

10. See Groom 1993, p. 127, pl. 204.

11. Guy Cogeval, who is currently working on the forthcoming catalogue raisonné of Vuillard's works, believes that the ledge alludes to the rooftop of another house. Conversation with the author, 2 Apr. 2000.

12. While these panels are presumed to have been exhibited at the 1904 Salon d'Automne under the title *Verdure*, the catalogue accompanying this Salon provides no definite identification of them as belonging to Adam Natanson. The asterisks marking these two works in the catalogue simply indicated that they were not for sale.

13. Segard 1914, vol. 2, pp. 259–60. See also Segard's comments on the panels as analogous to a " 'colored grisaille,' whose aim is to pull together the interior to be decorated and not to extend it beyond the wall with an illusion. . . . [The image] does not attract the eye, it relaxes it." Ibid., pp. 268–69.

14. See Groom 1993, p. 133, pl. 213. Annette Vaillant's memory of eating in front of *Window Overlooking the Woods* conflicts with these photographs, which show it installed in the library, not the dining room; see Vaillant (note 3), pp. 41–42.

15. Vaillant (note 3), pp. 41–42.

16. Their unwieldy size may explain why they were separated in 1950, when Léon Blum (who had purchased the panels from Alexander Natanson in 1929) died; *Window Overlooking the Woods* went to his son, Robert, who lived in a more modest dwelling on quai Bethune, and *First Fruits* was sold to Walter J. Chrysler, Jr.

17. Segard 1914, vol. 2, pp. 262–63.

CAT. 42

EDOUARD VUILLARD

Walking in the Vineyard, or *Promenade*
(*Promenade dans les vignes*)
1899/1900
Oil on canvas
260.5 x 249 cm (102 ½ x 98 in.)
Los Angeles County Museum of Art,
gift of Hans de Schulthess

PROVENANCE: Jack Aghion, from 1899/1900; Galerie Bernheim-Jeune, Paris, 1908; Karl Ernst Osthaus, Hagen, Germany, c. 1908; Museum Folkwang, Hagen, Germany, until 1922. Acquired in Germany in the 1950s by Rosenberg and Stiebel, New York; Alexandre Rabow Galleries, Los Angeles, 1955; Hans de Schulthess, Los Angeles, from

1955–56; Los Angeles County Museum of Art, gift of Hans de Schulthess, 1959.

EXHIBITIONS: Hagen, Museum Folkwang, *Moderne Kunst: Plastik, Malerei, Graphik*, 1912, no. 195, as *Herbst vor Paris*.

NOTES:

1. Vuillard painted numerous large portraits in oil, however, beginning in 1897.

2. See Groom 1993, pp. 134–43, for an extended discussion of this subject.

3. See ibid., pp. 136, 232 nn. 73–76.

4. Vuillard to Vallotton, 9 July 1900; Guisan and Jakubec 1973–75, vol. 2, pp. 41–42, letter 133.

5. Vallotton to his brother Paul, 1899, in Guisan and Jakubec 1973–75, vol. 1, p. 188, letter 126.

6. The remainder of Jack Aghion's collection was put up for sale after his death in 1918; see Paris, Hôtel Drouot, *Catalogue des tableaux modernes par Boudin, Caillebotte, Guillaumin . . .*, sale cat. (29 Mar. 1918). Included in this sale were four easel paintings by Vuillard, nos. 26–29.

7. Vuillard to Vallotton, autumn 1899, in Guisan and Jakubec 1975, p. 18.

8. From handwritten notes on a photocopy of album sheets of photographs (Salomon archives, Paris).

9. Groom 1993, pp. 139, 232 nn. 82–83.

10. Ibid., p. 138, pl. 218.

11. Maurice Denis, "Notes sur l'exposition des Indépendants," *Revue blanche* 2, 7 (25 Apr. 1892), p. 232.

CAT. 43

PIERRE BONNARD

Family in the Garden (Grand-Lemps)
(*La Famille au jardin [Le Grand-Lemps]*)
c. 1901
Oil on canvas
109.5 x 127.5 cm (43 ⅛ x 50 ¼ in.)
Stamped at lower right with seal of the estate: *Bonnard*
Kunsthaus Zürich

PROVENANCE: Pierre Bonnard Estate; private collection, Paris; sold, Sotheby's, London, 26 Mar. 1980, no. 31, to private collector; Christie's, New York, 12 Nov. 1985, no. 27, unsold; Kunsthaus Zürich, 1985.

NOTES:

1. Watkins 1994, p. 78.

2. Jean Louis Prat, in a recent entry on the painting, ascribed some of these compositional characteristics to Bonnard's use of a camera with a wide-angle lens around 1897; see Martigny 1999, p. 54, no. 10.

3. See Marianne Matta in Kunsthaus Zürich, *Bonnard*, exh. cat. (1984), p. 100, no. 22. Matta stated, rather than proved, the screen-to-painting evolution of this work, however.

4. See Christian Klemm, *Museum of Fine Arts, Zurich*, tr. by Philip Weller (Zurich, 1992), p. 62.

CAT. 44

PIERRE BONNARD

Screen with Rabbits
(*Paravent aux lapins*)
1902/06
Oil on paper, mounted on canvas
Six-panel screen: each panel,
161 x 45 cm (63 ⅜ x 17 ¾ in.)
Signed on left panel at lower left: *Bonnard*
Musée Départemental Maurice Denis "Le Prieuré," St.-Germain-en-Laye

PROVENANCE: Pierre Bonnard Estate. Musée Départemental Maurice Denis "Le Prieuré," St.-Germain-en-Laye, from 1983.

NOTES:

1. Fréches-Thory and Terrasse 1990, p. 167.

2. Fauns and satyrs are often confused, since in ancient mythology both were referred to as demigods of the countryside. Fauns, however, were benevolent protectors of shepherds and shepherdesses, while satyrs, usually seen with goat feet, were seducers, using their music to attract nymphs. See Pierre Larousse, *Grand Dictionnaire universel du XIX siècle* (Geneva, 1982), vol. 8, pp. 144–45; vol. 14, pp. 255–56.

3. The undulating wave of dark purple, through which "cut-out" vignettes appear, may be the first use by Bonnard of a compositional strategy that reached its most exaggerated form a few years later, in the panels decorated with wavy and monkey-filled borders that he painted for Misia Natanson Edwards (see cat. 45–47).

4. In Chinese art rabbits appear mostly as symbols of longevity or as a sign of the zodiac. I am indebted to Bernd Jesse, Assistant Curator of Japanese Art at the Art Institute of Chicago, for his assistance with these points.

5. See for example his *Project for a Fan: Rabbits in a Meadow* (Musée du Louvre, Paris), in Paris, Galeries Nationales du Grand Palais, *Japonisme*, exh. cat. (1988), p. 265, cat. 296; and *Project for Screen with Rabbits* (1894–95; Musée du Louvre, Paris), and *Ensemble Champêtre* (1894/96; The Museum of Modern Art, New York), in Paris 1993, pp. 365–67, cat. 185–86. See also his 1904 illustrations for Jules Renard's *Histoires naturelles*. In a later decorative painting, *Earthly Paradise* (cat. 52), Bonnard included more overtly amorous rabbits.

6. This connection was first pointed out in Cogeval 1993, p. 76.

7. Bonnard's graphic works for Longus's tale are described more fully and illustrated in part in New York 1989, pp. 172, 175ff.

8. For other sculptures related to *Daphnis et Chloé*, see Lausanne 1991, nos. 100–04 (ills.).

9. For identification of these landscapes with the Dauphiné region, see New York 1989, p. 185. By 1900, Roussel was also embarking on works based on antique myths and allegories. These themes, especially influenced by the Roman poet Virgil, would become Roussel's definitive thematic repertoire. In a 1904 exhibition at the Bernheim-Jeune gallery, Roussel showed an oil painting entitled *Fauns* (Paris, Galerie Bernheim-Jeune, *Bonnard, Roussel, Vallotton, Vuillard, Maillol*, exh. cat. [8–18 Apr. 1904], no. 19), while Bonnard showed his painting *Faun* (1890–99 Intro., fig. 3) that same year at the Libre Esthétique (Brussels, Libre Esthétique, *Peintres impressionnistes*, exh. cat. [25 Feb.–29 Mar. 1904], no. 4).

10. The nymphs and fauns may represent Bonnard's response to Paul Cézanne's early "battles of love," in which couples are locked together, fighting or embracing in a landscape. See Whitfield's insightful commentary on Bonnard's debt to Cézanne, in London 1998, pp. 18–19, 96.

11. See Antoine Terrasse, "Chronology," in Washington, D.C. 1984b, pp. 248–51.

12. This is in contrast to Bonnard's lithographic screen *Nannies' Promenade* (cat. 6), for example, which was appropriate for more public spaces, such as offices (see cat. 6, fig. 2) and studios (see 1900–30 Intro., fig. 12), because of its less intimate subject matter.

CAT. 45–47

PIERRE BONNARD

Decorative Ensemble, 1906–10

45. *After the Flood*
(*Après le déluge*)
Oil on canvas
250 x 450 cm (98 ⅜ x 177 ⅛ in.)
Signed at lower right: *Bonnard*
Ikeda Museum of Twentieth-Century Art, Ito, Japan

PROVENANCE: Misia Natanson Edwards (née Godebska), Paris, until c. 1915. Henri and Marcel Kapferer, Paris; sold, Galerie Charpentier, Paris, 28 May 1954, no. 37, to Walter P. Chrysler, Jr., New York; sold, Christie's, London, 14 Apr. 1970, no. 43, to Fiji Television Gallery, Tokyo; Ikeda Museum of Twentieth-Century Art, Ito, Japan.

EXHIBITIONS: Paris, Grand Palais des Champs-Elysées, *Salon d'Automne*, 1 Oct.–8 Nov. 1910, no. 133, as "*Panneaux décoratifs formant un ensemble (montures de Dantant)*."

46. *Landscape Animated with Bathers*, or *Pleasure*
(*Paysage animé de baigneuses*, or *Le Plaisir*)
Oil on canvas
251.5 x 464.7 cm (99 x 183 in.)
Signed at lower right: *Bonnard*
The J. Paul Getty Museum, Los Angeles

PROVENANCE: Misia Natanson Edwards (née Godebska), Paris, until c. 1915; Jos Hessel, Paris; Henri and Marcel Kapferer, Paris; Galerie Bernheim-Jeune, Paris; Donnadieu (or Donadeil) Collection, Nice. Jean Neger Collection, Paris, by 1958; The J. Paul Getty Museum, Los Angeles, from 1969.

EXHIBITIONS: Same as cat. 45.

47. *Pleasure: Decorative Panel*, or *Games*
(*Le Plaisir: Panneau décoratif*, or *Les Jeux*)
Oil on canvas
246 x 300 cm (96 ⅞ x 118 ⅛ in.)
Signed at lower right: *Bonnard*
Collection Paule and Adrien Maeght, Paris

PROVENANCE: Misia Natanson Edwards (née Godebska), Paris, until c. 1915. Henri and Marcel Kapferer, Paris; Collection Paule and Adrien Maeght, Paris.

EXHIBITIONS: Same as cat. 45.

NOTES:

1. Dantant was the person (or firm) who created the frames, or mounts (*montures*), for the panels. Unfortunately, there are no known photographs of the works before their sale and dispersion around 1915 to show how they were framed.

2. Louis Vauxcelles, "Le Salon d'Automne de 1910," *Art décoratif* 2 (July–Dec. 1910).

3. There is no water source visible in the so-called *Landscape Animated with Bathers* (cat. 46), for instance.

4. Fosca 1919, p. 45.

5. See Paris 1993, pp. 366–68, cat. 186–87.

6. Bonnard also borrowed Rubens's figural types for another classicizing work, *The Three Graces* (1908; Galerie Bernheim-Jeune, Paris); see Dauberville, vol. 2, p. 112, no. 493 (ill.).

7. For Denis's recommendations on framing, see idem. [Pierre Louis, pseud.], "Notes sur l'exposition des Indépendants," *Revue blanche* 2, 7 (25 Apr. 1892), p. 233. Alphonse Germain recommended that painted borders be drawn from flora, "*contrasting the tints and lines* with the dominant traits of the panel, *in consonance with the composition, the sentiment, with the desired effect*;" see "Le Paysage décoratif," *Ermitage* 2, 11 (Nov. 1891), pp. 644–45. Although most critics commented only on the inventiveness of the framing device, Bonnard's early biographer, François Fosca, was adamantly opposed to this feature (see Fosca 1919, p. 46): "In a dis-

concerting, bizarre way, the painter has surrounded each panel with a yellow, jagged border . . . [of] monkeys and magpies. . . . This border is absolutely inexplicable; it neither frames nor contains the painting and its color is distracting."

8. See London 1998, p. 259.

9. For information on Edwards's seduction of Misia, see Gold and Fizdale 1980, pp. 82–88.

10. Although Vuillard (possibly because of his involvement at the time with Lucie Hessel) never sailed with the Edwardses, he did travel in February 1908 to London with Misia, her husband, and Bonnard; see London 1991, p. 9.

11. See Gold and Fizdale 1980, p. 114.

12. Philippe Julian, "Reine de Paris pendant 40 ans: Misia," *Crapouillet* 28 (1973), p. 44.

13. Ibid., p. 43: "Edwards was a large and fat fifty-year-old with a blemished complexion, a malicious eye behind a thick pince-nez; a long and drooping nose that accentuated his resemblance to an elephant."

14. Edwards would sometimes lock Misia in her chambers when he was out; see Gold and Fizdale 1980, p. 92.

15. It is also possible that these surrounds may have been inspired by the ornately painted frames of Primaticcio's Renaissance frescoes in the Galerie François I at the Château de Fontainebleau, which Bonnard and Vuillard visited in 1908; see Groom 1993, p. 186.

16. A 1932 article on Misia's home provides an interesting glimpse into her unusual tastes. The furniture and decorations included mother-of-pearl inlaid tables, chairs, and couches (originally made for Charles X); a crystal chandelier in the shape of a boat; a table with a mermaid pedestal; and numerous Chinese figurines and statuettes, including one that is quite similar to the depiction of the Asian man in *Water Games*. While the furniture dates from the 1920s, it is possible that she may have owned some of the decorative objects at the time Bonnard painted her panels. If so, they could have served as sources of motifs and themes for the artist. See "Chez Mme Misia Sert," *Art et industrie* (June 1932), pp. 8–13.

17. See Natanson 1951, p. 141, who compared Bonnard's decorative paintings for Misia (referring to those now owned by Henri Kapferer) to tapestries.

18. Jean Godebski, in conversation with the author, 2 Sept. 1983.

19. Lucie Cousturier, "Pierre Bonnard," *Art décoratif* 28 (July–Dec. 1912), pp. 367–70.

20. Vuillard, Journals, entry, 25 Dec. 1910, MS 5397: "Allons chez Misia. Soirée des panneaux de Bonnard." See also an earlier reference, after a studio

visit, in ibid., entry, 8 Apr. 1910, MS 5397, to Bonnard's "panneaux charmants, fantaisies."

21. It is tempting to think that in the course of making these panels, Bonnard might have seen Léon Bakst's lavish and exotic costumes and stage decors for the ballet *Cleopâtre*, performed at the Théâtre du Châtelet on 2 June 1909; see Martine Kahane, *Les Ballets Russes à l'Opéra* (Paris, 1992), pp. 32–33.

22. "Dans le salon sous-marin de Mme Edwards / Qu'irisent les Bonnard, les ficus et les quartz," cited in Julian (note 12), p. 43. Misia's love for potted ficuses is seen in paintings and photographs of her earlier apartment on rue St.-Florentin (see 1890–99 Intro., fig. 4). The mention of quartz probably refers to the collection of rock crystals that Misia owned at least by 1920–21, when she was living at 252, rue de Rivoli with her third husband, José Maria Sert; see photograph in Gold and Fizdale 1980, between p. 242 and p. 243.

23. Entry, 12 Nov. 1915, in André Gide, *Journal* (Paris, 1939), pp. 516–17.

24. Jean Hugo to author, 24 Apr. 1983: "I lunched at Mme Misia Godebska's, quai Voltaire, around 1916 or 1917, during one of my leaves, but I did not see the decorative panels by Bonnard. Maybe they had already been sold, because she shortly after came to live at Hôtel Meurice, where, after the war, I often visited her." There is a great amount of confusion surrounding the dispersal of the ensemble, and almost every publication provides conflicting provenance information. According to Martine Martin, Marcel's daughter, her father and uncle owned all four panels. London, Royal Academy, *Pierre Bonnard*, exh. cat. (1966), p. 46, no. 91; and Natanson 1951, however, state that Henri only owned two. Claude Weill, Henri's daughter, claimed that her father owned three of the four (cat. 45, 47, and fig. 1) by around 1925.

CAT. 48–49

PIERRE BONNARD

48. *In the Country I: Mother and Little Boy*
(*A la campagne I: Mère et petit garçon*)
1907
Oil on canvas
100 x 32 cm (39 ⅜ x 12 ⅝ in.)
Signed at lower right: *Bonnard*
Joan and Nathan Lipson, Atlanta

PROVENANCE: Henri Kapferer, Paris, from c. 1907; Baroness Lambert, Brussels; by descent, to Madame Alain Capeillières, Brussels; sold, Sotheby's, London, 30 Mar. 1966, no. 8, to Arts Mundi, S.A., Geneva; Wildenstein, New York; Joan and Nathan Lipson, Atlanta, from 1970.

49. *In the Country II: Father and Little Girl*
(*A la campagne II: Père et fillette*)
1907
Oil on canvas
100 x 32 cm (39 ⅜ x 12 ⅝ in.)
Signed and dated at lower center: *Bonnard/1907*
Joan and Nathan Lipson, Atlanta

PROVENANCE: Same as cat. 48.
NOTES:
1. Watkins 1994, p. 89.

2. Illustrated in Dauberville, vol. 2, p. 90, no. 471; and The Art Institute of Chicago and New York, The Metropolitan Museum of Art, *From Poussin to Matisse: The Russian Taste for French Painting*, exh. cat. (1990), p. 120, cat. 38, respectively.

3. See Stump 1972, p. 95.

4. This struggle increased after 1910, with his definitive move away from Paris; see Sasha Newman, "Nudes and Landscapes," in New York 1989, p. 187.

5. See Paris, Galerie Bernheim-Jeune, *Exposition Bonnard* (1–20 Feb. 1909), no. 2, as *La Chasse*.

6. Today they hang similarly on either side of a mantelpiece in a home that coincidentally and artfully combines French eighteenth-century furniture with nineteenth-century and early modern paintings.

7. The brothers credited their similar artistic tastes to their businessman father, who collected Louis XV furniture, along with eighteenth-century engravings and illustrated books. Indeed, the purchase of these panels may have been a kind of homage to their father, who died that same year.

8. See Dauberville, vol. 2, p. 41, no. 396 (ill.). Information about the panels' installation after 1916 was provided by Marcel's granddaughter Francine Kapferer, based on photographs she possesses of the installation.

9. See, for example, Bonnard's much larger vertical panels painted in 1918 for Richard Bühler's dining room in Winterthur, Switzerland, one of which features Marthe with a cane and her dog in a landscape that is more balanced in its references to past and present (cat. 55, fig. 2).

CAT. 50

PIERRE BONNARD

Mediterranean
(*Méditerranée*)
1911
Oil on canvas
Triptych: center and left panels, 407 x 152 cm (160 ¼ x 59 ⅞ in.); right panel, 407 x 149 cm (160 ¼ x 58 ⅝ in.)
Signed and dated on right panel at lower left: *Bonnard/1911*
The State Hermitage Museum, St. Petersburg

PROVENANCE: Ivan A. Morozov, Moscow, from 1911; Second Museum of Modern Western Painting, Moscow, from 1918; State Museum of Modern Western Art, from 1923; The State Hermitage Museum, St. Petersburg, from 1948.

EXHIBITIONS: Paris, Galerie Bernheim-Jeune, *Bonnard*, 17 May–3 June 1911, no. 1, as "*Méditerranée, trois panneaux décoratifs*. Appart. à M. M . . . de Moscou." Paris, Grand Palais, *9ème Salon d'Automne*, 1 Oct.–8 Nov. 1911, nos. 171–73, each panel as "*Méditerranée (panneau entre colonnes)*."

NOTES:
1. Henri Focillon, *La Peinture au XIXème et XXème siècles* (Paris, 1928), p. 295.

2. Dauberville, vol. 2, pp. 221–22, nos. 641–42. Completed in the spring of 1911, these were sent to Morozov immediately following the Salon d'Automne in October of that year; see Albert Kostenevich, *French Art Treasures at the Hermitage: Splendid Masterpieces, New Discoveries* (New York, 1999), p. 398, nos. 16–17. For information on Morozov and his Moscow mansion, see ibid., pp. 39–48.

3. Only figs. 1 and 2 exist to suggest how *Mediterranean* was installed in Morozov's residence. According to Albert Kostenevich, Chief Curator of the State Hermitage Museum, Morozov disliked having the interior of his mansion photographed; Kostevenich, in conversation with the author, 1 May 2000.

4. Guillaume Apollinaire, "Salon d'Automne," *Intransigeant*, 12 Oct. 1911; tr. in Leroy C. Breunig, ed., *Apollinaire on Art: Essays and Reviews, 1902–1918* (New York, 1972), p. 185. See also Renée Jean's comments on the "calm sweetness" (*douceur calme*) of these decorations, in "Le Salon d'Automne," *Gazette des beaux-arts* 53, 4, 6 (Nov. 1911), p. 378.

5. Bonnard to his mother, [June 1909], cited in Annette Vaillant, *Bonnard ou le bonheur de voir* (Neuchâtel, 1965), p. 115.

6. *Woman with a Parrot* is illustrated in Dauberville, vol. 2, p. 197, no. 605. Gustave Coquiot, describing Bonnard's panels for Misia Edwards, echoed the artist's earlier perceptions of the south:

"Imagine dream palaces, delicate constructions of A Thousand and One Nights"; Gustave Coquiot, *Bonnard* (Paris, 1922), p. 58.

7. Bonnard to his mother (note 5).

8. Fosca 1919, p. 47.

9. London 1998, p. 259.

10. Bonnard may also have remembered Claude Monet's 1873 decorative panel, later known as *The Luncheon* (Musée d'Orsay, Paris), which was part of the Caillebotte bequest entering the Musée du Luxembourg in 1896; see Daniel Wildenstein, *Claude Monet: Biographie et catalogue raisonné* (Lausanne, 1975), vol. 2, p. 121, no. 285. Monet not only introduced decorative shadow effects, but he also framed his composition with a figure in near profile (at left), and on the opposite side, a strong diagonal (a garden bench). Except for the presence of a luncheon table, Monet's enclosed courtyard scene of a similarly sunlit and lazy afternoon (albeit in a Paris suburb) is compositionally similar to Bonnard's triptych, painted over thirty years later.

11. Bonnard was fond of the triptych format: between 1895 and 1900, in fact, he painted a number of smaller triptychs; see Dauberville, vol. 1, nos. 131, 136, 148–50, 237. But he also used it as a device for structuring his single-panel pieces, such as *Twilight* (cat. 5), *Family in the Garden* (cat. 43), and the panels for Misia, *After the Flood* and *Landscape Animated with Bathers* (cat. 45–46).

12. Fosca 1919, p. 47.

13. See Watkins 1994, p. 124. Watkins referred to this triptych as a radical alternative to Matisse's large *Dance* and *Music* panels, which were commissioned by another prominent Russian collector, Sergei Shchukin, in 1909 and exhibited at the Salon d'Automne in 1910; ibid., p. 121.

14. Vuillard, Journals, 16 May 1911, MS 5397: "Bleues tendres, nouveauté de fraîcheur."

15. See undated letter from Fénéon to Morozov, enclosing Bonnard's letter (The State Pushkin Museum Archives, Moscow), cited in Essen 1993, p. 128 n. 133.

16. For illustrations of these two works, see Hyman 1998, p. 104, no. 79; and Watkins 1994, p. 117, no. 92, respectively.

17. Essen 1993, p. 128 n. 133. Apparently Bonnard asked for 25,000 francs for both panels, the same sum he had asked for *Mediterranean*.

CAT. 51

PIERRE BONNARD

Conversation in Provence
(*Conversation en Provence*)
1912/13; reworked 1927
Oil on canvas
129.5 x 202 cm (51 x 79 ½ in.)
Signed at lower left: *Bonnard*
Národní Galerie, Prague
NOT IN EXHIBITION

PROVENANCE: Eugène Fasquelle, by 1913; sold to Galerie Bernheim-Jeune, Paris, 1917; sold to Jacques Laroche; sold, Hôtel Drouot, Paris, 8 Dec. 1928, no. 33, to Galerie Bernheim-Jeune; sold to Národní Galerie, Prague, 1931.

EXHIBITIONS: New York, Armory of the Sixty-ninth Infantry, *International Exhibition of Modern Art*, 15 Feb.–15 Mar. 1913, no. 193, as *Conversation provençale*. The Art Institute of Chicago, *International Exhibition of Modern Art, Association of American Painters and Sculptors, Inc.*, 24 Mar.–16 Apr. 1913, no. 20, as *A Provençale Conversation*. Venice, *12ème Exposition Internationale d'art de Venise*, 8 May–Oct. 1920, French section, no. 32, as *La Conversation provençale*. Prague, *Umění soucasné Francie*, 1931.

NOTES:

1. The exhibition continued on to Chicago and, in a smaller form, to Copley Hall, Boston (28 Apr.–18 May 1913). Bonnard's *Conversation in Provence* was not included in the Boston version of the show. See Milton W. Brown, *The Story of the Armory Show* (New York, 1988), p. 248. Using archival references from the papers of Kuhn, MacRae, and Pach, Brown corrected many errors in the original exhibition catalogues.

2. Dauberville, vol. 2, p. 241, no. 666.

3. Dauberville (note 2) gave it a date of 1911, probably based on the fact that a painting entitled *La Conversation provençale* was exhibited in 1911 at the Bernheim-Jeune gallery (see Paris, Galerie Bernheim-Jeune, *Oeuvres récentes (1910–1911) de Pierre Bonnard*, exh. cat. [17 May–3 June 1911], no. 11). Dr. Olga Uhrova of the Národní Galerie, however, believes this to be a different painting from the one in the Prague collection; conversation with the author, 12 Apr. 2000.

4. See Paris, Hôtel Drouot, *Catalogue des tableaux modernes provenant de la Villa "Sauge Pourprée" à Deauville*, 8 Dec. 1928, no. 33 (ill.). The 1927 reworking is mentioned in Dauberville, vol. 2, p. 241, no. 666, and confirmed by the Národní Galerie, although neither provides information that would shed light on the specific changes Bonnard made to the 1912/13 canvas.

5. See André Fontainas's entry on Bonnard, in Edouard-Joseph, *Dictionnaire biographique des artistes contemporains, 1910–1930* (Paris, 1930), vol. 1, p. 157.

6. See Paris 1984, p. 251. Pankiewicz made Bonnard's art known in Poland.

7. Bonnard rented Pankiewicz's villa for himself in January and February 1914; see London 1998, p. 259.

8. For this exhibition, see [Félix Fénéon], "L'Art français à Venise," *Bulletin de la vie artistique* 1, 11 (1 May 1920), pp. 294–96.

CAT. 52–54

PIERRE BONNARD

52. *Earthly Paradise*
(*Le Paradis terrestre*)
1916/20
Oil on canvas
130 x 160 cm (51 ⅛ x 63 in.)
Signed at lower left: *Bonnard*
The Art Institute of Chicago, estate of Joanne Toor Cummings; Bette and Neison Harris and Searle Family Trust endowments; through prior gifts of Mrs. Henry C. Woods, 1996.47

PROVENANCE: Gaston Bernheim de Villers and Josse Bernheim, Paris, from 1920; Gaston Bernheim de Villers, Villers; Madame Gaston Bernheim de Villers, by 1955; private collection, Paris; The Art Institute of Chicago, 1996.

EXHIBITIONS: Paris, Galerie Bernheim-Jeune, *Exposition Bonnard*, 24 May–11 June 1921, no. 4, as *Paradis*. Paris, Musée des Arts Décoratifs, *Cinquante Ans de peinture française*, 28 May–12 July 1925, not in catalogue.

53. *Pastoral Symphony*
(*Symphonie pastorale*)
1916/20
Oil on canvas
130 x 160 cm (51 ⅛ x 63 in.)
Signed at lower left: *Bonnard*
Private collection, courtesy Galerie Bernheim-Jeune, Paris
CHICAGO ONLY

PROVENANCE: Gaston Bernheim de Villers and Josse Bernheim, Paris, from 1920; Galerie Bernheim-Jeune, Paris; to Bernheim descendants; private collection, Paris.

EXHIBITIONS: Paris, Galerie Bernheim-Jeune, *Exposition Bonnard*, 24 May–11 June 1921, no. 1, as *Campagne*. Paris, Galerie Bernheim-Jeune, *34 Peintures de Bonnard*, 1946, no. 28.

54. *Workers on the Seine*
(*Les Travailleurs sur la Seine*)
1916/20
Oil on canvas
130 x 160 cm (51 ⅛ x 63 in.)
Signed at upper left: *Bonnard*
The National Museum of Western Art, Tokyo, donated by the heirs of Mr. Tomijiro Kakinuma, P.1992–1

PROVENANCE: Gaston Bernheim de Villers and Josse Bernheim, Paris, from 1920; Gaston Bernheim de Villers,

Villers; Mme Gaston Bernheim de Villers, by 1955; Galerie Beyeler, Basel; Paul Petrides, Paris; Tomijiro Kakinuma, Tokyo; by descent, to his heirs; donated to The National Museum of Western Art, Tokyo, 1992.

EXHIBITIONS: Paris, Galerie Bernheim-Jeune, *Exposition Bonnard*, 24 May–11 June 1921, no. 2, as *Paysage de ville*. Paris, Musée de l'Orangerie, *Exposition Bonnard*, Oct.–Nov. 1947, no. 51, as *Le Pont de la Jatte*.

NOTES:

1. Gaston Bernheim called himself Gaston Bernheim de Villers after he began his painting career in 1919.

2. Vuillard, Journals, entry, 12 June 1917, MS 5398.

3. Dauberville, vol. 2, p. 384, no. 868, listed *Workers on the Seine* under a panoply of titles: *Les Travailleurs à la Grande Jatte*, *Le Pont de la Jatte*, *Paysage de ville*, and *Cité moderne*.

4. Vuillard (note 2): "Open studio, sun, full of light, his paintings of the south. The four golden age panels, etc. clarity and gaiety, always an element for my admiration" ("Atelier ouvert, sol, tout clair, ses tableaux du midi. Les 4 panneaux age d'or, etc. clarté gaieté, toujours élément à mon admiration").

5. Vuillard, Journals, 4 Sept. 1917, MS 5398: "Saw again the four panels, Golden Age, paradise, etc. that charm me—unity, general harmony of tones . . . discussion of Monet, Renoir, etc. Doubts about Monet, work [illegible word] after nature; the war; responsibilities" ("Revois 4 panneaux age d'or, paradis, etc. qui me charment, unité, sens général de tons . . . causerie sur Monet, Renoir, etc. Doûtes de Monet, travail [illegible word] d'après nature; la guerre; responsabilités").

6. In 1910, Roussel painted a monumental panel, *The Abduction of the Daughters of Leucippus*, for the Bernheims' avenue Henri-Martin mansion (see cat. 65–66, fig. 1). Two years later Vuillard was commissioned to paint seven panels for the Bernheims' country home in Normandy (see cat. 82). Roussel was also asked to make panels for this home, although the project was never realized (see 1900–30 Intro.).

7. See Giambruni 1983, p. 9, who described Bonnard's family home as an ideal bucolic retreat, sheltered from big-city life. Located in the foothills of the Alps, the Dauphiné is a region of spectacular natural beauty, surrounded by mountains, teeming with valleys, forests, lakes, and streams. For family references to cows, see the letter from his grandmother about the cow "who puts her big head in the window;" and Bonnard's illustrations of 1944 in Bonnard 1944, pp. 6–7.

8. Hyman 1998, p. 55, fig. 40.

9. Bonnard's interest in and friendship with Renoir is discussed in Watkins 1994, p. 189; and in Hyman 1998,

pp. 66–67. Bonnard's nudes were often compared to Renoir's. In 1918, Renoir and Bonnard shared the honor of being named honorary presidents of the Groupement de la jeune peinture française; see André Fermigier, *Bonnard* (New York, 1969), p. 45.

10. For more on this affair, see 1900–30 Intro.; Hyman 1998, p. 112; and Nicholas Watkins, "The Death of Renée Monchaty, Bonnard's Model and Lover," *Burlington Magazine* 140, 1142 (May 1998), p. 327. Marthe de Méligny is known to have made Bonnard destroy all his paintings of Monchaty, but at least one painting exists that is generally understood to depict her, *Young Women in the Garden* (cat. 57, fig. 2). Hyman also hypothesized that she appears in another Bonnard painting, *Piazza del Popolo* (1922; private collection); see Hyman 1998, pp. 113–14, fig. 89. It is conceivable that works such as *Earthly Paradise*, which Marthe would never have seen once they were delivered to their owners, were coded statements on his relationship with Renée.

11. Hyman 1998, p. 59, fig. 44.

12. See Washington, D.C. 1984b, pp. 16–17.

13. For these references, see Paris 1984, p. 18.

14. In 1930, for example, André Fontainas called it *Visiting the Workers* (*La Visite aux travailleurs*), perhaps referring to the presence of women in the scene, in Edouard-Joseph, *Dictionnaire biographique des artistes contemporains, 1910–1930* (Paris, 1930), vol. 1, p. 157. This title may well have been supplied by the Bernheims, who also provided the photograph of the painting for the publication.

15. See, for example, *Le Pont des Arts* (1905; private collection, Paris); illustrated in Lausanne 1991, pp. 147–48, no. 21; and *Le Pont du Carousel* (c. 1903; Los Angeles County Museum of Art), illustrated in Watkins 1994, p. 95, no. 71.

16. Watkins 1994, p. 130.

CAT. 55

PIERRE BONNARD

The Terrace
(*La Grande Terrasse*, or *Le Jardin sauvage*)
1918
Oil on canvas
159 x 249 cm (62 ¾ x 98 ¼ in.)
Signed at left on the railing: *Bonnard*
The Phillips Collection, Washington, D.C.

PROVENANCE: Galerie Bernheim-Jeune, Paris, from 1919. The Phillips Collection, Washington, D.C., from 1935.

EXHIBITIONS: Paris, Grand Palais des Champs-Elysées, *Salon d'Automne*, 1 Nov.–19 Dec. 1919, no. 183, as *Le Jardin sauvage*. Washington, D.C., The Phillips Memorial Gallery, *European and

American Colorists*, 1 Oct.–31 Dec. 1937, as *The Terrace* (no catalogue). The Art Institute of Chicago, *Loan Exhibition of Paintings and Prints by Pierre Bonnard and Edouard Vuillard*, 15 Dec. 1938–15 Jan. 1939, no. 21, as *The Terrace*. Washington, D.C., The Phillips Memorial Gallery, *Paintings by Bonnard*, 18 Mar.–30 Sept. 1945, as *The Terrace* (no catalogue).

NOTES:

1. For images of Bonnard's balcony view from his home in Le Cannet, see Watkins 1994, pp. 152–59.

2. Ibid., p. 139.

3. Bonnard to Vuillard, 18 Aug. 1918, in Terrasse 1988, p. 274: "And you, you now have relative security [*demi-sécurité*] and a beautiful summer in which I hope you are enjoying yourself in the foliage. I have studied the greenery in my village a great deal. I'm beginning to have some ideas about [painting] it."

4. See also *Three Figures at the Foot of a Tree* (*Trois Personnages au pied d'un arbre*, 1917–18; private collection), illustrated in Dauberville, vol. 2, p. 410, no. 904.

5. The painting had already been purchased by the Bernheim-Jeune gallery at this time, so it is unknown if this was the artist's own title or one the gallery selected.

6. As Sasha Newman rightly pointed out, *The Terrace* epitomizes Bonnard's concern for structure, one of his central preoccupations in the years just preceding and during World War I; see Washington, D.C. 1984b, p. 136, cat. 15.

7. Watkins 1994, p. 151. See also the BBC film from the Omnibus series, *Pierre Bonnard: A Love Exposed*, which first aired 17 Feb. 1998, in which Watkins narrated the segment on Ma Roulotte and climbed the steps onto the terrace as he described this very modest home.

8. In this sense, the terrace pictures employ a compositional strategy—of shallow foreground space and deep backgrounds filled with riotous foliage—similar to the one he used at this time for two decorative paintings for the Bernheim brothers, *Earthly Paradise* (cat. 52) and *Pastoral Symphony* (cat. 53).

CAT. 56

PIERRE BONNARD

The Abduction of Europa
(*L'Enlèvement d'Europe*)
1919
Oil on canvas
117.5 x 153 cm (46 ¼ x 60 ¼ in.)
Signed at lower left: *Bonnard*
The Toledo Museum of Art, purchased with funds from the Libbey Endowment, gift of Edward Drummond Libbey, 1930

PROVENANCE: Galerie Druet, Paris; Ethel Hughes, Versailles; René Gimpel, Paris; Toledo Museum of Art.

EXHIBITIONS: San Francisco, California Palace of the Legion of Honor, *French Painting*, 8 June–8 July 1934, no. 61, as *The Abduction of Europa*.

NOTES:

1. Thadée Natanson commented on Bonnard's tendency to associate natural phenomena with myths and legends (seeing a bull in a rock, for example); see Natanson 1951, p. 140.

2. An illustration of *Piazza del Popolo*, as well as the identification of Marthe as the figure in the green veil in this work, is found in Hyman 1998, pp. 113–14, fig. 89.

3. For an interpretation emphasizing the playfulness of the scene, see St. Louis Museum of Art et al., *Impressionism: Selections from Five American Museums*, exh. cat. (1989), p. 28, cat. 3.

4. It has also been suggested recently that Bonnard inverted the myth so that Zeus, having changed himself into a bull to accomplish his predatory goals, is in turn transformed into a rock by the powerful Europa, who is not victim but vanquisher; see Cogeval 1993, p. 104.

5. See Hyman 1998, p. 107, for a similar interpretation.

6. Ibid., p. 109, fig. 83. This work is now thought to commemorate French Independence Day in 1916, rather than the armistice of 1918.

CAT. 57

PIERRE BONNARD

The Terrace at Vernon, or
Décor at Vernon
(*Décor à Vernon*)
1920/39
Oil on canvas
148 x 194.9 cm (58 ¼ x 76 ¾ in.)
Studio stamp at lower right
The Metropolitan Museum of Art, New York, gift of Mrs. Frank Jay Gould, 1968

PROVENANCE: Pierre Bonnard Estate; Mrs. Frank Jay Gould, Cannes, from 1964; The Metropolitan Museum of Art, New York, from 1968.

NOTES:

1. This work has previously gone under the title *The Terrace at Vernonnet*. According to Sophie Fourny-Dargère, Curator of the Musée de Vernon, Bonnard's house is located in Vernonnet, a former village that officially became part of the town of Vernon in 1804. It is therefore accurate to say that Bonnard's house was located in both Vernon (as is usually the case) and Vernonnet, the latter being more precise. Fourny-Dargère, in correspondence with the author, 8 Sept. 2000.

2. The 1939 end date for this work has been confirmed by the Metropolitan Museum of Art's Curator of Twentieth-Century Painting, William S. Lieberman, who believes that *The Terrace at Vernon* was painted after an unfinished grisaille version (1920; private collection); see Departmental Archives, The Metropolitan Museum of Art, New York.

3. See Le Comte F. de Clarac, *Musée de sculpture antique et moderne, ou, description historique et graphique du Louvre et de toutes ses parties* (Paris, 1828–30), vol. 2, pl. 199, no. 219. Bonnard may also have been inspired by the Greek statue *Dying Niobid* (fifth century B.C.; Museo delle Terme, Rome); see Washington, D.C. 1984b, p. 144, fig. 12.

4. See, for example, *Two Women Running on the Beach (The Race)* (1922; Musée Picasso, Paris), in *Picasso's Paintings, Watercolors, Drawings, and Sculpture: A Comprehensive Illustrated Catalogue, 1884–1973* (San Francisco, 1996), vol. 2, pt. 2, p. 54.

5. See London 1998, p. 122, cat. 35, figs. 71–72.

6. For this type of *kore*, see ibid., p. 122, no. 35, fig. 70.

7. See Nicholas Watkins, "The Death of Renée Monchaty, Bonnard's Model and Lover," *Burlington Magazine* 140, 1142 (May 1998), p. 327.

8. Hyman suggested that the smaller figures at the left may be chattering or gossiping about Marthe and that her stony expression is thus one of apprehension more than indifference; Hyman 1998, p. 115.

9. Watkins 1994, p. 151.

10. The ease with which Bonnard reworked his paintings is reflected in remarks of colleagues such as Georges Rouault. Rouault commented that Bonnard would often use up left-over oil paint of a color that particularly pleased him, by applying it to portions of other works that were hanging in his home or studio, a practice that Rouault termed "Bonnardizing"; cited in Hyman 1998, p. 126.

CAT. 58

PIERRE BONNARD

The Terrace at Vernon
(*La Terrasse de Vernon*)
1928
Oil on canvas
242.5 x 309 cm (95 ½ x 121 ⅝ in.)
Kunstsammlung Nordrhein-Westfalen, Düsseldorf

PROVENANCE: Pierre Bonnard, from 1928; Louis Carré Collection, Paris, from 1941; Galerie Nathan, Zurich. Kunstsammlung Nordrhein-Westfalen, Düsseldorf, from 1975.

EXHIBITIONS: Buenos Aires, Museo Nacional de Bellas Artes, *La pintura francesa de David a nuestros días*,

July–Aug. 1939, no. 144bis, traveled to Montevideo, Rio de Janeiro, São Paolo, San Francisco, New York, Chicago, Los Angeles, and Portland, Oregon, 1939–41, with varying titles.

NOTES:

1. The two figures may represent the most important women in Bonnard's life: his wife, Marthe (the woman in the hat), and his former lover Renée Monchaty (the blonde), who killed herself in 1925 (see cat. 52–54, 55).

2. Joachim Kaak, "Über die Verheissungen der Malerei—einige Bemerkungen zu *La terrasse de Vernon, 1928*," in Düsseldorf, Kunstsammlung Nordrhein-Westfalen, *Pierre Bonnard: Das Glück zu Malen*, exh. cat. (1993), p. 75. Kaak also pointed out that Bonnard merged two important themes in this work—the real and the Arcadian—transforming the modest reality of his home into an impressive dwelling within an immensely varied terrain; ibid., pp. 69–80.

3. Interestingly, what may be an arm is visible on the left side of the drawing in almost in the same position as the arm of the woman in the finished painting.

4. Bonnard, cited in Terrasse 1988, p. 122.

5. See Jean Clair and Antoine Terrasse, eds., *Bonnard/Matisse: Letters between Friends*, tr. by R. Howard (New York, 1992).

6. The delineated foliage in *The Terrace at Vernon* differs also from Bonnard's later landscapes, where cascades of color are used to organize space and suggest light; see Watkins 1994, p. 162.

7. For a cogent analysis of the artistic differences and similarities between these kindred spirits, see Antoine Terrasse, "Matisse and Bonnard: Forty Years of Friendship," in Clair and Terrasse (note 5), pp. 18–25.

8. André Lhôte, "Les Arts: A propos du jubilé du Salon d'Automne—Bonnard (chez Bernheim-Jeune)," *Nouvelle Revue française* (1 Jan. 1929), p. 133, cited in London 1998, p. 261.

9. Kaak (note 2), p. 74.

CAT. 59

MAURICE DENIS

Eurydice
c. 1905
Oil on canvas
85 x 111 cm (33 ½ x 43 ¾ in.)
Signed with vertical monogram at lower left: *MAVD*
Staatliche Museen zu Berlin, Nationalgalerie, on permanent loan from the Ernst von Siemens Foundation, Munich

PROVENANCE: Sold, in Weimar in 1905 (see *Exhibitions* below), to unknown buyer. Collection of Ernst and Hertha von Siemens; on permanent loan from the Ernst von Siemens

Foundation to the Staatliche Museen zu Berlin, Nationalgalerie, from 1992.

EXHIBITIONS: Weimar, Grossherzogliches Museum für Kunst und Kunstgewerbe, *Neo-Impressionisten*, Feb.–Apr. 1905, no. 28.

NOTES:

1. See Kunstsammlungen zu Weimar, *Aufstieg und Fall der Moderne: Kunst zu Weimar Sammlungen*, exh. cat. (1999), pp. 130, 137, cat. 65. The catalogue for the 1905 exhibition could not be found for verification. According to Dr. Thomas Föhl at the Kunstsammlungen zu Weimar, some of the catalogues for this series of exhibitions were no more than three-page pamphlets and some years were not produced; Föhl, letter to author, 2 May 2000.

2. Denis's record of gifts and sales, Denis family archives; this information was provided by Thérèse Barruel, in letter to author, 21 Oct. 1999.

3. This painting, however, after resurfacing in the early 1990s, has "disappeared" from the Tokyo gallery Le Point in the past two years.

4. Jean Paul Bouillon referred to these Brittany scenes as *Méditerranéisées*; see idem, in Lausanne, Musée Cantonal des Beaux-Arts, *De Vallotton à Dubuffet*, exh. cat., *Cahiers du Musée des Beaux-Arts de Lausanne* 5 (1996), p. 24.

5. See Paris, Grand Palais, *14ème Salon de la Société nationale des beaux-arts*, exh. cat. (17 Apr.–30 June 1904), no. 385, *Scène mythologique*. See also Paris, Grand Palais, *16ème Exposition de la Société nationale des beaux-arts*, exh. cat. (15 Apr.–20 June 1906), no. 387, *Calypso*; no. 388, *Nausicaa*; and Paris, Serres de la Ville, *22ème Exposition des artistes indépendants*, exh. cat. (20 Mar.–30 Apr. 1906), no. 1389, *Polyphème*.

6. See also *Galatea*, or *The Pursuit* (1908; Collection P.Y. Chichong, Tahiti); in St.-Germain-en-Laye 1997, p. 54, no. 17 (ill.).

7. See Edinburgh, National Gallery of Scotland, *Monet to Matisse: Landscape Painting in France, 1874–1914*, exh. cat. (1994), pp. 92–94.

8. Bouillon 1993, p. 108.

9. For more on Greek influences in Denis's art, see St.-Germain-en-Laye 1997, p. 20; and Bouillon 1993, pp. 122–25.

10. Thomas Bulfinch, *Bulfinch's Mythology: The Age of Fable* (Philadelphia, 1987), pp. 149–51.

11. See Richard Thomson in Edinburgh (note 7), pp. 89–90.

12. See Lyons 1994, p. 267, cat. 115.

13. Bulfinch (note 10), p. 146.

14. Bouillon 1993, p. 122.

15. It is also possible that Denis remembered the two versions of Paul Gauguin's pink-hued, melancholy beach scene *Riders on the Beach* which had been shown at the artist's posthumous retrospective, *Exposition Paul Gauguin*, at

Ambroise Vollard's gallery in Paris (4–29 Nov. 1903), nos. 39, 42. See Washington, D.C., National Gallery of Art, *The Art of Paul Gauguin*, exh. cat. (1988), p. 489, no. 278.

16. Closer coloristically to Denis are Vuillard's acidic decorative landscape *The Small House at L'Etang-la-Ville* (1899; Musée Départemental de l'Oise, Beauvais) and Bonnard's brilliant panels for Misia Edwards begun in 1906 (see cat. 45–47).

CAT. 60

MAURICE DENIS

Beach with Small Temple
(*La Plage au petit temple*)
1906
Oil on canvas
114 x 196 cm (44 ⅞ x 77 ⅛ in.)
Signed and dated at lower right:
MAURICE DENIS 1906
Musée Cantonal des Beaux-Arts, Lausanne, acquired with the support of the Association des Amis du Musée

PROVENANCE: Sold, Galerie Druet, Paris, to Madame Eugène Boch, 1907. Sold, Drouot-Richelieu, Paris, 18 Mar. 1996, no. 33, to Musée Cantonal des Beaux-Arts, Lausanne.

EXHIBITIONS: Paris, Grand Palais, *16ème Exposition de la Société nationale des beaux-arts*, 15 Apr.–30 June 1906, no. 390, as *Baigneuses*.

NOTES:

1. This is the title listed on the back of a photograph of the painting from Druet gallery and in the firm's account books; see Jean Paul Bouillon, "Du jardin à la plage: Deux Peintures de Maurice Denis au Musée Cantonal des Beaux-Arts," in Lausanne, Musée Cantonal des Beaux-Arts, *De Vallotton à Dubuffet*, exh. cat., *Cahiers du Musée des Beaux-Arts de Lausanne* 5 (1996), p. 28 n. 27.

2. For Denis's trip to Les Lauves with Roussel, see St.-Germain-en-Laye 1997, p. 22. Denis also wrote an article on the importance of Cézanne's art the year after the older artist's death; see Maurice Denis, "Cézanne," *Occident* 70 (Sept. 1907), pp. 118–33, repr. in Denis 1993, pp. 129–50.

3. Boch is probably most famous as the subject of Vincent van Gogh's painting known as *The Poet—Portrait of Eugène Boch* (1888; Musée d'Orsay, Paris); see Jan Hulsker, *The New Complete van Gogh* (Amsterdam/Philadelphia, 1996), p. 348, pl. 28.

4. How this nearly seven-foot-long painting and the smaller *Nausicaa* (fig. 3) were hung in Boch's Paris home (along with works by Cézanne, Cross, Fantin-Latour, Roussel, Toulouse-Lautrec, and others) is not known. *Beach with Small Temple* may have stayed with Boch's family after his death, since only *Nausicaa* was included in the sale of his

estate; see Paris, Hôtel Drouot, *Catalogue des tableaux modernes, pastels, aquarelles . . . dépendant de la succession de M B[och]*, sale cat. (16 Feb. 1951), no. 26.

5. For Dürer's *Melancholy*, see Joseph Leo Koerner, *The Moment of Self-Portraiture in German Renaissance Art* (Chicago, 1993), p. 24, fig. 14.

6. Bouillon (note 1), p. 26.

7. Ibid., p. 25.

8. *Eurydice* and *Beach with Small Temple* both measure approximately 114 x 195 cm. This is a size 120 canvas, the largest of what is called a "marine format." See London, National Gallery, *Art in the Making: Impressionism*, exh. cat. (1990), p. 46, fig. 31. See also Anthea Callen, *Techniques of the Impressionists* (London, 1987), p. 59, which lists slightly different dimensions for this format: 97 x 194 cm. Although *Beach with Small Temple* and *Eurydice* have nearly identical dimensions, given their very different iconography and compositions, and the standard nature of this canvas format, there is no reason to conclude, as Bouillon did, that they were necessarily conceived as pendants; see Bouillon (note 1), p. 26.

9. Jean Paul Bouillon, "Maillol et Denis, 'fraternité artistique' et moment historique," in Lausanne, Musée Cantonal des Beaux-Arts, *Aristide Maillol*, exh. cat. (1996), pp. 127–43. For *Mediterranean*, see St.-Germain-en-Laye 1997, p. 18, fig. 18.

10. Maurice Denis, "Aristide Maillol," *Occident* 48 (Nov. 1905), p. 242, repr. in Denis 1993, p. 101. See Bouillon (note 9), pp. 132–33. Bouillon asserted that Denis's important text on Maillol and his article "La Peinture," *Ermitage* 2, 11 (15 Nov. 1905), constitute Denis's attack on recent developments in the art of Matisse; see Denis 1993, pp. 83–84.

CAT. 61–62

MAURICE DENIS

61. *Washerwomen's Games*
(*Les Jeux des laveuses*)
1914
Oil on canvas
160 x 386.1 cm (63 x 152 ¼ in.)
Signed and dated at lower left:
MAURICE DENIS 1914
Private collection

PROVENANCE: Eugène Druet; Galerie Druet, Paris; Marcel Kapferer, Paris, from c. 1919; Galerie Pilzer, Paris; private collection.

EXHIBITIONS: Paris, Grand Palais, *24ème Exposition de la Société nationale des beaux-arts*, 13 Apr.–30 June 1914, no. 341, as *Les Jeux des laveuses*, under the larger heading "*Panneaux décoratifs sur le thème de Nausicaa* (Appartiennent à M. Druet)."

62. *The Awakening of Ulysses*
(*Le Réveil d'Ulysse*)
1914
Oil on canvas
160 x 285 cm (63 x 114 in.)
Private collection

PROVENANCE: Eugène Druet; Galerie Druet, Paris; Marcel Kapferer, Paris, from c. 1919; private collection; Sotheby's, New York, May 2000, no. 195, unsold.

EXHIBITIONS: Paris, Grand Palais, *24ème Exposition de la Société nationale des beaux-arts*, 13 Apr.–30 June 1914, no. 344, as *Le Réveil d'Ulysse*, under the larger heading "*Panneaux décoratifs sur le thème de Nausicaa (Appartiennent à M. Druet)."*

NOTES:

1. The panels were listed in the catalogue for the 1914 Salon de la nationale as: no. 340, *Le Char*; no. 341, *Les Jeux des laveuses*; no. 342, *Le Jeu de balle*; no. 343, *Le Jeu de balle*; no. 344, *Le Réveil d'Ulysse*; and no. 345, *Les Baigneuses*, under the larger heading "*Panneaux décoratifs sur le thème de Nausicaa (Appartiennent à M. Druet)."*

2. This information comes from a Certificate of Authentication by Claire Denis, dated 27 Feb. 2000, a copy of which she kindly supplied me.

3. Ibid.

4. See Thomas Bulfinch, *Bulfinch's Mythology: The Age of Fable* (Philadelphia, 1987), pp. 191–95.

5. "The virgins at sight of him fled in all directions, Nausicaa alone excepted, for *her* Minerva aided and endowed with courage and discernment"; ibid., p. 191.

6. The silhouettes of these women, who huddle closely together, recall J.A.D. Ingres's supine and langorous females in *Turkish Bath* (1852/63; Musée du Louvre, Paris). See Valerie Bajou-Charpentier, *Monsieur Ingres* (Paris, 1994), p. 341, fig. 233.

7. For the 1909 version of Nausicaa confronting Ulysses, see St.-Germain-en-Laye 1997, p. 22, fig. 26.

8. Vuillard, Journals, 12 June 1912, MS 5396: "Déjeuner chez les Kapferer jeunes célibataires."

9. Chicago 1994, p. 340, fig. 96.

10. In a recent sale catalogue, however, the setting for this painting is described as the beach at Trébeuron, about ten miles west of Perros-Guirec; see Paris, Hôtel George V, sale cat. (13 Dec. 1995), no. 28.

11. Denis married Elizabeth on 2 Feb. 1922. They had two children: Jean Baptiste (b. 19 July 1923) and Pauline (b. 1 Feb. 1925).

12. See also *Evening on the Terrace* (1921; Musée Départemental Maurice Denis "Le Prieuré," St.-Germain-en-Laye), which shows Elizabeth surrounded by

her stepchildren, in Lyons 1994, p. 290, cat. 134 (ill.).

CAT. 63

MAURICE DENIS

Bacchanale
(*La Bacchanale*)
1920
Oil on canvas
99.2 x 139.5 cm (39 x 55 in.)
Signed and dated at lower right of center: *MAV. DENIS. 1920*
Bridgestone Museum of Art, Ishibashi Foundation, Tokyo, acc. WP-65

PROVENANCE: Galerie Druet, from 1920; Galerie Teisaburo Kuga, from 1922. Kiuchi Jōshirō; Yoshitane Kiuchi, Tokyo; Shōjirō Ishibashi, from 1957; donated to the Ishibashi Foundation, 1961; Bridgestone Museum of Art, Ishibashi Foundation, Tokyo, from 1965.

EXHIBITIONS: Paris, Galerie Druet, *Exposition Maurice Denis*, 21 Nov.–2 Dec. 1921, no. 7, as *Grande Esquisse de la Bacchanale de Genève*. Tokyo, Dōshisha Hall, *Masterpieces of European Painting*, 30 Oct. 1922.

NOTES:

1. According to Claire Denis, the collector was advised to fold the canvas under to fit the smaller space, but decided instead to cut the canvas and sell the resulting fragments. The cut version remains in the New York collection; Claire Denis to the author, 15 Sept. 2000. The entire painting is reproduced in Enghien, Hôtel des Ventes, *Tableaux et sculptures des grands maîtres: XIXe et modernes*, sale cat. (25 Nov. 1984), no. 71. The three fragments cut from the original canvas are reproduced in New York, Christie's, *Impressionist and Modern Paintings, Drawings, and Sculpture* (18 Feb. 1988), no. 30, as *Le Perroquet orange*, *Le Perroquet vert*, and *Deux Petits Oiseaux*.

2. See Bouillon 1993, pp. 168, 198 n. 10.

3. There is also a smaller study (30 x 42 cm) for this work, also in the Bridgestone Museum of Art; see Tokyo, Bridgestone Museum of Art, *Masterpieces from the Collection* (1985), p. 110, no. 51.

4. Etienne Bricon, "Le Salon d'Automne," *Gazette des beaux-arts* 62, 5, 2 (Nov. 1920), p. 324. Bricon went on to write that the mural would be "marvelous as a decoration for a restaurant."

5. For *Bacchus and Ariadne*, see London, National Gallery, *Complete Illustrated Catalogue* (London, 1995), p. 668, pl. NG 35.

6. For *The Death of Sardanapalus*, see Stephen F. Eisenman, *Nineteenth-Century Art: A Critical History* (London, 1994), p. 70, fig. 64. For examples of the orientalist constumes of the Ballets Russes, see Strasbourg, Musée d'Art Moderne, *Les Ballets Russes de Serge Diaghilev, 1909–1929*, exh. cat. (1969).

7. Bouillon 1993, p. 168. Another pyramid is formed on the far left by the man with the flowing cape throwing a spear and the panthers pulling the chariot.

8. See Bricon (note 4), p. 323, who felt that the vignette of the mother and child was the only element of the composition that was typical of Denis, since it recalled to him the artists of the Quattrocento.

9. On Bacchus's presence in India, see Thomas Bulfinch, *Bulfinch's Mythology: The Age of Fable* (Philadelphia, 1987), p. 129. On the animals who pulled his chariot, see ibid., pp. 129–32.

CAT. 64

KER XAVIER ROUSSEL

Triumph of Bacchus, or *Mythological Scene*
(*Triumph de Bacchus*, or *Scène mythologique*)
1911; reworked 1913
Oil on canvas
166.5 x 119.5 cm (65 ½ x 47 in.)
Signed and dated at lower right:
K. X. Roussel 1913
The State Hermitage Museum, St. Petersburg

PROVENANCE: Ambroise Vollard, from 1911; Ivan A. Morozov, Moscow, from 1913; Second Museum of Modern Western Painting, Moscow, from 1918; State Museum of Modern Western Art, from 1923; The State Hermitage Museum, St. Petersburg, from 1948.

EXHIBITIONS: Paris, Galerie Bernheim-Jeune, *K. X. Roussel*, 27 Mar.–14 Apr. 1911, no. 9, as *Bacchus aux cymbales*. Paris, Grand Palais, *9ème Salon d'Automne*, 1 Oct.–8 Nov. 1911, no. 1413, as *Scène mythologique*.

NOTES:

1. These were the only two works Roussel exhibited that year. See also René Jean's positive comments on Roussel's "god of wine" and "Ceres mother of crops" in light of the new vogue for ancient Greek themes, in "Le Salon d'Automne," *Gazette des beaux-arts* 6 (Nov. 1911), p. 378. *Triumph of Bacchus* has also been called *Village Holiday*, *Rural Festival*, and *Kermesse*, more mundane names that, according to Albert Kostenevich, reflect "the early Soviet tendency to demythologize works of art"; see his *French Art Treasures at the Hermitage: Splendid Masterpieces, New Discoveries* (New York, 1999), pp. 452–53, no. 342.

2. For *Drunkenness at Twilight*, see St.-Germain-en-Laye 1994, p. 13, no. 20 (ill.).

3. One of these mannequins can be seen in a sketch for Vuillard's 1930 portrait of the artist at L'Etang-la-Ville (c. 1930; Musée du Petit Palais, Paris); see Paris 1968, p. 267, pl. 169.

4. Ambroise Vollard, *Recollections of a Picture Dealer*, tr. by Violet MacDonald (London, 1936), p. 90.

5. According to Kostenevich (note 1), p. 453, traces of the original grayish brown tones can still be seen along the margins of *Triumph of Bacchus*. Degas's positive response is interesting given his own use of intense oranges and pinks in this period; see Richard Kendall, "Colour: The Late Pastels and Oil Paintings," in London, National Gallery, *Degas: Beyond Impressionism*, exh. cat. (1996), pp. 89–124.

6. B. N. Ternovetz, *Letters, Diaries, Articles* (Moscow, 1977), p. 119, tr. in Albert Kostenevich, "Shchukin and Morozov," in The Art Institute of Chicago and New York, The Metropolitan Museum of Art, *From Poussin to Matisse: The Russian Taste for French Painting*, exh. cat. (1990), p. 32.

7. Albert Kostenevich, in conversation with the author, 1 May 2000. Kostenevich learned this from B. N. Ternovetz, who in turn heard it from Morozov himself.

8. By the time Morozov received the painting, his collection was almost complete. Instead of the hundreds of works he was known to purchase in a year, in 1913 he acquired only the two Roussels (cat. 64 and cat. 64, fig. 1), Renoir's *Child with a Whip*, Cézanne's early, romantic *Interior*, and paintings by Marquet and Derain. See Albert Kostenevich, "Russian Collectors of French Art," in Essen 1993, p. 112.

9. Matisse's triptych, consisting of *Window at Tangier*, *Zorah on the Terrace*, and *Entrance to the Casbah* (all 1912–13; The State Pushkin Museum, Moscow), was finally sent to Morozov's home on Prechistenka Street in spring 1913; see Essen 1993, pp. 110–11.

10. Jacques Salomon, *K. X. Roussel* (Paris, 1967), p. 30.

11. See Henry Dauberville, *La Bataille de l'impressionnisme* (Paris, 1967), p. 398. Dauberville quipped that the photographic archivists for the gallery were hard-pressed to keep up with Roussel's constant repainting. See also Stump 1972, pp. 89–90.

12. Although the official commission was not signed until 25 April 1912, Denis was already talking to Roussel about the possibility in January 1912; see St.-Germain-en-Laye 1994, p. 30, no. 55. See also Lucie Cousturier, "Un Rideau de théâtre," *Bulletin de la vie artistique* 5, 10 (15 May 1924), pp. 222–25 (this article is an excerpt, with editorial comments, from Cousturier's book *K.-X. Roussel*, which would be published in Paris in 1927).

13. See Stump 1972, pp. 114–15.

14. Jean Louis Vaudoyer, "La Décoration," *Art et décoration* 33 (Apr. 1913), pp. 126–27; cited in Stump 1972, p. 111. Lucie Cousturier described Roussel's struggle with the palette of the curtain and noted that the sea visible in the distance in the original curtain was painted out in the final version; Cousturier (note 12), p. 26. One is reminded

of Salomon's comment (note 10) on Roussel's tendency to paint a sea and then change it into a field of wheat.

15. Gabriel Mourey, "Le Théâtre et les Champs-Elysées," *Art et les artistes* 9 (Apr. 1913), pp. 29–30; cited in Stump 1972, p. 111.

16. Paul Jamot, "Le Théâtre des Champs-Elysées," *Gazette des beaux-arts* 9 (Apr. 1913), p. 290; cited in Stump 1972, p. 112.

17. At least one critic regretted its removal; see editorial comments preceding Cousturier (note 12), p. 222: "It has been some years since we've seen this masterpiece, and the intermissions seem long." In 1945, following Roussel's death in 1944, Robert Rey, Directeur des Arts Plastiques, Ministère de l'Education Nationale, Beaux-Arts, launched a vigorous campaign to make the curtain part of the national patrimony; see Stump 1972, pp. 116–18. The theme of Bacchus and the origins of music appears again in Roussel's oeuvre in *La Danse* (1936–37), a decoration for the Palais de Chaillot; see a study for this work in St.-Germain-en-Laye 1994, p. 53, no. 102.

CAT. 65–66

KER XAVIER ROUSSEL

65. *The Abduction of the Daughters of Leucippus*
(*Enlèvement des filles de Leucippe*)
1912/15
Oil on canvas
171 x 75 cm (67 ⅜ x 29 ½ in.)
Private collection, Paris

PROVENANCE: Jos Hessel, Paris; Jacques Arpels, Paris; sold, Galerie Charpentier, Paris, 1 June 1956, no. 199; private collection, Paris.

66. *The Sleep of Narcissus*
(*Le Repos de Narcise*)
1912/15
Oil on canvas
171 x 75 cm (67 ⅜ x 29 ½ in.)
Private collection, Paris

PROVENANCE: Same as cat. 67.
NOTES:

1. The apartment was on rue de Naples in the Batignolles district of Paris.

2. For the 1912/15 dating of these works, see Montreal 1998, p. 108, nos. 116–17; Stump 1972, p. 102, figs. 58–59; and St.-Germain-en-Laye 1994, pp. 26–27, nos. 49–50. But see also Paris, Galeries Durand-Ruel, *K. X. Roussel—Edouard Vuillard*, exh. cat. (1974), nos. 5–6, in which the panels are dated c. 1918.

3. See Paris, *26ème Exposition de la Société des artistes indépendants*, exh. cat. (18 Mar.–1 May 1910), no. 5567. See also Paris, Galerie Bernheim-Jeune, *Exposition Roussel*, exh. cat. (27 Mar.–14

Apr. 1911): no. 1, *L'Enlèvement des filles de Leucippe*; no. 2, *Les Filles de Leucippe au nuage blanc*; no. 3, *Les Filles de Leucippe à l'églantine rose*. See also St.-Germain-en-Laye 1994, pp. 26–27, nos. 49–50, in which the claim is made that Roussel showed *L'Enlèvement des filles de Leucippe* at the Salon d'Automne in 1910. At that time, he also exhibited two other variations on this same theme, identified in their titles by a white cloud and a pink wild-rose vine, respectively; see nos. 2–3 in the 1911 exh. cat. cited above. These were probably two of the oil studies for the Bernheims' definitive version of the subject. See also Stump 1972, p. 99 and fig. 53, in which yet another smaller version is reproduced. In addition, there is another large (nearly eight-foot-high) version still in the Roussel family, reproduced in Stump 1972, fig. 55.

4. See *The Oxford Classical Dictionary*, 3d ed., ed. by Simon Hornblower and Antony Spawforth (Oxford/New York, 1996), entries on Leucippus and the Leucippides.

5. Castor's and Pollux's heroism included the rescue of their sister Helen of Troy from Theseus. According to one story, Jupiter rewarded them for their brotherly attachment by placing them among the stars as Gemini (the twins). See Thomas Bulfinch, *Bulfinch's Mythology: The Age of Fable* (Philadelphia, 1987), pp. 130–31.

6. Probably for this reason the panel has continued to be known by its generic title rather than one specifying the females in it as the daughters of Leucippus.

7. Nos. 32 and 29, respectively, in Paris, Galerie Bernheim-Jeune (note 3).

8. Roussel seems to have focused only temporarily on darker themes in mythology, preferring mostly to paint bacchantes and dancing fauns (see cat. 64). Only in lithographs and in a series of paintings and decorative panels devoted to the spying faun and sleeping nymph (*Afternoon of a Faun*; cat. 69, 70) did he return to his interest in woman as unconscious victim of the "male gaze." In this sense, Roussel's nymphs and mythological heroines are markedly different from Denis's classicizing, wholesome nudes, and from the sensual and seemingly consensual nymphs of Bonnard's Arcadian pastorals.

9. Ten years later, Roussel would paint a series of panels for the living room of the Hessels' suburban residence near Versailles, known as the Château de Clayes, on the more conventional themes of the *Fountain of Youth* and the *Garden of the Hesperides*. These were destroyed when the château burned down during the liberation of Paris at the end of World War II.

CAT. 67–68

KER XAVIER ROUSSEL

67. *Autumn*
(*L'Automne*)
1915
Oil on paper, mounted on canvas
100 x 65 cm (39 ⅜ x 25 ⅝ in.)
Signed and dated at lower left:
Roussel 15
Neffe-Degandt, London

PROVENANCE: Stahl Family, Winterthur, Switzerland; Gebr. Douwes Fine Art, Amsterdam/London; Galerie Salis, Salzburg, Austria; Neffe Degandt, London.

68. *Spring*
(*Le Printemps*)
1915
Oil on paper mounted on canvas
100 x 65 cm (39 ⅜ x 25 ⅝ in.)
Signed and dated at lower left:
Roussel 15
Neffe-Degandt, London

PROVENANCE: Same as cat. 67.
NOTES:

1. For very poor reproductions of the 1918 murals and a listing of some of the studies, as well as related works from this period (also with very poor, photocopied images), see Stump 1972, pp. 133–36, figs. 79–88.

2. Stump 1972, p. 134.

3. Roussel, despite his very strong, negative feelings about the conflict, still apparently contemplated enlisting in the army; see Stump 1972, p. 130.

4. "Maison Lambert" is printed on the letterhead of letters from Roussel to Marcel Guérin (see note 7). Jörg Zutter, however, referred to this hospital as the "Clinique Valmont"; see Lausanne, Musée des Beaux-Arts, *La Collection du Dr. Henri-Auguste Widmer au Musée Cantonal des Beaux-Arts de Lausanne*, exh. cat. by Jörg Zutter and Catherine Lepdor (1998), p. 41. Denis recalled, upon visiting Roussel at the clinic, the very poor mental state in which he found his friend: "Roussel, staying with his collector friend, doctor (Widmer), on my side of Glion, received me in tears"; Denis, *Journal*, vol. 2, p. 180.

5. See Stump 1972, p. 135.

6. Stump, for instance, related Roussel's many depictions of bacchanales to his interest in Friedrich Nietzsche's *Birth of Tragedy* (1870), which espouses the life-affirming philosophy of Dionysus over the rational approach of Socrates and claims that art is the proper metaphysical activity of man; see Stump 1972, pp. 214–17.

7. Roussel to Marcel Guérin, [1914 or 1915], from Maison Lambert; repr. in Stump 1972, app. I, pp. 299–300.

8. For more on the idea of decoration as a "therapeutic reward," see Roger Benjamin, "The Decorative Landscape, Fauvism and the Arabesque of Observation," *Art Bulletin* 75, 2 (June 1993), pp. 299–300.

9. Faye Wrubel and Christian Neffe, in conversation with the author, 22 Apr. 1998.

10. Stump discussed this project at some length and said that in some cases "the result [of the spatial experiments] was a combination of logical distortions which were, in their way, as surprising as those of the Cubists"; Stump 1972, p. 134.

11. See ibid., pp. 254–57 and figs. 83–84, 89–90.

12. See Lucie Cousturier, *K.-X. Roussel* (Paris, 1927), p. 63.

CAT. 69

KER XAVIER ROUSSEL

The Cape of Antibes
(*Le Cap d'Antibes*)
c. 1928
Pastel, distemper, and charcoal on paper, mounted on canvas
86 x 127 cm (33 ⅞ x 50 in.)
Signed at lower right: *K-X Roussel*
Private collection, Paris

PROVENANCE: Galerie Berheim-Jeune, Paris; Léon Villiers, Paris; sold, Palais Galliéra, Paris, 28 Nov. 1963, no. 27; private collection, Paris.
NOTES:

1. A *zone de marécage*, or area of marshlands, existed along the southern shoreline of the cape until the 1930s. For the identification of the mountains, I am grateful to Jean Pierre Frances, Direction des affaires culturelles, Ville Antibes Juan-les-Pins; correspondence with the author, 5 Oct. 2000.

2. According to Simone Monteux, wife of Marcel, Roussel executed her father-in-law's murals directly onto the wall; in conversation with author, 9 Sept. 1982. Unfortunately, no other descriptions of Roussel working in this manner have been recorded.

3. The medium for *The Cape of Antibes* has always been published as distemper retouched or heightened with pastel. Faye Wrubel, Conservator of Paintings at the Art Institute of Chicago, who examined the work in 1998, believes, however, that there is much more pastel than distemper in this work, which would indicate that Roussel perhaps began it as a pastel and then tightened and strengthened it using distemper. Unfortunately, not enough has been written about the artist or about his technique to be able to posit a pattern or working process.

4. Götte 1982, pp. 268–69.

5. Illustrated in St.-Tropez 1993, pp. 62–63 and p. 80, respectively.

6. These works are illustrated in St.-Germain-en-Laye 1994, p. 44, no. 85; and p. 32, no. 56, respectively. Gisela Götte asserted that Roussel based this pose on Hokusai's "reclining smoker"; see Götte 1982, p. 305.

7. See for example St.-Germain-en-Laye 1994, p. 36, nos. 64–65; p. 66, nos. 66, 68; p. 42, no. 80; and p. 44, no. 85.

8. Stump 1972, p. 410, fig. 144, dated it c. 1910. This date was disputed by Götte, who stated that because of the degree of abstraction and the palette limited to two colors, it is likely to be a reprise and further exploration of the themes in *The Cape of Antibes*; Götte 1982, pp. 247–48.

CAT. 70

KER XAVIER ROUSSEL

Afternoon of a Faun
(*L'Après-midi d'un faune*)
c. 1930
Distemper on canvas
200 x 320 cm (78 ¾ x 126 in.)
Signed at lower right: *K.X. Roussel*
Musée Départemental de l'Oise, Beauvais

PROVENANCE: Jean Périer, Cap Ferrat, from c. 1930; Jean Charles Bloch; Musée Départemental de l'Oise, Beauvais, from 1982.

NOTES:

1. For Périer (sometimes spelled Perrier), see Stanley Sadie, ed., *The New Grove Dictionary of Opera* (London, 1992), vol. 3, p. 959. Debussy's opera was based on the play of the same name by Maurice Maeterlinck and was first performed in 1902.

2. Roussel also executed a monumental scene curtain for the Théâtre des Champs-Elysées (cat. 64, fig. 2). The theater went bankrupt in October 1913, only a little over a year after its opening, and did not resume full operations until January 1920; see Stump 1972, pp. 122–23.

3. See Stump 1972, pp. 141–42, for details about the reception of this somewhat shocking performance, in which a woman played a man's role.

4. For these commissions, see Stump 1972, pp. 145–51.

5. After breaking with the Bernheim-Jeune gallery, Hessel went on to make a fortune as a successful art dealer and organizer of "spectacular" sales at Hôtel Drouot; see Stump 1972, p. 147.

6. Antoine Salomon, in conversation with the author, 26 Nov. 1982. See also unpublished letter from Roussel to Marcel Guérin in the Bibliothèque Nationale, Paris, "La Collection Marcel Guérin, autographes d'artistes et d'écrivains XIII, XIX, et XX siècles," MS 24918, no. 308, in which Roussel asked Guérin if he needed a tutor for his children and recommended his mistress, Berthe de Waad.

7. Vollard, cited in Stump 1972, p. 153. Stump believed Vollard commissioned the illustrations for *Le Centaure* and *La Bacchante* from Roussel as early as 1910, although the artist probably did not begin serious work on the project until 1930. For reproductions of some of these lithographs, see Alain, *Introduction de l'oeuvre gravé de Roussel* (Paris, 1968), vol. 1, pls. 32–55. Unfortunately, Vollard gave no dates for the proposal that Roussel illustrate the Mallarmé poem.

8. For other versions, see Stump 1972, nos. 132–36.

9. Reproduced in Chicago 1994, p. 345, cat. 107.

10. For the small charcoal sketch, see St.-Germain-en-Laye 1994, p. 46, no. 90 (ill.). Another large charcoal drawing is nearly identical to the painting and is undoubtedly the final sketch; see Werth 1930, no. 30 (ill.).

11. The pond (*étang*) dried up around 1950. I am grateful to Capucine Redier for help in determining the possible location depicted in this painting.

12. This mountain, which is only vaguely discernible in the large panel, is quite clearly indicated in a smaller pastel, *Mallarmé's Afternoon of a Faun* (c. 1930; private collection); see London, Neffe-Degandt, *Bonnard, Roussel, Vuillard: Drawings, Watercolours, Pastels, and Paintings*, exh. cat. (1996), n. pag. (ill.). In this pastel, Roussel also included a background view of the sea, which further distances the setting from the Ile-de-France region of his home at L'Etang-la-Ville. Jean Pierre Frances, Direction des affaires culturelles, Ville Antibes Juan-les-Pins, suggested that this is the hill of La Garoupe in Cap d'Antibes; correspondence with the author, 5 Oct. 2000.

CAT. 71

EDOUARD VUILLARD

In the Garden, at the Vallottons
(*Dans le jardin, chez Vallotton*)
1900
Oil on cardboard
26.8 x 111 cm (10 ½ x 43 ¾ in.)
Signed at lower left: *E. Vuillard*
Staatsgalerie Stuttgart

PROVENANCE: Alfred Sutro, Paris; M. and A. Rosenberg, Zug, Switzerland; sold to Staatsgalerie Stuttgart, 11 Mar. 1966.

NOTES:

1. See for example Vuillard to Verkade, 1 Jan. 1894, in Mauner 1978, app. 21, p. 289.

2. Vuillard to Vallotton, Paris, 7 Nov. 1897, in Guisan and Jakubec 1973–75, vol. 1, p. 170, letter 110.

3. Vuillard to Vallotton, 26 July 1899, in Guisan and Jakubec 1975, p. 15.

4. Vallotton to Paul Vallotton, [1899], in Guisan and Jakubec 1973–75, vol. 1, p. 188, letter 126: "my marriage sickens him, [but] he will have a better idea about it in a couple of days."

5. Vuillard to Vallotton, 13 Sept. 1899, in Guisan and Jakubec 1973–75, vol. 1, p. 190, letter 129.

6. See for example *Window Overlooking Lake Léman* (1900; Walter Feilchenfeldt, Zurich); in London 1991, p. 82, cat. 55 (ill.).

7. Vuillard to Vallotton, 27 Sept. 1900, in Guisan and Jakubec 1973–75, vol. 2, p. 49, letter 140.

8. Vuillard to Vallotton, [dated Sept. 1900, but probably early Oct. 1900], in Guisan and Jakubec 1973–75, vol. 2, pp. 50–51, letter 141.

9. Marina Ducrey, in correspondence with author, 28 Sept. 2000.

10. I wish to thank Marina Ducrey for having made this photograph available to me for my research. This and other photographic documents will be included in the forthcoming catalogue raisonné of Vallotton's works currently in preparation by the Fondation Félix Vallotton, Lausanne.

11. The work is depicted hanging on the wall in several of Vallotton's paintings of his bachelor apartment on rue Jacob; see Groom 1993, p. 87, pls. 146–47.

12. See for example *Facing the Door* (c. 1909; Portland Museum of Art, Portland, Maine), in Brettell 1999, p. 196, cat. 51; and for *Annette at the Beach*, see Thomson 1988, p. 116, pl. 14.

CAT. 72

EDOUARD VUILLARD

Florist's Garden, or *View from the Artist's Window, Rue de la Tour*
(*Le Jardin fleuriste*, or *Vue de la fenêtre de l'artiste, rue de la Tour*)
1906/08
Distemper on paper, mounted on canvas
71.5 x 157.7 cm (28 ⅛ x 62 ⅛ in.)
Signed at lower left: *E. Vuillard*
Milwaukee Art Museum, gift of Mrs. Harry Lynde Bradley, M1956.20

PROVENANCE: Sam Salz, New York; Mr. and Mrs. Harry Lynde Bradley, from 1954; gift to the Milwaukee Art Museum, 1956.

EXHIBITIONS: Possibly exhibited in Paris, Galerie Bernheim-Jeune, *Exposition E. Vuillard*, 11–24 Nov. 1908, under "Paris," no. 5, as *Par la fenêtre*.

NOTES:

1. Vuillard to Natanson, 14 Nov. 1904, in Thadée Natanson, "Sur Edouard Vuillard d'après trois lettres et deux portraits," *Arts et métiers graphiques* 65 (15 Nov. 1938), p. 39, cited and tr. in Groom 1993, pp. 166, 238 n. 11. Vuillard's journals indicate that he was in the Midi in 1900–01 and in St.-Tropez in the spring of 1904 (MS 5397). Another journal reference indicates that he was at Misia Natanson's villa, Croix des Gardes, in Cannes in 1901, and then made a trip with Prince Bibesco and Bonnard to Spain (ibid.); see Court 1992, n. pag.

2. After the removal of the municipal florists, construction of streets and new buildings quickly followed. I am grateful to Claude Lanzenberg, Délégué Général, Société historique d'Auteuil et de Passy, for this information. In his opinion, Vuillard's painting is a combination of fantasy and fact; his letter to the author, 29 June 2000.

3. Lanzenberg, letter to the author, 8 Sept. 2000.

4. The works listed under "Paris" were, no. 1, *La Rue* (1908); no. 2, *La Voiture d'arrosage* (1908); no. 3, *La Tour Eiffel* (1908); no. 4, *L'Enfant au ruisseau* (1908); no. 5, *Par la fenêtre* (1906); and no. 6, *Square Lamartine* (winter 1906–07). The exhibition was the largest of Vuillard's one-man exhibitions to date, with seventy-five paintings on view.

5. See, for example, Monet's *Boulevard des Capucines* (1873; The State Pushkin Museum, Moscow) or Caillebotte's *Boulevard Haussmann, Snow* (1879 or 1881; private collection). Both are reproduced in The Art Institute of Chicago, *Gustave Caillebotte: Urban Impressionist*, exh. cat. (1995), cat. 64, fig. 1, and cat. 70, respectively.

6. For reproductions of some of these lithographs, see New York 1989, p. 139, cat. 59; p. 122, cat. 60; p. 125, cat. 66; pp. 135–36, cat. 68–69, 72; p. 138, cat. 76–77.

7. Vuillard to Vallotton, 18 Jan. 1906, in Guisan and Jakubec 1973–75, vol. 2, p. 101, letter 186. There is suggested that Vuillard was referring to Bonnard's *Place de Clichy* (1906–07; private collection, France), reproduced in Dauberville, vol. 2, p. 51, no. 410. This scene, however, seems to have been conceived at eye-level rather than from the balcony of Bonnard's apartment. The work described is more likely *Exterior Boulevard* (c. 1904; private collection); Dauberville, vol. 2, p. 28, no. 309.

8. This painting, with its sparser landscape and bleak sky, may well be the *Square Lamartine* (winter 1906–07) exhibited as no. 6 at the November 1908 retrospective (see note 4).

EDOUARD VUILLARD

73. *Avenue Henri-Martin*
c. 1908
Oil on paper, mounted on canvas
198.1 x 50.8 cm (78 x 20 in.)
Signed at lower right: *E. Vuillard*
Grace Hokin, Palm Beach, Fla.
NEW YORK ONLY

PROVENANCE: Sam Salz, New York;
Grace Hokin, Palm Beach, Fla.

74. *Bois de Boulogne*
c. 1908
Oil on paper, mounted on canvas
198.1 x 50.8 cm (78 x 20 in.)
Signed at lower right: *E. Vuillard*
Grace Hokin, Palm Beach, Fla.
NEW YORK ONLY

PROVENANCE: Same as cat. 73.

NOTES:

1. The two other works from this series are *Water Cart* and *Street* (both 1908; private collection); see Groom 1993, p. 167, pls. 263, 265.

2. Vuillard may also have featured the Bois de Boulogne in a similarly scaled and sketchlike panel known as *La Muette*; see Brussels, Musée Royaux des Beaux-Arts de Belgique, *Bonnard, Vuillard, Roussel*, exh. cat. (1975), p. 89 (ill.).

3. See for example Vuillard, Journals, 5 Nov. 1907, MS 5397: "Return home from lunch. Ran into the Bernheims; the hotels on rue de la Faisanderie; the rich and their fantasies," tr. in Groom 1993, pp. 169–70.

4. For the *flâneur* as both observer and observed, see Nicholas Green, "Decoding Modernity," in *The Spectacle of Nature: Landscape and Bourgeois Culture in Nineteenth-Century France* (Manchester, 1990), pp. 28–41 passim. See also Groom 1993, pp. 171–72.

5. See Groom 1993, p. 170, pl. 269.

EDOUARD VUILLARD

Place Vintimille, 1909/10

75. Study for *Rue de Calais*
Distemper on paper, mounted on canvas
165.1 x 47 cm (65 x 18 ½ in.)
Studio stamp at lower right:
E. Vuillard
The Armand Hammer Collection, UCLA, at the Armand Hammer Museum of Art and Cultural Center, Los Angeles

PROVENANCE: Sam Salz, New York; Mr. and Mrs. Henry R. Luce, New York; Danenberg Galleries, Inc.; The Armand Hammer Collection, UCLA, at the Armand Hammer Museum of Art and Cultural Center, Los Angeles.

76. Study for *Place Vintimille*
Distemper on paper, mounted on canvas
196 x 69 cm (77 ⅛ x 27 ⅛ in.)
Studio stamp at lower left:
E. Vuillard
Kunsthandel Wolfgang Werner, Bremen/Berlin
Kunsthandel Sabine Helms, Munich
CHICAGO ONLY

PROVENANCE: Collection of the artist, from 1909/10; Jacques Salomon, Paris; private collection, Paris; owned jointly by the galleries Wolfgang Werner, Bremen/Berlin, and Sabine Helms, Munich.

77. Study for *Place Vintimille*
Distemper on paper, mounted on canvas
196 x 69 cm (77 ⅛ x 27 ⅛ in.)
Studio stamp at lower left:
E. Vuillard
Kunsthandel Wolfgang Werner, Bremen/Berlin
Kunsthandel Sabine Helms, Munich
CHICAGO ONLY

PROVENANCE: Same as cat. 76.

78. *Place Vintimille*
Distemper on cardboard, mounted on canvas
200 x 69.5 cm (78 ¾ x 27 ⅜ in.)
Solomon R. Guggenheim Museum, New York, Thannhauser Collection, gift of Justin K. Thannhauser, 1978
NEW YORK ONLY

PROVENANCE: Henry Bernstein, Paris, from 1910; sold to Justin K. Thannhauser, New York, 1948; gift to Solomon R. Guggenheim Museum, New York, 1978.

79. *Place Vintimille*
Distemper on cardboard, mounted on canvas
200 x 69.9 cm (78 ¾ x 27 ½ in.)
Solomon R. Guggenheim Museum, New York, Thannhauser Collection, gift of Justin K. Thannhauser, 1978
NEW YORK ONLY

PROVENANCE: Same as cat. 78.
NOTES:

1. Vuillard was apparently not pleased with the setting for his Passy panels. He commented after a September 1909 visit to Bernstein's apartment on his discomfort at seeing his works embedded in an ostentatious décor of lacquer furniture; see Groom 1993, pp. 175, 240 n. 72.

2. Vuillard, Journals, 18 July 1908, MS 5397; tr. in Groom 1993, p. 172. In 1913, Vuillard moved to another apartment two floors below as a convenience to his mother. Only in 1926, when the renovation of the building forced Vuillard and his mother to move, did they relocate, some fifty yards away to another residence on the same square.

3. The critic Claude Roger-Marx, for instance, did not recognize the central panel as part of the ensemble, reproducing and discussing only the "two vertical panels from the Bernstein Collection" that "form one picture cut into two halves"; Roger-Marx 1946, p. 155.

4. Vuillard also executed nearly full-scale pastel studies for these works; see Groom 1993, p. 174, pl. 280.

5. Vuillard, Journals, 3 Dec. and 5 Dec. 1909, MS 5397; cited in Groom 1993, p. 240 n. 67 and pp. 175, 240 n. 68, respectively.

6. Many of Monet's paintings did not sell and thus returned to his studio; see Boston 1998, pp. 150–77.

7. Vuillard, Journals, 14 Dec. 1909, 11 Jan., 18 Jan., and 13 Feb. 1910, all MS 5397; see Groom 1993, pp. 175 and 240 nn. 73, 66, 70.

8. Vuillard, Journals, 14 Mar. 1910, MS 5397; see Groom 1993, p. 240 n. 66.

9. They are often identified as *côté rue de Bruxelles* and *côté rue de Douai*, after the streets that lead off to the left and right, respectively. These titles, which are simply meant to indicate the south and north sides of the square, will be changed in the forthcoming Vuillard catalogue raisonné, with each given the subtitle *rue de Vintimille*, since it is this street that runs to the east (lower edge of the paintings) and that connects rue de Calais, rue de Bruxelles, etc., to the square.

10. See Berlin, Kunsthandel Wolfgang Werner KG, *Edouard Vuillard: Intérieurs et paysages de Paris*, exh. cat. (1992), tr. by Carola Kupfer, n. pag.

11. See New York, Solomon R. Guggenheim Museum, *Guggenheim Museum: Thannhauser Collection*, cat. by Vivian Endicott Barnett (1992), pp. 189–90.

12. See Los Angeles, Armand Hammer Foundation, *The Armand Hammer Collection: Five Centuries of Masterpieces* (1980), p. 126, no. 46. For a reproduction of its original state, see Roger-Marx 1946, p. 161 (ill.).

13. Vuillard, Journals, 26 Mar. 1910, MS 5397; see Groom 1993, pp. 175, 240 n. 81.

14. See Groom 1993, pp. 176, 240 n. 84.

15. Ibid., p. 176 n. 85.

16. According to Georges Bernstein Gruber, Bernstein's daughter, the panels were installed in the dining room of this residence as well; see Groom 1993, p. 177.

EDOUARD VUILLARD

Five-panel Screen for Miss Marguerite Chapin: Place Vintimille
(*Paravent à cinq feuilles pour Miss Marguerite Chapin: La Place Vintimille*)
1911
Distemper on paper, mounted on canvas
Five panels: each panel, 230 x 60 cm (90 1/2 x 23 5/8 in.)
Signed at lower right of far right panel: *E. Vuillard*
National Gallery of Art, Washington, D.C., gift of Enid A. Haupt, 1998.47.1

PROVENANCE: Marguerite Chapin (later Princess of Bassiano), from 1911 until at least 1924; Albert Sancholle Henraux, Paris, by 1938, until at least 1945; Enid A. Haupt; gift to the National Gallery of Art, Washington, D.C., 1998.

EXHIBITIONS: Paris, Galerie Bernheim-Jeune, *Edouard Vuillard*, 15–27 Apr. 1912, no. 29, as *Le Square, paravent*. Paris, L'Hôtel de la Curiosité et des Beaux-Arts, *Première Exposition de collectionneurs, au profit de la Société des amis du Luxembourg*, 10 Mar.–10 Apr. 1924, no. 44, as *La Place Vintimille (paravent)*. Paris, Musée des Arts Décoratifs, *Exposition E. Vuillard*, May–June 1938, no. 135, as *Paravent à cinq feuilles. La Place Vintimille vue des fenêtres de l'artiste*.

NOTES:

1. For Marguerite Chapin's apartment and Vuillard's relationship with her, see Groom 1993, pp. 179–99.

2. *Interior with a Lady and Dog*, see Groom 1993, p. 180, pl. 284.

3. Vuillard, Journals, 5 May 1911, MS 5397, reprinted in Groom 1993, p. 244 n. 104.

4. Vuillard, Journals, 14 May 1914, MS 5397: "better disposition for taking up again work on the screen. Sketch panels—beginning again with the shadow tone at left" ("meilleure disposition pour reprendre travail paravent. Dessin feuillages ton ombre à gauche remise en train").

5. Groom 1993, p. 182, pl. 287.

6. Vuillard, Journals, 9 June 1911, MS 5397: "[I] go to Mlle Chapin's, screen not finished," and 12 June 1911: "Assemble stretched screen wallpaper," both MS 5397; see Groom 1993, p. 244 n. 107.

7. Roger-Marx 1946, pp. 154–55.

8. Because it was used as a functional decorative object in Chapin's interior, the paper darkened unevenly owing to varying light exposure. The top quarter, which did not receive direct lighting, is less damaged and has retained its lighter, tan color. I am grateful to Chief Curator Philip Conisbee and Painting Conservator Judy Walsh of the National Gallery for having arranged for me a special viewing of this enormous work.

9. For the description of this work as a "féerie bourgeoise," see Roger-Marx 1946, p. 42, referring to the title of a conference he gave on the occasion of Vuillard's retrospective at the Musée des Arts Décoratifs in May–June 1938.

10. For the Bassiano residences, see Groom 1993, p. 198. For a description of Marguerite's collection in the 1920s, see Alex Ceslas Rzewuski, *A Travers l'invisible cristal: Confessions d'un Dominicain* (Paris, 1976), pp. 163–64. Vuillard's last commission for Marguerite was a portrait of her children, Leila and Camillo, under the chestnut trees of Villa Romaine in 1921–22; see Groom 1993, p. 198.

CAT. 81

EDOUARD VUILLARD

Place St.-Augustin, or *Little Carts in June: Seltzer Bottle*
(*La Place St.-Augustin*, or *Les Petites Voitures en juin: Le Siphon*)
1912–13
Distemper on paper, mounted on canvas
156 x 193 cm (61 ⅜ x 76 in.)
Signed at lower right: *E. Vuillard*
Private collection, London

PROVENANCE: Galerie Bernheim-Jeune, Paris, from 1913; Jos Hessel; Dr. Henri Vaquez, from 1920; Monsieur A. G., by 1938; private collection, Paris; private collection, London.

EXHIBITIONS: Paris, Galerie Bernheim-Jeune, *Exposition Vuillard: Oeuvres récents*, 15–30 Dec. 1913, under *Deux panneaux décoratifs*, nos. 6–7. Paris, Musée des Arts Décoratifs, *Exposition E. Vuillard*, May–June 1938, no. 151, as "*La Place Saint-Augustin . . . A M[onsieur] A. G.*"

NOTES:

1. Salomon 1968, p. 131.

2. See Segard 1914, vol. 2, p. 322, where they are listed as *Les Petites Voitures en juin. Femme à la rose* and *Les Petites Voitures en juin. Le Siphon*, under the heading "Autres panneaux décoratifs exécutés sans destination." Provenance information has been generously provided by Antoine Salomon. Apparently Jos Hessel still owned the pendant, now in the Minneapolis Institute of Arts (fig. 1), at the time of the 1938 retrospective of Vuillard's work (see Exhibitions), where it is listed under his name and titled *Voiture des quatres saisons, place Saint Augustin*, no. 10.

3. See Albert Kostenevich, *Hidden Treasures Revealed: Impressionist Masterpieces and Other Important French Paintings Preserved by the State Hermitage Museum* (Moscow/St. Petersburg/New York, 1995), pp. 73–75, pl. 16.

4. For Vuillard's portrait *Reine Natanson* (1913–14; private collection), see Groom 1993, p. 194, pl. 313.

5. See Vuillard, *Journals*, 30 May 1912, MS 5397: "[I] go to the Place St.-Augustin. Pencil sketch [for] June painting—[illegible] execution. . . . Go to the studio. Preparation to execute the design. Pastel" ("Vais à la Place St. Augustin. Croquis tableau de juin— [illegible] éxecution. . . .vais à l'atelier. Entretien exécuter projet. Pastel"). See also his entries for 31 May 1912 and 6 June 1912, MS 5397.

6. See Vuillard, *Journals*, 12 Apr. 1913, MS 5397: "Reprend Place St. Augustin." See also entries for 14 Apr. 1913, 15 Apr. 1913, and 29 Apr. 1913, all MS 5397; and 18 June 1913, MS 5397: "Retouch, put tone on top" ("Retouche, place ton en haut").

7. Vuillard may also have been thinking of Bonnard's 1911 pendants for Ivan Morozov, *Morning in Paris* and *Evening in Paris* (The State Hermitage Museum, St. Petersburg), which also shows Place de Clichy from a street-level vantage point. The donkey cart on which *Morning in Paris* is centered may also have inspired Vuillard's central motif of a flower cart in *Seltzer Bottle*. See Dauberville, vol. 2, pp. 221–22, nos. 641–42 (ill.).

8. Roger-Marx 1946, p. 141.

CAT. 82

EDOUARD VUILLARD

Tea in a Garden at the Water's Edge
(*Personnages goûtant dans un jardin au bord de l'eau*)
1913; reworked c. 1934
Distemper on canvas
192.1 x 234.3 cm (75 ⅝ x 92 ¼ in.)
Signed and dated at lower left:
E. Vuillard / 1913
Private collection, courtesy Galerie Bernheim-Jeune
NEW YORK ONLY

PROVENANCE: Josse and Gaston Bernheim, from 1913; private collection; Josse Bernheim, from 1935; private collection; Sotheby's, New York, 11 May 1999, no. 133 (unsold).

EXHIBITIONS: Paris, Galerie Bernheim-Jeune, *Exposition Vuillard: Oeuvres récents*, 15–30 Dec. 1913, under "Cinq Panneaux décoratifs pour le vestibule d'une villa," no. 2, as *Le Bord de la rivière*. Pittsburgh, Carnegie Institute, *The Thirty-fifth Annual International Exhibition of Paintings*, 1935, no. 175, as *The Terrace*. Paris, Musée du Petit Palais, *Les Maîtres de l'art indépendant, 1895–1937*, 1937, no. 20, as *Le Bord de la rivière*. Paris, Musée des Arts Décoratifs, *Exposition E. Vuillard*, May–June 1938, no. 149b, as *Personnages goûtant dans un jardin au bord de l'eau*.

NOTES:

1. Paris, Galerie Bernheim-Jeune, *Edouard Vuillard, Exposition*, exh. cat. (15–28 Apr. 1912), no. 27, as *Encadrement*

de porte, peinture décorative pour une villa. This door surround, originally consisting of the lost and Musée d'Orsay panels and a uniting overdoor (private collection), has been dispersed and the larger panels, which were irregular in shape, have been cut down. For their original form, see Thomson 1988, pp. 102–03, fig. 91.

2. For *Woman at a French Window*, see Paris 1968, pp. 115 and 246, no. 147 (ill.). For *People Seated around a Set Table*, see Roger-Marx 1946, p. 150 (ill.). There is no reproduction available for *Woman in Blue Embroidering before a Window*.

3. I am grateful to Mathias Chivot, currently working on the forthcoming catalogue raisonné of Vuillard's work, for providing me with an image of this work, which to my knowledge has never been published; Mathias Chivot, letter to the author, 13 Oct. 2000. In the catalogue for Vuillard's 1938 retrospective (see Exhibitions above), descriptive titles are given for seven paintings, corresponding to known works from the 1912 and 1913 Bernheim-Jeune exhibitions, which are numbered "a–g." A letter "h" is also listed (although without a title), indicating an eighth work in the series, possibly this one. The titles given to the panels in this entry are drawn from this 1938 catalogue.

4. The identification of this panel and its place within the ensemble are uncertain, however. If this vertical work was indeed part of the ensemble exhibited at Bernheim-Jeune in 1913, then it is odd that it was not listed with them in the catalogue.

5. Again, I would like to thank Mathias Chivot for this information (note 3). These works are probably the *bouche-trous*, or fillers, that Vuillard executed in 1913 to flesh out the decorative ensemble; see Salomon 1968, p. 114.

6. For *Surgeons* (*Les Chirurgiens*), see Roger-Marx 1946, p. 164 (ill.).

7. This ensemble preceded Vuillard's 1917 commission to make violin-shaped canvases for Henri Laroche; see Thomson 1988, p. 122, pl. 110.

8. Photographs in the Bernheim-Jeune archives, Paris, show the original format for *Tea in a Garden at the Water's Edge*, *Woman and Child on a Veranda*, *Two Women Embroidering on a Veranda*, and *People Seated around a Set Table*. Vuillard's revisions were most likely prompted by his desire to show paintings of a more traditional format in his upcoming 1938 retrospective.

9. See Groom 1993, p. 200, pl. 321.

10. Antoine Salomon suggested that the little girl playing with a doll is either Annette Natanson or her younger sister Denise; see New York, Sotheby's, *Impressionist and Modern Art, Part I*, sale cat. (1999), p. 96, no. 133. Since Annette was born in 1902 and thus would have been an adolescent at the time, it is likely that the little girl pictured is Denise.

11. For this third panel, *Luncheon at Vasouy* (1901, reworked 1936; National Gallery, London), see Groom 1993, pp. 108–13, pls. 178, 181.

12. For Henry Dauberville's description of his mother, Mathilde, as "one of the most beautiful people of her generation," see his *La Bataille de l'Impressionnisme* (Paris, 1967), p. 501.

13. The most obvious "eating" scene of the cycle is *People Seated around a Set Table* (sometimes called *At Tea* or *At Breakfast*), which shows the table set with large bowls for coffee, baguettes, fruit, sugar, and butter.

14. See Roger-Marx 1946, p. 142.

15. The late Emile Gruet, archivist, Galerie Bernheim-Jeune, in conversation with the author, 7 Oct. 1981.

16. Vuillard, *Journals*, 12 Sept. 1913, MS 5397: "déjeuner Bois Lurette avec Claude Monet. Promenade auto."

17. For reproductions of the interior of the Bernheims' apartment at 107, avenue Henri-Martin, which at one point boasted eighty Renoirs in the grand salon, twenty Toulouse-Lautrecs in the dining room, and thirty Cézannes, see Henry Dauberville (note 12), p. 422.

18. Gruet (note 15).

CAT. 83

EDOUARD VUILLARD

Place Vintimille, or *Berlioz Square*
1915–16; reworked 1923
Distemper on canvas
162.6 x 228.6 cm (64 x 90 in.)
Signed at lower right: *E. Vuillard*
The Metropolitan Museum of Art, New York, promised gift of Anonymous Donor
NEW YORK ONLY

PROVENANCE: Collection of the artist, from 1916 (commissioned by Emile Lévy, Paris, 1915, but unfinished at his death on 23 Jan. 1916); Marcel Kapferer, Paris, from 1923; on loan to Musée du Luxembourg, Paris, 1929–30; Mrs. Daniel Wildenstein, New York; Ms. Lita Hazen, from 1966; sold, Sotheby's, New York, 1 May 1996, no. 16, to private collector, New York; promised gift of Anonymous Donor to The Metropolitan Museum of Art.

EXHIBITIONS: Paris, Galerie Georges Petit, Mar. 1916. Kunsthaus Zürich, *Französische Kunst des XIX und XX Jahrunderts*, 1917, no. 358, as *Le Square Berlioz*. Pittsburgh, Carnegie Institute, *Twenty-first Annual Exhibition of Paintings*, 1922, no. 228, as *Place Vintimille*. Paris, *21ème Salon d'Automne*, 4 Nov.–16 Dec. 1928, no. 2380, as *La Place Vintimille*. New York, Jacques Seligmann and Co., Inc., *Exhibition of Paintings by Bonnard, Vuillard, Roussel*, 1930, no. 20, as *Place Vintimille*. Kunsthaus Zürich, *Pierre Bonnard, Edouard Vuillard*, 1932, no. 167, as *Square Berlioz*. Paris, Musée des Arts

Décoratifs, *Exposition E. Vuillard*, May–June 1938, no. 161, as *Le Square Vintimille vu des fenêtres de l'artiste*.

NOTES:

1. The following entry relies on new information provided by Antoine Salomon from the forthcoming catalogue raisonné of Vuillard's works, partially published in New York, Sotheby's, *Impressionist and Modern Art, Part I*, sale cat. (1 May 1996), no. 16, as *Le Square Berlioz (La Place Vintimille)*, n. pag.

2. This overdoor decoration, known as *Putti* (1915/16) and now divided into two separate panels, shows cherubs playing with different kinds of art objects: sketches, tanagra figures, engravings, porcelains, statues, and books; see Groom 1993, p. 199, pls. 320a–b. Both the smaller frieze and *Place Vintimille* are depicted in another painting by the artist, *In the Studio* (1916/17; Musée Cantonal des Beaux-Arts, Lausanne); see Lausanne, Musée Cantonal des Beaux-Arts, *La Collection de Dr. Henri-Auguste Widmer au Musée Cantonal des Beaux-Arts de Lausanne*, cat. by Jörg Zutter and Catherine Lepdor (1998), p. 44.

3. According to Salomon (note 1), two of these photographs, splattered with paint, almost certainly served as aides-mémoire for Vuillard and, when placed side-by-side, "present a somewhat overlapping panorama that corresponds closely to the one pictured in Vuillard's panel."

4. See Roger-Marx 1946, pp. 154–55.

5. At the outbreak of war in August 1914, Vuillard was forty-five years old. He served for four months as a rail-road-crossing guard in the Conflans-Ste.-Honorine region, close to Paris. In 1917, he was invited by the Minister of Culture to visit the front at Gérardmer, during which time he painted the *Interrogation of the Prisoner* (1917; Musée d'Histoire Contemporaine, Paris); see Lyons 1990, p. 224, no. 134 (ill.).

6. See Salomon (note 1).

7. In a pastel executed around 1915, Vuillard represented a scene of workers seated on the curb of Place Vintimille, with heads bowed in fatigue or thought; see London, Sotheby's, *Impressionist and Modern Painting*, sale cat. (25 Oct. 2000), no. 149.

8. Vuillard, Journals, 11 Sept. 1915, MS 5397: "Visite de E. Lévy déçu de l'aspect actuel du grand panneau."

9. No catalogue exists for this exhibition. Information about it has been supplied by the Salomon archives, Paris.

10. According to Salomon (note 1), Vuillard reworked the painting at this time in order to make it "fit" better into the interior of Kapferer's home at 64, avenue Henri-Martin. This assertion cannot be confirmed by information available at this time, however.

11. See Arsène Alexandre's review of this installation, "Le Promeneur au nouveau Luxembourg," *Figaro Supplément artistique* 6, 226 (28 Mar. 1929), pp. 394–95.

12. See unpublished letter from Vuillard to Koechlin, 18 Feb. 1929, in the Bibliothèque Nationale, Paris, "La Collection Marcel Guérin, autographes d'artistes et d'écrivains XIII, XIX, et XX siècles," MS 24839, no. 579:

Your so amiable letter . . . devastates me. I have just come . . . from a discussion with one of my friends, one of my old-est patrons, M. Kapferer, on the subject of the unhappy painting. Truly, I would prefer to be represented at the Luxem-bourg by a work of a different type. (Votre lettre si aimable . . . me désole. Je viens . . . de m'engager avec un de mes amis et de mes plus anciens amateurs, M. Kapferer, au sujet de ce malheureux tableau. A vrai dire, j'aimerais mieux être représenté au Luxembourg par une oeuvre d'un autre genre.)

13. In ibid., Vuillard to Koechlin, 22 Feb. 1929, MS 24839, no. 580: "Permettez moi d'être franc, comme je vous le dis-ais dans ma première lettre, je préfér-erais être représenté dans un musée officiel par une peinture d'un autre genre que celui de la *Place Vintimille*."

14. Ibid.:

As moreover M. Kapferer owns many paintings by me that are not of this genre . . . that he really loves, I don't want to force him to give it up. I hope that you will not think badly of me for speaking frankly with you. After all, I am still of this world and a better opportunity for you and for me can still occur. (Comme d'autre part M. Kapferer a plusieurs tableaux de moi sauf de ce genre, qu'il me l'a demandé et qu'il y tient réellement je ne veux pas lui imposer d'y renoncer. J'espère que vous ne m'en voulez pas de vous parler franchement. Après tout, je suis encore de ce monde et une meilleure occasion pour vous et pour moi peut se représenter.)

15. Vuillard to Koechlin, after 22 Feb. 1929, MS 24918, no. 581:

Your fear that it will be the same next time troubles me, because I see that you do not grasp the particular conditions of this situation and above all the rea-sons for my conduct that I articulated for you. (Votre crainte 'qu'il n'en aille de même à la prochaine occasion' me peine, car je vois que vous n'appreciez pas les conditions particulières dans lesquelles s'est présentée cette affaire et surtout les raisons que je vous ai exposées de ma conduite.)

CAT. 84

EDOUARD VUILLARD

Foliage: Oak Tree and Fruit Seller
(*Verdure: Chêne et frutière*)
1918
Distemper on canvas
193 x 283.2 cm (76 x 111 ½ in.)
Signed and dated at lower right:
E. Vuillard 1918
The Art Institute of Chicago, a
Millenium Gift of Sara Lee
Corporation, 1999.373

PROVENANCE: George Bernheim, Paris, from 1918, until at least 1938; Mr. and Mrs. Roger Darnetal (Bernheim's son); Daniel Varenne, Geneva; Nathan Cummings, Chicago; The Art Institute of Chicago, from 1999.

EXHIBITIONS: Paris, Musée des Arts Décoratifs, *Exposition E. Vuillard*, May–June 1938, no. 163, as *Verdure*.

NOTES:

1. For a description of this property, see Brettell 1999, pp. 200–03, cat. 52.

2. Vuillard, Journals, 20 July 1918, MS 5398: "Croquis de la fruitière, les arbres, projets"; cited in letter from Juliet Bareau (c/o Antoine Salomon) to Richard Raymond Alasko, 1 July 1985, documentation files, Department of Modern and Contemporary Art, The Art Institute of Chicago.

3. See Bareau (note 2).

4. This photograph is in the Salomon archives, Paris.

5. See Brettell 1999, p. 200. *Frutière* is an outdated French term for *marchand de fruits*. Vuillard's use of the term indicates the female gender of this vendor.

6. See Bareau (note 2).

7. Bonnard to Vuillard, 18 Aug. 1918; Terrasse 1988, p. 274: "I hope you are enjoying yourself in the foliage. I have studied the greenery in my village a great deal. I am beginning to have some ideas about [painting] it." For Vuillard's response of 30 Aug. 1918, see ibid.

8. Brettell 1999, p. 203, compared Vuillard's painting, as an expression of hope, with Monet's *Weeping Willow* (Musée de l'Orangerie, Paris), signed and dated on Armistice Day and offered to the French nation through Georges Clemenceau.

9. According to Faye Wrubel, Conser-vator of Paintings at the Art Institute of Chicago, it is also possible that this was an even later attempt at restoration.

10. Vuillard, Journals, 29 Dec. 1918, MS 5398: "Scène terrible avec George Bernheim à propos de la verdure"; cited in Bareau (note 2).

11. By 1917, Bernheim represented Pablo Picasso, at least partially, through a syndicate with Hessel and Paul Rosenberg backed by Nathan Wilden-stein; see John Richardson, *A Life of Picasso* (New York, 1996), vol. 2, p. 359.

12. See Brettell 1999, p. 203, cat. 52, fig. 2.

13. In a journal entry about his visit to the factory, 17 Mar. 1917, MS 5398, Vuillard wrote: "Flux of sensations—terribly interesting—disordered—feverish"; tr. in Thomson 1988, p. 119.

CAT. 85

EDOUARD VUILLARD

Morning in the Garden at Vaucresson
(*Le Jardin du Clos Cézanne à Vaucresson*)
1923; reworked 1937
Distemper on canvas
151.2 x 110.8 cm (59 ½ x 43 ⅝ in.)
Signed at lower left: *E. Vuillard*
The Metropolitan Museum of Art,
New York, Catharine Lorillard Wolfe
Collection, Wolfe Fund, 1952

PROVENANCE: Collection of the artist, from 1923; Jos Hessel, Paris, from 1938; Madame Jacques Arpels, Paris; Paul Rosenberg Gallery, New York, 1943; Knoedler, New York, from 1943; Catharine Lorillard Wolfe Fund, from 1952; The Metropolitan Museum of Art, from 1952.

EXHIBITIONS: Paris, Galerie Paul Rosenberg, *Bonnard—Vuillard*, 1936, no. 41. Paris, Musée des Arts Décoratifs, *Exposition E. Vuillard*, May–June 1938, no. 180, as *Jardin à Vaucresson*. New York, World's Fair, French Pavilion, *Contemporary French Art*, 1939, no. 159, as *Le Clos Cézanne à Vaucresson*.

NOTES:

1. Jacques Salomon described the Château des Clayes as a baronial man-sion, although by the time the Hessels purchased it, only the small pavilion dating from the period of Henri IV, the royal entrance, and the garden park designed by André Le Nôtre remained, much of the royal residence having been destroyed during the French Revolution; see Jacques Salomon, *Auprès de Vuillard* (Paris, 1953), p. 85.

2. *Madame Descorps and Her Son in a Garden, Vaucresson* (1919; private collec-tion); see London 1991, p. 8 (ill.).

3. *Mme Descorps and Her Son in a Garden, Vaucresson* (note 2); *Sunny Morning* (1910; private collection, London), in Groom 1993, p. 200, pl. 321; *The Bassiano Children in a Garden* (1921; private collection), in New York, Christie's, *Impressionist and Modern Works on Paper*, sale cat. (13 May 1999), no. 187 (ill.); and *Woman in Gray in an Allée* (1914, reworked 1938; private collec-tion), in Lyons 1990, p. 193 (ill.).

4. Although the two panels seemingly depict different places, the fact that Jos Hessel exhibited them both in 1939 with "Clos Cézanne" in the title attests to their shared setting. For a photo-graph of *Morning in the Garden at Vaucresson* in the dining room of the Château des Clayes, see Romain Coolus, "Le Château des Clayes," *Renaissance* (July 1930), p. 191.

UNPUBLISHED SOURCES

COURT 1992
Court, Marie. "Vuillard: Les Années de jeunesse vues à travers les carnets de l'Institut." Unpub. thesis. Université Blaise Pascale, Clermont-Ferrand, 1992. Contains transcriptions of the following parts of Vuillard's journals, housed in the Bibliothèque de l'Institut de France, Paris: MS 5396 (*carnet* 1, 1890; *carnet* 2, 1890–1905).

MUSÉE MD
Archives of the Musée Départemental Maurice Denis "Le Prieuré," St.-Germain-en-Laye.

VUILLARD, JOURNALS
Edouard Vuillard's journals are housed in the Bibliothèque de l'Institut de France, Paris. They consist principally of MS 5396 (two *carnets*, 1890–1905); MS 5397 (nine *carnets*, 1907–16); MS 5398 (eleven *carnets*, 1916–22, 1924–26, and nine supplementary *carnets*, 1922–29); MS 5399 (thirteen *carnets*, 1929–40, and one supplementary *carnet*, 1940).

PUBLISHED SOURCES

BARAZZETTI-DEMOULIN 1945
Barazzetti-Demoulin, Suzanne. *Maurice Denis*. Paris, 1945.

BARRUEL 1992
Barruel, Thérèse. "Maurice Denis et Ernest Chausson: Correspondance inédite et catalogue des oeuvres de Denis ayant appartenu à Chausson." *Revue de l'art* 98 (1992), pp. 66–76.

BONNARD 1944
Bonnard, Pierre. *Correspondances*. Paris, 1944.

BOSTON 1998
Boston, Museum of Fine Arts. *Monet in the Twentieth Century*. Exh. cat. by Paul Hayes Tucker, George T. M. Shackelford, and Mary Anne Stevens. 1998.

BOUILLON 1985
Bouillon, Jean Paul. *Journal de l'art nouveau, 1870–1914*. Geneva, 1985.

BOUILLON 1993
Bouillon, Jean Paul. *Maurice Denis*. Geneva, 1993.

BOUVET 1981
Bouvet, Francis. *Bonnard: The Complete Graphic Work*. New York, 1981.

BRETTELL 1999
Brettell, Richard. *Monet to Moore: The Millenium Gift of Sara Lee Corporation*. Exh. cat. New Haven/London, 1999.

CHICAGO 1994
The Art Institute of Chicago. *Odilon Redon: Prince of Dreams, 1840–1916*. Exh. cat. by Douglas W. Druick et al. 1994.

CHIPP 1968
Chipp, Herschel B. *Theories of Modern Art*. Berkeley, 1968.

COGEVAL 1993
Cogeval, Guy. *Bonnard*. Paris, 1993.

DAUBERVILLE
Dauberville, Jean and Henry. *Bonnard: Catalogue raisonné de l'oeuvre peint*. Four vols. Paris, 1965 (vols. 1–3), 1974 (vol. 4). Revised by Michel and Guy Patrice Dauberville, 1992 (vol. 1).

DENIS 1890
Denis, Maurice. "Définition du néo-traditionnisme." *Art et critique* 65 and 66 (23 and 30 Aug. 1890), pp. 540–42, 556–58.

DENIS 1920
Denis, Maurice. *Théories, 1890–1910 . . . Du Symbolisme et de Gauguin vers un nouvel ordre classique*. Fourth edition. Paris, 1920.

DENIS 1932
Denis, Maurice. *Henry Lerolle et ses amis: Suivi de quelques lettres d'amis*. Paris, 1932.

DENIS, JOURNAL
Denis, Maurice. *Journal*. Three vols. Paris, 1957 (vols. 1–2), 1959 (vol. 3).

DENIS 1993
Denis, Maurice. *Le Ciel et l'arcadie*. Edited by Jean Paul Bouillon. Paris, 1993.

ESSEN 1993
Museum Folkwang Essen. *Morozov and Shchukin—The Russian Collectors*. Exh. cat. 1993.

FOSCA 1919
Fosca, François. *Bonnard*. Paris, 1919.

FRÈCHES-THORY 1986
Frèches-Thory, Claire. "Pierre Bonnard: Tableaux récemment acquis par le Musée d'Orsay." *Revue du Louvre* 36, 6 (1986), pp. 417–31.

FRÈCHES-THORY AND TERRASSE 1990
Frèches-Thory, Claire, and Antoine Terrasse. *Les Nabis: Bonnard, Vuillard and Their Circle.* Translated by Mary Pardoe. Paris, 1990.

GEFFROY 1892–1903
Geffroy, Gustave. *La Vie artistique.* Eight vols. Paris, 1892 (vol. 1), 1893 (vol. 2), 1894 (vol. 3), 1895 (vol. 4), 1897 (vol. 5), 1900 (vol. 6), 1901 (vol. 7), 1903 (vol. 8).

GIAMBRUNI 1983
Helen Emery Giambruni. *Early Bonnard, 1885–1900.* Ann Arbor, Mich., 1983.

GOLD AND FIZDALE 1980
Gold, Arthur, and Robert Fizdale. *Misia: The Life of Misia Sert.* New York, 1980.

GÖTTE 1982
Götte, Gisela. *Ker-Xavier Roussel, 1867–1944: Untersuchungen zu seiner Entwicklung vor Allem zum Verhältnis Frühwerk-Spätwerk.* Two vols. Bremen, 1982.

GROOM 1993
Groom, Gloria. *Edouard Vuillard: Painter-Decorator: Patrons and Projects, 1892–1912.* New Haven/London, 1993.

GUISAN AND JAKUBEC 1973–75
Guisan, Gilbert, and Doris Jakubec. *Félix Vallotton: Documents pour une biographie et pour l'histoire d'une oeuvre.* Three vols. Paris, 1973 (vol. 1), 1974 (vol. 2), 1975 (vol. 3).

GUISAN AND JAKUBEC 1975
Guisan, Gilbert, and Doris Jakubec, eds. "Félix Vallotton, Edouard Vuillard et leurs amis de *La Revue blanche*." *Etudes de lettres* 3, 8 (Oct.–Dec. 1975).

HAVARD 1887–90
Havard, Henry. *Dictionnaire de l'ameublement et de la décoration depuis le XIIe siècle jusqu'à nos jours.* Four vols. Paris, 1887–90.

HEILBRUN AND NÉAGU 1988
Heilbrun, Françoise, and Philippe Néagu. *Pierre Bonnard: Photographs and Paintings.* New York, 1988. English edition of *Bonnard photographe.* Exh. cat. Paris, Musée d'Orsay. 1988.

HOUSTON 1989
Houston, Museum of Fine Arts. *The Intimate Interiors of Edouard Vuillard.* Exh. cat. by Elizabeth Easton. 1989.

HYMAN 1998
Hyman, Timothy. *Bonnard.* London, 1998.

KOZLOFF 1958
Kozloff, Max. *Pierre Bonnard: From Impressionism to Abstraction.* Ann Arbor, Mich., 1958.

LAUSANNE 1991
Lausanne, Fondation de l'Hermitage. *Pierre Bonnard, 1867–1947.* Exh. cat. 1991.

LONDON 1991
London, South Bank Centre. *Vuillard.* Exh. cat. by Belinda Thomson. 1991.

LONDON 1994
London, Hayward Gallery. *Bonnard at Le Bosquet.* Exh. cat. 1994.

LONDON 1998
London, Tate Gallery. *Bonnard.* Exh. cat. by Sarah Whitfield and John Elderfield. 1998.

LUGNÉ-POË 1930
Lugné-Poë, Aurélien. *La Parade I: Le Sot du tremplin: Souvenirs et impressions du théâtre.* Paris, 1930.

LYONS 1990
Lyons, Musée des Beaux-Arts. *Vuillard.* Exh. cat. by Ann Dumas and Guy Cogeval. 1990.

LYONS 1994
Lyons, Musée des Beaux-Arts. *Maurice Denis, 1870–1943.* Exh. cat. 1994.

MARTIGNY 1999
Martigny, Switzerland, Fondation Pierre Gianadda. *Bonnard.* Exh. cat. by Jean Louis Prat. 1999.

MATHIEU 1990
Mathieu, Pierre Louis. *The Symbolist Generation, 1870–1910.* New York, 1990.

MAUNER 1978
Mauner, George. *The Nabis: Their History and Their Art, 1888–1896.* New York, 1978.

MEIER-GRAEFE 1908
Meier-Graefe, Julius. *Modern Art: Being a Contribution to a New System of Aesthetics.* Translated by Florence Simmonds and George W. Chrystal. London/New York, 1908.

MONTREAL 1998
Montreal Museum of Fine Arts. *The Time of the Nabis.* Exh. cat. 1998.

NATANSON 1951
Natanson, Thadée. *Le Bonnard que je propose.* Paris, 1951.

NEW BRUNSWICK 1988
New Brunswick, N.J., Jane Voorhees Zimmerli Art Museum. *The Nabis and the Parisian Avant-Garde.* Exh. cat. by Patricia Eckert Boyer. 1988.

NEW YORK 1989
New York, The Metropolitan Museum of Art. *Pierre Bonnard: The Grapic Art.* Exh. cat. by Colta Ives, Helen Giambruni, and Sasha M. Newman. 1989.

NEW YORK 1994
New York, The Museum of Modern Art. *Masterpieces from the David and Peggy Rockefeller Collection: Manet to Picasso.* Exh. cat. by Kirk Varnedoe. 1994.

PARADISE 1985
Paradise, JoAnne. *Gustave Geffroy and the Criticism of Painting.* Ann Arbor, Mich., 1985.

PARIS 1968
Paris, Orangerie des Tuileries. *Edouard Vuillard—K.-X. Roussel.* Exh. cat. 1968.

PARIS 1984
Paris, Musée National d'Art Moderne. *Bonnard*. Exh. cat. 1984. Also published in English with some variations in content: see Washington, D.C. 1984b.

PARIS 1986
Paris, Musée du Petit Palais. *Le Triomphe des mairies: Grand Décors républicains à Paris, 1870–1914*. Exh. cat. 1986.

PARIS 1990
Paris, Huguette Berès. *Au temps des Nabis*. Exh. cat. 1990.

PARIS 1993
Paris, Galeries Nationales du Grand Palais. *Nabis, 1888–1900*. Exh. cat. by Claire Frèches-Thory and Ursula Perucchi-Petri. 1993. All references in this book are to this edition. Also published in German: Kunsthaus Zürich. *Die Nabis: Propheten der Moderne*. 1993.

PERUCCHI-PETRI 1976
Perucchi-Petri, Ursula. *Die Nabis und Japan: Das Frühwerk von Bonnard, Vuillard und Denis*. Munich, 1976.

PISSARRO, *CORRESPONDANCE*
Pissarro, Camille. *Correspondance de Camille Pissarro*. Edited by Janine Bailly-Herzberg. Five vols. Paris, 1980 (vol. 1), 1986 (vol. 2), 1988 (vol. 3), 1989 (vol. 4), 1991 (vol. 5).

REFF 1981
Reff, Theodore, ed. *Salons of the "Indépendants," 1892–1895*. New York/London, 1981.

REWALD 1949
Rewald, John. "Excerpts from the Unpublished Diary of Paul Signac, I, 1894–1895." *Gazette des beaux-arts* 91, 6, 36 (July–Sept. 1949), pp. 97–128, 166–74.

REWALD 1953
Rewald, John. "Excerpts from the Unpublished Diary of Paul Signac, III, 1898–1899." *Gazette des beaux-arts* 95, 6, 42 (July–Aug. 1953), pp. 27–57, 72–80.

REWALD 1962
Rewald, John. *Post-Impressionism: From Van Gogh to Gauguin*. New York, 1962.

REWALD 1972
Rewald, John, ed., with the assistance of Lucien Pissarro. *Camille Pissarro: Letters to His Son Lucien*. Mamaroneck, N.Y., 1972.

ROCHESTER 1984
Memorial Art Gallery of the University of Rochester. *Artists of La Revue blanche*. Exh. cat. by Bret Waller and Grace Seiberling. 1984.

ROGER-MARX 1946
Roger-Marx, Claude. *Vuillard: His Life and Work*. Translated by E. B. D'Auvergne. London, 1946.

ROUSSEL 1967
Jacques Roussel. *K. X. Roussel*. Foreword by Günter Busch. Paris, 1967.

RUSSELL 1971
Russell, John. *Vuillard*. London, 1971.

ST.-GERMAIN-EN-LAYE 1980
St.-Germain-en-Laye, Musée Départemental du Prieuré. *Symbolistes et Nabis: Maurice Denis et son temps*. Exh. cat. 1980.

ST.-GERMAIN-EN-LAYE 1994
St.-Germain-en-Laye, Musée Départemental Maurice Denis "Le Prieuré." *K. X. Roussel, 1867–1944*. Exh. cat. by Agnès Delannoy. 1994.

ST.-GERMAIN-EN-LAYE 1997
St.-Germain-en-Laye, Musée Départemental Maurice Denis "Le Prieuré." *Lumières de sable: Plages de Maurice Denis*. Exh. cat. by Agnès Delannoy. 1997.

ST.-GERMAIN-EN-LAYE 1999
St.-Germain-en-Laye, Musée Départemental Maurice Denis "Le Prieuré." *Maurice Denis: La Légende de Saint Hubert, 1896–1897*. Exh. cat. 1999.

ST.-TROPEZ 1993
L'Annonciade, Musée de St.-Tropez. *K. X. Roussel*. Exh. cat. 1993.

SALOMON 1968
Salomon, Jacques. *Vuillard*. Foreword by John Rewald. Paris, 1968.

SCHÄFER 1997
Schäfer, Carina. *Maurice Denis et le comte Kessler 1902–1913*. Publications Européenes Universitaires, Histoire de l'Art, series 28, vol. 309. Frankfurt, 1997.

SEGARD 1914
Segard, Achille. *Peintres d'aujourd'hui: Les Décorateurs*. Two vols. Paris, 1914.

SILVER 1989
Silver, Kenneth E. *Esprit de Corps: The Art of the Parisian Avant-Garde and the First World War, 1914–1925*. Princeton, N.J., 1989.

SILVERMAN 1989
Silverman, Debora L. *Art Nouveau in Fin-de-Siècle France: Politics, Psychology, and Style*. Berkeley, 1989.

STUMP 1972
Stump, Jeanne. *The Art of Ker Xavier Roussel*. Ann Arbor, Mich., 1972.

TERRASSE 1988
Terrasse, Antoine. *Pierre Bonnard*. Paris, 1967. Reprint: Paris, 1988.

THOMSON 1988
Thomson, Belinda. *Vuillard*. Oxford, 1988.

VERKADE 1930
Verkade, Dom Willibrord, O.S.B. *Yesterdays of an Artist-Monk*. Translated by John L. Stoddard. New York/London, 1930.

WASHINGTON, D.C. 1984A
Washington, D.C., National Gallery of Art. *The Folding Image: Screens by Western Artists of the Nineteenth and Twentieth Centuries.* Exh. cat. by Michael Komanecky and Virginia Fabbri Butera. 1984.

WASHINGTON, D.C. 1984B
Washington, D.C., The Phillips Collection. *Bonnard: The Late Paintings.* Exh. cat. 1984. Also published in French with some variations in content: see Paris 1984.

WATKINS 1994
Watkins, Nicholas. *Bonnard.* London, 1994.

WATKINS 1997
Watkins, Nicholas. *Interpreting Bonnard: Color and Light.* New York, 1997.

WEISBERG 1986
Weisberg, Gabriel P. *Art Nouveau Bing: Paris Style 1900.* New York, 1986.

WERTH 1930
Werth, Léon. *K. X. Roussel.* Paris, 1930.

PUBLIC INSTITUTIONS

FRANCE
Musée Départemental de l'Oise, Beauvais: cat. 70
Musée des Arts Décoratifs, Paris: cat. 10
Musée d'Orsay, Paris: cat. 5, 15, 26
Musée Départemental Maurice Denis "Le Prieuré,"
St.-Germain-en-Laye: cat. 14, 20, 21, 24, 44

GERMANY
Staatliche Museen zu Berlin, Nationalgalerie: cat. 59
Kunsthandel Wolfgang Werner, Bremen/Berlin, and
Kunsthandel Sabine Helms, Munich: cat. 76, 77
Kunstsammlung Nordrhein-Westfalen, Düsseldorf:
cat. 58
Staatliche Kunsthalle Karlsruhe: cat. 40
Staatsgalerie Stuttgart: cat. 71

JAPAN
Ikeda Museum of Twentieth-Century Art, Ito: cat. 45
Bridgestone Museum of Art, Ishibashi Foundation,
Tokyo: cat. 63
The National Museum of Western Art, Tokyo: cat. 54
Pola Museum, Tokyo: cat. 8, 9

NETHERLANDS
Kröller-Müller Museum, Otterlo: cat. 12

RUSSIA
The State Hermitage Museum, St. Petersburg:
cat. 50, 64

SWITZERLAND
Fondation d'Art du Docteur Rau, Embrach-
Embraport: cat. 13
Musée Cantonal des Beaux-Arts, Lausanne: cat. 60
Kunsthaus Zürich: cat. 2, 3, 43

UNITED KINGDOM
Neffe-Degandt, London: cat. 67, 68
Southampton City Art Gallery: cat. 4

UNITED STATES
The Baltimore Museum of Art: Watkins, fig. 7
The Art Institute of Chicago: cat. 41, 52, 84
The Cleveland Museum of Art: cat. 33
The Armand Hammer Collection, UCLA, at the
Armand Hammer Museum of Art and Cultural
Center, Los Angeles: cat. 75
The J. Paul Getty Museum, Los Angeles: cat. 46
Los Angeles County Museum of Art: cat. 42
Milwaukee Art Museum: cat. 72
The Metropolitan Museum of Art, New York: cat. 35,
57, 83, 85
The Museum of Modern Art, New York: cat. 36
Solomon R. Guggenheim Museum, New York: cat.
78, 79
Carnegie Museum of Art, Pittsburgh: cat. 30
Virginia Museum of Fine Arts, Richmond: cat. 7
The Toledo Museum of Art: cat. 56
National Gallery of Art, Washington, D.C.: cat. 39, 80
The Phillips Collection, Washington, D.C.: cat. 55

PRIVATE COLLECTORS
Mr. and Mrs. Arthur G. Altschul, New York: cat. 11
Grace Hokin, Palm Beach, Florida: cat. 73, 74
Tom James Co./Oxxford Clothes: cat. 1, 17, 18, 32
Joan and Nathan Lipson, Atlanta, Georgia: cat. 48, 49
Collection Paule and Adrien Maeght, Paris: cat. 47
Private collection, courtesy Galerie Bernheim-Jeune,
Paris: cat. 53
Private collection, courtesy Galerie Bernheim-Jeune,
Paris: cat. 82
Private collection, courtesy Galerie Hopkins-Thomas-
Custot, Paris: cat. 29
Private collection, courtesy Nancy Whyte Fine Arts:
cat. 37
Anonymous lenders: Watkins, fig. 19; cat. 6, 6a, 16, 19,
22, 23, 25, 27, 28, 31, 34, 38, 61, 62, 65, 66, 69, 81;
Claude Monet, *Vase of Dahlias*, 1883, oil on panel,
128.3 x 37.1 cm (hors cat.); and Gustav Stickley,
Directors' Table, c. 1903, oak, 75.6 x 243.2 x 138.4 cm
(hors cat.).

PHOTOGRAPHY CREDITS

Nicholas Watkins, "The Genesis of a Decorative Aesthetic"
Fig. 2: © Photo RMN—R.G. Ojeda; fig. 3: © Photothèque des Musées de la Ville de Paris, Photograph by Pierrain; fig. 5: © 1989 The Art Institute of Chicago, all rights reserved; fig. 6: photograph © 1994, The Art Institute of Chicago, all rights reserved; fig. 7: The Baltimore Museum of Art, BMA 1972.79.34; fig. 8: Photograph—Bibliothèque Nationale de France; fig. 9: © Crown copyright. NMR; figs. 12, 22: © Photo RMN; fig. 14: © Photo RMN—Hervé Lewandowski; fig. 17: © Photo RMN—Jean Schormans; fig. 20: BF #719 © Reproduced with the Permission of The Barnes Foundation™, all rights reserved; fig. 23: photograph © 1998, The Art Institute of Chicago, all rights reserved; fig. 24: © Estate of Roy Lichtenstein

Gloria Groom, "Coming of Age: Patrons and Projects, 1890–99"
Fig. 4: © Christie's Images New York; fig. 5: Photograph—Bibliothèque Nationale de France; fig. 7: © Photothèque des Musées de la Ville de Paris, Photograph by Pierrain; figs. 16–18: © Le Musée Départemental du Prieuré, St.-Germain-en-Laye; figs. 20, 21: © Photothèque des Musées de la Ville de Paris, Photograph by Pierrain

Catalogue entries 1–42
Cat. 2, 3: © 1998 by Kunsthaus Zürich, all rights reserved; cat. 2–3, fig. 2: Photograph by Malcolm Varon, N.Y.C., © 2000; cat. 2–3, figs. 3, 4: © 2000 Kunsthaus Zürich, all rights reserved; cat. 4: Southampton City Art Gallery, Hampshire, UK/Bridgeman Art Library; cat. 4, fig. 2: © Sterling and Francine Clark Art Institute, Williamstown, Massachusetts; cat. 5: © Photo RMN; cat. 5, fig. 1: © Christie's Images New York; cat. 6: Photograph by Michael Tropea; cat. 6, fig. 1: Photograph by Malcolm Varon, N.Y.C., © 2000; cat. 8, 9: Courtesy of Galerie Nichido, Tokyo; cat. 7–9, fig. 1: © Photo RMN—Gérard Blot; cat. 10: Musée des Arts Décoratifs, Paris, L. Sully Jaulmes, all rights reserved; cat. 10–13, fig. 2: Petit Palais—Musée d'Art Moderne—Genève, Photograph by Studio Monique Bernaz, Geneva; cat. 14 and cat. 14, figs. 1–2: © Le Musée Départemental du Prieuré, St.-Germain-en-Laye; cat. 15: © Photo RMN—H. Lewandowski; cat. 15, fig. 1: Département de la Réunion, Photograph by Jacques Kuyten; cat. 15, fig. 2: © Christie's Images New York; cat. 17, 18: © 2000 The Art Institute of Chicago, all rights reserved. Photographed by Greg Williams; cat. 20, 21, 24 and cat. 19–24, figs. 1, 7, 9–11: © Le Musée Départemental du Prieuré, St.-Germain-en-Laye; cat. 19–24, fig. 3: Catalogue Raisonné Maurice Denis © Denis family; cat. 19–24, fig. 4: Bildarchiv Foto Marburg, Archive no. 606.212; cat. 25: Catalogue Raisonné Maurice Denis © Denis family; cat. 25, fig. 3: Lauros-Giraudon; cat. 26: © Photo RMN—Hervé Lewandowski; cat. 28, fig. 2: © Musée des Beaux-Arts de Rouen, Photograph by Didier Tragin/Catherine Lancien; cat. 31, fig. 2: © Musée des Beaux-Arts de la Ville de Reims; cat. 32: Courtesy of Galerie Bellier, Paris; cat.

33: © The Cleveland Museum of Art, 2000; cat. 32–33, fig. 1: Musées Royaux des Beaux-Arts de Belgique, Bruxelles—Koninklijke Musea voor Schone Kunsten van België, Brussel; cat. 35: Photograph © 1994 The Metropolitan Museum of Art; cat. 36: © 2000 The Museum of Modern Art, New York; cat. 39: © 1999 Board of Trustees, National Gallery of Art, Washington; cat. 40, fig. 2: © 1993 The Art Institute of Chicago, all rights reserved; cat. 41: © 1990 The Art Institute of Chicago, all rights reserved; cat. 42: © 2000 Museum Associates/LACMA; cat. 42, fig. 3: Bildarchiv Foto Marburg, Archive no. 615.236

Gloria Groom, "Into the Mainstream: Decorative Painting, 1900–30"
Fig. 1: Collection of the McNay Art Museum, Photograph by Steven Tucker; fig. 2: © Photo RMN; fig. 3: © Photo RMN—Hervé Lewandowski; fig. 5: © 2000 The Museum of Modern Art, New York; fig. 14: Photographer: Image Source, 9/99 #2; fig. 16: © 1960 The Dayton Art Institute

Catalogue entries 43–85
Cat. 43: © 1998 by Kunsthaus Zürich, all rights reserved; cat. 43, fig. 1: © RMN; cat. 44: © Le Musée Départemental du Prieuré, St.-Germain-en-Laye; cat. 44, fig. 2: © RMN; cat. 47: © Photo Galerie Maeght; cat. 45–47, fig. 1: © Photo RMN—Hervé Lewandowski; cat. 48–49, fig. 2: © Photothèque des Musées de la Ville de Paris; cat. 51: Národní Galerie, Prague, Photograph by M. Sosková; cat. 51, fig. 1: J. Lathion © Nasjonalgalleriet 2000; cat. 51, fig. 2: © 2000 Museum Associates/LACMA; cat. 52: © 1997, The Art Institute of Chicago, all rights reserved, Photograph by Greg Williams; cat. 52–54, fig. 2: © 1994, The Art Institute of Chicago, all rights reserved; cat. 55, fig. 1: © RMN—Reversement Orsay; cat. 57: Photograph © 1980 The Metropolitan Museum of Art; cat. 57, fig. 1: Tate Gallery, London/Art Resource, NY; cat. 58: © Walter Klein, Düsseldorf; cat. 59: © bpk, Berlin, 2000 (Photo: Karin März, 1999, Staatliche Museen zu Berlin); cat. 60: Musée Cantonal des Beaux-Arts de Lausanne, Photograph by J. C. Ducret; cat. 60, fig. 2: © Photothèque des Musées de la Ville de Paris, Photograph by Pierrain; cat. 61–62, fig. 2, and cat. 63, fig. 1: Petit Palais—Musée d'Art Moderne—Genève, Photograph by Studio Monique Bernaz, Geneva; cat. 63, fig. 2: © RMN—R.G. Ojeda; cat. 65, 66: Courtesy of Musée de l'Annonciade, St.-Tropez, Photograph by P. S. Azema; cat. 65–66, fig. 1: © Photo RMN; cat. 69: Courtesy of Musée de l'Annonciade, St.-Tropez, Photograph by P. S. Azema; cat. 70: © Photo-Contact, Beauvais; cat. 71, fig. 2: © 2000 Kunsthaus Zürich, all rights reserved; cat. 73–74, fig. 1: Photograph by Malcolm Varon, N.Y.C., © 2000; cat. 73–74, fig. 2: Photograph by Charles Uht; cat. 75: Photograph by Robert Wedemeyer; cat. 78, 79: Photograph by David Heald, © The Solomon R. Guggenheim Foundation, New York (FN 78.2514 T74.a–b); cat. 75–79, fig. 1: Photograph by Malcolm Varon, N.Y.C., © 2000; cat. 75–79, fig. 2: Photograph by Charles Uht; cat. 80: © 1999 Board of Trustees, National Gallery of Art, Washington, Photograph by Lyle Peterzell; cat. 81, fig. 2: Photograph by Charles Choffet; cat. 82: Courtesy of Sotheby's; cat. 83, 85: Photograph © 2000 The Metropolitan Museum of Art

Biographies
Denis, fig. 2: © Photo RMN—H. Lewandowski; Vuillard, fig. 1: © RMN—P. Schmidt